ANDREW MARTINDALE

THE TRIUMPHS OF CAESAR
BY ANDREA MANTEGNA
IN THE COLLECTION OF HER MAJESTY THE QUEEN
AT HAMPTON COURT

Frontispiece. Detail of Canvas VI

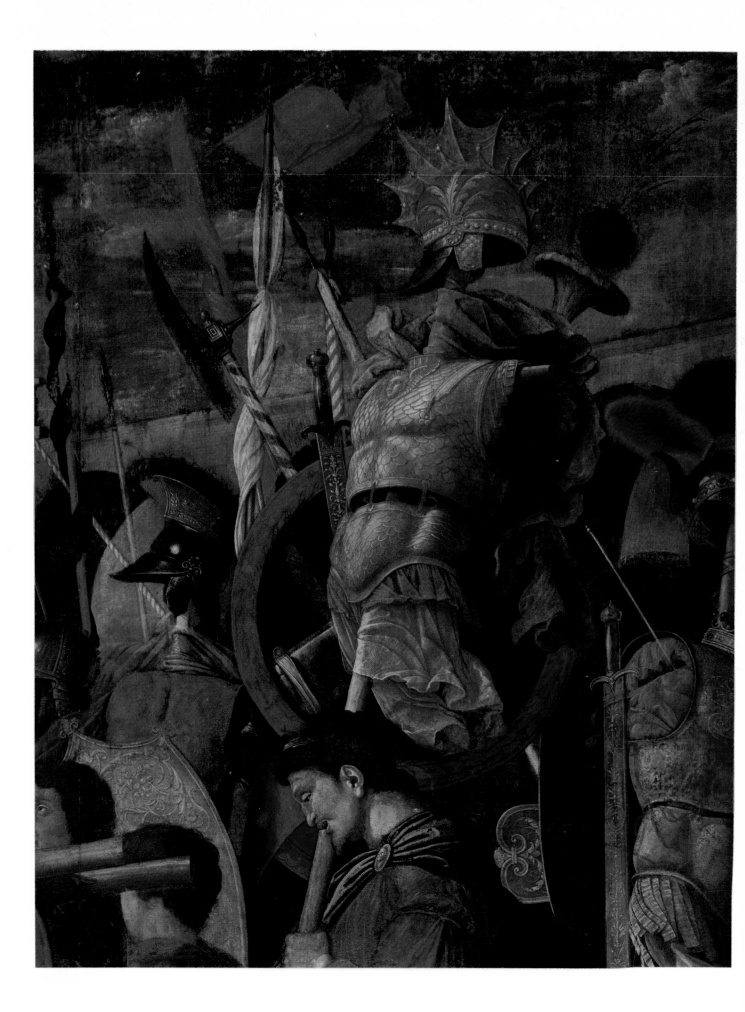

THE TRIUMPHS OF CAESAR

BY ANDREA MANTEGNA

IN THE COLLECTION OF
HER MAJESTY THE QUEEN
AT HAMPTON COURT

BY ANDREW MARTINDALE

WITH A FOREWORD
BY SIR ANTHONY BLUNT

HARVEY MILLER PUBLISHERS ∽ LONDON

Published by Harvey Miller · 20 Marryat Road · London SW19 5BD · England

Distribution: Heyden & Son Ltd., Spectrum House, Hillview Gardens, London NW4 2JQ, England; 247 South 41st St., Philadelphia PA 19104, USA; Münsterstrasse 22, 4440 Rheine/Westf., Germany.

The reproduction in this Catalogue
of paintings in the Royal Collection
is by gracious permission of Her Majesty the Queen

ISBN 0 905203 16 x

Printed by R & R Clark Ltd., Hopetoun Street, Edinburgh, Scotland
Black and white illustrations originated by Quantock Studio, Orpington, Kent, England
Colour illustrations originated by Schwitter AG, Basle, Switzerland

CONTENTS

Roberti Burn
Andreae Ewbank Burn
et Andreae Roberti Burn

 Exemplo

Johannis Wilde
Christopherique Hohler

 Praeceptis

Foreword by Sir Anthony Blunt

WHEN I WAS appointed Surveyor of Pictures to King George VI in 1945, one of my first concerns was to examine the condition of the nine canvases composing Mantegna's *Triumphs of Caesar* which had been enclosed during the war in a protective shelter and were being taken out and replaced in the setting in the Lower Orangery at Hampton Court prepared for them, in 1935, by my predecessor C. H. Collins Baker with the help of Kennedy North. I had known and loved the pictures from childhood, but had always realized that owing to what they had suffered at the hands of time and unwise restorers very little—if anything—of Mantegna's original paint was visible and, though Kennedy North's restoration saved the paintings from further flaking, the wax which he used had soon become opaque and, further, the frontal lighting in the Orangery caused more reflection than illumination.

The chances of improving the condition of the canvases seemed almost nil; so much time, money and scientific ingenuity had been spent on them with such meagre results that it seemed hopeless to make a new attack. The question of better presentation seemed almost equally difficult. The nine canvases, each nine foot square and needing to be shown as a series on a single wall, demanded a room nearly a hundred feet long, and, although galleries of that length exist in the palace of Hampton Court itself, they would all have had the frontal lighting that had been so disastrous in the Lower Orangery. The best that could be done, it seemed, was to control the lighting as far as possible by the use of Venetian blinds which could be used to black out individual windows and so control the reflections produced on a particular canvas. This was obviously an uncomfortable compromise, but a satisfactory solution seemed unattainable. Some years later John Brealey—who had worked as a restorer on the pictures at Petworth, in the Gambier-Parry Collection at Highnam Court and on individual pictures in the Royal Collection—hinted that we ought to try again.

After a careful examination of the paintings in collaboration with Stephen Rees Jones of the Technology Department of the Courtauld Institute, Brealey began on the incredibly delicate and difficult task of bringing the paintings back to life.

The first process was relatively simple; it consisted in thinning down the wax on the surface of the paintings, leaving only the thin layer necessary for the actual safety of the pigment. The second stage, removal of the old repaints, was far more complicated; because Mantegna's tempera is soft and vulnerable to even quite mild solvents. A variety of technical methods, controlled by great caution and sensitivity, however, enabled Brealey to take off the work of previous restorers from Laguerre to Roger Fry and to reveal all that was left of Mantegna's original paint. Where, however, tests or examination by X-ray showed that nothing appeared to be left under the repaints, these were not removed, but were toned down wherever—as was quite often the case—Laguerre's colours were too strident to be tolerable. In the case of one canvas, *The Captives*, tests showed that there appeared to be almost no original paint left under the repaints and it was decided not to proceed with the cleaning. It is now hung on a separate wall near the entrance to

the gallery and gives a good idea of what the other paintings looked like before they were cleaned.

Once the repaints were removed from the eight canvases on which cleaning was possible the question arose how far they should be 'restored'. It would, of course, have been theoretically possible to touch in every minute abrasion but, apart from the immense time that such an operation would have taken, it was felt that this would mean falsifying the effect of the paintings and it was thought better to do the minimum of inpainting and to leave what remained of Mantegna's paint to speak for itself. The *Triumphs* may be a ruin but it is a noble one, as noble as those of ancient Rome which Mantegna so deeply admired.

In the course of the restoration it became clear that Kennedy North's relining canvases were coming loose from the old canvases and were causing dangerous and disfiguring sagging, and it was therefore decided to reline the paintings—all but one (Canvas IV) the canvas of which was holding firmly and not causing the picture to bulge. In the process of relining, the canvases used in the late seventeenth-century relining, which were beginning to rot, were also removed. Fortunately Mantegna's original support, which consisted of a canvas so fine that it is almost like linen, was still in perfect condition so that the later layers could be pulled off it without the slightest risk of damage.

The result of Brealey's work was beyond my highest hopes. Although the surfaces of all the canvases had suffered hundreds of minute losses of paint in the earlier relinings, and though in many areas Mantegna's pigment had disappeared almost completely, far more of the original had survived than anyone had supposed before the removal of the repaints was begun. As was so often the case the old restorers had found it quicker and easier to repaint whole areas rather than touch in the minute damages or abrasions. The result was that in some cases such as the *Vase Bearers* and the *Elephants* the paintings survived in a state which enabled one to form a clear, almost complete, idea of the artist's original intention, and in the other, less well preserved canvases superb details and often whole figures emerged in reasonable condition. The result was that a series of masterpieces which had been regarded by most art-historians as lost for ever were resuscitated and preserved for future generations.

There remained the question of presentation. Search for alternative accommodation in one or other of the royal palaces proved fruitless and the construction of a completely new gallery was prohibitively expensive. It was therefore necessary to see whether the Lower Orangery could be adapted in such a way as to provide better lighting and adequate protection against the alarming changes in temperature which occurred particularly in the summer months. The Ministry of Works (later to become the Department of the Environment) were as anxious as we were to find a solution but the problem was not easy, since it had to be done without disfiguring the appearance of the building which is a fine red brick structure dating from the reign of Queen Anne. Brealey and I were determined to have natural top lighting—supported as necessary by artificial lighting—and this involved alterations to the roof of the building. In addition it was essential to widen the Orangery to allow the spectator to view the paintings at a greater distance than the eighteen feet allowed in the structure as it stood.

After several attempts the Ministry architect, Mr Peter Holland, produced a design which

included the moving of the back wall of the Orangery so that it was as near as possible to the Tudor wing behind it—thus giving us an extra depth of nearly ten feet—and the reconstruction of the north slope of the roof so that lay-lights could be inserted over the newly gained space to provide strong natural illumination for the pictures. At the same time the windows on the south wall of the Orangery were blocked up to cut out the reflections and were filled with non-conducting material to prevent them from heating up the air in the room itself. Fortunately these alterations could be made without the view of the exterior of the Orangery being affected from any point, save from one or two of the former Grace and Favour apartments which were in any case destined to be transformed into a new range of air-conditioned rooms for the display of pictures. Internally the Orangery was divided into three sections: a long middle room in which the pictures were hung in a single row along the north wall, and two smaller rooms, one at the west end forming an ante-room to the gallery, the other containing the exit passage and the apparatus needed for controlling the temperature and humidity of the main gallery.

The last problem to be settled was how the pictures were actually to be displayed. Originally we hoped to be able to put them in an architectural setting with pilasters standing between the canvases and carrying an entablature, which was probably the way Mantegna himself wanted them to be shown and certainly how they were displayed when they were first described in the early part of the sixteenth century, but this scheme had to be abandoned for two reasons. First it would have been difficult to find craftsmen skilled enough to design and carve decorated pilasters of the kind we wanted, based on those which Mantegna introduced into some of his paintings and which appear on some of the early engravings after the *Triumphs*, and, furthermore, constructions of this type almost invariably look dated after the lapse of time—as for instance is the case with the rich Quattrocento-type frames which were fashionable in the last decades of the nineteenth century. The other reason was, however, more powerful—even decisive: in order to avoid reflection from the top light it was necessary to hang the canvases sloping slightly forward and this could not be combined with an architectural setting, since the canvases would appear at an angle to the pilasters which obviously could not be tilted. We were therefore forced to decide that the pictures must be given separate frames, as had been the case before they were put into the Orangery. These frames were designed—by Mr Paul Levy—so as to be as inconspicuous as possible in their skilfully dulled gold and to be of such a size that the combined width of two frames and the narrow space which separated any pair of pictures provided what seems to be the interval intended by Mantegna between one canvas and the next.

In order to soften the monotony of the long wall opposite the paintings, which was no longer broken up by the light of the windows, a series of busts of Roman Emperors, which had been in the Royal Collection since the early eighteenth century, were set up between the windows on wooden pedestals painted to simulate yellow marble. In addition to this the Trustees of the British Museum generously lent a magnificent late Roman battle sarcophagus, so the decoration of the gallery was completed by a series of sculptures of precisely the type that Mantegna would have admired. The ante-room was filled with further sculpture, partly from the Royal Collection and partly from the British Museum, and to

this were added tubs with trees, to remind visitors of the original function of the building.

The obligations incurred in the carrying out of this project are so many that it would be impossible to acknowledge them all adequately.

In the search for a suitable place to show the *Triumphs* members of the Department of the Environment were consistently helpful and inventive of ideas, some of which proved in the end not to be practicable. In the last stage, the actual remodelling of the Lower Orangery, Mr Peter Holland was prevented by illness from seeing his plans through to completion. He was replaced by Mr John Thorneycroft, who showed both skill and enthusiasm in working out the final details of the scheme, including the installation of the pictures and the sculpture and the painting of the wall behind the *Triumphs* to the exact tone demanded by Mr Brealey—a crucial element in the whole presentation. Both Mr Holland and Mr Thorneycroft were working under the general direction of Mr Harold Yexley.

But our greatest obligation is to John Brealey for providing the original stimulus to embark on the venture and for carrying out the vital part of it. Without his vision it would never have been started; without his skill the actual restoration would never have been carried out; and without his blind faith that everything would come out all right in the end and that somehow the obstacles—expected and unexpected—would be overcome we should all have been tempted on many occasions to abandon the whole scheme in despair. His patience and ingenuity in finding new methods of removing a repaint which had resisted all normal treatment, his inventiveness in overcoming the difficulties involved in relining canvases of this size—and above all his passionate devotion to the paintings themselves—must be recorded since I am probably the only person who witnessed their full range and intensity. But I think that he would agree that the result justified the travail.

In the later stages of the restoration he received valuable help from Miss Joan Seddon and throughout the operation he was able to rely on the devoted assistance of Mr William Watson, the Superintendent of the Royal Collection at Hampton Court. The restoration was mainly carried out in the Queen's Guard Room and Presence Chamber in Hampton Court Palace, but for a period of three years, from 1963 to 1966, owing to the kindness of the Director, Sir Norman Reid, accommodation was provided in rooms normally used for the storage of pictures at the Tate Gallery.

Author's Preface

SIR ANTHONY BLUNT, then Surveyor of the Queen's Pictures, invited me to write this book in 1962. At that time, when the cleaning of the *Triumphs of Caesar* was just about to be taken in hand by Mr John Brealey and the reconstruction of the Orangery was already being considered, the moment seemed to have come both to provide a long overdue monograph on the paintings and to give Mantegna's work its place in the general series of catalogues of the Royal Collection. At this early stage, the book was planned as a collaborative effort between Sir Anthony and myself and it is a source of regret to me that Sir Anthony's other commitments forced him to relinquish this idea. The book has taken an inordinately long time to prepare partly because it became a single-handed task attended to in the midst of a full academic life. But as the work proceeded, it also became clear that far more investigation would be needed into the early history of the paintings and that the whole enquiry possessed complications of which I had only the smallest inkling when I began the work. Some of this stems from the paucity of historical documentation about the paintings; but much of it derives from the inherent interest of these works. The ramifications of their study in fact reach out into almost every aspect of Mantegna's painting and every period of his life and it was sometimes difficult to resist the temptation to write a full-scale monograph on the artist with the *Triumphs of Caesar* as its centre point. As it is, the present extended treatment will be seen, I hope, to reflect the genius of Mantegna rather than the misplaced ingenuity of the author. It is the natural hope of any writer embarking on a study such as the present one that problems which have baffled others will yield to him—or, to put it more picturesquely, that the walls of Jericho are only waiting for his particular trumpet. In my case they were not; which is why this book suggests possibilities rather than solutions.

There were several areas where it had seemed to me that some progress in the study of the *Triumphs of Caesar* might have been possible. First, there were the archives. When I started work it became clear almost at once that it was virtually impossible, reading the pages of Luzio and others, to tell exactly who had been through what documents. It seemed therefore that a systematic search through as many relevant archives as possible might yield information overlooked by previous scholars. This I did in the *Archivio di Stato* at Mantua, concentrating particularly on the years 1470–1520. Here I was extremely fortunate to find that Professor Clifford M. Brown of Carleton University, Ottawa, had already spent many months in the archives there, working on this period. The results of his search are gradually being published, but he very kindly let me have in advance his findings in as far as they affected my work. Together we have augmented the stock of early references to the *Triumphs*; and, although the results may seem meagre, I now feel far more certain that there is nothing left to be found in Mantua about these paintings during this period. It is true that letters do get misfiled, and something may turn up in a totally unexpected place. But further discoveries are likely to come from archives outside Mantua.

Next, there was the elucidation of the fifteenth-century topography of the palace. I had

hoped that it would be possible to establish the original home of the paintings. However, I had not realized before going to Mantua how complicated is the early history of the Palace; and how so very much of the early building has been obscured by the alterations of the sixteenth, seventeenth and eighteenth centuries. In my opinion, the only complex of early buildings large enough to house the *Triumphs* is the so-called *Corte* opposite the Duomo. As a result of my work in the archives, I am now much clearer about the use to which the *Corte* was put during the period and about the internal disposition of the rooms. More work along the same lines will certainly produce more complete answers, but I am not yet able to enlarge on the subject in detail.

The third area of hope lay in the results of the recent restoration of the paintings. I had hoped that the minute examination necessary to the work might also reveal something about the sequence of the painting. It has merely shown that there are no detailed technical differences between the canvases. All were painted with that meticulous thoroughness which is the hall-mark of Mantegna's style.

Many people have contributed to this book. In particular, Mrs Jean Sampson did a great deal of research for the fifth chapter ('The *Triumphs of Caesar* and Classical Antiquity'). Without this extensive help, this chapter would have been very much less informative, and many of the useful detailed observations about classical prototypes are hers. My first thanks must go to her. It is a matter of great personal regret to me that Professor Donald Strong did not live to see this book published. He showed great interest in the subject and there is much in the results which would have interested and, I hope, amused him.

In Mantua, I received help all round. I am greatly indebted to Professor Giovanni Paccagnini, then *Soprintendente*, who promptly made it possible for me to see at leisure all that I wished in the Palazzo Ducale. He also gave me his own views on the *Triumphs*, in advance of his book on the Palazzo Ducale (which has since been published). My work in the *Archivio di Stato* was made easier by the swift service from the staff, then under the direction of the Avvocato Gianbattista Pascucci. Finally, I should like to thank Signorina Doriana Dall'Aglio of the *Ente Provinciale del Turismo* for patiently listening to various problems that arose while I was in Mantua, and for her help.

In England, I received much technical advice and help from Mr Stephen Rees Jones of the Courtauld Institute of Art; and I had many instructive conversations with Mr John Brealey, while he was working on the paintings. Indeed, I should like to record the exhilarating combination of enthusiasm and friendliness with which he met my frequent enquiries; and the patience with which he offered me the benefit of his own professional knowledge and insight. This benefit will be apparent particularly in the Catalogue. Sir Oliver Millar, Surveyor of the Queen's Pictures, was very helpful in placing the considerable bibliographical and archival resources of the Lord Chamberlain's Office at my disposal. I should particularly like to acknowledge the use I have made of Sir Oliver's own research amongst the Lord Chamberlain's Papers in the Public Record Office, London. My many friends and colleagues, with whom I have discussed various aspects of my work, are too numerous to mention here individually, but I hope that, where necessary, this help is duly acknowledged in the text. I shall, however, make particular mention of the continuing encouragement and interest of Professor Sir

Anthony Blunt, who read the text and made a number of suggestions which have fundamentally improved the finished book. I should also like to thank Professor John Shearman, who, over the passage of years, has handed to me a considerable mass of bibliographical and art-historical information about the paintings; also Dr John Onians for many helpful discussions. One of my visits to the archives at Mantua was financed by a generous award from the Leverhulme Foundation (1969). Finally, a special 'thank you' to Jane, my wife, for encouragement over a long period, for sympathy and for many constructive suggestions that have made this book better than it would otherwise have been.

It is conventional, at this point, to accept responsibility for the errors that remain in spite of all that one's friends can do. There have indeed been a number of peculiarities about the task of writing this book. For instance, for most of the time that I have been writing, I have not had the chance of seeing the *Triumphs* as a group of paintings properly lit and extended in line. The physical conditions under which they were being cleaned and restored made this impossible. I have, of course, had unique, unparalleled and probably unrepeatable chances of detailed examination of individual canvases. But this engenders a different type of thought from that produced by a prolonged contemplation of the scheme as a whole. This may have left its mark on the book, though it does not mean that I think the result is myopic. The further peculiarity is that this book is, of course, an extended catalogue entry. Its centre of interest is the 'Triumphs of Caesar', not Mantegna nor the Gonzaga court, nor fifteenth-century north-Italian humanism. Thus although these subjects are all obviously germane to the *Triumphs*, the reader will not get from this book a full and rounded picture of any of them. This is regrettable. On a painter of Mantegna's calibre much will always remain to be said since each generation will see a different image reflected in his art. On the fifteenth-century Gonzaga court, very little has been written except on the art and culture connected with Isabella d'Este. This perhaps gives the impression that life at Mantua was all jewels, paintings, antiques and humanist jokes and riddles. But I have also been through seemingly endless quantities of reports, often sent off daily to the Marchese, on the state of the horses in the stables; and Francesco Gonzaga, who was Mantegna's chief patron, after the death of Federico in 1484, was a powerful but average, unbrilliant military gentleman. More could profitably be written on these aspects of the Gonzaga court and it would certainly illumine our understanding of the terms in which the *Triumphs of Caesar* were first appreciated.

Errors of emphasis and (less excusably) errors of fact will remain. For these I can best answer with the words with which Samuel Clarke ended the preface to his edition (1712) of Caesar's *Commentaries*:

Sicuti me forte, ut par est in longiori opere, dormitantem reperis; aequum te praebeas judicem, benevole lector, memor quam simus omnes ad errorem proclives. Vale.

Norwich A. M.

Introduction

'In another Gallery, the triumphal Entry of a Roman Emperor, very curious.'
 Cox, *Magna Britannia* (1724), on Hampton Court

'In spite of the mischief of enemies and the no less destructive civilities of friends, they remain very interesting specimens of the master's genius.'
 Passavant, *The Tour of a German Artist in England* (1836)

'Truth is as difficult to get at as a fly in amber.'
 Mr Kennedy North in a letter to Mr C. H. Collins Baker (1931)

AT THE PALACE of Hampton Court are nine large canvases painted by Andrea Mantegna. They represent various episodes in a Roman triumphal procession, the *triumphator* appearing in the last canvas, seated on a chariot. The subject of these canvases is the Gallic Triumph of Julius Caesar; and it is an abbreviated form of this title, *viz.* the *Triumph of Caesar*, which might perhaps have been used for the title of the present book. However, in the earliest period of their existence, these paintings were with some regularity called *trionfi* (triumphs). This reflects the fifteenth-century use of the word *trionfo*, and, strictly in iconographical terms, here represents muddled thinking. Yet, as a description of a work which contains within a unified context a multitude of diverse material grouped in nine distinct canvases, the plural form *trionfi* has much to recommend it. Moreover, 'Triumph' being singular in number and 'paintings' plural, any writer will have continually to move uneasily between singular and plural grammatical forms unless he takes evasive action. In practice, working 'outwards' from the fifteenth-century evidence, I came from the very outset to think of these paintings as *Trionfi di Cesare*. In English, this has become the *Triumphs of Caesar*; and that is what these paintings are called throughout this book.[1]

The *Triumphs* came to England from Mantua in 1629–30 at the end of the negotiations by which Charles I purchased the major part of the Gonzaga collection. They must be among the least known masterpieces of western Europe;[2] and there exist various recurring misconceptions about them and a considerable amount of misinformation. They were once called *chiaroscuri*, meaning, in the context, *grisailles*;[3] fortunately this idea seems to have died at birth. But even in the latest literature, they are often called 'cartoons' and are sometimes said to be painted on paper pasted on linen. The idea that they are cartoons is explicable if not excusable, since for much of their history at Hampton Court, they have been in close proximity to the Raphael Cartoons (now housed in the Victoria and Albert Museum). It seems clear that guides and commentators came, as a matter of habit, to speak also of the

[1] For the use of the word *trionfo* in fourteenth- and fifteenth-century Italy, see Chapter 4. An 'official' title for these paintings is given in the decree of 1492 (Document 5) —*Iulii Cesaris Triumphus.*

[2] Many factors have played a part in discouraging atten-

tion so that one Italian writer could speak of the series as *pochissimo nota al pubblico e d'altronde qualche volta anche agli specialisti.* (G. Paccagnini, *Catalogo della Mostra 'Andrea Mantegna'*, Venice, 1961, p. 46.)

[3] In 1900 in the Cernazai sale catalogue, see below, p. 103.

'Mantegna Cartoons'. The second mistake is neither explicable nor excusable. In the 1881 guide to the paintings of Hampton Court, the *Triumphs* were correctly described as 'painted on twilled linen'.[1]

This recent confusion is more than matched by the extraordinary obscurity of the early history of the paintings. A handful of documentary references exists from Mantegna's own lifetime, but they show little for certain beyond the fact that the project was already being worked on in 1486 (Document 1, p. 181) and was still unfinished in 1492 (Document 5, p. 182). Uncertainty surrounds most of the main issues. No document reveals the exact date when the series was begun nor which of the Gonzagas commissioned it; and there is the greatest confusion over where it was intended to be hung, when it was finished—or whether, indeed, the series ever was finished.

Mantegna entered the service of the Gonzaga family probably in 1459 at the age of about twenty-eight; and he remained the Gonzagas' painter until his death in 1506. During these years he also became general adviser on many of the artistic projects of this court; and he personally contributed three major schemes of decoration to the main palace in Mantua. All of these are referred to in a decree of 1492 in which the Marchese Francesco, in the course of granting land to Mantegna, described his services to the Gonzaga dynasty. The first scheme was in the castle chapel; the second was in the *camera dipinta* (which came to be called the *Camera degli Sposi*); the third was the sequence of the *Triumphs of Caesar*. Mantegna was also partly responsible for a fourth decorative scheme, the *Studiolo* of Isabella d'Este; but Isabella appears to have reserved the right to enlist the services of any painter she chose and the *Studiolo* can hardly be reckoned as Mantegna's creation. The three earlier works soon became famous throughout Italy, and interested visitors were already being taken to see them in the 1490s (Documents 6 and 9, p. 182). The castle chapel vanished mysteriously early in its existence, but fortunately the other two schemes survive.

The *Triumphs of Caesar*, the later of these two surviving schemes, painted when Mantegna was already in his fifties, must by fifteenth-century standards be accounted the work of an ageing man. At the least, therefore, they demand attention as fully mature productions by one of the most accomplished artists of the fifteenth century. The series is also significant because it sums up a lifetime's experience of one of the most perceptive classical anti-quarians of the century. It has sometimes been supposed that Mantegna's work shows a conflict between his archaeological and artistic interests; and perhaps in the early Eremitani frescoes the archaeological detail was so deliberately studied that it detracted from the narrative power of the subject. However, in the *Triumphs of Caesar*, although the great variety of classical 'stage-properties' is handled with extraordinary expertise, this variety is subordinated to a figure-style of unprecedented power and vigour.

[1] For a recent statement that they are painted on paper, see R. Cipriani, *Tutta la Pittura del Mantegna* (Milan, 1956), p. 65. They were thought by F. Knapp (*Andrea Mantegna—Klassiker der Kunst*, Vol. 16, Stuttgart and Leipzig, 1910, p. xxix) to be cartoons painted on paper for tapestries. More recently, in 1928, a French writer called them *fresques*. The description here quoted comes from Ernest Law, *Historical Catalogue of the Pictures at Hampton Court Palace* (London, 1881), p. 258. He also pointed out that 'they are not properly called cartoons at all', and that the paintings should be 'affixed to the wall as a frieze'. It has seemed pointless to trace the history of errors about the *Triumphs*, but interested readers will find perhaps the most completely misleading statements in the French edition of the *Klassiker der Kunst* volume on Mantegna (Paris, 1911, p. xxxvi).

The extent of Mantegna's artistic achievement in the *Triumphs* was largely obscured by subsequent developments. In an era of rapid change his pictorial style was out-dated, first by the Umbrian and then by the Florentine and Roman and Venetian schools of painting. By the mid-sixteenth century, the *Triumphs* were remembered chiefly as a *tour-de-force* of painting with a lowered viewpoint. The unhappy treatment that the paintings received has, down to the present day, further obscured the painter's achievement. Even before they were brought to England for Charles I they had been moved at least six times in Mantua; and although for the most part once at Hampton Court they remained there, they were still moved several times within the palace buildings. Moreover, they were the subject of almost ruinous restoration during the late seventeenth century. By the early twentieth century their condition was, to say the least, sad; and most historians have dismissed them as irrecoverable wrecks.

Fortunately such pessimism has proved unjustified. The *Triumphs* have recently been meticulously cleaned; and far more of Mantegna's painting survives than had originally been suspected or thought likely. Their general condition may still leave much to be desired but it is now possible to enjoy Mantegna's painting without making constant visual allowances for the fate suffered by the canvases and without being constantly obliged to speculate on their appearance when they left the painter's studio. This 'rediscovery' of the *Triumphs* will surely lead to a reassessment of their significance in Mantegna's *œuvre*.

1 · Andrea Mantegna at Padua

'THE BEST THING that Mantegna ever painted'—this was the verdict of the historian Giorgio Vasari,[1] writing in the middle of the sixteenth century. Most people will endorse his enthusiasm, for the *Triumphs* exist above all to be admired and to give pleasure. Beyond this, however, they also possess the power to stimulate curiosity, and therein, perhaps, lies the starting point of this book. It seems likely that Mantegna himself would have accepted that these paintings were for the curious as well as for the appreciative and the curiosity which he was here seeking to arouse would presumably have concerned the Romans, their martial customs and their military uniform and equipment. The power of this particular aspect of the paintings to fascinate is not completely dead, as anyone will know who has listened to the conversations of visitors in the Orangery at Hampton Court. Today, however, it is more likely that the spectator's curiosity will be reserved, not for the Romans, but for Mantegna himself; and how it was that one of the greatest artists of that generation came to execute a work on so large a scale devoted to the re-creation of this particular historical event—the elaborate procession which accompanied a victorious Roman general on his official entry into the city of Rome.

Much of this book is the result of an attempt to satisfy such curiosity about the train of activity, thought and inspiration which brought the *Triumphs of Caesar* into existence. For the historian, such considerations inevitably involve Mantegna's earlier career. Unfortunately, since the present study is not a monograph on the artist, much of his earlier life must be passed over without comment. Only a little will be said for instance about the *Camera degli Sposi*; and this is certainly not the place for yet another analysis of the S. Zeno altar. In terms of style, this omission is perhaps less serious than it might appear at first sight. The stylistic gulf that yawns between the *Triumphs of Caesar* and for instance the early Eremitani frescoes is immense; and general stylistic comparisons across this period will tend merely to emphasize how different the early and late works are, the one from the other. Turning, however, to Mantegna's intellectual involvement in classical archaeology, the case is rather different since these interests clearly were with him throughout his life; and in this field the apparent gap between 'early' and 'late' Mantegna is much smaller. Thus, in reviewing the course of Mantegna's pictorial development, a suitable descriptive word would perhaps be 'change'; but for his intellectual interests, it is more appropriate to speak of 'development'. Some brief allusion to this earlier development is essential to any account of the *Triumphs of Caesar*. Mantegna's involvement with the classical past is central to their study; and in Mantegna's own past, two questions seem to become increasingly insistent, the more one contemplates these paintings. The first concerns the circumstances in which these somewhat specialized interests emerged; the second concerns the character of the Gonzaga court as the setting in which these same interests flourished.

Mantegna himself was born in 1431 or 1432 and his earliest recorded work was painted

[1] *è la miglior cosa che lavorasse mai.* For the context, see Document 30.

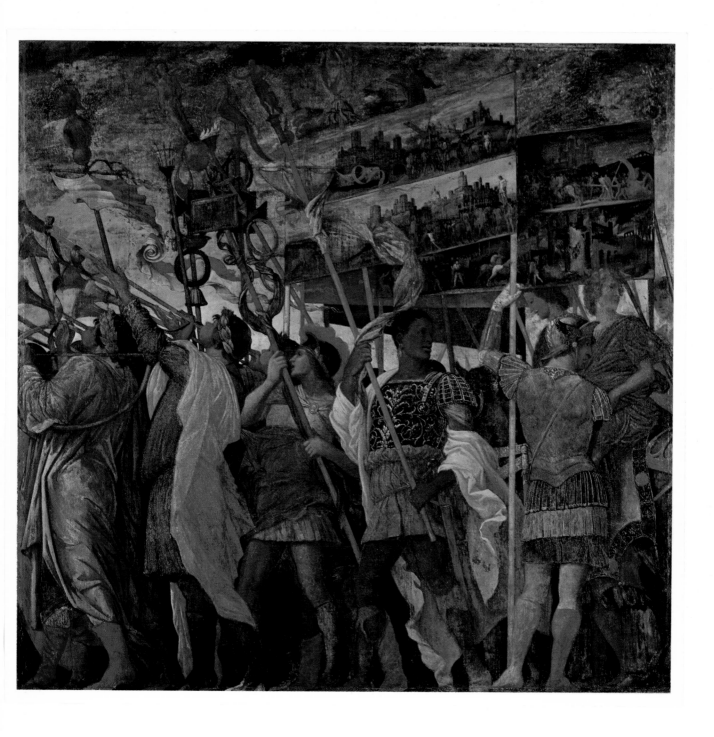

Canvas I: Trumpeters, Bearers of Standards and Banners

when he was only seventeen years old.[1] From the first period in his life, the period of the 1440s and 1450s before he went to Mantua, it will be convenient to recall two particular commissions in order to remind the reader of the characteristics assumed by this early painting. These have already been mentioned above, the first being Mantegna's contribution to the decoration of the Ovetari chapel in the church of the Eremitani, Padua (*nos. 132, 133*).[2] The second is the altarpiece completed for the church of S. Zeno, Verona.[3] These works have many surprises. Not least is the young artist's extraordinary skill and technical virtuosity. His figure and drapery style already have a highly individual character, the shapes being insistently three-dimensional and described with a precise and wiry linearity. The drapery, in particular, has a chunky heaviness and the whole effect may with some degree of literalness be called 'lapidary'. The artist, moreover, clearly enjoyed devising exciting spatial effects. Compositions are sometimes disturbed by startling feats of foreshortening; and the recently invented one-point perspective is frequently called into play. Often the senses of the spectator are shocked by illusionistic tricks which confuse the world of reality with that of the painted scene.

The strong individuality of this pictorial style is greatly enhanced by Mantegna's highly expert appreciation of the visual character of the ancient world, its architecture, civilian costume and military uniform. It will be necessary later in this book to refer back to these early paintings because it is clear that many points of antiquarian expertise which appear in the *Triumphs* already formed part of Mantegna's intellectual equipment as a young man. It will also be apparent that, in addition to possessing this unprecedented archaeological insight, Mantegna was already involved in a curious imaginative dilemma that faces most antiquarians. His scenes are sometimes placed in imposing unruined classical settings, the aim being presumably to convey the grandeur of Rome as it was. By contrast, some scenes are set against mouldering ruins—the grandeur of Rome 'as it is'. The enjoyment of ruins often goes hand in hand with the pleasures of reconstruction, but they are normally incompatible in the same scheme of painting, since the contrast in itself implies the passage of time.

There is still much argument about the circumstances in which Mantegna developed these highly individual traits. He is known to have entered at an early age the workshop of the Paduan painter Francesco Squarcione. Unfortunately Squarcione's work has almost all vanished; and his reputation was unjustifiably inflated in the sixteenth century in the interests of Paduan patriotism.[4] Sufficient evidence, nevertheless, survives from his own lifetime to reconstruct something of his place in the contemporary scene. He certainly took in a succession of pupils—the earliest documented in 1431—and some of them subsequently became very good (notably Mantegna himself, Marco Zoppo and Giorgio Schiavone). What he was expected to teach young artists is known since this emerged in contracts concluded with their parents or guardians. (It included the practice of perspective and foreshortening and

[1] For the early life of Mantegna see G. Fiocco, *L'Arte di Andrea Mantegna* (Venice, 1959). Mantegna's earliest recorded work is the lost S. Sofia altar (Padua) which was inscribed with the date 1448 and the information that Mantegna was then aged 17. Fiocco, *op. cit.*, pp. 94–5.

[2] For an account of the documentation, see Fiocco, *op. cit.*, Chapter VIII. Mantegna's contribution is datable between 1448 and 1457.

[3] 1456–9. The documents have recently been reprinted with some additional unpublished material by L. Puppi, *Il trittico di Andrea Mantegna per la Basilica di San Zeno Maggiore in Verona* (Verona, 1972).

[4] For an unfavourable assessment of Squarcione see Fiocco, *op. cit.*, Chapter VI.

the art of figure proportions.[1]) He may, as was later claimed, have collected antiques. In the 1430s this would have been precocious but not impossible. He is known to have had a *cartone* of Antonio Pollaiuolo and it is not impossible that he should have had portfolios of other drawings.[2] Mantegna's passion for perspectival projections and classical reconstructions could perhaps have been stimulated by this setting. However, judged from his surviving work, Squarcione could have taught Mantegna very little about painting as such.[3] This is one of the greatest enigmas of Mantegna's training. Indeed, had all the evidence for the apprenticeship under Squarcione been destroyed, art historians would almost certainly speculate on his having had a period of training under an artist of undisputed technical accomplishment such as Andrea Castagno or Piero della Francesca.[4]

The indifferent impression created by Squarcione's surviving work in effect raises general doubts about his significance. Mantegna's painting, even in his early years, has the appearance of being the work of a scholarly and learned person. It is not merely that classical architecture and costume were given detailed attention. Examples of Latin epigraphy are introduced; and once, somewhat unexpectedly, a painting (the St Sebastian, now in Vienna) is signed in Greek. There is a strong impression that his enthusiasm for the antique was nourished and given substance by association with scholars; and it is of some importance, therefore, to examine what is known about his academic acquaintance. The evidence for this only emerges in the 1460s, after Mantegna's removal to Mantua. It is perhaps simplest to begin with the well-known antiquarian expedition on the shores of Lake Garda in 1464.

The events of this expedition were later recounted by one of the participants, Felice Feliciano.[5] Its purpose seems to have been to combine 'business' with pleasure. The 'business' side was the inspection of classical remains. The pleasure was contained in the accompanying 'play-acting' and fancy dress since the participants wore crowns and garlands and the leaders adopted titles such as 'emperor' or 'consul'. One of them played a lute as the boat sailed across the water. Exactly how many people were involved in this expedition is not clear, since the account merely speaks of a crowd of people.[6] But the names of the leaders were Felice Feliciano, Samuele da Tradate, Giovanni Antenoreo and Andrea Mantegna. Little seems to be known of Samuele da Tradate who, like Mantegna, was then a member

[1] Fiocco, *op. cit.*, p. 65. Contract of 1467 in which Squarcione undertook to teach *la raxon d'un piano lineato ben segondo el mio modo e meter figure sul dicto piano una in zà l'altra in là in diversi luogi . . . e metere masarizie, zòe chariega, bancha, chasa . . . e insegnarge intendere una testa d'omo in schurzo per figura de isomatria . . . e insegnarge le raxon de uno corpo nudo mexurado de driedo e denanzi. . . .*

[2] See below, p. 76, note 3. When Felice Feliciano, Mantegna's friend (see below, p. 25), made his will in 1466 one of the items he left was a collection of 'drawings and pictures on paper by many excellent masters of design'. (See C. Mitchell, *Proceedings of the British Academy*, XLVII, 1961, 'Felice Feliciano Antiquarius', p. 199.)

[3] Two works survive from Squarcione's *œuvre*. The documented Lazzara polyptych, now in the Museo Civico, Padua, was painted in 1449–52. The signed Madonna in Berlin is undated. Recently, an attempt has been made further to define the character of Squarcione's work by Annegrit Schmitt in *Münchner Jahrbuch der bildenden Kunst*, XXV (1974), 'Francesco Squarcione als Zeichner und Stecher'. Her argument centres around a group of drawings sold in London in 1958; and she attributes these to Squar-

cione himself. There will obviously be further argument about these drawings which seem, to me, to vary in competence. The most interesting are a group of deft Pollaiuolo-like figure studies. It is always possible that Squarcione's skill developed along these lines at the end of his life (he died in 1468). But in the meantime, the Lazzara altar of 1449–52 remains an obstacle to any conclusion that Squarcione was technically and imaginatively good enough *c.* 1440–45 to teach the young Mantegna very much about painting.

[4] Castagno was painting in Venice in 1442. Piero della Francesca, working at some unknown period in Ferrara, was at Rimini in 1451.

[5] The text was printed by P. Kristeller, *Andrea Mantegna* —in German, Berlin and Leipzig, 1902; in English, London, 1901; referred to henceforward respectively as Kristeller (G) and (E). See Kristeller (G) Dokument 34 and (E) Document 15. The manuscript, now in the Chapter Library at Treviso (Cod. I. 138), is described by C. Mitchell, *op. cit.* note 7, p. 209.

[6] *una cum florentissima caterva sequente.*

of the Gonzaga court.[1] But, of the remaining two, Giovanni Antenoreo seems to be of considerable importance.

Giovanni Antenoreo is, of course, a pseudonym. 'Antenoreo' refers to the mythical founder of Padua, Antenor; it is a flowery and somewhat pedantic way of indicating allegiance to Padua. It has been suggested that this person was a Giovanni da Padova who was working as a building engineer at the Gonzaga court between 1458 and 1481. He was known to Mantegna and was indeed one of the emissaries sent by the Marchese Lodovico to try to coax him into leaving Padua for service at Mantua. (Needless to say he never appears as Giovanni Antenoreo in the Mantuan documents.[2]) There is, however, something special about this 'Giovanni Antenoreo' in that he alone in the party adopted a pseudonym at all. This pseudonym suggests a learned turn of imagination and, perhaps also, signifies a difference of status. Accordingly, it has plausibly been suggested that the man who became Antenor for the day in 1464 was Giovanni Marcanova, the eminent Paduan academic and doctor, professor at Bologna university, friend and patron of Feliciano. This seems more than likely.[3]

Marcanova was born around 1418 and was thus older than either Mantegna or Feliciano. He gained a doctorate in the School of Arts and Medicine at Padua in 1442; and he continued to teach there until 1453 when he was appointed to the Chair of Philosophy at Bologna. He died at Bologna in 1467.[4] A considerable amount is known about his later life; and an inventory made two days after his death recorded the contents of his library. For a private collection, this was immense, containing more than 500 manuscripts which had been amassed over a period of some thirty years;[5] and in his later years, especially during the 1460s, he had increased it through the services of Felice Feliciano, who was a professional scribe. Of these volumes one of the most splendid contains a collection of classical inscriptions which Marcanova had begun to put together earlier in his life. This manuscript is now at Modena and seems to have received its final form in 1465.[6] The contents of this manuscript now constitute his chief claim to attention as an antiquarian.

[1] Kristeller (G), p. 184 and (E), p. 176. Mitchell, *op. cit.*, noted that the Treviso manuscript containing the account of the expedition (p. 23, note 5) was commissioned by Samuele. The contents of the manuscript are almost entirely concerned with Cyriacus of Ancona, which must give a clear indication of Samuele's interests. Samuele da Tradate was perhaps the painter Samuele who was working from Mantegna's designs at the Gonzaga villa at Cavriana in March 1464—see Kristeller (G) Dok. 31 and 32 and (E) Doc. 11 and 12.

[2] Fiocco, *op. cit.*, p. 50, favoured Giovanni da Padova as Antenoreo and has been followed by Garavaglia in Bellonci-Garavaglia, *L'Opera completa del Mantegna* (Milan, 1967). Kristeller (G) Dok. 13, 27, 50, 57 and 81 refer. None of these is included in Kristeller (E).

[3] This identification seems to have been first suggested by Kristeller (G), p. 185 and (E), p. 176. C. Huelsen, *La Roma di Ciriaco d'Ancona* (Rome, 1907), pointed out that the inscriptions taken during the Garda expedition and copied by Feliciano into the Treviso manuscript (note 1 above) also reappear in Marcanova's own sylloge now at Modena, Bibl. Estense, cod. α. L.5.15. On this manuscript see also C. Mitchell, *op. cit.*, p. 208.

[4] In the older literature, Marcanova is called a Venetian; but, to judge from his will, most of his affiliations seem to have been with the town of Padua. Since this was ruled by Venice, he was not improperly called 'Venetian' in some documentary sources. For the most recent account of Marcanova's life, see L. Sighinolfi in *Collectanea variae doctrinae Leoni S. Olschki oblata* (Munich, 1921), p. 187, 'La Biblioteca di Giovanni Marcanova'.

[5] *Ex libris* inscriptions suggest that the collection was begun c. 1440. See L. Dorez in *Mélanges G. B. de Rossi* (Paris-Rome, 1892), p. 113, 'La Bibliothèque de Giovanni Marcanova'.

[6] It was published by Huelsen—see note 3 above. See also C. Mitchell, *op. cit.*, p. 208. This is the manuscript mentioned above, note 3, now in the Bibl. Estense (Modena) cod. α. L.5.15. The collection was dedicated to Malatesta Novello, lord of Cesena. Further evidence for Marcanova's antiquarian bent may be forthcoming from his books, more than fifty of which survive in the Marciana, Venice, identifiable by their *ex libris* inscriptions. A brief sample made by the present writer turned up an extraordinary mixture of quality. Some are beautiful productions in a contemporary hand, finely decorated bearing his arms and almost qualifying for the description *de luxe*. Others are objects of mean and dreadful appearance hardly fit to occupy the same shelves. There is a large proportion of volumes from the thirteenth and fourteenth centuries. It would be of great interest to know the extent to which these early texts were academically useful, as opposed merely to possessing antiquarian interest (that is, to a mid fifteenth-century professor of Natural Philosophy).

It would be convenient to be able to conclude that Marcanova, who was teaching in Padua between 1442 and 1453, exercised an important influence on the direction taken in the development of Mantegna's interests. This is indeed highly probable although still unproven. The books in Marcanova's library confirm his antiquarian bent—he possessed, for instance, a complete set of the works of Flavio Biondo;[1] but where dated volumes survive, the historical and antiquarian works all come from the last ten years of his life. By contrast, the dated manuscripts surviving from Marcanova's Paduan period (i.e. before 1453) are almost exclusively in the field of his teaching—Natural Philosophy.[2] Fortunately, there is cogent evidence that Marcanova's antiquarian interests were not merely the hobby of an ageing man. One of the manuscripts of his collection of inscriptions states that the collection was begun while he was still at Padua (*Patavii opus incoeptum*).[3] It seems, therefore, permissible to imagine the scholar and the young painter collaborating at Padua to study the vestiges of antiquity. Perhaps this is why two of the three inscriptions (one indeed from a Veronese monument) in Mantegna's Eremitani frescoes later reappear in Marcanova's own sylloge.[4]

Mantegna's earliest connections with Feliciano are also shrouded in some uncertainty. The two men were almost of the same age but Feliciano was a native of Verona.[5] The possibility that Mantegna and Marcanova may jointly have journeyed from Padua *c.* 1445–50 to study the antiquities of Verona is therefore relevant. Nevertheless, the first record connecting Feliciano and Mantegna takes the form of a sonnet to the painter by Feliciano in a book of verses dated 1460.[6] Thereafter, however, the evidence of their friendship is indisputable and Feliciano in his writing referred to Mantegna with real affection.[7] Much has been written in general terms about the importance of Padua as the cultural centre in which Mantegna's antiquarian interests might have flourished and increased.[8] But, in the present state of research, Marcanova and Feliciano seem to be the most likely literate and intelligent men to have inspired and nurtured Mantegna's studies. Clearly as scholars they were not in the same league as the great humanists, like Guarino da Verona or Vittorino da Feltre, but as enthusiastic and friendly companions in the pursuit of the Antique, they may well have been better value. Moreover, this previous acquaintance would help to explain how they continued to consort together after Mantegna had moved away to Mantua in 1459–60.

Thus during these early years Mantegna's painting acquired the learned archaeological stamp which remained one of its chief characteristics. It would be a ridiculous misjudgement

[1] See Sighinolfi, *op. cit.*, p. 203.

[2] For a list of identified and dated manuscripts, see L. Dorez, *op. cit.*

[3] This is the sylloge now Berne, Stadtbibl. cod. B. 42. See E. W. Bodnar, *Cyriacus of Ancona and Athens* (Brussels, 1960), p. 98. The inscription says that this particular collection by Marcanova was begun in Padua, assembled at Cesena in 1457, completed in transcription at Cesena (*Caesenae scribi absolutum*) and set out in its present form at Marcanova's expense in 1460.

[4] See Andrea Moschetti, *Atti del Reale Istituto Veneto di Scienze, Lettere ed Arti*, LXXXIX (1929–30), p. 227, 'Le iscrizioni lapidarie romane negli affreschi del Mantegna agli Eremitani'.

[5] See Mitchell, *op. cit.* Feliciano was born in 1433.

[6] Printed by Kristeller (G) as Schriftquelle 3. For the date, see Mitchell, *op. cit.*, p. 199. The manuscript is Modena, Bibl. Estense cod. α. N.7.28.

[7] In the account of the expedition on Lake Garda, Felice described Mantegna alone as *amicus incomparabilis*. In a collection of inscriptions dedicated to Mantegna, he used the same expression, continuing that he was offering the collection to Mantegna *quoniam nihil est apud me potius et antiquius, quam te fieri perquam doctissimum, atque omnibus in rebus praeclaris consumatum virum evadere*. The dedication was printed by Kristeller (G) as Schriftquelle 6. However, he gave it the date 1463. G. Mardersteig, *Felice Feliciano Veronese, Alphabetum Romanum* (Verona, 1960), dates it 1464. The oldest manuscript of this collection is Verona, Bibl. Capitolare, Cod. 269.

[8] On this, see Kristeller, Chap. I *passim*.

of his superb technical accomplishment to dub him, for this reason, a scholar's painter. Nevertheless there is an academic element in his work which it is difficult to find, at least so obviously in the painting, for instance, of his brother-in-law Giovanni Bellini. There is no reason to doubt that it was this remarkable brand of individuality which gained him a wider public and eventually brought about the most profound change in his personal circumstances when he left his home at Padua to become a household servant of the Marquess of Mantua. It is necessary now briefly to review this period of Mantegna's life and to consider Mantua as an intellectual centre.

2 · The Court at Mantua

LODOVICO GONZAGA first invited Mantegna to Mantua in 1456.[1] At this date the Gonzagas needed an artist to replace Pisanello who had just died (probably in 1455) most unfortunately leaving his great Arthurian paintings in the *Corte Vecchia* at Mantua unfinished.[2] More particularly Lodovico needed a court painter to decorate the Castello di S. Giorgio which he was in the process of turning into a dwelling place for himself and his wife, Barbara of Brandenburg. The choice of Mantegna demonstrates the reputation the young artist had acquired through the Eremitani frescoes, the St Luke altarpiece painted in 1453–4 for the church of S. Giustina, Padua, and perhaps also the lost S. Sofia altar of 1448.[3]

Mantegna's appointment, however, was more significant than this for he was not merely hired as a craftsman to do a particular job of work. The negotiations were over the terms by which he should become a personal retainer in the Gonzaga household.[4] Moreover, it is clear that Lodovico really wanted him very much indeed. There can have been few artists ever who, between the ages of twenty-five and twenty-eight, received so many emissaries, and courteous but insistent letters addressed personally from such an important secular ruler. Lodovico even went so far as to grant Mantegna, in advance of his arrival at Mantua, a blazon which, by incorporating a Gonzaga device, effectively labelled him a 'Gonzaga man' should he choose to display it.[5]

Mantegna probably transferred permanently to Mantua in 1460. His reception *inter familiares* of the Marchese meant that for reasons other than his technical skill as a painter, he was somebody whom the Marchese wished to have ready access to his presence. As will be seen, many of the interests of the two men coincided. But the appointment must also reflect aspects of Mantegna's personality which are now almost entirely obscured. Only four times do the documents provide evidence of his being an agreeable companion. The first, the expedition on Lake Garda in 1464, has already been discussed. The second and third both concern Lodovico's second son, the Cardinal Francesco. In July 1472 he asked that

[1] This is apparent from Lodovico's letter of 5 January 1457. See Kristeller, (G) only, Dok. 9. Printed also in Puppi, *op. cit.*, Document I.

[2] For the latest study of Pisanello, taking into account the rediscovered *Sala di Pisanello* in the *Corte Vecchia* at Mantua, see G. Paccagnini, *Pisanello* (London, 1973) and, by the same author, with M. Figlioli, the catalogue of the Mantuan exhibition *Pisanello alla corte dei Gonzaga* (Milan, 1972). Pisanello had connections with Mantua throughout most of his life. For convincing arguments that the Sala di Pisanello was begun for the Marchese Gianfrancesco between 1434 and 1446, see I. Toesca, *Burlington Magazine*, CXVI (1974), p. 210, 'A frieze by Pisanello'.

[3] The enthusiasm for Mantegna's skill emerges clearly in a letter written in May 1460 by the Chancellor Zaccaria Scaggi to Barbara of Brandenburg. Seeking to describe the beautiful Florentine women who greeted Lodovico on his way south to the baths of Petrioli, he wrote *parevano veramente uscite de le mane di Andrea Mantegna che e cosi*

buon maestro. See A. Portioli, *I Gonzaga ai Bagni di Petrioli di Siena* (Mantua, 1869), p. 6.

[4] The practical arrangements concerning board, lodging and stipend are described in Kristeller (G) Dok. 11 and (E) Doc. 4 of 15 April 1458. Mantegna is first designated as *familiaris noster* in the grant of arms of 30 January 1459. (Kristeller, (G) only, Dok. 14.)

[5] Eight communications survive, including the grant of arms. They are printed in Kristeller and Puppi, *opera cit.* Clifford M. Brown, *Mitteilungen des Kunsthistorischen Instituts in Florenz*, XVII (1973), has recently published (p. 158) a further document of 23 January 1459 in which Lodovico ordered Mantegna to be issued with a length of crimson damask embroidered with silver to make a jupon. It seems that crimson and white were Gonzaga colours (see their predominance in the hosiery in the so-called 'court scene' of the *Camera degli Sposi*) so that Mantegna was apparently being issued with a rather expensive sort of livery.

Mantegna might accompany him to the baths at Porretta so that they might converse about the cardinal's collection of gems and bronzes; and in September of the same year Mantegna entertained the Cardinal to dinner.[1] The fourth instance is a letter of June 1489 written by Mantegna from Rome to Lodovico's grandson, the Marchese Francesco. In this, Mantegna gave a lively and amusing account of the captive Turkish prince Djem.[2]

It is necessary to emphasize this, because the harsher side of Mantegna's existence, represented by the non-payment of his salary and antagonisms with his neighbours, usually gets greater prominence. These misfortunes produced correspondence and counter-correspondence. The first letter complaining about the non-payment of salary occurs in 1463—not so very long after his arrival in Mantua. Thereafter, these letters survive sporadically up to the 1490s; and in one case at least, the plaintive tone of Mantegna contrasts unfavourably with the dignified reply of the Marchese Lodovico.[3] Other letters suggest that Mantegna was on occasion difficult, one of the Marchese's correspondents remarking that there were few neighbours with whom Mantegna had not had a law-suit.[4] But the more attractive side of Mantegna's personality must be given due weight. It is unlikely that three generations of Gonzagas would have tolerated his continued presence in the household over forty-six years had he been simply a petty and tedious man.

It is remarkably difficult to sense the intellectual climate of Mantua during the 1460s and 1470s. At an earlier period, the city had acquired considerable fame through the presence of Vittorino da Feltre and his academic establishment known as the *Ca' Giocosa*.[5] Vittorino seems to have been the sort of scholar who taught brilliantly and published very little. Although it is difficult not to feel some sympathy with this, it means that much of the information about him is derived from the writings of his pupils. All the available children of the Gonzaga court, including the twelve-year-old Barbara of Brandenburg, seem to have passed through his hands. In addition, children were sent from all over northern Italy so that there were a number of distinguished strangers such as Federico da Montefeltro, the future duke of Urbino.

The *Ca' Giocosa* as an educational establishment was clearly an institution of great interest. Many people will find something ominously familiar in Vittorino's views on moderation in food and drink, the necessity of a balanced diet and a strict timetable, and the just combination of mental and physical exercises. But equally clearly, both the unique quality of the teaching and the standards of scholarship depended on Vittorino himself. His success was such that there appears at one stage to have been a move to use his educational

[1] See Kristeller, (G) only, Dok. 45–48.

[2] See Kristeller, (G) only, Dok. 104 of 15 June 1489. For the general implications of the development which led to artists entering princely households see A. Martindale, *The Rise of the Artist* (London, 1972), Chapter 2, 'The Artist at Court'.

[3] The two letters in question belong to the year 1478 and were printed by Kristeller (G) Dok. 70 and 71, and (E) Doc. 30 and 31. Nothing is heard on this subject in the printed documents after the decree of 1492 granting Mantegna 200 *biolche* of land at Bosco della Caccia near Borgoforte (Kristeller [G] Dok. 115 and [E] Doc. 52. It is in this decree that the *Triumphs of Caesar* are mentioned.) Since Mantegna had requested this land earlier, being as much land *quanto*

montava lo avanzo dilla provisione mia, it may be that some sort of tidying-up operation had taken place under the Marchese Francesco and that Mantegna's finances were at last placed on a more stable footing.

[4] See Kristeller, (G) only, Dok. 62. In this letter of 1475, the correspondent remarked to the Marchese Lodovico *che cio sia vera esso Andrea non ebbe mai vicino alcuno col qual non habia litigato*.

[5] See E. Paglia, *Archivio Storico Lombardo*, Sec. Ser. I (1884), p. 150, 'La Casa Giocosa di Vittorino da Feltre in Mantova'. Also E. Faccioli, *Mantova Le Lettere*, Vol. II (Mantua, n.d.), Chap. 1, 'Vittorino da Feltre e la sua scuola'. The building itself faced on to the Piazza Sordello.

establishment as the foundation on which to erect a university. Gianfrancesco Gonzaga went so far in 1433 as to obtain an imperial privilege licensing the establishment of a university at Mantua but, for reasons which are not known, the project was not taken further.[1]

However, when Vittorino died in 1446, he proved irreplaceable. Scholars indeed came to Mantua but the Gonzaga family appears to have struck a perennial problem—that first-rate scholars, who are also dedicated to a lifetime of teaching school-children, are always in short supply. Vittorino's immediate successors were indeed men of some distinction.[2] Jacopo da S. Cassiano (1446–9) was a translator of Archimedes and other Greek writers.[3] Ognibene da Lonigo (1449–53) edited Lucan, Sallust and Quintilian and composed treatises on verse and grammar.[4] Platina (1453–6) needs no gloss. But Jacopo left for a career in Rome, Ognibene went back to the university at Vicenza whence he had come and Platina went to Florence. The idea of a lifetime spent teaching at Mantua had insufficient attraction for them.

With the departure of Platina in 1456, the educational situation at Mantua seems to have taken a downward turn. His successors were Bartolommeo Marasca (1456–9) about whom little seems to be known; and Senofonte Filelfo (1459) who stayed for a very short period (he was the eldest son of Francesco Filelfo). By the 1460s the *Ca' Giocosa* had ceased to be an academic institution and was converted to other uses.[5] At the same moment, the succession of school-masters seems to be broken and the reason is probably a simple one. By 1460, Federico Gonzaga, the eldest son of Lodovico, had reached the age of nineteen and his brother Francesco was aged sixteen. The next son Gianfrancesco was apparently educated in Germany.[6] Consequently, the need for a resident family tutor had greatly diminished.

The succession appears to have revived when Federico's children reached the age of education. Thus between 1473 and 1478, Federico employed Gaspare Tribraco and Gianfrancesco Gennesi. This last was displaced to make way for another of Francesco Filelfo's sons, Giovanni Maria; and when he died in 1480 he was succeeded by Colombino da Verona. But by 1483 there was again a vacancy which Federico (now marquess) had decided not to fill for a similar reason—his eldest son Francesco was past the age of the school-room.[7]

From this it will be seen that the days of academic distinction for Mantua were passing when Mantegna arrived c. 1459–60. Thenceforward the scholarly 'establishment' seems to have been either non-existent or of strictly local importance. In these circumstances the interests, attainments and personality of the patrons take on a much greater significance and interest. In particular, the personality and interests of Lodovico Gonzaga must have

[1] For the details see H. Rashdall, *The Universities of Europe*, revised by E. Powicke (London, 1958), Vol. II, p. 330.

[2] In general for what follows, the main printed evidence is in A. Luzio and R. Renier, *Giornale storico della letteratura italiana*, XVI (1890), p. 119, 'I Filelfo alla corte dei Gonzaga' (called below 'Luzio/Filelfo'); and A. Luzio and R. Renier in the same journal, XIII (1889), p. 430, 'Il Platina e i Gonzaga' (called below 'Luzio/Platina').

[3] A pupil of Vittorino; see Luzio/Filelfo, p. 139.

[4] Another pupil of Vittorino; see Luzio/Filelfo, p. 140. Ognibene's work was sufficiently in demand for much of it to be printed already in the 1470s. A quick *aperçu* of his literary output can be gained from the catalogue of the British Library. He was the master of Platina, who took over Ognibene's teaching on his departure (Luzio/Platina, p. 430).

[5] In 1462 it was being used by stonemasons, see Paglia, *op. cit.* Two further unpublished documents of 1466 confirm this—see Archivio Gonzaga Busta 2405, (a) 15 Nov. Albertino da Pavia to Marchese Lodovico from Mantua, (b) 12 Dec. Luca Tagliapietre to Marchese Lodovico from Mantua.

[6] According to Julia Cartwright in *Isabella d'Este* (London, 1923) I, p. 29.

[7] For all the above information see Luzio/Filelfo.

been of great importance to Mantegna. Lodovico has, indeed, some claim to being Vittorino's most important pupil—not because of his great learning but because he inherited from Vittorino a respect for scholarship, for the arts and for the study of the classical past. Subsequently a powerful and influential ruler, he supported all these activities. In fact many small pieces of information about Lodovico cumulatively produce the impression of a humane and interesting man. He was himself sufficiently a scholar to be able to read at least the Latin classics for enjoyment.[1] He was much interested in Virgil, discussed with Platina a project for erecting a monument[2] to the poet and took a personal interest in the re-establishment of an uncorrupt text of the poet's works.[3] He was much interested in the history of Mantua so that Platina was able to write to him personally from Florence seeking information from people at court; and when the History of Mantua finally appeared in 1469, Lodovico invited Platina to accompany him to the baths of Petrioli to discuss improvements and corrections.[4] He was sufficiently an antiquarian to have his own sylloge of inscriptions;[5] and his library possessed at least one book of drawings of antique sculpture.[6] He was himself well enough known as a bibliophile for attempts to be made to get him to buy Aurispa's library after the death of that scholar.[7] These interests were, to a considerable extent, also those which Mantegna expressed in his paintings; and this must have influenced the young artist when he was considering entering Lodovico's household. It must also have influenced Lodovico when he first issued the invitation although he did not then know Mantegna personally and it is not clear who recommended Mantegna to him. In view of this community of interest,[8] there can be little doubt that all the important decisions about the decoration of the palace chapel (on which Mantegna was immediately engaged) and of the *Camera degli Sposi* which followed it (probably in 1465) were directly the result of conversations between Mantegna and the Marchese. It remains to be seen whether this situation has any bearing on the date of the *Triumphs of Caesar*.

[1] See Luzio/Filelfo, p. 146; letter from Lodovico to Barbara of Brandenburg asking for manuscripts to be sent to him while at the baths of Petrioli. He asked for a Lucan, a Quintus Curtius and a *De Civitate Dei* of St Augustine.

[2] Luzio/Platina, p. 431.

[3] Luzio/Platina, p. 431. A letter of 1459 from Lodovico to Platina (in Florence) asked for a copy of the Georgics, *Scripta cum li diptongi destesi, cioè ae, oe, e cum li aspiratione apuntate e le dictione scripte per ortographia, corecta secondo che sapete facessemo coreger la Bucolica*—evidence of a reasonably business-like attitude to textual editing. In a work of Platina's, written apparently *c.* 1455 while he was teaching in Mantua, and entitled *Divi Ludovici Marchionis Mantuae Somnium*, Virgil is made to appear to Lodovico in a dream and to praise him for his work in preserving and correcting the texts of the poems.

[4] Luzio/Platina, p. 434 ff.

[5] See Luzio/Filelfo, p. 159. In 1461, Lodovico heard of a collection of Cyriacan inscriptions in Milan and wrote off to an agent in an attempt to borrow it. He wished to extract whatever inscriptions were not in his collection. In return, he offered to add those of his which were not in the Milanese volume.

[6] See letters published by Clifford M. Brown, *Mitteilungen des Kunsthistorischen Instituts in Florenz*, XVII (1973), pp. 158–9.

[7] See Luzio/Filelfo, p. 148. Aurispa died in 1460 and the proposal came from Ferrara in January 1461. There were said to be more than 700 volumes.

[8] They were also a decisive factor, apparently, in attracting Alberti to Mantua during these years. Alberti first met Lodovico in 1459 at the Council of Mantua and he stayed on in the city during 1460. He revisited Mantua in 1463 and again in 1470 and 1471—indeed in 1470 he seems to have contemplated buying property there (he died in 1472). Alberti was probably intellectually the most impressive visitor to Mantua during this period but his known visits were few and far between. The two churches, S. Sebastiano and S. Andrea, were built from his plans by Lodovico's resident architect-mason Luca Fancelli.

3 · The Early History of the *Triumphs*

THE DOCUMENTARY EVIDENCE AND ITS INTERPRETATION

THE LITTLE that is known for certain about the early history of the *Triumphs of Caesar* can be seen by studying the register of documents assembled at the end of this book (Appendix IV). The earliest mention of them concerns a visit to Mantua by the Duke of Ferrara in August 1486 (see Document 1, p. 181). After a short trip on the lake, the duke disembarked at the *Porto de Corte* 'to go and see the Triumphs of Caesar which Mantegna is painting—which Triumphs pleased him greatly. Then he came by the *Via Coperta* into the castle.' Setting aside the topographical problems posed by this letter, it shows that in 1486 the painting of the *Triumphs* was in progress. It gives no indication when they were begun. In 1489, writing from Rome to the Marchese Francesco, Mantegna himself stated that he was proud of the *Triumphs* and that he hoped to paint others—by implication others in the same series (see Document 2, p. 181). This is confirmed by the decree of 1492 in which the Marchese Francesco made a land grant to the painter (see Document 5, p. 182). The preamble dwells at length on Mantegna's excellence and mentions specifically his 'famous works, worthy of admiration, which he formerly painted in the chapel and chamber of our citadel and the Triumph of Caesar which he is now painting for us with figures which almost live and breathe—so that the Triumph seems to exist rather than to be represented'. Finally, in 1501, in the auditorium of an *apparato* 'one of the sides was decorated with the six paintings of the triumphant Caesar', according to a correspondent of the Duke of Ferrara.[1]

Of the original purpose or site for which the *Triumphs* were designed, the documentary evidence reveals nothing; and it is indeed remarkable that the intended destination of such an important scheme of secular decoration should apparently soon have been forgotten. In 1521, an historian of Mantua, Equicola, wrote that a special room was built for them in the palace of S. Sebastiano by the Marchese Francesco (see Document 26, p. 185). This is correct but the ambiguous phraseology might suggest that they lacked a proper home before *c.* 1506–7 when that palace was built. Various ideas have been put forward subsequently by commentators and art-historians which take into account this possibility.

Throughout most of these speculations, the use of the *Triumphs* in a theatrical context constantly recurs. In the letter of 1501 the *Triumphs* were described as forming part of a theatrical auditorium (see Document 13, p. 183); they were also mobile since they were painted on canvas. A suggestion therefore persists that the *Triumphs* had no proper home precisely because they were intended to be festive decorations. Although generally abandoned by the majority of writers,[2] it may be as well to rehearse once again the reasons which make this idea so unlikely.

First, the *Triumphs* were not, like most gala decoration, executed in a hurry; they took,

[1] Document 13. The expression 'the six paintings' is not necessarily significant since the writer was a visitor from Ferrara and was not necessarily in a position to know the total number of canvases.

[2] R. Cipriani, *Tutta la Pittura del Mantegna* (Milan, 1956), p. 65, is the only recent scholar who appears somewhat diffidently to support this idea.

at the very least, six years to complete in their present form, while the recent cleaning has confirmed that they are painted with quite extraordinary minuteness and precision—indeed one is reminded of Vasari's description of the contemporary chapel in the Vatican as *piuttosta cosa miniata che dipintura.*[1] Then, the fact that they were painted on canvas has another explanation which disposes of the view that they were designed for such gala displays; for in a letter of 1491 from Ghisulfo to the Marchese Francesco (see Document 4, p. 182), the all-important point was made that painting on canvas was more *durable*. Whether this is in general true or not is irrelevant to the present argument.[2] It was what 'the experts' said in 1491—experts, moreover, not only in Mantua but also in Venice, where the Bellini workshop was then engaged in replacing the wall-paintings in the ducal palace with large areas of painted canvas. Thus, while it is obvious that painting on canvas is more mobile, this is not necessarily a reason for supposing that the *Triumphs* were intended to be mobile.[3]

Nevertheless, the potential mobility of the *Triumphs* together with the lack of information about their original or intended home has continued to exercise the imagination of scholars; and in 1934, Professor Waterhouse produced an ingenious explanation combining these features.[4] According to him, the idea of the *Triumphs* was pressed by Mantegna on a somewhat unwilling Marchese Francesco, who offered the artist a room which was really too small for such a grandiose project. Mantegna accepted the room with mental reservations, hoping to be able to exact a more congenial site at a later stage. For this reason he painted on canvas, since it was essential that the work could be moved when this moment arrived. Unfortunately, while he was in Rome (1488–90), the Court discovered for itself the virtues of this mobility and began to use the canvases for purposes for which the artist had not intended them (masques, etc.). This, so the argument runs, was one reason why Mantegna lost interest in the scheme after his return from Rome. (As will be seen, there are grounds for thinking that Mantegna left the series unfinished; see below, p. 64.) As an explanation, this deserves to be better known, particularly on account of its pleasant moral tone, with a mild deceit meeting its just deserts; but the argument as a whole also represents one of the few attempts in print to examine the *Triumphs* in detail and, having asked a great many relevant questions, to draw conclusions from such an examination.

In broad terms, Waterhouse's exposition probably represents the generally accepted view —that, whatever the original purpose of the *Triumphs*, they soon came to be used with some degree of regularity as decorative stage properties for court theatricals. Indeed, the documents show at least four occasions on which *trionfi* were so used (see Documents 12, 13, 17, 18, 20, 21, and 22—pp. 183–4); and if, as is sometimes argued, the expression *trionfi* in the documents always implied Mantegna's *Triumphs of Caesar* (as *the* Triumphs *par excellence*), this has further consequences for the early history of the paintings. Not merely would they have been used in court festivities, but, by the early sixteenth century, Mantegna's *Triumphs of Caesar* would have been divided between at least three different sites.

[1] G. Milanesi, *Le Opere di Giorgio Vasari* (Florence, 1878–85; hereafter referred to as Vasari-Milanesi), Vol. III, p. 400.

[2] There is actually considerable substance to it. Already by 1506, the Mantegna family was called upon to repair the wall-paintings in the *Camera degli Sposi*.

[3] Other writers from Kristeller onwards have emphasized these and similar points. See, for instance, E. Tietze-Conrat, *Mantegna* (London, 1955), pp. 21–2.

[4] *Burlington Magazine*, LXIV (1934), p. 103, 'Mantegna's cartoons at Hampton Court—their origin and history'.

For *trionfi* are recorded in family residences at Gonzaga and Marmirolo, and probably also in Mantegna's house at Mantua; indeed it has sometimes been assumed, from a letter of 1494, that already by this date provision was being made to accommodate two of the *Triumphs of Caesar* in the Marchese's bedroom at Gonzaga.[1]

In these circumstances, it seems necessary to emphasize that these same documents prove reasonably conclusively the existence of other sets of *trionfi*;[2] and Cantelmo's letter of 1501 provides the only firm evidence that the paintings now at Hampton Court were used as adjuncts to theatrical performances. It is possible that this was a common occurrence: it is also possible that their use in 1501 was unique and never to be repeated. It remains ambiguous whether, for the *apparato* recorded in 1497 (see Document 12, p. 183), the *Triumphs of Caesar* were used to decorate the *cortile* where it was held. It now seems more likely that, for the *apparati* of 1505 and 1506, other *trionfi* were brought in from Gonzaga.[3]

The riddle 'when is a *trionfo* not a *Triumph of Caesar*?' is diverting in several senses. But the questions about the original purpose and destination of the Hampton Court paintings are more interesting, and neither is revealed by the surviving documents. However, the decree of 1492 mentions the *Triumphs* alongside the decoration of the chapel in the Castello di S. Giorgio and the celebrated *Camera Dipinta* (subsequently known as the *Camera degli Sposi*), and this association surely suggests that the *Triumphs*, too, were intended as a scheme of room decoration.[4] It has indeed recently been suggested that they

[1] See Document 10, p. 183. This letter, which is not given a place of origin, came almost certainly from Gonzaga and refers to work there. References to Mantua and Marmirolo make it clear that it was not written at either of those places; and work was proceeding concurrently at Gonzaga in which the activity of Ghisulfo can be shown from another letter of 13 February 1494 (Arch. Gonz. Busta 2446, f. 54).

[2] For instance, Cantelmo's letter of 1501 (Document 13, p. 183) distinguishes the *Triumphs of Caesar* from a set of Petrarchian *Triumphs*; and the documents also suggest that the *trionfi* at Marmirolo and Gonzaga, far from being parts of the *Triumphs of Caesar*, were in fact different *Triumphs* by other artists.

The Marmirolo *trionfi* are probably referred to in a letter of 1491 (Document 4, p. 182). Their subject is not disclosed but they were painted on canvas and could therefore also be moved. The painters of this series were named as Francesco and Tondo. The second painter has not been identified, but Francesco seems likely to have been Francesco di Buonsignori who was working for the Gonzaga at the time.

The *Triumphs* at Gonzaga are probably referred to in Collenuzio's letters of 1494 (Documents 10 and 11, p. 183), already mentioned. The little that is said about them makes it highly unlikely that the two paintings in question were part of the Hampton Court series. First, paintings nine foot square make unsuitable decorations for a *camerino* —in this instance, the Marchese's bedchamber. Secondly, that room also contained another painting, described simply as a *quadro* but explicitly said to be by Andrea Mantegna. In two successive letters, Mantegna's name is attached only to this *quadro* whereas no name is attached to the two *trionfi*. This suggests strongly that they were by another artist. By 1495 the chief painter at Gonzaga was Francesco di Buonsignori (see Mantua, Archivio Gonzaga, Busta 2447, ff. 18–19. Letter of 21 October from Ghisulfo to the Marchese), who had been working for the family before this date (Luzio, *Galleria*, p. 191). The

Gonzaga *trionfi* may therefore have been his. Indeed, an undated, unlocalized letter from Buonsignori (at present filed with the correspondence *ex Mantua* for 1492) proves that at some stage he painted a 'Triumph of Fame' for the Marchese, although the ultimate destination of that work is not known. (See Document 7, p. 182. Document 8, p. 182, records a further *trionfo* by Nicolò da Verona.)

Milanese's letter of 1505 (Document 17, p. 184) mentions some canvases in the possession of Andrea Mantegna which, although no title is specified, may have been *trionfi* since they were to be used in *apparati*. Nothing else is known about these. They may have been part of the present Hampton Court set; on the other hand they may have been the Petrarchian *Triumphs* displayed in 1501; or they could have formed part of a totally different project.

Documents 17, 18, 20, 21 (p. 184). The remarks of Fra Mariano (Document 22, p. 184) are unlikely to imply the *Triumphs of Caesar* because he termed one of them a *quadretto*. (But a different translation was suggested by Waterhouse, *op. cit.*)

[4] One is reminded of the series of rooms said to have been painted by Piero della Francesca in the palace at Ferrara (see Vasari-Milanesi, Vol. II, p. 491). A further series of rooms was painted by Bonifacio Bembo in the *Castello* at Pavia (see C. Baroni and S. Samek Ludovici, *La Pittura Lombarda del Quattrocento*, Messina–Florence, 1952, p. 108 ff.). On these comparisons, see also below, p. 75. The general notion that the *Triumphs* were intended for a particular site is supported by an observation of Professor Waterhouse (*op. cit.*). He pointed out that the wording of the letter of 1491 (Document 4, p. 182) shows that painting on canvas, at least on this scale, was still something of a novelty and the subject of remark. The presumption is strong that Francesco and Tondo and Andrea Mantegna had all been expected to paint their schemes directly on the wall. In this case, it would of course mean inevitably that the series was destined for a particular place.

were from the first meant to go in the large hall or *Sala* in the castle which in the fifteenth century stood adjacent to the *Camera*.[1] This suggestion had much common sense to recommend it but various considerations now make it unlikely. The first is that never at any time is a *Sala dei Trionfi* (or its equivalent) referred to in the *Castello*.[2] By itself this is inconclusive, but it is worth noting.

The second consideration depends on the interpretation of the letter of 1486 and needs explanation. The indisputable fact that emerges from this letter is that the Duke did not go to the *Castello* in order to see the *Triumphs*. However, it may still be argued that he saw Mantegna himself at work in some temporary studio;[3] and that the completed *Triumphs* had yet to be moved to their eventual home in the *Castello*. But this explanation really depends on the assumption that very little work had yet been done on them. It is virtually inconceivable that these huge canvases would not have been put into their intended positions almost as soon as they were painted, if for no better reason than to get them out of the way. If work had only just begun in 1486 and Mantegna was working on (say) only the second canvas, the theory that the Duke visited his studio has some plausibility. But if Mantegna had already been at work on the *Triumphs* for ten years (i.e. since the period following on the completion of the *Camera degli Sposi*) and had completed (say) seven canvases, the conclusion is almost inescapable that the Duke saw those canvases displayed in the site for which they were intended. To repeat, the 1486 letter makes it clear that in those circumstances the paintings could not have been intended for the *Castello*. Third, and most important, the paintings themselves do not suggest that they were planned for the *Sala* next door to the *Camera degli Sposi* (nor indeed for any available site within the *Castello*).

THE *TRIUMPHS OF CAESAR* AND THEIR ORIGINAL SETTING

A glance at the *Triumphs* extended in line (*nos. 1–50, 268*) reveals immediately that the lighting is imagined as if it came from the same general direction for each canvas. It is almost frontal, but with a slight bias towards the spectator's left, creating larger or smaller areas of shadow down the right-hand side of figures and objects. It is surprising that this fact has never received attention. In the *Camera degli Sposi* the lighting had been contrived by Mantegna with the greatest care to correspond to the natural lighting of the room. There is no reason to suppose that the same was not true for the *Triumphs*. In fact, the imagined lighting

[1] This theory is fully set out by G. Paccagnini in *Il Palazzo Ducale di Mantova* (Turin, 1969), p. 88. Professor Paccagnini kindly and courteously explained the idea to me in Mantua and showed me the archaeological evidence for the existence of the *Sala*. This evidence is entirely convincing, but for reasons given below, it seems to me unlikely that the *Triumphs* were ever intended to be displayed there.

[2] See, for instance, Arch. Gonz. Busta 2443 (1493), contents unnumbered. Letter from Federico del Casalmaggiore to Isabella d'Este of 16 July describing the preparations made to lodge a Turkish embassy in the *Castello*. The letter describes the decoration of the main rooms, listing them as follows:

Alozaméti (della Duchessa de Urbino), il camerino dil sole, il camerino di m^a Colona, la camera depinta, la sala davāti, la camera di ms guidon, la camera di m^a Beatrice, la saletta ch sta davāti. Also *la loza disotto*.

Thus at this stage, only two rooms had 'names'—*il camerino dil sole* and *la camera depinta* (i.e. the *Camera degli Sposi*). The other rooms were known by the names of their customary occupants except for the *sala*, which was merely called *la sala*. The same arrangements were described by Giovanni da Gonzaga in a letter to Isabella d'Este of 18 July 1493 (Arch. Gonz. Busta 2108). In both letters the *sala* was said to be decorated with the famous *spaliera* for which see p. 95, note 2 below. My attention was drawn to this last letter by Professor C. M. Brown.

[3] For an early statement of this view see H. Thode, *Andrea Mantegna* (Bielefeld and Leipzig, 1897), p. 90 ff.

gives the strongest possible grounds for assuming that the canvases were intended to be displayed in line in a gallery or long room where the opposite wall contained windows.[1] It also seems important that physical continuity is shown between some scenes but not between others. As a result the canvases fall into three distinct groups. Numbered from left to right, the first three form one group; numbers four, five and six form the second group; and the remaining canvases make up the third group. The evident continuity within the groups makes it possible to calculate the intended distances between the canvases—about eleven inches; and some more substantial interruption occurred after every third painting (see General Observations on the Paintings, p. 128). One further feature which may be deduced about the *Triumphs* is the height at which they were intended to be seen. This was a little above head-height, probably about seven feet up. As Serlio noted, the feet of the figures are 'superiori a la veduta nostra' so that 'non si vede pianura alcuna'.[2]

No certain information survives about the architectural framing of the canvases, although the eleven-inch gap already mentioned would conveniently accommodate a pilaster—of the sort, for instance, shown in the seventh canvas ('The Captives', *no. 37*) with its type of Corinthian capital and panel of arabesque decoration running down the main shaft.[3] The profiles of flanking pilasters are visible in the Louvre drawing (*no. 51* catalogued on p. 163). This arabesque decoration is very similar in character to that on the painted pilasters of the *Camera degli Sposi*; and together these pieces of evidence may perhaps give some indication of the appearance of pilasters which originally separated the *Triumphs*. The possibility also exists that those pilasters were carved with arms trophies since this type of decoration, popular with masons in Urbino and Venice during the last quarter of the fifteenth century, would have been appropriate in this context.[4] On the other hand, such pilasters are unlikely to have had capitals and bases which projected very much, since any such projection would have overlaid the canvases on either side. Here the Louvre drawing is again interesting since the pilasters have virtually no projection at all. The capital is represented by two mouldings corresponding to the abacus and necking; the base likewise has a simple moulded projection. Such simplicity is strongly reminiscent of the architecture to be found in Mantegna's earlier *Death of the Virgin* (Madrid, Prado, *no. 142*) and this should give some further idea of his intentions concerning the display of these paintings.

It would seem, therefore, that it is possible to deduce a reasonable amount about the

[1] The size of this gallery or room cannot of course be calculated on account of the apparently unfinished nature of the series (see below, p. 64). The existing canvases require over 90 ft. (27.5 m.) for their display. It may be added in passing that their exhibition formerly in the Queen's Gallery and the Communication Gallery and latterly in the Orangery at Hampton Court would seem to give a fair impression of the original intentions underlying the commission. By contrast, their display *round* a room (if this were, for instance, the case at S. Sebastiano) would probably be wrong. Kristeller appears to have been alone among previous writers in suggesting that the paintings were designed for a long wall (Kristeller [G], p. 297 and [E], p. 283).

[2] See Document 27, p. 185. A useful comparison will be found in the *Camera degli Sposi*, where the figures over the mantelpiece are seen from a very similar angle. The height of the mantelpiece from the ground is *c.* 86 in. (2.20 m.).

[3] The 'Captives' canvas is the worst preserved of the series, but the architectural detail now visible repeats with a few minor changes the detail to be found in the Andreani woodcut (*no. 95*).

[4] Pilasters carved with trophies of arms seem to have been used later when the *Triumphs* were displayed in the palace of S. Sebastiano (see below, p. 95). Two well-known engravings of pilasters have been associated with the *Triumphs*: see Bartsch, xiii, p. 236, 14; also Hind, Mantegna 15b and, under Zoan Andrea, No. 25, A1 and B (here *nos. 61, 62*). Of these three pilasters, one adjoins an engraving associated with the sixth canvas. Their status is uncertain although the artist of Hind, Mantegna 15b presumably thought he was transmitting one of Mantegna's designs. The shafts have a slight, rather flowery type of arabesque decoration and Ionic capitals, a combination which has no other parallel in Mantegna's work.

character of the original site of the *Triumphs*: and it remains to ask whether anything further can be said about where this was likely to have been. It is here necessary to comment on the wording of the letter of 1486 (Document 1). The topography of the palace enclosure in the fifteenth century has been much confused by the subsequent building operations of the sixteenth and seventeenth centuries. The situation is not helped by the absence of any early plan or view of the Palazzo Ducale. The earliest view is dated 1574[1] (*no. 263*) and was followed by the large fresco in the Vatican (datable 1580–3).[2] The famous view of Mantua by Bertazzolo[3] is dated 1596 (*no. 265*) and, apparently dependent on this, there follows the small wall-painting of 1616 in the *Saletta delle Città* (in the *Palazzo Ducale* at Mantua).[4] For the present purpose it is a pity that the earliest of these is so poor in quality. Since it is also demonstrably wrong in so many points of detail, it may seem hard to accept it as being of any use as evidence; but in its general topographical impressions it is correct. For instance, the position of S. Andrea in relation to the Duomo is more or less right, while the *Porto Catena* is placed correctly in relation to the *Ponte S. Giorgio* and the now vanished *Porto dell'Ancona*. The *Cortile della Cavallerizza* is clearly shown, although the draughtsman has become hopelessly confused by the towers of the *Castello di S. Giorgio*. What is important, however, is the overall impression given of a walled enclosure surrounded, on the lagoon side, immediately by water. Thus the earliest view suggests the original appearance of this area before the process of embankment had begun. It is not clear when this embankment was carried out, but it is already a feature of the Vatican view a few years later. The purpose of the new arrangement, clearly visible in Bertazzolo's view, was to carry traffic from the bridge round the north side of the *Castello* so that it no longer had to pass through the palace area. This was not apparently the original arrangement. Previously, the road from the *Borgo S. Giorgio* led directly from the bridge into the palace complex, past the south side of the *Castello*. Originally it passed through the *Rocchetta S. Nicola*,[5] and when this was absorbed into the later buildings (actually into the present *Sala dei Capitani*), the course of the road was preserved in an alley (visible in Bertazzolo's engraving), which still leads at ground level to the *Piazza S. Barbara*. The new entrance guarding this road is called, in Bertazzolo's plan, the *Porta del Baluardo*.[6] This arrangement, whereby a major bridge led directly into a fortified area, is not unique; the Scaliger bridge at Verona follows a similar plan. Although this may not seem at first sight to have much bearing on Mantegna's *Triumphs*, it is of course highly important in determining what happened to the Duke of Ferrara when he disembarked from his boat in 1486 and this in turn is relevant to the early history of the paintings. The letter speaks of his landing not at the *Ponte S. Giorgio* nor at a *Porta S. Giorgio* but at the *Porto de Corte* (i.e. the harbour attached to the Court). It is at least fortunate that there is no ambiguity about the word *Corte*, which was always quite distinct from *Castello* and signified the area now occupied by

[1] The 1574 view was made for G. Braun and F. Hohenberg, *Civitates Orbis Terrarum*, Lib. 2, No. 50.

[2] D. Redig de Campos, *I Palazzi Vaticani* (Bologna, 1967), p. 174 ff.

[3] According to Paccagnini (*Il Palazzo Ducale*, p. 8), the Bertazzolo engraving was made initially in 1596 but re-issued in 1628. The illustration is taken from a copy of 1628 now in the Biblioteca Comunale in Mantua. I have not seen a copy of 1596.

[4] E. Marani and C. Perina, *op. cit.*, III, p. 170.

[5] Paccagnini, *Il Palazzo Ducale*, p. 10.

[6] See E. Marani and C. Perina, *op. cit.*, III, p. 39, note 8.

the major surviving thirteenth- and fourteenth-century palace buildings.[1] The *Porta de Corte* was the main entrance almost opposite the Duomo,[2] and therefore the *Porto de Corte* should have been the watergate serving this entrance. By the time of Bertazzolo, this *Porta* was served by a landgate reached from the *Ponte S. Giorgio*[3] but in the view of 1574 a watergate is clearly visible to the right of the bridge. In the absence of any other evidence, it is reasonable to assume that this was the *Porto de Corte*.

No other reference to this *Porto* has yet been found, but the evidence for the *Via Coperta* is more substantial and revealing. Although seldom mentioned, its general character is clear since it was the main thoroughfare between *Castello* and *Corte* and those who used it were going on foot from either one to the other.[4] (Once again, the fact that Duke Ercole used it to get *to* the *Castello* makes it virtually certain that the paintings he had just seen were not *in* the *Castello*.) In fact, the Duke appears to have been taken on a round trip of the Gonzaga residences. Landing at the watergate, he proceeded up to the *Corte* and thence back, along the *Via Coperta*, to the *Castello*. It seems likely, from this, that the Duke saw Mantegna's paintings in *Corte*; and the suggestion has already been made that in certain circumstances the Duke would have seen such paintings as Mantegna had already completed *in situ* (see above, p. 34). It remains to be asked whether this is either likely or possible; and at this point some account of *Corte* in the later fifteenth century is necessary.

THE PALAZZO DELLA CORTE IN THE LATER FIFTEENTH CENTURY

The *Palazzo della Corte* is a large rambling group of buildings (plan on p. 38 and *no. 264*). The crucial step in its history seems to have been taken when (for reasons unknown) the Bonacolsi family who ruled Mantua before the Gonzaga decided to build, alongside the former church of S. Croce, the palace now known as the *Domus Magna*.[5] This was quickly

[1] This emerges clearly, for instance, from the quarantine precautions during the plague of 1506. Thus Calandra, writing to Isabella about the consequent boredom said *essendo nui e li sescalchi et altri officiali renchiusi in questo hora mai longhe pregione quelli in corte nui qui in questo castello . . .* (Arch. Gonz. Busta 2469, f. 204. Letter of 13 May 1506.) The expression *corte vecchia* has only been found in use once before the 1520s. It occurs in the letter from Giovanni da Gonzaga to Isabella of 18 July 1493 (Arch. Gonz. Busta 2108). What the writer thought of as *corte nuova* is not clear, but it was perhaps the new palace (the *Domus Nova*) built by Fancelli in the 1480s. How that was used in the late fifteenth century is not known; but no other correspondent of these years felt it necessary to make a *vecchia-nuova* distinction in writing about *corte*.

[2] It is marked as such on Bertazzolo's map, but see also an account of a visit of an Ambassador and Viceroy in 1512, where the procession arrived *su la piaza di s. petro* (i.e. the present piazza Sordello) *al directo di la porta di la corte*. (Arch. Gonz. Busta 2485. Letter Amycomᵃ della Torre to Federico Gonzaga of 13 August 1512).

[3] The area is shown occupied by the *Teatro* and the *Porta di S. Giorgio* which was, of course, a landgate.

[4] A letter of 1499 describing the visit of a papal legate (Arch. Gonz. Busta 2993, Libro 10, f. 52ʳ. Letter from Isabella d'Este to the Marchese Francesco of 28 September)

shows Isabella d'Este also using the *Via Coperta* to get from *Corte* to the *Castello*. *Io per vedere la entrata steti a la camera di cani in corte et mētre chl smonto et stette in chiesa venne in castello per la via coperta al pede de la scala grāde lo expectai acompagnata da molte gentildōne.* (This letter was brought to my attention by Professor Clifford M. Brown.) Further, in 1516 (Arch. Gonz. Busta 2494, contents unnumbered. Letter from Calandra to Federico Gonzaga of 25 June), during the stay of the Duchess and Dowager Duchess of Urbino, Calandra wrote *me para proprio ch li sia la s.v. aveder' tanta gente ch viene avisitare le sigʳᵉ duchesse et hanno sarata lavia coperta ch nō se po andare piu de corte in castello et hanno aperta q̄lli dui nessari ch sono li in la via coperta acioch le done possino far' li suoi servicij ch homo alcuno le possino vedere.* A recent study of Alfonso d'Este's *Camarini d'Alabastro* (C. Hope, 'The Camerini d'Alabastro' of Alfonso d'Este', *Burlington Magazine*, CXIII, 1971, p. 641) has thrown considerable light on the *Via Coperta* at Ferrara. This, an elevated covered way, links the Palace with the *Castello*. The outer walls survive but the interior arrangements have been totally reconstructed. However, it seems reasonable to suppose that the *Via Coperta* at Mantua was similar in kind and function although necessarily much longer.

[5] For the history of the Palace, see generally G. Paccagnini, *Il Palazzo Ducale* (Turin, 1969).

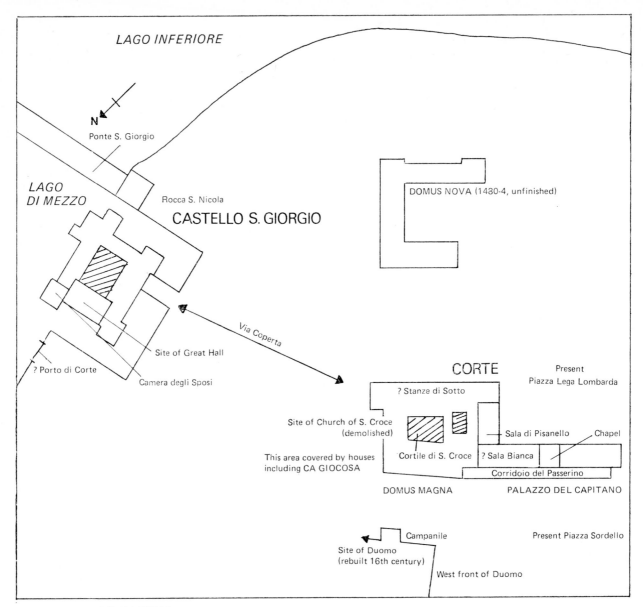

THE PALACE OF MANTUA
IN THE SECOND HALF OF THE 15th CENTURY,
including its principal components

The small amount of certainty that exists concerning the pre-16th century palace of Mantua will be apparent from this sketch-plan. The purpose here is to indicate the topographical relation of the various parts, without any claim to detailed archæological accuracy.

followed *c*. 1300 by the much larger adjacent *Palazzo del Capitano*,[1] and it appears to have been substantially this group of buildings which was taken over by the Gonzaga family when they came to power in 1328. The two palaces, although different in size, seem to have been similar in type: each appears to have had store-rooms on the ground floor, living-rooms and offices on the *Piano Nobile*, and a large hall on the upper floor. In much of this, they

[1] Guido Bonacolsi was elected *Capitano del Popolo* in 1299 and the construction of the Palace seems to have followed rapidly upon this event. It is currently agreed that, although the core of the *Domus Magna* is probably thirteenth-century, the façade post-dates the construction of the *Palazzo del Capitano*.

were similar to other Bonacolsi palaces in Mantua,[1] and the arrangements also resemble the organization of other buildings elsewhere in Italy.[2]

It is clear that this 'inheritance', although imposing in size, was scarcely convenient as a family dwelling. The immense hall over the top of the *Palazzo del Capitano*, for instance, seems to have remained for all time an architectural 'white elephant'. The Gonzagas never really devised a social use for it, and in time it seems to have been used as an armoury.[3] Also, on the evidence of external rearrangements to windows, the difference in floor levels between the two palaces seems to have caused problems.[4] But in spite of these difficulties, there is considerable evidence to show that in the century between *c*. 1350 and 1450 the Gonzagas had spent much time and money on improvements. For instance, an impressive amount of window enlargement dates from the late fourteenth century, while substantial fragments survive of fourteenth- and early fifteenth-century schemes of interior decoration.[5] A rear wing was added comprising an open gallery on the first floor (later closed in, to become the *Sala di Pisanello*) with a loggia beneath.[6] A further suite of rooms was added, parallel to the *Domus Magna*, to form between the two the *Cortile di S. Croce*. (This is the range of buildings now incorporating the *Appartamento degli Arazzi*.)[7] There is much that is still unclear about the late medieval organization of these palaces—the staircase arrangements, for instance, are still obscure;[8] but it is nevertheless possible to get a fairly clear picture of what Mantegna's contemporaries meant when they used the word *Corte*.[9]

It is important to note in what esteem *Corte* was held. Attention tends now automatically to be focused on the *Castello* because of the *Camera degli Sposi* and the lost Mantegna chapel. But the *Castello*, as a palace, was largely the creation of the Marchese Ludovico. The reasons were presumably those of security—it was certainly the safest place in Mantua —but it also had the distinction of being extremely inconvenient, and by the end of the century, as the headquarters of the régime, it was becoming uncomfortably overcrowded. Apart from the Marchese Francesco on the ground floor[10] and Isabella d'Este on the *Piano*

[1] For instance, the palaces on the opposite side of the Piazza Sordello.

[2] Obvious parallels are the *Palazzo Ducale*, Venice, and the *Palazzo dei Priori*, Perugia. There must certainly be others. The suite of state rooms with the chapel on the first floor at Mantua has similarities to the arrangements in the *Palazzo Pubblico*, Siena.

[3] It is said to have been used for the Church Council of 1459. Its use as an armoury seems to date from the sixteenth century. The problem of the original access to this imposing room (it is over 200 feet long) has never been satisfactorily solved. At present the visitor enters through what is little more than a large hole in the wall in the south-east corner.

[4] See the point in the façade where the two palaces meet. The smaller proportions of the *Domus Magna* mean that originally its upper floor was very much lower than the adjacent upper floor of the *Palazzo del Capitano*. Originally, transit from one to the other at this level must have been difficult, and it may be that the rearrangements suggested by the windows were intended to alleviate this situation. Unfortunately, the original interior has been so altered by subsequent 'improvements' that its interpretation presents serious problems.

[5] For an account of these, with illustrations, see the exhibition catalogue *Pisanello alla corte dei Gonzaga* (1972),

by G. Paccagnini and M. Figlioli, p. 17 ff. For the dating of the various Gonzaga emblems from this period, see G. Gerola, *Archivio Storico Lombardo*, Anno XLV (1918), p. 97: 'Vecchie insegne di casa Gonzaga'.

[6] Paccagnini, *Il Palazzo Ducale*, p. 30 ff.

[7] These rooms were later converted for use by Isabella d'Este. See Paccagnini, *ut sup.*, p. 18.

[8] Also the problem of the main entrance to the *Corte* at any particular date, is a complicated one that requires further study.

[9] There were a number of rather ill-defined adjuncts to this complex. The most famous was the so-called *Ca' Giocosa*, built *c*. 1388-9, and, as the *Ca' Giocosa*, inhabited by Vittorino da Feltre between 1423 and 1446. This has already been mentioned in Chapter Two. It was described in 1475 as being 'sulla Piazza di S. Pietro'. See E. Paglia, *Archivio Storico Lombardo*, Second series I (1884), p. 150: 'La Casa Giocosa di Vittorino da Feltre in Mantova'.

[10] Arch. Gonz. Busta 2992, Libro 6, f. 65^v–67^r. Letter Isabella d'Este to the Marchese Francesco of 21 March 1496. When her brother, the Cardinal d'Este, visited Mantua *allogia in le camere de sotto* [in the *Castello*] *dove soleva stare v s.*

Nobile,[1] the *Castello* by this date had to contain the chancery,[2] an armoury,[3] a prison,[4] and a guard (which might well swell to a garrison in times of emergency).[5] There seems to have been constant activity coupled with a permanent shortage of space.[6] It is largely as a result of this that there is a fairly constant stream of information in the archives about the happenings in *Castello*. The same cannot be said of *Corte*.

And yet, none of Lodovico's descendants lived permanently in the castle. His son, Federico, had his own rooms in *Corte* during the 1460s,[7] and on succession built his own palace, the so-called *Domus Nova*.[8] His grandson, Francesco, for some years had apartments in the castle alongside the chancery and the armoury, but he built his own city palace at S. Sebastiano in the opening years of the sixteenth century, see below, pp. 92 ff. His great-grandson, Federico II, also lived in *Corte* before succeeding;[9] he was subsequently responsible for the immense rebuilding programme supervised by Giulio Romano. At no material time therefore after the death of Lodovico was there a large number of people anxious to live in *Castello*. What, then, were the attractions of *Corte*?

There seem to have been two desirable suites of rooms in the *Corte* which, between 1450 and 1510, are mentioned in the archives again and again. They were used as lodgings both by the family and by distinguished visitors. One set can be reasonably identified with rooms beneath the present *Appartamento degli Arazzi*. In 1493, these were called the *quattro ample e honorevole camere di sotto*.[10] A further suite called the *Camere Bianche* with a *Sala Bianca* has not been identified with certainty. It was on the *Piano Nobile* and is likely to have occupied the area now known as the *Appartamento della Guastalla*.[11] In addition there was a set of rooms which seems to have been on the first floor of the *Domus Magna*. This had no

[1] Isabella's original *Grotta* and *Studiolo* were, of course, in the entrance tower overlooking the *Ponte S. Giorgio*.

[2] Arch. Gonz. Busta 2453, f. 202. Letter Giacomo de Striggi to the Marchese Francesco of 20 May 1499. In the course of business Striggi went *in Cancellaria in Castello*.

[3] The resident cannon-founder *c.* 1500 was Federico Calandra, who occupied a *Camera Grande* in the *Castello* (Arch. Gonz. Busta 2453, f. 160. Letter Federico Calandra to the Marchese Francesco of 2 January 1499). See also Arch. Gonz. Busta 2459, contents unnumbered, letter Federico Calandra to the Marchese Francesco undated—about the arrival of 106 German arquebuses which Calandra laid out for display *sotto la locetta come se intro in castello*.

[4] Arch. Gonz. Busta 2463, f. 147. Letter from Antonio della Scrina to the Marchese Francesco of 5 September 1504. A captive was confined *ī pregione ī lo fondo de la torre del Castello*.

[5] Arch. Gonz. Busta 2461. This contains, among other things, a series of letters written by Il Milanese to the Marchese Francesco in 1503. There are several mentions of a garrison of *provisionati* and *balestrieri*, which at times seems to have numbered about 100.

[6] For references to shortage of space see the letter of Federico Calandra of 1499 mentioned in note 3 above. See also Arch. Gonz. Busta 2457, f. 234. Letter from Antimacho to the Marchese Francesco about the difficulty of finding a *camera* for a man being held for questioning.

[7] Arch Gonz. Busta 2907. Contents unnumbered. Letter of Federico Gonzaga to Barbara Gonzaga of 2 August 1463. Information about *Corte* including *le camere dou'io sto a Mantova*.

[8] See Paccagnini, *Il Palazzo Ducale*, p. 46 ff.

[9] Arch. Gonz. Busta 2497, contents unnumbered. Letter from Calandra to Federico Gonzaga of 21 August 1518. The visiting Cardinal of S. Sisto was treated with great honour and *alloggiato nelle camere de v s in corte*.

[10] See Arch. Gonz. Busta 2108 (1493), contents unnumbered. Letter from Giovanni da Gonzaga to Isabella d'Este of 18 July, in which it is related that a visiting papal ambassador was lodged there. These rooms were inhabited by the Cardinal Sigismondo Gonzaga in 1506 (Arch. Gonz. Busta 2469, f. 112. Letter from Federico Malatesta to the Marchese Francesco). See also Arch. Gonz. Busta 2485, contents unnumbered, letter from Amycomᵃ della Torre to Federico Gonzaga of 13 August 1512. Here, in an account of an official reception, it is clear that the Papal Legate in the *stantie di sotto* got the second-best suite of rooms. Precedence was given to the Viceroy of Naples, who got the *Camere Bianche* (see note 11 below).

[11] See Arch. Gonz. Busta 2422, contents unnumbered. Letter from Matteo Antimacho to the Marchese Federico of 21 June 1479. Account of the reception of the wife of Gianfrancesco Gonzaga who, with much noise and music, *fu c'ducta ala corte dove al pede dela scala* she was received by Barbara of Brandenburg. Then *ascese ala sala biancha, poi subito intrat' ī una de quelle camere*—The rooms are mentioned elsewhere—for instance, in the 1506 and 1512 letters of the preceding note. The *Sale Bianca* also appears in Luca Fancelli's report of 15 December 1480 on the state of the *Sala di Pisanello*. In the context of the letter it would make good sense if the two rooms were adjacent. On these and related matters see A. Martindale, *Burlington Magazine*, cxvi (1974), p. 101: 'The Sala di Pisanello at Mantua—A New Reference'.

general title, but the names and sequence of most of the rooms can be deduced from the archives.[1] Once again there is still much that is unclear about these various arrangements but one feature remains in evidence throughout the present period: the *Corte* was regarded as commodious, capacious, and desirable. A cycle of paintings by Mantegna in *Corte* should cause no surprise.

However, there seems to have been only one place in *Corte* where a cycle the size of the *Triumphs* could have been housed.[2] This is the so-called *Corridoio del Passerino*, originally a long communicating gallery running the full length of the *Palazzo del Capitano* on the first floor (*no. 266*). In the course of the fourteenth century, this gallery was chopped up into small rooms, some of whose positions are easily identifiable from the remains of their painted decoration on the inner wall of the *Corridoio*. This alteration must have been possible as a result of some change in the entrance and transit arrangements of that period,[3] but one result was that by the second half of the fifteenth century the *Corridoio del Passerino* would not easily have been recognizable as such, except to the resident engineer. However, it would have required not more than the briefest inspection by a competent engineer to see that the physical rehabilitation of the *Corridoio* would have taken, at the most, about a week. The thickness of the partition walls, as revealed by the surviving wall paintings, was minimal (two or three inches). They must have been of the flimsiest imaginable construction; and a team of demolition men followed by plasterers could have accomplished this task in a very few days. In practical terms, therefore, there would have been no problem in selecting this area as a site for the *Triumphs of Caesar*.

Moreover, the *Triumphs* make good sense in this position, more especially since the recovery of the paintings of Pisanello. It will be obvious that the knightly qualities commemorated in the Arthurian stories of Pisanello to some extent complement the martial qualities of Caesar.[4] Two important cycles would seem an admirable and appropriate way of regaling important guests at the Gonzaga court. But more than this, *Corte* possessed an impressive series of enormous rooms. These included the present *Sala dei Papi*, the *Sala di Pisanello*, the very big adjacent *Sala* (probably the *Sala Bianca*), a splendidly painted chapel, and the rooms beyond at the west end of the palace. A linking *Corridoio de' Trionfi* could form an equally impressive and logical adjunct to this sequence. Nor will it escape notice that the *Corridoio* will comfortably contain a triumphal programme nearly double the length of the existing series of paintings. Thus it would have been possible in this context to retain Caesar and his chariot where he should be—near to the centre of the procession[5]—and to

[1] These rooms present more of a problem on account of the alterations made to the building since the fifteenth century. An extremely useful letter is Arch. Gonz. Busta 2398 of 29 November 1463. Filippino de Grossis to the Marchesa Barbara. This letter is an answer to an enquiry about the provision of beds and mattresses *in corte*. Filippino went from room to room noting the contents; and the result is a list of the rooms in the sequence in which they might normally be visited. These rooms turn up in other contexts. One, the *Camera dei Cani*, was chosen by Isabella d'Este as a point from which to watch a procession in the Piazza outside (see Letter of 1499 quoted in note 4, p. 37). On the façade of the Piazza Sordello there is really only one window on the level of the *piano nobile* that one could comfortably use for this purpose. The room to which it belongs lies between the *Corridoio del Passerino* and the *Appartamento*

delle Imperatrici and this may tentatively be identified with the *Camera dei Cani*. Systematic reading of the archives has produced much more information about these rooms but this is not the place to examine the subject.

[2] The problem is to find a continuous wall surface at the very least 91 ft. 8 in. long (approx. 28 m.). This excludes even the *sala* lying to the east of the chapel of the *Palazzo del Capitano*, and now subdivided into two rooms. This was approximately 88 ft. long (27 m.).

[3] See Paccagnini and Figlioli, *op. cit.*

[4] The iconography has been discussed in G. Paccagnini, *Pisanello* (London, 1973), Chapter 3.

[5] Such a programme of fifteen canvases with intervals as suggested above might be expected to cover *c.* 159 ft. The *corridoio* is over 200 ft. long.

extend the series of canvases to include the army following on behind the *triumphator*. It seems necessary, therefore, to concentrate on the history of the *Corridoio*.

Of course, it is hardly to be expected that a *corridoio* should have much of a history except when it ceased to be a *Corridoio*. One occasion on which this area was subdivided into small rooms has already been mentioned. This happened again in 1773.[1] From the point of view of the present enquiry, it is interesting that between these dates the *Corridoio* was indeed rehabilitated as a connecting passage for the state rooms on the *Piano Nobile* of the *Palazzo del Capitano*. This suite is now known as the *Appartamento della Guastalla*—a name dating from the late seventeenth century.[2] The major work of redecorating these rooms was carried out in the opening years of the same century by the architect Viani. There was an eighteenth-century tradition that the opening up of the *Corridoio* was also his work.[3] No available documentary basis for this assertion exists, however, and the possibility remains that the recovery of the *Corridoio* was the work of an earlier period.[4] The *Triumphs of Caesar* may have been intended for the *Corridoio*—it is indeed difficult to single out any other place where they could have been hung. But more than this cannot be said until the history of the *Palazzo del Capitano* and the *Domus Magna* has been established—indeed, until the whole early history of the way *Corte* was used has been pieced together. The evidence is emerging, piece by piece, and there seems no reason to doubt that more positive answers should be forthcoming at some future date.[5] But at the moment, the *Corridoio del Passerino* seems to present the most convincing solution to the problem of the original site of the *Triumphs of Caesar*.[6]

THE DATE OF THE *TRIUMPHS OF CAESAR*

The precise dating of the *Triumphs of Caesar* will probably always depend at certain crucial points on matters of opinion rather than fact. However, if the enquiry is to be taken any

[1] The alterations are described in nineteenth-century guidebooks. The partitions were removed once more in this century. See V. Restori, *Mantova e dintorni* (Mantua, 1937); also C. Cottafavi, *Bollettino d'Arte*, XXV (1931–2), p. 377, 'Il Palazzo del Capitano'.

[2] Anna Isabella di Guastalla married Ferdinando Carlo di Nevers, tenth Duke, in 1671.

[3] See Marani and Perina, *op. cit. III*, p. 164. The eighteenth-century tradition comes from Amadei.

[4] Some work appears to have taken place in the early sixteenth century since Cottafavi (as cited in note 1) mentioned traces of Leonbrunesque decoration *nel ultimo tratto del corridoio*.

[5] In all discussions on the early history of the palace, Stefano Davari's *Notizie storiche topografiche della Città di Mantova* (Mantua, 1903) remains a fundamental work. It is a pity that this has not been superseded, for Davari had the annoying habit of quoting documents out of context and sometimes without dates. Davari thought that, in the mid fourteenth century, the Gonzaga family had as many as four palaces in the area behind the *Palazzo del Capitano*. He also linked with these some room descriptions which he printed from the archives. All this must be treated with caution since it depends on topographical information and

topographical definitions and distinctions which at present are not forthcoming (at least in print. For instance, what was the *Palazzo del Capitano* called in the fourteenth century? Where exactly was the Church of S. Alessandro? Where was the boundary between the parishes of S. Alessandro and S. Croce? And so on.) It seems possible that some of Davari's lists of rooms may refer to the buildings of *corte* rather than to vanished palaces. Certainly, there is a considerable overlap of room names. This could be of interest since already by 1391 there existed a *camera Lanzaloti* (compare the later subject-matter of the *sala di Pisanello*); and at least by 1447 there was a loggia of Caesar and Pompey (compare the later subject-matter of Mantegna). It should be possible to deduce where these were, but this is not the context in which to rewrite the early history of the *Palazzo Ducale*.

[6] While this book was at proof-stage, Mr Michael Vickers published a different interpretation of the evidence relating to the original site of the *Triumphs* (*Burlington Magazine*, CXX (1978), p. 365, 'The intended setting of Mantegna's "Triumph of Caesar", "Battle of the Sea Gods" and "Bacchanals"'). His arguments received criticism subsequently from Charles Hope and Elizabeth McGrath (p. 603) and from myself (p. 675); and for a discussion of Mr Vickers' ideas and his own rejoinders to the criticisms, the reader is referred to those pages.

further, it seems necessary to begin by speculating on the length of time it would have taken Mantegna to paint each canvas. Fortunately, it is possible to make some useful suggestions about this. For instance, in 1495–6 Mantegna painted the *Madonna della Vittoria* (now in the Louvre, Paris, *no. 146*), which, in point of content and technique, is very similar to the *Triumphs* in that it is minutely painted in tempera on gesso priming and contains, as its main constituents, figures clothed in drapery and armour. On 30 August 1495 the altarpiece was not yet begun;[1] but it was ceremonially installed in its chapel on 6 July 1496,[2] and in a letter of 7 July 1496 it was described as *de recenti picta*.[3] The 6 July was the anniversary of the battle of Fornovo, the subject of the celebrations; and although these ceremonies do not in themselves date the completion of the altarpiece, the information that it had been 'recently painted' suggests that its completion was not long before its installation. In fact a period between September 1495 and May 1496—nine months—would seem a reasonable assessment of the evidence. The *Madonna della Vittoria* is substantially smaller than the canvases of the *Triumphs*, so that, if the altarpiece took nine months, it is difficult to believe that it took Mantegna much less than a year to paint each of the *Triumphs*.[4]

If it is thought that Mantegna's work on the *Triumphs* extended well into the 1490s, there is little objection to the series being wholly a commission of Francesco Gonzaga. There must have been a two-year break from 1488 to 1490 since Mantegna is known to have been working for Innocent VIII in Rome during those years; and further time would have been lost between 1495 and 1497 while Mantegna was painting the *Madonna della Vittoria*, the *Trivulzio Madonna* and the *Parnassus (no. 141)*. Taking this into account, the *Triumphs* would have occupied the remaining period between 1484 and *c.* 1499, granted a production rate of about one canvas every year.[5]

Cumulatively, however, the evidence suggests at least the possibility of a different answer. The manner in which Mantegna occupied his time in Mantua has always been a matter for speculation. His major works are known—the castle chapel and chamber, the *Triumphs of Caesar*, the *Madonna della Vittoria*, and the paintings for Isabella d'Este. The dates which have been available until recently for these works have suggested a series of chronologically detached activities. Thus, the chapel has been dated 1459 +, the *Camera degli Sposi c.* 1470–1474, the *Triumphs of Caesar c.* 1486–92, the *Madonna della Vittoria* 1495–6, the paintings for Isabella from 1496 onwards. The speculation has been about the periods of apparent inactivity in between these commissions.[6]

[1] Kristeller, (G) only, Dok. 139.

[2] Kristeller (G) Dok. 140 and (E) Doc. 60.

[3] Kristeller (G) Dok. 141 and (E) Doc. 61.

[4] It is only possible to get the most general answers to this question since little is known on many important points. For instance, Mantegna had two sons Lodovico and Francesco, who were painters and, presumably, assistants. Their intervention must have speeded up operations but nothing clear is known about the operations of the workshop. This may nevertheless be relevant to the eleven months from October 1496 to August 1497, during which time Mantegna completed both the *Parnassus* (Paris, Louvre) and the *Trivulzio Madonna* (Milan, Castello Sforzesco). This was rapid work indeed (although the *Parnassus*, at least, gives no signs of this). To be precise (and using rather crudely the available measurements), in 1496–7 Mantegna covered 9.214 sq. metres of picture surface in eleven months; in

1495–6, he had covered 4.5 sq. metres of picture surface in, perhaps, nine months. Each canvas of the *Triumphs* has approximately 7.51 sq. metres of picture surface—an intermediate figure, suggesting perhaps an intermediate period of time of ten months (i.e. each canvas could have been painted within a year). Against any undue shortening of this timescale should be set the vast concentration and complication of the detail of the *Triumphs* in comparison with, e.g., the *Trivulzio Madonna*.

[5] Granted that the 'Senators' composition was available to Liberale da Verona for purposes of plagiarism by the late 1490s, the time limits for the formulation of the *Triumphs* cannot plausibly be extended much beyond 1495. (For Liberale da Verona, see below, p. 99, note 3.)

[6] In this context, emphasis tends to be placed on Mantegna's work on palaces outside Mantua, his superintendence of court festivities, his designing of jewellery, plate

It is now clear that one at least of these supposed periods of inactivity did not exist. The castle chapel, already begun in 1459,[1] was still being decorated in 1462[2] and probably as late as 1464.[3] The *Camera degli Sposi* is now known to have been begun by April 1465[4] and the painting lasted at least until the date of the inscription above the entrance, 1474. In the decree of 1492 three works were thought worthy to be singled out as Mantegna's major creations in Mantua up to that date. The second, the *Camera*, can now be shown to have followed fairly closely on the first. Is it possible that the third of these major works, the *Triumphs*, also followed on the second and that therefore all three were commissioned by Lodovico Gonzaga?

It is suggested later in this study that eight of the canvases had been painted before Mantegna went to Rome in 1488. Briefly the argument for this is that the compositions of 'The Captives' (*no. 37*) and the unpainted 'Senators' (known from a drawing—*no. 56*) together show a radical reappraisal of the character of the setting against which the figures were displayed. It is argued that the nature of this change was conditioned by Mantegna's experience of the city of Rome, and, if this were so, it is hardly possible that the *Triumphs* could have been commissioned by Francesco Gonzaga whose rule only began in 1484. Even at a rate of one canvas a year, the series would in these circumstances have been planned in 1479; and it would have required only a very small delay for the whole scheme to have been planned in the closing years of Lodovico's government—that is, before his death in 1478.[5] Indeed, there are two such delays recorded during this very period. In February 1484,[6] Bishop Lodovico wrote to Giovanni della Rovere that Mantegna was going to be occupied for the whole summer painting a *camera* for the Marchese Federico (Mantegna had already at the time of the letter made a start on the work); and late in 1485, the Marchese Francesco was pursuing Mantegna with requests that he complete a Madonna for the Duchess of Ferrara.[7]

The answer to this problem will depend to a considerable extent on an assessment of the relative potential of Lodovico, Federico and Francesco as patrons. About Francesco's personal interests a certain amount is known. He was passionately enthusiastic about horses[8] and, at least at an early age, not very keen on the classics.[9] He was an orthodox and not entirely successful military commander, now chiefly remembered as the general who

and tapestries, his engraving and so on. In view of the subsequent arguments here put forward, it seems more important to emphasize the paucity of evidence for these activities. In particular, there is almost no evidence that Mantegna was called upon personally to paint in the country residences of the Gonzaga, although he certainly provided designs for other painters to use. (See *passim* the documents printed by Kristeller.) The inference could be that he was fully occupied in Mantua.

[1] Kristeller (G) Dok. 19 and (E) Doc. 7.

[2] This document of September 1462 was noted by Clifford M. Brown, *Burlington Magazine*, CXIV (1972), p. 861, 'New documents for Andrea Mantegna's Camera degli Sposi' in note 2. It refers to work in *la Capelleta nostra*.

[3] Kristeller (G) Dok. 33 and (E) Doc. 13 and 14. This letter from Mantegna to Lodovico Gonzaga, written from Goito and partially about work there, also refers to *opera inla chapeleta*. This ought to be the chapel at Mantua but could conceivably refer to an oratory in Goito.

[4] See Clifford M. Brown, *op. cit.* above. The document, discovered by Rodolfo Signorini, is dated 26 April 1465.

[5] For the arguments concerning the effects of the Roman visit see below, p. 88. A. Venturi came to a similar general conclusion about the dating (*Storia dell'Arte Italiana*, Vol. VII, 3—Milan, 1914, p. 204), supposing that the series must have been begun soon after 1480. His reasons included *le dimensioni straordinarie delle tele, il lungo studio messovi attorno, le interruzioni avvenute per soddisfare ai desideri di principi e per l'andata a Roma*.

[6] See Kristeller, (G) only, Dok. 87.

[7] See Kristeller (G) Dok. 91–4 and (E) Doc. 42–4 only.

[8] I was aware, going through the Mantuan archives, of many bundles of reports on the stables and horses, often issued daily and addressed to Francesco Gonzaga.

[9] See Luzio and Renier, *op. cit.*, p. 198. There is a letter from Mario Filelfo to Federico Gonzaga containing a report on his pupils. Of Francesco he wrote *non e troppo memorioso, che l'un di impara, l'altro si smenticha*. Francesco was aged 12.

THE EARLY HISTORY OF THE 'TRIUMPHS'

failed to annihilate the French army at the battle of Fornovo. He admired the *Triumphs of Caesar* and they became the chief decorative feature of his new palace at S. Sebastiano *c.* 1508. But he is not, for this reason, the strongest candidate for being the original patron.

About the Marchese Federico comparatively little is known. He only ruled for four years and died at the early age of 42. Born in 1441 his educational background was similar to that of his son Francesco, but there is little evidence for his intellectual interests or attainments. His teachers were probably rather better. He was taught by Platina between 1453 and 1456; and before that by Ognibene da Lonigo who dedicated to Federico his small book *De octo partibus orationis*. It was Ognibene to whom Federico later referred as *mio maistro a scola*.[1] It is not at all clear how much progress Federico made in his studies. Two letters exist on the subject both unfortunately by Francesco Filelfo, and both written with an eye to employment, either for himself or his son. One, written in 1457 and thus shortly after the departure of Platina, deals at length with the problems of teaching children and adolescents and merely suggests that there are hidden qualities in Federico which need careful treatment to be brought out.[2] The second rudely accuses Lodovico and Barbara of Brandenburg of neglecting Federico's education and suggests that Federico *se dolerà di le S.V. che non li habiate usata altra sollicitudine et industria a farlo uxire di la schiera di li ignoranti*. What is surprising, however, is that Barbara in her reply did not deny this charge. 'We still hope', she wrote, 'that when he begins to develop a taste for letters (which he is not doing at present), knowing what he does know of himself, he ought yet to adjust himself to learning—towards which we continually encourage him.'[3] Since, by 1459, Federico was already eighteen, these statements seem somewhat despairing. More remarkably, they appear to admit to Filelfo that Federico was not an unqualified academic success. It seems unlikely that a few months teaching by Senofonte Filelfo (1459) would have put this right. Federico's short rule was almost entirely dominated by war since he had the misfortune to inherit from his father the aftermath of the assassination of Galeazzo Sforza (1476) and the Pazzi conspiracy (1478). The peace which tided over these events was only concluded in 1484, shortly before Federico himself died. Nevertheless, this politically unhappy reign did not stop Federico from commissioning and building one of the grandest palaces in Mantua, the so-called *Domus Nova* of Luca Fancelli.[4]

Of the three Gonzagas concerned, Lodovico alone is known without doubt to have had the cultural interests and the academic attainments which would have enabled him to play a part in the creation and planning of the *Triumphs* (see above, p. 30). He also had the benefits of an extended period of peace in which to consider schemes for the decoration of his chief palace, since a period of comparative stability existed in Italy between 1454 and 1476.[5] To this period belong the summons of Mantegna to Mantua and the decoration of Lodovico's

[1] Luzio/Filelfo, p. 142.

[2] Extract printed in Luzio/Filelfo, p. 165. The whole letter appears in the collected letters of Francesco Filelfo at the start of Book 14.

[3] Luzio/Filelfo, p. 172. Barbara replied *nondimancho havemo anchor speranza che quando el comenci a gustar piu le lettere che'l non far al presente, sapendo quello che'l sa da se istesso el si debia pur adaptar a l'imparare, ad che nui confortiamo continuamente.*

[4] But this palace appears to have remained undecorated inside and unused until the second half of the sixteenth century. See E. Marani and C. Perina, *Mantova: Le Arti*, Vol. III (Mantua, 1962), p. 28.

[5] This period was bounded on one side by the peace of Lodi between Milan and Venice (1454), following the seizure of power in Milan by Francesco Sforza; and on the other by the political crisis in 1476 following the assassination of Galeazzo Sforza.

private apartments in the *Castello di S. Giorgio*; and it does not seem impossible that the *Triumphs of Caesar* were also in part the brain child of Lodovico—that they were his contribution to the decoration of the 'public' rooms in the *Corte* and an attempt to make up for the *Sala di Pisanello* which had been left unfinished earlier in his reign. The fact that he could not have lived to see them completed (indeed, very little could have been done by 1478) is no obstacle to this. Federico's views about the *Triumphs* are, for obvious reasons, unknown. But Francesco liked them,[1] and, in this interpretation, would have encouraged Mantegna to continue the great scheme begun by his grandfather. Only in the 1490s did various circumstances, discussed later (on pp. 90 f.), combine to bring the operation to an end.

Three further considerations support the view that the *Triumphs of Caesar* were begun under Lodovico Gonzaga. The first is that in 1477, Paola Gonzaga, daughter of Lodovico, went north to marry Leonhard, Count of Görz. She took as part of her luggage two *cassoni* the front panels of which are now in Klagenfurt (*nos. 125, 126*) and are discussed further on p. 53. These panels are decorated with reliefs of the *Justice of Trajan*; and they give an interesting authentic impression of a Roman military procession. One of the problems in all discussion of these scenes has been their chronological isolation, for the absence of comparative material dating from the 1470s has made it difficult to assess their significance. They make much better art-historical sense, however, if their creation was contemporary with the opening phases of Mantegna's *Triumphs of Caesar*. In the second place, if the *Triumphs* were started during the period 1474–8, their inception would have been much closer chronologically to the period *c.* 1459–65, a time when a number of literary expositions on the nature of the antique Triumph were produced (see below, Chapter 4, pp. 50–2). Then continuity of and interest in those ideas across the intervening years could, of course, have been provided by both Lodovico Gonzaga and Mantegna.[2]

In the third place, Vasari recorded what was presumably a local tradition that the *Triumphs* were painted for Lodovico (see Documents 28 and 30 on p. 186). There is always the possibility that, in this instance, tradition was right.

[1] Francesco twice placed the *Triumphs* among 'our works' which might make it appear that they were his commission. Thus (Document 3) in 1489 he urged Mantegna in Rome to finish the work for the Pope quickly because 'here also (Mantua) you have some works of ours to finish, particularly the *Triumphs*'. Again, in the Decree of 1492 Francesco stated that Mantegna 'is now painting the Triumph of Julius Caesar for us'. However, Mantegna was the Marchese's painter and it is very difficult to see how else Francesco would have referred to his current work, whatever its origins.

[2] It is true that such continuity could also have been provided in the person of Federico who was aged 17 in 1459. But Francesco Gonzaga at least had no personal links with the period since he was born in 1466.

4 · Triumphs in the Early Renaissance

BEFORE INVESTIGATING the classical background to the *Triumphs of Caesar*, something should be said about the earlier literary and visual traditions concerning the character of these processions. Especially in view of the general uncertainty over the circumstances of Mantegna's commission, it is of some interest to know what the classical Triumph signified to educated Italians by the second half of the fifteenth century.[1]

Official processions are, of course, a more or less universal phenomenon at all times. Italians and northerners alike staged official entries into towns; and it might therefore be supposed that, for instance, the victorious entry of Henry VII of England into York in 1486 was substantially similar to the victorious entry of Alfonso I into Naples in 1443. But this was not the case; the two processions were, in fact, essentially different in character. It is worth examining these differences since they suggest that up to the early sixteenth century the Italians were unique in Europe in retaining some sort of idea of the secular Triumph *all'antico*.

Northern 'entries' seem to have increased in frequency and complexity in the later Middle Ages; but they retained a number of common characteristics.[2] Indeed, numerous descriptions of royal entries produce a similar pattern of events. The procession was, of course, made up of a splendid gathering of courtiers and dignitaries and had as its centre the king or ruler. But the main points of interest (in the form normally of *tableaux vivants*) although orientated towards the King in the centre, lay *outside* the procession. Winding its way through the streets of a town, this procession stopped at frequent intervals before particular *tableaux*—at which point it became an audience. The *tableaux* themselves were, of course, used to convey (often at some length) messages of goodwill, flattery, praise, excuse or whatever was required.

The Italians also staged this type of event;[3] but by the end of the fourteenth century, they had in addition a developed appreciation of the classical Triumph, something basically different in being, in twentieth-century terms, 'spectator-orientated'. Its main points of interest did not lie outside the procession. Instead, everything was contained within it, so that to anyone standing firm at one point along the processional way, everything of importance or interest would pass before his eyes. It is not clear whether the evidence of the fourteenth century represents survival or revival, but the existence of the concept itself at that period is beyond doubt.

This is not the place to rewrite the history of *Trionfi*,[4] but some influential factors in the spread of the idea may be noted. Its existence is most easily traced in the writings of

[1] Some of the conclusions of this chapter must be tentative: texts describing processions, triumphal or otherwise, are not easily found; and the material consulted here is not necessarily exhaustive.

[2] See J. Chartrou, *Les entrées solennelles et triomphales à la Renaissance, 1484–1551* (Paris, 1928). Also B. Guenée, *Comptes-Rendus de l'Académie des Inscriptions et Belles-Lettres*, 1967, p. 210: 'Les Entrées Royales Françaises à la Fin du Moyen-Age'. For England, see S. Anglo, *Spectacle, Pageantry and Early Tudor Policy* (Oxford, 1969).

[3] See, for instance, the account of the entry of Borso d'Este into Reggio in 1453, in J. Burckhardt, *The Civilisation of the Renaissance in Italy*, Part V.

[4] The standard work is W. Weisbach, *Trionfi* (Berlin, 1919). This has lately been supplemented by G. Carandente, *I Trionfi nel Primo Rinascimento* (1963).

Petrarch, whose account of the Triumph of Scipio Africanus was perhaps the first post-classical attempt to reconstruct such an event.[1] This is based for much of its detail on Livy, *Ab Urbe Condita, Book XXX*, and, precisely because Livy gave no real hint of the order of the procession, it is in its order and sequence that Petrarch's description is least classical. But the essential impression of a long succession of magnificent sights contained within the procession is there; also the archaeological observation that the procession passed through Rome to the Capitol.[2] Fazio degli Uberti also verbally reconstructed a Triumph on the grounds that '*e buono udir la gloria che ricevea qual era triunfato*'. This is not an historical reconstruction and, to that extent, any extravagance was perhaps permissible. Consequently an oppressive number of different animals was marshalled in the imagination, including giraffes, monkeys, leopards and (rather surprisingly) porcupines—an effect reminiscent of the great Late Gothic representations of the Adoration of the Magi. Fazio also included dwarfs. However, he set out the ingredients more or less in the right order; and the general impression of a magnificent parade is entirely correct.[3]

The same impression of a parade was conveyed by both Petrarch and Boccaccio in poems which included triumphal processions. Petrarch's *Trionfi* depend on the device of the poet falling asleep and having a dream: the dreamer stays on one spot while in front of his eyes is paraded a bizarre but impressive collection of characters from history and mythology. Boccaccio's *Trionfi*, which occur in the poem *Amorosa Visione*, on the other hand, were imagined as wall decorations in a visionary castle. Thus in rather different literary contexts the element of 'spectator-orientation' was maintained.

The impression of extravagance was important and the word *trionfale* was certainly used by the late fourteenth century to describe something festive or extravagant.[4] On the other hand, it is also true that the allegorical Triumphs popularized by Petrarch undoubtedly had a restrictive effect on the range of meaning and associations attached to the term. An allegorical Triumph normally conveyed a limited message which could well be contained within the bounds of a single triumphal presentation piece. The illustrators of Petrarch had moved in that direction by the middle of the fifteenth century. Thus the various Petrarchian *Trionfi* came to be represented by individual carnival floats surrounded by a cluster of followers. This represented a drastic restriction of the triumphal idea.[5] It is

[1] Petrarch, *Africa*, ed. Francesco Corradini (Padua, 1874). See pp. 397–401.

[2] See also in Petrarch's *Trionfi*, Part VI, 'Triumphus Famae', lines 26 ff.:

> *E poi mi fu mostrata*
> *Dopo sì glorioso e bel principio*
> *Gente di ferro e di valore armata*
> *Sì come in Campidoglio al tempo antico*
> *Talora o per Via Sacra o per Via Lata*
> *Venian.*

[3] Fazio degli Uberti, *Il Dittamondo*, ed. G. Corsi (Bari, 1952), Book II, Chapter 3. The order sketched out has the Triumphator in the centre. Before him go the booty, exotic animals and captives. Behind him go military leaders, senators and soldiers. Perhaps as a result of literary activity of this sort, there is some small indication that in the late fourteenth century Triumphs were one of the things about which interested visitors asked—especially in the context of the Triumphal Arches. The small anonymous hand book entitled *La edifichation de molti pallazi e tempii e altri gradissimi edificii de roma . . .*, printed in Venice in 1480,

but originally written in 1363 for the private use of the Marchesa of Ancona, pre-empts the enquiry with ten lines on the subject. (Recently reprinted in *Five early guides to Rome and Florence*—introduction by P. Murray—Farnborough, 1972.)

[4] See C. Guasti, *Le Feste di San Giovanni Battista* (Florence, 1884). An account of the festival drawn up between 1380 and 1405 described the Piazza della Signoria (Florence) as *una cosa trionfale e magnifica* on account of the splendid decorations put up there.

[5] For many representations, see P. Schubring, *Cassoni* (Leipzig, 1923). The circumstances in which the iconography of the Petrarchian *Trionfi* developed are still confused, but see Carandente, *op. cit.* It seems to have occurred *c.* 1430–50 and it is probable that the Florentine manuscript and *cassone* workshop attached to Apollonio di Giovanni was important (on whom see also E. H. Gombrich, *Journal of the Warburg and Courtauld Institutes*, Vol. XVIII (1955), pp. 16 ff.: 'Apollonio di Giovanni. A Florentine cassone workshop seen through the eyes of a humanist poet.')

probably for this reason that *un trionfo* came, during the fifteenth century, to mean as often as not one of these individual floats which might itself be merely part of a larger procession. This in turn occasionally led to the confounding of the two meanings of the expression. Thus in 1491 in Florence, an observer wrote about the appearance '*dei quindici trionfi quando Pagolo Emidio, a tempo di Ciesere, trionfo a Roma*'. Paulus Aemilius certainly did not celebrate fifteen Triumphs: instead the writer was referring to the fifteen floats of the procession which had been staged by Lorenzo de' Medici.[1]

Examples of *trionfi* celebrating people rather than ideas are hard to find. A minor example may be cited from the late fourteenth century, when the victor of the *palio* in Florence was paraded round the city in a triumphal chariot. This is of some importance since it was presumably an annual event.[2] But the first attempt to re-create in reality, rather than imagination, a military Triumph seems to be the triumphal entry of Alfonso of Aragón into Naples in 1443. The description of the procession[3] makes it clear that there was nothing academic about its content. The programme bore no relation to any classical precedent, there being, for instance, no booty, no trophies of arms and no triumphal army. One float had a representation of the seven virtues and the whole thing was probably closer in appearance to a contemporary festival procession. Nevertheless, those who recorded it thought of it as a Triumph[4] and it was eventually immortalized in stone on the Triumphal Arch of the Castel Nuovo (*no. 130*). There is, however, a shortage of examples of this type of event in Italy during the fifteenth century, presumably reflecting the absence of resounding and decisive military operations. In fact, the military Triumph was not properly revived until the end of the century during the French invasions of Italy. The receptions of Charles VIII at Siena (1494) and of Louis XII at Milan (1499), Brescia (1507) and Milan again (1507 and 1509), appear to have been marked by an attempt to imitate the ancient accounts of triumphs.[5] It is possible that by this date the organizers may have been influenced by the fame and content of Mantegna's paintings.[6] It remains ironical that every one of these Triumphs staged by Italians should have celebrated the victories of foreign armies.

True military Triumphs were few; but other processions were staged which contained what might be called triumphal allusions. There is a good description of a procession organized in Rome under Paul II (1464–71).[7] A further display was organized near Urbino in 1488 by Duke Guidobaldo in memory of his father.[8] Probably *c.* 1490, Lorenzo de' Medici considered the possibility of reforming the celebrations on St John the Baptist's day by

[1] See Guasti, *ut sup.*, for further accounts. These floats were sometimes referred to as *Edifizii* and occasionally as *Dificii e Trionfi*. For a further example of this ambiguous usage of *trionfo*, etc., see Landucci's account of the festivities laid on for Charles VIII in 1494 (*Diario Fiorentino*, edited by Iodoco del Badia, Florence, 1883, p. 79): *Era veramente una cosa trionfale, tante erano grandi e ben fatte ogni cosa—E fecesi spiritegli e giganti, e triunfi andare per la terra, e feciono el dificio della Nunziata. . . .*

[2] See Guasti, *ibid.* The late fourteenth-century account describes the victor as processing *sur una caretta triunfale con quattro ruote adorna con quattro lioni intagliati che paiono vivi, uno in sur ogni canto del carro, tirato da due cavalli covertati col segno del Comune loro, e due garzoni che gli cavalcano e guidano.*

[3] It was printed by C. von Fabriczy, *Jahrbuch der Königlich Preussischen Kunstsammlungen*, XIX (1898), p.

146: 'Der Triumphbogen Alfonsos I am Castel Nuovo zu Neapel'.

[4] *Ibid.* See the words of two contemporaries *Rex Alphonsus ascendit in curru triumphali et equitavit per totam civitatem Neapolis*. Also *Re Alfonso con lo carro triumphale cavalco per la cita di napoli conli Signori del regno appresso ad uso derima [di Roma] con grandissima pompa et triumpho.*

[5] See Chartrou, *op. cit.*

[6] In 1500, Cesare Borgia staged a Triumph of Julius Caesar in Rome. See J. Burckhardt, *loc. cit.*

[7] Written by Michael Cannesius of Viterbo. See L. A. Muratori, *Rerum Italicarum Scriptores*, Vol. 3, Part II, Col. 1018 f. (Milan, 1734).

[8] See A. Luzio and R. Renier, *Mantova e Urbino* (Rome, 1893), pp. 44–5.

reducing the length of the procession and introducing four floats bearing respectively Caesar, Pompey, Octavian and Trajan.[1]

But as far as the literary evidence survives none of these processions could have claimed archaeological inspiration. The Florentine floats were accompanied by eight others celebrating religious themes, and, moreover, the Romans portrayed were there to symbolize various virtues. The Urbino procession was distinguished by a large number of animals and birds and one of the chariots was pulled by 'centaurs', while the procession in Rome, in celebration of the greatness of that city, was led by giants, who were followed by Cupid, Diana and a company of nymphs. The centre of the procession was held by figures of those conquered by the Romans, including Cleopatra. They in turn were followed by Mars, Bacchus and other antique gods.

The Neapolitan procession of 1443 had been organized by Florentines. This is of interest since in Florence itself this event was followed by a spate of representations of classical Triumphs on *cassoni*[2] which provide the first real evidence for what people thought classical Triumphs looked like; and also by extension, evidence for the appearance of those processions already mentioned. It is not particularly surprising to find that the archaeological sense of the *cassone*-painters (and presumably of the Florentine public at large) left much to be desired. Form and content are hopelessly awry (*no. 127*).

The anachronisms and muddles inherent in the spectacles and paintings cannot, of course, have worried contemporaries. Indeed, to insist too much on them would be to endow these things with an academic purpose which they clearly did not have. Consequently, evidence from a far more serious and studious quarter is interesting since it illustrates the imaginative difficulties of those who, on academic grounds alone, should have known better. This evidence is to be found in the book *Roma Triumphans* by Flavio Biondo.[3] The tenth section of this work is devoted to the subject of classical triumphs and is as remarkable for the immense quantity of literary material brought together as for the erudite account of the triumphal route in Rome itself (see below, pp. 61–2). As an *envoi* to the entire work, Flavio ended with a sketch of the ingredients for a contemporary revival of this ancient custom. What emerges, however, is something that sounds very like a fifteenth-century carnival procession. Indeed, in attempting to find parallels for the famous *pegmata* of Josephus, Flavio gave a description of the floats displayed in Florence on St John the Baptist's day.[4] As an antiquarian, Flavio was more than adequate when dealing with texts and monuments; but this part of *Roma Triumphans* gives some insight into the way in which his experience coloured his attempts at imaginative interpretation or reconstruction.

Flavio Biondo's account of the antique Triumph is only one of three known to have

[1] See A. d'Ancona, *Origini del Teatro in Italia* (1877 ed.), Vol. I, p. 274.

[2] For examples see Schubring and Carandente, *opera cit.*

[3] *Roma Triumphans* was written 1457–9. For further information, see below, p. 58.

[4] For Flavio, the outstanding characteristics of Triumphs were their splendour and variety, for *nihil magis quisque curaret q̄ ne ea adduceret Spectaculorum machinarumque genera: quae prioribus pompis visa erāt:* Flavio's Triumph contained groups representing confraternities and other orders, each with its own show: *Singuli veri ordines sacerdotum: singulae sodalitates: singula pegmatum et machinarum agmina suos habere ludos: et simphoniacos: singulos pantomimos: per quos a praecedentibus collegiis dividerentur.* The diversions included female dwarfs (*mulierculae*), figures with gigantic heads, men dressed up as women, and others. All this makes quite interesting comparison with other literary and pictorial representations. Giants were mentioned in the Roman procession under Paul II. Dwarfs were included by Fazio degli Uberti and one may be seen in a *cassone* painting of the *Triumph of Caesar* now in the collection of the New York Historical Society (*no. 127*).

been compiled around the year 1460. Another writer, Roberto Valturio, approached the subject from a different angle by including a study of Triumphs at the end of a work on military science—*De Re Militari* written in 1460 (see further below, p. 58). Finally, and perhaps more significantly, Giovanni Marcanova wrote a treatise on the subject. Because of Marcanova's connections with Mantegna, it is especially unfortunate that the text of this is lost; all that is known is that in the course of Marcanova's sylloge of inscriptions, the reader is referred for further information 'to our book which we have written concerning the honours of the Romans in triumph and in matters of war'. This was also probably composed *c.* 1460.[1]

The surviving accounts of Flavio Biondo and Valturio have a distinct character. Their authors were essentially learned collectors of information and had little time for imaginative or poetic speculation. Neither introduces his account of the Triumph with any form of explanatory prologue. Flavio, at the start of Book X (the opening of the section on Triumphs) enters immediately into a discussion of the lesser honour of the *ovatio*. Valturio, at the start of his Book XII, opens with an examination of the etymology of *triumphum*. It is therefore of some interest that a far more evocative comment on antique triumphs was re-introduced into circulation during these years. This had occurred in a letter written from Rome by the scholar Manuel Chrysoloras in 1411 to the Byzantine emperor. In the course of this Chrysoloras described the city of Rome—as a prelude to a comparison with the city of Constantinople. The letter had some circulation in the original Greek; but in 1454 (just after the fall of Constantinople) it was translated into Latin for the young Galeazzo Maria Sforza by the Veronese scholar Francesco Aleardo. This Latin translation survives in a contemporary copy embellished with the Gonzaga arms and therefore presumably from the Mantuan Library.[2]

In the course of his description of the city of Rome, Chrysoloras noted the existence of commemorative arches; and he examined at some length the way in which sculptural decoration gave a detailed impression of the military achievements of the conquerors—'all of which is so portrayed and represented that you would think the events lived' (translated from the Latin text). Later in the letter, Chrysoloras composed a particularly evocative passage based on his reflections as he walked amidst the Roman ruins.

> 'Often when I, solitary, happen upon those triumphal ways and courses, I ponder on the princes, rulers and other prisoners who have been brought here—Armenians perhaps, or Persians and some from even more distant lands. I ponder too on the emperors who triumphed—what elation, what pleasure did they feel! But what misery did the conquered experience! I imagine the multitude of citizens crowded about, others high up watching from the houses. I hear the resonance, noise and clangour

[1] This is the sylloge written out by Feliciano in 1465; now at Modena, Bibl. Estense, Cod. α L.5.15. It was published by C. Huelsen, *La Roma Antica di Ciriaco d'Ancona* (Rome, 1907). For a consideration of the manuscript in the total context of the work of Felice Feliciano see C. Mitchell, *Proceedings of the British Academy*, XLVII (1961), p. 197: 'Felice Feliciano *Antiquarius*'. The lost work on Triumphs is mentioned on f. 4, where Marcanova instructs those who wish for further information *de potestate imperatoria et tribunicia—idcirco recurre ad librum nostrum quem de dignitatibus Romanorum triumpho et rebus bellicis composuimus, in quo plene satis haec tractantur.*

[2] I am entirely indebted for notice of this letter to Mr David Thomason, who kindly provided me with a copy of the Latin text of the first part concerning the city of Rome. It is to be hoped that Mr Thomason will publish the whole text as a part of a study on Chrysoloras and his influence.

of the military accoutrements and the applause of the crowd showing their approval and praise. On the one hand the captives, seemingly the most unfortunate and unhappy of men, on the other the victors, to themselves and others the most favoured and fortunate. Now indeed the score is equal, all things are descended into the dust; nor would you distinguish more easily the fate of Pompey or Lucullus from that of Mithradates or Tigranes.'[1]

A number of interesting trains of thought emerge from Chrysoloras' letter. It sets the scholarly desire to reconstruct and restore from the evidence an historical situation alongside the imaginative pleasures to be had from contemplating ruins.[2] It notes the power of the artist to portray something so that the events seemed to live again, many centuries later. It stresses, by implication, the importance of detailed archaeological observation in the reconstruction of the past. All this is interesting but unexceptional for its date: it corresponds precisely to the spirit of the Eremitani frescoes on which Mantegna had already been working for some years before 1454. Thus, the translated Chrysoloras letter makes interesting reading alongside Mantegna's painting although it does not in itself help to explain it. What is much more interesting is that the classical Triumph is portrayed as an event full of excitement and drama and suitable for imaginative exploitation. It seems of particular relevance that a text of this sort should apparently have been circulating (in Latin translation) in North Italy during the period in which Mantegna moved from Padua to Mantua.

Visual consequences of this literary activity are hard to trace although one interesting drawing may be noted in the manuscript of Marcanova's collection of inscriptions now at Modena (Cod. α L.5.15). Inserted into the middle of this work are a number of folios (ff. 24–44) containing full-page illustrations of buildings and monuments in Rome. They are mainly 'reconstructions' of a bizarre and fanciful sort. The scenes are often peopled by figures clothed in fifteenth-century costume. But one scene, containing a picture of a triumphal arch, shows also part of a triumphal procession (f. 35, *no. 128*). There are various oddities, but the general grasp of costume is far superior to that of any of the Florentine *cassone* painters. These drawings are probably by Felice Feliciano, the scribe and antiquarian who copied the manuscript; and his achievement draws attention to the importance of northeast Italy for the subject under consideration. Any 'advances' in the Marcanova manuscript certainly resulted from the progress of archaeological research and the pressure of archaeological interest emanating from Padua.[3] It remains to be asked whether this literary and pictorial activity can be shown to have any bearing on the *Triumphs* painted by Mantegna.

The question has already been raised and, in general terms, the answer is clear. The later the *Triumphs* were painted, the less immediately significant does this scholarly research become. On the other hand, had the idea for a decorative scheme based on the Triumph of a Roman general been launched in the reign of Lodovico, the personal links of both patron

[1] *Ne magis Pompeii aut Luculli, quam Mithradatis aut Tigranis fortunam cognosceres.*

[2] The mutability of *fortuna* was, of course, a favourite theme of Renaissance writing and ruins were an obvious trigger-mechanism. One may recall Poggio, *De Varietate Fortunae*, Book I.

[3] Rather similar sorts of drawings are to be found in the sketchbooks of Jacopo Bellini. For an abrupt but jolly contrast, one may compare the figures of the Florentine Picture Chronicle of *c.* 1460–70, now in the British Museum. See A. E. Popham and P. Pouncey, *Italian Drawings in the Department of Prints and Drawings in the British Museum. The Fourteenth and Fifteenth Centuries* (London, 1950), No. 274, f. 55 has an illustration of Julius Caesar (*no. 131*).

and artist to the writers and period in question would have been much closer. The arguments for such an early date have been discussed above; they include the evidence of the *cassone* panels now at Klagenfurt mentioned on p. 46 (*nos. 125, 126*) where it was noted that the *cassoni* formed part of the luggage of Paola Gonzaga, daughter of the Marchese Lodovico, when she went to marry Leonhard, Count of Görz in 1477.[1] The compositions on the panels are modelled in low-relief in gesso; the settings are painted in. The scenes, which have been much discussed mainly in connection with the possibility of Mantegna's intervention, show a triumphal procession—the triumphal return of Trajan from Asia. They also tell a story of Trajan's justice to the widow who had lost her son. The detail of the procession is remarkable, giving the earliest authentic impression of a Roman military procession yet encountered in this chapter. The 'programme' of the procession is necessarily interrupted by the exigencies of story-telling and bears only a slight relationship to the classical descriptions of a Triumph.[2] But the costume is very well portrayed, much of its detail bearing a direct relationship to that found in the paintings at Hampton Court.[3]

An interesting feature of the Klagenfurt reliefs is the interpretation given to the narrative. The legend, by the fifteenth century a strange agglomeration from different sources, told a basically simple story.[4] Once, when the Emperor Trajan was returning in triumph from a campaign, he was stopped by a widow, who informed the emperor that her only son had been ridden down and killed by his son. The emperor halted to deliver judgement on the case, his decision being that the widow should receive his own son as compensation. Much of the moral force of this simple tale is obscured in these reliefs which portray, first and foremost, a military procession; the episodes of the legend are incidents in the cavalcade.

The archaeological grasp of these scenes combined with the provenance of the reliefs from Mantua within the Gonzaga family circle makes the conclusion virtually inescapable that Mantegna had some hand in their design, if not in their execution.[5] The main problem is their relation to Mantegna's other work.[6] In this context, they have always seemed isolated. However, they would seem much less so, if the *Triumphs of Caesar* were already being

[1] The reliefs, formerly attached to chests belonging to the church at Millstatt, are now in the Landesmuseum at Klagenfurt. They can be associated, *via* an inventory of 1478, with two other chests now in the cathedral at Graz. Those chests are decorated with ivory reliefs of the *Trionfi* of Petrarch. The main accounts of these works are as follows: R. Eisler, *Jahrbuch der K.K. Zentral-Kommission für Erforschung und Erhaltung der Kunst- und Historischen Denkmale*, NF III (1905), Part II, p. 64, 'Die Hochzeitstruhen der letzten Gräfin von Görz'; G. Fiocco, *Mantegna* (Milan, 1937), p. 97 ff.; R. Milesi in *Festschrift für Rudolf Egger* (Klagenfurt, 1954), Vol. III, p. 382, 'Mantegna und die Reliefs der Brauttruhen Paola Gonzagas'; id., *Mantegna und die Reliefs der Brauttruhen Paola Gonzagas* (Klagenfurt, 1975).

[2] The procession is led by trumpeters but things such as trophies of arms, booty or prisoners are absent. In fact, the scene has more the appearance of a casual cavalcade.

[3] Many of the helmet shapes and some of the banners are similar. The armour is similar too, even to the absence of the *lorica segmentata* (see below, p. 68). The *signiferi* wear lion-skins where Vegetius describes bear-skins—an error repeated in the Hampton Court paintings.

[4] On the legend, see especially Eisler, *op. cit.*, above.

[5] In the absence of any sculpture certainly by Mantegna, stylistic attributions are highly speculative. These reliefs are, in many points, strongly reminiscent of Donatello's Paduan reliefs. The compositional style is, however, more regulated and orderly. Particularly in the first relief, the artist adopted the trick of using a limited number of types of figure-pose and repeating them across the composition. This is a common practice in certain sorts of classical relief and also in some of the figure compositions of Antonio Pollaiuolo. The obscure connections with Pollaiuolo's art receive further attention below, p. 76. Mantegna had been in Tuscany in 1466 and 1467; and there are interesting Pollaiuolo-esque features about some of the figure-studies in the mythological series in the *Camera degli Sposi*.

[6] Fiocco, *op. cit.*, p. 99 f., who was much impressed by the quality of the Klagenfurt reliefs, saw them quite definitely as Mantegna's prelude to the *Triumphs of Caesar*. He pointed to certain similarities between the Klagenfurt architecture and the background of the 'Senators' composition but the overall evidence does not seem to me to point to a direct transition from one to the other. See below, Chapter 6.

planned during the same period. If Mantegna was at the time even merely turning over in his imagination the possibilities of a Roman Triumph for a major pictorial programme, the unusual form given to the Justice of Trajan on these two *cassone* panels would cause no surprise. Seen in this way, the dated Klagenfurt panels may perhaps present a further argument for placing the start of the *Triumphs of Caesar* during the lifetime of Lodovico Gonzaga.[1]

From all this, there emerges the strong possibility that the thought and inspiration underlying the planning of the *Triumphs of Caesar* occupied a far larger portion of Mantegna's working life than has hitherto been generally supposed. The practical planning may go back before 1478. But the conversations underlying at least its academic content and conducted between Mantegna and, in that case, Lodovico Gonzaga may go back even further. It may finally be added that part of the imaginative inspiration may date from an even earlier period, for there existed in north-eastern Italy in the fifteenth century at least two earlier monumentally large painted *Triumphs* from the hand of a major artist. By chance, Marcantonio Michiel recorded that there was a triumphal scene in the *Palazzo del Capitano* at Padua—a 'Triumph of Marius' painted by Avanzo.[2] The authority for this was Gerolamo Campagnola who also provided Vasari with a piece of relevant information. According to Campagnola, there was a hall in the Scaliger palace at Verona where, amongst other things Avanzo (again) painted two further *Triumphs* (but the subjects are not specified). Vasari added, on Campagnola's authority, that Mantegna was accustomed to praise these Veronese *Triumphs* as *pittura rarissima*.[3] Far more than any of the Florentine *cassone* paintings, these monumental wall paintings would have been accessible to Mantegna during the early period of his life; and the narrative genius of Avanzo could have acted as an imaginative visual stimulus much as the translation of Chrysoloras could have been an imaginative literary stimulus at a slightly later date.

Towards the end of *Roma Triumphans* Flavio Biondo, having analysed the surviving evidence for the various elements in a Roman Triumph, attempted to draw all the threads together and to present the reader with an impression of such an event. It is of passing

[1] A recent study of the Kress collection *Triumphs of Petrarch* (now in the Denver Art Museum, Colorado) has lent substance to the proposition that *Triumphs* as a pictorial theme were under discussion in the circle of Mantegna during the 1460s and 1470s. In *Arte Veneta*, 1973, p. 81, 'I Trionfi della Collezione Kress: una proposta attributiva e divagazioni sul tema', C. Furlan has re-opened the subject of the dating of these panels and Mantegna's part in their creation. It is known from the description of the theatre auditorium of 1501 (Document 13) that at that time there was a series of paintings of the Triumphs of Petrarch supposed, by the visiting Ferrarese Cantelmo, to be by Andrea Mantegna. Nothing further is known about these apart from the fact that they were mobile and probably on a smaller scale than the *Triumphs of Caesar* (they decorated the front of the stage). That the theme had earlier received attention in Mantua is proved by the second pair of marriage chests taken north to Görz by Paola Gonzaga in 1477 (see p. 53, note 1) which are decorated with the ivory reliefs of the *Triumphs of Petrarch*, now in Graz cathedral. The Kress *Triumphs* have normally been grouped with the Graz reliefs—partly on iconographical grounds; and the general character of the scenes makes a connection with Mantegna indisputable. Dr Fur-

lan's re-attribution of the Kress panels to Girolamo da Cremona may not command general assent; but her suggestion that these works date from the early 1470s, that they derive from lost Mantegna compositions, and that Mantegna's own *excursus* into a predominantly Florentine programme of subject-matter was the result of his visits to Florence in 1466 and 1467 is a sensible one.

[2] This information is set in a broader context by T. E. Mommsen in *Art Bulletin*, 34 (1952), p. 95, 'Petrarch and the decoration of the *Sala Virorum Illustrium* in Padua'. See particularly p. 107 and pp. 113–14.

[3] Vasari's source was a letter, now lost, from Gerolamo Campagnola to the Paduan academic Leonico Tomeo. It seems to have dated from the last years of the fifteenth century and it contained, according to Vasari in his *Life of Andrea Mantegna*, notitia d'alcuni pittori vecchi. Perhaps it was also accessible to Marcantonio Michiel who also quotes what appears to be Gerolamo's authority on several occasions. This letter evidently contained various *obiter dicta* of Mantegna. Vasari also noted the same source when relating Mantegna's admiration for Uccello's *Sala dei Giganti* in the Casa de' Vitaliani at Padua.

interest that he wrote of this exercise as a 'painting in writing'.[1] It is conceivable that Mantegna (and perhaps Lodovico Gonzaga) were acting on this cue and that Mantegna was consciously reversing Flavio's image to produce in some sense a 'writing in painting'. Certainly an important part of his material evidence was of a literary kind; and, in general, something must now be said about his use of the literary, archaeological and antiquarian evidence at his disposal.

[1] *Triunphos iam et Romam absolvimus triumphantem: si unum operi claudēdo addeī nō modo scilicet scriptura sicut nuper fecimus depictos: sed veros et priscis digniores triūphos Romae ducendos esse sperari posse.*

5 · The *Triumphs of Caesar* and Classical Antiquity

A MODERN HISTORIAN attempting to reconstruct the character and appearance of a Roman Triumph would turn to various somewhat heterogeneous sources. It may be said with some confidence that, of these, virtually all the main literary sources and many of the visual sources would have been available to Mantegna.

The accumulated body of literary information about Triumphs is considerable and a survey of the available texts is necessary since these have a direct bearing both on Mantegna's general representation of a Triumph and on his selection of detail. For its large number of references to individual Triumphs, Livy's *Ab Urbe Condita* is the most important source;[1] but, on the other hand, the most complete descriptions of specific Triumphs occur in the writings of Appian,[2] Plutarch[3] and Josephus.[4] To these may be added the brief notes in Suetonius,[5] passing if important references in Pliny the Elder and Cicero, together with an enormous quantity of incidental references scattered throughout the range of Roman literature.[6]

For any research, Mantegna would of course have had the use of the Gonzaga library. It is unfortunate that so little is known about this library in the second half of the fifteenth century[7] but at least it can be said that by *c.* 1475 all the main texts had been printed; and

[1] Livy, *Ab Urbe Condita*, ed. princeps, Rome, 1469.

[2] Appian, Ῥωμαικά translated into Latin by Piero Candido Decembrio, 1453; printed in Latin in Venice 1477. For a recent edition of the classical text, see that prepared for the Loeb Library by Horace White (London and Cambridge, Mass., 1912–58). The main description of a triumph is there found in Vol. I, p. 507. This, the triumph of Scipio Africanus, is in Appian's Book VIII.

[3] Plutarch, Βίοι παράλληλοι. Translated into Latin by various scholars; printed at Rome, 1470. The chief triumphal description comes in the Life of Paulus Aemilius which was translated by Leonardo Bruni. For a modern edition of the classical text, see that prepared for the Loeb Library by Bernadotte Perrin (London and Cambridge, Mass., 1926–50). The triumph is there to be found in Vol. VI, pp. 440–1 ff.

[4] Flavius Josephus. Ἱστορία Ἰουδαικοῦ Πολέμου πρὸς Ῥωμαίους. Translated into Latin by T. Rufinus of Aquileia in the fourth century; printed in Latin in Rome in 1475. For a modern edition of the classical text, see the edition of Josephus' works prepared for the Loeb Library by H. St. J. Thackeray (London and Cambridge, Mass., 1950–65). The triumphal passage occurs in Vol. III, pp. 540–1 ff.

[5] Suetonius, *De Vita Caesarum*, printed at Rome in 1470. For a modern edition of the text see the Loeb edition (London and New York, 1914) prepared by J. C. Rolfe. The Triumphs of Julius Caesar are there to be found in Volume I, pp. 50–1.

[6] References to Cicero, *In Pisonem*, and Pliny, *Historia Naturalis*, may be picked out in Flavio Biondo (see following note). In general, Pauly-Wissowa, *Real-Enzyklopädie der Klassischen Altertumswissenschaft* (Stuttgart, 1893), s.v. *Triumphus*, will give some idea of the character and extent of the sources on Triumphs. It is worth noting that throughout the Middle Ages, short notices on Triumphs were available to anyone within reach of a well-stocked library. Both Isidore (*Etymologiae*, Book XVIII, Chapter II,

see Migne, *Patrologia Latina*, 82, col. 641) and Rabanus Maurus (*De Universo*, Book XX, Chapter II, see Migne, *Patrologia Latina*, 111, col. 534) included chapters *De Triumphis*. Their emphasis is predictably laid on etymology and in Rabanus Maurus on Christian significance, and it is most unlikely that they played any part in the formation of Mantegna's plans. The iconographical information they provide is negligible.

[7] For the comparatively small amount known about the Gonzaga library, see Ubaldo Meroni, *Mostra dei Codici Gonzagheschi* (Catalogue, Mantua, 1966). No inventories for the books survive between 1407 and 1541. The library itself was dispersed by sale in 1707. Professor Meroni attempted, in this exhibition, to reassemble as many manuscripts from this library as could be traced and secured. The catalogue itself presents the available information about the library's history down to 1540. Perhaps the most influential factor in the fifteenth century was the presence in Mantua of Vittorino da Feltre (1423–46), who was probably instrumental in pressing the Gonzaga family into acquiring Greek manuscripts. They possessed Plutarch's *Lives* in Greek (*op. cit.*, p. 77) and probably also Josephus' *Jewish War* (also in Greek; *op. cit.*, p. 47). A later letter of 1466 refers to a copy of Appian (presumably in Latin; *op. cit.*, p. 58). It is of interest that by the late fifteenth century a very large proportion of both the classical and fifteenth-century texts mentioned in this book (both in Latin and, where relevant, in the original Greek, too) were to be found in the ducal library at Urbino. But it is well known that the Montefeltro library was especially good. See C. Guasti, *Giornale Storico degli Archivi Toscani*, VI and VII (1862–3), *passim*: 'Inventario della libreria Urbinate compilato nel secolo XV'. Contrast the D'Este Library (see A. Venturi, *Atti e Memorie della R. Deputazione di Storia Patria per le Provincie di Romagna*, Ser. III, Vol. VI, 'L'Arte Ferrarese nel periodo d'Ercole I d'Este') for which an inventory exists, compiled 1471–9.

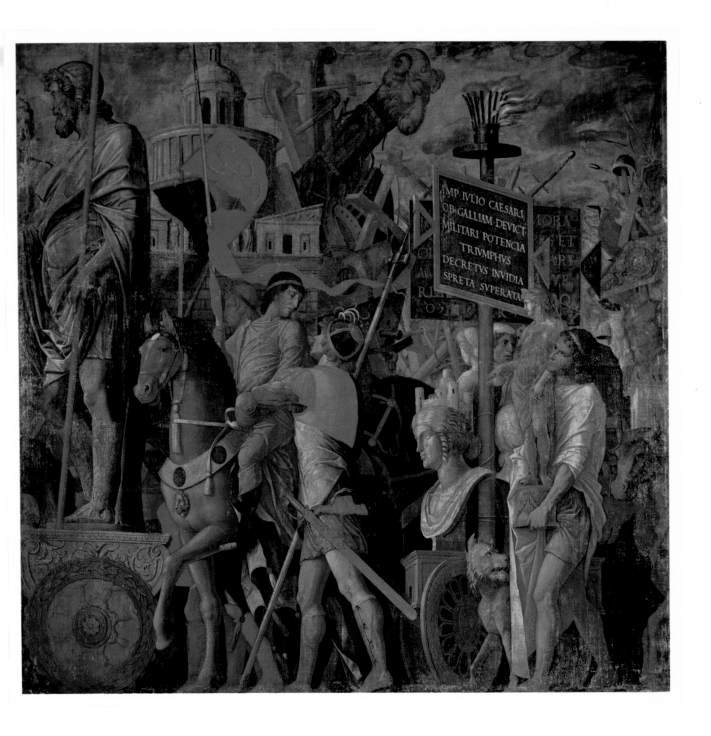

Canvas II: Colossal Statues on Carts, a Representation of a Captured City, Siege Equipment, inscribed Plaques, Images

there is no real doubt that Mantegna could, by his own efforts, have assembled almost all the references which appear below. As a matter of fact, one is saved a great deal of speculation about the nature of Mantegna's 'researches' by two works, both of which appeared in the second half of the fifteenth century and which were mentioned in the previous chapter. One of these was Flavio Biondo's *Roma Triumphans*;[1] the other was Roberto Valturio's *De Re Militari*.[2] Both writers included extended sections on Roman *Trionfi*. Together, they show that by *c.* 1465 much literary research on the subject had already been done. Flavio Biondo's work would have been the more satisfying to consult since he almost invariably cited the sources he was using.[3] Valturio seldom did this in any detail, and partly as a result his prose would seem to have a superior literary character. A brief look at either of these two writers will confirm what has already been said about the variety of the available textual evidence.

Viewed from a literary standpoint, the first surprise about Mantegna's paintings is the choice of subject-matter—the Gallic Triumph of Julius Caesar. There can be no doubt that this is the subject, since the second canvas has an inscription recording the senatorial decree of this Triumph, *OB GALLIAM DEVICT⟨AM⟩*.[4] This is surprising because very little information is given about this Triumph in any of the classical sources. Thus, as an archaeological exercise, the choice of the Gallic Triumph was unpromising;[5] had Mantegna's intention been merely to attempt to re-create as vividly and accurately as possible the splendour and excitement of a triumphal occasion, one of the other Triumphs would have served his purpose much better.

[1] Flavio Biondo, *Roma Triumphans*, written 1457–9. Printed in Mantua ?1472. It was presented to Pius II in Mantua in 1459.

[2] Roberto Valturio, *De Re Militari*, written in 1460. Printed in Verona 1472. Italian translation printed in Verona 1483. The lost treatise by Giovanni Marcanova, *De Dignitatibus Romanorum Triumpho et Rebus Bellicis* may be recalled at this point. This is referred to in the Modena manuscript (Bibl. Estense, Cod. α L.5.15 f. 4), in which is found the corpus of inscriptions, already mentioned, assembled by Marcanova himself, and dated 1465.

[3] Flavio Biondo's main sources for the Roman Triumph included all those mentioned above; and also Aulus Gellius, *Noctes Atticae*, and Flavius Vopiscus in the *Historiae Augustae*.

[4] The Louvre drawing noted below (*no. 51*, p. 163) and associated with the first canvas also carries three banners inscribed *GALIA C* and *GALIA CAPTA*. A problematic inscription in the ninth canvas, adjacent to the figure of Caesar, contains the letters *GAL. ED.* A. N. Tamassia (*Rendiconti della Pontificia Accademia Romana di Archeologia*, Serie III, Vol. XXVIII, Fasc. III–IV, 1955–6: 'Visioni di Antichità nell'opera del Mantegna') suggested (p. 243) that the series represented the five-fold Triumph of Caesar. More recently Robert Payne (*The Roman Triumph*, London, 1962, p. 231) even suggested that 'it is not one triumph but all triumphs; not the triumph of Caesar alone but that of all *triumphatores*'. Inasmuch as the paintings represent an iconographical mixture culled from widely dispersed sources, Payne's statement is perhaps unintentionally nearer to the truth than that of Tamassia. Mantegna's own statements about the subject-matter must be contained in the inscriptions. These now present, in many instances,

almost insuperable problems of interpretation, but only the conquest of Gaul is clearly mentioned. The inscriptions are gathered together in Appendix II.

[5] Mantegna seems to have been ignorant of one possible source—the Ῥωμαικά of Dio Cassius (XLIII. 19. See Loeb edition, editor E. Cary, London and Harvard, 1968–70, p. 245). Dio repeated the list of Caesar's first four triumphs (over the Gauls, Egypt, Pharnaces and Juba) which, he said, were celebrated on four successive days. He listed among the captives Queen Arsinoë of Egypt and Vercingetorix, the Gaulish chieftain. It is a matter of opinion whether either of these is visible in the seventh canvas (q.v.). Dio's chief contribution to our knowledge of the procession is the information that Caesar was permitted an unprecedented number of lictors (calculated at seventy-two. See Michael Grant, *Julius Caesar*, London, 1969, reprint 1972, p. 217 ff. I am indebted to Professor Grant for drawing my attention to the description of Dio Cassius.) Since Mantegna omits lictors entirely from his procession, it seems unlikely that he was acquainted with this text. This is indeed probable. Greek manuscripts of Dio Cassius were apparently not frequent in the fifteenth century and there was no Latin translation. The *editio princeps* appeared in Paris in 1548 (see introduction to Loeb edition above).

On the other hand, Mantegna knew the much briefer account of Suetonius (*Divus Julius*, Chapters 37–8); but this, while listing the Triumphs, contained only two details about the contents of the processions. Of these, one (the torch-bearing elephants) belonged to the Gallic Triumph; but the other (the inscription *Veni Vidi Vici*) came from the Pontic Triumph.

According to Suetonius (*loc. cit.*) the Gallic Triumph was the first and most magnificent. This point is further discussed by M. E. Deutsch, *The Philological Quarterly*, 1924, p. 275, 'The Apparatus of Caesar's Triumphs'.

Special significance must therefore be attached to the choice of Julius Caesar. On a general level, much has been written on the enormous fascination exercised by Caesar throughout the Middle Ages and the Renaissance.[1] The reasons for this are certainly connected with the literary sources relating the events of his life. For, of course, scholars and writers were not merely dependent on the dry utterances of Suetonius. There were the contrasted viewpoints of Sallust and Lucan; and also the almost hypnotic directness of the *Commentaries* themselves.[2] These combined to give an extraordinarily complex picture of Caesar as a personality. Further, there was the fact that he died by assassination. This introduced the theme of greatness overthrown and dramatically brought to nothing.[3] When, however, it came to measuring this greatness, opinions differed. Long before the fifteenth century, scholars and writers seized upon the contradictory elements in Caesar's biography. On the one hand there was the image of the great military saviour of the Roman people; on the other, that of the ambitious military dictator who overthrew the Republic and plunged the country into civil war. Petrarch, in his *Vita* exposed this contradiction[4] but it had already been noted in the thirteenth century;[5] and, as is well known, the controversy continued through the fifteenth century.[6]

But if Caesar's character appeared equivocal, there was one point on which almost all were agreed. He was probably the greatest general that the world had ever seen.[7] It was never controversial to glorify this aspect of his achievement. This may provide an im-

[1] The subject of Caesar's fluctuating reputation from classical antiquity onwards was treated by F. Gundolf, *Caesar: Geschichte seines Ruhms* (Berlin, 1924. French and English translations followed). This is a diffuse book, written without supporting notes, which makes it difficult to use.

[2] Sallust, *Bellum Catilinae*; Lucan, *Pharsalia*; Caesar, *De Bello Gallico, De Bello Civili*.

[3] This was emphasized by Petrarch in *De Viris Illustribus* (ed. L. Razzolini, Bologna, 1874 and 1879, with the fourteenth-century Italian translation of Donato degli Albanzani. Quotations below will be from the translation as being something more easily read by Mantegna and possibly also by us. See this edition Vol. II, p. 1). *Gaio Giulio Cesare, come spesso volte avviene degli uomini, ebbe debole principio, ma il progresso fu magnifico e il fine precipitose.* Also p. 687: *Così colui il quale in prima aveva soggiogato tante terre e poi nella città di Roma aveva soggiogato il mondo con meravigliosa felicitade, in una ora caduto in terra con ventitre ferite morì e per tutta la terra fu udito grande romore di questa ruina.*

[4] *Loc. cit.*, II, p. 435. Here at Chapter 20, the second part of the *Vita* starts. Its opening is instructive: *E infino a qui i fatti di Giulio Cesare sono stati chiari, gloriosi, magnifici . . . Da qui innanzi diremo quelle medesime armi crudeli e ingiuste essere convertite nella interiora della patria con miserabile mutazioni. Benché a questo non manchi grande scusa, ma veramente niuna può essere sufficiente cagione a muovere armi contro alla patria.*

[5] The contrast was, indeed, scarcely avoidable, given the two sources Sallust and Lucan. Interested readers will find some account of the legend of Caesar in the Middle Ages in L.-F. Flutre, *Les Manuscrits des Faits des Romains* (Paris, 1932), and in *Li Fait des Romains dans les Littératures française et italienne du XIIIᵉ au XVIᵉ siècle* (Paris, 1932) by the same author. It seems that Caesar made a comparatively late appearance in vernacular literature, probably at Paris in the second decade of the thirteenth century. The account

of his career forms the only completed part of a large work entitled *Li Fait des Romains*. It was extraordinarily popular and forty-seven manuscripts have been traced of its text. Late in the thirteenth century, it was translated into Italian —indeed this appears to have happened more than once. Flutre estimated that fourteenth- and fifteenth-century Italians could have known *Li Fait* through at least six different textual traditions of translation. One of these—an abridged version, of which forty-six manuscripts have been traced—was especially popular. An incomplete version of *Li Fait* was published in Venice in 1492 entitled *Cesariano*.

[6] The contrasted statements of Guarino and Poggio are well known. See *Epistolario di Guarino Veronese* (ed. R. Sabadini, Venice, 1915–19), Vol. II, p. 216. Letter to Lionello d'Este 1435. Also Poggio Bracciolini, *Opera Omnia* (ed. R. Fubini, Turin, 1964), Vol. I, p. 358. Letter to Scipio Mainenti Ferrarese 1435. Suetonius' account of Caesar's admiration for Alexander the Great doubtless inspired the comparison between the two added by Piero Candido Decembrio as a postscript to his translation of the Life of Alexander the Great by Quintus Curtius Rufus (*La Historia d'Alexandro Magno*, printed in Florence 1478). In reputation, Caesar's chief rival was probably Scipio Africanus, the man who, having defeated Hannibal, did not then turn his armies against Rome. He was generally supposed to have had a more noble character, see Petrarch, *op. cit.*, I, p. 619: *Appena tu troverai il nome della virtu senza il nome di Scipione.*

[7] Petrarch, *op. cit.*, p. 663 *nelle cose di battaglia niuno gli andò innanzi, e di questo non è dubbio. Così è scritto di lui: Fu uomo, del quale niuno mai fu più chiaro in fatto d'armi.* Poggio (*loc. cit.*, p. 360) grudgingly admitted this military prowess: *Nihil ergo reperimus in Caesaris vita quod digne laudari mereatur, praeter res bello gestas, quas non possumus negare non fuisse magnificas, licet patriae et civibus perniciosas. . . .* Probably on the strength of this, he was admitted as one of the *Neuf Preux*.

portant clue to the purpose or emphasis of Mantegna's commission—namely, that it represents a particularized glorification of military prowess. Although nothing is known about the circumstances of the commission, it seems most likely that the series alludes to the military pretensions of the Gonzaga family.[1] Nevertheless, the choice of subject brought in its train the curious result that although this Triumph is of Julius Caesar, virtually all the detail, as far as it can be derived from literary sources, comes from the Triumphs of other generals.

Mantegna was not the first person to devote thought to the appearance of an ancient Triumph; but he was the first to attempt an accurate visual representation. Fortunately, he had at his disposal scholarly assistance of a kind not available before the fifteenth century. The texts which he could have assembled (either by himself or by referring to those works already mentioned or by talking to his patron and his friends) combined to do two things. They provided a lengthy description of the elements of a Roman triumphal procession; and a more sketchy account of the triumphal route.

This route still presents various problems. According to Josephus, the procession set out from the *Campus Martius*, where the general(s) had spent the previous night at the

[1] That the series celebrates in a somewhat generalized way the theme of military prowess is supported by the presence of an inscription on the triumphal arch commemorating the deeds of Marius, Caesar's uncle-by-marriage. (See Appendix II, inscription 12.) Apart from his ability as a general and his qualities as a soldier it is difficult to find anything else in the career of Marius which would make him *persona grata* in a Gonzaga palace. It is tempting to see in this juxtaposition of Caesar and Marius the theme of military genius being handed on from one generation to another. Since Marius was married to Caesar's aunt Julia, there cannot in a biological sense have been any question of this. Nevertheless, Caesar was born in the year 100 B.C. when Marius was at the height of his powers; and that it was felt that something passed from the older to the younger man is strongly suggested by the uncomplimentary *bon mot* attributed by Suetonius and Plutarch to Sulla—'There are many Marius's in this man Caesar'. (See Suetonius, *De Vita Caesarum*, Loeb edition cit., Vol. I, p. 4, *nam Caesari multos Marios inesse*.) The task of assigning the commission of the *Triumphs of Caesar* on historical grounds to a particular Gonzaga Marchese is impossible. Some remarks have already been made about this historical background. The Gonzaga buildings at Mantua already possessed a *camera picta ad imagines et figuras imperatorum* and a *lobia gloriete picta ad istoriam Cesari et Pompei*. (See earlier in Chapter 3, p. 42, note 5.) To this, Pisanello had added an 'Arthurian' room and the addition of a *Triumph of Caesar* might have been the work of anyone interested in enhancing the appointments of the *Corte* with more painting along the same military lines.
However, it should be pointed out that, given the political situation in North Italy, all the Gonzagas had, perforce, military pretensions; and the *Triumphs* themselves give no indication pointing to any particular member of the family. The only piece of heraldry occurs in the seventh canvas—a small oval shield displaying a *bend* running from the dexter base to the sinister chief. The colouring is now dark, muddy and indistinguishable, but the device is unlike any known to have been borne by the Gonzagas (see Meroni, *op. cit.*), F. Portheim in *Repertorium für Kunstwissenschaft*, IX, 1886, p. 266 ff., 'Andrea Mantegnas Triumph Caesars', supposed that the young backward-turning rider to the right of the first canvas was a portrait of the young Francesco. This Marchese is shown aged about eight in the *Camera degli Sposi* and aged thirty in the *Madonna della Vittoria* and the resemblance is not striking enough to support Portheim's idea. Both Federico and Francesco were appointed to Generalships in northern Italy. (For information on this see S. Brinton, *The Gonzaga Lords of Mantua*, London, 1927. Federico became Captain-General of the Milanese forces in 1478. Francesco became Captain-General of the anti-French League forces in 1494.) Vasari stated (see Document 27) that the Triumphs were done for Lodovico Gonzaga (died 1478). This was presumably in Thode's mind when he suggested (*Andrea Mantegna*, Bielefeld and Leipzig, 1897, p. 90 ff.) that the series was conceived as a set of engravings under Lodovico and converted into something larger at the accession of Francesco (1485). Curiously enough, Lodovico possessed earlier some things which he called *carte dali triumphi* (they were sent to him at Cremona in 1458 by special messenger along with a pair of sheets. See Archivio Gonzaga Busta 2886, Copia-lettere Libro 35, f. 20ʳ., Letter to Petro Spagnolo of 23 November; and the reply Busta 2390, f. 297, Letter of 24 November), but in the circumstances these are likely to have been playing cards. Lodovico also held military commands during the wars surrounding the accession to power of Francesco Sforza, 1447–54, and briefly commanded the Milanese forces of Galeazzo Sforza in 1470.
It is remarkable that the precise point at which a Gallic Triumph would have become unexpectedly topical (after Francesco's 'victory' over the French at the battle of Fornovo, 1495) apparently coincides with the period in which interest in the completion of the series seems to have waned (see below, p. 90). In passing, it may be added that there were apparently no traditions connecting Julius Caesar's career with Mantua. If this had been the case, they would almost certainly have been mentioned by Equicola in his *Commentarii Mantuani*. There is, however, a passing topographical reference in the *Triumphs* to the area of Italy between Mantua and Venice. The iconography of the triumphal arch in the ninth canvas suggests that it commemorates the victory of Marius over the Cimbri. The campaign in which the Cimbri were destroyed was fought in the Adige and Po valleys and the final victory was at Vercellae, near modern Rovigo.

Temple of Isis.[1] It passed into the city through the *Porta Triumphalis*[2] and ended up at the Temple of Jupiter on the Capitol.[3] Plutarch and Josephus both imply that at some stage the processions might pass through various theatres in order to give the crowds a better view.[4] Extracts from other writers can be used to fill out this incomplete picture; the results can then be combined with what is known of the street plan of ancient Rome.[5]

In a sense, however, this exercise is superfluous from the point of view of the present study. Flavio Biondo in *Roma Triumphans, Book X*, had already stated what course he thought the Triumphal route took. He is worth quoting in full, since this was almost certainly the most authoritative archaeological statement on the subject available to Mantegna.

Eos qui triumphū ducturi erāt satis supra ostendit Iosephus semper ad portam consedisse: quam ipse dicit nomē inde nactam fuisse: q triumphi per eam ducerentur: nosq in Roma instaurata priscorum testimonio & auctoritate docuimus territorium triumphale. ad eum fuisse locum ubi apud basilicā principis apostolorum petri: sancti andreae ecclesia & coenotaphium extant: quo in celeberrimo priscis etiam temporibus loco apud id tunc apollinis templū nunc sanctae petronillae: & sanctae mariae febricosorum ecclesiā: obeliscus est ille sublimis: quem caium principem in neronis circo erexisse plinius est auctor. In eo itaq territorio triumphali parata triumphi pompa per viam procedebat triumphalē:[6] cuius stratae silicibus particula adhuc cernitur sub sancti spiritus in saxia hospitali: ut per nūc dirutum pontem tyberis triumphalem ibi proximum: & portam pariter dirutam eius pontis triumphalem: cuius ampla cernere est fundamēta in urbem & ad capitolium duceretur. Continuabatur autem ea triumphalis via ad posteriorem nunc porticum ecclesiae sancti celsi: ad quam arcus marmorei ipsam amplexi viam altera extat coxa corrosam e marmore statuam retinens collosseam. Reflexa inde via sancti laurētii in damaso ecclesiam: & post florae campum petebat: idq hic maxime proximis temporibus cernere fuit: quod ī continuatis super eam domibus fundamenta iacere aut puteos effodere molientes siliceam veterem offenderunt spaciosissimam a: campoq florae ad nuno [*sic*] plateam iudeorum inde iunonis templum: nunc sancti angeli in foro piscium ecclesiam: post ad sanctum georgium ī velabro procedens via sub novis aedibus ruinisq ab effodientibus invenit' quousq iani tēplo velabroq proxima in clivum desitura capitolinum detecta cernitur. A velabro autem clivum inchoasse capitolinum: per quē ad iovis optimi maximi templum erat assensus satis in Roma ostendimus instaurata. Notissimumq est ex suetonio illud quod brevi supra diximus: Caesarē gallici triumphi die praetervehentem velabrum curru pene excussum

[1] *prope Isidis templum.* Josephus (here quoted from the Latin translation) was followed by Valturio in everything regarding the route.

[2] *ipse (Vespasianus) vero ad portam recedit quae ab eo quod per illam semper triumphorum pompa ducitur nomen accepit.*

[3] *Pompae autem finis fuit Capitolini Iovis templum.* Appian and Suetonius also mentioned the end of the procession on the Capitoline Hill.

[4] According to Plutarch, *Populus Romanus . . . in equestribus teatris quos arcus appellant . . . sese ad spectandum triumphum comparaverat* (this was repeated by Valturio).

Josephus states *inter spectacula transeuntes triumphum ducebant.*

[5] See Pauly-Wissowa, *loc. cit.*

[6] Cf. Valturio, *op. cit.*, Book XII, Chap. 5: *Quale* (sc. *la venuta di l'imperatore*) *veniva per la via triumphale vicina al monte Vaticano quale fu nominata triumphale perche la pompa dil triumpho per quella traduceva quivi cioe al mōte vaticano.* On this, see also Flavio Biondo, *Roma Instaurata*, Book I, Chapter xli. The existence of this *Via Triumphalis* was confusing. The nomenclature seems to be very old; but it now appears to have had nothing to do with military triumphs, which set out from the *Campus Martius* on the other side of the river.

fuisse axe diffracto: haec itaq fuit triumphantium via ab obelisco territorio portaq triumphali ad iovis templum: cuius magna & dissipata nunc fundamentorum ubi de facinorosis in capitolino colle suppliciū sumitur: vestigia extare videmus.

It is possible to follow most of this route, both in the surviving city plan of Rome and also in maps of the city drawn up in the fifteenth and sixteenth centuries (*nos. 162, 163*).[1] It will immediately be apparent that a large number of landmarks occur on it. Starting in the Borgo Vaticano they are as follows (monuments mentioned by Flavio are marked thus *):

(i) The Vatican Obelisk*
(ii) *Meta Romuli*
(iii) *Pons Triumphalis*￼*
(iv) *Porta Triumphalis*￼*
(v) *Arcus* by S. Celso*[2]
(vi) *Porticus Octaviae*[3] by S. Angelo in Pescheria*
(vii) Theatre of Marcellus
(viii) *Arcus Iani* (called by Flavio Templum Iani)*
(ix) *Arcus Argentariorum* by S. Giorgio in Velabro
(x) Ruins on the Palatine Hill
(xi) Ruins in the Forum at the foot of the Capitol
(xii) *Clivus Capitolinus*
(xiii) *Templum Iovis Maximi Capitolini.*￼*

A peculiarity of this itinerary is the omission of the *Via Sacra* and consequently of the Arch of Constantine and the Colosseum.[4] Nevertheless, a reasonable number of major monuments might have been portrayed in a clearly defined order, had Mantegna wished to give the procession an authentic setting. It goes almost without saying that problems would have arisen in their selection, since almost anything recognizable would have belonged to post-Republican Rome; but this merely highlights the problems of archaeological reconstruction. In any case, Mantegna's antique monuments refuse to conform to such a scheme. The discrepancies are so numerous that it seems hardly worth labouring the point.[5] The

[1] Two illustrations have been chosen, both to be found in A. P. Frutaz, *Le Piante di Roma* (Rome, 1962). On the first, the Strozzi Plan of 1474, see also G. Scaglia, *Journal of the Warburg and Courtauld Institutes*, XXVII (1964), p. 137, 'The Origin of an Archaeological Plan of Rome by Alessandro Strozzi', where the close connections with Flavio Biondo are stressed.

[2] This was the *Arcus Gratiani, Valentiniani et Theodosii*. See E. Nash, *Pictorial Dictionary of Ancient Rome* (London, 1961–2).

[3] Flavio's identification of the *Porticus Ottaviae* with the *Templum Iunonis* is a mystery. The Strozzi map gives the identifications *T(emplum) Severiani* and *T(emplum) Vestae*. On these, see Scaglia, *op. cit.*, p. 148.

[4] By the time he wrote *Roma Triumphans*, Flavio Biondo's views on the triumphal route had been confused by the recent discovery of an inscription which seemed to give a totally different site for the Temple of Isis. The new site lay between the church of S. Sisto and the Baths of Caracalla, and Flavio was forced to assume that the generals

spent the previous night illegally inside the city but still began the procession the next morning at the *Porta Triumphalis*. Both of the above buildings are marked on the Strozzi map and a glance at *no. 162* will show that this modification does not make any better sense of Mantegna's background.

[5] The procession proceeding from right to left, the spectator is shown the right-hand side of the triumphal route in the background. Objects which might be identifiable include an arch, a pyramid, a column and something that looks superficially like an aqueduct. No surviving columns or aqueducts would have appeared on that side of the route. The pyramid may be intended as the *Meta Romuli* but in that case should lie to the right of the Arch, if this is intended as the *Porta Triumphalis*. It is sometimes suggested that the beautiful landscape of the fourth and fifth canvases is meant to evoke the ruins on the Palatine hill. This would be topographically possible following Flavio Biondo's route, but the visible ruins cannot be related to surviving ruins there. They correspond, however, quite well to Poggio's rather generalized evocation (*De*

canvases do not contain an archaeological report on the possible appearance of the triumphal route in Rome. The settings have nevertheless a special interest of a rather different kind. It will be noticed that there is a distinct change in the character of the background in the course of the procession. The fourth, fifth and sixth canvases seek to evoke Ancient Rome through a series of reasonably familiar types of object more or less in a state of decay. This is, of course, anachronistic in the historical context but immensely effective as a piece of romantic scene-setting. By contrast, the seventh canvas and the 'Senators' drawing, discussed on p. 66, place the procession in a Roman street backed by extremely solid, undecayed houses. This contrast has already received comment, on p. 22, and receives attention below on p. 84.

The paintings, then, in no sense present either a 'portrait' of a particular triumph or a 'portrait' of a particular place. For all that, their general content is neither speculative nor imaginary. The accounts make it clear that the general pattern of triumphal processions remained fairly constant, being divided into three distinct parts. The aim of the first part was to display the captured objects and people and to illustrate the campaign. The centre-piece of the procession was the triumphing general himself. Finally, the rear of the procession was brought up by the triumphant army.

There has been considerable speculation on the literary basis for the Triumphs of Caesar.[1] There can be no doubt that the main literary sources of Mantegna's visual programme were Plutarch and Appian, and a conflation of their accounts produces an iconographical content and order tolerably close to that found in the paintings (see Appendix III). This is of interest because, despite the free interchange between the texts within the paintings, the result has some claim to academic accuracy. The various participants, be they trumpeters, carriers of booty, animals or prisoners, may be said to appear in their correct position *vis-à-vis* the text from which they are derived and detailed comment will be found in the catalogue on pp. 133 ff. Art is thus happily combined with scholarship.

It would still be interesting to know how Mantegna picked his way through the profusion of texts as laid out, for instance, by Flavio Biondo.[2] Some writers have stressed the importance of Valturio. The *De Re Militari* can indeed be used to explain one rather unusual piece of iconography—the palm branch that Mantegna made Caesar hold in his left hand, (see below, Catalogue, p. 159). Nevertheless, in describing the attributes of the victorious general, Valturio himself placed the customary laurel branch in his left hand and adds

Varietate Fortunae, Book I), *Respice ad Palatinum montem, et ibi fortunam incusa, quae domum a Nerone post incensam urbem totius orbis spoliis confectam, atque absumptis imperii viribus ornatam, quam silvae, lacus, obelisci, porticus, colossi, theatra varii coloris marmorea admirandum videntibus reddebant, ita prostravit ut nulla rei cujusquam effigies superextet, quam aliquid certum, praeter vasta rudera queas dicere.*

[1] Some writers (e.g.: Thode, *op. cit.*, and Waterhouse, *op. cit.*) have stressed, perhaps wisely, the lost treatise of Marcanova already mentioned on p. 51. K. Giehlow (*Jahrbuch der Kunsthistorischen Sammlungen des Allerhöchsten Kaiserhauses*, XXXII (1915), Part I, 'Die Hieroglyphenkunde des Humanismus in der Allegorie der Renaissance besonders der Ehrenpforte Kaisers Maximilian I', p. 88 ff.) claimed that virtually everything was to be found in Valturio. He was followed in this opinion

by I. Blum (*Die Bedeutung der Antike für das Werk des Andrea Mantegna*, Strasbourg, 1936, p. 91) and E. Tietze-Conrat (*op. cit.*, p. 23 and 184). E. Battisti (*Arte, Pensiero e Cultura a Mantova nel Primo Rinascimento*, Florence, 1965, p. 23, 'Il Mantegna e la letteratura classica') in pursuit of a somewhat elusive pro-Greek anti-Roman thesis, claimed Appian as the most important source.

[2] Permissible triumphal detail, drawn from the pages of Flavio Biondo, included chariots pulled by elephants or stags, torques, beds and other objects of luxury, gaming boards, couches, not to mention Josephus' famous *pegmata*; and many other sorts of animal, including tigers and camels. In general, Mantegna ignored the Triumphs of G. Manlius (Livy, xxxix. 6) and the Emperor Aurelian (Flavius Vopiscus, *Divus Aurelianus*, 33), both related *in extenso* by Flavio Biondo.

many details which were not followed by Mantegna.[1] However, the chief defect of Valturio's account was that he omitted to give the order of the procession. Nobody reading his book could extract a clear idea of the sequence of show-pieces, which could only be gained by referring back to the original texts. Add to this the fact that Josephus, one of Valturio's main sources, seems to play only a minor role in Mantegna's iconography, and Valturio's importance as a formative influence diminishes rapidly.

The programme which was finally settled for the *Triumphs* represents a very striking piece of simplification, in which a considerable amount of permissible triumphal detail was set aside in favour of dependence on two accounts, only supplemented by a small amount of miscellaneous detail taken from other writers. It is important to stress Mantegna's adherence to particular texts since, for whatever reason, it will be apparent that the nine canvases give an incomplete account of a Triumph. They portray only the first part of the procession and the Triumphal general, omitting entirely the third part, the army marching by regiments. In Mantegna's work, as it survives, Julius Caesar comes at the very end of the line; in all normal circumstances he should be at or near the centre. One is therefore obliged to ask whether the series, as it has come down to us, is in some sense incomplete.

It seems most improbable that any canvases have been lost. This has certainly not happened since the late sixteenth century as is borne out by the woodcuts of Andreani, see below, p. 103, and there is no reason to suppose that any losses occurred at an earlier date.[2] The wording of Mario Equicola's account is indeed instructive in this context[3] since, writing *c.* 1520, he said even at that date that the series 'seemed' (*parea*) truncated and mutilated, but not that it had actually been treated in this way.

Equicola was recording the fact that the triumphal programme was finished off by Costa. He was in effect reiterating what has already been said above—that, as it stands, Mantegna's procession is incomplete, according to the texts from which it is derived. It is possible to place two rather different interpretations on these suggestions. On the one hand, it may be

[1] Valturio's description (Book XII, Chap. IV) of the *triumphator* runs, in abbreviated form as follows *Molti ancora erano li ornamenti de li triūphi cioe la corona di auro . . . una taza di auro . . . uno anello di ferro la toga depincta & rechamata inspecie di una palma una virga di avolio . . . oltra dinquesto havera colorita la facia de minio . . . ancora la bulla . . . dependente a li triumphanti a la parte dil core et haveva la figura di uno core.* Valturio then describes the man standing behind the *triumphator* in his chariot holding a crown (what sort of crown?) above the general's head. The remainder of the chapter discusses the nature of the *toga palmata* and the significance of the palm and the laurel. In Chapter 5 the general is said to sit *vestito di la purpura tessuta cum li fili di auro et in la mane dextra portava il ramo di lauro*. As a whole, this is not especially close to Mantegna's image. Another curious comparison can be made in the case of the siege equipment. Giehlow (*op. cit.*, p. 91) pointed out that Valturio's illustrations in Book X might well have been influential. It is very difficult to be convinced by this. In the first place, none of Valturio's siege equipment has any detailed resemblance to anything in the second canvas. Further, the only appliance readily identifiable among Mantegna's trophies is a battering-ram (*Aries*); but this is not mentioned among Valturio's trophies (*Cathapulte: Baliste: Tormenta* taken from Livy, *Ab Urbe Condita*, XXXIX, 5, and translated into Italian rather surprisingly as *Veretoni, Manganelli* and *Bombarde*). Conversely, giant catapults do

not appear among Mantegna's siege equipment. For further comment see the Catalogue, pp. 138–9.

[2] Tietze-Conrat, *op. cit.*, p. 244, in saying that the 'Senators' composition (see p. 66 below) 'no longer exists' might seem to imply that it had actually been painted; and Giehlow (*op. cit.*, p. 91) supposed that already by Andreani's time some parts had been lost. The theory that there were originally eleven canvases has recently been revived both by G. Paccagnini (*Il Palazzo Ducale di Mantova*, Turin, 1969, p. 88) and G. Carandente (*I Trionfi nel primo Rinascimento*, 1963, p. 84: *dovevano comprendere undici scene*). This seems to depend (Carandente, p. 89) on the interpretation of the letter of 1494 (Document 10, p. 183). If the existing nine canvases were completed by 1494, and if the two *Triumphs* mentioned in that letter were by Mantegna and in some sense, which is surely odd, an addition to the series, then it can be said that Mantegna planned eleven canvases. But it seems extremely unlikely that those two *Triumphs* have anything to do with the paintings which form the subject of this book (see above, p. 33). The only times that numbers of canvases are mentioned during the sixteenth century (Documents 29 and 32), the figure is fewer than nine.

[3] For a full discussion of Equicola's evidence, see below Chapter 7 and his text (Document 26).

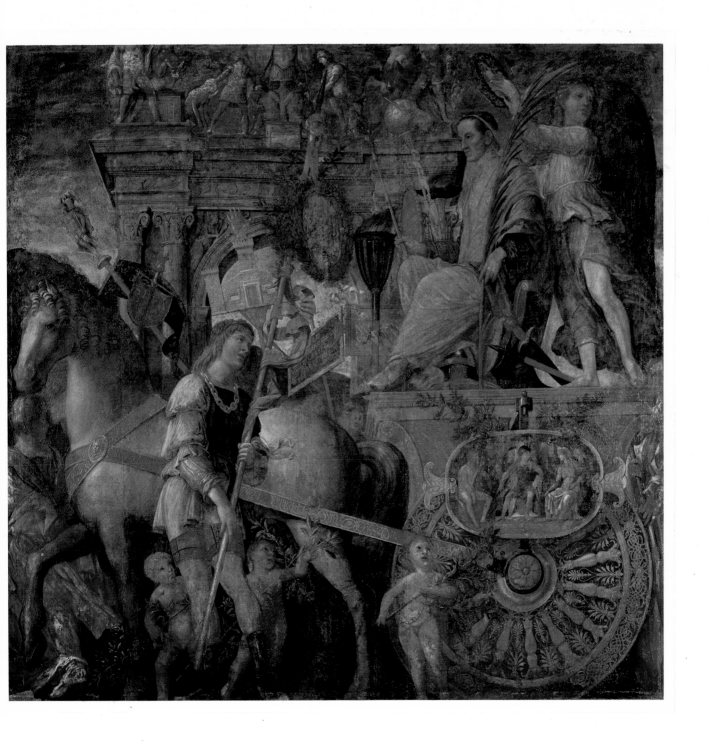

Canvas IX: The Triumphator, Julius Caesar, on his Chariot

argued that no historian should claim to know better than the artist himself; and that Mantegna, well aware perhaps that he was being unscholarly, made an arbitrary selection of the material to fit both the needs of the site and his own artistic inclinations. In this case, there could be no question of the series being 'incomplete' because the nine canvases would form an artistic whole and, all academic considerations set aside, should be regarded as achieving in artistic terms whatever it was that Mantegna intended.

It would be difficult to argue against this, but for the survival of two pieces of evidence. First, the canvases are not completely finished. There is a curious featureless area in the painting of the seventh, the 'Captives' (*no. 37*). Further, there are inconsistencies of character between landscapes in adjacent canvases which suggest that final corrections were never carried out.[1] Second, and more interesting, although only nine canvases exist, a tenth scene survives both as a drawing and as an engraving (*no. 56*). This scene is traditionally called 'The Senators', although it is generally accepted that this title is wrong. The most likely explanation of this composition is that it is intended to represent the secretaries and aides who walked behind the general's chariot.[2] They were followed immediately by the army, whose leading ranks are indeed visible, entering the composition on the right-hand side. Thus Mantegna's imagination was at work in at least one area beyond that covered by the finished paintings. As with so much else to do with the *Triumphs*, the evidence is inconclusive; and yet the survival of this composition shows that there is at the least a strong possibility that at some moment Mantegna toyed with the idea of a procession in which Caesar, followed by the army, would have been placed nearer to the middle of the total composition. In the absence of firm information about the original site for which the paintings were intended, it is perhaps unwise to speculate further.

The verbal descriptions were undoubtedly vital in the planning of the cycle. However, it will be obvious that they offer lists of iconographical detail rather than vivid pictorial imagery. It is difficult to say with confidence how far the printed word affected not merely what was painted but also how it was painted. For instance, a passage from Plutarch may have inspired parts of the composition of the third canvas (*no. 16*) in which the captured arms might well be said to be 'resplendent with polished bronze and iron and [in parts at least] so disposed that they seem to have fallen into their arrangement by the purest chance'.[3] Apart from this, however, the texts provided little more than a list of possible subject-matter.[4] For their interpretation, Mantegna was dependent on his own knowledge and imagination.

No discussion of Mantegna's approach to the classical detail of the *Triumphs* is possible

[1] For Canvas VII, see below, p. 152. It is most unfortunate that this should be the worst preserved canvas. Nevertheless, the early copies (*nos. 84, 95, 102, 103*) all record a blank area above the window opening; and they fail to agree on the existence of the capital alongside. In an otherwise highly finished work, this appears inexplicable unless the area was never filled in properly by the artist. The inconsistencies occur in the landscapes spanning the gaps between Canvases IV and V; and VIII and IX (q.v. in catalogue).

[2] The title of 'Senators' already existed by Goethe's time and I am unable to find out where it originated. Goethe, in his essay *Triumphzug von Mantegna* (*Werke*, Weimar, 1898, I. Abt., Band 49, p. 266 ff.) suggested that the figures repre-

sented the teaching profession. For the more generally accepted interpretation, see Appian, *Demū qui exercitum secuti fuerant scriptores: ministri: scutiferive.*

[3] See below, p. 141. It is also possible that the woebegone appearance of Perseus and his household, as described by Appian, may have influenced the planning of the seventh canvas. See below, p. 152 for further comment.

[4] The somewhat elusive relationship of Mantegna's painting to texts other than Appian, Plutarch and Suetonius is well illustrated by an examination of Vegetius' *Epitoma Rei Militaris* (printed Rome, 1487; and probably at Paris before 1473. Manuscript distribution uncertain but a copy existed in the Urbino Library). Vegetius distinguished between the

without some consideration of what had gone before. Already by the time of the Eremitani frescoes (*c.* 1450) he was able to produce a surprisingly authentic series of studies of Roman military costume. These studies were not, of course, entirely without antecedents. Earlier artists from Giotto or Duccio to Piero della Francesca had realized that Roman soldiers looked different from contemporary soldiers. These distinctions crystallized round various specific features: Roman soldiers, it was observed, wore a cuirass, modelled round the chest and ending in the region of the waist; below this they wore a skirt, usually made of straps hanging vertically to reach the region of the knee; underneath all this, they might wear a tunic, which could be seen protruding beneath the lower edge of the skirt. But over the protection of the arms, shoulders, legs and head the imagination was allowed free play. For instance, it was seen that the upper arm was protected by further layers of leather straps, normally emerging from the arm-hole of the cuirass and hanging vertically downwards. It seems, however, that earlier artists found it hard to accept this as sufficient protection. Fantastic circular discs or moulded metal pieces were introduced to mask the joint between the cuirass and the leather straps; and the lower arm was frequently encased in plate armour. Similarly, the joint of the knee was often covered with a fantastic ornamental elaboration, leading to more plate armour on the lower leg (*nos. 155, 156*).[1] Supposedly 'Roman' helmets, it should be added, came in an extraordinary number of shapes and sizes.

Mantegna did not immediately banish these flights of fancy; anachronisms certainly occur in the Eremitani scenes.[2] Nevertheless the elaborate 'growths' round the knees and shoulders are almost invariably omitted in the frescoes (as also in the S. Zeno altar). By this simple observation, Mantegna gave his military figures an appearance of authenticity absent from almost all previous representations (*nos. 132, 144*).

Turning from this early work to the *Triumphs*, it would appear that Mantegna's archaeological sense developed very little. Whatever may have fixed his concept of Roman soldiery during the 1450s, substantially the same image was re-created thirty-five years later. One curious feature may be noticed. Mantegna, when devising armour, almost always painted some form of breastplate or cuirass. A cursory examination of almost any Roman

various military wind-instruments (III, Chapter V), *Tuba quae directa est, appellatur; Buccina, quae in semetipsam aereo circulo flectitur. Cornu quod ex uris agrestibus, argento nexum, temperatum arte et spiritu . . . auditur.* All three varieties are visible; but the only ox-horn is slung across the back of one of the trumpeters. In view of Vegetius' remarks, one might imagine it to be inappropriate to a noisy occasion such as a Triumph. Mantegna may therefore have been following Vegetius in showing it *not* being blown. But elsewhere Vegetius is disregarded. For instance, he twice described the *vexilla* carried by the infantry. In a list of the personnel of the legion (II, Chap. VII) he wrote *Aquiliferi qui aquilam portant. Imaginarii vel imaginiferi qui imperatorum imagines portant . . . signiferi qui signa portant: quos nunc draconarios vocant.* Perhaps *imagines imperatorum* would have constituted too obvious an anachronism; with perhaps one exception (Canvas VIII) they do not appear. But no form of dragon-standard appears either; and only one eagle-standard (again in the eighth canvas). Likewise, Vegetius described the uniform of the *signiferi*, all of whom, he said, were given helmets covered with a bear-skin (II, Chap. XVI, *galeas, ad terrorem hostium, ursinis pellibus tectus*). In the only example of a *signifer* in the *Triumphs*,

the figure is covered with a lionskin (Canvas VIII).

[1] The earlier artists must certainly have been influenced by developments in contemporary armour and the gradual move towards a complete encasement in plating, with the necessarily complicated contrivances to guard the joints of the human body. One of the most illustrious of these hybrid creations was Donatello's *Gattamelata*. It is of interest that Filarete thought the statue looked odd, although his criticism was that Gattamelata never went around in clothes like that. As is noted below, Filarete's own interpretation of the military *abito antico* was much more authentic (p. 71).

[2] The most completely anachronistic soldier is probably the one on horse-back to the right of the scene of the *Martyrdom of St James*. But in both the Eremitani frescoes and the S. Zeno altar there are several cases of plate-armour covering the forearms. This still occurs occasionally in the *Triumphs*. For instance, in the first canvas the backward-turned soldier has metal protective covering on his forearm. He also has some curious jointed plating along the bottom of his cuirass.

representation of military figures would have revealed that these were rare in the Roman army, presumably on account of their expense. The ordinary soldier wore instead a chest- and arm-covering formed of the distinct bands of the *lorica segmentata*; and literally hundreds of examples of this may be seen on the columns of Trajan and Marcus Aurelius. By ignoring this, and adhering to the convention adopted in his early years, Mantegna was in effect putting all his soldiers into officers' uniform.[1]

Mantegna's conception of the Roman army did not in this respect grow more 'correct' with the passing years. What developed instead was his appreciation of the decorative pos- sibilities of his antique sources. The shape and decoration of swords, helmets, greaves, boots and shields is already varied in the Eremitani chapel and the S. Zeno altar; and many of these ideas were later simply expanded and elaborated.[2] It is possible that Mantegna's studies of antique costume were stimulated by his participation in court masques and theatricals. Unfortunately, the state of the evidence is such that it is now the paintings that are used to throw light on the theatre rather than *vice versa*. Nevertheless, the presence and possibilities of such a stimulus seem clear.[3] The scale of this development is impressive; the remarkable variety of helmet and sword design or of cuirass decoration coupled with the necessary addition of such things as trophies, animals, musical instruments or carts means that the detailed interest of the *Triumphs* never flags for a moment.

The quantity of literature already existing on the subject of the visual sources of Man- tegna's classicism proves both the fascination and the difficulty of the subject.[4] It will always be complicated by the fact that Mantegna was an artist first and an archaeologist second. Antiquity, for all its attractions, was only a starting point. Consequently the search for prototypes has, almost without exception, an inconclusive quality. It is a little as if one were being continually presented with sets of musical variations for which the original themes were missing.

These ambiguities are not made easier by the subject of the paintings—the Gallic Triumph. The archaeological problems facing Mantegna were very similar to the literary ones. There had never been very much visual information available in Italy about the

[1] For a recent account of the equipment of the Roman army see G. Webster, *The Roman Imperial Army of the first and second centuries A.D.* (London, 1969), p. 122 ff. By the second century A.D. the *lorica segmentata* was normal for all legionaries, but it was later replaced by a body-covering of overlapping scales. An example of this last is visible in the Marcus Aurelius *Adlocutio* relief (*no. 193*) and Mantegna introduced something of the sort into the trophies of the sixth canvas. The elaborate cuirass designs found in statuary normally clothe figures of either gods (e.g. Mars) or emperors. How far others were permitted this sort of adornment is uncertain. In any case, it is highly unlikely that anyone did serious campaigning in armour of this sort. Trajan and his staff are shown on the Column in cuirasses of an extremely simple pattern. For further observations, see the catalogue *passim*.

[2] In both the Eremitani frescoes and the S. Zeno altar, several cuirasses have simple arabesque designs. In the *Crucifixion* panel (*no. 144*) the horseman has a cuirass with a spotted pattern (compare a cuirass in Canvas III). Kite- shaped shields and peltas also appear in the early works; and in the *Martyrdom of St James* (*no. 133*) there is a shield decorated with a winged head similar to a shield in Canvas

III. Detailed references back to these early works will be found in the commentaries on the individual canvases.

[3] While I was writing this book, Mrs Stella Newton's work on Renaissance dress and costume appeared. In it she argues that the costume of the *Triumphs* is strongly in- fluenced both by contemporary fashion and by the practical necessity of acting. She suggests that all the costumes could be constructed and worn; and for this reason in particular it seems to her permissible to use the *Triumphs* as evidence for the visual appearance of the late fifteenth-century theatre in North Italy. Although this seems entirely likely the problems of Mantegna's sources are not solved by the observation. It is still of interest to know the 'raw' archaeo- logical material upon which Mantegna's imagination worked.

[4] See the earlier studies of Portheim and Blum, already mentioned. More recent works include those by A. M. Tamassia (*Rendiconti della Pontificia Accademia Romana di Archeologia*, Ser. III, Vol. XXVIII, Fasc. III–IV, 1955–6, 'Visioni di Antichità nell'opera del Mantegna'), P. D. Knabenshue (*Art Bulletin*, Vol. 41, 1959, 'Ancient and Medieval Elements in Mantegna's Trial of St. James') and C. Vermeule (*European Art and the Classical Past*, Cam- bridge, Mass., 1964).

appearance of Gauls. The western provinces had, by and large, been settled before the great age of Roman monumental construction. The carving on the major commemorative enterprises in Rome and elsewhere tends to refer to events on the north-eastern and eastern frontiers of the empire.[1] Once again, therefore, a Triumph which is notionally 'Gallic' is in visual terms built up from sources which, for the most part, have little direct historical relevance to this subject matter. Mantegna may not have set much store by academic considerations of this sort, but they underline the fact that from the start he was moving in a world of fantasy. The main antithesis in the paintings was not Roman v. Gallic; it was the more general one of Roman v. Barbarian or simply Roman v. non-Roman. Mantegna's imagination came fully into play in the process of devising objects which, while sufficiently bizarre or unusual to be 'un-Roman', were not too bizarre to be 'un-antique'.

Mantegna's visual sources may be classified initially by size—large and small. Of the small—coins, medals and gems—little can be said. Nothing is known about fifteenth-century coin collections in detail, and apparently none of the surviving pieces can be traced back much beyond 1500. Coins are frequently suggested below as source material but they have to be used *in vacuo* since it is quite impossible to determine exactly what would have been available to Mantegna.[2] A little is known about the fifteenth-century collections of gems and cameos, although the task of relating surviving gems to collectors has only recently been taken in hand.[3]

The case is very different with the larger monuments; and a reasonable amount is known about what was visible in the fifteenth century. One particular fact is worth emphasizing. North Italy, although well equipped with architectural remains, was ill-equipped with remains bearing sculpted figures or reliefs, whereas, by contrast, Rome possessed a wealth of figure sculpture; and in any analysis of the classical content of the *Triumphs* it is to Rome that the historian is obliged to turn again and again, and not to the archaeological museums

[1] Not very much is known about the appearance of Gauls, although reliefs of battles between Romans and Gauls survive on some of the monuments in Provence. The arch at Orange features in the Barberini Codex of Giuliano da Sangallo, who gives a side-elevation showing some nude figures, presumably prisoners, standing beneath the trophies. These figures are today so battered as to be almost indecipherable but the general impression that Gauls fought with very little clothing on must have seemed to be confirmed from the other reliefs on the Orange arch and also from the monument at St. Rémy. It seems that Alberti knew the Orange arch, in which case it may also have been known to Mantegna. But as a source of costume studies it was unpromising. The arch at Carpentras shows a barbarian prisoner clothed in an animal skin. The major monuments in Rome commemorate campaigns as follows:

Arch of Titus, *c.* A.D. 80—against the Jews
Column of Trajan, A.D. 113—against the Dacians
The Great Trajanic Frieze (Arch of Constantine)—also against the Dacians
The Column of Marcus Aurelius, *c.* A.D. 193—against the Sarmatians and Marcomannians (Danube frontier)
Reliefs perhaps from an Arch of Marcus Aurelius (Arch of Constantine and Palazzo dei Conservatori)—probably against the same
Arch of Septimius Severus, A.D. 203—against the Persians.

[2] For a recent survey of the numismatic evidence see

R. Weiss, *The Renaissance Discovery of Classical Antiquity* (Oxford, 1969), p. 167 ff. A certain amount is known about the location and size of the main fifteenth-century collections, but nothing is known in detail about their contents. Information about the items actually in circulation during the fifteenth century can now be gleaned only from imitations or derivations in contemporary art. A few drawings survive from the time of Pisanello showing heads apparently from coins or medals (M. Fossi Todorow, *I Disegni del Pisanello*, Florence, 1966, Catalogue Nos. 279r and 218v). A little more information is forthcoming from the sketchbooks of Jacopo Bellini, which show both Greek and Roman coin types, obverse and reverse, used as a species of architectural decoration. Antique coins appear to underlie some of the decorative ideas of Filarete in his bronze doors. As Weiss pointed out, coins also feature in the decoration of fifteenth-century manuscripts (see especially Paris, B.N., Ms lat. 5814, published by J. J. G. Alexander in *Italian Renaissance Illumination*, London 1977, pp. 20 and 64–67). The coins with the earliest post-classical 'pedigree' are probably those inserted in the base of the bronze *Venus Pudica* by Antico. This statuette, now in the Kunsthistorisches Museum, Vienna, was originally in the collection of Isabella d'Este.

[3] On this, see especially N. Dacos, A. Giuliano and U. Pannuti, *Il tesoro di Lorenzo il Magnifico*, Vol. I (Florence, 1973). *Le Gemme*.

of Mantua, Verona, or Venice.[1] The list of Roman monuments subsequently cited is comparatively small.

(i) The Arch of Constantine[2] incorporating amongst other things reliefs from the time of Marcus Aurelius and the so-called Great Trajanic Frieze.
(ii) The Arch of Titus.[3]
(iii) The Arch of Septimius Severus.[4]
(iv) The Column of Trajan.[5]
(v) The Column of Marcus Aurelius.[6]
(vi) Three reliefs from the time of Marcus Aurelius formerly in the church of S. Martina and now in the Palazzo dei Conservatori, Rome.[7]
(vii) Two reliefs from the time of Hadrian, formerly on the Arco di Portogallo and now in the Palazzo dei Conservatori, Rome.[8]
(viii) Two piers, carved with trophies of arms, formerly at S. Sabina, Rome, and now in the Uffizi, Florence.[9]
(ix) The Trophies from the *Nymphaeum Aquae Juliae* now on the Capitol but formerly *in situ* near the church of S. Eusebio.[10]

The evidence points to the view that Mantegna knew what they looked like.[11]

This knowledge would have been acquired at least by the time work started on the *Triumphs* and some of it must have been acquired by the time of the Eremitani frescoes *c*. 1450. There is no evidence that Mantegna had himself been to Rome; but, acquainted as he was with artists and antiquarians, the transmission of information about the appearance of these Roman monuments might not seem to present any particular difficulty. However, if one attempts to imagine the means by which it was transmitted, one comes up against the problem that these were years in which archaeological drawing was undergoing an awkward and obscure transition. The first half of the fifteenth century seems to have been dominated by archaeologists who were not artists; and, *vice versa*, by artists who were not archaeol-

[1] It should be noted that all these institutions were founded after the fifteenth century, and little or nothing is known about the previous history of the contents. The Archaeological Museum in Verona is a creation of the first half of the eighteenth century. See S. Maffei, *Museum Veronense* (Verona, 1749), *Praefatio*. Also C. Garibotti in *Miscellanea Maffeiana* (Verona, 1955), 'Il Museum Veronese'. The archaeological museum in Venice was founded in the sixteenth century by the Grimani family; but of the original bequest of 1523 only five pieces can now be identified with any certainty. See B. F. Tamaro, *Il Museo Archeologico del Palazzo Reale di Venezia* (Rome, 1969). The archaeological collection at Mantua was brought together in the late eighteenth century. It chiefly comprised whatever still survived in the outlying possessions formerly of the Gonzaga, especially at Sabbioneta. Much of that was probably assembled by the first duke of Sabbioneta, Vespasiano Gonzaga (1531-91), but the Sabbioneta Archive was destroyed in 1831 and nothing is known in detail about the collections in the sixteenth century. See A. Levi, *Sculture Greche e Romane del Palazzo Ducale di Mantova* (Rome, 1931).

[2] See E. Nash, *Pictorial Dictionary of Ancient Rome* (London, 1961).

[3] E. Nash, *ut sup.*

[4] R. Brilliant, *Memoirs of the American Academy at Rome*, XXIX, 1967, 'The Arch of Septimius Severus'.

[5] K. Lehmann-Hartleben, *Die Trajanssäule* (Berlin and Leipzig, 1926).

[6] C. Caprino and others, *La Colonna di Marco Aurelio* (Rome, 1955).

[7] I. S. Ryberg, *The Panel Reliefs of Marcus Aurelius* (New York, 1967).

[8] H. Stuart Jones, *The Sculptures of the Palazzo dei Conservatori* (Oxford, 1926).

[9] J. W. Crous, *Mitteilungen des Deutschen Archäologischen Instituts, Römische Abteilung*, Vol. XLVIII (1933), p. 1 ff., 'Florentiner Waffenpfeiler und Armilustrium'.

[10] See E. Nash, *op. cit.* They were moved to the Capitol in 1590.

[11] This was also the conclusion of R. Eisler, *Monatsberichte über Kunst und Kunstwissenschaft*, III (1903), p. 159, 'Mantegnas frühe Werke und die römische Antike'. Eisler thought (p. 163) that the most important figurative sources in the neighbourhood of Padua were likely to be coins; and (p. 168) that the *Triumphs* were almost unthinkable without a knowledge of the material in Rome.

ogists. Drawings by artists, although frequently of high quality, seldom convey the sort of precise detailed information necessary for the *Triumphs* (or indeed for the Eremitani frescoes).[1] Drawings by archaeologists seldom convey any information of a detailed nature at all, apart from the inscription, which is usually the *raison d'être* for the drawing.[2] The archaeologists on the whole liked ruins and stones with writing on them; the artists liked nudes and draped figures. There is very little surviving graphic evidence from before *c.* 1470 of people making detailed records of the more formal examples of official Roman imperial art.

Substantial evidence of this sort emerges only later in the century, and it derived from Florence. The *Codex Escurialensis*[3] and the *Codex Barberini*[4] together reveal something of the turn of events there from *c.* 1470 onwards. Interestingly, these books provide two types of visual record. There are precise drawings of objects such as reliefs, suitable for passing on to the uninformed a 'close-up' view of classical antiquity,[5] but there are also some striking 'views' of Rome, giving a romantic impression of the city with its decaying monuments. In these books, the skill and imagination of the artist at last join forces with the interests of the academic.

These twin types of observation are so strikingly similar to Mantegna's own artistic vision (as, for instance, in the Louvre *St Sebastian, no. 145*) that it is hard to avoid the conclusion that he himself had accumulated drawings and records of a similar sort. A detailed knowledge of sculpture in Rome seems to be clear by the time of the *Triumphs*, but when and how it was acquired remains uncertain. Mantegna was not alone in his studies of Roman military costume. The earliest archaeologically convincing essays of this sort seem to appear in Filarete's Vatican bronze doors (*no. 129*).[6] A number of brilliant reliefs of trophies of arms surround a series of doorways in the Ducal palace at Urbino—reliefs which seem to be worked up from a knowledge of the S. Sabina reliefs now in the Uffizi.[7] Also notable are the

[1] Much of this material was brought together by B. Degenhart and A. Schmitt in *Münchner Jahrbuch der bildenden Kunst*, 3rd ser., Vol. XI, 1960, p. 59 ff.: 'Gentile da Fabriano in Rom und die Anfänge des Antikenstudiums'. Recently, Clifford M. Brown has published a letter of 1476 showing that Lodovico Gonzaga had precisely such a book of drawings containing details from *certe sculture antiche, le quale la piú parte sono bataglie di centauri, di fauni e di satiri, cosi ancora d'uomini et di femine accavallo et appié, et altre cose simili.* See *Mitteilungen des kunsthistorischen Instituts in Florenz*, XVII (1973), pp. 158–9.

[2] On this subject, see R. Weiss, *op. cit.*, passim. The most important figure is Cyriacus of Ancona. On the diffusion of his epigraphic collections, see Charles Mitchell, *Proceedings of the British Academy*, Vol. XLVII, p. 197, 'Felice Feliciano Antiquarius'. Also more generally Charles Mitchell in *Italian Renaissance Studies*, ed. E. F. Jacob (London, 1960), p. 455 ff., 'Archaeology and Romance in Renaissance Italy'. Since the manuscripts of Cyriacus appear to have been almost if not entirely destroyed, any assessment of his skill and interests as a draughtsman has to be made from the copies. From the available illustrations, he seems to have drawn indifferently ruins and monuments, with their inscriptions. He never appears to have indulged in drawing figure sculpture for its own sake. Indeed, it may be doubted whether he would have had the skill to do so. It is true that some of the derivatives contain some fine work, notably that in the possession of Professor Ashmole (see B. Ashmole, *Proceedings of the British Academy*, Vol.

XLV, p. 25 ff., 'Cyriac of Ancona'). This, however, was compiled late in the century (by Bartholomaeus Fontius, *c.* 1490. See F. Saxl, *Journal of the Warburg and Courtauld Institutes*, Vol. IV (1941), p. 19 ff., 'The Classical Inscription in Renaissance Art and Politics'); and it is so far superior to the earlier derivatives emanating from the circle of Feliciano that one cannot help suspecting that Cyriacus' originals have in some way been improved.

[3] H. Egger, *Codex Escurialensis: ein Skizzenbuch aus der Werkstatt Domenico Ghirlandaios* (Vienna, 1906).

[4] C. Huelsen, *Il Libro di Giuliano da Sangallo* (Leipzig, 1910).

[5] The Codex Escurialensis contains copies both of one of the Marcus Aurelius reliefs and also of one of the S Sabina weapon trophy reliefs (*no. 153*).

[6] See M. Lazzaroni and A. Muños, *Filarete Scultore e Architetto del Secolo XV* (Rome, 1908), for illustrations and a description: also C. Seymour, *Arte Lombarda*, 38/39 (1973), p. 36, 'Some reflections on Filarete's use of antique visual sources'. The doors are signed and dated 1445.

[7] The archaeology of the palace has not yet been clarified but the three so-called Portals of War (attached to the *Sala del Iole*, the *Sala delle Veglie* and the Reception Room in the Duchess's Suite) probably date from the 1470s. The designs have been ascribed to Francesco di Giorgio. See P. Rotondi, *The Ducal Palace of Urbino* (London, 1969), *passim*.

arms trophies carved on the *Scala dei Giganti* of the Ducal Palace, Venice.[1] It is not impossible, therefore, that Mantegna too, at an earlier date had a set of detailed studies which ultimately would have provided the knowledge underlying the imaginative inspiration which he poured into the *Triumphs*.[2] What he needed to know was the possibility of embellishment in a military procession. This meant investigating the full range of such things as helmet design, the way in which arms trophies were constructed, the sort of siege equipment used by Roman armies or the sort of standards that soldiers might carry above their heads. The appearance of these studies is now a matter of speculation;[3] and sometimes the painted result of all this is either odd or nonsensical.[4] But mostly it is splendid and painted with a marvellously concentrated intensity which still survives in spite of the unhappy history of the paintings.

It remains to discuss the extent to which Mantegna was dependent on antique sources for the poses in which he placed his figures. Much is usually made of this type of imitation in the study of Renaissance art; and there are moments in the development of the study of the human figure when, it must be admitted, the examples provided by and in the sculpture of the classical world seem to have a special importance. It would seem, for instance, very difficult to imagine the creation of some of the figure compositions of Antonio Pollaiuolo without that artist's direct recourse to the antique. Similarly the mythological paintings on the ceiling of Mantegna's *Camera degli Sposi* may also be seen to have a reasonably close and obvious derivation from the antique. But before proceeding further, it is necessary to pause in order to ask what it was that the antique sculptors had to offer the Renaissance artists. Apart from the *apparatus* of Roman pomp and circumstance already described, the sculptors offered a number of well-defined lessons in the manipulation of the human figure. That Mantegna learnt these lessons can scarcely be doubted since, throughout the *Triumphs*, the spectator is constantly reminded of this artistic background. One has only to look, for

[1] This was built soon after 1485. See M. Muraro in *De Artibus Opuscula XL: Essays in Honor of Erwin Panofsky*, ed. Millard Meiss (New York, 1961), 'La Scala senza Giganti'.

[2] K. Clark (*Journal of the Royal Society of Arts*, Vol. 106, 1957–8, p. 663, 'Andrea Mantegna', also concluded that Mantegna had some knowledge of Roman monuments early in his career, suggesting that he might have had access to note-books belonging to Donatello. It is also conceivable that Alberti possessed note-books of Roman material which would have been available to Mantegna. This is all very speculative. Nevertheless a very few drawings of the required character (and almost of the required skill) survive from the middle years of the century. They were noted by Degenhart and Schmitt, *op. cit*. One (*ibid.*, p. 126), ascribed by the authors to Pisanello, is of one of the Marcus Aurelius reliefs. Another (*ibid.*, p. 127), copying part of the great Trajanic frieze on the arch of Constantine and coming from the Ambrosiana sketch-book, is dated by the authors to soon after the middle of the century. A third from the same source (*ibid.*, p. 128) copies another of the Marcus Aurelius reliefs. See also S. A. Strong, *Papers of the British School at Rome*, Vol. VI (1913), p. 174, 'Six drawings from the Column of Trajan with the date 1467'. These, now in the collection of the Duke of Devonshire, are of mediocre quality but the observation of detail is good.

[3] Some indication may be derived from the Berlin Sketchbook (see p. 149). A drawing survives in the Albertina, Vienna, which has recently been re-attributed (convincingly) to Mantegna, and seems to be a sole survival from the artist's sketches after the antique (*nos. 139, 140*). It shows on the *recto* a part of the Trajanic frieze on the Arch of Constantine; and on the *verso* a sculpture of a seated female. The *verso* is inscribed *aroma* and one inference is that it may be a sketch made by Mantegna while he was in Rome between 1488 and 1490. From the style of the figure drawing, this seems plausible. The *aquilifer* on the left has all the energy, weight and force of the figure style of the *Triumphs* and there is no difficulty in believing this to be a drawing done in the same term of years. The drawing is published in W. Koschatzky, Konrad Oberhuber and Eckhart Knab, *Italian Drawings in the Albertina* (Greenwich, Connecticut, 1971), No. 16. The Albertina inventory number is 2583.

[4] The oddness of some of the features is to some extent masked by the conviction with which they are painted. As mentioned on p. 139, the use of much of Mantegna's 'siege equipment' seems to me to be entirely obscure. The elephants nonchalantly lumbering along and balancing huge candlesticks on their backs are quite remarkable. Further, the suicidal nature of some of the cuirasses carried in the sixth canvas is worth noting. Finally, a glance at the eighth canvas will reveal that Mantegna was not clear how bagpipes worked.

instance, at the opening scenes from the frieze of the column of Trajan, or the Aurelian reliefs on the Arch of Constantine to find many figure poses which are similar to those used by Mantegna. It is very difficult to believe, however, that Mantegna, a mature experienced artist of perhaps fifty years of age, would need continuous recourse to this type of assistance. Indeed, the absence of precise copies of figures and figure poses in the *Triumphs* suggests that this was not the case. Mantegna may have learnt many general principles of figure construction from antique reliefs; but it is arguable that he was using his imagination to manipulate them.

It is, in fact, possible to imagine only one reason for a mature and brilliant artist to introduce direct 'quotations' of this sort from the antique into a painting. There is, unfortunately, no explicit fifteenth-century evidence to support the hypothesis and it involves assumptions about the 'audience' for which these works were intended. Nevertheless, it is possible that classical allusions were introduced, rather like literary quotations, simply in order to be recognized by the *cognoscenti*. Presumably this was the reason for the disguised *spinario* figure in Brunelleschi's trial bronze relief. Allusions of this sort create harmless intellectual riddles which testify to the erudition of all concerned. The rules of the game demand that the spectators search for figures in a given composition which stand out as being in some sense abnormal or unsuited to the purpose in hand. For instance, nothing in the Old Testament suggests that one of Abraham's servants spent a protracted period of time looking at the sole of his foot; and this slightly bizarre quality helps one to recognize the Brunelleschi figure for what it is. The majority of Mantegna's figures in the *Triumphs* merely walk from one side of the picture to the other and bear only a generalized relation to the types of relief mentioned above. But there are four rather elaborate figures which perhaps deserve closer attention, namely the two youths standing or kneeling on the backs of the elephants (Canvas V, *no. 30*), the trophy bearer who rests his load on the ground (Canvas VI, *no. 34*) and the standard bearer who twists in a spiralling movement in front of Caesar's chariot (Canvas IX, *no. 42*). It has indeed been suggested by one scholar that this last figure is really a bow-stretching Eros in disguise (cf. *no. 206*). Perhaps other classical prototypes will be discovered for the other figures.[1] It is, however, necessary to point out that, for three of the figures, there exists earlier versions in the Mantegnesque drawings for the *Triumphs* in Paris and London (*nos. 52, 54*). From these drawings it will be seen that the final strongly three-dimensional character of the figures evolved out of something originally flatter and less arresting. The possibility still remains, therefore, that the final emphatic character of these figures is the product of Mantegna's imagination. For, from whatever sources Mantegna was drawing ideas, it was in the end his imaginative transformation of this material that mattered. Confronted by the paintings, the spectator may be excused for thinking that the busy burrowing of scholars attempting to uncover classical prototypes is an irrelevance. There is much to be said for this view and it is with some misgiving that this book extends the warren of investigation a little further. The exercise completed, however, much remains unexplained. Some of these gaps will certainly be filled

[1] Professor John Shearman has drawn my attention to the fact that in the seventh canvas ('The Captives') the woman bending down to attend to a child bears a reasonably close resemblance to a similar figure in Botticelli's fresco in the Sistine Chapel of 'Moses in Egypt and Midian'. This is an interesting observation and would tend to support the view here put forward that the 'Captives' composition postdates Mantegna's visit to Rome.

by others;[1] but what is inexplicable in terms of archaeology is likely to have been the result of inspired invention. Thus many of the links in the chain of creation will probably remain for ever obscure.

[1] After the bulk of this book had been written, Mr Michael Vickers published an article in the *Burlington Magazine*, CXVIII (1976), p. 824, called 'The "Palazzo Santacroce Sketchbook": a new source for Andrea Mantegna's "Triumphs of Caesar", "Bacchanals" and "Battle of the Sea Gods".' The essay concerns the reliefs from the so-called 'altar of Domitius Ahenobartus', formerly in the Palazzo Santacroce, Rome, and now divided between the Glyptothek, Munich and the Louvre, Paris; and the author maintains that Mantegna was heavily indebted to those reliefs in devising both the general plan, and the detail of the *Triumphs of Caesar*. Since many of the 'direct quotations' and 'discernible echoes' which 'permeate the series of panels so deeply' must, according to Mr Vickers, have already been present in Mantegna's creative consciousness at the start of work on the *Triumphs* and hence before the visit to Rome in 1488, the author postulates the existence of what he terms a *Palazzo Santacroce Sketchbook* in order to account for his observed relationships between the two sets of images.

I cannot find myself in agreement with Mr Vickers on the significance of these reliefs. The points raised by him seem to me to veer rather uneasily between style and iconography so that I find it difficult to grasp the character of the supposed fascination of these reliefs for Mantegna. I also find the quality of the *census* portion disappointing and hence unsatisfactory as a stylistic source. There is, however, a much more serious objection to his argument. The reliefs were apparently unknown to any (other) scholar or artist before the mid-seventeenth century. The reason becomes clear in an article written recently by F. Coarelli in *Dialoghi di Archeologia*, II (1968), p. 358, ' "L'Ara di Domizio Enobarto" e la cultura artistica in Roma nel II secolo a.C.' (as Mr Vickers acknowledges, the article only became known to him after his work had gone to press). The reliefs almost certainly reached the Palazzo Santacroce in 1639–40 from the excavations for the adjacent church of S. Salvatore in Campo. At this period, a large number of pieces of carved marble was dug out, since the church was on a part of the site of a classical temple—probably of Neptune. The accounts survive for this building and the references to the circumstances in which the *marmi* were found seem explicit, the operative words being *fondamenti* and *cantine* (a house had to be demolished to make way for the church). This evidence suggests therefore, that the reliefs under discussion were underground before 1639. Mr Vickers suggests that between *c.* 1490 and 1639 the reliefs were 'invisible' because they had had houses built over them during the intervening dates. With those who remain unconvinced by his detailed observations, this argument is unlikely to find favour. The sixteenth-century plans and *vues cavalières* of Rome (see A. P. Frutaz, *Le Piante di Roma*, Rome, 1962, *passim*) make it clear that the area was indeed occupied throughout that period by houses. Being near the centre of the ancient and medieval city, there is no reason to think that this was not the case at all relevant dates; and the supposition that they were visible to fifteenth-century antiquarians (but what other antiquarians?) yet underground and invisible to sixteenth-century antiquarians seems to me to be questionable.

6 · The Evolution of the *Triumphs* and Mantegna's Style

T HE PROBLEM OF TRANSLATING this accumulated knowledge into an artistically satisfactory scheme was a formidable one. To fill a long row of sizable canvases with a line of people set above eye level and processing in somewhat specialized fancy-dress presents difficulties which it requires little imagination to appreciate. The main danger is monotony. A certain amount of variety can be introduced into the costume and stage-properties; but this will not reduce various severe disadvantages. Little variety can be expected from the background or landscape since, given the low viewpoint, this will not easily be visible. Further, the amount of variety to be derived from facial types and changes of expression will be limited since, given the low viewpoint, it will be difficult to see beyond the figures in the front rank. Lastly, the nearest thing to the spectator will be an immense forest of legs.[1] It is of some interest to examine how Mantegna dealt with these problems; but it is first necessary to relate the style of the *Triumphs* to his previous work.

Remarks about the evolution of the composition of these great paintings are complicated by the absence of firm points of reference during the preceding years. There are no dated works between the time of the inscription in the *Camera degli Sposi* (1474) and the first mention of the Hampton Court paintings (1486). Consequently, it is the *Camera* that must form the point of departure.

The *Camera degli Sposi*, in spite of its individual qualities, is not an isolated type of decorative scheme. The general subject matter, with members of the ruling family seen in informal circumstances, found a parallel on a much more extensive scale at Pavia.[2] There, however, the court painter was Bonifacio Bembo whose works, now unfortunately destroyed, would have had little in common stylistically with those of Mantegna. In style, the *Camera* would have been closer to rooms painted earlier in the *Castello* at Ferrara by Piero della Francesca.[3] Indeed, the narrative style of the *Camera* has much in common with the surviving work of Piero. The solidity and apparent immobility of the figures, and the way that the action has almost congealed are peculiarities not merely of Mantegna's style at that time but also of a pictorial fashion of the period (*nos. 134, 135*).[4] With Mantegna's figures, the most impressive parts are probably the faces; one can appreciate Mantegna's strength as a portrait painter. On the other hand, the bodies as a whole leave something to be desired. The gestures are stiff and lack spontaneity; and the stockinged legs only prove, almost prophetically, how difficult it is to do anything with legs when they are brought so obviously into the spectator's line of vision.

[1] Some of these problems had already been faced in the Eremitani frescoes. See Kristeller's remarks, (G), p. 105. A good contrast is to be found in the near-contemporary wall paintings of the Sistine Chapel. These, by virtue of their high viewpoint and subject-matter have a variety of setting and action quite beyond the bounds of possibility for Mantegna.

[2] See C. Baroni and S. Samek Ludovici, *La Pittura Lombarda del Quattrocento* (Florence, 1952), p. 109 ff. for the castle decorations at Pavia. They were executed in 1469.

[3] See Vasari-Milanesi, Vol. II, p. 491.

[4] Unfortunately Piero's Ferrarese frescoes too have been destroyed and there are no accounts at all of their subject-matter. The Dukes of Ferrara also possessed two country villas decorated extensively with scenes of secular court life —especially of hunting. Those at the now vanished villa of Belfiore seem to have dated from the late fourteenth century and underline the fact that Mantegna was contributing in a highly individual way to a well established iconographical tradition. On the Ferrarese villas, see W. L. Gundersheimer, *Art and Life at the Court of Ercole I d'Este: the 'De Triumphis religionis' of Giovanni Sabadino degli Arienti* (Geneva, 1972).

The *Triumphs of Caesar* are comparable in scale to the main scenes in the *Camera*, only a little smaller. However, in most other respects, they offer contrasts rather than comparisons. Of course, the subject matter is very different but this in itself cannot account for the dramatic change of style. The rigid control has gone, to be replaced by a far more impressive and masterly handling of the figure relationships and figure structure. The actors turn and twist and respond to each other by glance and gesture with a grace and ease foreign to the actors in the *Camera*.

At least, this is true of the main figures in the *Camera*. But one of its interesting features is that there are within it two styles of figure-painting—the staid monumental 'official' style of the main scenes; and a more lively style, suggested by the *putti*, but to be seen chiefly in the segments of the vault (*nos. 136–8*). There, small scenes of classical mythology are acted out by vigorous, mobile little figures who communicate by gesture and grimace in a manner very different from the staid courtliness of the scenes below. Looking ahead to the *Triumphs*, it is the genesis and development of this figure style that should perhaps be explored.[1]

These ceiling decorations are, of course, consciously classical, the style matching the subject matter. They also surround the painted busts of Roman emperors. The idea of decorating architecture with scenes resembling reliefs was not new in Mantegna's work; such features, painted in a classicizing style, are found in the S. Zeno altar and in the Uffizi triptych. Yet the Mantuan reliefs are different. The physique of the nude figures is rather heavier; also, the figures are larger in scale, occupying a greater proportion of the total 'relief' field. The overall impression is of a greater interest here in presenting strongly modelled figures as the main focus of the spectator's attention.

Bearing in mind Mantegna's documented presence in Tuscany in 1466 and 1467, one cannot help being struck by certain interesting comparisons in the work of Antonio Pollaiuolo. The relationship will probably remain difficult to elucidate since the two artists were almost exactly contemporary and there is no means of knowing at what stage each became aware of the other's work. But their careers seem to overlap in various rather disparate ways; both completed series of compositions including the activities of Hercules, while the figures in the lunettes of the *Camera* mostly adopt poses which are either strongly reminiscent of the work of Antonio or are actually to be found there. The *Women of Thrace* wielding a club and *Hercules* firing an arrow (*no. 136*), both in the *Camera*, adopt poses found also in Pollaiuolo's famous engraved *Battle of Nude Men*. Both artists produced versions of *Hercules and Antaeus* (*no. 137*), Mantegna in this instance being closer to the known antique prototype.[2] Compositions from both artists exist displaying nude figures against a dark ground. But more especially, both developed an expressive, graceful and *mouvementé* figure style based probably on an intelligent reappraisal of particular sorts of sarcophagus relief. It would seem to be in this way that Mantegna came to appreciate better how to set the human figure in motion.[3]

[1] The actual execution of parts of the vault may, of course, have been entrusted to assistants.

[2] The subject is discussed by A. Mezzetti, *Bollettino d'Arte*, Series IV, XLIII (1958), p. 232, 'Un Ercole e Anteo del Mantegna'.

[3] Mantegna's acquaintance with the work of Antonio

Pollaiuolo may have begun before the late 1460s, bearing in mind the *cartone* said to have been in the possession of Squarcione. All that is known about this, however, is that it was in Squarcione's studio in 1474. There is no indication when it was acquired. See A. Sabbatini, *Antonio e Piero del Pollaiuolo* (Florence, 1944), p. 70.

Nevertheless, the step from the *Camera degli Sposi* to the *Triumphs* remains a considerable one. Mantegna's achievement was to galvanize figures on a scale similar to those of the Gonzaga family groups into the activity suggested by the small mythological figures on the ceiling, for the figures in the *Triumphs* are not merely vigorous and active; they are also massive and imposing. There seems to be a strong likelihood that the change was assisted by some sort of reappraisal of Donatello's art. Mantegna had, of course, been acquainted with Donatello's work since adolescence and the facets of the sculptor's style which then interested him are well known. On the whole it would seem that the passion and violence of Donatello's work left him to a large extent unaffected during those early years, even though the predella scenes of the S. Zeno altar contain various formal devices suggestive of the sculptor's influence. However, simply as story-tellers the two artists were at that time worlds apart. How far the final form of the *Triumphs* was influenced or stimulated by Donatello's work it is probably impossible to say, although one might well expect the greatest impresario of the early Renaissance to have left his mark on one of the most power-ful and imposing pictorial schemes of the fifteenth century. It is of some interest that the sculptor provided a curious but interesting prototype for the scheme of the *Triumphs*. In Mantegna's work, the pictorial composition is imagined as a single event, a procession of figures marching across the spectator's line of vision. The breaks between the canvases were contrived to appear as no more than incidental interruptions, probably of pillars or other obstacles set in front of the procession and behind which the figures temporarily disappear from view. Donatello had produced very much the same effect in the *Cantoria* executed for the Duomo, Florence. There a procession of dancing *putti* passes along the front of the gallery, behind a row of free-standing colonettes which support the cornice above. The parallel in time, place and subject matter is a distant one. But Donatello's *Cantoria* is the closest surviving precursor for the dramatic scheme of the *Triumphs*. At least, this adds force to the suggestion that, in the uncharted gap in Mantegna's career after 1474 the influence of Donatello was a continuous one.

The steps by which the scheme of the *Triumphs of Caesar* reached its final form are hard to trace. No technical variations can be detected within the paintings which might suggest a possible order of work;[1] and, with perhaps one exception, no autograph drawings survive. Yet, remarkable as it may seem, the *Triumphs* were painted with virtually no important *pentimenti*. Such a feat would not have been possible without complete preparation before-hand, which must have involved both *modelli* for the individual scenes and studies for their parts. It is just possible that some of this preparatory work survived into the sixteenth century. For, in the 1567–9 inventory of the Vendramin collection in Venice, there appears the following item '*Un altro libro longo grando coverto di cuorro rosso de 37 carte computado li Trionfi de Mantegna dissegnade a man*'.[2] However, this entry is not clear in its meaning and, alas, the book itself has long since disappeared.

No detailed studies survive which can be related to individual parts of the *Triumphs*, but a number of drawings and engravings are known which, at first sight, appear to be con-nected with individual canvases. However, on closer inspection their exact status may well

[1] This is true of what survives; but there are considerable areas and one whole canvas where Mantegna's painting has virtually vanished.

[2] See A. Rava, *Nuovo Archivio Veneto*, N.S. 39 (1920), p. 155, ' "Il Camerino delle Anticaglie" di Gabriele Vendramin'.

seem to defy definition. Their apparently haphazard survival, their slightly differing styles, and their varying quality and relationship to the paintings may all seem so bewildering as to be explicable only in terms of chance and the random operations of numerous Mantegnesque imitators. Yet it is possible to arrive at slightly more positive conclusions about their significance.

It was already suggested in the last century that the engravings at least might represent the remnants of a project of Mantegna to 'publish' the *Triumphs*.[1] An obvious argument against this is the uneven quality of the engravings—indeed it is now generally agreed that they were not executed under Mantegna's personal supervision. This view is given greater force by the existence in two cases of pen versions which are superior to the engravings in quality. But there are other reasons for refusing to accept the view that these engravings represent the debris of a project to publish the *Triumphs*; for it would surely be anachronistic to imagine a fifteenth-century artist using engraving for this purpose,[2] and in any case, the engravings seem to be in slightly different styles.[3]

It is more fruitful to discard the theory of abortive publication, and to look at the graphic material relevant to the *Triumphs* as a whole, which consists of three engravings and seven drawings.[4] Apart from the composition known as the 'Senators' each can be directly related to a specific canvas. This is an important point and needs emphasis, for one is not dealing with a group of imitative works generally inspired by the *Triumphs*. With one possible exception, it is true, one is faced by the work of copyists; and in particular its relative approximation to the quality of Mantegna's drawing is a matter for debate. But the Mantegna originals from which these compositions were copied were, in all likelihood, studies for different sections of the painted series.

This interpretation, which seems now to be accepted by most scholars,[5] receives support from a hitherto unremarked fact: all the drawings and engravings are virtually identical in size: 26–27 cm. square.[6] Coincidence on this scale can be ruled out. The reason for this identity must be that there was a series of originals also virtually identical in size—which in its turn poses an interesting problem about Mantegna's working methods. The most plausible explanation is that Mantegna probably had in his studio some sort of 'mock-up' of the architectural elevation into which his canvases were eventually going to be fitted. This would have resulted in the production of an unknowable number of relatively complete

[1] H. Thode, *Andrea Mantegna* (Bielefeld and Leipzig, 1897), p. 90 ff., dealing with the *Triumphs*, suggested that the scheme was planned under the Marchese Lodovico initially as a set of engravings, of which two survive (Hind, Nos. 14 and 15).

[2] No known instance of a fifteenth-century artist 'publishing' a work in this way occurs. K. Clark (*Journal of the Royal Society of Arts*, 106, 1957–8, p. 663, 'Andrea Mantegna') suggested that Mantegna's engravings all seem to reproduce motifs which he executed in other materials. In terms of general subject-matter, this may be true; but none of the seven best engravings reproduces compositions or parts of compositions to be found elsewhere in his surviving painting.

[3] These differences relate to the structure of the figures, the organization of the procession and the conception of the setting.

[4] For detailed examination of the drawings and engravings, see the Catalogue, p. 163. In general it should here be noted that several instances survive in which a pen drawing repeats the composition of an engraving. In some cases the results are indifferent and the copyist may well have been working from the engraving. In three instances, however, the results are appreciably better than the engraving, in that the drawings possess a subtlety of lighting and texture not found in the engravings. They cannot be derived from the engravings but must depend directly on the common prototype by Mantegna. Where relevant they are used in this study for comparison and discussion in preference to the engravings. They are at present in Dublin (*no. 57*), Paris (*no. 52*) and Vienna (*no. 56*) and, together with other drawings at Vienna, London, Paris and Chantilly, bring the number of relevant drawings to seven.

[5] For instance, by E. Tietze-Conrat, *Mantegna* (London, 1955), p. 244, cat. No. (14) on the subject of the composition of the 'Soldiers carrying Trophies'.

[6] The following table gives the various measurements in centimeters.

studies, of necessity similar in size, which were then fitted into the model to give an impression of the final effect. Presumably this would have been as much for the Marchese's enlightenment as Mantegna's.

Writers on Mantegna have been struck by the random character of the survival of these drawings and engravings.[1] Some canvases (II, IV and VIII) have no associated drawings or engravings; four have only a single associated drawing; two have both a drawing and an engraving. The 'Senators' exists in both drawn and engraved form, but not as a painting. This conjures up a picture of a portfolio from Mantegna's studio containing an indefinite number of essays in triumphal scenes, to which followers and others had irregular and perhaps illicit access. Some of the copying was no doubt done for practice. Some was done with the aim of isolated publication—perhaps, again, illicit. Whatever the truth, it is an irony of history that throughout the sixteenth century, Mantegna's *Triumphs of Caesar* were probably better known through these indifferent and partial engravings than through the completed paintings at Mantua.[2]

It is of some interest that these surviving drawings, and engravings, fall into distinct groups. The first and seemingly earliest group consists of the Vienna 'Trophy Bearers' (see Catalogue, p. 164), the Paris 'Elephants' (see Catalogue, p. 164) and the Louvre and British Museum versions of the first and ninth canvases (see Catalogue, p. 163 and p. 164; *nos. 51, 54*). Certain common characteristics emerge, some of which are best explained in terms of the problems mentioned at the start of this chapter. The problem of what to do with the legs is amply demonstrated by these studies. Not merely are there a great many legs, but there are also signs of the difficulties to be solved in convincingly uniting a pattern of legs with a pattern of torsos above. Of course, patterns of legs have good classical precedents, and it is not hard for instance to find parallels for the decorative effect produced by the horses in the British Museum drawing (e.g. on the Arch of Titus, *no. 175*). However, it is surely relevant that, contrary to all classical precedents, the number of horses harnessed to the chariot was here finally reduced from four to two;[3] and in general the number of visible legs was considerably diminished.

ENGRAVINGS	H.	W.	REMARKS
Elephants (Hind 14)	27	26	Height exaggerated by presence of blank area along upper margin.
Trophies (Hind 15)	26	25.4	
Senators (Hind 16)	27	26.2	
DRAWINGS	H.	W.	
British Museum 'Triumphal Chariot'	26.2	27.3	
Vienna 'Trophies'	26	26.1	
Dublin 'Trophies'	26	26	
Louvre 'Trumpets'	26.5	26	
Chantilly 'Captives'	27	27	This represents the approximate measurements of the picture area. But the borders are slightly uneven.
Vienna 'Senators'	25	26.8	The height has been cut down—compare the engravings of the same subject.
Paris 'Elephants'	25.1	26	

[1] See A. M. Hind's remarks in *Early Italian Engraving* (London, 1948), Vol. V, p. 22 ff., in discussing the engravings.

[2] The activity of these copyists could obviously have gone on for as long as the originals were available. The 'Senators' engraving provided figures for a *cassone* panel by Liberale da Verona (*no. 124*, now in the National Gallery, London). This is undocumented but has been placed in the late 1490s (see Martin Davies, *The National Gallery. The Early Italian Schools*, London, p. 283): it thus provides a *terminus ante quem* for the engraving. The only dated copy—also of the 'Senators' and of 1517—is a drawing at Haarlem (see Catalogue, p. 167). But in this, the procession moves from left to right, and it must therefore derive from the engraving. For the possible role of Giulio Campagnola, see below, pp. 98-9.

[3] Most writers, classical and fifteenth-century, would have agreed that this was wrong. Valturio, in particular, several times mentioned the presence of four horses.

79

The second problem is hardly tackled at all, since little attempt is made to characterize or to give variety to the faces. Indeed, it is probably true to say that these drawings are not addressed to this problem. By contrast, however, they lay considerable emphasis on the 'stage-properties' appearing in each canvas. It is clear that the general lay-out of the canvases had been foreseen by the time of these drawings, so that the genesis of the relevant final composition is easily recognizable. What had not been satisfactorily settled was the degree of depth to be suggested within the procession itself; and the extent to which the background should be developed.

On these points, the British Museum drawing, being unfinished, is uninformative; but it is remarkable that the other compositions possess virtually no suggested depth at all, although in its final (painted) version, the Vienna composition received least modification. However, the design represented by the Louvre composition was modified by a rearrangement of the painted banners, which gave greater apparent depth to the procession itself; and an even greater change overtook the composition of the 'Elephants', into which an entire landscape was introduced.

This analysis of the studies seems to throw some light on Mantegna's early thoughts on the subject of Caesar's triumphal procession. Whereas the archaeology of the scheme and its academic side did not later alter very much, the composition of each scene was originally conceived in far flatter terms. The studies suggest that the original 'stage' was relatively shallow; and that the problem of filling the upper parts of the canvas was solved initially by the introduction of objects, in greater or lesser density, raised aloft above the heads of the figures.

A further distinctive feature of this first group of drawings is the figure style, which can best be described as small in scale and restrained in action. Perhaps something more robust is suggested in the Louvre drawing, but the youth holding the ox in the 'Elephants' composition is a restrained shadow of his final self; and the standard-bearers in the other studies have a slender curving elegance which is, in the main, avoided in the paintings. The scale and build of these figures are also different from those of the final paintings. Little emphasis is given to the heads, which are rather small. The shoulders, too, tend to be narrow and the muscles of the arms and legs underdeveloped, although the heights of the figures relative to the whole canvas are much the same as in the paintings. All this suggests, that when confronted by the task of constructing a procession of energetic, moving figures, Mantegna first approached it *via* the small-scale Pollaiuolo-like style of the ceiling of the *Camera degli Sposi* and not the static monumental Piero-like style of the walls.

The existence of this graceful small-scale style is traceable elsewhere in Mantegna's work. The Mars and Venus figures of the *Parnassus (no. 141)*, or the detail of the 'Fall' in the *Madonna della Vittoria (no. 146)* both offer a figure style very close to the 'early' studies of the *Triumphs*. Mantegna seems, in a sense, to have possessed different figure styles for different tasks.[1] What appears to have happened with the *Triumphs* is that they were initially thought out in a style somewhat unsuited to heroic large-scale work, because at that point it was the natural way for Mantegna to achieve the vigour and movement required by the subject-matter.

[1] There is, for instance, a considerable contrast between the style of the *Parnassus* and the style of the altar for S. Maria in Organo, although both were probably being painted in 1497.

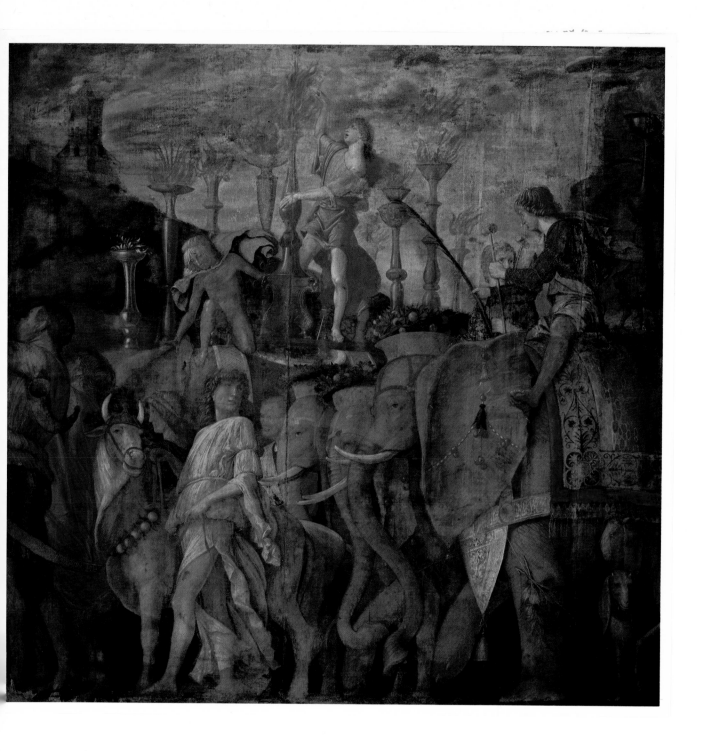

Canvas V: Trumpeters, Oxen with Attendants, Elephants

The change of figure-style is one of the things documented by the second group of drawings (*nos. 57, 55, 56*), those in Dublin, Chantilly and Vienna (see also Catalogue, pp. 165–6). The development is sufficiently obvious and hardly needs comment. The heads are larger and the faces more varied in type; the bodies have a heavier build and the muscles are more obviously developed. Moreover, the Dublin study displays a further interesting development away from the conception of the procession as a rather closely packed façade of figures and objects. This is the impression created by the Louvre and Vienna drawings already mentioned, and even by the eighth and ninth canvases as they were eventually painted. In the Dublin study, and in most of the paintings, the impression given is of a series of well-defined and carefully selected shapes which stand clearly distinct from the main mass. Significant gaps are opened between these shapes, leading the eye back into the thickness of the procession. The Dublin composition is dominated by four large figures set in the foreground and flanked by shallow but well-marked spaces. In the second canvas, a young man in the foreground seizes a horsebridle while to the right an older man stalks forward carrying a large statue. The third canvas is dominated by the rather languid youth and the first of the booty-carriers—and so on. It is a case of fewer compositional points being made with greater force. At the same time, the number of legs is reduced. This is done partly by the simple expedient of building up the areas of shadow around these lower parts, and partly by the device of trailing drapery, which effectively masks the composition at the points required (as, for instance, between the stretcher-bearers in the third and sixth canvases).

A comparison of the Dublin drawing with the finished canvas reveals one area which in the drawing is hardly explored at all—that of human physiognomy. Mantegna's skill as a characterizer of faces is obvious from the *Camera degli Sposi*. The range of facial types is very considerable in the *Triumphs* (it is indeed unfortunate that these faces in particular attracted the attention of Laguerre in the seventeenth century). It might be expected that this type of detail would be considered late in the planning process; and the rather slender evidence of these drawings and engravings lends some support to this idea.

There are other points to be noticed about the Dublin study. It has no architectural background, although the figure composition is almost identical with that of the finished painting. Yet it is not a case of the background to the finished work merely being omitted —on the contrary, in the drawing the various trophies are arranged in such a way as to make a background setting unnecessary, for they are placed to form a succession of shapes rising towards the top right-hand corner. In the painting, they are slightly rearranged to admit the view of the so-called 'aqueduct' behind, and the diagonal movement is largely suggested by this 'aqueduct'. Altogether the Dublin drawing suggests that at a comparatively late stage in the development of the figure style and composition, the problem of the background had still not been settled. Mantegna was apparently still thinking of a series of canvases in which, perhaps, no background scenery was visible at all. This approach has already been noted in the study for the adjacent 'Elephants'.

Yet, of course, there is far more to the finished compositions than such simple contrasts as 'background' versus 'no background' and the pleasing juxtaposition of exotic shapes and decoration. It may seem unnecessary to insist on their subtlety but the *Triumphs of*

Caesar are still hard to appreciate. There is nothing mysterious about this difficulty. Nobody, given a book of this nature, will have difficulty in admiring the *Triumphs* as a series of individual paintings containing much marvellous detail. Merely turning over the pages of the plates will make this aspect of the *Triumphs* spring to life. But it demands a very determined effort of will and imagination to grasp the scheme of the *Triumphs* as a whole. Even in the presence of the originals this is still difficult because formidable practical problems have made it necessary to rehang the paintings in gilt frames. But the *Triumphs* need an architectural setting in order easily to be understood as a continuous composition. They lost this probably when they were moved from the Palace of S. Sebastiano back to the Ducal Palace in Mantua in the early seventeenth century; and certainly in England they seem, as far as is known, always to have been displayed detached in individual frames. They therefore lack—and have always lacked since they arrived at Hampton Court— surroundings which emphasize and bring out their horizontal continuity of shapes and ideas. Gilt frames can all too easily isolate what they surround, and in the Orangery today it takes a positive effort to comprehend the *Triumphs* in pairs, in groups of three, in groups of six.

Particularly for the first six paintings this exercise is rewarding (*no. 268*). The first three and a half paintings form a unified composition in which the main blocks of shapes are placed parallel to the picture surface. The foreground is marked out by a chain of brightly lit and gaily coloured people and animals so that the eye travels easily from the trumpeters, who head the procession, along the first three canvases and on into the fourth canvas, where the figure of the vase-bearer marks the first big *caesura* in the overall plan. In the first canvas, the stage is in a very literal sense set for what happens to the rear of this section by the pictorial banners. These four banners fan out to indicate a foreground of considerable depth, which is first filled by the city model and siege equipment of the second canvas; and then, after a small gap (through which one has a brief glimpse of a street façade beyond) by the captured arms trophies of the second and third canvases.

Once the visual character of the procession up to the Vase-bearer has been grasped as a whole, it will also be noticed that what follows is organized very differently. Instead of groups of people and objects moving parallel to the picture plane, Canvases IV, V and VI are characterized by groups of people, animals and objects set obliquely to this plane. This reorganization is hinted at in the figure of the boy with the sacrificial ox in Canvas IV; it emerges emphatically in the serried line of elephants in Canvas V, and in the stretcher-bearers and the 'aqueduct' of Canvas VI, while the elaborate cuirass held aloft in Canvas VI also contributes to this overall effect. These obliquely placed shapes are, of course, particularly effective when the spectator progresses along the procession from left to right.

It would be difficult to overstate the masterly planning of these six canvases. Even setting aside the vast interest of their iconographical detail, they possess such a store of visual richness that their fascination is wellnigh inexhaustible. It is therefore with a sense of anticipation that one turns to the three final canvases; and it is equally with a sense of surprise that one gets the distinct impression that something has gone wrong.

There are many curiosities about the final group of three canvases. The eighth canvas alone diverges seriously from the proper triumphal iconography. It shows standard-bearers

and soldiers turning back towards Caesar on his chariot. This provides an effective build-up towards the triumphal general in the ninth canvas and the idea is probably adapted from an *Adlocutio* scene. Nevertheless, it is iconographically wrong, since incense and crown-bearers ought to be shown here. It is also the case that in the composition of Canvases VII and VIII, lictors have been omitted.[1] By way of compensation, the last three canvases are symbolically richer than any other part of the series.[2]

It has already been noticed that Canvases VIII and IX are compositionally simple. Canvas VIII, already at a disadvantage by virtue of heavy repainting by Laguerre, is in its composition probably the least interesting of the whole set.[3] The 'line of figures in fancy-dress' approach is here at its most obvious and nine canvases painted according to these principles would have been a disaster. Most of the improvements suggested in the studies were aimed at getting away from such a solution. There is a strong possibility therefore that, whatever the precise date of its execution, the composition of Canvas VIII represents a survival from an early stratum of Mantegna's plans for the *Triumphs*. It is further possible that the same is true of the iconographic peculiarities of the last group as a whole. There may have been a time during the planning when the textual information seemed less important than ultimately seems to have been the case (at least in the other six canvases). Perhaps too much is uncertain to make it worth while carrying this line of speculation further (for a summary of the peculiarities of the final group see below, p. 129). However, the real peculiarity of the last group of paintings lies in the architectural background of the seventh canvas, the 'Captives'; and this is probably the best moment to examine the question of the settings and the problems and difficulties facing Mantegna in organizing a background for his long procession of figures.

The setting demanded by the subject-matter was the city of Rome. Mantegna, even before his visit to Rome in 1488, would have been quite capable of devising such a setting. He knew what the chief Roman monuments were; and he knew how to paint buildings of a convincing classical appearance. Yet the preceding survey has suggested that the very earliest designs excluded such a background, and the reason is not difficult to imagine. A unified architectural setting for a layout of such length would have produced virtually insuperable problems of viewpoint; but on the other hand isolated architectural settings for each canvas would have broken up the continuity of the procession by drawing the attention of the spectator to the centre and rear of the individual paintings.[4] There was in any case some difficulty in devising credible architectural settings, given the low viewpoint. Where the procession has any visible depth (as, for instance, in the fifth canvas) it will be clear that the ground tends to 'fall away' behind the picture plane. This means that

[1] There seems to be some doubt whether it was clearly known in the fifteenth century what lictors were. E. Tietze-Conrat (*Mantegna*, p. 184) suggested that the torch candelabra carried by the elephants in the fifth canvas were a misunderstanding of the *fasces* carried by lictors on the Arch of Titus. She pointed out that *fasces* were later misunderstood by Dosio, who turned them into smoking torches. However, it should be noted that anyone wanting to know about lictors had only to find the relevant passage in Flavio Biondo's *Roma Triumphans*. In Book III they are described as ministers who followed the magistrates carrying bundles of rods bound with iron. It seems un-

likely that Mantegna was ignorant on this point.

[2] See Appendix I on 'Mantegna, the *Triumphs*, Hieroglyphs and Symbolism'.

[3] Something of the lassitude of the 'early' studies seems to invade this canvas. The rather flaccid youth in the centre has the same limp quality as the youth in the centre of the 'Elephants' composition, as sketched out in the drawing.

[4] This is well illustrated by the Klagenfurt reliefs, already mentioned on pp. 46 and 53–4 (see *nos. 125, 126*). There the architecture is used to direct the attention to the centre, where the main action takes place.

background architecture, in order to play any significant part in the scene-setting, would have had to be of enormous and incredible height in order to reach the vacant upper parts of the canvas.

Mantegna's first six canvases in the procession display two solutions to this problem. The first group of three produces a scheme already suggested in the studies for them. The upper parts of the composition are filled with objects—trophies, banners and so on— which rise up towards the centre of the second canvas and then fall away again towards the right-hand edge of the third. One tiny concession to the notional *milieu* (the city of Rome) occurs in the second canvas. There, through a small rift between the siege equipment and the trophies of arms, can be seen a portion of a rather distant building with one spectator peering out. However, it is clear that the idea of a background panorama of antique architecture did not form part of Mantegna's thinking at this point.

The second group of canvases was probably originally sketched out in like manner (if this is the correct interpretation of the drawings), but in the paintings, Mantegna introduced a background panorama without abandoning the compositional principles of the first three canvases. Perhaps the threat of monotony forced him to reconsider the setting;[1] but for whatever reason, he introduced landscape and architectural features. In pattern, these rise and fall in a manner very similar to the weapons and other objects in the previous group. Their physical relationship to the procession is left unresolved. Especially in the sixth canvas it will be seen that the column and 'aqueduct', given the low viewpoint of the series, must either have an impossible height or be set on a convenient hill. In the context, however, this type of quibble is irrelevant. The landscape background in particular—fortunately extremely well preserved—is one of the most successful and beautiful parts of the cycle.[2]

With the third group of canvases a new development takes place. It is true that the settings of the eighth and ninth canvases possess characteristics common to those already discussed. The triumphal arch has the same indeterminate physical relationship to the figures as the 'aqueduct' and in effect plays the same compositional role as the objects held aloft elsewhere in the series. It is with the seventh canvas, the 'Captives', that something entirely new emerges—an attempt to place the procession in a Roman street (*no. 37*).[3]

The seventh canvas has in any case the additional peculiarity of being apparently incomplete, with an odd gap in the painting of the upper left-hand corner, which appears never to have been finished off. Superficially, it looks almost as if a blank piece of canvas had been sewn in at this point; but this is not so, for the original canvas runs unbroken through from top to bottom. As this is the worst-preserved painting of the entire series and virtually everything now visible is by Laguerre it is difficult to produce emphatic statements about its condition when it left Mantegna's hands. Its state *c.* 1600 is reasonably clear since all the copyists agreed in leaving this area absolutely blank (*nos. 84, 95, 102, 103, 114*), but they also

[1] By juxtaposing the Paris 'Elephants', the Dublin 'Trophy-Bearers' and the figures from the fourth canvas, it will be seen that the general disposition of shapes and forms across these three areas has the makings of a satisfactory composition with little need for a landscape setting.

[2] The general form of this landscape and the part it plays in the painting has much in common with that of the *Martyrdom of St James* formerly in the Eremitani church at Padua (*no. 133*).

[3] There have been occasional suggestions (Portheim, Blum and Tamassia, *opera cit.*) that this setting represents a Roman theatre. It is true that both Josephus and Plutarch mentioned that the procession might pass through the theatres; and the point was also noted by Valturio. But not by any stretch of the imagination could this be interpreted as the inside of a theatre. The idea seems, in any case, to be further discouraged by the Chantilly drawing which, even more clearly, shows a street.

disagreed in a most surprising way on the existence of the capital in the centre;[1] and also on the existence of a second pilaster down the left-hand margin. Perhaps, then, when Mantegna ceased work on this canvas, these features existed only as an unpainted drawing whose condition gradually deteriorated during the sixteenth century. In this way, it would be possible for the drawing to attain a condition c. 1600 in which one copyist could include a detail and others ignore it. But it is difficult to accept that the area was ever properly finished by Mantegna; and this unfinished character makes it probable that this canvas was painted last.

The painting of the 'Captives' should be taken in conjunction with the Chantilly drawing and the Vienna drawing of the 'Senators' (no. 56), to which of course it is related. These drawings are of considerable interest since in them the sense of enclosed space is conveyed even more strongly than in the painting of the 'Captives'. The viewpoint of the drawings is slightly higher than that of the painting so that the rear figures in the procession hardly 'fall away' at all. This brings the buildings into a far happier physical relationship to the figures, and makes it appear that the procession really is passing through a city.

The management of this architectural setting is ingenious. It has already been pointed out that centralized architectural settings engender difficulties because of their tendency to break up the flow of action in the foreground, and to destroy any sense of progression from one side of the picture to the other. The scheme devised by Mantegna was one with which he had already experimented in the Eremitani frescoes; he made no attempt to provide the buildings with a single vanishing-point after the manner advocated by Alberti. Instead, the background is vertically divided almost down the middle, one half being 'open' and the other 'closed'. Something of this nature had been tried in the fresco of *St James being led to Martyrdom*, where the left half of the composition was dominated by the front face of an arch and the right half contained a series of receding buildings set at irregular angles. This irregularity was important since it modified what might otherwise have seemed an uncompromising thrust backwards. In the two Triumphal scenes under consideration this arrangement is adopted and further developed: the left-hand parts of the compositions are now filled with solid architecture presenting a flat frontal façade; the right-hand parts of the compositions are dominated by objects of varying geometrical shapes—a circular tower and a pyramid turned at an angle. This combination ingeniously suggests buildings in a credible spatial context immediately behind the procession without drawing the spectator's attention compellingly back into the space behind.[2]

It seems likely that the 'Captives' and the 'Senators' were designed in conjunction with each other; indeed, if what has been suggested is correct, then the 'Captives' heading the third group of three paintings would have to some extent balanced the 'Senators' heading a fourth (unexecuted) group. Both designs should, of course, be seen in their historical and iconographical context. In the very early stages of work a composition must have been designed by Mantegna for a seventh canvas. The theme of 'Captives' was demanded by the

[1] For the capital, at least, it might be argued that this was an invention of Andreani (1599) since he is now the earliest (and only pre-1630) independent source for its existence; it could then arguably have been copied by Laguerre (c. 1695) from Andreani, in order to tidy up this area. Against this, it must be said that the capital itself is an unusually precise copy of one on the Roman *Porta dei Leoni* at Verona (no. 168)—a good reason for supposing that it is basically Mantegna's work.

[2] Basically the same construction was used by Titian for his fresco of *The Miracle of the Speaking Babe* in the Scuola del Santo, Padua.

texts and it is probable that the general iconographical material was also fixed. Further, both the 'aqueduct' leading towards this scene from the sixth canvas and the triumphal arch in the ninth suggest that some form of architectural feature was intended at this point anyway, and architecture would at any stage have conveniently filled the upper parts of this painting—prisoners cannot in the nature of things wave trophies above their heads.

The change in the character of the settings in these two scenes is nevertheless remarkable and it seems appropriate here to insist on this. It is, after all, true that similar contrasts had been present in the Eremitani frescoes (*nos. 132, 133*). Three of the four lower scenes from the Life of St James are shown in 'un-ruined' Roman urban surroundings (compare the 'Captives' and the 'Senators'); whereas the *Martyrdom of St James* is depicted against a setting containing decaying ruins. Rome 'as she might have been' is painted alongside 'Rome as she is'. It is reasonable to ask whether this does not form a simple precedent for the *Triumphs*.

It is difficult to answer this question except in the rather controversial terms of hypotheses about the way Mantegna ought to have developed as an artist. The Eremitani frescoes were the *tour de force* of a young man who tackled at one go a whole range of pictorial problems at that time exercising painters. Apart from the introduction of classical ruins and their contrast with archaeological reconstruction, there were contrasts of perspective–construction and viewpoint. But especially there was the major contrast between the variety of this approach and the unequivocal illusionistic links that bound the entire series to the spectator's world. The spectator was forced into a position where he had to reconcile simultaneously all these visual contrasts; and it must have been a disturbing experience. This is not to say that the Eremitani cycle contained anything as crude as 'errors', but in triumphantly satisfying several sets of interests, Mantegna had raised a considerable range of problems which he probably did not appreciate at the time.

The *Triumphs* were probably started between twenty and thirty years later, and the need for visual unity was far greater than in the Eremitani frescoes. There the individual scenes were at least of detached historical episodes taking place at different times. In the *Triumphs*, the individual canvases are only parts of a greater whole whose episodes occur simultaneously. It is difficult to believe that Mantegna would not have appreciated this; indeed had the 'Captives' and 'Senators' compositions disappeared without trace, one would have no hesitation in making the obvious statement that he realized that visual unity was essential for the success of the scheme; and that the sort of abrupt contrasts found at Padua would spell disaster for the *Triumphs*. Thus the task remains of explaining the 'Captives' and 'Senators' compositions, which seem visually to disturb an otherwise harmonious and subtle scheme. The fact that this change in character is confined to one composition which was apparently left unfinished and another which was, it seems, never painted at all, suggests that it occurred late in the actual process of painting the *Triumphs*. Something, it seems, happened which led Mantegna not merely to reorganize the setting of the 'Captives' but also apparently to re-examine the background of what was to follow (the 'Senators'). What this was will, perhaps, never be known, but one event that springs to mind is the visit to Rome. It seems at least worth asking whether this might have stimulated the changes which have been discussed.

If, as is sometimes suggested, Mantegna had already paid several unrecorded visits to Rome, then clearly a visit in 1488–90 would have made very little difference. It was earlier argued that, whereas the circumstantial evidence that Mantegna knew the main Roman monuments seemed virtually conclusive, there was no clear evidence that he had himself been there; for it is possible that his knowledge was derived from secondary sources. The compositions of the 'Captives' and 'Senators' tend, if anything, to support the idea that the visit of 1488–90 might have been the first. In that case, Rome would have made a very deep impression; and it is not difficult to suggest one way in which such an impression would work on an artist. For a visit to Rome would transform an abstraction or concept into a reality. Rome, up to then envisaged at second hand in a sort of 'shorthand' of famous sights and monuments, would suddenly have achieved a solid reality—a city through which one could wander. It could well have been an experience of this sort that brought Mantegna to realize that, in devising the compositional subtleties of the original plan of the *Triumphs*, he had eradicated one of its most vital and exciting features. The parade passed through the streets of Rome; and no reconstruction, however imaginative, could afford to ignore this.

Such a hypothesis is speculative, but it would help to explain two things. The first has already been noted—namely the evident transition in the scheme from Rome represented by a series of background symbols to Rome seen as a city with a three-dimensional existence. Naturally such a transition would have been extremely difficult to incorporate into Mantegna's visual scheme at such a late stage. There was, and is, something unbalanced about the contrast between arch, 'aqueduct', and tiny buildings floating in the background and the sudden juxtaposition of a street front. Difficulties of detail were also to be overcome, since the Chantilly composition, had it been executed, would have entailed changes in the eighth canvas in order to suggest continuity from one to the other. As it happened, it was the Chantilly composition that was modified, the buildings surrounding the pyramid being replaced by a receding piece of architecture whose line is continued in the diagonal of the adjacent hill.

There would also have been various other almost insuperable obstacles—insuperable, that is, short of repainting the series. The procession was in intention winding its way into Rome towards the Capitol, and such a sequence should have had its densest agglomeration of architecture at the front of the procession. But in the existing series, the superficial impression conveyed is the exact opposite, since, for those who have not noticed the tiny patch of architecture in the second canvas (*no. 9*), it appears that the whole parade is moving from the city into the open country. Moreover a technical problem seems to have arisen over the viewpoint of these later contributions to the series. In the Chantilly and Vienna drawings, the viewpoints are perceptibly higher than those of the paintings. In the painted version of the 'Captives', the viewpoint is lowered for the figures but not for the pyramid behind; and for the remaining architecture, it would appear that there are several viewpoints. Thus the whole reality of the setting has been considerably diminished.[1] This merely underlines the problems of revising the scenic context of the Triumph at such a

[1] The architectural changes have some sort of archaeological basis, which is discussed in the catalogue. But the necessity to make any changes at all came almost certainly from the lowering of the viewpoint. In the Chantilly drawing, the relationship of the portal to the foreground procession is a fairly straightforward and realistic one. With the lowered viewpoint, however, this relationship was destroyed; and alterations to the façade were consequently carried out.

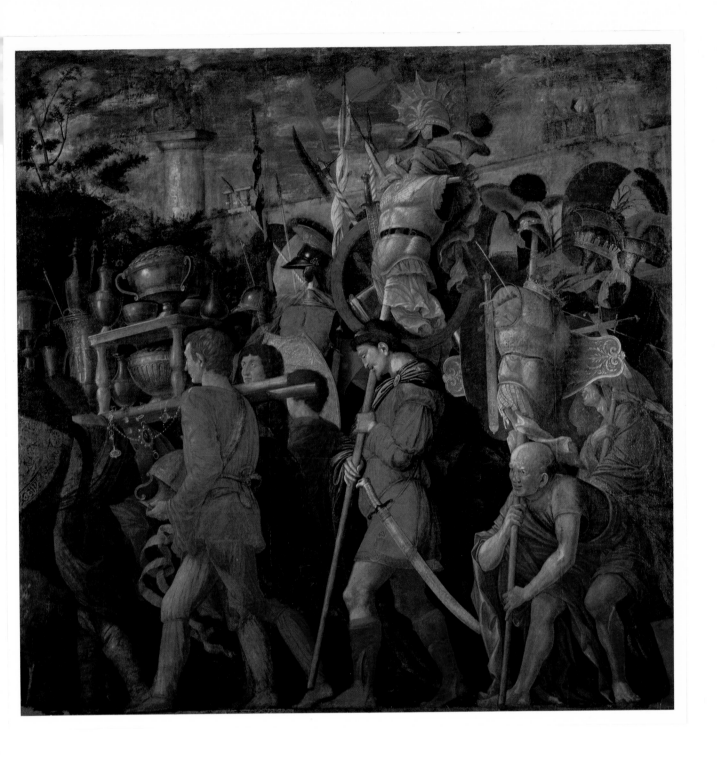

Canvas VI: Bearers of Coin and Plate, Bearers of Trophies of special Armour

late stage while preserving the unity of the finished work. The impossibility of such a task leads on to the second point which might be explained by this sequence of events—Mantegna's failure to complete the cycle.

Various explanations have been proposed for Mantegna's failure to complete the iconographical scheme demanded by the texts. These relate chiefly to the way in which Gonzaga patronage was exercised. Did Isabella d'Este make difficulties about the completion of the *Triumphs*? Were other commissions given priority? Were there indeed undisclosed and unexpected problems over the site for which the *Triumphs* were intended? Did the Court take to 'borrowing' the canvases for plays and other festivities? None of these explanations is impossible even though they cannot be proved; they invoke conditions in which Mantegna may well have been obliged to work and this may have affected his production of a complete 'Gallic Triumph'. But if Mantegna himself had in some way grown dissatisfied with the whole conception of the series, this would have provided by far the most powerful reason for work on the series slowing down and finally stopping.[1]

In support of this suggestion, one final piece of evidence may be cited. Canvases IV and V (the 'Vase-Bearer' and the 'Elephants') possess an altogether different tonality from Canvases I, II, III, VI and IX (Canvases VII and VIII are too heavily overpainted to offer reliable comparisons). In general terms, the colouring of Canvases IV and V has a greater luminosity with its preponderance of red, brown and golden pigments; and the modelling in light and shade produces shadow tones which descend towards brown rather than black. The different approach to colour emerges in a comparison of the booty in Canvas IV with that in Canvases III and VI. The different approach to shadow may be seen by comparing the shading of the white oxen and brown elephants with that of the horses in Canvases II and IX. In fact, in the 'Vase-Bearer' and 'Elephants', dense black shadow is seldom found. They have, in effect, a physical warmth about their colour and tonality which is lacking in the others. Moving from the 'Elephants' to the adjacent canvas containing the 'aqueduct', one has the curious sensation that the sun has gone behind a cloud.

Occasion has been found in the Catalogue, pp. 147 and 157, to comment on small discrepancies which exist between the canvases—discrepancies which suggest that when Mantegna was at work on any particular canvas, its immediate neighbours were not always at hand. The tonal discrepancy under discussion, however, is of an altogether different character. Indeed, to anyone contemplating the *Triumphs* at Hampton Court, it becomes increasingly disturbing; and it is very difficult to explain. It is too considerable to be a mere error of judgement—at least for a painter of Mantegna's age and experience; and yet it is difficult not to believe that it would have disturbed him too.

The change is most easily understood in the context of a lengthy period of execution for

[1] Most writers are justifiably reticent about the possible effects of Mantegna's visit to Rome. Many agree that the series must have been planned in some form before 1488 and some, like E. Tietze-Conrat (*Mantegna*, p. 23), do not think that the Roman visit can have been particularly influential. Those writers, like Blum and Waterhouse, *opera cit.*, who have considered the change of character in the composition of the 'Captives', have concluded, at least tentatively, that that change was in some sense prompted by the visit. Both assigned the last three canvases to 1490 or after. Blum also thought that *grosse Teile nach der*

Heimkehr unter dem Eindruck der römischen Kunst gründlich umgearbeitet wurden.
It should be noted that Blum and Waterhouse differed fundamentally in their assessment of the last three canvases. Blum saw them as possessing in common a relief-like character which was different from the other six. She also thought that they were especially influenced by specific Roman works, notably the great Trajanic frieze and Trajan's Column. Waterhouse was struck chiefly by their dissimilarity and the fact that they failed to form a series, unlike the first six canvases.

the *Triumphs*. In such circumstances, it would provide evidence for stylistic development on the part of the artist. Its sequence would not be particularly obscure, since the canvases with cooler tonality are comparable to the range of tones in the *Camera degli Sposi*; and the 'Vase-Bearer' and 'Elephants' move perceptibly in the direction of the warmth and brilliance of the *Parnassus* and the *Madonna della Vittoria*. They would thus occupy a relatively late chronological position. The 'Captives' canvas should, of course, provide decisive evidence as to whether this theory is worth entertaining. Most unfortunately, it is in this respect unreadable, since Laguerre's re-painting has combined with Kennedy North's paraffin wax to render the original tonality absolutely obscure. However, the tonal discrepancy of Canvases IV and V taken in conjunction with the possibility of an extended time-scale is a reminder that the longer Mantegna worked on the *Triumphs*, the more difficult it would have become for him to match the style in which they were begun. The situation can be seen most easily in its most extreme form. Supposing, for the sake of the argument, that Mantegna, after prolonged discussions with Lodovico Gonzaga, was in a position to start work on the *Triumphs* immediately after the completion of the *Camera degli Sposi* (1474), it is quite possible that six canvases could have been completed by Federico's death ten years later (1484). The two 'discrepant' canvases could have followed during the years 1484–8, leaving the 'Captives' and 'Senators' to occupy Mantegna after his return from Rome late in 1490. Something has already been said about the problems raised by the settings of these last two compositions. But if in 1494, Mantegna was still working on a scheme begun twenty years earlier under Francesco Gonzaga's grandfather, it is hardly surprising that the stylistic problems should also have been found to be becoming increasingly intractable. This too would provide further reason for work on the series tailing off and then being brought to a full stop.

In conclusion, and after so much speculation, it will be a courtesy to the reader to attempt a summary of the few facts. All that is known about the painting of the *Triumphs* is that something was available for display to visitors by 1486; and that they were still considered to be unfinished in 1492. Francesco Gonzaga was anxious to get Mantegna back from Rome in 1489 in order that he might finish off whatever had been started; and the same Marchese removed whatever had been completed to his new private residence at S. Sebastiano *c.* 1508. Six of the canvases were used to decorate an auditorium in 1501. All the rest is uncertain. It has nevertheless seemed worth while to spend time and thought on problems and peculiarities of these canvases and to attempt to account for their genesis in a way which is historically credible. They combine to form one of the grandest creations of the fifteenth century; and if, as a result of this exercise, the reader has a heightened appreciation of the genius of their creator, it will have been worth while.

7 · The History of the *Triumphs of Caesar* during the Sixteenth and Early Seventeenth Centuries

THE FIRST SUBSTANTIAL ACCOUNT of the *Triumphs of Caesar* dates from some years after Mantegna's death and occurs in the *Commentarii Mantuani* of Mario Equicola (printed in 1521).[1] By this date the *Triumphs* were no longer in their original position in *Corte*. As Equicola makes clear, they had been moved to a new site, a *sala* especially constructed to receive them in the palace at S. Sebastiano which the Marchese Francesco built for himself towards the end of his life. Here they were seen and praised by a succession of sixteenth-century writers, including Vasari (Documents 27, 30 and 31). It is a little surprising to find conflicting accounts of the exact number of canvases visible, but Scardeone[2] and Raffaello Toscano[3] both stated that there were seven. In fact it is only with the woodcuts of Andreani (*nos. 87–97*), published in 1599, that nine paintings clearly emerge (see Document 33): these are the paintings now at Hampton Court.

The Palazzo di S. Sebastiano still exists, probably more or less in its entirety,[4] although there are no readily accessible plans and the interior has to a considerable extent been subdivided. Calculations about the sixteenth-century home of the *Triumphs* have therefore to be made with some caution. The chief clue to the location of the *Triumphs* in the palace is to be found in Vasari's statement that they were in the *Sala Grande*.[5] In any urban palace in sixteenth-century Italy this should have indicated a large room on the first floor. Such a room existed at S. Sebastiano over the loggia and it was long enough to take the *Triumphs* on its side walls.[6] However, the stages by which this *sala* was decorated are not clear,

[1] See Document 26. Mario Equicola, *Commentari Mantuani* (1521), Book 4 (no pagination). Equicola entered the service of Isabella d'Este in 1508, eventually becoming her secretary; and died at Mantua in 1525. He should thus provide good evidence. See J. Cartwright, *Isabella d'Este* (London, 1923), I, p. 283, and II, p. 241.

[2] B. Scardeone, *De Antiquitate Urbis Patavii* (Basle, 1560), p. 372 f. See Document 29.

[3] R. Toscano, *L'Edificatione di Mantova* (Mantua, 1587). See Document 32.

[4] The palace of S. Sebastiano stands at the junction of the Largo XXIV Maggio and the Via della Repubblica. Its history since the seventeenth century was traced by Yriarte (*op. cit.*) with intermittent documentary evidence. In Amadei's time (*c.* 1720–40) the palace was used as a barracks. (F. Amadei, *Cronaca Universale della Città di Mantova*, Mantua, 1954, Vol. II, p. 439.) By the nineteenth century it was a hospital. Some account of it is given by G. and A. Pacchioni (*Mantua*, Bergamo, 1930, pp. 39–40) when it was an isolation hospital. The main occupants are now the *Istituto Musicale 'Lucio Campiani'*, but the loggia has been enclosed and the ground floor houses a Communist Party working-men's club. Some other parts of the building are converted into a private house.

[5] See Document 31. *Dipinse [Lorenzo Costa] ancora nella sala grande, dove hoggi sono i trionfi di mano del Mantegna, due quadri, cioè in ciascuna testa uno.* It seems necessary to emphasize this, together with Equicola's information that

the *sala* was planned specifically with the *Triumphs* in mind. In the latest monograph on Mantegna it is suggested that in the sixteenth century the paintings were arranged around the circular *cortile* of the Casa di Mantegna (see M. Bellonci and N. Garavaglia, *L'Opera completa di Mantegna*, Milan, 1967, p. 3). There seems to be no justification for this view but it may possibly have been suggested by some hexameters written in celebration of Federico Gonzaga by G. Benivole da Pietola in the early 1520s. There is a short section on Mantegna, which runs as follows:

Ille, vetustatis verax imitator Apelles
Alter, honos nostri Mantinia temporis, aedes
Condidit has, formam et parvi dedit amphiteatri.
Pinxit et antiquae simulata palatia Romae,
Semirutas aevo statuas grandesque obeliscos,
Naumachiam, atque arcus, circensia pegmata, thermas
Atque triumphantis victricia Caesaris arma.

(Printed by Kristeller. [G] Schriftquelle 23.)

[6] The length of the original *sala* is hard to calculate because the first floor is now partly occupied by a private apartment. However, the complete length of the floor above is accessible and measurable and from this it appears that the *sala* was probably about 31.4 m. long. Thus the *Triumphs*, which in their present form require a space about 27.5 m. long to display them in line, could have been displayed as a frieze along one wall. However, this conclusion depends on how much importance is attached to Vasari's statement in the 1550 edition (it was not repeated in the 1568 edition) that the *Triumphs* were *intorno a una*

although in general terms the history of the building is straightforward. The palace appears to have been built mainly in the years 1506 and 1507,[1] the lower rooms being decorated first, followed by the *sala* and the upper floors; and the painting of the exterior took place in 1507. It was sometimes referred to as the *Palazzo Novo* perhaps to distinguish it from those buildings already existing when Francesco began to build.[2]

Although the decoration of the *sala* is unsatisfactorily documented, there is one crucial reference in a letter of November 1506.[3] In this letter, one of the Marchese's correspondents writes *De le casa tuta e fenita de soto e se comencio a lavorar di sopra ala sala*. The work was probably finished by October 1508 when the *sala nova* is mentioned,[4] although the date at which Mantegna's paintings were transferred there is not known. However, the Marchese Francesco came to use the Palace of S. Sebastiano as his customary town residence,[5] employing it for entertainments and receptions;[6] and from two such occasions definite information emerges about Mantegna's paintings. In 1512, the Marchese gave a supper for the Duke of

sala. There are also many archaeological problems attached to the structure of this palace. The chief one is that the present first floor has a height of approx. 3.83 m.; but if Equicola was right and the room was planned with the *Triumphs* in mind, a height of 5 m. or more would be required. It also seems clear that the window arrangements on the south side are not the original ones. Therefore, until further archaeological investigation is done, it seems pointless to take this part of the enquiry further.

[1] The acquisition of land in the area by Francesco began earlier. G. Gerola (*Atti del Reale Istituto Veneto di Scienze, Lettere ed Arti*, LXVIII, 1908–9, p. 914) published a transfer of land in 1502 from Mantegna to the Gonzagas. The transfer appears to have included the famous *Casa di Mantegna*. That it already contained some sort of habitable property is shown by Arch. Gonz. Busta 2463 (1504) f. 18, *De le altre cause che io parlai ī lo palatio da Sto Sebastiano*: also f. 193, *gia essendo lei ala casa di sto sebastiano*. (Letters to the Marchese Francesco.) Note also that, in spite of furious building operations, the Lady Violante was able to go into confinement there in 1506 (Arch. Gonz. Busta 2469, ff. 583–4 and 639). The chronology of the main building operation is hard to fix from the documents, because the Marchese's correspondents continually assert that a particular work is completed or nearly completed, only immediately to qualify the statement. It is clear that Francesco was in a great hurry. The following archival references may be noted:

For the lower rooms—Arch. Gonz. Busta 2469 (1506): f. 12 and 13 (14th ? Jan.); f. 464 (18th Sept.); f. 544 (11th Oct.); f. 625 (15th Oct.); f. 688–9 (5th Nov.).

For the *sala*—the same Busta (1506), ff. 544 (11th Oct.), 583–4 (17th Oct.), 586 (18th Oct.), 688–9 (5th Nov.).

For the exterior and loggia—Arch. Gonz. Busta 2470 (1507): f. 462 (11th April); f. 463 (13th April); f. 464 (21st April).

[2] Arch. Gonz. Busta 2469 (1506), f. 639 (27th Oct.): *Dapoi fossimo a sto sebastiano a veder' il pallaccio di V.S. il quale gli piacque tanto dil mondo maxime questa parte nova in capo dil Giardino. . . .* Also Busta 2485 (1512), contents unnumbered. Letter Amycom[a] della Torre to Federico Gonzaga, 4th August: *Il sequente giorno il pto S^re vro p̄re detta cena a Gurgen, et al Ambasciator di Spagna dove anche lintervenne Madama . . . al palazzo di s. sebastiano di fuori su la strata dal pallazo novo versa la Chiesa et tutti ad una tabula.*

[3] Arch. Gonz. Busta 2469 (1506), f. 688–9 (5th Nov.).

[4] Arch. Gonz. Busta 2472 (1508), f. 620, Letter Nicolo Bertiolo to Marchese Francesco of 13th October.
In September 1506, Isabella d'Este paid a visit to the *allogiamti novi de s^to sebastiano* and admired, amongst other things, some paintings; for she wrote that *quelli pictur' compareno mirabilm̄te* (Arch. Gonz. Busta 2994, Libro 19, ff. 71^v–72^r). It has often been assumed that these paintings were Mantegna's *Triumphs* but this seems unlikely in view of the date. Other painted decoration existed in the palace. Note that others also went to admire the new buildings. Compare Arch. Gonz. Busta 2469 (1506), f. 718, Ghivizano to the Marchese Francesco on 2nd Nov.: *Hozi el masaro di v. exia s. mea menato a vedere quelo he fato ala fabrica de s^to sebastiano la quale sta tanto bene che meliorare nō se poria in modo ch̄ tuta ride nō se poria homo Inmaginaro quanto de alegra.* On the other hand, work on some pilasters being prepared in Venice during April 1506 may possibly have something to do with the *sala*, assuming that the master-mason Girolamo Arcari knew what he was doing and had planned the work perhaps a year in advance (Document 19). But the wording is ambiguous; and the palace of S. Sebastiano is associated in the letter not with the *coloni*, but (a few lines *later*) with a painting by Gentile Bellini. It may be noted that Yriarte (*op. cit.*, p. 746) claimed to know a document which showed that Francesco Mantegna was the author of these *coloni*, but unfortunately gave no reference.

[5] Arch. Gonz. Busta 2485 (1512) contents unnumbered. Letter from Amycom[a] della Torre to Federico Gonzaga, 25th Feb.: *El s^re vro p̄re non ha voluto andar' ad festa alcuna se non ad una sua p̄ haver' sua s^ria D̄nica passata facto recitar una Comedia nel pallazo suo di s. sebastiano sotto la loggia.* Also same Busta, same correspondents, 29th May: *non gli e intervenuto il s^re vro patre quale si trovava a Pietule: et sua ex^tia gionse heri qua al suo consueto allogiamento dil pallazo di s. sebastiano.*

[6] Arch. Gonz. Busta 2482 (1511), f. 4. Letter from Alvise Gonzaga to Federico Gonzaga: *lo exercitio n̄ro ogni giorno e de Imperare lre: et andare spesso a visitare la Ex^tia dl s' n̄ro p̄re el quale adesso sta a s'. sebastiano.* Also Busta 2487 (1513), contents unnumbered. Letter from Amycom[a] della Torre to Federico Gonzaga of 13th Feb.: *lo Ill^mo S^re vro p̄re nel zorno di Carnevale a s. sebastiano nanti cena fece recitare la Comedia de Terentio de landria el sotto ne la loza domesticamente senza troppo sumptuosita de apparati. . . . Doppo cena si danso poi su la sala sino a octo hore.*

Milan 'in the *sala* of the Triumphs of Caesar here at S. Sebastiano' (see Document 22A); and in 1515, some Venetian ambassadors visited the palace, inspected the upper parts, and admired, amongst other things, Mantegna's *Triumphs*.[1] In the words of a correspondent 'the . . . ambassadors wished to see all the upper part of the palace, right through to the *camera* of Messer Ludovico. It pleased them very much, especially the Triumphs of Messer Andrea Mantegna.'

Although Mantegna's *Triumphs* were the main artistic feature of the *sala* at S. Sebastiano, they were set out as part of an overall decorative scheme about which there are still some confusions of detail. Equicola wrote (in or before 1521) that Lorenzo Costa was called in by the Marchese Francesco to make good certain deficiencies in the iconographical programme of Mantegna's *Triumphs*. As Equicola pointed out, the Triumph lacked spectators and also the 'pomp' which ought to follow in the wake of the triumphant general. He appears to say that Costa included these items in additional canvases placed at the two ends of the *sala* (see Document 31). Vasari, however, described Costa's additions and their subject-matter is not what one might immediately expect from Equicola's remarks.

The first, painted *a guazzo*, represented a scene of sacrifice to Hercules. It thus had little to do with the iconography of a Triumph. It contained portraits of Francesco and three of his children, the youngest of the three being born in 1506;[2] Vasari said that it was painted many years before the second. This, according to Vasari, had nothing to do with the Marchese Francesco but commemorated the appointment of Francesco's son Federico as Captain-General of the Papal forces under Leo X (1520–1). The first painting has vanished. The second survives in the National Gallery at Prague (*no. 119*). It is signed by Costa and dated 1522.[3] Normally known as 'The Triumph of Federico Gonzaga', it shows Federico (distinguishable as a portrait at the extreme left). He is followed by a *mêlée* of soldiers on foot and on horseback, who straggle across the picture in what, in normal circumstances, would be a very strange composition. However, if the painting were still on the end wall of a long room, and set at right angles to the main line of Mantegna's *Triumphs* it would indeed suggest most ingeniously a continuation of that procession. Moreover, the Marchese Federico could be following on immediately behind Caesar's chariot, supposing that canvas to be adjacent.[4]

There are a number of possible explanations of this confusion between the statements of

[1] See Document 23. At first sight, this would appear to place the *Triumphs* in the *camera de mᵃ Ludovico*; but it seems more likely that the ensuing *che* refers back to *il palazzo disopra*.

The *direttore* of the Archivio di Stato, Venice (avv. Luigi Lanfranchi) has kindly ascertained for me that *Relazioni* of Venetian *oratori* and *ambasciatori* no longer survive for this period. However, Professor C. M. Brown pointed out to me that a group of letters written by members of this mission came into the hands of Sanudo and were copied into his diary. One in particular (Doc. 24) gives an account of the visit to the palace of S. Sebastiano, where the paintings of Mantegna were said to adorn the walls *da la spaliera in su*. The *Triumphs* were the first thing the party apparently saw on entering; and this confirms the idea that the canvases were in the *sala*, through which they would have had to pass to reach the *camera* of the Marchese.

[2] See Document 31. In Vasari's description, the Marchese (Francesco) is described with three male children—Federico

(b. 1500), Ercole (b. 1505) and Ferrante (b. 1506).

[3] Vasari also stated that it was one of Costa's last works. Costa survived until 1535 but his last dated work is 1525. This is a painting seen at the castle of Teplitz by A. Venturi (*Storia dell'Arte Italiana*, VII.3, p. 816) and also published by E. Schaeffer (*Von Bildern und Menschen der Renaissance*, Berlin, 1914, p. 125). It is now in the National Gallery, Prague (see R. Varese, *Lorenzo Costa*, Milan, 1967, p. 75). It measures 2.66 × 6.38; the area occupied by the *sala* at S. Sebastiano is approximately 7 m. broad.

[4] This observation, if correct, has an incidental importance since it would tend to support the conclusion that the 'Senators' composition was either never begun or never finished, or had come to some untimely end before the *sala* of the Palace was decorated. Since the painting of the 'Captives' appears to be unfinished, the first of these possibilities seems the most likely. On the 'Senators' see above, pp. 66 and 86 and Catalogue, p. 160.

Equicola and Vasari but the simplest is the following. The *Triumphs* were hung along one wall in the *sala* of the palace.[1] At one end, Costa painted a 'scene of sacrifice' intended to represent the climax of the triumphal celebrations. Strictly, this should have been a sacrifice to Jupiter Capitolinus; but for reasons about which it is hardly worth speculating Costa painted, or Equicola recorded, a 'sacrifice to Hercules'. Some time later, Costa began at the opposite end of the room a scene which was indeed meant to portray the army following on the triumphal chariot of Caesar (*la pompa che sequir solea il triumphante*). In the course of this commission, Francesco Gonzaga died (1519). His son, Federico, permitted the painter to finish the work (which is dated 1522) but at the last moment altered the programme so that it commemorated his own military success of 1520–1.

These various pieces of evidence combine to give a reasonable picture of the way the *Triumphs* were displayed at S. Sebastiano. According to the Venetian writer in 1515, the palace 'was adorned with the most beautiful paintings [which extended] from the *spaliera* upwards—extremely beautiful, and by the hand of Mantegna' (Document 24, p. 185). This suggests that the *sala* had a panelled dado probably incorporating a bench.[2] The height of this dado, and of the paintings is indicated by Serlio—'because the feet of the figures are above our line of vision, one cannot see any ground plane' (Document 27, p. 185). At S. Sebastiano, it is known that the *Triumphs* were framed by pilasters, recorded by Andreani (*no. 87*) and decorated with trophies of arms.[3] Thus the general effect could be reconstructed.

Subsequently, the *Triumphs* were returned to what had by then become (and all visitors now know as) the *Palazzo Ducale*. The exact date of their removal is uncertain,[4] but in January 1627 the paintings were said to be in the *Galleria della Mostra*.[1] This must have

[1] The view that the *Triumphs* were ranged down one wall of the *sala* receives some support from the otherwise apparently trivial alteration in Vasari's account of them in 1568 already mentioned on p. 92 above. In 1550 (Document 28) he had stated that they were *intorno a una sala*; but in 1568 (Document 30) this was changed to *in una sala*.

[2] The meaning of *spaliera* is not immediately obvious. Its root is *spalla* (shoulder) and *spalle* (back) and comes thence, as *spalliera*, to be applied to the back of a piece of furniture. It was, however, also applied in a more general sense to what might be termed 'wall-furnishing'. The linking train of thought is not necessarily a distant one. A fixed and panelled dado incorporating a bench and therefore forming its back could reasonably have been called a *Spaliera*—and, indeed, it is hard to imagine another explanation at S. Sebastiano. There was, however, an even more generalized use for the word which seems to have removed it from its connection with furniture. In Document 1, p. 181, the Duke of Ferrara was recorded as wishing to see *la Spalera* (1486), a sight which was also shown to the Venetian visitors in 1492 (see Document 6), together with *la camera depincta*. (See A. Luzio, *La Galleria dei Gonzaga venduta all'Inghilterra nel 1627–8* [Milan, 1913], afterwards referred to as Luzio, *Galleria*, p. 25, note 1. This has the reference Arch. Gonzaga Busta 2441, contents unnumbered, letter Antimacho to the Marchese Francesco of 1 Sept.). This object is given a gloss in a letter of 1493 (Arch. Gonzaga Busta 2443, contents unnumbered, Letter Federico del Casalmaggiore to Isabella, 16th July) in which the writer was describing the decoration of the *castello* on the occasion of the stay of the Turkish ambassador there. Recounting the rooms one by one, he wrote *la sala davāti e cū la bella spaliera adornata poi almodo cōsueto*. In the letter, the *spaliera* is in opposition to *tapezarie* on the walls of

other rooms. It is usually assumed that the *spaliera* was a large stamped leather hanging, painted record of which is thought to survive on the east and south walls of the *Camera degli Sposi*. As decoration of the Great Hall (*sala*) of the castle and as something earlier singled out by the Duke as a sight to be seen, this *spaliera* must have been large and splendid. But how the application of the word in this context is connected with its root meaning is not clear.

[3] See Bartsch xii, p. 104. This sheet with its six pilasters is inscribed *IN MANTUA, A.A 1598*, and therefore seems likely to represent what Andreani saw in the palace of S. Sebastiano. Pilasters carved with trophies of arms were also popular with masons at Urbino (designs ascribed to Francesco di Giorgio) and Venice during the last quarter of the fifteenth century. It would not therefore be anachronistic to suppose that Mantegna intended something similar for the *original* setting of the *Triumphs* (see above, p. 35).

[4] C. Yriarte (*Cosmopolis*, V, 1897, No. 15, p. 738 ff., 'La Maison de Mantegna à Mantoue et les Triomphes de César à Hampton Court') claimed (p. 747) that the *Triumphs* were moved back to the *Palazzo Ducale* during the 1530s and established around the walls of the *Sala di Troia*. He stated that at the time of writing one could still see on the walls traces of the *emplacements* where the *Triumphs* had been hung. Apart from that, however, he presented no documentary evidence of this move and the theory was dropped in all subsequent writing. When Andreani published them in 1599, the *Triumphs* were still at S. Sebastiano. Yriarte also stated (*op. cit.*) that the palace of S. Sebastiano was sold by Vincenzo I to Pirro Maria Gonzaga on 30th May 1607. He gave no reference for what is presumably a document. If this is true, paintings of the value of the *Triumphs* must already have been moved back to the Ducal Palace.

been a temporary arrangement, since this *galleria* is architecturally unsuited for their display.[2] A letter from Daniel Nys of October 1627 mentions a *sala del Trionfo di Julio Cesare*, while a further letter of February 1629 speaks of *due sale nove* constructed by Duke Vincenzo II (1626–7).[3] Their life in this new setting was short.

Already under Duke Ferdinando (1613–26), the Gonzaga house had sunk irretrievably into debt, overwhelmed by financial problems. Daniel Nys, acting as agent for Charles I, opened negotiations for the purchase of the Gonzaga art collections, and, although these negotiations came to nothing under Ferdinando, his brother Vincenzo II had no inhibitions about selling off a large number of paintings. But even Vincenzo refused to part with the major paintings, among which were numbered the *Triumphs of Caesar*. This prompted Nys' memorable letter to England in which he described how he had been told 'that I had left the most beautiful paintings behind, and that, not having the Triumphs of Julius Caesar, I had nothing at all'. Fortunately for Nys, Charles I, and the English today, Vincenzo II died almost at once and with him was extinguished the direct line of the Gonzagas. His successor, Carlo I of the collateral branch of Nevers, found himself immediately in conflict with the Emperor Ferdinand II over the succession, and in need of money. Nys had little difficulty in persuading him to part with the rest of the collection. The *Triumphs* left for England in 1629; and since Mantua was besieged by imperial troops in the same year and sacked in 1630, perhaps this was just as well.[4]

[1] See Luzio, *Galleria*, p. 105.

[2] The *Galleria della Mostra* was built in the opening years of the seventeenth century (see E. Marini and C. Perina, *Mantova: Le Arti*, III, Mantua, 1962, p. 187). A series of nine shallow recesses down the long wall might seem designed to take these paintings. But the recesses measure either 1.81 m. square, or 3 × 1.81 m., and are therefore too small for the *Triumphs* (c. 2.74 m. square).

[3] Luzio, *Galleria*, pp. 147 and 159.

[4] See Luzio, *Galleria*, generally for the history of the dismemberment of the collection.

8 · The Influence of the *Triumphs of Caesar* in the Sixteenth Century

THE *TRIUMPHS OF CAESAR* received reasonably frequent mention in the critical literature of the sixteenth century.[1] Already at the end of the fifteenth century, they were being displayed to interested visitors as one of the sights of Mantua. If Andreani is to be believed, the same was still the case at the end of the sixteenth century.[2] As noted in Chapter 9, p. 103, there seems to have been an increase of interest in them during the opening years of the seventeenth century. However, if one examines this evidence more closely, it becomes a little less flattering. The reasons for admiring the paintings during the sixteenth century were curiously vague. It is quite clear that the reputation of the *Triumphs* lived on but it is by no means clear how many people actually managed to see the paintings. The amount of critical description is woefully small and the most striking feature remembered about them was their unusual perspectival construction with its lowered viewpoint.[3]

There is only one extended sixteenth-century description of the *Triumphs*—predictably by Vasari (Document 30, p. 186); and, as a word-picture conveying a triumphal effect, it is up to his accustomed standards:

'For the same marquis [Lodovico] Andrea painted the Triumph of Caesar in a chamber of the palace of S. Sebastiano at Mantua, and this is the best thing which he ever did. It shows in an excellent arrangement the beauty and decoration of the chariot, a man abusing the victor, the relations, perfumes, incense, sacrifices, priests, bulls crowned for sacrifice, prisoners, booty taken by the soldiers, the parading regiments, elephants, spoils, victories, the images of cities and fortresses in various wagons with a quantity of trophies of spears and arms for the head and back arrayed on poles, coiffures, ornaments and vases without number. Among the crowds of spectators is a woman holding a child by the hand, who has run a thorn into his foot, and he is weeping and showing it to his mother very gracefully and naturally. Andrea, as I may have intimated elsewhere, had the admirable idea in this work of placing the plane on which the figures stood higher than the point of view, and while showing the feet of those in the fore-ground, he concealed those of the figures farther back, as the nature of the point of view demanded. The same method is applied to the spoils, vases and other implements and ornaments. The same idea was observed by Andrea degli Impiccati in his Last Supper in the refectory of S. Maria Nuova. Thus we see that at that time men of genius were busily engaged in investigating and imitating the truths of Nature. And, in a word, the entire work could not be made more beautiful or improved, and if the marquis valued Andrea before, his affection and esteem were greatly increased.'

[1] In general, see the Documents.

[2] See the title-page (*no. 88*) *ut iam per annos supra centum, non solum incolarum, verumetiam ex variis orbis partibus, advenarum oculos tanquam mirabile quoddam ad sui inspec-* *tionem attrahant . . .*

[3] See Serlio, Document 27. For general remarks about Mantegna as an expert in perspective see the documents printed by Kristeller (G).

As an account of what was actually to be seen, this is in almost every respect misleading. For instance, Vasari mentions 'the soldier who abuses the *triumphator*' (*colui che vitupera il trionfante*). It is true that soldiers were allowed to sing insulting songs about their general at a Triumph; but the feature does not appear in Mantegna's paintings since he omitted the army following the general.[1] Likewise Vasari's mention of the parading regiments (*ordinanza delle squadre*) is also nonsense. *Parenti*, *profumi* and *incensi*, possible ingredients of a Triumph and noted by Vasari, are all omitted by Mantegna. Likewise 'the images of cities and fortresses in different wagons' (*le città e le rocche in varii carri contrafatte*) is hardly an accurate description of what is visible. Vasari's 'crowds of spectators' (*moltitudine degli spettatori*) is rather less informative than Equicola's *mancavanovi li spectatori* (the spectators are missing). Finally, Vasari's one piece of detailed description is only partially correct. This is of a child among the spectators who is complaining because of a thorn in his foot. There is indeed a complaining child in the seventh canvas. But there is now no evidence that it ever had a thorn; and it is among the prisoners. The impression derived from this is that, when Vasari saw the *Triumphs*, it was a very brisk visit; and what he eventually wrote was an account of what he thought he ought to have seen, based on the classical accounts which he obviously knew. However, if the greatest art historian and critic of the sixteenth century could make descriptive errors on this scale about what he called Mantegna's greatest work, one cannot help wondering what actually were the conditions for viewing the *Triumphs*.

Until a history of the palace of S. Sebastiano is written, the opportunities for inspecting the *Triumphs* during the sixteenth century will remain a mystery. It is difficult not to suspect that they were in some way restricted—which would account for ignorance about such basic details as the number of canvases (as noted earlier, Scardeone [1560] thought there were seven, Document 29). Such ignorance would, of course, have been impossible had there been engraved or drawn reproductions available. It appears this was not the case. The somewhat ambiguous position of Giulio Campagnola needs, however, to be examined.

In 1502, Pomponius Gauricus in his *De Sculptura* praised Giulio Campagnola for being amongst those artists who chose good models; and he instanced the fact that Giulio had 'imitated' Mantegna's *Triumphs of Caesar*.[2] This could be interpreted as meaning that Giulio had executed a copy of the series[3] which was well known in its day but has since been lost. There is, however, a more interesting possibility. This gift of Giulio for 'imitation' is mentioned in the earliest references to him;[4] and there is the strong possibility that he visited Mantua and worked under Mantegna in 1498.[5] There is thus an equal possibility

[1] Possibly Vasari misunderstood the attitudes of those soldiers in Canvases VIII and IX who are looking up at Caesar.

[2] Document 14. It seems beyond question (see R. Weiss, *Journal of the Warburg and Courtauld Institutes*, XVI, 1953, 'The Castle of Gaillon in 1509–10', p. 12) that *Iulius* here is Giulio Campagnola.

[3] Kristeller, (G) p. 462 and (E) p. 441, seemed to suggest that Giulio had copied the whole series.

[4] The evidence for Giulio was conveniently summarised by Hind, *op. cit.*, Vol. 5, p. 189 f. In a letter of Matteo Bosso of 1495, it is said of Giulio *Quid quod stilo atque peniculo claros ita aemulatur pictores: ut vix ulla vel Mātineae vel*

Bellini imago tam porro sit elegans: quam: si in mentem induxerit atque contēderit: non examussim effingat et proprius aequet. In another letter of 1497, of Michael de Placiola (printed in Kristeller (G) Dok. 148) Giulio is recommended as somebody who had achieved such perfection in painting *che'l Belino non po far cossa si bella che Julio non facci uno simele exemplo a l'exemplare.*

[5] Giulio Campagnola was born at Padua in 1482. The letter of 1497, cited above, written when Giulio was aged 15, was part of an attempt to get Giulio received into the Gonzaga household at Mantua. He was recommended as a talented, agreeable and suitable young man for such a position; but Michael de Placiola included in his proposals the plan that Giulio should occupy his leisure *in lettere et*

that some of the drawings and engravings which are closely connected with the *Triumphs* are his work. Since their purpose in this instance would have been to demonstrate a facility for copying for which he was apparently well known, the fact that none of these drawings or engravings bears any particularly close relationship to Giulio's later style is of little consequence.[1] For the same reason, however, it would be extremely hazardous to assign particular drawings and engravings to him. If he was as good as his friends and relations said he was, then the 'Senators' drawing in Vienna which is among the best of the surviving drawings might plausibly be assigned to him (the style is discussed in the Catalogue, p. 165). Published subsequently as an engraving, it would have reached a wider public and entered the cabinets of the connoisseurs.[2] Thus by 1502, Gauricus' readers would have known what he was talking about. There seems little point, however, in speculating further about these drawings and engravings from such uncertain premises.

Whatever the truth about their authorship, the three 'triumphal engravings' seem to underlie the few 'triumphal borrowings' traceable in the work of other Italian artists in the late fifteenth and sixteenth centuries. The latest of these is by Perino del Vaga c. 1530 (*no. 117*).[3] It might be expected that Giulio Romano would have borrowed a few figures or figure-groups in the course of his extensive operations in Mantua itself, but nothing of the sort seems to be the case.

On reflection, this is not perhaps so surprising. Mantegna belonged to that small distinguished company of first-rate *quattrocento* artists—Verrocchio and Signorelli among them—whose style was rapidly overtaken by events in Rome during the early years of the sixteenth century. It is only necessary to look at Perino del Vaga's version of the engraving to see the stylistic gulf that yawned between the great Mantuan artist and a painter schooled in the Rome of Raphael and Michelangelo. Perhaps then the virtual absence of direct 'borrowing' should not be overemphasized.

For reasons which are not entirely clear, Mantegna's *Triumphs* had a more immediate if limited influence north of the Alps. Some time between 1502 and 1510, a sculptured replica of the procession was made for the courtyard of the Château of Gaillon.[4] In 1503 a minor northern artist called Jacopo da Strasbourg issued (in Venice) a set of woodcuts of a *Triumph of Caesar*, inspired by Mantegna (*nos. 66–77*).[5] Jacopo certainly knew the engrav-

qualche bel opera o de pictura o de miniatura . . . secundo che'l fusse guidato da m.Andrea [Mantegna]. Nothing is known for certain about Giulio's movements until 1499, at which date he was in Ferrara; but the transition ⸱ ⸱ ⸱ n Padua to Mantua, and then, on the recommendat ⸱n perhaps of Isabella, to Ferrara seems a plausible one.

[1] But Giulio's *œuvre* contains one strongly Mantegnesque engraving of John the Baptist—see P. Kristeller, *Giulio Campagnola* (Berlin, 1907), No. 3.

[2] See the Catalogue, p. 167. More copies survive of the 'Senators' engraving than of any of the other 'triumphal' engravings.

[3] I have noted the following direct borrowings by Italian artists:
(*a*) Liberale da Verona, *Dido's Suicide* (London, National Gallery, no. 1336, *no. 124*), ascribed to the 1490s, which draws on 'The Senators'.
(*b*) Giolfino (attributed), *The Triumph of Pompey* (Verona, Museo Civico, *no. 118*), which draws elements from all three engravings.
(*c*) Palma Vecchio: *The Triumph of Caesar* (Coral Gables, Fla., Lowe Art Museum, University of Miami, *no. 120*) which draws elements from the 'Elephants' and the 'Trophy-Bearers.'
(*d*) Perino del Vaga, *The Triumph of Paulus Aemilius.* (Genoa, Palazzo Doria, Sala dei Trionfi, *no. 117*). This is taken directly from the 'Trophy-Bearers' see P. Askew, *Burlington Magazine*, Vol. XCVIII, 1956, p. 46 ff., 'Perino del Vaga's Decorations for the Palazzo Doria, Genoa'.

[4] R. Weiss, *ut sup.* The relief is now lost.

[5] These engravings are mentioned by J. D. Passavant, *Le Peintre-Graveur* (Leipzig, 1860–4), Vol. 1, p. 133, who recorded that each sheet had *une explication latine* and that the first sheet was signed and dated by an inscription. I have not been able to see a copy with the inscription on the first sheet. But the Warburg Institute (London) possesses photographs of a set now in New York, containing the *explications*.

ings of the 'Elephants' and 'Trophy-Bearers'. He made his elephants span two blocks (*nos. 72, 73*); and he also imitated the *ferculum* and the figure of the stooping standard-bearer (*no. 69*). There is little to show that he had personal knowledge of the paintings, but he had information about them which led to the inclusion of some otherwise unusual details. The banners with pictures of cities reappear (*no. 70*), taken from Mantegna's first canvas. The mocking man with bells on his wrists from the seventh canvas also reappears (*no. 75*). Caesar comes almost at the end of the procession, although, from the civilians and soldiers behind him (*no. 76*) it is apparent that Jacopo knew the 'Senators' composition. But what is more remarkable is Jacopo's sense of the Triumph as an event that could only be reconstructed by close adherence to texts (which were printed beneath the individual scenes). The elements of his *Triumph* are almost the same as those of Mantegna, made up out of the same sort of patchwork of Appian and Plutarch with occasional references to Josephus and Pliny.[1]

A few years later (probably in 1508) Jacopo's woodcuts were pirated and adapted by the Parisian publisher and printer Simon Vostre.[2] There is a series of Books of Hours in which Jacopo's work was used as the basis for some (printed) marginal decorations. Each little picture has a phrase or two of explanatory Latin text beneath it; and reading the whole series in sequence, one is again confronted by the familiar literary patchwork.[3]

Far more interesting than this was the adaptation of the three Mantegnesque engravings made by Hans Holbein the Younger in 1517–18 for the façade decoration of the Hertenstein House in Lucerne. The house was unfortunately demolished in 1825, but the paintings had previously been copied, and these copies show that Holbein ingeniously extended the matter of the three engravings so that it stretched across nine horizontally placed panels of the façade. There is nothing in the figure painting to suggest that Holbein had seen the originals at Mantua. It is nevertheless interesting that he set his figures as a continuous procession behind painted pilasters. It is clear therefore that he had some special knowledge about the way in which the *Triumphs* were intended to be displayed.[4]

Thus in three distinct cases, one can trace the spread of Mantegnesque ideas north of the Alps; and in these circumstances, it becomes extremely tantalizing to find at the court of Brussels, *c.* 1510, mention of a set of eight tapestries (now unfortunately lost) representing the Triumph of Caesar.[5]

[1] Jacopo's programme is by no means entirely dependent on Mantegna. For instance, he made his procession head for the Colosseum. By introducing soldiers (albeit cavalrymen) after Caesar (*no. 77*), he demonstrated his awareness of the last part of the procession which was never painted by Mantegna. Finally, he introduced Caesar's horse (*no. 74*). This marvellous animal, so it was said, had toes like human feet (Pliny, *Historia Naturalis*, VIII, 64, and Suetonius, *De Vita Caesarum, Divus Julius*, chap. 61). It is less clear why Jacopo gave the animal the horn of a unicorn, but the passage from Suetonius is quoted in the text beneath, making the identification with Caesar's horse plain.

[2] Simon Vostre had a continuous record of publishing throughout this period. The Books of Hours can only be dated approximately through the opening date of the Liturgical Tables. The introduction of the *Triumphs of Caesar* as decorative material can be dated from the Hours for the Use of Rouen. Those with the Table beginning in 1506 do not have the *Triumphs*; those with the Table beginning in 1508 do. The *Triumphs* also appear in Hours

for other Uses—Chartres and Paris (both with the Tables beginning in 1508) and also Orléans (Table beginning 1510). For a description of two of these books see P. Lacombe, *Livres d'Heures imprimés au XVᵉ et au XVIᵉ siècle conservés dans les bibliothèques publiques de Paris* (Paris, 1907), No. 174 (Chartres, *c.* 1508) and Rouen, *c.* 1508.

[3] Almost throughout Vostre's production the textual and visual patchwork is closely related to Jacopo da Strasbourg's wood-engravings. But it is curious that, in the Hours for the Use of Orléans, the publisher supplied a French text which bears virtually no relation to the Latin sources.

[4] For an account of this façade, see P. Ganz, *The Paintings of Hans Holbein* (London, 1956), p. 262, Cat. Nos. 158–61.

[5] See P. Saintenoy, *Les Arts et les Artistes à la cour de Bruxelles* (Brussels, 1934), p. 167. Here is transcribed an entry in the accounts at Lille, recording a payment to a tapestry dealer *pour huit pièces du triumphe de Julius César*

From what has been said, it may appear that Mantegna's ideas were in some way more important and influential than his style. Perhaps this may have seemed the case to the followers of Raphael. It is certainly difficult to imagine much common ground between the exponents of the *maniera* and the stark overpowering strength of Mantegna's masterpiece. On the whole, the art-historian who searches for precise evidence of stylistic 'influence' will be disappointed. The works directly and obviously inspired by the *Triumphs* are, by and large, trivial. It seems to have been about a century before the *Triumphs* were appraised justly and sympathetically; and the historian is left with the interesting problem as to what it was that the patrons and artists *c.* 1600 appreciated in them, which had evidently been missed by earlier generations.

Mantegna's ideas about the appearance of antique detail and ornament are important, but any temptation to emphasize them at the expense of his pictorial style should be firmly suppressed. Indeed, such a procedure must seem entirely implausible to anyone seeing the paintings. The fact is that the ideas about Antiquity and the style in which they are painted are inseparable; and although a large part of this book is devoted to picking apart and assessing the significance of the classical and not-so-classical detail, it would be misguided to visit the work in the expectation of being treated to academic fare tastefully presented. Mantegna's appreciation of the Ancient World matured slowly. But from faithfully reconstructing the classical world as a series of objects and details, he came by slow degrees to paint it as a world inhabited by living people—*prope vivis et spirantibus adhuc imaginibus*, as the Marchese Francesco put it. Undoubtedly this required a powerful imagination. It also required a profound knowledge and a dedicated mind, to counteract the excesses that the imagination might, untrammelled, perpetrate. Somewhere in the centre of that complex lies the secret of Mantegna's achievement. It is an achievement that carries instant conviction. It does not matter that the bagpipes are unplayable, the siege-equipment inscrutable, the armour sometimes unusable or even dangerous, the architecture at times ambiguous. It does not even matter that a few patently fifteenth-century objects have crept in. The total effect is such as instantly to make one feel that one is in the presence of the Age of the Caesars. This was an experience which was entirely new in the years around 1480–90; and in spite of the effects of time on these works, it is still possible to re-create in the imagination something of the force that the experience must have had. In Mantegna's hands, the world of the classical past suddenly became a living reality.

It was the pulsating life behind the minutely observed external forms which made it so vivid; and this central fact was subsequently grasped by at least one great artist. The young Titian himself produced (probably *c.* 1510–15) a Triumph—an immense woodcut illustrating an allegorical *Triumph of Faith* (*no. 122*). A comparison of this with the *Triumph* produced by Jacopo da Strasbourg in Venice in 1503 is instructive. The 1503 *Triumph* is weighed down by classical paraphernalia, which tend to crush the inadequate and at times pathetic pictorial style. The artist plagiarized much of the antique detail but was totally unable to provide

pour servir en salle. It is, of course, true that these may have been similar to the Berne *Caesar* Tapestries (*c.* 1465–70. See Exhibition Catalogue *Die Burgunderbeute und Werke Burgundischer Hofkunst*, Berne, 1969, p. 372 ff.) Nevertheless, Mrs E. J. Kalf has recently published a Tournai tapestry of *c.* 1520–30, which is indubitably based on the two engravings of the 'Elephants' and the 'Trophy-Bearers'. (E. J. Kalf, *Bulletin van het Rijksmuseum* Year 23 (1975), p. 166, 'Prenten naar Andrea Mantegna in verband gebracht met een Wandtapijt'.)

an adequate figure style to go with it. Titian's *Triumph* makes no attempt to be classical; and there are no direct quotations from Mantegna's work. The similarities of treatment, however, remain striking. Many of Mantegna's figures find echoes in the *Triumph of Faith*; and the spacing of some of the elements and the juxtaposition of heads and other objects are often similar. It is as if the younger artist, penetrating the elaborate classical disguise, had got through to the basic elements which give the work its vivid life. The excitement of the events taking place made at least as deep an impression on Titian as the correctness of the detail in which they were clothed. The first surviving reference to Titian's presence in Mantua only comes in 1519, but the *Triumph of Faith* certainly suggests that he had visited the city before that date.

Nor was this the end of Titian's indebtedness to Mantegna. A few years later he painted the Frari *Assunta*. This appears to be partly inspired by Mantegna's own early *Assunta* in the Eremitani, Padua; however, the dramatic row of powerful, gesticulating figures seen from a low viewpoint surely carries with it further memories of the *Triumphs of Caesar*. It is in works of this calibre rather than in the plagiarisms of mediocre artists that one will find the most fitting monuments to the influence of the *Triumphs* on the art of the High Renaissance.

9 · The Later Copies and their Derivatives *c.* 1600–1750

THE EARLIEST COMPLETE DATED COPY of the *Triumphs* is the series of woodcuts by Andrea Andreani (*nos.* 89–97) issued in Mantua in 1598–9. In conjunction with these were issued two pages showing pilaster designs, and an ornamental title page showing the bust of Mantegna which is now in S. Andrea, Mantua.[1] The occasion of Andreani's woodcuts is not known, but there seems to have been some sort of revival of interest in the *Triumphs* around the turn of the sixteenth century. It was at this period that they were moved back to the main *Palazzo Ducale* from the palace at S. Sebastiano as discussed above, pp. 95–6. Only a little later, Daniel Nys was informed that they were judged by the Duke to be among his most treasured possessions.[2] It is precisely from this period that there survive a number of small painted copies.

The purpose of these copies is not clear. A minor Mantuan artist called Lodovico Dondo was paid to produce a set in 1614.[3] These are lost; but in Munich there are the remains of another set, signed by Dondo, and dated 1602 (*nos. 98-102*). Painted on copper they are in most respects rather crude, and it might be imagined that they were suitable for the 'quality' tourist trade.[4] A similar but isolated copy survives at Brescia of the 'Captives' canvas (*no. 103*). Perhaps it was a part of another set; yet presumably it was also possible to order copies of individual canvases. Judging from its style, the Brescia painting is also by Dondo.[5] Finally, at Siena, a further incomplete set exists (*nos. 104-7*). Judged by some to be finer than the works of Dondo, there seems, nevertheless, to be little to choose between the sets; and there is no reason to suppose that they are very different in date.[6]

Two further sets of copies dating from this period may be mentioned. When the paintings were sold to Charles I, Daniel Nys undertook to have a set of full-scale copies made to fill the gaps in the ducal collection.[7] Their fate is unknown, but at the beginning of this century full-scale copies of the third and fourth canvases appeared briefly on the North Italian art market. Judging from the photographs their quality was indifferent; and their present whereabouts is unknown.[8] It is nevertheless possible that they are survivals from Nys' set. No other full-scale copies are known.

[1] For Andreani, see A. Reichel, *Die Clair-Obscur-Schnitte des XVI., XVII. und XVIII. Jahrhunderts* (Zürich, Leipzig, Vienna, 1926), p. 35 ff. The woodcuts are virtually identical in size—37 × 37 cm.

[2] Letter of 1629 quoted by Luzio, *Galleria*, p. 159.

[3] Luzio, *Galleria*, p. 105.

[4] Munich, Alte Pinakothek, Inv. Nos. 5281, 1146, 1135, 1147, 1134, oil on copper, height 19.1–19.5 cm., width 18.1–18.3 cm. I am very grateful to Dr Regina Löwe for looking at the Dondo paintings since I was unable to do so myself. She confirmed the rather unfavourable impression they create in photographs but added that there are qualitative differences within the set. There was evidently more of this sort of reproduction since, in the inventory printed by Luzio (*Galleria*, p. 119), sixteen others appear (Item 399). To take up other suggestions made by Dr Löwe, it is possible that the Gonzagas themselves gave these miniature copies away to friends; and perhaps ultimately the impending sale of the collection further stimulated a demand for replicas.

[5] Brescia, Pinacoteca Tosio Martinengo. Catalogued in 1927 as 'Maestro Mantovano del secolo XVI'. Catalogue no. 25; Inventory no. 131. Oil on panel, 18.5 × 19.5 cm.

[6] For a different assessment, see G. Paccagnini, *Andrea Mantegna, Catalogo della Mostra* (Mantua, 1961), p. 46. Only four paintings survive, in the possession of the Pinacoteca, Siena. They measure 21 × 19 cm. and are in oil painted on copper.

[7] Luzio, *Galleria*, p. 157.

[8] See the catalogue of the sale of the Cernazai collection, Udine, by the Milan dealer A. Cenolini, 24–31 October 1900. These two canvases were traced back to the Manin collection, Venice. Their size was 275 × 265 cm. Their history since 1900 has not been traceable. I am, nevertheless, very grateful to the Professor Commendatore Carlo Someda de Marco of the Accademia di Scienze, Lettere e Arti, Udine, for making enquiries in an attempt to find out what happened to them. The catalogue illustrations are unfortunately too poor for reproduction.

Another set of copies exists in Vienna (*nos. 78–86*).[1] These are the finest of all the surviving copies. When they were first published, it was suggested that they might have been made to assist the creation of Andreani's woodcuts. There is nothing in their history to help in their dating[2] and their style has so far resisted analysis. But two features, it was pointed out, supported their connection with Andreani. They are virtually the same size as the woodcuts; and they are, unexpectedly, painted in grisaille. This theory was almost at once taken up and developed.[3] It was observed that the woodcuts and the Vienna paintings had a number of differences in common when compared to the originals. Andreani on his title page (*no. 88*) mentioned another Mantuan artist, a painter called Bernardo Malpizio; and although Malpizio's part in the undertaking is not clearly defined, it was suggested that the Vienna copies were made by Malpizio as an aid for Andreani.

A close examination of the detailed variations between the originals and the copies and their distribution through the different copies lends support to the broad outlines of this argument. At the same time it is also clear that the situation was more complicated. The table below lists and describes the significant variations as they are found in all the copies.[4] They amount to differences in the placing of either objects or decoration. The table shows conclusively that the Vienna copies stand apart in containing all the possible variations. Thus they establish themselves as a kind of *Urtext* for the various errors to be found elsewhere.

The table below shows equally that none of the other copies contains all the variations present in the Vienna copies. For instance, the Munich version of the second canvas (*no. 98*) is closer to the original than to the Vienna copy. But the Munich version of the fourth canvas (*no. 99*) is closer to the Vienna copy. More important, the same sort of alternation occurs in the Andreani woodcuts. All of this suggests what might perhaps be expected—that copyists in the late sixteenth and the early part of the seventeenth centuries had only intermittent access to the originals; and that they were forced to rely to some extent on available reproductions. These observations have a bearing on the date of a rather different set of copies painted originally on the walls of a private house in Mantua but now exhibited in the *Castello* (*nos. 108–116*). They are inscribed with the date 1673, but the authenticity of this has been questioned.[5] For this reason it is of some interest that their author, alone of all the copyists whose work survives, omitted the extra torch that often and erroneously

[1] E. R. von Engerth, *Kunthistorische Sammlungen des Allerhöchsten Kaiserhauses: Gemälde, Beschreibendes Verzeichnis* (Vienna, 1884), Vol. I, p. 202. They are painted on paper, mounted on canvas. The average size is 38 × 38 cm.

[2] They are first mentioned in the 1659 Inventory of the Archduke Leopold Wilhelm.

[3] See Portheim, *op. cit.*

[4] Note that Andreani occasionally simplifies the design by omitting bands of decoration. Such simplifications are not included in the attached table. There is a further complication. The Vienna paintings are not all in good condition. In particular, the second composition (*no. 79*) seems to be severely cracked and rubbed (if compared, for instance, to the seventh composition). Many areas now appear bare of detailed ornament, where there ought to be decoration— for instance, the boots of the Colossus, the trappings of the horse or the architecture. In the case of the horse-trappings, however, close examination shows traces of this decoration still surviving. The same is true of the architecture. In

another bare area, the circumference of the wheel on the left hand cart, traces of the foliage decoration which ought to be there are indeed still visible. On the whole, therefore, the absence of particular areas of detailed treatment in the Vienna copies has been ignored in the table of 'significant variations'.

[5] These wall paintings were discovered during the course of demolishing no. 16, Via Mazzini, Mantua, in 1926. They were first properly published by Luzio in A. Luzio and R. Paribeni, *Il Trionfo di Cesare di Andrea Mantegna* (Rome, 1940), p. 28 ff. This account received comment from G. Fiocco in *Bollettino del Museo Civico di Padova*, 1939-40, p. 186 ff. G. Paccagnini resumed the discussion (*ut sup.*, p. 47) differing in his assessment of the date. As painted this reads *MDCLXXIII*. But both Luzio and Fiocco claimed that this was a later overpaint and that an original date was still legible beneath. Fiocco thought that this should read *MDCXXVIII*—which would, of course, fit the theory here proposed that they were done before the *Triumphs* were removed in 1629.

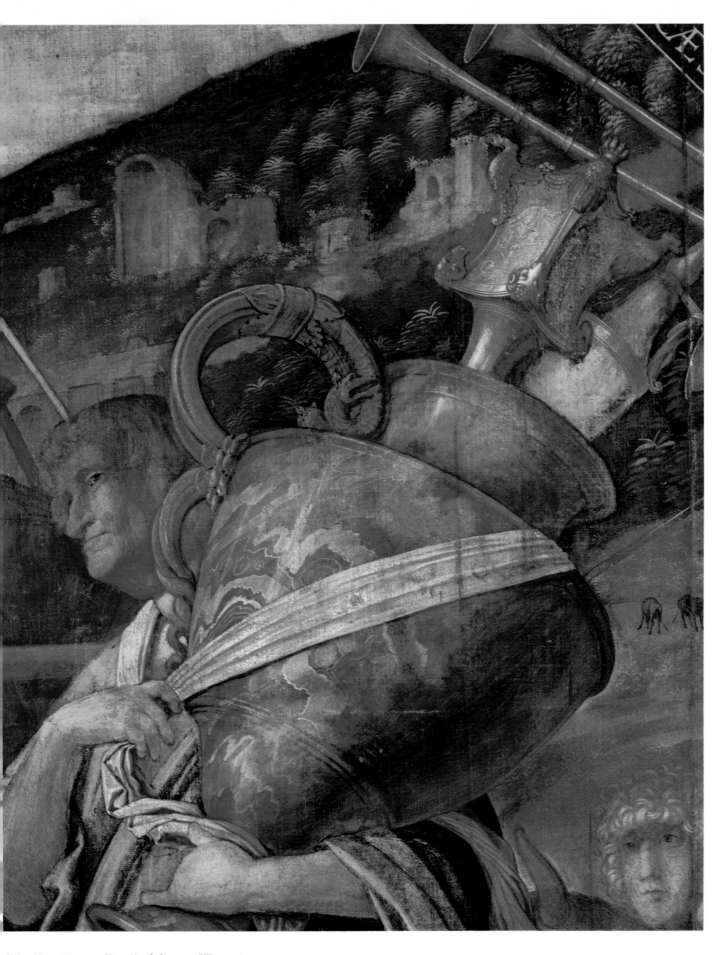

The Vase Bearer. Detail of Canvas IV

seems to have been inserted in the fifth composition. This would suggest that he had access to the originals and must therefore have been at work before they left Mantua in 1629.

All this does not entirely clarify the status of the Vienna paintings, but it does support the theory that they antedate all the other copies. However, it seems unlikely that objects of this quality should have been done merely to facilitate a series of woodcuts (although the woodcuts are of high quality too). Moreover, Andreani on his title page, in dedicating his work to Vincenzo I, makes it clear that it was done at the Duke's instigation (see *no. 88*, also Document 33, p. 187). In these circumstances, one could not doubt that Andreani would have had reasonable access to the originals; it would hardly have been necessary to commission first another set of replicas. Perhaps, then, the Vienna copies already existed as a quite different commission and were made available to Andreani for reference purposes in his studio.[1]

This early seventeenth-century enthusiasm for the *Triumphs of Caesar* found its most brilliant expression in the small painting by Rubens, now in the National Gallery, London (*no. 123*). Although this is more than a mere copy, it seems appropriate to introduce it in this context. It is based on the fourth and fifth canvases. Recent opinion supports a date *c.* 1630 for this work, which is only the most spectacular of a number of drawings and paintings showing Rubens' regard for Mantegna's *Triumphs*.[2] Since Rubens altered much of Mantegna's detail, it was clearly the colour, excitement and movement that interested him; and it is, in fact, notable that although he transformed Mantegna's meticulous technique into his own pictorial style, Mantegna's inspiration is enhanced rather than obliterated.

After their arrival at Hampton Court, the *Triumphs of Caesar* appear to have passed temporarily out of artistic currency. However, interest in them seems to have reawakened towards the end of the century, albeit briefly; and it appears to have been aroused by events of the reign of William III—the rebuilding works at Hampton Court after 1689 and the restoration by Louis Laguerre of the paintings (see Chapter 10 for the later history of the paintings). In 1692, a set of engravings was issued by the Roman publisher Domenico de' Rossi; and although his motives are unknown, it is difficult to believe that the two sets of

[1] Very little is known about Bernardo Malpizio. See Kristeller's account in Thieme-Becker's *Künstlerlexikon* under *Andrea Andreani*. Malpizio was also a publisher.

One can now do little more than speculate on the relationship of the Vienna paintings to the originals. It occurred to me, however, that the Vienna copies might have been an attempt to perpetuate (? in the later sixteenth century) some now lost Mantegna *modelli*; and that, in this case, the variations would also have originally been Mantegna's and might therefore conceivably survive in the *substrata* of the Hampton Court paintings. During the recent conservation, therefore, the critical areas of the originals were examined by infra-red photography and, where possible, by X-ray. In no case were there any *pentimenti* visible in the originals which pointed in the direction of the Vienna version.

A residue of doubt nevertheless remains. It will be noticed that, uniquely, the Vienna painter introduced a half-seen figure emerging on the extreme right of the eighth composition (*no. 85*). This, as an idea, matches reasonably well a figure disappearing on the extreme left of a study for the ninth canvas, known through the drawing in the British Museum (*no. 54*). So did the Vienna painter have access to some of Mantegna's unexecuted ideas?

[2] The fullest recent treatment of this work is to be found in G. Martin, *The Flemish School c. 1600–c. 1900* (National Gallery Catalogues, London, 1970), p. 163 ff. He argues that this painting is basically a copy of Canvas V to which subsequent additions were made to the left and probably also the right. Whether Rubens intended to treat the complete set of nine *Triumphs* in this way is not clear. The priest, augur and sacrificial group in the centre were inserted by Rubens to bridge the gap filled, in the original, by a pilaster.

It seems generally accepted that Rubens, although he would certainly have known the originals, must have been using a combination of his memory and copies (probably Andreani's woodcuts) when he painted this work. His recourse to copies is proved by the presence of the tell-tale extra *candelabrum*, clearly visible behind the left-hand elephant-rider.

The size of the Rubens is unrelated to that of any of the copies; the right-hand section of his canvas (see G. Martin *op. cit.*, Appendix I) which corresponds to the area inspired by Mantegna's fifth composition is 86.8 × 90.2 cm. The smaller copies are *c.* 19 × 19 cm.; Andreani's versions are 37 × 37 cm.; those at Vienna 38 × 38 cm. Thus Rubens' version is more than twice the size of the largest of the others.

THE TRIUMPHS OF MANTEGNA

The Later Copies

CANVAS	DESCRIPTIONS OF ALTERNATIVES	ORIGINAL PAINTINGS	VIENNA	ANDREANI	MUNICH	SIENA	EX CERNAZAI COLL., UDINE (LOST)	MANTUAN WALL PAINTINGS	AUDENAERD ENGRAVINGS
II	Cart carrying Colossus. Upper moulding (a) with foliage decoration or (b) plain	a	b	b	a	a	—	?b	b
	Rear drapery of central soldier flutters (a) virtually clear of end of car or (b) so that it obscures a part of it	a	b	a	a	a	—	?a	a
III	(b) Olive foliage projecting upwards along right margin or (a) no foliage	a	b	a	—	—	?a	?a	a
	Miniature herm figure in vessel has (a) turned head or (b) frontal head	a	b	b	—	—	?	?	b
IV	Decorative bands round front ox have (a) decorated ends or (b) plain ends	a	b	b	b	b	—	?	b
	Decorative band round rear ox has (a) arabesque pattern or (b) chevron pattern	a	b	b	b	?	—	?	b
	Female figure on standard has head (a) pointing upwards or (b) turned towards one side	a	b	b	b	?b	—	?	?
V	(b) torch flame projecting above back of crouching youth or (a) open sky	a	b	b	—	b	b	a	b
VII	(a) Capital on pilaster or (b) no capital	a	b	a	b	Brescia b	—	a	a
VIII	(a) figure on extreme left (cut by margin) or (b) no such figure	a	b	a	—	—	—	a	a
	(b) figure of standard-bearer emerging on extreme right or (a) no such figure	a	b	a	—	—	—	a	a
IX	Upper figures above arch are (a) cut or (b) complete	a	b	a	a	—	—	b	a

events are unconnected. De' Rossi in effect paid the Dutch engraver Robert van Audenaerd to re-engrave the Andreani woodcuts.[1] Audenaerd's work was in turn re-engraved by C. Huyberts[2] and reached the libraries of gentlemen as illustrative material to Samuel Clarke's edition of Caesar's *Commentaries* (1712).[3] It was again used in a similar context in William Duncan's translation of the *Commentaries* (1753).[4] Between these dates, George I had paid for further restoration work on the *Triumphs* by the painter Joseph Goupy (see below, p. 112). Perhaps the pictorial consequences of this revived interest seem meagre, but at least one work deserves special notice. This is Pellegrini's spirited pastiche of Mantegna's work over the staircase of Kimbolton Castle, painted at some date after 1710.[5] Thereafter, however, interest in the *Triumphs* seems to have lapsed. Too flamboyant, perhaps, for Neo-Classical taste, too archaeological for the romantic, it was not until the following century that they were rescued from further polite if temporary oblivion; and the word 'rescue' is not ill chosen. For this has, in fact, been the theme of the last chapter in their history.

[1] Van Audenaerd's engravings differ only in minor detail from Andreani. Uniquely, he introduced into Canvas IV a standard with a hand stuck on its top. Since the whole of this area of the engraving is defective when compared to Andreani, the assumption is likely that van Audenaerd's own set of Andreani was also defective at this point. Perhaps the top left corner of this scene had become torn away and lost, and van Audenaerd thus would have had to supply it from his imagination. In general, the inscriptions are missing but the *tabula ansata* in Canvas II is inscribed 'De Gallia Aegypto Ponto Africa Hispania' showing that the engraver at least interpreted the procession as a fivefold Triumph. The engraver also supplied pilasters which are almost exactly those of Andreani, but in reverse.

[2] For Huyberts see Thieme-Becker, *Künstlerlexikon*.

[3] Samuel Clarke, *C. Julii Caesaris Opera quae extant* (London, 1712).

[4] William Duncan, *The Commentaries of Caesar* (London, 1753).

[5] On Pellegrini and Kimbolton Castle, see E. Croft-Murray, *Decorative Painting in England 1537–1837*, Vol. II (Feltham, 1970), p. 255.

10 · The Later History of the *Triumphs*, 1630–1919

IT IS NOT CLEAR when the *Triumphs of Caesar* eventually arrived in England. They must have left Mantua before the imperial siege in 1629 and they had apparently been despatched from Venice by October 1630.[1] It is to be inferred that they were taken directly to Hampton Court and placed in the King's Gallery,[2] but in fact nothing is known about their fortunes until after the execution of Charles I in 1649. Almost at once valuations were made of the possessions of the royal family as a preliminary to any later disposal. The pictures at Hampton Court were valued on 3–5 October, 1649 by a quorum of the trustees appointed to value the King's goods. In due course, they listed '*Nine. peeces beinge a triumph. of Julius Ceaser; done by Andre de Mantanger 1000:00:00*'.[3]

By May 1650 these had apparently been sent up for sale to Somerset House with other parts of the collection[4] but were added to the goods reserved for the use of the Council of State and returned to Hampton Court. The precise reasons for the withdrawal are not known. It is sometimes suggested that Cromwell took a fancy to the martial subject-matter, but there is little evidence for this.[5] It is as likely that it was a simple resolution to retain one of the most valuable items, which also happened to make extremely good palace decoration. It is also possible that somebody had realized that the *Triumphs* might make first-class designs for the tapestry factory at Mortlake.

In the second half of the seventeenth century, their use at Mortlake is known to have been considered and, for a brief period in their history, the *Triumphs* became in some sense cartoons. In 1653, the Council ordered that the paintings should be delivered to Sir Gilbert Pickering who was at that time the Governor of the Mortlake factory.[6] Unfortunately, a silence falls on the sources almost immediately and it is not clear what were the results of this order—if any. But in 1657, on 26 May, the Council was called upon to debate a petition from the tapestry-workmen that they be allowed to design for their looms something which they called 'the story of the Triumphs of Caesar'. From the subsequent payments made in 1657–8 to finance this design, it becomes clear that only one 'story' of the *Triumphs* was

[1] See Letter Daniel Nys to Thomas Rowlandson of October 1630, reporting that virtually everything from Mantua had now been shipped from Venice and that there were 'no more pictures'. Printed in W. Noel Sainsbury, *Original Unpublished Papers Illustrative of the Life of Sir Peter Paul Rubens* (London, 1859), p. 536, document CXII.

[2] The *Triumphs* do not feature in Van der Doort's Catalogue of 1637–40 of the Royal Collection since this was primarily concerned with the palace of Whitehall. See Oliver Millar, *Walpole Society*, 37 (1958–60), 'Abraham van der Doort's catalogue of the collections of Charles I'.

[3] See Oliver Millar, *Walpole Society*, 43 (1970–2), 'The Inventories and Valuations of the King's Goods 1649–51', p. 186. The inventory gives no details about the location and hanging of the *Triumphs*, but the valuation of £1000 was among the very highest to be placed on any of the royal pictures.

[4] See G.-J. Comte de Cosnac, *Les Richesses du Palais Mazarin* (Paris, 1884), p. 413. The list is headed *Estat de*

quelques tableaux exposés en vente à la maison de Somerset Mai 1650, and includes (p. 416) Neuf pièces du triomphe de Jules César.

[5] The decision to retain the *Triumphs* had not yet been taken in April 1650; but on the 23 April, the Council of State requested to know, before they were sold, how much had been bid for them (London, Public Record Office (hereafter PRO), State Papers (hereafter SP), 25/64, p. 238) —which suggests that some doubt already existed. One piece of evidence indicates that the story of Caesar had some attraction for Cromwell. In an inventory of the tapestries of Henry VIII (see W. G. Thomson, *Tapestry Weaving in England*, London, 1914, p. 36) there were listed at Hampton Court *10 pieces of newe Arras of thistorie of Julius Caesar*. When Charles I's goods were listed in 1649, apparently the same tapestries were still at Hampton Court, listed as *Ten. peeces of Rich Arras of yᵉ history of Julius Cæsar*. (Oliver Millar, *op. cit.* note 3 above, p. 158.) These were taken over for the use of the Protector at Whitehall.

[6] PRO, SP, 25/70, p. 294.

involved—that is, only one panel of tapestry was being prepared. It is not possible, on the evidence, to say whether a single one of Mantegna's canvases was being used as a basis for the work or whether some sort of pastiche was involved. Nor is it known whether anything was actually woven.[1] Evidence for this only emerges after the Restoration in 1660. In April 1669, the Lord Chamberlain addressed a warrant to the Master of the Great Wardrobe, ordering him to 'provide, buy and deliver' for the Queen's service in her Privy Chamber at Whitehall 'Five pieces of Mortlake Hangings of the Triumph of Caesar containing One hundred ffifftie two Ells'.[2] Further evidence from May 1670 shows that the first of these 'peeces' was 'now on the looms', and by describing the designs as 'new drawne of, from the originails' supports the general impression that very little had in fact been achieved under the Commonwealth.[3]

The fate of the royal tapestries is not known but three Mortlake tapestries incorporating designs from Mantegna's *Triumphs* survive in the possession of the Duke of Buccleuch and are at present at Bowhill House (near Selkirk, Scotland). They were probably made for Ralph Montague (later Duke of Montague) and, apart from their intrinsic quality, they are of considerable 'documentary' interest. When they were made, the deterioration of the *Triumphs* was less advanced than it is now and the Bowhill *Triumphs* contain detail which has since vanished. In particular, the weavers recorded three inscriptions from the ninth canvas which have now either totally vanished or become partially illegible—a circumstance which has a bearing on the understanding of the iconography.[4]

At Cromwell's death in 1659, an inventory was made of the contents of the Protector's palaces and one hears for the first time where the *Triumphs* were hung—in the Long Gallery at Hampton Court.[5] Soon after the Restoration, in an inventory made *c.* 1666–7, the paintings

[1] PRO, SP, 25/77, p. 827. Two 'stories' were commissioned, the second being 'the Story of Abraham'. Payments for the two can be followed through 1658.

[2] See PRO, Lord Chamberlain's Papers (hereafter LC), 5/62, f. 58v.

[3] For the evidence of May 1670, see W. G. Thomson, *A History of Tapestry*, 3rd ed. (Wakefield, 1973), p. 301, for a letter of Sir Sackville Crowe dated May 7th. In it Sir Sackville Crowe, commenting to the Countess of Rutland about a series of tapestry designs, wrote: 'The latter, of *Caesar's Triumphs*, are by the best master, Montagnio, new drawne of, from the originails, and no hangings yett made by them, only a sute for the King, the first now on the looms. Which of themsoever [the various designs] your Honour falls on, something of each patterne must be left out, and only the cheefe parte of each designe made proportionable to your measures, which the latter patterne of Cesar's I doubt withoute spoileing the worke beeing full of figures will hardly be brought unto. Soe rather recommend one of the other designs, for that of *Cesar's* being full of figures, faces and nakeds wilbe deere and never made for 25s per stick, hardly under 40s.'

[4] The fullest account of the various 'Mortlake' Triumphs is to be found in W. G. Thomson, *Tapestry Weaving in England* (London, 1914), where will be found illustrations of the Bowhill tapestries (Figs. 28, 29 and 30). Thomson mentions the record of a further set of five representing the *Triumphs of Caesar*, formerly at Burley-on-the-Hill and belonging *c.* 1700 to Lord Nottingham (*op. cit.*, p. 148). The Mortlake factory came into the possession of Ralph Montague in about 1674. Since the resignation of Sir Sack-

ville Crowe in 1667, it appears to have been managed by Lady Anne Harvey, Ralph Montague's sister. She continued to manage it up to her death in 1703.
I am very grateful to the Duke of Buccleuch and his family for making arrangements for me to see the Bowhill *Triumphs*. The set was shown in an exhibition of tapestries at the Victoria and Albert Museum, London, in 1914; and the three tapestries were described in the catalogue. Their compositions do not repeat any one canvas individually, but are produced by a curiously precise 'scissors-and-paste' method. Thus, the 'first' as hung in their present location (number 15 in the London catalogue) contains the whole of Canvas VI and most of the adjacent elephant from Canvas V. The 'second' and longest (number 14 in the catalogue) contains the composition of Canvas VIII and that of IV; however, the two halves of VIII are transposed so that the procession is here led by the boy with the tambourine, and the standard-bearers are followed by the musicians. Finally, the 'third' (equal in size to the 'first' and numbered 16 in the catalogue) contains the composition of Canvas IX; but, in order to place Caesar in the centre of the tapestry further figures, the youth with the *patera* and the *victimarius*, are reintroduced (from Canvas IV and tapestry 'two') in order to extend the composition on the right. Thus these two last figures with the trumpets and trumpeters behind them actually appear twice in the tapestry series.
For the reading of the inscriptions, see Appendix II.

[5] See E. Law, *The History of Hampton Court Palace* (London, 1885–91), Vol. 2, p. 180. The inventory reference is PRO, SP, 18/203, 41.

are recorded in the same gallery, now called by its more normal name, 'The King's Gallery'. In this inventory the paintings are described, and some indication is given of the circumstances in which they were displayed. Perhaps unexpectedly, they were not hung entirely in the right order, and they were hung together with a considerable number of other paintings.[1] It was in this situation that they were seen by the diarist, John Evelyn. On 9 June 1662, while attending the new Queen Catherine of Braganza at Hampton Court, he noted 'Many rare pictures, especially the Caesarean Triumphs of Andrea Mantegna, formerly the Duke of Mantua's'. The King's Gallery, of course, formed part of the Tudor palace which was, to a considerable extent, destroyed and rebuilt under William III.[2] Nothing is known about the appearance and dimensions of the King's Gallery and consequently little further can be said about the arrangements made for Mantegna's paintings.

There is, however, no reason to suppose that the *Triumphs* had not always been displayed in the King's Gallery since they arrived in England. They required a room of considerable size, and as one of the most important items in the Royal Collection, the King's Gallery would in any case seem a suitable place of honour in which to hang them. They remained there up to the end of the reign of James II,[3] but with the rebuilding of the royal apartments at Hampton Court by William III came the first signs of a decline in the prestige which the *Triumphs* had hitherto enjoyed. The new 'King's Gallery' was designed to take, not Mantegna's *Triumphs* but Raphael's cartoons. It has, indeed, always been known as the 'Cartoon Gallery'.

The *Triumphs* were thenceforward, for nearly 150 years, relegated to the Queen's Apartments and the east range of the Fountain Court. But if the star of Raphael was in the ascendant, this does not mean that the *Triumphs* had in some dire sense fallen from grace. In a palace of any pretensions, the King's Apartments are matched by the Queen's. The *Triumphs* may have been dislodged from the King's Gallery but it was only to be moved next door to the Queen's Gallery. Moreover, as if to emphasize the esteem in which they were still held, an extensive programme of restoration was set in hand.

Initially, the restoration (which included relining) was handed over to the Keeper of the King's pictures, Parry Walton, who had completed work on three of the canvases by July

[1] This inventory of *c.* 1665–7 is in the Lord Chamberlain's Office, St. James's Palace. The *Triumphs*, in the 'King's Gallery', are described as follows:

(142) 'One of Cæsars Tryumphs wherin are carved Statues of Stoane and brasse', measurements given as 107 × 112 in.

(145) 'One of Cæsars Tryumphs wherein are many sounding of Trumpets', measurements as above.

(147) 'One of Cæsars Tryumphs wherein a carried sev'all peices of Armor and a Bason of Golde', measurements as above.

(149) 'One of Cæsars Tryumphs wherein are carried a Pot of Golde & Silver, two Bulls lead, & Trumpeters come after', measurements as above.

(151) 'One of Cæsars Tryumphs wherein one leades a bull and behinde him are three Camells', measurements as above.

(153) 'One of Cæsars Tryumphs wherin some ar carrying mony in a bason with Jewells & Rings hanging downe', measurements as above.

(154) 'One of Cæsars Tryumphs, wherein are carried nine Statue heads on Speares, & an Eagle, wth severall sorts of Musicke', measurements as above.

(155) 'CÆSAR riding in his Chariot in Tryumph', measurements as above.

(168) 'One of Cæsars Tryumphs wherein are men and women & children lead to prison. Much spoyled', measurements as above.

It is a minor puzzle that the writer mistook the elephants in Canvas V for camels. More important, it will be noted that Canvas VII (The Captives) is already described as 'Much spoyled'. Perhaps for this reason it had been moved to one end of the sequence.

[2] For the history of the palace, see E. Law, *op. cit.*, p. 110, note 5.

[3] See the inventory of James II's pictures 1688–9 in the British Library, MS Harley 1890 (printed by W. Bathoe, 1758), ff. 79ᵛ–80.

1693.[1] Walton's activity, however, was almost immediately overtaken by that of Louis Laguerre who (if George Vertue is any guide), was subsequently remembered as the principal restorer of the *Triumphs*. Laguerre came to England in 1683/4 and had previously been employed as a decorative painter at Christ's Hospital (London) and Chatsworth where he was active 1689–94. At some date after this, he agreed with William III to work on all nine canvases of Mantegna, a commission for which he was paid in 1701 and 1702.[2]

This restoration has some claim to be Laguerre's best known work, and since it has subsequently been denounced by generations of critics and art-historians, it may be appropriate to record the satisfaction that it originally gave. The evidence for this lies in the notebooks of George Vertue, where he describes Laguerre's career. According to Vertue, King William employed Laguerre 'to repair the large pictures of Mantegna. when these paintings were set up in the Palace were they now are tho these paintings were in a most decayed condition, & the subjects so different from the present manner of paintings. yet he happily mimickd the Master as to complete them to the great satisfaction of the King and all the Curious. . . '.[3] In this condition, and in this position, they were seen and admired by Celia Fiennes in the opening years of the eighteenth century[4] and by Von Uffenbach in 1710.[5] They were still there at the time of the subsequent inventory made for Queen Anne.[6] The Queen's Gallery, known in 1710 as the 'Hall of Triumph', did not remain so for very long. At some period late in the reign of George I (1714–27) the *Triumphs* were removed to make way for the Le Brun tapestries which still decorate the gallery. This is perhaps surprising in view of the fact that in 1717 further restoration work had been carried out (apparently on four of the canvases) by the French painter Joseph Goupy.[7] According to a

[1] The two sources for the activity of Parry Walton are the Treasury Books in the London Public Record Office (see W. A. Shaw, *Calendar of Treasury Books preserved in the Public Record Office*, XVII, Pt. II, London, 1939) and the Journal of Constantine Huygens, the private secretary of William III (see *Historisch Genootschap te Utrecht, Werken*, NS 23 (1876), 'Journaal van Constantijn Huygens, den zoon van 21 October 1688 tot 2 Sept. 1696', Part I). According to Huygens, whose account is nevertheless slightly ambiguous, the *Triumphs* seem already to have been removed from their gallery at Hampton Court by May 1689 (see above, *sub* May 6, p. 120) and it was intended that they should be 'set in order' by 'Mr Walon'. They were apparently taken to Windsor (*ibid.*, p. 366 *sub* 27 November 1690) but in December 1690 work had still not begun on them (*ibid.*, p. 377 *sub* 19 December when Huygens spoke to the King *van de schilderijen van Mantegna en de patroonen van Rafel. De eerste wilde voort gerepareert hebben*). However, in 1693 on July 10 (W. A. Shaw, *ut sup.*, pp. 707–8) an order was made to pay Parry Walton, as part of a composite account covering 2⅔ years, £60 for repairing three canvases of 'Andrew Mountan' and lining them. (I am obliged to Sir Oliver Millar for bringing Huygens' journal and the Treasury notices to my attention.)

[2] For Laguerre's activity see W. A. Shaw, *op. cit.*, XVI (London, 1938) and XVII (London, 1939). The details of Laguerre's employment only emerge during the negotiations for the financial settlement in 1701 and 1702 (XVI, pp. 88 and 314, XVII, pp. 42 and 59). His payment for 'painting the cartoons' of 'Andrew Montague' was to be £360, twice the rate per canvas paid to Parry Walton. When Christopher Hatton visited Hampton Court in 1697, he noted the cartoons of Raphael, but made no mention of the Mantegna paintings. They were presumably in Laguerre's hands by

that date. See the *Correspondence of the Family of Hatton* edited by E. M. Thomson for the Camden Society (London, 1878), ii, p. 229: Letter from Christopher Hatton to Charles Hatton of 2 September.

[3] See *Walpole Society*, 20 (1931–2), Vol. II, p. 125. Vertue was born in 1685 but had already begun to collect material in the early years of the eighteenth century.

[4] *The Journeys*, edited by C. Morris (London, 1949), p. 355, where she described proceeding from the Queen's Closet 'into a large long gallery wanscoated and pictures of all the Roman Warrs on one side, the other side was large lofty windows . . .'.

[5] *London in 1710: from the Travels of Zacharias Conrad von Uffenbach*, edited by W. H. Quarrell and M. Mare (London, 1934). The visit was on 24 October. After seeing 'King William's Apartment', 'we were taken into the so-called Hall of Triumph because in it hang nine great paintings representing the triumph of Julius Caesar with the words: "Veni, Vidi, Vici". They were painted by Julio Romano, Andrea Mantegna or Montagnia, with matchless elegance and tolerable delicacy of execution, especially as far as the garments are concerned. . . .'

[6] See Inventory *c.* 1710–12 in the Lord Chamberlain's Office, St James's Palace. The paintings were listed in the 'Green Gallery' but this was another name for the Queen's Gallery.

[7] In 1724, they were still in the Queen's Gallery; see Cox, *Magna Britannia* (London, 1724), Vol. 3, p. 9, under *Hampton Court*: 'in another Gallery the triumphal Entry of a Roman Emperor, very curious'. The author named the *Triumphs*, after the Raphael Cartoons, as worth special mention.
The information about Goupy's restoration emerged as

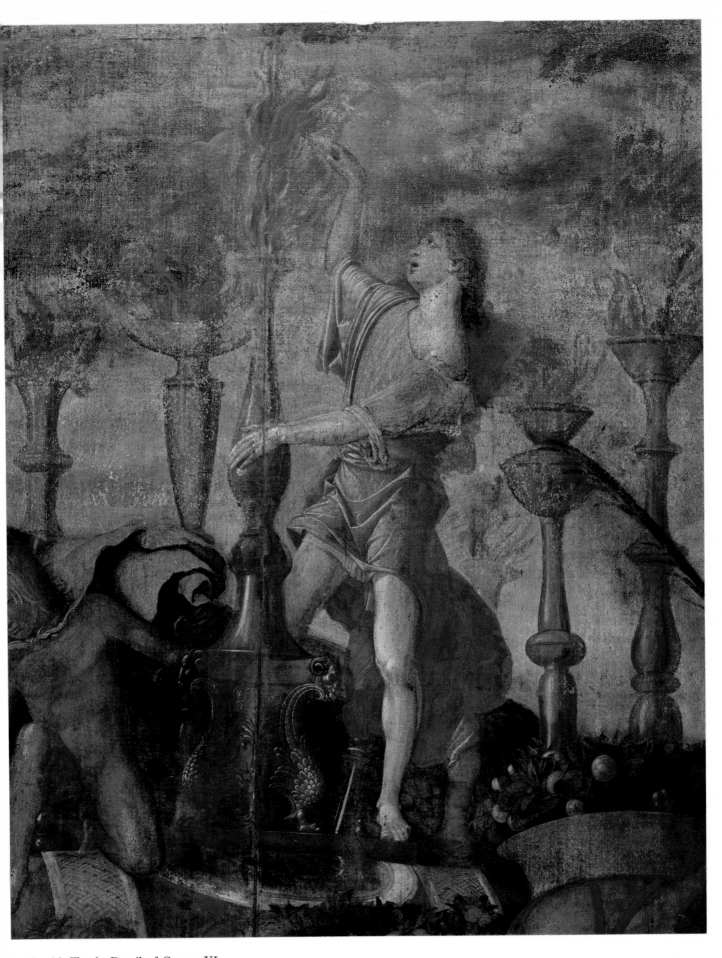

Youth with Torch. Detail of Canvas VI

later historian, George I placed them in the Public Dining Room, but the evidence for this is not clear. It is, however, certain that in 1742, when Bickham's *Deliciae Britannicae* appeared, they were in the Queen's Drawing Room.[1] They seem to have remained there for nearly a century.

The *Deliciae Britannicae* contains an interesting account of the *Triumphs*, together with a short critique of Mantegna's style. One is not surprised to hear that Mantegna's 'neglect . . . of seasoning his studies after the antique with the living beauties of nature has made his pencil somewhat hard and dry'. The author nevertheless concluded (had he been reading Vasari or was he being patriotic?) that 'the very best of all his works is this Triumph of Caesar'. What is also interesting is that the author and his eighteenth-century successors gave no hint that they saw anything odd or wrong about the condition of the *Triumphs*.[2]

It was not until the second quarter of the nineteenth century that their condition first appears to have caused comment.[3] In 1837 they were seen by Passavant, who noted that they had been 'so desperately restored and repainted by Laguerre that the original colour is only in a very few instances perceptible'. Passavant concluded 'it would be difficult, however, entirely to conceal their excellences, and in spite of the mischief of enemies, and the no less destructive civilities of friends, they remain very interesting specimens of that master's genius'.[4] That the *Triumphs* were actually unpleasant and unsatisfactory to look at was also implied by Mrs Jameson a few years later. After a long account and appreciation of the paintings, she went on: 'I have said this much of the history and merits of these remarkable pictures, because, in their present defaced and dilapidated condition, hurried and uninformed visitors will be likely to pass them over with a cursory glance. They ought therefore to be told, that next to the Cartoons of Raphael, Hampton Court contains nothing so valuable in the eye of the connoisseur as these old paintings.'[5]

During the 1830s, when the *Triumphs* were seen by both Passavant and Waagen, they were still in the Queen's Drawing Room. For reasons unknown, they had been moved to the Public Dining Room by the time that Mrs Jameson was writing her book, but when her book was published in 1842 they had already been moved yet again, to the Communication Gallery, variously known as the Portrait Gallery, the Mantegna Gallery and the Old Admiral's Gallery.[6] They remained there until the First World War.

The verdicts already quoted on the state of the *Triumphs* were depressing without spelling

part of the evidence of some legal proceedings in 1738. It has not been possible to distinguish Goupy's presumably extensive work (he was paid £200) from that of Laguerre. (C. R. Grundy, *Walpole Society*, 9, 1921, p. 77, 'Documents relating to an action brought against Joseph Goupy in 1738': see p. 80 for the reference to the *Triumphs*.)

[1] The assertion about the move to the Public Dining Room was made by Ernest Law in his *Historical Catalogue of the Pictures at Hampton Court Palace* (London, 1881), p. 256 ff., but no supporting references were given. For their location in the Queen's Drawing Room see G. Bickham, *Deliciae Britannicae or the Curiosities of Hampton Court and Windsor Castle Delineated* (London, 1742), p. 85.

[2] The substance of the *Deliciae Britannicae* was plagiarized by the authors of *The Beauties of the Royal Palaces* (Windsor, 1796, p. 14) and *The Hampton Court Guide*

(Kingston, 1817).

[3] The latest writer to comment favourably on Laguerre's work seems to have been J. Norris Brewer (*The Beauties of England and Wales*, Vol. X, Part 5 [1816], p. 473), who wrote that the *Triumphs* had been 'repaired with much care and judgement by Laguerre'.

[4] M. Passavant, *Tour of a German Artist in England* (London, 1836), Vol. I, p. 93.

[5] Mrs A. B. Jameson, *A Handbook to the Public Galleries of Art in and near London* (London, 1842), p. 371 ff.

[6] For the visit of G. F. Waagen, see his *Works of Art and Artists in England* (London, 1838), Vol. 2, p. 110 ff. The *Triumphs* were said to be in the Communication Gallery by E. Jesse, *A Summer's Day at Hampton Court* (London, 5th edition, 1842).

out total disaster. Thereafter, reports of the paintings are of virtually unrelieved gloom. It clearly became fashionable to 'write off' the *Triumphs* and some critics went to ridiculous lengths in this direction. One even declared that 'in the entire series there are perhaps not a dozen square inches left where Mantegna's hand is visible'.[1] Nevertheless, the physical state of the canvases left much to be desired. Fortunately, at this point they came under the care of one of the most conscientious Surveyors of the Royal Pictures, Richard Redgrave. In the earliest authoritative inventory of the royal pictures his account of the condition of the *Triumphs* (dated 10 May 1867) makes two general points.[2] Mantegna's pigment at that date was either held in position by Laguerre's overpaint, in which case it was invisible; or it was free of Laguerre's work, in which case it was tending to flake off.

Redgrave was the first Surveyor to face what has since become a familiar dilemma. Could the *Triumphs* be restored—that is, could later repaint be removed, damage be retouched and so on? Or should they merely be conserved? At first Redgrave hoped for a restoration under his personal supervision.[3] Early in 1861, with the support of the Prince Consort, he gained permission to take one of the canvases to the South Kensington Museum, so that he could make frequent and prolonged inspections of it.[4] By the beginning of May, the ninth canvas of 'Caesar's chariot' had been removed thither. It remained there for a little over a year. During that time, the opinions of several eminent experts and restorers were sought but the general conclusion was the same. Apart from the removal of some repaint in the sky, no restoration should be attempted since the condition of the painting was too fragile. Instead, the surface should be fixed with a thin size, and the entire series should be sealed behind glass to prevent further deterioration.[5] Eight years later, in 1870, the subject was reopened. This time it was on account of the Arundel Society, who wished to take some photographs for sale to the public. Representatives visited Hampton Court and inspected the sixth and the eighth canvases. They decided against photography on seeing the condition of the paintings, and their comments were similar to those in previous reports. Redgrave himself does not seem entirely to have abandoned the hope that restoration would ultimately become possible, but no further proposals were made under his Surveyorship. As he wrote in 1870, 'Were it possible to result in the removal of the present vile repairs, the putting what remains in order would be a cause of great expense, of many months labour and work of very great anxiety during the whole time.'[6] This has subsequently been proved an understatement.

But already in 1861, a major step towards their conservation had been taken. The entire series had been placed behind glass.[7] This was beneficial to the extent that it helped to protect the picture surface against sudden violent changes in humidity and temperature. It

[1] Mary Logan, *The Guide to the Italian Pictures at Hampton Court* (London, 1894), p. 46.

[2] Inventory in the Lord Chamberlain's Office, St James's Palace.

[3] PRO, LC 1/96 (1861), f. 13.

[4] PRO, LC, 1/96 (1861), f. 29.

[5] The various reports are now at the PRO, LC 1/110 (1862) 9, 32, 43.

[6] For the dealings with the Arundel Society, see PRO, LC 1/229 (1870), 51, 64, 115. For Redgrave's letter of 1870 see 1/229 (1870), 51.
Tanya Ledger has kindly drawn my attention to further

correspondence relating to the Arundel Society proposals for the issue to the public of sets of photographs either 'plain' or hand-coloured (apparently from the originals by an unnamed student of Ruskin). See B.L. MS. Add. 38997 f. 240. The scheme was postponed since the Society was under the impression that cleaning was to take place.

[7] Notices relating to the allocation of money for this purpose will be found in PRO, LC 1/96 (1861), 5, 12, 13 (January). Presumably this step reflected developments in the technique of glass production. The same development is reflected in the character of Victorian domestic window glazing and in a building such as the Crystal Palace. At any earlier period it would not have been possible to produce evenly manufactured panes of glass nine feet square.

produced, however, one unfortunate consequence. Hung in the Communication Gallery, the *Triumphs* faced a row of windows. The light coming through these windows produced reflections in the glass whose intensity waxed and waned according to the weather conditions outside. Effectively, Mantegna's paintings were now invisible.

Concern about the *Triumphs* was influenced by a heightened degree of public interest in them. It had long been recognized that the two outstanding items in the Royal Collection of paintings at Hampton Court were the *Triumphs* and the Raphael Cartoons, and ever since the foundation of the National Gallery there had been intermittent suggestions that both works might fittingly be included in a national collection.[1] Throughout the whole discussion, the Raphael Cartoons caused more interest; in the end, of course, Queen Victoria graciously permitted them to be sent on long loan to the newly founded museum in South Kensington (1865). There was a House of Commons motion that the Mantegnas should also be transferred.[2] Finally, however, interest in them waned and nothing further was heard about the proposal. The *Triumphs* remained in the Communication Gallery down to the First World War. The only change in their situation appears to have been the installation of some sort of mechanical device to facilitate their removal in case of fire.[3] During the First World War they were taken down as a precaution in case of air raids; in fact, it was directly as a result of this that the events took place which open the most recent chapter in the history of the paintings.

[1] The National Gallery was founded in 1824. See on this subject the diary of Benjamin Robert Haydon (edited by W. B. Pope, Cambridge, Mass., 1960) under 31 December 1824 (Vol. ii, p. 502), where Haydon was recording some general thoughts at the beginning of the new year. 'More intercourse with the World, which Portrait Painting has given me, has opened my eyes to the thorough ignorance of educated men, to their utter insensibility to any thing like a grand idea. The National Gallery may do something if they add the Cartoons of Raphael and Mantegna to the other works.'

[2] On 4 March 1865, Mr W. E. Ewart gave notice in the House of Commons of the following motion, 'That it is expedient, for the benefit of artists, as well as of the public, that the Cartoons of Raphael and the frescoes of Andrea

Mantegna be removed from Hampton Court Palace to London' (see *The Times*, 5 March 1865). The motion duly appeared on the order paper for 31 March but was not apparently debated (see *The Times*, 31 March and 1 April). At a parallel debate in the House of Lords on the same day (on a petition presented by Lord St Leonards on behalf of the inhabitants of Kingston-upon-Thames and its neighbourhood) it was reported that the Queen had already consented to the loan of the Raphael Cartoons. Consequently, much of the point of Mr Ewart's motion had vanished.

[3] This seems to have taken place in 1886. See J. Shearman, *Raphael's Cartoons in the collection of Her Majesty the Queen and the Tapestries for the Sistine Chapel* (London, 1972), p. 160, note 153.

11 · The Later History of the *Triumphs*, 1919 to the Present Day

BY THE TIME OF THE FIRST WORLD WAR, it seems to have been accepted that the Communication Gallery was less than ideal as an exhibition site for the *Triumphs*. During the War, two things happened which were to influence subsequent events. First, it was discovered that the machinery supposed to facilitate their quick removal in case of fire did not really work. The paintings, covered by their enormous sheets of glass, were too cumbersome for the existing emergency precautions.[1] Second, the paintings were nevertheless taken out of the Gallery; and this automatically raised the question whether they should go back there again after the War.

It is not clear who first suggested that the *Triumphs* might go in the Lower Orangery, which at this time was used for housing plants and shrubs; but the person who pushed the idea through was the Surveyor, Sir Lionel Cust. He was convinced that, in the Orangery, the paintings would be displayed 'in a better way than has ever been the case since they first came to England'.[2] This assumption was well founded, but the disadvantages of the Orangery were only dimly perceived in 1919. The problems of climatic control were far greater than in the Communication Gallery, and the problems of reflection and lighting have only recently been solved. It was indeed realized that the reflections might cause difficulties, but the problem was to be solved by hanging the *Triumphs* high on the walls. Alternatively, the glass might be removed and the painted surface covered with a 'layer of celluloid'.[3]

A belief in the efficacy of cellulose occurs again in this period in a slightly different context. Some years earlier, Roger Fry had been consulted on the possibility of restoring the *Triumphs* and for a number of years he had actually worked on the first canvas.[4] He

[1] Lord Chamberlain's Office (LCO). Letter, Sir Lionel Earle (Secretary to the Office of Works) to Collins Baker (Surveyor of the King's Pictures), 24 January 1931 '... the primary reason for the removal of the Mantegnas from the Communication Gallery was the danger from fire. There was a cumbersome apparatus which was installed at great expense, in order to get them out of the palace as quickly as possible, but when we were demobilizing the frescoes on account of aircraft attack, I found that it took three hours to get one picture away.'

[2] LCO. Report of Sir Lionel Cust to Sir Douglas Dawson, 7 December 1919, on the possibility of housing the *Triumphs* in the Lower Orangery. His only reservations about the Orangery were over its climatic conditions, but now 'that the electric radiators are in working use, I am quite satisfied that these paintings are quite safe from damp or injury during the winter'. The Royal Academy report referred to below on p. 118, note 2 makes it clear that discussions about the Orangery were already taking place in July of this year.

[3] According to Sir Lionel Earle (letter cited in note 1), the question of damp 'was very carefully considered by Sir Charles Holmes and others and it was eventually agreed that the Orangery was entirely suitable'. In a further letter of Sir Lionel Earle to Sir Douglas Dawson, 1 March 1920, the most serious problem was said to be the glitter due to the thick glass. The suggestion of a cellulose coating occurs in this letter.

[4] From his correspondence, Fry seems to have been 'working at one of the Mantegnas' already in 1910 (D. Sutton, *The Letters of Roger Fry*, London, 1972, p. 336, Letter 292). E. Law in *Mantegna's Triumph of Julius Caesar* (London, 1921, p. 87 ff.) covers this ground, quoting Lionel Cust. He provides the information that in the reign of Edward VII an examination was made 'with a view of ascertaining whether some fixative mixture should be applied to the surfaces of the painting which would arrest and make impossible any further decay'. Fry's services were sought as a result of these moves. What happened during the War is not known, but Fry continued work subsequently. On 8 March 1920 Mr Baldwin, answering a question in the House of Commons, said: 'I understood that an attempt was recently made to discover if it would be possible in the case of one of the pictures, in which the original painting by Mantegna was entirely concealed, to remove the overpainting and reveal the original work.' In fact, Fry was still at work in 1921, although in a letter written on 12 May he seems to have been on the point of giving up (D. Sutton, *op. cit.*, p. 507, Letter 498). He wrote: 'I shan't work any more on the Mantegna at present and so I shall begin to paint seriously again.' His final report, now in the LCO, is undated.

eventually recommended that nothing more should be attempted but the harshness of his judgement on the condition of the painting went far beyond any previous assessment. For most of the canvases he wrote: 'I do not think it worth while to take any special steps . . . nor is their permanent preservation a matter of importance—at least as regards 7, 8 and 9, which are nothing but gross caricatures of Mantegna's art.' Only for Canvases V and VI did Fry think it worth taking any positive steps. Here he recommended that they be 'covered with celluloid solution', even though this would 'prevent any possibility of further attempts to remove repaints'.[1]

Fry's harshness was probably conditioned by the fact that he had attempted to restore the paintings and had failed. In his report he describes his experiences with the first canvas, which he selected for experiment because it 'showed scarcely any original work at all'. He reported minor successes in small areas in uncovering Mantegnesque detail and Lionel Cust urged him to proceed further with the cleaning. Probably fortunately, Fry declined, writing that the state of the paintings was in general too poor for them to be touched.[2]

The idea of covering the *Triumphs* with a cellulose solution seems to have been dropped,[3] for, when they were installed in the Lower Orangery, it was once again with the glass covering that they had had in the Communication Gallery. They remained, therefore, to a large extent, invisible.[4] However, the next upheaval in their history was the result of a rather different chain of events. In 1927, Cust was succeeded as Surveyor by C. H. Collins Baker. At about this period, the problem of humidity control in the conservation of works of art was being widely discussed[5] and in 1929 a hygrometer was installed in the Lower Orangery, from which humidity and temperature charts were compiled. Collins Baker was alarmed to find that the day-to-day humidity level of the Orangery varied very considerably, and at times, violently. He assumed from this that the *Triumphs* had, since their removal there, been placed in peril and he instituted a series of enquiries into their state.[6]

[1] Cellulose is, of course, soluble, so that Fry's recommendation was less drastic than it perhaps sounds. Cellulose was a fashionable substance at this period and its introduction into the discussion has a certain historical interest.

[2] Fry described the successful uncovering of Mantegnesque detail on the horse's trappings to the right-hand side of the first canvas. He was silent about a disastrous attack on the face of the soldier in the centre. This was totally destroyed and the present face, replacing Fry's repainting, is an entirely modern reconstruction based on the Vienna copy. It is worth noting that Fry's work did not pass unnoticed. In the 1921 letter quoted on p. 117, note 4, he recorded that a committee of the Royal Academy had inspected his work and drawn up a 'violent report against me'. Fry complained that the R.A.'s had seen his work when it was half-finished, and he was justifiably annoyed by this. This visit had actually taken place on 24th July 1919 in the presence of Cust. The report duly appeared in print as Appendix 14 of the *Annual Report from the Council of the Royal Academy* for 1919. It was not printed until the following year, which may help to explain the lapse of time before Fry became aware of it. Appendix 14 does not mention Fry by name and it is not complimentary. Of the canvas on which Fry was working the report says: 'that this picture had been almost entirely repainted; any beauty of drawing and colour that remained was thereby totally destroyed, and the result can only be described as lamentable. . . . The manner in which this repainting has been carried out betrays, in our

opinion, deplorable incompetence. Much as we regret the work that has been done, we fear nothing now can remedy it. Our principal concern is that it be respectfully urged that nothing further whatever be done in the way of restoration to the remaining canvases.' According to the main report (p. 22) the Council of the R.A. had since received assurances from the Lord Chamberlain that 'no further work of the kind' would be undertaken. The report of the visiting Academicians reveals incidentally that the *Triumphs* were then in a panelled room on the ground floor (unidentified).

[3] No trace of a cellulose covering was found during the recent restoration.

[4] The exhibition of the *Triumphs* in the Orangery was reported in *The Times*, 4 July 1921. On 18 April 1922, a correspondent to the paper complained about their invisibility although 'by kneeling or crouching upon the floor I could see a small part of the upper half of the pictures'.

[5] A national 'Committee on Ailing Pictures' had been set up, which led directly to the establishment of the conservation laboratories at the National Gallery and the Courtauld Institute of Art.

[6] LCO. Letters between J. Macintyre (Chief Engineer, Office of Works) and Collins Baker, February 1930. Macintyre was a member of the 'Committee for Ailing Pictures' and Collins Baker asked that he refer the problem of the *Triumphs* to that Committee.

Meetings were held in the summer of 1930, but their findings were entirely inconclusive. Eight years of fluctuating humidity in a permanent state of dampness should have produced mould growths but none were found. The same conditions, by inducing rapid expansion and contraction of the stretchers and canvas, should have caused further flaking of the picture surface. But when the glass covers were removed and the inside of the frames inspected, only a quantity of dead flies and other insects was found. There was no trace of fallen pigment.[1]

However, the inspection proved yet again that the state of the paintings was extremely delicate. Moreover, by 1930 the earlier tentative suggestions about a celluloid covering had been superseded by a belief in the efficacy of wax. The first suggestion that the paintings might be conserved by the application of wax came apparently from the Government Chemist, who had been called in for consultation.[2] The treatment recommended itself for various reasons. Not least was the possibility that in these conditions the paintings might be displayed once again without glass.

Nobody seems to have questioned the beneficial effects of the application of wax[3] and it was in this context that Collins Baker consulted one of the chief restorers of the day, Kennedy North.[4] During the second half of 1930, a major campaign was mounted to preserve the *Triumphs* from continued deterioration.

The approach to this task, as it emerges in the correspondence, is so alien to present attitudes that it has a certain historical interest. It is an axiom of contemporary restoration and conservation that, as far as possible, no process should be applied to a painting which is suspected, in general terms, of being irreversible. In 1930 this was not the case. The efforts of those responsible were bent towards a type of permanency in their achievement which now may seem misguided and arrogant. But it would be unjust to judge those concerned harshly. They were all involved in a situation which was new—the application of scientific technology to the conservation of works of art. Throughout it was the possibilities of science that seem to have caught people's imagination and not its limitations.[5]

[1] The Committee included Macintyre and Dr J. Fox who, as Government Chemist, was the first of the official scientists to be called in for advice. The notes of the meeting are dated 6 June 1930 (LCO). Fox's own report (LCO), dated 5 August, stated that cultures of mould had been grown under laboratory conditions from samples taken from the *Triumphs*. He added, however, that this should not cause worry since the climatic conditions of the Orangery itself clearly inhibited the growth of mould. This resort to laboratory techniques for information is again a feature of the period and has an historical interest. Independently, Dr S. Gloyne of the City of London Hospital also made cultures of the mould growths said to have 'been found by Mr Kennedy North to be spreading over the pictures in large areas'. See C. H. Collins Baker, *Burlington Magazine*, LXIV (1934), 'Mantegna Cartoons at Hampton Court. II. The Preservation of the Cartoons', p. 108.

[2] Dr Fox's formula was: Beeswax 28%; Turpentine 67%; Linseed Oil 5% (LCO. Letter Fox to Macintyre, 5 August 1930).

[3] LCO. Letter Sir Lionel Earle to Collins Baker, 14 October 1930. Earle wrote that he thought the wax treatment 'was probably sound' and added 'You may think it well to consult Professor Tristram who, I fancy, is the best expert in this country as regards the preservation of mural paintings'. The wax treatment was discussed and virtually settled before anybody had determined the chemical composition of Mantegna's paint. The decision appears to have have been taken at a meeting in late September between Collins Baker, Sir Frank Baines and Macintyre (LCO. Letters Sir Frank to Collins Baker, 29 September 1930, and Collins Baker to Sir Lionel Earle, 1 October 1930).

[4] LCO. Letter Collins Baker to Lord Cromer, 2 October 1930. This is the first occasion in the LCO correspondence in which Kennedy North's name is mentioned. He had already been consulted and had proposed a two-part treatment: (a) preliminary waxing; (b) a 'longer process of protection' lasting several years.

[5] See Collins Baker in the *Burlington Magazine*, LXIV (1934), 'Mantegna Cartoons at Hampton Court II. The Preservation of the Cartoons', p. 107. 'Only within the last few years have the problems of inherent disease and climatic environment and causation been systematically tackled in connection with the preservation of pictures. The action of . . . industrial atmosphere, and of mould growths . . .; the effect of excessive variations in humidity and temperature . . . in relation to the varnish, the paint, the priming and the fabric of pictures are only now receiving scientific attention.' A

Later in 1930, Collins Baker called upon L. A. Jordan, a special authority on 'diseases of varnish', to report on two problems. The first was whether the *Triumphs* were painted in egg tempera. The second was 'To determine upon a suitable procedure whereby the obvious state of decay of the pictures may be arrested'.[1] For the first, Jordan took pigment samples and did laboratory tests to determine their nitrogen content. The results were inconclusive. But on the second, the results were more impressive. Working in collaboration with Kennedy North, Jordan indeed recommended a 'suitable procedure' for conserving the *Triumphs*, proving its efficacy with the aid of micro-photographs and the latest scientific weathering tests 'such as are normally applied to paint films for industrial use'.[2]

The programme of conservation was basically very simple. The *Triumphs* were to be glazed with a solution of silicon ester and then encased between layers of wax. Silicon ester was Jordan's contribution and its purpose was to stabilize the paint surface. The permanent qualities of this process could scarcely be doubted since, according to the report, the chief industrial use of silicon ester was 'the treatment of porous stone and the preservation of ancient structures by cementing action'.[3] But the weakness of silicon ester was that a film of it 'will not reduce the natural porosity of the picture surface'. In order to give the canvases protection against humidity, the additional wax treatment was necessary.

Jordan further suggested that the bonding between the silicon and the wax might be improved by the interposition of vinyl resin. Nothing further was heard of this; and during the most recent restoration, no evidence was found of Kennedy North using silicon ester. But the programme of wax treatment went ahead, the canvases also being relined[4] and provided with new stretchers.[5] At the same time, the seventeenth-century gilt frames were

belief in the potential benefits of applied science was common and found expression, for instance, in the setting up after the First World War of a number of Government-sponsored Research Stations. Of these, the British Paint and Varnish Makers Research Association at Teddington and the Forest Products Research Laboratory at Princes Risborough were both referred to for help and advice, during the work on the *Triumphs*. Another example of this process of calling to one's aid scientific research and technology was the use of X-rays. Pioneer work in this field was done at Vienna in the late 1920s, but Kennedy North's own X-ray photographs of the *Triumphs*, made in 1931, must rank among the earliest large-scale use of X-rays in England. Indeed, covering each a circular area with a diameter of 9 ft. 7 in., they were claimed by Collins Baker to be the largest undertaken in the history of radiology (*ut sup.*, p. 113).

[1] The report, in the LCO, is dated December 1930.

[2] This research was done at the research station at Teddington (mentioned above), of which Jordan was the director.

[3] This comes from Jordan's report. For some time Kennedy North had reservations about using silicon ester. These were overcome after a meeting with a Mr George King, described as a chemist 'whose sole work is concerned with silicon ester' (LCO Letter Kennedy North to Collins Baker, 7 March 1931). Kennedy North's original objections are not clear, but 'It is obvious', he wrote, 'that up till now we have not been presented with any real information about silicon ester.' He added that 'the Kings have placed

in my hands the whole secret of the making of the medium' and he was anxious not to betray their confidence. Consequently, the precise formula that he proposed to employ for the compound is never revealed. According to Collins Baker (LCO. Letter to Sir George Crichton, Comptroller of the Lord Chamberlain's Office, 7 March 1931), the Keeper of the Privy Purse had made the 'whimsical' suggestion that silicon ester might turn the *Triumphs* black in fifty years. Had the Keeper of the Privy Purse been talking of the wax treatment, he would not have been very far wrong. Silicon, however, does not discolour, but its application is a virtually irreversible process. Fortunately, therefore, Kennedy North does not, in the end, seem to have applied it. At least, no clear evidence of its presence emerged during the recent restoration.

[4] Kennedy North insisted that the new canvas should be of a sort manufactured only in Belgium—Courtrai flax was said to be best because of the length of the fibre. The reputation of Belgian linen and canvas weaving was, apparently, another characteristic feature of the period. In a letter to Collins Baker (LCO. 1931—undated but probably March), Kennedy North enclosed a small sample of the finished product.

[5] See Letter from Kennedy North to Collins Baker 12 May 1932 (LCO). The new stretchers were (and are) of teak. In a letter to Collins Baker (LCO), 3 March 1931, Kennedy North asked for the accelerated weathering of sixty cubic feet of teak by 'the people at Princes Risboro'', i.e.: the Forest Products Research Laboratory. By August this wood was back at Rugby, where it was worked (LCO. Letter Kennedy North to Collins Baker 5 August 1931).

disposed of in preparation for new frames of mahogany (but in the end the new frames were never made).[1]

In January 1931, Kennedy North forecast that the whole operation would take four years.[2] It eventually took three and he was able to announce to Collins Baker on 10 February 1934 that this work was complete.[3] As 1933 passed, the Office of Works finished its further work in the Orangery and Macintyre devised an ingenious and, for its time, advanced method of temperature and humidity control.[4] Indeed, the Orangery seems to have been ready by November[5] and although work on the paintings was not completed until the following year, this gave the engineers time to test their new equipment, which proved satisfactory.[6] The newly housed paintings received a private visit from King George V and Queen Mary on 27 March 1934. The official gathering, including representatives of the national press, was on the following day and was addressed by Ormsby-Gore of the Office of Works and the Lord Chamberlain, Lord Cromer.[7]

The definitive establishment of the *Triumphs* in the Lower Orangery was undoubtedly beneficial. The Orangery is a largely proportioned building; and, even if it is impossible to indicate with certainty the original setting of the *Triumphs* for comparison, the Orangery seems to correspond reasonably well in size to the ample measurements of the medieval Mantuan palace. The operations of 1930–4, however, failed in two notable respects.

The first 'failure' was the deliberate policy that the operation should be a 'conservation' and not a 'restoration'. *The Times* reporter was told that the *Triumphs* had been handed over to Kennedy North 'with the provision that no repaint whatever should be made however much of the paint existing in 1931 might be lost in the process'.[8] Kennedy North himself in a letter to *The Times* said that his task had not been to remove overpaint, but to conserve the painting intact 'with the honourable scars of time and all the additions by painters other than Mantegna, without any repainting of my own'.[9] Since for about a century experts had been saying that the *Triumphs* were past restoring, this attitude is perhaps not surprising. A conservation policy in itself would have been justifiable had it been allied to a more penetrating use of historical imagination. It seems clear that nobody at this time could imagine that what was impossible in 1930 would not be impossible for all time. Consequently the steps taken aimed at achieving a degree of permanency which has greatly hindered the recent restoration.[10]

[1] The decision to reframe the paintings was an unfortunate one, and was, apparently, prompted by Collins Baker's own dislike of conventional gilt frames. Up to 1933, the late seventeenth-century frames survived but these were now disposed of for scrap to a gold-refining firm, Messrs Collingbridge & Co. Ltd. The nine huge frames were sold for £2, which the firm regarded as a nominal price since, in their view, the cost of collecting the frame and recovering the gold would be 'rather high' (LCO. Letter 23 March 1933). For the only known photograph of one of the late 17th century frames, see *no. 274*.

[2] This emerges in a report drawn up by Collins Baker. It is undated and unaddressed, but was probably written for the Lord Chamberlain in January.

[3] Letter in LCO. In the same letter, Kennedy North asked for the exclusive control of the conservation of the *Triumphs* for a further two years.

[4] Macintyre's 'air treatment plant' was described by him in the *Burlington Magazine*, LXIV (1934), p. 113, 'Air Condi-

tioning in the Lower Orangery'. It was still functioning nearly forty years later (1973).

[5] LCO. Letter Sir Patrick Duff (Office of Works) to Collins Baker. 'I gather that, as far as our work is concerned, all that is necessary at the present stage has been done.'

[6] LCO. Letter J. Macintyre to Collins Baker, 9 January 1934.

[7] A full report appeared in *The Times* on 29 March 1934.

[8] *The Times* report of 29 March 1934.

[9] Letter of Kennedy North to *The Times* of 3 May 1934. The recent restoration has shown that this is substantially correct (see General Observations to the Catalogue below, p. 127). In view of this, one may perhaps ask the purpose of the vast and expensive programme of X-ray photography.

[10] Note, for instance, Collins Baker's remarks in the *Burlington Magazine*, LXIV (1934), p. 109: 'In my view... Mr Kennedy North's achievement has been astonishing. Today these surfaces are so firm and tough that they will take hard friction.'

The second 'failure' was in the lighting and display conditions. The placing of the pictures on the wall opposite the long row of windows meant that the reflections made them almost invisible.[1] Further the setting was discouragingly austere: the pictures were placed behind a continuous wooden wall, painted battle-ship grey, without any frames and simply appearing behind rectangular openings in the surface of the wall (which actually concealed the apparatus which was supposed to make their quick removal possible but which in the event proved not to be effective).

In late August 1939, just before the outbreak of war, the Office of Works arranged for the Mantegnas to be taken down and stored in a specially built brick and sand-bagged shelter erected within the Orangery since it was realised that a serious risk of damage would be involved in any attempt to move them to a place of safety further from London. Fortunately, though fire bombs fell on the palace, the Orangery escaped undamaged.

In 1945 the canvases were taken out of their shelter and put back in the setting designed for them in 1935 but in the interval Kennedy North's wax had begun to grow opaque so that, as one observer said, it was like looking at them through a piece of frosted glass.[2]

In 1962 after a further examination of the paintings Mr John Brealey was asked to embark on a campaign of cleaning and succeeded in removing most of the earlier repaint and bringing to view far more of Mantegna's original paint than was thought to survive. A detailed account of the restoration and of the new presentation is given in the Foreword by Sir Anthony Blunt, who was Surveyor of the Pictures at the relevant time. Here it will be enough to say that in their cleaned state and in their setting in the remodelled Lower Orangery, the *Triumphs* are almost certainly shown in better display conditions then ever before in their history. Never before has so much deliberate attention been paid to their lighting and environment. This has been done in the knowledge that Mantegna's *Triumphs of Caesar* are not merely hapless victims of fate or total wrecks to be 'written off' in the accounting books of Art. Notwithstanding their dreadful history, they are still spellbinding and certainly more so now than at any time within living memory; and if our generation has succeeded thus in handing them on to the twenty-first century, we shall have achieved something from which we may justly derive satisfaction and pride.

[1] On 23rd January 1935 the Surveyor of the Pictures, Kenneth Clark (now Lord Clark), wrote to Macintyre of the Office of Works 'I must tell you frankly that I find it impossible to see the pictures under any condition'.

[2] When, in 1949, W. C. MacLeod and other members of the Ministry of Works reported on 'ways and means of improving the visibility of the Mantegna cartoons' their report contained the information that 'the attendant in the Gallery, who has worked there for many years, states that every day visitors complain they have paid a fee of 3d and find it impossible to see the pictures'. (Cf. report in the Lord Chamberlain's Office dated 23 August 1949.)

THE TRIUMPHS OF CAESAR:
CATALOGUE OF PAINTINGS,
DRAWINGS AND ENGRAVINGS

Section A: The Paintings

General Observations

PICTURE SIZES

Mantegna's canvases, as one might expect, originally extended a sufficient amount on all sides to enable them to be fixed round the supporting wooden stretchers. For all the measurable canvases this 'overlap' has been cut off, the remaining area being mounted on later backing. Thus the majority of the measurements given below refer to this surviving painted area. They are approximate because the edges are often uneven. Only in the case of Canvas VII have no measurements been possible because, when he rebacked the paintings, Kennedy North folded forward the edges of his new canvas so that they overlapped the edge of the paintings. In eight cases these have been unfolded and opened up so that the full extent of Mantegna's canvas became apparent; but in the case of 'The Captives' virtually no remedial work has been attempted (1974) and Kennedy North's canvas remains in position.

For the second and ninth canvases, the full width of Mantegna's painted surface survives with an area of plain canvas extending beyond it. This provides evidence of the exact width of Mantegna's paintings (c. 9 ft. 1¾ in.–9 ft. 2 in., 2.78-2.79 m.) and enables one to say with confidence that virtually nothing has been lost in the painted width of any of the nine canvases. For the original height, parts of two lower margins (Canvases V and VI) and one upper margin (Canvas II) similarly survive intact. On this evidence it is clear that the series has lost virtually nothing in this dimension either. The second, third, sixth and eighth canvases all have a height of approximately 8 ft. 9½ in. (2.68 m.) and this must have been the mean height of the whole series. This observation is of some importance since the upper edges of large canvases, bearing as they do most of the weight of the painting, are notoriously vulnerable to damage, particularly

if the paintings are taken off their stretchers to make them more easily movable. It is known that the *Triumphs* were moved around early in their existence, and the importance of these considerations appears in the ninth canvas and its derivatives. Andreani (1599) and Dondo (1602) both agree with the surviving painting in truncating the statues on the top of the triumphal arch. In the Vienna version (*no. 86*), however, the artist completed these figures. He thus suggested by implication that a strip of canvas *c.* 4 in.–5 in. had been lost all along the top. It seems clear, however, that the Vienna artist was exercising artistic licence and in some sense, improving the original he was copying. (See also the sixteenth-century history of the *Triumphs* in Chapter 7 and the discussion of the Vienna copies in Chapter 9, see especially p. 106, note 1.)

MEDIUM AND CONDITION

The *Triumphs of Caesar* are painted in tempera—almost certainly egg tempera—on a very thin gesso priming. No evidence at all has been found that Mantegna used an oil medium.[1] The visual characteristics of the results have much in common with the painting of the *Camera degli Sposi*. The medium used in the *Camera* has not yet been analysed[2] although it is agreed that it is not painted *al fresco*. There is something to be said for the idea that Mantegna transferred the technique of the walls of the *Camera* to the canvases of the *Triumphs*.

Mantegna's work has reached the twentieth century in a sadly damaged condition. Some allowances have to be made in viewing them and it is essential to describe what these are. An illustration of a macro-photograph (*no. 275*) will demonstrate the condition of a representative specimen of the picture surface. It will be seen that the paint on the crown of the weave of the canvas has almost entirely vanished and the

[1] In 1962 and 1974, paint samples were taken from the *Triumphs* respectively by Miss Joyce Plesters and Mr John Mills, both of the National Gallery, London. Both reached similar results, Miss Plesters by microscopic and chemical examination, Mr Mills by gas chromatography. Their reports remain in the archives of the National Gallery.

[2] I have not seen any technical report on the *Camera* but some indications of the problems were given by G. Paccagnini in *Scritti di Storia dell' Arte in onore di Mario Salmi* (Rome, 1962) 'Appunti sulla tecnica della Camera Picta di Andrea Mantegna'. The remarks here are prompted by the observation of Mr John Brealey and myself.

painted area is represented by the pigment lodged in the interstices of the weave. From a distance of course the neutral areas do not register individually and do not seriously detract from the immediate impression created by the image. They demonstrate, however, the extremely worn condition of the surface and leave no doubt that important elements in the painting have been either worn or cleaned away. There have evidently been massive losses, in fact, in glazes; the cool scumbles which would originally have quietened some of the brilliance have often disappeared. Thus throughout the series, the scarlets are now without exception disquietingly strident. Much delicate detail must also have vanished.

CANVAS

The original canvas of the *Triumphs* was, until the last restoration, mounted on two later layers. The intermediate layer probably dated in its entirety from the late seventeenth century. The records show that three canvases were relined 1690–3. It seems likely that the remainder were treated during Laguerre's restoration which was completed by 1702 (see also above, pp. 111–12). The main reinforcing canvas was added by Kennedy North between 1931 and 1934. The seventeenth-century canvas has now been removed from all the paintings except IV and VII (IV alone did not need relining and VII has not been treated in the recent restoration).

The general make-up of all Mantegna's huge canvases is identical. In each case, the picture is composed of two broad and one narrow canvas strip, sewn together and hanging vertically. Slight variations suggest that the canvases were made up at different times but to the same general specification. Since the joins appear to be made along the selvage of the canvas, the width of the central strip will give some idea of the size of the loom. This is given in the entries for the individual canvases. It varies between 46¾ in. and 48½ in. (119 and 123 cm.) although this is necessarily only the 'exposed' width on the front and excludes the turned-back edges by which the joins are made behind.

The threads are linen (flax) and the weave structure of the canvas is 'twill'. The effect is created by the alternate weaving of paired threads of the warp as shown below.

The canvas surface on both sides gives the effect,

therefore, of diagonal striation. The threads vary in thickness but in general those of the weft are considerably thicker than those of the warp. The weave itself is very regular and close. Overall the warp count varies from 28 to 37 threads to the inch, the weft from 50 to 58. (I am most grateful to Mrs Catherine Hassall of the Courtauld Institute for obtaining for me this technical information on the canvas.)

THE LATER TREATMENT

It may be assumed that the history of repair work on these canvases is a continuous one almost from the beginning of their existence. It seems entirely likely (but in practice undemonstrable) that Mantegna's workshop was required to carry out remedial treatment when the paintings were installed at S. Sebastiano; and thereafter each step in the history of their decline must have been marked by counter-measures designed to repair the damage. Historically comparatively little is known about this process. Seven distinct campaigns of restoration or conservation are known being those of (a) Parry Walton (see p. 111), *c.* 1690–3; (b) Laguerre (see p. 112), *c.* 1694–1702; (c)

Joseph Goupy (see p. 112) in 1717; (d) Redgrave in the 1860s (see p. 115); (e) Roger Fry (see p. 117) *c*. 1910–21; (f) Kennedy North 1931–4; and (g) John Brealey assisted by Miss Joan Seddon 1962–74. The further opportunities for scientific analysis which presented themselves in the last campaign have made it possible to identify some of the characteristics of (a), (b), (c) and (e). The ensuing paragraphs incorporate many conclusions from the National Gallery report (see p. 125, note 1).

It has not been possible to distinguish between the work of Walton, Laguerre and Goupy. The restorers of this period used as a medium a drying oil (perhaps linseed oil) and a variety of pigments often laid over a red-brown ground. Their paint layers are characteristically thick, hard and oily— a factor which has made their removal extremely difficult, particularly in view of the delicacy of the fifteenth-century tempera beneath. Paint with these qualities has been attributed generally to Laguerre although presumably any repairs or touching-up executed between *c*. 1630 and 1800 are likely to possess some or all of them.

Redgrave's campaign seems to have been so judicious and conservative as to leave no traces at all. But it may be observed that it achieved its purpose, in that he transmitted intact to the twentieth century what was clearly a series of problem paintings inherited from the eighteenth century.

Roger Fry worked mainly on the first canvas. Whatever his success in removing Laguerre's overpaint he seems merely to have substituted his own. His medium was basically an animal glue and consequently the paint was probably a gouache or a glue distemper. Fry's work showed some care but, like Laguerre's, little delicacy. He seems to have experienced some difficulty in matching his work against the original since the finished result was achieved by many thin regular layers of superimposed paint. Cross-sections showed that Fry might overlay as many as ten thin layers of paint in his attempt to achieve a particular result. He was apparently not concerned to match exactly the original pigments, but used, where convenient, such later inventions as Prussian blue, cobalt blue and viridian. Roger Fry's contribution has a certain interest, since, like Laguerre, he may be seen as the last in a

tradition of artist-restorers who sought to improve the original by implanting on them his own individual artistic style. With hindsight, and particularly after a visit to the 'Roger Fry Room' in the Courtauld Institute Galleries (London), it is possible to see that this was unlikely to prove a success. In fact Fry is now an easy target for criticism on two particular grounds. First, from his own writings he had a very considerable standing as a critic and writer on aesthetics. This merely throws into relief the comparative crudity of his painting, particularly when, unhappily, it is directly matched against the technique of a master such as Mantegna. Second, his approach to the job was sufficiently casual to permit him to allow his friends and pupils to help intermittently. There is an oral tradition, for instance (from the painter's brother), that Paul Nash was one day allowed to 'put in a leg'. In the 1960s the overall result seemed so discordant and unpleasing that Fry's painting was entirely removed during the recent restoration.

Kennedy North never claimed to be a 'restorer', and, in retrospect, this seems to have been true. He was primarily a reliner of pictures; and the particular service that he offered his clients was that their paintings would be preserved in paraffin wax. In this, he was entirely in line with other eminent contemporaries, such as Professor Tristram. The use of wax still enjoys considerable popularity and may indeed be recommended in certain circumstances. Criticism of Kennedy North is based not merely on the easy judgement that fifteenth-century tempera paintings on linen were, and are, the wrong subjects for this treatment. His work has, on examination, proved to be of surprising crudity and clumsiness. Kennedy North, it is said, boasted that he coaxed a ton of wax into the *Triumphs*. This surprising statement may well be true. Certainly the canvases are remarkably lighter after the removal of his wax. (Before the present restoration it required four or five men to move one canvas; today, each canvas can be managed by two people.) This almost unbelievable quantity of wax was forced into the paintings in conditions of secrecy; but the techniques used are known partly through oral tradition and partly because of the marks left in the wax. Kennedy North's tools were amongst other things, a builder's blow-lamp, as reported by oral tradition, and a large tailor's flat-iron; and he seems to have worked on the floor of his studio. (Both the marks of the iron and the imprints of floor-boards

were visible in the wax at the start of the recent restoration.) He did not remove the seventeenth-century canvas before applying his own; and the fact that the seventeenth-century canvas was itself coming away from Mantegna's canvas caused him troubles which he never solved. He applied his wax in any case haphazardly and unevenly; but the loose areas between the earlier canvases formed pockets which all too easily filled up with wax and could not be flattened out after the wax had hardened. The result was a remarkably uneven picture surface, and a series of superimposed canvases placed under extraordinary and varying strain through the additional weight of the wax which had been ironed into them. The wax, sadly discoloured and opaque, has now been removed from the picture surface; far larger quantities have been removed from the back. But the general impregnation of these paintings with paraffin wax may now be regarded as a permanent characteristic.

THE ORIGINAL ORDER AND GROUPING OF THE 'TRIUMPHS'

The order in which the canvases are commonly displayed is right. It agrees with the order given by Andreani in 1599 (*nos. 88–97*) and also with that of the copies of the early seventeenth century now at Munich and Siena (*nos. 98–107*), see p. 103. This therefore is, at the least, the order in which the canvases were displayed at S. Sebastiano. But the order is also that suggested by the classical texts (see Appendix III); and the compositions themselves confirm the order.

Bearing in mind that the canvases have not apparently suffered appreciably from cutting, see p. 125 above, it becomes significant that some of them are directly related to their immediate neighbours whereas others are not. In some cases, the figures, objects and scenery can be seen to span the gap between canvases. In other cases, such direct links are lacking. This must be stated in detail.

Canvases I and II

A direct link here is provided by a black horse (which is slightly elongated in order to bridge the gap). It is true that the cart carrying the large standing figure in Canvas II has no obvious means of propulsion in Canvas I. But Mantegna's interest in the traction or propulsion of carts and chariots seems throughout the series to have been

negligible; there is no single instance of it being explained satisfactorily.

Canvases II and III

Here the bull forms a direct linking feature; and behind the bull rise two chests of trophies, each of which also spans the gap.

Canvases III and IV

Although there is a linking 'motif' here—bearers carrying booty—there is no direct physical connection.

Canvases IV and V

The main linking feature here is the line of the landscape. As noted elsewhere (p. 147) the character of the landscape changes between the two canvases. It is suggested that this is an inconsistency resulting from the canvases being removed from the studio and installed as they were completed; and that the inconsistency would have been removed *in situ*, had the series ever been entirely finished. The trumpets in IV also link with the trumpeters in V, the large trumpeter in V playing the curious trumpet with the double 'bell' in IV.

Canvases V and VI

The links here are made by the goats, the elephant and the rocky hill behind. There is a further slight change in the character of the background between Canvases V and VI. It is sometimes said that this is true also of the character of the decoration of the elephant trappings, but this is not so. Certainly the cloth covering the elephant's rump in VI is not identical in its decoration to the main 'saddle-cloth' in V, but it is very similar in its arabesques, cufic lettering and colouring (silver, gold and blue) to the 'apron' hanging down on the front of the elephant; and the front and rear parts of these trappings must be intended to go together.

Canvases VI and VII

In all the questions about composition, Canvas VII provides a set of problems peculiar to itself. Professor Waterhouse (*op. cit.*) called VII 'especially recalcitrant', an opinion with which most writers on the *Triumphs* will agree. For the moment, it may be noted that there is a further

physical break here. The linking motif (contrast III and IV) is also absent.

Canvases VII and VIII

Direct links are here at their weakest. The only linking feature is the foliage which spreads from one canvas to the next.

In an early version of Canvas VII known through a drawing after Mantegna at Chantilly (*no. 55*), *cythara* players were introduced, creating a direct visual link with Canvas VIII. (On the Chantilly drawing, see below, p. 165.)

Canvases VIII and IX

The link here lies in the horizon; the background contains the line of a hill which begins in VIII, and, rising up to a peak, sinks down into IX, to disappear behind the triumphal arch. Again, the character of the landscape changes between these canvases as discussed below, p. 157. In an early version of Canvas IX, known through an unfinished drawing after Mantegna in the British Museum (*no. 54*) the rear of a trophy-bearer is introduced on the left, creating a further visual link with Canvas VIII.

This examination suggests that the *Triumphs* were originally intended to be grouped in threes. Although the dividing architecture is lost, it is still possible to calculate the width which divided those canvases which were grouped together. This becomes clear between Canvases II and III where a bull extends from one to the other. For this, a gap of about 11 in. (*c.* 28 cm.) would seem to be required. It will be found that 11 in. is a suitable dividing width within all three groups. 11 in. is also a convenient width for a pilaster. For the distances dividing the groups themselves there are no indications, but the likelihood is that there was originally a break of a kind more substantial than an 11 in. pilaster. Whatever the nature of this obstacle, it will be observed that the bearers in IV are turning slightly inwards while those in III seem to be emerging outwards. The same is true of the Trophy bearer on the right of VI who has temporarily rested his load and turns forward out of the picture, in a manner similar to the bearers in III, but there is no corresponding movement into the picture on the left of VII. (Professor Waterhouse, *op. cit.*, and others have been inclined to place Canvas III with Canvases IV, V and VI, but the physical break noted here seems to be a significant one.)

Of these groups, the third is the least coherent. But the line of the horizon binds Canvases VIII and IX together; and the Chantilly and British Museum drawings suggest that the figurative links were, at least at one stage, planned to be more complete. The problems posed by this group are, however, considerable. It contains both the simplest (Canvas VIII) and the most complex (Canvas VII) narrative. It combines the heaviest concentration of symbolism with the weakest attention to the iconographical programme of the texts. It seems to contain Mantegna's latest work on the *Triumphs* (if the 'Captives' was never completed). It may, in the simplicity of Canvas VIII, preserve some of his earliest thoughts on the construction of a triumphal procession. It may be suggested, therefore, that the peculiarities of this third group reflect changes of emphasis and changes of composition which took place between Mantegna's earliest essays in formulating the programme and layout of the procession and his return from Rome.

There are two further curious features about the Canvases IV, V and VI which need explanation: the trumpet player in Canvas V, who turns slightly inwards, is blowing a trumpet in Canvas IV, which is facing slightly outwards. It could be argued from this that the two canvases were intended to be turned back at an angle to each other. This would bring these two parts of the trumpet into a happier relationship. Further, the grouping and direction of the figures on either side of this break might arguably make better sense, and the hillside would gain an extra dimension. Something similar could be argued in respect of the break between Canvases V and VI, where the bearers with their booty plunge into the picture at a rather uncomfortable angle to the line of elephants. It is arguable that Canvas VII looks happier if it is turned forward at an angle to its neighbour. This particular effect was noticed also by Garavaglia (M. Bellonci and N. Garavaglia, *op. cit.*, p. 112), who suggested that the *Triumphs* were intended for the rectangular *cortile* of a palace and that this would fit into one of the corners.

However, putting these two observations together, it might equally be argued that the original wall surface contained a convex and a concave angular turn, coinciding with the second group of paintings. Such a curious configuration seems most unlikely; and the wall should be instantly recognizable if it still exists. Moreover,

during the recent restoration, I had the unique opportunity of arranging Canvases V, VI and VII in precisely this way; and, while acknowledging the points made above, I remained unconvinced that the overall result was indisputably more satisfactory or made better visual sense than when the same canvases were placed in a straight line. The curiosity of the 'bent trumpet' seems more likely to be the result of a slight miscalculation when the paintings were being executed. It would have been relatively easy to rectify. But the second feature seems entirely intentional. It is worth noting that the Dublin drawing for Canvas VI (*no. 57*) gives a marginally less extreme 'plunging' effect to the booty carriers, so that this effect was increased when the 'aqueduct' was added; and if one adds to these features the line of elephants in Canvas V and the boy with the ox in Canvas IV, it will be seen that they are all parts of the series of oblique accents which gives this section of the composition its distinctive character (see above, p. 83).

(i) Front view

(ii) Front view (iii) Rear view

THE COSTUME OF THE 'TRIUMPHS'

Some remarks have already been made in the text on the subject of Mantegna's Roman costume and armour. His basic ideas seem to have been formed early in life and could almost all have been derived from the reliefs on the Arch of Constantine and the reliefs formerly in the church of S. Martina (now in the Conservatori Museum). Two particular features deserve more extended treatment. The first is the design of the cuirasses painted by Mantegna in the *Triumphs*. These follow three basic types, as illustrated below:

i) the short cuirass, extending only to the waist. The lower edge is cut square so that it runs parallel to the ground. Examples of this are to be found in Canvases I, III, VII and VIII.

ii) the longer cuirass extending down to the hips and modelled so that the lower front edge curves downwards to protect the stomach. Examples of this are to be found in Canvases III and VI and in the 'Senators' composition.

iii) a further type of longer cuirass, extending well below the waist, but with its lower parts consisting of overlapping flanges. An example of this is to be found in Canvas I, but no clear example exists elsewhere in the paintings. The trumpeter to the left of the 'Elephants' drawing (*no. 52*) wears one but this was altered when the fifth canvas was painted.

These three basic types already existed in Mantegna's earlier work. All are visible in the *Crucifixion* from the S. Zeno altar, which is now in the Louvre (*no. 144*). The third type is obviously unantique. No antique examples exist showing a modelled cuirass with a flanged lower part and these flanges must be borrowed from contemporary plate-armour, as seen in Mantegna's own early *St George* (Venice, Accademia).[1] The addition of these flanges must have been the result

[1] By a curious coincidence, the best surviving collection of Italian fifteenth-century armour comes from Mantua. The pieces were used *c.* 1520 to dress up some votive figures in the church of the Madonna delle Grazie; and the implication is that the Marchese Federico was taking the opportunity to clear out a number of the superannuated items from the armoury inherited from his father Francesco. The pieces were rediscovered between the wars, and the

best account of Italian fifteenth-century armour is now contained in J. G. Mann's articles on them (*Archaeologia*, 80 [1930], p. 117, 'The Sanctuary of the Madonna delle Grazie with notes on the evolution of Italian armour during the fifteenth century'; and *Archaeologia*, 87 [1937], p. 311, 'A further Account of the Armour preserved in the Sanctuary of the Madonna delle Grazie near Mantua'). Short skirts composed of flanges or *lames* similar to that in the

of a practical streak in Mantegna's imagination. A rigid cuirass of such length would have seriously impeded the movements of its wearer.

The other two types are more or less classical. The square-cut type is essentially early although it also appears on Trajan's column (*no. 182*). The second type comes near to those found on imperial statues of the Julio-Claudian period. It is also found on the Aurelian reliefs on the Arch of Constantine (*no. 199*). (For an informed recent survey on the subject see C. Vermeule, *Berytus*, XIII, 1959–60, p. 1 ff.: 'Hellenistic and Roman Cuirassed Statues'.)

There are two individual peculiarities in Mantegna's cuirasses. Whatever his models, he never attempted to imitate the more elaborate designs found in Roman Imperial sculpture. His patterning is always simple and restrained. The second peculiarity is the almost total absence of the rounded tabs which normally decorate the lower edge of a classical cuirass. These had certainly entered, as it were, the archaeological consciousness of the age since they are to be found on Donatello's *Gattamelata*. But the only time they occur in Mantegna's work is in the S. Zeno *Crucifixion* (*no. 144*); and in the two early engravings of the 'Flagellation' and the 'Deposition'.

Much of the civilian costume in the *Triumphs* was probably derived from the same sources as the military. For instance the reliefs from the Arch of Constantine and S. Martina illustrate the short cloaks fastened with a clasp at the shoulder and the short tunics falling nearly to knee level. Also visible is the long dress of the youth in Canvas V, slit up the side to the level of the thigh. Togas are there and also the long loose 'barbarian' trousers, with which Mantegna clothed some of the booty-carriers. General discussion of costume is excluded from the notes which follow which are for the most part concerned with points of detail. In order, therefore, to illustrate what has been suggested, some comparative illustrations have been included (*nos. 269–72*).

Two items of costume deserve comment at this juncture. The first is the appearance of men dressed in tight-fitting shorts (Canvases III and IX). The costume had appeared earlier in the Eremitani frescoes but seems to be un-Italian;

it is also un-Roman. Its origins are not clear. Second, there is often a discrepancy between Mantegna's 'Roman' footwear and that to be seen in the classical sources. Mantegna's footwear frequently takes the form of boots, which almost invariably reach nearly to the knee. Roman boots, especially military ones, were much shorter, reaching perhaps halfway up the calf. Knee-length boots were common, though by no means universal, in the fifteenth century, and it is possible that Mantegna was unwittingly transposing an anachronism into the classical past. It is, however, worth pointing out that Mantegna's chosen length reaches roughly to the point to which Roman breeches descended. Somebody else's drawing of the Marcus Aurelius 'Adlocutio' (*no. 193*) might well produce an ambiguity at this point such that Mantegna might have mistaken the significance of the horizontal line.

ARCHITECTURE IN THE 'TRIUMPHS'

The background to the *Triumphs* includes monuments and buildings of various sorts. Some, reconstructions of particular types of Roman monument (such as the Pyramid or the Arch), are discussed in their proper place. The remainder fall into different categories. A large model is carried in the second canvas. A series of ruins appears in the fourth, fifth and sixth canvases. Finally, there are unruined buildings in the seventh canvas and in the 'Senators' composition.

Stylistically, the most interesting distinction here is between ruin and non-ruin; and this is fully discussed in the main text (pp. 63 and 84). Something still remains to be said, however, about the types of building introduced by Mantegna, about the architectural detail and about its relationship to contemporary architectural practice. Throughout Mantegna's painting, one type of architectural structure appears again and again. This is centrally planned, either square or circular, and rises up in tiers. Such buildings are not necessarily classical in detail; and one early example (in the *Martyrdom of St James* in the Ovetari chapel, *no. 133*) is a plain crenellated military structure. Similar buildings appear in the painted *tabulae* held up by the soldiers in the first

first canvas seem to have come in after *c.* 1450. Before this date, they were longer. Likewise, long pointed tassets protecting the thighs (see the 'Senators' composition, below p. 161) are a feature of the period *c.* 1450–1500. Before this date, they were shorter and squared off; after this date

they were composed of horizontal *lames*. I am obliged to Dr Alan Borg of the Sainsbury Centre for the Visual Arts, University of East Anglia, for drawing my attention to these articles.

triumphal canvas (*no. 7*). A further version appears in the *Camera degli Sposi* behind the scene generally known as 'the Encounter' (*no. 135*). The *Camera*, however, also contains a more elaborate edition of the same idea (beside the inscription) in which a plain rectangular base, capped by a stepped circular podium, supports two circular storeys. The top storey is smaller in diameter than the middle; but the surface of both these upper storeys is articulated by attached columns supporting an entablature. Three more examples of this type of structure are to be found in the *Triumphs*. The 'model' in the second canvas is composed of a rectangular base supporting a circular upper storey which in turn is capped by a domed octagonal turret. Among the ruins to be seen behind the figures in the fourth canvas (*no. 26*) is a large circular building of two tiers. Finally, in the 'Senators' composition there is a further two-tiered circular structure (*no. 56*).

Taken as a group, it seems clear that Mantegna saw this centrally planned tiered type of building as being typically Roman. Others before him had had similar ideas and, for instance, the views of Rome painted by Taddeo di Bartolo (*no. 164*) and the Limbourg brothers earlier in the century are sprinkled with buildings which are either tiered or centrally planned or both. This is reasonable; for the Castel S. Angelo, the Colosseum, the Torre delle Milizie (medieval), the Pantheon, the Tomb of Caecilia Metella, the Mausoleum of Augustus, S. Stefano Rotondo, and S. Costanza all serve to buttress this impression. In fact, many of these buildings formed part of the current 'shorthand' to indicate either 'Rome' or, less frequently, the 'classical past'. Mantegna, for instance, had used some of them to add character to the representation of Jerusalem—alongside errant Columns of Trajan and Pyramids of Romulus. (See the two versions of the *Agony in the Garden* now at London (*no. 143*) and Tours. Reflections of this view of antique architecture are to be found in the Sketchbooks of Jacopo Bellini, *no. 121*.) It is not in the least necessary that he should have been to Rome in order to know what they looked like. The drawings of others could as easily have conveyed their general appearance and also the simple fact—which comes out clearly in Mantegna's reinterpretations—that they vary considerably in detail. Some are plain and military in appearance (Castel S. Angelo), while others look grand and in some sense palatial (Colosseum). Some are entirely curvilinear in plan (Colosseum or the Tomb of Caecilia Metella).

Some are entirely rectangular (Torre delle Milizie). Some are a mixture (Castel S. Angelo). Some are domed (Pantheon), others have a horizontal roof (Tomb of Caecilia Metella)—and so on. This was the raw material on which Mantegna's imagination worked. The result was a series of architectural fantasies which owed much to these Roman prototypes. The detail, too, owed something to antique monuments. These problems receive comment in the succeeding catalogue. It is enough here to note the capital in the seventh canvas which comes from the *Porta de' Leoni* at Verona (for which observation I am indebted to Howard Burns—see *no. 168*), or the *bucrania* adorning the tower behind the 'Senators', which, in this position, presumably come from the Tomb of Caecilia Metella Rome (*no. 154*). The results of this process have some similarity to Alberti's recommendations on the subject of tomb design—and it seems, indeed, highly unlikely that Mantegna was unaware of the *De Re Aedificatoria*. Alberti described four main categories of monument—the temple, the pyramid, the column and the mausoleum. (*L'Architettura, De Re Aedificatoria*, ed. G. Orlandi and P. Portoghesi [Milan, 1966], p. 681, 'video alibi sacelli alibi pyramides alibi columnas alibi aliud ut moles et eiusmodi positas' [Book VIII, Chapter 3]). Of these it can be argued that three at least—the pyramid, the column and the mausoleum—are clearly present both in the *Triumphs* and elsewhere in Mantegna's painting (for instance in the *Camera degli Sposi*—where in addition a building in the background of the so-called 'Encounter' might be construed as a temple-tomb). Moreover, when recommending a design for a mausoleum, Alberti's structure bears a strong resemblance to some of Mantegna's buildings (Alberti, *ut sup.*, p. 691). It would, nevertheless, be misleading to suppose that Mantegna was in any close sense following the suggestions put forward in the *De Re Aedificatoria*. If he was being consciously Albertian, it is striking that some of his 'tombs' are in the middle of cities. Alberti was not completely dogmatic on this point; but it is clear that he approved both the idea that tombs should be situated along roads outside the city (they provided diversion for travellers, see Book VIII, Chapter 1, *ut sup.*, p. 669); and also the principle that tombs should be set in deserted places (Book VIII, Chapter 2, *ut sup.*, p. 677). Moreover, they are without exception devoid of inscriptions; and since, as Alberti insisted, an inscription was necessary to inform the spectator of the name and deeds of

the person commemorated, they are lacking one of the most essential of his requirements. (Book VIII, Chap. 2 *ut sup.*, p. 677, 'At nos eos non improbabimus—ubivis corpus condendum instituerint—qui dignissimis locis nominis monumenta mandarint.')

There is, in fact, much that is puzzling about Mantegna's relationship to contemporary architectural thought and practice. Mantuan architecture *c.* 1460 onwards was dominated by Alberti and Luca Fancelli. Alberti before his death in 1472 designed and began the two churches of S. Sebastiano and S. Andrea; while Fancelli was responsible for the great *Domus Nova* begun *c.* 1480 for the Marchese Federico. But if one compares these exteriors with the architecture which appears in Mantegna's painting, one is chiefly struck by the differences. Mantegna made particular use of attached columns and half-columns and also of deep rustication—neither of which play an important role in the Mantuan works of Alberti and Fancelli. Mantegna's façades gained thereby a relief and texture which is absent in their work. In practice, the closest parallels are to be found in Venice and its dependencies.

Some of Mantegna's architectural details can be traced to that area. For instance, the balusters running along the top of the 'aqueduct' in Canvas VI are very similar in form to those in the chancel of S. Maria dei Miracoli (1481–9). (This early example of the baluster form, *no. 262*, was pointed out to me by Mr Howard Burns; similar forms were also employed on the Cappella Colleoni, Bergamo.) The domed lantern on the top of the model 'city' in the second canvas is very like the lantern over the crossing of Sibenik cathedral, Dalmatia, last quarter of the fifteenth century. (See L. H. Heydenreich and W. Lotz, *Architecture in Italy 1400–1600*, Harmondsworth, 1974, plate 95.) The articulation of a façade by an entablature supported by columns or half-columns (it is not always completely clear which Mantegna is painting) was not common practice outside Rome during this period. Mantegna adopts this form almost as a matter of course; and although its ultimate basis must be a monument such as the Colosseum, the nearest parallel, geographically, is probably in a façade such as that of S. Zaccaria in Venice (Heydenreich and Lotz, *ut sup.*, plate 82). Mantegna's application of this idea is occasionally unhappy. On the palace to the rear of Canvas VII (the 'Captives') the intermediate

columns/half-columns are set above the middle of apertures in the storey beneath. Yet considerable imagination is exercised in varying the proportions of the colonnade from monument to monument and in changing the character of the window or aperture set between the vertical members.

The other means towards surface richness lay in Mantegna's extensive use of rustication of a peculiar character. It is smoothly finished; and where it is plainly visible (as on the left of the seventh canvas) it can be seen that the edges of the projecting blocks are chamfered. The origins of such a pattern of rustication are obscure. It seems to have occurred on Roman monuments in Capua and was copied by Frederick II's masons on the lower courses of the Capua gate (1230s).[1] It may once have been visible on antique monuments in Rome itself. The author of the *Codex Escurialensis* depicted rustication on the base of the Castel S. Angelo in such a way as to suggest at least clearly rectangular blocks with 'hard edges'. However, by the last quarter of the fifteenth century, the form of rustication had already reappeared in Venice, notably on the Cà del Duca, *c.* 1460 (Heydenreich and Lotz, *ut sup.*, plate 79) and on Coducci's church of S. Michele in Isola (1469–78; see *no. 261*). Thus once again Mantegna's architectural conceptions seem to have been influenced by Venetian practice. It must, however, be said that there is no record that Mantegna ever visited Venice after he moved to Mantua (1459–60) and the nature of this connection remains therefore a mystery.

Canvas I. Trumpeters, bearers of standards and banners

Size: H. 8 ft. 9 in. W. 9 ft. 1½ in. (2·66 m. × 2·78 m.).
Width of central canvas strip: 47 in. (120 cm.).

Nos. 1–7

The state of this painting is poor. The face of the soldier carrying the female statuette on a pole with the cornucopia is entirely modern, reconstructed from the Vienna copy; and most of the figures and drapery are Laguerre's work. However, in parts of the dress of the negroid figure and the right-hand standing soldier, Mantegna's work has been recovered, revealing, amongst other things, some extremely fine painting in gold.

[1] The subject was examined by Cresswell Shearer, *The Renaissance of Architecture in Southern Italy* (Cambridge, 1935). His investigations showed incidentally how elusive prototypes for this precise type of rustication are.

By contrast, the upper part of the painting has some well-preserved areas. Of the two pictorial banners, the front one is almost all Mantegna's work, as are parts of the lower section of the banner behind. In addition, the foremost pennant is well preserved, together with the neighbouring ribbons and streamers.

The textual basis for this composition in Appian and Plutarch produces in combination *Tubae*, *Signa* and *Tabulae*. The interpretation of *tuba* presented no difficulties. *Tuba* is Latin for 'trumpet', Vegetius gave general directions about the types of trumpet used in the Roman army and it only remained to find out what they looked like (see above, p. 66, note 4). The other two terms were more ambiguous.

Signum has various shades of meaning.[1] The commonest type of *signum* was the *signum militare* or military standard, seen frequently on Roman monuments and often mentioned in Livy (for the observations of Vegetius, see again p. 66, note 4). Mantegna, perhaps surprisingly, ignored these objects. But since they are, in effect, regimental banners, he may well have seen them as being appropriate to the army at the end of the procession—a part of the procession which was not in the end included. His choice of *signum* to mean 'image' or 'statue' offered the obvious advantage that the chosen emblems could enrich the iconography of the *Triumph*. It found support in another passage of Livy, which was quoted *in extenso* by Flavio Biondo. This is a description of the Triumph of T. Quintus (*Ab Urbe Condita*, XXXIV. 51) and it includes *signa aerea et marmorea*. Moreover, the passage was transcribed by Valturio; and when his translator reached this point, he rendered the words as *statue di bronzo e di marmore*. Mantegna's images are apparently of bronze. Placed on the ends of poles, they seem to derive from a triumphal relief on the Arch of Constantine (*no. 192*).

Tabula might also have presented some scope for argument. It has a wide range of meaning in classical Latin, but almost always with the connotation of an object inscribed with writing. This primary meaning might conceivably be represented here by the *tabulae ansatae* (literally *tabulae* 'with handles', i.e. with projecting end-pieces). However, *tabula* could indicate a painting although it was normal in these circumstances to qualify it as *tabula picta*. Although Plutarch did not thus qualify it, Mantegna interpreted it as such. His reasons for doing so are probably two-fold. First the common Italian translation for *tabula* is *tavola*, which is the word normally used to describe a painted panel. Second, as with *signum*, he was following some sort of generally acceptable interpretation, for the Italian translator of Valturio glossed the word *tabulae* as *tavolete depente*. Plutarch's *tabulae* came thus to be combined with Appian's *imagines earum quas gessissent* to form historiated banners.

TUBAE

The appearance of these seems to be derived from two or three sources in Rome.

(a) For the curved trumpet, Trajan's Column, scene 8 (*nos. 185, 188*).

(b) For the straight trumpet, the Marcus Aurelius relief from S. Martina (*no. 194*) or the Arch of Titus (*no. 176*).

SIGNA

The Crescent Moon with a fringe of short ribbons

The fringe may be found on the Aurelian reliefs on the Arch of Constantine (*no. 193*). Crescent shapes topping standards, but apparently containing faces, occur on Trajan's Column (*no. 185*). The crescent is not uncommonly included in representations of standards on coins, but normally at the bottom rather than the top (*nos. 219, 242*). Crescents also occur on coins as emblems by themselves (*no. 220*).

The peacock set above open wreaths

Birds on standards are found on the Aurelian reliefs (*no. 195*) and also on the Arch of the Sergii at Pola (*no. 211*). They are normally imperial eagles. The peacock emblem would appear to be transposed from a coin type (*no. 221*). On some coin types, it is identified as a symbol of *Concordia*.

Open wreaths occur suspended above the heads of the figures in the Aurelian relief mentioned above. They are also found occasionally on coins (*no. 222*) but solid discs are more common. It is possible that Mantegna, who never paints solid discs, may have misinterpreted a secondary graphic source.

[1] On matters of vocabulary, the Lexicon of Lewis and Short has been consulted.

Statuette of a nude male, holding perhaps a ewer; beneath, a banner

The placing of statuettes on poles may have been prompted by the reliefs on the Arch of Constantine (*no. 196*). It will be seen that the remains on one of these is similar to Mantegna's figure. No precise parallel has been found although, in its miniature proportions, it comes closest to coin types (*no. 223*). Its stance and gesture, rhetorical in character, have, however, many applications and turn up in many different contexts. Jacopo Bellini decorated the front of a palace with such a figure (Paris, Louvre Sketchbook, p. 31). The banner does not seem in the least antique and it is to be suspected that it is fifteenth century, although it is hard to find examples.

Statuette of female holding cornucopia, standing on sphere; beneath, a pendant 'tabula ansata'

The identity of this figure is uncertain since the cornucopia may be carried by *Pax* (*no. 225*), *Liberalitas* (*no. 224*), *Securitas* (*no. 226*) or *Fortuna* (*no. 227*). The presence of the globe suggests *Fortuna* although she normally has a rudder as well.

The *tabula ansata* occurs frequently on sarcophagi. But it may also be seen carried aloft by soldiers on the Arch of Titus (*no. 176*). Further examples are to be found on the Arch at Benevento. The peculiarity of the Mantegna *tabulae* is that they hang from poles on ribbons. All classical examples are fastened rigidly to the tops of poles. The reason is probably a simple one. By slinging them on ribbons, Mantegna could ensure that they hung horizontally and were thus easily legible, even though the poles to which they were attached were being carried at an angle.

For the inscription see Appendix II.

Female statuette holding basket of fruit

On coins, the basket of fruit is normally borne by *Fides* (*no. 228*) but she should also carry ears of wheat and other attributes. In any case, none of the coin-types looks like this figure, which, it has been suggested, may be based on a statue of a Season (Autumn) sometimes called *Pomona*. (Tamassia, *op. cit.* 'Pomona' is now catalogued as No. 124 in G. A. Mansuelli *Galleria degli Uffizi. Le Sculture*. Rome, 1958.) This is known

to have been in Florence at least since Vasari's time (*no. 204*). That parallel is closer but the pose and attributes are still extremely uncommon.

TORCHES ON POLES

These appear in five canvases—I, II, V, VII and IX. Suetonius' description of the Gallic Triumph says that Caesar ascended to the Capitol *ad lumina . . . elephantis . . . lychnuchos gestantibus.* The reason for these torches has never been explained and it is arguable that, to Mantegna, it might sound as if the event took place at night. Flavio Biondo's translator (*Roma Trionfante*, 1543, f. 357V) actually glossed Suetonius to read that Caesar '*monto nel Campidoglio di notte con torchi accesi*'. Mantegna's procession certainly takes place in broad daylight; but the torches may preserve in symbolic form the memory of the original event which—it should be repeated—is the only authentic detail apparently known to Mantegna about the Gallic Triumph. Perhaps to support the idea of a night-scene, Mantegna also placed a symbolic face in the sky of the third canvas. It has been suggested that this face represents a wind-god.[1] Its present appearance is due to Laguerre but the copies show that something similar existed *c.* 1600. The idea that it represents the wind is discouraged by the fact that it is not blowing; and also that all the adjacent drapery is blowing towards it and not away from it. Fragmentary remains suggest that it was originally coloured a silvery combination of blue and white and for these reasons it may be suggested that it symbolizes the moon and is to be read in conjunction with the flaming torches as a symbol of night. (It should be added in passing that its colours were never such that it could have represented the Sun.)

The shape of the torches is uncommon but something similar occurs near the base of Trajan's Column.

Bust with helmet, shoulder armour and cloak

Sometimes called *Roma Victrix* (see C. Yriarte, *Mantegna* [Paris, 1901], pp. 90 ff. on the *Triumphs*). It is no longer clear whether this head is male or female. The copyists gave it long hair

[1] See M. Muraro in *Arte Pensiero e Cultura a Mantova nel Primo Rinascimento* (Florence, 1965), p. 103, 'Mantegna e Alberti'. Muraro's starting point was the reasonable assumption that Mantegna was familiar with Alberti's ideas.

One of these was that in order to give reason to a piece of fluttering drapery, a painter might show a wind-god in the sky. Mantegna twice painted faces in the sky—here and in the Louvre *Minerva expelling Vice*.

and therefore presumably saw it as female. It appears to be made of bronze.

TABULAE

Nothing comparable to these banners appears in classical representations. They seem to be a reconstruction based on literary descriptions, but Mantegna's train of thought is obscure. The description of ancient Triumphs make it clear that paintings were carried in Triumphs. In some cases these appear to have been portraits of people. For example, in Pompey's Triumph, representations were carried of those who had escaped capture by death [Appian, Μιθριδάτειος 117]. Mantegna's starting point for these banners is probably Appian's *scripturae deinde et imagines earum quas gessissent*. The sort of things which might be displayed were suggested by Josephus in connection with a series of large processional floats (*pegmata*). The exact nature of these has never been determined, and it is not clear, for instance, whether the scenes which they bore were painted or, in some sense, three-dimensional.[1] Nevertheless, through them the spectators were able to contemplate, in all their gory detail, impressions drawn from what must have been one of the more unpleasant wars of the Roman Empire. Mantegna's scenes do not follow Josephus' at all closely but run as follows:

Front Banner, top tier

(a) the approach of an army to a fortified town. The army is apparently being received by a group of men standing on the bridge, but the significance of this is now very hard to determine. Boats are moored alongside, and behind the masking drapery to the left rise projections, some of which may be the masts of other ships.

Front Banner, bottom tier

(b) a battle outside a fortified town and

(c) an *adlocutio* scene outside another fortified town, which appears to have been invested with a palisade.

Second Banner, top tier

(d) military manœuvres outside a fortified town.

Second Banner, bottom tier

(e) a line of armed men marching forward beside some tents. They are greeted by a man who emerges from the front tent. To the right (just visible) is the lower part of a gallows.

(f) The sack of a city. To the right, more gallows.

Of these episodes, only (f) resembles the unremitting tales of woe and disaster related in the representations of Josephus. Mantegna's other scenes are far more matter of fact; and since all the walled cities are different, the assumption is that the scenes relate to isolated incidents in the Gallic War. It is not, however, possible to relate them at all closely to Caesar's own *Commentary* and probably nothing as academic was intended. If this were the case, then one of the scenes must have been intended to represent the siege and capture of Alesia; but there is nothing specific enough in the detail to support such an identification.

The form of these narrative representations—in narrow bands—probably derives from classical models. Little more is known now about these than was known in the fifteenth century, but the narrative reliefs of the Arch of Septimius Severus may preserve their appearance.[2] Mantegna seems to have taken a two-tiered representation of this sort (*no. 200*) and translated it into the pictorial style of the fifteenth century.

For, rather surprisingly, visible antique detail is sparse. The bridge in (a) formerly had a balustrade and the curve of the arch was faced with rusticated stonework. (This area is now too rubbed for these to be visible, but the balustrade is visible in X-ray.) The motif of the river running in the foreground of (a) and juxtaposed to an assembled host may have been suggested by the opening scene of Trajan's Column (*no. 183*). The boats are similar with their projecting prows and lightly curved sterns. But there is little else that looks

[1] It is not clear how the fifteenth-century writers imagined the *pegmata*. Flavio Biondo, as was seen earlier (p. 50), likened them to the floats found in the procession of St John the Baptist's day in Florence; and, in line with this, he, his translator (1544), Valturio, and Valturio's translator (1472) all used the word *machina* when invoking this passage from Josephus. But what they imagined happened on the top of the *pegmata/machinae* is not revealed, and it is significant that Valturio removed these scenes altogether from the *pegmata* and turned them instead into dramas acted out in the course of the games which succeeded the Triumph. It is unfortunate that the *pegmata* were not mentioned by Appian or Plutarch; as it is, we are deprived of Mantegna's own reconstruction of these curious objects.

[2] Tamassia, *op. cit.*, thought that these banners might have been inspired by the reliefs on the inside of the Arch of Titus, but this does not seem to be the case.

particularly classical. The towns look like medieval walled cities, the only 'antique' feature being that the castles are often built in tiers, as discussed in the introductory note on Mantegna's architecture, p. 131. The siege-tower with its pivoted scaling ladder is not derived from any classical source. This is indeed a point where contemporary practice ought to be relevant. But no close parallels have been found; Valturio's illustrations, for instance, do not offer anything very similar.

The most classical feature is the *Adlocutio*. Several representations of this exist on coins, especially of the first century A.D. There is, too, a representation among the Aurelian reliefs on the Arch of Constantine. On these, however, it will be seen that the Emperor is almost always clearly separated from the soldiers, who never cluster round in front of him. In this respect, Mantegna's *Adlocutio* is more like representations on the Columns of Trajan and Marcus Aurelius (*no. 182*).

The fourth scene (d) produces almost nothing classical. The mysterious siege-engine is so far unexplained. It is not a battering-ram since its construction is unsuitable. So what did Mantegna suppose it was going to do? One cannot help feeling that a military gentleman such as the Marchese Francesco would have asked the same question—and that Mantegna would have had an answer ready. The nearest classical objects seem to be the dragon-standards on the base of Trajan's column (*no. 184*) and it is possible that Mantegna's creation was the result of a misunderstanding. For Roman battering-rams, see the remarks on Canvas II below, p. 139.

The remaining scenes (e–f) owe nothing to any known antique model. The victims hanged on gibbets were presumably a permanent part of the contemporary scene. The scenes of fire and destruction come out of Mantegna's imagination and are notably more vivid than comparable scenes on Trajan's Column.

ARMOUR AND COSTUME

Helmet with wings

This type of helmet is frequently to be found crowning the head of *Roma* on Republican coins (*no. 229*). These examples also display the serrated cresting. However, the peak of the helmet is noticeably different, Mantegna's tending to curve upwards and forwards. Even in the S. Zeno altar

and the Eremitani Chapel, Mantegna's Roman helmets were already assuming this shape. On classical monuments it is extremely rare although there is some suggestion of it in the Cancelleria reliefs, Rome, Vatican (but these were only discovered in 1938). The same is true of the Aurelian *Adlocutio* relief (*no. 193*) and Mantegna may merely be exaggerating this tendency.

Straight sword with bird-headed hilt

Roman swords were commonly straight (*no. 187*). The addition of the bird's head was probably suggested by the S. Sabina weapon reliefs (*no. 212*).

Leopard-skin boots with uncovered toes

These may derive from the boots of *Roma* and *Mars* in the *Adventus* relief on the Arch of Constantine (*no. 199*). Mantegna's boots were spotted and bore leopard heads. The detail is now indistinguishable in the original but may be recovered through Andreani's copy (*no. 89*). The animal basis of the classical models is impossible to identify with certainty.

Cuirass decorated with arabesques

All-over decoration of this character is never found on Roman cuirasses. Mantegna has transposed a type of decoration common in architectural relief ornament—for instance on pilasters. Something very similar is to be found on the lower parts of the Ara Pacis (*no. 167*).

The Louvre Drawing (*no. 51*)

(Full catalogue entry on this drawing is on p. 163; comments below relate to its iconographical differences from Canvas I)

Tabulae

The choice of subject matter was originally different. In the drawing, the rear painting contains only views of cities. There seems, therefore, to be some distinction between the 'places' here and the 'events' on the front banner. This may therefore have been Mantegna's original formulation of Appian's contrast between the *captarum urbium simulacra* and the *imagines earum quas gessissent*.

The subject matter of the front banner is similar to that which was finally painted. The upper tier

(a) shows siege equipment being brought up to a walled city; the second tier (b) shows an armed encounter; and the third tier (c) shows the general staff (on horseback) with some foot soldiers before a walled city. The style is sketchy and the significance hard to determine. They are less classical than the final version to the extent that the *adlocutio* was subsequently added.

One interesting detail survived from this first draft—the extraordinary war-machine with the dragon's head set on a long curving 'neck'. The arrangement of the supports is different since it is on trestle-like legs rather than wheels. But its use is no more obvious.

The two banners and the 'tabula ansata'

These are inscribed thus—GALIA.C (both banners) and GALIA CAPTA (the *tabula ansata*). For the inscriptions, see Appendix II.

Canvas II. Colossal statues on carts, a representation of a captured city, siege equipment, inscribed plaques, images

Size: H. 8 ft. 9 in. W. 9 ft. 1¾ in. (2·66 m. × 2·78 m.).
The full width of Mantegna's painted surface survives in this canvas. A portion of the upper margin is also intact.
Width of central canvas strip: 46¾ in. (119 cm.).
Nos. 8–15

By contrast with the first, this canvas is one of the best preserved in the series. Almost everything visible dates from Mantegna's time even though the state of preservation is sometimes disappointing. One area in which Laguerre's work predominates is in the figure on the right carrying the statuette. The condition of the drapery is fair but the head, arm and legs are all post-Mantegna Parts of the statuette are also later. But the lettering on the front *tabula ansata* seems to be entirely of Mantegna and large areas of Mantegna's detailed painting (for instance, the chariot, the horse trappings, the dog's head and flaming torch) are brilliantly preserved. The main deficiency lies in the destruction of many of the cool scumbles which once overlay the strong body colours. This means in particular that the reds almost all stand out now more than they did originally. Thus, the colour balance of the picture has been upset. This

is, nevertheless, an outstandingly well-preserved painting.

The main elements in this picture are drawn from Appian and Plutarch with a possible reference to Livy. All the relevant passages are to be found in Flavio Biondo's *Roma Triumphans*. The most conspicuous features are two *colossi*, an architectural construction, a cart bearing busts, two *tabulae ansatae* and a miscellaneous collection of what appears to be siege equipment. To the right are some arms trophies, which will be dealt with under the heading of Canvas III. The architectural construction, coming in this position, must be one of Appian's *ligneae turres captarum urbium simulacra*. The idea of siege equipment is added to Appian's text, probably from the description in Livy of the Triumph of M. Fulvius (*Ab Urbe Condita*, XXXIX. 5) although Mantegna's display does not correspond in detail to Livy's description. (Valturio also quoted from this passage, which his translator dragged rather peremptorily into the age of gunpowder, with terms from contemporary weaponry.) The cart with its bust represents the first of the displays of spoils referred to in Appian at this point (*currus spoliis refertos deducebant*).

The foremost *tabula ansata* gives the main surviving indication in the paintings of the subject of the entire Triumph and must therefore correspond to Appian's *scripturae . . . earum quas gessissent*.

COLOSSI

These figures, painted in grisaille, are meant to be statues. Plutarch's account does not name the subject of these figures but Josephus mentioned large figures of what must have been Roman gods. Since these figures are entirely without attributes (except for the staff) their names present a problem. They have been called Jupiter and Juno and the male head is undeniably of a Zeus-Asclepios type (*no. 202*). Both Yriarte, *Mantegna*, p. 90 ff., and Portheim, *op. cit.*, suggested this identification. Paribeni (Luzio and Paribeni, *op. cit.*, p. 58) suggested a male identification, *Quirinus*, for the second figure; but it is female. It is unlikely that the male figure is intended as a barbarian ruler and the resemblance to the Trajanic Dacians on the Arch of Constantine is not a close one, though Vermeule (*European Art and the Classical Past*, Cambridge,

Mass., 1964, p. 147 ff.) suggested that it was. It is true that, if one goes outside the texts mentioned, one can find Triumphs in which large statues of the conquered rulers were carried (see Appian 117 and Pliny, *Historia Naturalis*, XXXIII. 54—both Triumphs of Pompey). Tamassia, *op. cit.*, thought that this figure was a free representation of Mars; but pointed out correctly that the head was like some representation of Pluto. The tight-fitting hat on the statue looks like a misunderstanding of a hair arrangement common to many classical statues. The hair is sometimes bound tightly round the forehead and temples with a band, which flattens out the area of hair within the band. This can produce the effect of a tight-fitting skull cap. Such a misunderstanding would be the more likely if Mantegna was working from someone else's drawing. As it stands, the hat is unclassical. No antique parallels have been found for the boots, but Mantegna had himself painted similar boots in the Eremitani frescoes.

CARTS

Unstable little carts with flat tops are rare in antique art, although two occur on Trajan's column (*no. 186*). There, however, they are very plain; and Mantegna's ideas on cart decoration must come from elsewhere. The left-hand wheel is close to a wheel design on one of the S. Sabina weapon reliefs (*no. 213*). The right-hand wheel, by contrast, seems to be based on a shield pattern (*no. 177*).

SIEGE EQUIPMENT

The relevant passage in Livy was known to and quoted by both Flavio Biondo and Valturio. The specific items mentioned are *catapultae balistae et tormenta*, rendered by Valturio's translator as *veretoni, manganelli* and *bombarde*. No such equipment is visible here. The only unmistakable object is the *aries* or battering-ram—but this is not mentioned in the texts. It does, however, make a fairly constant appearance in the visual sources (*no. 201*) although never on the same massive scale.

The vertical object with the volute-shaped end, reaching nearly to the top of the canvas, is probably derived from the ship's prows to be seen in the S. Sabina weapon reliefs (*nos. 213, 215*).

The object projecting to the right of the flaming torch may perhaps be intended as a scaling-ladder, but a very unsteady one. (For comparison, some medieval scaling ladders survive in the *Waffnungsammlung* of the Kunsthistorisches Museum, Vienna). The large pole with the pulley may be a hoist; the screw device looks as if it ought to be a clamp. It may be noted here that the Roman infantry also had hooks and grappling-irons, mentioned in passing by Caesar. (See also Vegetius, *Epitome Rei Militaris*, xxv. [*Enumeratio ferramentorum vel machinarum legionis*] *Habet ferreos harpagones, quos lupos vocant, et falces ferreas confixas longissimis contis*.) These may underlie the hooks and spikes visible in Mantegna's equipment.

In general, on closer inspection, although everything looks highly offensive, it is difficult to imagine how Mantegna thought it would be used. It is equally hard to see it as a meaningless *jeu d'esprit* since this is presumably one of the areas that would have engaged the professional attention of the military members of the Gonzaga family.

MODEL BUILDING

This cannot be a real building since the siege equipment extending behind it reveals its comparatively small scale. It must therefore be a model and is probably one of Appian's *turres ligneae*. There is, nevertheless, an unexpected difference between its appearance and that of the cities in painted banners of the previous canvas.

In its design, this building is of some interest and has received considerable comment and is discussed in the introductory note on Mantegna's architecture, p. 131 f. It adheres to the tiered formula of much of Mantegna's architecture but it also seems to owe something to current speculations about the original form of the Castel S. Angelo. Of these the most elaborate was probably that of Cyriacus of Ancona, now known through representations on the Vatican doors of Filarete and in a later manuscript (*no. 129*). (On this, see B. Ashmole, *Proceedings of the British Academy*, XLV, 1957, p. 25: 'Cyriac of Ancona'.) The main features that Mantegna took over were the rusticated rectangular lower storey and the colonnaded circular upper storey. In spite of a general similarity, however, this cannot itself be intended as a reconstructed Castel S. Angelo. Whether recording its actual appearance or reconstructing its original appearance, all the representations of

the Castel S. Angelo agree that it had a frieze of *bucrania* capping the rectangular base. There is marginally less agreement on the presence of projecting pilasters at the corners. (They existed, but the general view on f.20ᵛ of the *Codex Escurialensis* omits them.) Neither of these features is present in Mantegna's construction. Here the decoration of the base is very different and the colonnade is in a different position. Further, there are adornments added to the parapets which have nothing to do with the fortress.

The most striking features are the curious corner pieces with the half-pediments. These seem to come from the façade of Trajan's market in Rome (*no. 165*), the appearance of which was recorded in the Vatican Sangallo Sketchbook, f. 5ᵛ (see C. Huelson, *Il libro di Giuliano da Sangallo*, Leipzig, 1910). This drawing, probably a copy, is peculiar in that it omits the half-pediments under discussion, although they form part of the original structure. The drawing, however, demonstrates that something of this façade was visible in the late fifteenth century. It is also true that certain sarcophagi (notably the Velletri sarcophagus) exhibit this feature.

The figures along the parapet in between are extremely rubbed, and it is probably advisable to describe what remains. From left to right, therefore one sees

(a) a draped figure, probably male, the drapery so arranged that his left leg is exposed for much of its length. His right arm is bent inwards at the elbow, his left arm extended down the side. Both arms appear to be bare. The body turns slightly to his right, the head slightly to his left.

(b) a female figure in full-length dress, frontally placed. The head and arms are concealed by a banner. Her left arm is extended down the side,

the hand bent slightly inwards towards the centre. It appears to catch at part of an over-mantle that wraps diagonally across the lower part of the dress.

(c) the figure is now indistinguishable.

(d) a naked male figure, curving in the region of the abdomen gracefully towards his left. The head is turned slightly to his right. The figure has a cloak that hangs down behind so that it is visible to the right and to the left. His left arm extends downwards, and the hand probably clasps the cloak. His right arm, which is raised, is hidden behind a banner. As far as these figures are legible, they have a generally antique appearance. However, no precise parallels have been found though Tamassia, *op. cit.*, proposed a number of comparisons.

FEMALE BUST WITH MURAL CROWN

Ultimately the idea for this may go back to the famous *Tyche* of Antioch said to be by Eutychides, the pupil of Lysippos. But it was also the customary way of representing Cybele, as for instance on a group of Roman republican coins (*no. 230*).[1] There are a number of images of heads with mural crowns (*no. 179*). According to Tamassia, *op. cit.*, there is one in the Museo Archeologico in Venice which formed part of the Grimani donation of 1593.

Mantegna's head is in detail very different from any of the classical representations of Cybele. The female head with its carefully waved hair and descending ringlets is based on a different type—probably like the 'Lucilla' bust (*no. 203*) still in Mantua. (See Levi, *op. cit.*, catalogue no. 135.)[2]

The crown, however, will not match any known

[1] The identification of this bust with Cybele was made by Yriarte (*Mantegna*, p. 90 f.). This links with the very similar representation of Cybele in the painting of the *Triumph of Scipio* now in the National Gallery, London. Cybele received her mural crown as the protector of social well-being and civilized existence connected with town life; and a captured image of Cybele makes quite good sense beside the model of a captured town. It makes less obvious sense in a Gaulish context and one is tempted to suggest that some enterprising etymologist had got hold of the information that the emasculated priests of Cybele were called *galli*.

[2] Vermeule, *op. cit.*, p. 47, asked whether this bust preserved the likeness of Mantegna's so-called *Faustina*, and linked with it the similar bust in the *Triumph of Scipio*, now in the National Gallery, London. There is a rather bad *Faustina the Elder*-type bust in the Palazzo Ducale at Mantua which has in the past been identified with Mantegna's *Faustina* (Levi, *Sculture Greche e Romane del*

Palazzo Ducale di Mantova, Rome, 1931, Cat. No. 130). As already explained, the history of the Mantuan pieces does not extend back beyond the seventeenth century and this identification has no solid historical basis; moreover, in view of Mantegna's expressed attachment to his bust, one would hope that it was of a better quality than the piece now in Mantua. This identification, however, provides the main objection to the association of his *Faustina* with the two Cybele busts in the paintings in that these are not what would nowadays be called *Faustina the Elder* types (*no. 238*). But it is possible that Mantegna's bust was of a type resembling *Faustina the Younger*. She is normally shown with a bun of hair projecting behind in a manner reasonably similar to the Cybele busts. The correspondence about Mantegna's *Faustina* (printed by Kristeller) does not state explicitly which *Faustina* the bust represented. All in all, Vermeule's hypothesis is an attractive one. There was apparently some confusion in the fifteenth century over the correct appearance of either *Faustina* since a 'portrait' medallion on the façade of the Colleoni Chapel, Bergamo, inscribed *DIVA*

Roman example, for in all those, the outer 'fortifications' have rectangular towers, as does the bust of Cybele in the London *Triumph of Scipio*.

FEMALE BUST WITH CRESCENT ON TOP

Very little of the detail of this image is visible. It is presumably intended as an image of a moon goddess but the iconography is unusual. A similar bust had already appeared on the relief set on the building behind the Eremitani scene of the removal of the body of St Christopher. (Montfaucon, *L'Antiquité Expliquée*, Paris, 1719, Vol. I, Plates XCI and XCII, illustrated several images of Diana bearing a crescent on her head.)

STATUETTE OF FEMALE HOLDING JUG

Representations of people carrying statuettes in processions occur in Roman art. Although the general appearance of this statuette is antique, no close antique parallels have been found.

ARMOUR

Straight sword with hand-guard on hilt

The guard is not a classical feature; equally it is uncommon in the fifteenth century but examples occur—for instance, in the St Ursula cycle by Carpaccio (see *The Return of the English Ambassadors* to England and *The Martyrdom of St Ursula*). The length of this sword is also unclassical.

Pole-axe

This is a common medieval weapon. But axes feature on the S. Sabina weapon reliefs (*nos. 212–18*) and are carved in such a way that they might be mistaken for halberds, especially where the end of the shaft is concealed by other weapons. Similar weapons are to be found in the predella of the S. Zeno altar.

Trophies of arms

See the remarks for Canvas III.

FAUSTINA, does not correspond to any known Faustina. On the other hand there is a very good *Faustina the Elder* medallion (probably taken straight from a coin) on the west

THE TORCH-BRAZIER

This is discussed under the heading of Canvas I.

THE HORSE

The horse, with one leg raised, and bearing round his neck a medallion with a lion's head represents a clear allusion to the bronze horses of S. Marco, Venice (see p. 158).

'TABULA ANSATA'

The inscription is set out with other inscriptions in Appendix II, p. 175.

Canvas III. Bearers of trophies of arms, coins and plate

Size: H. 8 ft. $9\frac{1}{2}$ in. W. 9 ft. $1\frac{1}{2}$ in. (2·68 m. × 2·78 m.). Width of central canvas: 47 in. (120 cm.). *Nos. 16–19*

The third canvas is indifferently preserved. The drapery and faces of the main figures are largely Laguerre and only the face on the extreme left contains remnants of Mantegna's work. On the other hand, there are a large number of brilliant well-preserved details among the trophies of arms —for instance the elaborately decorated *pelta*.

THE TROPHIES OF ARMS

The text of Plutarch lists a number of different types of armament which *multis curribus delata fuerunt splendentia aere et ferro absterso, atque ita disposita ut casu maxime cecidisse viderentur*. This description fits well the fortuitous character of parts of Mantegna's display, which also appears to be transported in carts. The arms which, according to Plutarch, were displayed in the Triumph of Aemilius Paulus are listed below. Bruni's Latin version is placed first, followed by the Latin version of Valturio. The Italian version of Valturio's translator is put next, followed by an English translation.

façade of the Palazzo Thiene, Vicenza. Mantegna himself painted some female figures with hair styles more like that of Faustina the Elder in the seventh canvas ('The Captives').

BRUNI'S LATIN VERSION	VALTURIO'S LATIN VERSION	VALTURIO IN ITALIAN TRANSLATION	ENGLISH TRANSLATION
Geseae	Galeae	Celate	Helmets
Scuta	Scuta	Scuti	Shields
Thoraces	Thoraces	Corace	Breastplates or cuirasses
Ocreae	Ocreae	Schinere	Greaves
Crethenses Peltae	Peltae	Targiete	Shields
Traicia Gerra	Gesa	Gesse cioe le haste quali usano li Franciosi	Javelins
Pharatre	Coryti	Coriete cioe le sagitte overo li carchassi	Quivers
Equorum frena	Equorum frena	Freni et morsi di cavalli	Horses' bits and bridles
Enses nudi	Enses stricti	Spate nudate	Unsheathed swords
Sarissae*	Sarissae	(no translation)	(Macedonian) Lances

* For *Sarissae Macedoniae* see Aelian, *De Instruendis Aciebus*, on the Macedonian phalanx. The *sarissa* was a lance 14 cubits long.

From this it will be seen that the components of Mantegna's trophies must in the first instance have been derived from Plutarch, since all these weapons are represented (but not the horse harness). Indeed, the only deviation is the addition of the pole-axe: and perhaps also the battle-axe (it is not always clear how long the handles are). Those shapes are probably added from the repertoire of the S. Sabina weapon reliefs. It is also possible that the fan-like arrangements of weapons silhouetted against the sky may have been inspired by the same weapon reliefs (*no. 216*).

Cuirasses

Normally with skirt of vertical straps (*pteryges*) hanging below. Cuirasses are frequently to be found on the weapon reliefs. The patterning of Mantegna's is somewhat whimsical. One (in the centre) has arabesques and spots (a spotted cuirass is visible in the earlier S. Zeno *Crucifixion, no. 144*). Another (middle, slightly left) has a design on it rather like the courses of masonry. The nearest antique examples have simple arabesques (*no. 210*). Another rather unexpected feature of the cuirasses is the somewhat garish colouring—red, yellow, gold, black or green examples are to be found either here or in the

sixth canvas (but something comparable is also found in the S. Zeno altar).

Shields

The S. Sabina weapon reliefs show at once that a wide range of shapes and patterns was permissible in shields.

THE PELTA. Often found on the weapon reliefs (*nos. 212–18*), but normally of a shape similar to the elaborate example on the left. The deeper shape (rear, centre) appears to be unknown in classical art and may be the result of some misunderstanding. It already featured in the *Resurrection* predella panel of the S. Zeno altar. It is also found in the Codex Escurialensis (f. 16).

THE KITE-SHAPED SHIELD. See the weapon reliefs (*nos. 212–18*) but the Capitol trophies in Rome give a better account of this shape (*no. 208*).

CIRCULAR AND OVAL SHIELDS. See the S. Sabina weapon reliefs. Mantegna introduced this type of shield into the London *Agony in the Garden*. (*No. 143*)

The decoration of shields varied considerably, and, once again, the S. Sabina reliefs offer a wide range of pattern.

THE GORGON'S HEAD. Very common. The shield near the centre of this canvas has been compared to examples on the Trophies now set up on the Capitol (*no. 208*; see Portheim, *op. cit.*). For the head in an entwined pattern (perhaps of serpents) in the second canvas no adequate parallels have been found. The head-motif already appears on a shield in the Eremitani *Martyrdom of St James* (*no. 133*).

FOLIAGE PATTERN BORDERS. See *no. 182*.

ARABESQUE DESIGNS. See *nos. 209, 210*.

THE FIGURED PELTA. The central group consists of a galloping beardless centaur with, on his back, a near-naked female, who clasps her arms round his neck. The centaur holds aloft, in his right hand, a length of drapery, which billows out behind and then curls forward, to be caught up over the female's left thigh. In the foreground bounds a dog. Ahead runs a male figure, naked apart from some flowing streamers of drapery, who turns to blow a horn. To the rear are two more figures; behind is a naked man, who runs forward raising an ill-defined weapon (? a stick)

in his hand; and in the foreground stands a bearded satyr, who thrusts forward a *thyrsos*, the staff commonly carried by the attendants of Dionysus.

Although centaurs appear commonly in classical reliefs (especially in dionysiac scenes) they never carry naked females on their backs. Normally they carry satyrs or *erotes* (*no. 170*). There seems, in fact, to be only one classical situation in which the central group is explicable—namely, Nessus carrying off Deianira (noted by Tamassia, *op. cit.*). Mantegna had already painted this subject in the *Camera degli Sposi* (*no. 138*) and although the figure composition is slightly different, it looks as if he transposed the iconographical scheme into what appears to be a dionysiac context. It is just possible that this was suggested by a classical source since one surviving classical relief (*no. 173*) has a similar group. There is, however, a fundamental difference, in that there a female centaur carries a male satyr.

A dionysiac context is suggested by the satyr with the *thyrsos*. But the opposite figure, taken with his horn and the dog, as strongly suggests a hunting scene. Vermeule thought that the rear pair of figures was based on some copy of the group of the *Tyrannicides* by Kritias and Nesiotes. The recollection seems to be a distant one.

Helmets

The plain helmets stuck on the ends of poles are familiar from coins (*no. 232*) although the fastening bands are hard to parallel. They are also found in representations on Trajan's Column. This plain basin-type helmet also appears in the St Ursula cycle of Carpaccio. It is probably too simple to be typical of any particular century.

The strange plumed helmet with the flat top in the second canvas has not been found either in classical antiquity or the fifteenth century.

The more elaborate helmets are also hard to place, although the S. Sabina reliefs (*no. 217*) contain a rather exotic helmet with a plume and with projecting pieces, front and rear.

Swords and Daggers

Bird-headed pommels appear on the S. Sabina reliefs (*no. 212*). Many lightly decorated sheaths are also shown. Swords with curved blades are rare although a barbarian in the Great Trajanic Frieze holds one unsheathed. They seem to have had a limited popularity in the fifteenth century in Europe (*no. 161*) and it will be remembered

that Castagno's *Pippo Spano* holds one. A curved sword is also held by one of the Huns in Carpaccio's *Martyrdom of St Ursula* (*no. 157*).

Greaves

The shape of Roman greaves can be read only with difficulty from the S. Sabina reliefs; likewise, from other Roman reliefs. The difficulty might well have been insuperable, had Mantegna been working from drawings. Roman greaves were no more than a front covering for the shin and knee. They did not continue right round the leg (*no. 216*). Mantegna painted plain, shiny, modelled cylinders of metal apparently hinged at the side. This idea must be drawn from examples of contemporary plate armour; and it shows considerable similarity to the leg-covering of the Marchese Francesco in Mantegna's *Madonna della Vittoria* (*no. 146*).

Pole-axes

See above, p. 141, but some are a little more elaborate than these, one having an eagle's head protruding from the side opposite the main blade.

Bows and Arrows

The quivers are very like those on the Trophies now on the Capitol—cylinders bound with horizontal bands (*no. 208*). Similar bows appear on Trajan's Column, both on the plinth and on the spiral relief.

War-hammer with bird's head

This has a fifteenth-century appearance (*no. 159*).

THE BULLION AND OTHER BOOTY

The idea of booty being carried on *fercula* or stretchers must come from the Arch of Titus relief (*no. 176*). There are, however, a few detailed points taken from Plutarch and Appian. Plutarch said, for instance, that the men carried *numismata* in *vasa*. Three large bowls heaped with coins are shown in the third and fourth canvases. Appian mentioned crowns at this point, and they duly appear in the fourth canvas. It is also possible that the idea of having each *ferculum* supported by four men only may derive from Plutarch's *quattuor viri singula vasa portabant*. One of the *fercula* on the Arch of Titus appears to be borne by about eight men.

Plutarch listed among the booty *craterae* (wine bowls), *phialae* (shallow saucer-like bowls) and *calices* (goblets or drinking cups). Valturio quoted this passage but unfortunately the translator defaulted at this point, slurring over the passage without attempting to give Italian equivalents. Mantegna, however, made no attempt to keep literally to the text and it is, indeed, unlikely that he would have had much idea what Roman plate looked like. The varied collection of plate which was eventually painted must have come largely from Mantegna's imagination.

Plutarch's account of the Triumph suggested that there should be two groups of booty-carriers, the second of whom should have smarter plate and booty than the first. Plutarch made a distinction between gold and silver booty. Mantegna's distinctions are somewhat different. In Canvas III, there is a preponderance of what appears to be polished steel—to the extent that it appears indistinguishable from the metal from which the adjacent cuirasses are made (the vessels are, however, parcel gilt). By contrast, the plate in Canvas IV seems to be mainly of gold although it lacks the brilliance and sparkle of the sheen of the metal in Canvas III. The plate in Canvas VI is in its substance probably the most fascinating not only because of its brilliant painting but also because of its ambiguous quality. It seems to be intended to be silver, parcel gilt.

Mantegna also appears to have transposed a motif from Plutarch's second group to the first group. This was the idea of having one outstandingly large object carried separately—as in the fourth canvas. (*Auream phialem decem talentorum quam Emilius ex lapidibus effecerat.*)

The variety of shapes for classical vessels suggested by the most easily accessible visual sources is very limited. There is a sacrificial jug or ewer which appears frequently on coins (*no. 231*) and on a few reliefs (*no. 174*). Its form seldom varies although the amount of decoration fluctuates. It normally has a simple fluted belly (*no. 231*). There are also representations of bowls sometimes moulded into fluted or scalloped shapes. But such simplicity is quite unlike the variety of invention found in the *Triumphs* (the variety is also far greater than anything found in Mantegna's earlier work).

Mantegna's activity as a designer of metalwork is virtually unknown. It is mentioned in two letters from Lancilloto de Andreasi to the Marchese dated respectively 12 and 17 February 1483. (They were published by Kristeller [G] Dok. 84

and 85 and [E] Doc. 37 and 38 and are now catalogued as Archivio Gonzaga Busta 2430, ff. 656 and 657.) But the well-known description by Sannazaro of a vase said to have been designed by Mantegna refers to a fictitious object which Sannazaro himself imagined to be of painted maple-wood. (This description is mentioned by E. Tietze-Conrat [*Mantegna*, p. 249] and examined more fully by O. Kurz in *Studi in onore di Riccardo Filangieri* [Naples, 1959], II, p. 277: 'Sannazaro and Mantegna'.) The main evidence for Mantegna's abilities in this direction must surely now be the *Triumphs* themselves. The problematic drawing of a chalice recorded in Hollar's engraving of 1640 does not seem to bear any relationship to the plate in the *Triumphs*. (See G. Parthey, *Wenzel Hollar: Beschreibendes Verzeichniss seiner Kupferstiche* [Berlin, 1853], No. 2643.) Hollar saw the drawing in the Arundel Collection.

The variety of design displayed in these canvases is very remarkable. Taking into account both the vessels and the candelabra in the fifth canvas, the range of invention is far greater than that found in any other contemporary pictorial representation. It is also, needless to say, far greater than anything actually surviving. Moreover, the mention of the description of Sannazaro is not entirely pointless. One of the features in his description was a handle in the form of a snake which curved upwards until the snake's head reached the brim of the vase. This very motif is also one of the features of the outsize vase carried separately in the fourth canvas. In the so-called Mantegna Sketchbook (see below, p. 149) there is drawn, on f. 46ᵛ, a large ewer (*no. 148*), also with a snake handle. This sketchbook contains several pages of metalwork designs (*no. 147*) and in many cases the shapes are similar to those seen in the *Triumphs*. There is one covered bowl with its rim decorated with cufic letters—compare the large bowl carried in the fourth canvas.

The individual shapes are so bizarre as almost to defy comment. The chalice-like object in the third canvas comes closest to a traditional *krater*, identified by Vermeule as a 'Neo-Attic krater' (*op. cit.*). Of the various embellishments, the snake-handle and the band of cufic letters have already been mentioned. The little figure of Neptune in the third canvas probably comes from a coin type (*no. 233*) although such representations seem to be very rare. The dancing females on the 'krater' may be a motif derived from Cyriacus of Ancona. They are reasonably

similar to some nymphs seen by Cyriacus on a relief at Samothrace and identified by him as Muses. Cyriacus' drawing is known through the copy in the Ashmole ms. (See E. F. Jacob, *Italian Renaissance Studies* [London 1960], p. 455 ff., Charles Mitchell 'Archaeology and Romance in Renaissance Italy'.)

The Vienna Drawing (*no. 53*)

(Full Catalogue entry on this drawing is on p. 164; comments below relate in particular to Canvas III)

Two fragmentary inscriptions. These were eventually omitted. See Appendix II.

Round shield with Medusa head design. See *no. 213*.

Shield and Wheel with broad border and radiating pattern in centre. See *no. 177*. Donatello showed a similar shield in his Paduan relief of *The Miracle of the Speaking Babe.*

Kite-shaped shield with winged thunderbolt design. This is a motif common on coins (*no. 234*). But it is also to be seen on representations of shields, for instance in the great Trajanic Frieze. It was apparently a normal pattern for the shields of legionaries (see G. Webster, *op. cit.*, p. 122 ff.), and Mantegna had already used it in the S. Zeno *Crucifixion* (*no. 144*).

The booty is less elaborate than in the painting; and by implication the arrangement is closer to Plutarch's text. For there is only one vase full of coins on the *ferculum*; and it is presumably carried by four men, of whom only the first two are visible (see above, p. 143).

The cart in the centre is more elaborate. In the painting, the decorative trophies of arms on the sides are transferred to a chest full of arms, higher up in the picture. The *pelta* is, in this study, a comparatively uninteresting object bearing a light foliage pattern. The elaborate figured *pelta* in the painting replaced both this and the inscribed chest as a centre of interest.

Canvas IV. Bearers of coin and booty, man carrying a large marble vase containing a candelabrum, oxen with attendant youth, trumpeters

Size: These measurements were unfortunately not taken during the recent conservation. They are nevertheless within the limits of the measurements of the other canvases. H. 8 ft. 9 in.– 8 ft. 9¾ in. (2·66–2·68 m.). W. 9 ft. 1¾ in.– 9 ft. 2 in. (2·78–2·79 m.). Width of central strip of canvas: 46¾ in. (119 cm.) *Nos. 20–27*

This canvas is extremely well preserved, and it should be remarked at once that it is the only canvas to preserve Mantegna's sky virtually intact. The main area of Laguerre's reworking is in the figure on the extreme left. The face of the adjacent bearer has also been retouched and also the wooded hillside on the extreme right of the picture. The woods in the centre are Mantegna's work. The lettering beneath the trumpets is post-Mantegna but agrees with the copies.

For the carriers of booty, see remarks under the heading of the previous canvas. For the rest, the canvas contains a youth leading a white ox (Appian and Plutarch) and trumpeters (Plutarch). The sacrificial oxen and attendant youths in Canvases IV and V are both inspired by the text of Plutarch, who speaks of *Boves auratis cornibus vinctis ornati et sertis* led by *adolescentes succincti ad immolandum: et pueri aureas et argenteas patinas sacrificii gratia deferebant.*

ARCHITECTURE

Various suggestions have been made about the genesis of the ruined buildings (see also General Observations introducing this Catalogue). An early idea was that they represented a recollection of the ruins on the Palatine Hill (Portheim, *op. cit.*). The main objection is that, as far as things survive, nothing on the Palatine Hill has ever looked like these ruins. Most scholars see them as Mantegna's own imaginative creations based on particular remains elsewhere in Rome. On two of these derivations there is some measure of agreement. The main arcaded and tiered circular building is based either on the Colosseum or the Theatre of Marcellus. The ruin on the left seems to reflect some knowledge of the Basilica of Maxentius.[1] What remains seems problematic; but in fact this is true of all Mantegna's background ruins. They tend to become insoluble conundrums if one tries to analyse them in terms of derivations from actual ruins. The balance

[1] See, for instance, Blum and Tamassia, *opera cit.* Tamassia also suggested that the column was based on either that of Trajan or that of Marcus Aurelius. But Mantegna's column has no spiral decoration.

between the real and the imaginary is so finely struck that it becomes virtually impossible to disentangle the two.

STANDARDS

Statuette of nude female, standing on a globe and holding a globe. Beneath, a circlet and a pair of wings.

No clear antique parallel exists for the figure, although the general disposition of the upper parts of the body suggests that the starting point was a *Venus Pudica*. The fact that Caesar claimed descent from Venus may be relevant. The nearest classical parallel is a coin-type showing *Venus Genetrix* (*no. 235*) in which the 'globe' is actually an apple.

The circlet is perhaps a misunderstanding of the discs on *signa militaria* (see above, p. 134). The Vienna copy alone shows an inscription, for which see Appendix II.

Bust on a pole with decorated shaft

For the bust, see p. 157. The decoration of this shaft is odd. The ball-shaped section here has a peculiar furry texture and it is not clear what it is meant to be made of.

Standard with bulbous upper sections, a spray of laurel leaves and 'tabula ansata'

This last is now completely blank but the Vienna copyist filled in the letters S.P.Q.R. Of the three bulbous sections, the uppermost is badly preserved. The other two, however, retain an odd furry texture, similar to that seen on the standard just discussed and equally puzzling.

Open wreaths and sprays of laurel foliage

The wreaths have an uneven texture but appear to be of foliage too. For open circlets, see above.

OXEN LED TO SACRIFICE AND 'VICTIMARIUS' WITH MALLET

A scene of sacrifice appears among the Aurelian reliefs (*no. 197*), but Mantegna's interpretation of the subject is so different that his archaeological

sources must have been different too. In that relief and in most representations of sacrifices, the ox is led by a grown man who is stripped to the waist and, as *victimarius*, armed with an axe. Presumably on the authority of Plutarch, Mantegna set a youth to lead the ox. A fully-grown man, negroid in type, hovers in the background but he is fully clothed; also, he holds an implement far rarer than an axe and similar to a croquet-mallet. An example of this is to be found on Trajan's Column (*no. 188*).

The decking-out of the oxen can be found in various classical examples. The broad decorative fillet round the belly of the animal is a reasonably common item. The muzzle and harness are less common, likewise the headdress; but all these features are to be found carved on the Arch at Benevento (*no. 181*). One feature missing there, the pendant string of beads, can be found elsewhere (*no. 171*). So far, therefore, Mantegna's work is reasonably authentic from an archaeological standpoint. The garlands do not, however, seem to have any classical sanction. They are, indeed, to be found frequently round the bellies of centaurs in Dionysiac scenes (*no. 170*) and Mantegna's ideas may have been stimulated from this source. It is also true that in one of the Aurelian reliefs (*no. 195*) there is a small sacrificial pig which has a garland.

The horns of the ox in this canvas are gilded (see Plutarch); but those of the ox in the next canvas are plain.

The peculiar pose of the youth who leads the ox apparently with the tips of his fingers has been noted by others. This pose occurs in the work of other painters (Blum, *op. cit.*, noted that similar poses were to be found in Botticelli's *Birth of Venus* and *Minerva with the Centaur*), and there may be some common antique prototype. One possibility is the figure of *Victoria* on the Great Trajanic Frieze (*no. 190*).

VESSELS

These have already been dealt with under the heading of the previous canvas, p. 143.

CANDELABRUM

(Upside down in large vessel)—on the design of the *candelabra* see below, p. 148.

FACE OF VASE-BEARER

Its character seems to be based on a coin portrait. Its fleshy quality with the emphasis on chin and nose suggests Domitian (*no. 236*).

Canvas V. Trumpeters, oxen with attendants, elephants

Size: H. 8 ft. 9¼ in. W. 9 ft. 1¼in. (2·67 m. × 2·77 m.). The lower margin of Mantegna's painting is preserved.
Width of central canvas strip: 48½ in. (123 cm.).
Nos. 28–31

This canvas is also very well preserved. The vertical leg of the youth standing on the elephant's back is unusually perfect and may serve as an example of Mantegna's finished modelling.
The canvas is unique in containing long vertical discolourations, which appear to be water stains. To the extent that they lie beneath all the retouching and belong therefore to the lowest *stratum*, they may be damage sustained in the sixteenth century.

A curious change in the character of the landscape takes place between Canvases IV and V. In Canvas IV, the hillside is predominantly wooded; here it is predominantly rocky and barren, although apparently a continuation of its neighbour. It is true that the preservation is poor at this point, but the copies confirm that this contrast existed *c.* 1600. The discontinuity may have been the result of the paintings being removed to their eventual site as they were completed. It is to be presumed that Mantegna originally intended, when the series was completed and installed, to carry out a certain amount of emendation *in situ* precisely in order to iron out this sort of irregularity. Something similar

occurs in the transition from V to VI and from VIII to IX.

TRUMPETERS

See the remarks on *Tubae* under the heading of Canvas I, p. 134.

OXEN WITH ATTENDANTS

See the remarks made under the heading of Canvas IV.

ELEPHANTS

Of all the features in the *Triumphs*, this is in many ways the most surprising. It does not prevent the visual impact from being splendid: and it is only on reflection that one begins to wonder what Mantegna had in mind when he painted these extraordinary apparitions. The initial stages are relatively clear. Appian mentioned elephants and Mantegna supplied some surprisingly authentic-looking animals. But an elephant which had recently been landed in Venice (1479) was actually brought to Mantua and Mantegna must have seen it.[1] Thus he was able to relate the various parts of the body more successfully and realistically than had most other artists previously. The length and thickness of the legs is well judged against the bulk of the body, and the size of the ears and length of the trunk are reasonably correct. The ears and the ridges on the trunk suggest that Mantegna's animal is based on an African elephant. It is true that this still leaves something to be desired. The trunks are too narrow—a feature that emphasizes the sucker-like tip. The ears, too, have a peculiar webbed character which is also apparent in the drawing (*no. 52*). Both these characteristics are sometimes found in earlier representations. They seem to have formed part of the artistic 'folk-lore' concerning the

[1] For recent remarks on elephants in Renaissance art, see M. Meiss, *Andrea Mantegna as Illuminator* (New York, 1957), pp. 11–12. There are two 1479 references. The first is taken from the *Schedi Davari* in the Archivio di Stato, Mantua. I have not been able to find the original letter, which was written in Mantua by the painter Anselmo Leonbeni on 16 February. According to Davari's notes, Leonbeni intended to go to stay with a relation in Padua in order that he might draw the elephant which had been taken to Venice. He then intended to return to Mantua. That the animal actually reached Mantua may be deduced

from a letter of a few months later (Archivio Gonzaga Busta 2422, Contents unnumbered, Letter of 21 May 1479, Matteo Cremasis to the Marchese Federico) when in the course of a series of routine medical reports on the Marchesa, the family physician said *Hera sera sua signōia fa venir lo elefante ī castelo e si' la panthera. đ cħ q̄lla ne hebe piacer asai sono ēt aīalj đ havirne piacere. eq̄llo tuo domatore ge fece fare alcūj movim̄ti semp̄ dopo q̄lli a uno a uno facendo esso elefante reverētia ala Ill.Ma' đ cħ q̄lla ne stete bono peço cū piacere ridendo.* This was written from the *castello* at Mantua.

appearance of elephants and their re-emergence here in the *Triumphs* is interesting if not surprising.[1]

ELEPHANTS' ADORNMENTS

It is very difficult to reconstruct the steps by which Mantegna devised these adornments. The creatures occasionally appear on coins drawing chariots (*nos. 237, 239*) and these images normally show the drivers or *mahouts* perched on their backs. Occasionally some sort of cloth is shown slung over their backs but nothing as elaborate as Mantegna's decoration ever appears. The resplendent apron with its attached bell seems to be Mantegna's invention; the piercing of the ears to take decoration may be his invention too. Perhaps this is the way in which elephants were decked out when they were paraded in fifteenth-century menageries. But the headpieces have some sort of classical past. They were (and are) more easily recognizable on the heads of a famous pair of statues of Satyrs now in the Capitoline Museum, Rome. (See H. Stuart Jones, *The Sculptures of the Museo Capitolino* [Oxford, 1912] and catalogued as Cortile 5 and 23.) They were known in the sixteenth century but already make an appearance in the so-called Mantegna Sketchbook (*no. 152*) discussed on p. 149 at the end of this entry.

'LYCHNUCHI'

Mantegna wished to combine with Appian's elephants the one authentic recorded detail about the Gallic Triumph of Caesar. According to Suetonius, Caesar's elephants were holding *lychnuchi*. How a fifteenth-century scholar would have glossed this word is not clear. Since *lychnuchus* is a transliteration from Greek, it appears infrequently in literature. It was used by Cicero (*Ad Quintum Fratrem III. 7.2*) to mean probably a table lamp (*Hanc scripsi ante lucem, ad lychnuchum ligneolum*). But Pliny used it to describe metal objects of an altogether larger and more ostentatious kind (*Historia Naturalis XXXIV,*

Chap. 3. VIII. Placuere et lychnuchi pensiles in delubris, aut arborum modo malaferentium lucentes; qualis est in templo Apollinis Palatini). Suetonius further described some nocturnal gladiatorial fights staged by Domitian (*Vita IV,* 1) as being lit by *lychnuchi*. None of these texts suggests the solution finally adopted by Mantegna.

The sixteenth-century translator of Flavio Biondo's *Roma Triumphans*, Lucio Fauno, rendered it as *torchi* (*sic*). (This work translated as *Roma Trionfante*, was published in Venice in 1544 and dedicated to Michelangelo, and the account of Caesar's Triumph occurs on pp. 367-8.) On the other hand Calepinus in his dictionary was less specific. *Lychnuchi grece nominantur quicquid lucernas sustinet quasi lucernifer* (Paris, 1519 edition).

Mantegna seems to have glossed *lychnuchi* as *candelabra* rather than *torchi*. However, he set on the top of each stem a bowl or bucket-shaped container and this transformed each into a flaming beacon. The resulting object is not unlike the incense burners which appear, though infrequently, in Roman art (*nos. 180, 240*). As already noted (p. 84, note 1) Tietze-Conrat, *op. cit.*, p. 184, suggested that the *lychnuchi* as represented by Mantegna were misunderstandings of the fasces carried by lictors on the Arch of Titus. Vermeule in *European Art and the Classical Past* agreed with her. But the *fasces* bear no visual resemblance to the objects tied on the elephants' backs.

Numerous marble bases survive from classical antiquity, some of which may have been influential in forming Mantegna's ideas on the subject. It is not generally clear, however, whether their stems would have supported *candelae* or bowls for incense. They are technically often rather heavily carved and lack the delicacy of Mantegna's *candelabra*.

This delicacy could only have been achieved in metal and that is the substance of Mantegna's *lychnuchi*. Its type varies. The *lychnuchus* on the left seems to be of silver; but that on the extreme right has a duller sheen similar to gunmetal. The two standing in the rear on the right have a pale golden tinge. The rest have a strong rose-red

[1] For a useful account of the different types of elephant see Sir Gavin de Beer, *Hannibal's March* (London, 1967), Appendix A, 'The Elephant of Maillane'. The Mantuan elephant, if it is recalled in Mantegna's painting, is likely to have been the smaller of the two African elephants, the so-called 'forest' variety. Judging from the painting, sheer size was not one of the qualities which impressed itself on Mantegna.

In the course of writing this book, I happened to be in communication with Professor G. Evelyn, Sterling Professor of Zoology at Yale. Amongst other things, he emphasized the unrealistic features of these elephants and felt that the traditional iconography was still very influential. For an earlier representation of the elephant, see Schubring, *Cassoni*, Plate XLVI.

colour and it is difficult to imagine what substance Mantegna had in mind for these. The same is true of the upturned *lychnuchus* in Canvas IV with its base inset with blue panels. The importance of the *lychnuchi* changed during the planning of Canvas V and this problem is dealt with in the discussion of the Elephants Drawing below.

In devising this scene, there is one further source which may have stimulated Mantegna's imagination. Sarcophagus reliefs showing the *Indian Triumph of Bacchus* normally have elephants. A famous version was to be seen at the end of the fifteenth century in the church of S. Lorenzo fuori le Mura, Rome. This, had it been known to Mantegna, would have shown that a surprising amount could be carried on the back of an elephant. It might have been the imaginative starting point for the elephant in the centre of the fifth canvas which has a large *lychnuchus* and two youths perched on its back.

STANDING YOUTH

The action of the standing youth is hard to interpret although he is presumably tending the fire in some way. His stance seems to be another rather indeterminate derivation from the antique, and similar poses occur in the work of Botticelli (see the youth on the left in the *Primavera*).

LONG-EARED GOATS, COMMONLY CALLED NUBIAN GOATS

The species forms the main breed of goat in the warmer Mediterranean countries, including Southern Italy. It is not clear whether they were ever common in Lombardy, but one appears, *c.* 1390, in the so-called sketchbook of Giovanni de' Grassi now in the Biblioteca Civica, Bergamo. (For the identification of these animals I am also indebted to Professor Evelyn who provided me with a large amount of interesting information about them; see p. 148, note 1.)

The Elephants Drawing (*no. 52*)

(Catalogued below, page 164)

One of the main purposes of the composition represented by the drawing was to display an impressive array of *lychnuchi*. Sixteen are shown,

almost every one of a different decorative design. (In the painting, ten are shown and only two are at all elaborately decorated.) The variety of their design is striking, including long vertical acanthus leaves, vertical fluting, spiral fluting and a scaly pattern. The only place where such variety can be paralleled is in the so-called Mantegna Sketchbook, now in Berlin (*no. 149*). The decorative motifs and the same degree of elaboration also occur on the painted columns which frame the Kress *Triumphs of Petrarch* now in the Denver Art Museum, Colorado.

The 'Mantegna Sketchbook' has never been published and is seldom mentioned. It was apparently known to Kristeller, who thought it was North Italian and dated it to the last decade of the fifteenth century. He did not mention it, however, in his monograph on the artist. Its present location is the Zeichnungssammlung of the Kunstbibliothek der Staatlichen Museen, Preussischer Kulturbesitz, Berlin, where it has the number OZ *III*. The links with Mantegna's *Triumphs* are close; direct links with the antique less frequent. However, on f.78 there is a drawing of a portion of one of the S. Sabina weapon reliefs. Also on f.85 there are the two Capitoline Satyrs referred to under Elephant's Adornments (*nos. 151, 152*). I am much indebted to Dr Marianne Fischer and Dr Sabine Jacob for information about this book. In particular, Dr Jacob sent to me a tracing of the watermark that appears in the paper. This is not in Briquet. It shows an animal with an open mouth, a tail, wings (? spines on its back) and two feet. It is difficult to say whether it is a bird or a dragon. However, it is very similar to a watermark appearing in the paper on which Doc. 8 is written (dated from Mantua 1493). This would support a Mantuan provenance for the drawing-book, and a date *c.* 1490.

Canvas VI. Bearers of coin and plate, bearers of trophies of special armour

Size: H. 8 ft. 9½ in. W. 9 ft. 1¾ in. (2·68 m. × 2·78 m.). The lower margin of Mantegna's painting is preserved.
Width of central canvas strip: 47 in. (120 cm.).
Nos. 32–36

This scene is still mainly Mantegna's work and contains a large amount of well preserved detail. In particular, the trees in the top left-hand corner

are worth noting, since they are minutely worked with individual modelling given to each leaf. It is areas of this sort that recall to mind Vasari's remark about the contemporary Vatican chapel—*piutosta cosa miniata che depintura*. On the other hand, the sky is poorly preserved (but the area seen through the left arch of the 'aqueduct' is satisfactory). The right-hand end of the 'aqueduct' along with the spectators has deteriorated to a mere shadow. The stooping figure on the right has also suffered considerably in the legs and drapery through Laguerre's retouching.

A second group of booty-carriers was described by Plutarch as *qui aurea numismata gerebant in vasis trium talentorum*. They were followed by men carrying the arms of the conquered leader (*post haec Persei currus et arma et diadema super armis positum*). In this canvas a similar idea is evoked by a small group of trophies composed of noticeably more exotic and flamboyantly decorated pieces of armour. In two cases crowns are visible, suggesting a royal captive.

ARCHITECTURE

Column with spiral reliefs and, on top, an equestrian monument

A similar combination occurs already in the background of the London *Agony in the Garden*, where a spiral column appears to be capped by an equestrian statue (*no. 143*). The original statues of the Marcus Aurelius and Trajan columns had been destroyed at some obscure distant date in the past and this represents imaginative reconstruction. Portheim found a similar idea in a relief in the decoration of the Certosa at Pavia; but he omitted to describe its position and I myself have failed to find it. Although the general design of the column is akin to those of Trajan and Marcus Aurelius, it is hard from this to say whether Mantegna had ever seen either of them. The spiral is far too steep, with the result that the figures are set vertically in relation to the ground but not in relation to the band of relief itself. Mantegna had already produced a decorated column of this sort in the London *Agony in the Garden*, already mentioned, and Jacopo Bellini had drawn something very similar (*no. 121*). The result in all cases has something of the quality of a spiral staircase with ascending figures. It is difficult to believe that someone of Mantegna's perceptive powers would have continued to

devise a column of this character had he ever seen the real thing; and this seems therefore to supply supporting evidence that Mantegna had not at this stage been to Rome.

The equestrian figure on the top is apparently made of gilded bronze and may be derived from known Roman monuments, of which the Marcus Aurelius statue was the most famous. Representations also existed on coins (*no. 241*), which could have augmented Mantegna's source material. The difficulty lies in the fact that Mantegna's statue fails to agree in its detail with any known prototype. The points of disagreement always lie in the relative positions of the hands, the head of the rider, and the horse's head.

In addition, the face, although much rubbed, seems to be beardless (the Vienna copyist shows a bearded figure, but Andreani's is beardless). It was not therefore intended as a reminder of the statue of Marcus Aurelius. Another famous equestrian statue was indeed mentioned by Suetonius and others, set up by Caesar himself to his own horse. (See Suetonius, *Divus Iulius LXI*, for an account of Caesar's horse, *cuius etiam instar pro aede Veneris Genetricis postea dedicavit*. Also Pliny, *Historia Naturalis*, Book VIII, Chap. 64.) It stood in the Forum Julium but nothing was or is known about its appearance except that Pliny and Suetonius repeated the belief that Caesar's horse had toes. The proof of this appears to have been the statue, which must, therefore, have had something odd about its feet. But the beardless rider of Mantegna's statue may have been intended for Caesar himself. The subjects of the reliefs on the column are no longer readable.

'Aqueduct'

Rome has many aqueducts and it has often been suggested that this building is based on one of the most outstanding, the *Aqua Claudia*, which is probably at its most impressive where the water course passes over the *Porta Maggiore*. Both Portheim and Tamassia made the association with this aqueduct. The aqueducts were one of the sights of Rome, and they feature prominently in the Taddeo di Bartolo view (*no. 164*). One at least—the *Aqua Virgo*, restored by Nicholas V in 1453—was still in use in the fifteenth century. It runs for much of its length underground. (See S. B. Plattner and T. Ashby, *A Topographical Dictionary of Ancient Rome*, London, 1929, p. 28 ff.) At the same time the balustrades and the people placed along the top make one

wonder what Mantegna thought he was painting. Perhaps he had combined in his mind the Roman monuments (known from other people's drawings?) with the huge bridge at Spoleto, which carries both a road and a watercourse (*no. 260*), though the history of this bridge is obscure. It is possible that it incorporates Roman material; but the main structure is probably four-teenth century (see J. White, *Art and Architecture of Italy 1250–1400*, Harmondsworth, 1966, p. 330). Perhaps some of the Roman aqueducts themselves had come to be used as bridges. As it is, the function of the painted monument is ambiguous. The women and children along the top may be a reference to Valturio's account of spectators on the housetops (given in a gloss on the classical texts, but not included in the Italian translation). However, they are not on housetops.

The balustrades are architecturally interesting, in that they provide an early example of the baluster form, which was apparently unknown in antiquity. (I am indebted to Mr Howard Burns for pointing out this detail to me. See also the introductory remarks on architecture, p. 133.)

PLATE

For general remarks on the plate, see under Canvas III, p. 143. Following the texts this ought to be made of gold, but it has a very curious and ambiguous sheen which suggests silver gilt.

The table with the baluster legs may be inspired by the text of Josephus where one is described as *mensa aurea ponderis talenti magni* and came of course from the Temple in Jerusalem. It seems more likely, however, that it results from some knowledge of the representation of the object on the Arch of Titus (*no. 176*). It is in any case a means of providing an extra tier for precious objects.

TROPHIES AND ARMS

These are the most elaborate examples of armour in the paintings. The fact that they are associated with crowns makes it clear that they are the arms of the captured enemy prince.

Cuirasses on poles

The decorative motifs are in part traceable to

antique originals. The Aurelian *Adlocutio* relief (*no. 193*) shows an example of scaly upper armour. In this case, however, the soldier has a short 'shirt' made up of overlapping scales rather than a rigid cuirass. This became a common form of armour (see G. Webster, *op. cit.*, p. 122 ff.) and also features in the reliefs on Trajan's column (*no. 187*). A better parallel is to be found on the Trophies on the Capitol (*no. 208*). Mantegna had already painted a cuirass with scale decoration in the Eremitani *Martyrdom of St James (no. 133)*. The cuirass with a winged head repeats a very common idea. There is an example on a sculpture in the Capitoline Museum (*no. 207*) known to have been there already *c.* 1530; but many others exist. (See H. Stuart Jones, *The Sculptures of the Capitoline Museum*, Oxford, 1912. Catalogued as Atrio 40. The torso of this figure was seen by Heemskerck.) The more elaborately carved Roman examples show clearly how the cuirass was fitted. The two parts were hinged down one side under the arm, and fastened with clips down the other. The upper parts were secured by straps which came over the shoulders. These particular details are rarely shown by Mantegna who almost always painted cuirasses which it would be physically impossible either to put on or to take off. However, on this particular canvas they appear, although not both on the same cuirass. The scaly cuirass has the shoulder straps; the other has what appears to be a fastening clip just beneath its right arm-hole, but the shoulder straps are shown on one of the figures in the 'Senators' composition. Mantegna's varied approach to the classical cuirass can be seen in the roundels of the Emperors on the ceiling of the *Camera degli Sposi*. These details do not occur in the Dublin drawing, see below, p. 152.

What is unique about these cuirasses is the suicidal gap round the waist. Nobody in their senses would design armour like this, and some sort of misunderstanding has crept in between Mantegna and his original sources. It will be noticed that one of the commonest features of Roman armour is the *cingulum*, a loose band which goes round the cuirass and is tied in a knot in front (*no. 199*). Sometimes it is shown without this knot or with the knot concealed. Did Mantegna misinterpret an ambiguous drawing which included a *cingulum*? It is difficult to think of a convincing explanation of such an odd feature; and one can only imagine that the Gonzaga family must have been astonished. The same type of armour appears again in Mantegna's *Madonna*

della Vittoria and *Parnassus* (*nos. 146, 141*, both now in the Louvre, Paris).[1]

Helmets

Some of these helmets have a similarity to those already discussed with the third canvas (see above, p. 143). But in general they seem to defy explanation in classical terms. Their general shape and decoration, however, has a strong fifteenth-century flavour. The sweeping projection to the rear, for instance, is also a feature of the fifteenth-century *salade* (*no. 158*). The projecting peak, although less common, can be found in other representations (*no. 160*), where the figures are wearing contemporary armour. The spiky cresting, like a cock's-comb, can also be found elsewhere in simplified form.

Shields. See above under Canvas III.

Curved sword—in centre. See above under Canvas III.

Soldiers in 'barbarian' trousers—see above, p. 131.

The Dublin Drawing (*no. 57*)

(Full Catalogue entry on this drawing is on p. 166; comments below relate in particular to Canvas VI)

The character of the decoration is not radically different from that of the painting. There is slightly more decoration on the booty and its ultimate diminution may represent a move similar to the simplification of the candelabra which took place in the adjacent canvas. On the other hand, the armour ultimately became more varied and elaborate. This presumably represents a shift of interest and an attempt (entirely successful) to make this armour the focus of attention in the painting. In the drawing this is not the case and the centres of interest are distributed far more evenly throughout the picture.

[1] A further example is cited and illustrated by Mrs Newton (*op. cit.*). Another is to be found among the arms trophies carved on the north side of the *Scala dei Giganti* of the *Palazzo Ducale*, Venice (*c.* 1485–90). Mrs Newton argues that this is a good example of a piece of practical stage armour *all'antico* designed to permit movement at the waist. This may well be so but the problems of flexible stage armour can be solved in many ways; and it is

Canvas VII. Captives, buffoons and soldiers

Size: Not measurable; see introductory note.
Width of central canvas strip: 46¾ in. (119 cm.).
Nos. 37, 273

Already in the seventeenth century, this canvas was described as 'much spoyled' and Laguerre appears to have repainted it in its entirety. The copies show that he preserved the iconography of the scene; but the ruins of Mantegna's work are at present dreadfully buried beneath Laguerre's thick pigment.

The names of the prisoners in Caesar's Triumphs are partially recorded by Dio Cassius. Paribeni, who interpreted the whole procession as the five-fold Triumph of Caesar, has suggested, in his monumental collaborative work with Luzio (*op. cit.*) that Mantegna may have intended here to represent Arsinoë (sister of Ptolemy of Egypt), Juba King of Numidia, and Vercingetorix the Gaulish chieftain. If this were the case, Mantegna would have been following the lead of Dio Cassius. However, there is little in the painting to suggest that this is an essay in contrasted national characteristics. The group seems rather to have been inspired by Plutarch. In the Triumph of Aemilius Paulus, the prisoners formed a substantial group including household servants, children and friends. The chief captive, Perseus, walked in the middle clothed in dark garments and sandals (*fusca veste amictus et crepidas more patrio habens*). On a reduced scale, this corresponds quite closely both to the Chantilly drawing and to the completed painting.

The musicians and buffoons (the musicians also appear in the following canvas) are derived from Appian's text. They are there described as a *turba citharedorum ac tibiarum* who proceeded *canentes psallentesque . . . succincti coronisque aureis redimiti*. One of them, in a long garment (*talari veste*) decorated with tassels (*fimbriis*) and gold armlets (*armillis auro splendentibus*), was deputed to make insulting jokes at the expense of the captured enemy. There is an obvious dis-

still of interest to know whether there is any antique arrangement that might serve as a point of departure for this particular solution. P. & K. Lehmann have recently described this gap as depicting a *cingulum* (especially with reference to the figure of Mars in the *Parnassus*) but this is a misreading of the image. See *Samothracian Reflections: Aspects of the Revival of the Antique* (Princeton, 1973), pp. 79-80.

crepancy over the musical instruments, since Mantegna gave one of his musicians bagpipes (in Canvas VIII). But apart from this, all the required ingredients are present in the Chantilly drawing (*no. 55* catalogued on p. 165), with the exception of the tassels. (In the finished seventh canvas, the tassels are there too, but not the gold armlets.) The *citharedi* originally extended from the seventh canvas into the eighth, suggesting continuity from one composition to the next. Ultimately they were retained only in the eighth canvas, and the seventh canvas was left to the buffoons.

ARCHITECTURE

Pyramid capped by a sphere

This seems to be a conflation of two monuments, both from the Borgo Vaticano:
The *Meta Romuli*, a pyramid which was demolished in 1499 and was occasionally depicted with a rectangular cap (*no. 164*).
The Vatican Obelisk, sometimes shown as a pyramid. During the Middle Ages it had a sphere on the top which was alleged to contain the ashes of Julius Caesar (*no. 162*). This legend, certainly current through the Middle Ages, was repeated by Flavio Biondo in *Roma Instaurata*. (See Book I, Chap. xli, where he mentions *cineres C. Caesaris Obelisco insigni positos qui cernitur in territorio triumphali*.) It was given more or less pyramidal form by Taddeo di Bartolo (*no. 164*).

Façade behind the Pyramid

This has two visible storeys but it would be difficult to say how much is hidden behind the figures. The lower storey has smooth rustication: two windows are visible, each with a key-stone shaped within the pattern of the rustication. The upper storey is articulated by a series of half-columns with plain moulded capitals and bases. They support a plain moulded entablature. Recessed between the half-columns is a series of round-headed openings.
It is difficult to say what Mantegna intended this building to be. It does not look like the inside of a theatre and the suggestion that the procession is here supposed to be passing through a theatre may be dismissed (see also above, p. 85, note 3). Neither does it look like the outside of a theatre where the external façades were normally composed of superimposed rows of arcading. This is

much more like a palace façade and one would have no difficulty in identifying it as such if its relation to the ground level were not so ambiguous. As a palace it would be architecturally extremely interesting. The lower floor has the flat rustication found also on the palace at Urbino. But here, Bramante's idea of 'debasing' the lowest storey by giving it no proper order of its own and of modelling the main features within the pattern of the rustication is already present. The upper floor contrasts with the lower in a Bramantesque way by being deeply modelled and possessing an order. It derives ultimately from the Theatre of Marcellus; but the nearest fifteenth-century parallel lies probably in the *cortile* of the Palazzo Venezia in Rome. This canvas may have been remodelled after Mantegna's Roman visit (1488–1490)—at least, so it has been argued earlier in the fourth chapter. The architecture may, therefore, reflect what Mantegna saw in Rome.

The façade with the barred window

Adolpho Venturi saw this building as a representation of the Mamertine Prison, which stands quite close to the triumphal route. (A. Venturi, *Storia dell'Arte Italiana*, VII, 3, p. 208.) The chief argument against this is that the inmates do not look like prisoners. It is, of course, hard to argue about matters of detail from the original; but in both the original and in the Vienna copy, one of the women 'inmates' wears a small crown. These therefore seem to be ordinary spectators, dressed, as Plutarch pointed out, in their best clothes (*Populus Romanus nitidis vestibus ornatus*).
The problem makes better sense if approached from a different direction—to be precise, from the Chantilly drawing (*no. 55*). This shows an imposing round-headed entrance with closed doors. Across it is slung a swag and upon the swag is perched an eagle. Eagles with outspread wings are not uncommon in Roman art and this may have come from a number of sources (*no. 259*). But the architecture is very similar to that of the Temple of Janus as it appears on a common coin type of Nero (*no. 243*). It seems quite likely that Mantegna intended it as such. It would make good iconographic sense at this point, the finality of the bound prisoners being directly related to the peace implied by the closed doors of the temple. It has already been explained how the scheme represented by the Chantilly drawing had to be revised. This involved disposing of the doorway,

which, given the lowered viewpoint, would have become uncomfortably attenuated in its apparent height. In its place Mantegna appears to have put the adjacent wall of the Temple of Janus taken from the same coin type. Whether it could still represent the temple is unclear. Certainly, by removing the closed doors, much of the force of the image is lost.

If this is correct (and the combination of the Chantilly drawing and the seventh canvas is indeed striking) it demonstrates a certain archaeological independence on Mantegna's part. There were at least three shrines or temples dedicated to Janus in ancient Rome. The earliest was 'ad infimum Argiletum'—that is, close to the Senate House (later the Church of S. Adriano) in the *Foro Romano*. There was a later shrine, built under Domitian in the Forum of Nerva. A third temple was built 'ad theatrum Marcelli'. (The earliest temple of Janus 'ad infimum Argiletum' was described by Livy in Book I, 19. For the forum of Nerva, see Robert Burn, *Rome and the Campagna*, London and Cambridge, 1871, p. 135 ff. For the temple of Janus *ad theatrum Marcelli*, see E. Nash, *op. cit.*)

Flavio Biondo, knowing only the arch called traditionally 'Janus Quadrifrons', identified this with the 'temple of Janus'. (See *Roma Instaurata*, Book I, Chapter xlvi, *De iani templo*. 'Idē nunc templum quod candido marmore extructum patētibus quadrifariam portis ad sanctum Georgium in velo aureo extat pene integrum*. Flavio Biondo, aware of Livy's reference, used this identification to locate [wrongly] the Argiletum—see the same work, Book II, Chapter liii, *Argiletum quid*.) It would be pleasant to think that Mantegna, having visited Rome and seen this monument, concluded that it could never have been a temple; hence his reversion to numismatic evidence.

In detail, this façade has a few points of interest. The smooth, rather shallow rustication is not common at this time. And it is more uncommon in that the corners of the projecting stones are chamfered, which gives the surface a broader and more spacious pattern. This has already been discussed in the introduction to this catalogue.

The vertical pilaster has a panel of arabesque decoration which is very similar to that of the *Ara Pacis* (*no. 167*). The problems which this raises are discussed below.

As already mentioned, the capital, as it appears in the painting and in Andreani's wood-cut, is very like capitals on the *Porta dei Leoni*, Verona (*no. 168*). The upper part of this architecture is

unfinished and remains a puzzle, and has already been discussed on p. 85.

THE FIGURES

The Captives

It is commonly agreed that the Captives group is strikingly like the type of relief sculpture found on the *Ara Pacis* of Augustus (*no. 169*). The closely packed lines of figures, their changing direction and stance, the juxtaposition of full-face, three-quarter view and profile heads, the contrast of grown men, women and children—all these features the Mantegna Captives have in common with the Roman reliefs and in contrast to the figure compositions of the other canvases. The composition of the 'Senators' also has these same features. The first recorded excavations on the site of the *Ara Pacis* took place in 1568. It is not known what was dug up then; neither is it known whether anything had been discovered from the site before that date. (See G. Moretti, *Ara Pacis Augustae*, Rome, 1948.)

In many cases of this sort of investigation, precise knowledge on the part of the artist of a particular object is not essential. If a given motif could not be obtained from one object or range of objects, there is normally the possibility that another, equivalent range existed to stimulate his imagination. But this is not the case with *Ara Pacis*. Very few Roman monuments look like it; and where examples of sculpture in a similar style occur, they are either far more insignificant or far more fragmentary (or both). Blum (*op. cit.*) pointed out that a similar group of figures featured in a sacrificial scene on Trajan's column. A further possible source might have been the reliefs supposedly from the *Ara Pietatis Augustae*, now in the Villa Medici. Nothing is known of their history, however, before 1584, when they entered the Medici possessions from the Capranica della Valle collection (see E. Nash, *op. cit.*). The 'Captives' and 'Senators' would in fact seem to provide the most compelling evidence that some parts of the *Ara Pacis* had been discovered and were on view in Rome by the time of Mantegna's visit in 1489. The main argument against such an idea would probably be the seeming absence of further reflections of this work in the art of the period; but the supposition that it was accessible would explain certain features in the

work of the Lombardo family, notably the reliefs of the *cappella del Santo* in the Basilica at Padua.

The group of females

This forms an addition to the composition as conceived in the Chantilly drawing. Its immediate purpose is not difficult to appreciate. The tiny children with their nurses form a poignant contrast to the downcast ranks of male prisoners, in the manner described by Plutarch (*nõ satis infortuniũ propter suũ etatẽ ĩtelligẽtes quẹ res magis homines ad misericordiã comovebat*). Vasari stated that the child beside the dog was complaining because of a thorn stuck in its foot (Document 27). This detail, if it ever existed, escaped all the copyists; and it seems just as likely that the child, now endowed with a heavily rubicund seventeenth-century countenance, was simply meant to be trying to attract attention to itself. C. Yriarte (*Mantegna*, Paris, 1901), p. 90 ff., supposed that the child was asking to be carried—which seems quite reasonable.

It remains a matter for speculation whether further symbolism can be read into this group. A female figure with bared breasts and attendant children may normally represent *Caritas* or *Fecunditas* but neither seems entirely appropriate at this point. (For close but later parallels, see the representation of *Caritas* in the Scalzi frescoes of Andrea del Sarto; also of *Fecunditas* on a medal by Giulio della Torre celebrating Beatrice, wife of Zenone de' Turchi [G. F. Hill, *A Corpus of Italian Medals*, London, 1930, No. 575].)

The grotesque mockers

Appian described only one mocker and this forms the basis of the Chantilly drawing. There the single mocker is dressed in a long robe and has arm-bands (as described in Appian's text). In the final painting, there are two mockers. The rear one has a tasselled robe—this too corresponds to Appian's description. But the dwarf-like proportions of the front one have no classical precedents and Mantegna must here have been drawing from the ingredients of fifteenth-century processions described in an earlier chapter. See above, p. 50. Portheim, *op. cit.*, introduced two ideas which require comment. The first was that the *deformitas* of Mantegna's mockers was the result of a misunderstanding of the *deformitas* attributed by Josephus to the captives. But the Latin translation seems clear at this point. Second, he referred Appian's description of the mocker to the bagpipe

player in the eighth canvas. This seems to be an error.

In conclusion, it should be said that, originally, the seventh canvas must have been the most complex dramatic study of the whole series, and it is one of the most tragic and tantalizing occurrences in the history of fifteenth-century art that the sad resignation of the captives, the innocence and ignorance of the children, the taunts of the grotesque tormentors and the snarling hostility of the little dog should alike be lost beneath the thick later overpainting.

MUSICAL INSTRUMENTS

It appears from the Chantilly drawing, that the musicians were originally planned to span the gap between the seventh and eighth canvases. Cithara-players were intended to be seen on either side of the break, although there were apparently no physical links. As finally painted, the seventh canvas contains no musicians.

The musical instruments contained in these compositions are the following: pipe and tabor (Chantilly drawing), *citharae* (Chantilly drawing and Canvas VIII), a short trumpet, bagpipes and a tambourine (all in Canvas VIII).

The range of musical instruments commonly appearing in classical art is small. The two most likely sources would have been sarcophagi depicting either Apollo and the Muses or Dionysus. These normally show various sorts of *tibia* or pipe; and the different shapes of the *lyra* and *cithara*.

'Lyra' and 'Cithara'

The first point of interest is that Mantegna distinguished between the *lyra* and the *cithara*. The last, the instrument of Apollo, was clearly implied by the texts. The *lyra* had easily recognizable elongated side supports. These were sometimes made of horn, and curved upwards to end in points. Mantegna's stringed instruments are all *citharae*.

'Tibia'

The short trumpet-like shapes in the eighth canvas may be derived from classical *tibiae*. These vary considerably in length and shape, at least as they came to be represented in sculpture. Mantegna may have made a rough intellectual equation between the classical *tibia* and the old-fashioned flageolet.

'Bagpipes'

Mantegna's lack of musical curiosity seems indicated by the foremost player in Canvas VIII, who appears to be playing a species of bagpipes. A moment's inspection of these 'bagpipes' will reveal that Mantegna had not stopped to inquire how bagpipes worked. Mantegna was not the first artist to be confused by the workings of bagpipes. A different sort of misunderstanding can be found among the music-making angels on Nanni di Banco's *Porta della Mandorla*. Further, the player appears to have put the entire mouth-piece of his instrument into his mouth in a manner which suggests that Mantegna had not watched wind-players very closely while they were playing.

Bagpipes and pipe and tabor are not included in the textual accounts of Triumphs so that there is no special reason for their inclusion here.

The tambourine appears on sarcophagi in a dionysiac context; but seems to be too universal an instrument to be considered specifically either as classical or post-classical.

STANDARDS

A bowl with flames engulfing an open hand, a 'tabula ansata' with inscription

For the *tabula ansata* see above, p. 134; for the inscription see Appendix II. The upward-pointing hand was frequently used to cap legionary standards. In this form, it is found on coins (*nos. 219, 242*), on the Great Trajanic Frieze and on the columns of Trajan and Marcus Aurelius. It is never found surrounded by flames. This may have some symbolic significance, for which see Appendix I.

Helmet, capped by an eagle holding a tablet in its beak

Something similar to this helmet with its extended neck shield is to be found in one of the Aurelian reliefs (*no. 193*). Like the 'hand' above, the eagle comes from military standards (*no. 195*).

ARMOUR

Helmet

The great curving crest can be found in the Aurelian 'Adventus' relief (*no. 199*) and in the Great Trajanic Frieze (*no. 190*).

The Chantilly Drawing (*no. 55*)

Catalogued below, p. 165.

The drawing has been discussed both in the main text and above, pp. 153 ff.

Note that the buffoon is, in type, very similar to the Silenus of the Bacchanal engraving attributed to Mantegna.

Canvas VIII. Musicians, standard bearers

Size: H. 8 ft. 9½ in. W. 9 ft. 1½ in. (2·68 m. × 2·78 m.).
Width of central canvas strip: 47 in. (120 cm.).
Nos. 38–41

The figures were almost entirely overpainted by Laguerre and virtually nothing of Mantegna's work has been recovered. But there are some well-preserved details among the crowned busts above. Note also the banner showing Romulus, Remus and the Wolf.

Iconographically, the musicians go with the mockers in the seventh canvas (q.v.). The remaining characters are iconographically out of place. This has already been discussed in the main text, pp. 83–4.

THE FIGURES

The Musicians

See remarks under the heading of Canvas VII.

The Signifer

In the Roman army, he wore a skin, but normally it was a bearskin, not a lionskin (as here); and he normally wore it over some clothes. Mantegna was well aware that *signiferi* wore clothes and armour beneath their animal skins and he had already painted one in the *Crucifixion* predella panel of the S. Zeno altar (*no. 144*). The lionskin and the near-nudity of this *signifer* suggest strongly that the image is being confused with that of Hercules, of whom many similar representations exist (*no. 205*). The image introduced here, bearing the banner of Romulus and Remus and (above) a bust, presumably of *Roma*, must in some sense be symbolic. It seems unlikely,

however, that one is meant actually to be in the presence of Hercules himself. He was almost always bearded and Mantegna had already twice depicted him as such on the ceiling of the *Camera degli Sposi*. This figure has more the appearance of an actor dressed up to impersonate Hercules, and by his presence paying a graceful compliment to the might and military prowess of the victorious Caesar. Such an appearance has no basis in the classical accounts of Triumphs and is more directly reminiscent of some of the impersonations in fifteenth-century processions.[1]

THE STANDARDS

Square hanging banner with Romulus and Remus and the wolf

Banners of this shape were common in the Roman army and many examples appear on the S. Sabina weapon reliefs (*no. 216*), on the Aurelian *Lustratio* relief (*no. 195*) and elsewhere.

Female bust with helmet—perhaps 'Roma'. Probably derived from a coin type (*no. 244*).

Eagle with outspread wings, holding 'tabula ansata' in beak, standing on a miniature building

The eagle is probably derived from the Aurelian *Lustratio* relief (*no. 195*). A standard bearer in the Great Trajanic Frieze (*no. 189*) carries at the top of his standard what appears to be a small fortress. This may have served as a basis for Mantegna's little building.

Busts on poles

These are apparently of bronze. The mural crowns have already been discussed on p. 140 above. The rather delicate branched support of one of these finds a parallel in the S. Sabina weapon reliefs (*no. 215*). One male bust is visible, perhaps one of the *imagines imperatorum* said by Vegetius to have been carried by the Roman army (see pp. 66–7, note 4 above).

[1] See Chapter 2 on fifteenth-century triumphal processions. On the possible symbolism of Hercules in the fifteenth century, see L. D. Ettlinger, *Mitteilungen des Kunsthistorischen Instituts in Florenz*, XVI (1972), p. 119, 'Hercules Florentinus'. In addition to his famed physical prowess, Hercules also came to be admired as an example of political and civic wisdom and virtue. He was seen too as a defender of liberty against tyranny. This, of course, introduces an interesting ambiguity into the situation. Was

Canvas IX. The triumphator, Julius Caesar, on his chariot

Size: H. 8 ft. 9¾ in. W. 9 ft. 2 in. (2·68 m. × 2·79 m.).
This is one of the two canvases in which the width of Mantegna's canvas still extends beyond the painted area.
Width of central canvas strip: 47 in. (120 cm.).

Nos. 42–50

The preservation is very imperfect. The detailed painting of the Arch is well preserved, as is also the standard in the centre shaped like a castle. The horse's head is reasonably well preserved and likewise the trappings. The '*Veni, Vidi, Vici*' banner preserves substantial remnants of autograph Mantegna lettering unobscured by later restoration. But Caesar's chariot has suffered severely; and Caesar's head is now largely a reconstruction based on the Vienna copy.

As with the fourth and fifth canvases, there is an unexpected change which overtakes the landscape as it passes from the eighth (bare and featureless) to the ninth canvas (wooded). In both the preservation is poor. The predominantly green smudge of foliage on the left of the ninth canvas is Laguerre's pigment, but copious Mantegnesque foliage is still visible behind the arch. In any case, the copies show that the contrast existed *c.* 1600, and thus probably in Mantegna's own lifetime. Once again, this type of irregularity suggests that the canvases were taken away from the studio as each was ready; and that a certain amount of adjustment *in situ* would have taken place had the series ever been finished.

THE TRIUMPHAL ARCH

The closest classical parallel to this arch is that of the Sergii at Pola (*no. 166*). Up to the level of the frieze, the similarities are considerable, but there are some obvious differences. The capitals are not like those at Pola. A closer parallel for them is to be found in Rome in a capital now in

Mantegna complimenting Caesar? Or was he hinting at the imminent presence of forces which were soon to overthrow the tyrant and dictator? The second alternative has a number of implications which were hardly likely to appeal to the Gonzaga family; so the first probably expresses Mantegna's intention. But the ambiguity demonstrates the difficulty of attaching precise meanings to Mantegna's symbolism.
See also below Appendix I.

S. Maria in Trastevere. Likewise the frieze is based on monuments in Rome. For comment on this and its possible significance see Appendix I.

The most surprising feature of this arch is the curious plinth with concave sides on which the figure groups stand. Numerous coins could have provided Mantegna with an impression of the finished effect of a Triumphal Arch (*no. 245*). None of them has this plinth, which remains an architectural puzzle.

The figure groups on the Arch

(a) The large flanking figures are derived from the famous Horse-Tamers on the Quirinal in Rome. Mantegna had already used one of them as the basis for a decorative plaque in the S. Zeno altar.

(b) The centre group of captives seated at the foot of an arms trophy forms a motif frequently found on coins (*no. 246*). A coin of this type was known to Jacopo Bellini—see the Louvre Sketchbook. (C. Ricci, *Iacopo Bellini e i suoi libri di disegni*, Florence, 1908, Plate 30. Ricci identified this coin-type, which is inscribed *Germania Capta*, as belonging to the reign of Domitian and dated A.D. 85.) For a further note on the arms trophy, and the possible allusion of this arch to Caius Marius, see Appendix II, pp. 176–7.

(c) The motif, found in the remaining groups, of captives being executed is much less common. Something similar is found on the *Gemma Augustea* (now in Vienna), but in the late fifteenth century this was still in the Treasury of St. Sernin, Toulouse.

THE TRIUMPHAL CHARIOT AND HORSES

In view of the representations of Triumphs on the arch of Titus and on the Aurelian relief from S. Martina (*no. 194*), the climax of the procession is unexpected. Caesar sits on a flat-topped carriage. Something of the sort is found on coins (*no. 247*) although there the vehicle is usually drawn by elephants or lions. Closer still is the representation of the triumphal chariot of Alfonso I on the Castel Nuovo, Naples, where Alfonso has a similar flat-topped two-wheeled carriage (*no. 130*). Mantegna seems to have been acquiescing in a strong fifteenth-century tradition whereby the central person in a Triumph was thus somewhat precariously exposed (see also the representations

of Petrarchian and classical Triumphs painted on *cassoni* and elsewhere).

The harness of the horse is also surprising and it looks as if some misunderstanding is again at work. The harness, which is unpractical, is not obviously based on anything, either classical or fifteenth century; that of the British Museum drawing (*no. 54*) is more plausible (see below, p. 160). Perhaps it is a misunderstanding of the Hadrianic roundels on the Arch of Constantine (*no. 191*). The large disc which holds the parts together may have been suggested by Valturio's gloss on the texts to the effect that the horses were *falerati*. The bronze horses of S. Marco originally had medallions decorated with lion's heads hanging round their necks; these vanished while the horses were in Paris early in the nineteenth century. I am grateful to Miss Marilyn Perry for pointing this out to me. I cannot, however, trace whence Valturio's idea (Book XII, Chapter 5) comes. It does not seem to appear in Flavio Biondo's work and what Valturio meant is not clear. Certainly his translator did not know either and evaded the issue by rendering *falerati* as *de honorificentissime sopraveste coperti*. On the rump of the foremost horse is Mantegna's monogram 'AM'.

The decoration of the chariot follows both literary and visual sources. There seem to have been no rules about the correct figures. The triumphal chariot of Marcus Aurelius (*no. 194*) has on it *Roma* (probably) between Neptune and Minerva. Another possibility was the so-called Capitoline trio, with Jupiter between Minerva and Juno (*no. 178*). In *Roma Triumphans X*, Flavio Biondo imagined a chariot with these three figures, to whom he added Mercury (see also Appendix I). Mantegna's chariot has Mars between Neptune and (probably, in the circumstances) *Concordia* (*no. 253*, where Ceres is shown holding a cornucopia), and Montfaucon (*L'Antiquité Expliquée*, Paris, 1719, Vol. I, Plate CCVI) illustrated coins of Hadrian and Marcus Aurelius showing *Hilaritas* holding a cornucopia and a palm branch. A coin of Nerva gives a similar iconography for *Securitas* (*no. 226*). In the context of the peace supposedly established by the military victory, *Concordia* is probably more appropriate. It is perhaps worth mentioning that, according to Dio Cassius (Book XLIV, 4 ff.), the Senate resolved to build a temple of *Concordia Nova* to celebrate Caesar's victories; although, as already noted (p. 58, note 5) Mantegna does not seem to have used the writing of Dio in constructing his iconography.

The central figure follows a type found fairly often on coins (*no. 248*); likewise *Concordia* (*no. 253*). Parallels for Neptune are less common (*no. 258*).

VICTORY CROWNING CAESAR

Pliny, among others, provided the information that a slave stood behind the *triumphator* holding a crown over his head (*Historia Naturalis*, Book XXXIII, 4). In discussing the introduction of gold into Rome, and its use in triumphs, Pliny said *et cum corona ex auro Etrusca sustineretur a tergo, anulus tamen in digito ferreus erat, aeque triumphantis, et servi fortasse coronam sustinentis.* Flavio Biondo observed *sed in his quae nūc extāt marmoreis triumphātium figuris: fortuna alata non servus coronam sustentat.* He was presumably referring to the representations on the arch of Titus (*no. 175*): and it must have been this image which Mantegna was following, in which case Flavio Biondo's identification of the figure as *Fortuna* was mistaken—she is *Victoria*. The slave was thus replaced by *Victoria*, whose attributes are a laurel crown and a palm branch (*no. 252*). A winged *Victoria* also appears on the Great Trajanic Frieze. In both cases the attributes are now lost. (Any palm branch would presumably have been of metal.) Normally *Victoria* holds the laurel crown in one hand and the palm branch in the other; but Mantegna made her hold the crown in both hands. The palm branch was then transferred to Caesar. It was assumed by Vermeule (*op. cit.*, p. 48) that this figure was understood as a youth dressed up with wings attached to his back. This is probably an unnecessary gloss, since it is clear from the *putti* beneath that history and allegory are mingled in this canvas. (The *putti* are dealt with below, and in Appendix I.) A comparable mixture of elements occurs in the *oculus* of the *Camera degli Sposi*. In fact, Mantegna's symbolism seems to be concentrated in the final canvases, which helps to give them a special character, see pp. 83–4.

CAESAR

He is dressed in a golden cloak, which fastens at the shoulder. Round his head is a gold fillet with what appears to be a jewel set in the centre. In his left hand is a large palm branch. In his right hand is a gold sceptre topped by an eagle.

Caesar's appearance was known from coins (*nos. 249, 250*). He had a cadaverous face with protruding cheekbones; and a long neck with a pronounced Adam's apple. This is very much the type of face given in the various copies of the *Triumphs*. It has already been said that the present head in the painting is reconstructed from the Vienna copy. It seems truer to Caesar's appearance than the bust painted on the ceiling of the *Camera degli Sposi*.

The cloak that Caesar wears has an appearance similar to that in the Aurelian relief (*no. 194*). The eagle-headed sceptre is to be found on certain coins (*no. 254*) and occasionally on reliefs (*no. 177*). This attribute may have been prompted by Valturio, who in a gloss writes *Scipio eburneus: sive Iovis optimi maximi sceptrum.* The eagle was the bird of Jupiter. As already indicated, the palm-branch should be held by *Victoria* and, in being transferred to Caesar, gains an unexpected prominence. The symbolism of the palm was explained by Valturio with reference to Aristotle and Plutarch. (This was first observed by K. Giehlow, *op. cit.*) What was admired was the resilience of the tree, which enabled it to bend to pressure indefinitely without breaking, and ultimately to spring back up again. In this context it has become a compliment to the virtues of Caesar. What is chiefly amazing about the image of Caesar is that it fails to conform to the texts in almost every respect. Not unexpectedly, there is a considerable amount of information about the costume of the triumphal general. Plutarch, Appian and Josephus all agreed that the robe was purple; Plutarch and Appian described it as being interwoven with gold thread. (There was some uncertainty on the detail of the *toga palmata*, the chief garment of the triumphator. See Valturio, *op. cit.*, Book XII, Chap. IV, 'hāc [scilicet *togam*] *Palmatam auctores vocant: velque vestis ea sit: quam* [sic] *qui palmam meruerunt uterentur: vel que palmę ī ea expressę videretur.*) Appian described an ivory sceptre. Valturio put together a miscellaneous assortment of attributes which have been listed elsewhere (see Chapter 5, p. 64, note I). Only one (the laurel crown) agrees with Mantegna's image. In the figure of Caesar, therefore, one finds Mantegna at his most independent; and if one sets this alongside the absence of the incense-bearers and crown-carriers in the eighth canvas and of the lictors in the seventh, the last canvases seem to take on a character and independence of their own, as discussed on pp. 83–4.

'PUTTI' IN THE FOREGROUND

They hold branches and must have a symbolic or allegorical significance of which the possibilities are explored in Appendix I, p. 172. There are good compositional reasons for the presence of the *putti* since they help to hide the legs.

YOUTH CARRYING BANNER IN FOREGROUND

It has been suggested by Blum, *op. cit.*, that this rather mannered stance is based on a well-known figure of Eros stretching a bow (*no. 206*). That he is something special is certainly possible; for the British Museum drawing (see *no. 54*) shows that a *signifer* similar to that of the eighth canvas was at one stage placed here.

STANDARDS

Rudder, Globe and Cornucopia

This is examined in Appendix I, p. 171.

Mars in armour, holding trophy in left hand and a palm (?) branch in right

Both ideas probably come from coin types (*nos. 256, 257*); the resulting image effectively combines *Mars Ultor* with *Mars Pacifer*.

Open right hand, set on a castle

As with the similar standard in the eighth canvas, it is difficult to find parallels for this. However, once again the only comparable object is found in work emanating from the immediate circle of Mantegna—the Berlin Mantegna Sketchbook, f. 71ʳ (*no. 150*), which is discussed on p. 149.

BANNERS WITH INSCRIPTIONS

See Appendix II, pp. 176–7.

The British Museum Drawing (*no. 54*)

(Full Catalogue entry on this drawing is on p. 164; iconographical observations below relate to Canvas IX)

The Chariot

This is merely decorated with painted trophies of arms. In the final version, the symbolism was heightened by the addition of the three seated figures. Some of the painted arms were converted into three-dimensions and displayed round the pedestal on which Caesar sits (cf. *no. 248*).

The Horses

There are four horses. This number was subsequently reduced to two, perhaps to reduce the number of visible legs. The harness here is more plausible than in the final painting though not, for that reason, more classical.

Caesar

Caesar is virtually identical to the painted image, as far as pose and attributes go. If the copyist is to be trusted, it would seem that there was a stage when Mantegna had still not got an authentic likeness at hand. This head is not especially like that of Caesar on his coins.

The figure disappearing to the extreme left

This shows that, at one stage in the planning, the crowd of standard-bearers in the eighth canvas was intended to spill over into the ninth. It cannot, of course, be known whether there would have been any direct physical links, as for instance in the trumpets which span the gap between the fourth and fifth canvas although this half-seen figure is matched by another half-seen figure emerging at the extreme right of the Vienna copy of Canvas VIII (see p. 106, note 1). The half-seen figure in the ninth composition was eventually altered in favour of one almost totally visible, walking between the horses and apparently leading them.

Composition X. The Senators (*no. 56*)

(For comments on style, see below, p. 165)

This scene is known only through drawn or engraved copies apparently after a lost original drawing. It seems reasonably certain that it was never painted (see pp. 64–6). It is based on Appian's description of the *scriptores, ministri scutiferive* who followed the *triumphator*.

ARCHITECTURE

Palace with loggia

This has been likened to a Bramantesque palace (see C. Vermeule, *op. cit.*), but no particular

building seems to be intended. The characteristics of Mantegna's architecture are discussed in the General Observations to this Catalogue, p. 131.

Two-storeyed circular building

This has been compared to a Marcanovan version of the Castel S. Angelo (see C. Vermeule, *op. cit.*). Again, no particular building is probably intended but the monument which underlies it is more probably the Tomb of Caecilia Metella. The distinctive feature which they have in common is the frieze of *bucrania*. (It was for this reason called *capo di bove* and is so named in the Codex Escurialensis.) The general similarity between Mantegna's building and the Tomb as it was drawn by the fifteenth-century artist of the Codex Escurialensis (*no. 154*) is striking.

FIGURES

This civilian group also seems to be inspired by the type of relief found on the *Ara Pacis*. For this, see earlier remarks, on p. 154. One strongly characterized face with a bull-neck stands out. This is very like coin images of Vespasian and may be so derived (*no. 255*).

ARMOUR

'Lorica Segmentata'

The soldier on the extreme right of the drawing is the only man in the entire procession to be wearing something like a *lorica segmentata*. He has, however, hinged plate armour round his legs.

Helmets

The helmet of the same soldier on the extreme right probably comes from a coin type (*no. 229*). The helmet shaped like a shell is like some of the helmets carved on the Arch of the Sergii, Pola (*no. 211*).

The thigh protection of the soldier towards the right

This is almost impossible to parallel in any age. It is not classical. It is not clear what was at the back of Mantegna's mind but one of the developments of late medieval armour was the provision of a pair of metal plates which hung down in front over the thighs rather like an apron. They are called *tuiles* or tassets and Mantegna's early *St George* (Venice, Accademia) shows them quite clearly. Mantegna himself never used the idea again; but the same items reappear in Costa's painting of *Isabella crowned by Cupid* (Paris, Louvre), done for Isabella's *Studiolo* probably *c.* 1506. As mentioned elsewhere, this was also one of the figures 'lifted' by Liberale da Verona for the *cassone* panel now in the National Gallery, London, probably *c.* 1495–1500 (see also p. 99, note 3). The curious thigh-protection also reappears in a Mantegnesque grisaille painting of *Mucius Scaevola* now in the Alte Pinakothek, Munich (Inv. No. 13792). There may be other instances in which this somewhat bizarre form of armour caught the imagination of other artists. The evolution of Italian armour in relation to this feature has been noted on p. 130, note 1.

Section B: The Drawings and Engravings

General Observations

The status and iconography of these in relation to the paintings has already been discussed, partly in the text and partly in the catalogue of the paintings. The following remarks are intended to suggest their stylistic relationship to Mantegna's autograph drawings and engravings. This, of course, presupposes some degree of certainty about the autograph work—a certainty which does not really exist.

Mantegna's engravings, in spite of the many arguments that they have aroused, are in many ways easier to deal with than the drawings. In the 1550 edition of the *Vite* (reissued Milan no date, under the editorship of C. Ricci, Vol. II, pp. 222–223), Vasari provided a list of engravings which were, according to him, by Mantegna. This list was repeated almost in its entirety by Scardeone a few years later. (B. Scardeone, *De Antiquitate Urbis Patavii* [Basle, 1560], p. 371 ff., *De Andrea Mantinea*. See Document 29.) This verdict on their authenticity was presumably partly the result of oral tradition and partly the result of connoisseurship. Among these engravings were listed some relating to the *Triumphs*—presumably the three surviving 'triumphal' compositions (listed below as Engravings 1–3). On account of their disappointing quality it is generally agreed that this was a mistake. But the remaining engravings, where they have been identified, are of a high quality which extends to all aspects of the work—the modelling of anatomy and drapery, the mastery of foreshortening or the manipulation of the figures in the composition, in addition to the less easily definable characteristics relating to the emotional or spiritual content of the works. Their technical accomplishment, too, is such that they were almost certainly produced directly under Mantegna's supervision for it is generally believed that Mantegna himself worked as an engraver. The main problems concern the chronology of this work. (For a recent examination of the controversy, see A. Mezzetti in the Catalogue of the Mantegna Exhibition, pp. 188–92, cited under Giovanni Paccagnini in the bibliography.)

The drawings themselves provide a very different problem. Only one signed and dated drawing survives—the Uffizi *Judith* of 1491. This is chiefly executed in brush washes and is therefore hard to compare with the main bulk of the attributed items, almost all of which rely for the most part on line. Virtually every one of these has formed the focus of argument. Since it is not the purpose of this book to add yet another set of opinions to the many that already exist in print, little will be done beyond alluding to those drawings mentioned in the following notes. They number four. One of these, of St James being led to Martyrdom, formerly in the Gathorne-Hardy collection, seems to be widely accepted now as a study for the Eremitani fresco. The arguments have recently been restated and they seem reasonable (G. Robertson, *Giovanni Bellini* [Oxford, 1968], p. 22.) The other three drawings are all in the British Museum. The most frequently mentioned is the *Madonna and Child with an Angel*, but there are passing references to the *Mars, Venus and Diana* and the *Calumny of Apelles* of which a detailed account is given in the museum catalogue (A. E. Popham and P. Pouncey, *Italian Drawings in the Department of Prints and Drawings in the British Museum, The Fourteenth and Fifteenth Centuries* [London, 1950], where they are respectively cat. nos. 159, 156 and 158). Their choice here has to some extent been influenced by their accessibility, but the overriding factor was their impressive quality. Nobody has disputed that they are Mantegnesque in style and technique; but their quality alone makes it likely that they are by Mantegna himself. They have been used as points of reference in the account which follows.

The Drawings

**Paris, Louvre: Cabinet des Dessins,
Collection Edmond de Rothschild
775DR**
**'The Trumpeters and Bearers of
Painted Banners'**

Size: H. 265 mm. W. (between the pilasters)
260 mm.
Pen and brown ink. *No. 51*

This is probably the most interesting of the draw-
ings connected with the *Triumphs*. It has various
odd features which might be interpreted as weak-
nesses; and perhaps for this reason it has been
dismissed by most writers as yet another variant or
copy by a Mantegnesque follower. It was seen by
Kristeller in the collection of Baron Edmond de
Rothschild, Paris. Kristeller considered it to be
a *gute Kopie nach dem ersten Bilde* (G. p. 462, also
E. p. 441). A. Mezzetti in the catalogue of the
Mantegna exhibition, p. 207 (cited under Gio-
vanni Paccagnini in the bibliography), is one of
the recent critics to reject it. Only Hind (*op. cit.*)
seems to have had a higher opinion of it, for he
thought it came close to Mantegna's style.

It seems highly unlikely that this is a copy. It has
none of the rather careful precision of the other
drawings considered here. Some areas, notably
the banners, are extremely free in treatment. In
other areas, there are signs that the composition
was still being worked out. The top left-hand
trumpet has a second 'bell' sketched in very
lightly beneath and slightly displaced. Below this,
and drawn so that it projects beyond the edge of
the composition, is another trumpet. Its stem
leads one down (past a supporting hand appar-
ently drawn in as an afterthought) to the main
area of uncertainty in the centre of the group of
trumpeters. It is very difficult to make sense of
the composition just behind the man with the
curling trumpet. A foot and leg, up to the thigh,
are reasonably clear although sketchily drawn.
But there appear to be two upper parts competing
for this lower part. The area of heads and
trumpets is not always easy to understand. It will
also be noticed that, lightly drawn beneath the

drapery, there are sometimes lines suggesting the
underlying anatomy. These do not always co-
incide with the figures as they were eventually
placed. None of this suggests the work of a
copyist. It seems far more likely to be a sketch
in which the major question of the relationship
of the pattern of heads and objects to the pattern
of feet and bodies was still being worked out.

Uncertainty about the status of this drawing must
in part arise from the lack of suitable autograph
comparative material. The ex-Gathorne-Hardy
study, done for the Eremitani frescoes, is about
thirty years earlier in date and far more experi-
mental in its purpose. Nearer in appearance (and
perhaps purpose) is the British Museum *Madonna
and Child with an Angel*, and here one can find
many resemblances. The character of the hatch-
ing is similar, running across broadly described
areas. The thin angular series of lines indicat-
ing the drapery round the Madonna's feet has
parallels in the drapery of the trumpeters. The
modelling of the legs of the Christ-Child is
similar to that of the legs of the two right-hand
standing soldiers. The head of the angel can be
compared to some of the heads in the Louvre
drawing, particularly in the treatment of the hair.
Ultimately, the status of this drawing must be
determined by a judgement of its quality. The
muddles and uncertainties may be explained as
evidence of 'planning in progress'. For the rest,
the banners and standards seem to be extremely
good. The most disappointing parts are probably
the faces of the soldiers. But one can find other
chinless faces in the British Museum drawing of
Mars, Venus and Diana. All in all, it has seemed
possible to me that this may be an autograph
work of Mantegna himself.

As a postscript, it may be added that the presence
of the pilaster profiles support this conclusion.
They are not things which a copyist, interested
in the composition, would normally include (in
fact, they are unique to this drawing). They make
sense, however, if this was a sketch intended to be
set in a studio 'mock-up' of the architecture of
the wall-surface against which the canvases were
eventually to be displayed, as suggested on page 78.

Paris, Private Collection:
'The Elephants'

Size: H. 251 mm. W. 260 mm.
Brown ink, pen and wash. The composition has been slightly cut along the upper margin.

No. 52

This drawing,[1] hitherto unpublished, gives the best account of the composition better known through its engraved version (*no. 59*). In all the detailed treatment it is markedly more sensitive than the engraving. Nevertheless, it also has many of the engraving's weaknesses. The pattern on the saddle cloth of the rear elephant is rather crudely drawn and many of the faces lack life and liveliness (contrast here, for instance, the drawing of the *Calumny of Apelles* in the British Museum). In particular, the drawing repeats the flaccid and ambiguous right hand of the central youth, harshly criticized by Hind when he passed judgement on the engraving. Nevertheless, the copy probably gives a fair idea of the appearance of the original, and cross-references for the style may be made to the Louvre drawing (*no. 51*). General similarities include the relative lack of interest in faces, and also in the unresolved problems of linking the pattern of heads and objects in the upper part of the picture to the pattern of feet. The drapery is markedly similar. Comparisons may also be made with the Albertina drawing (*no. 53*). Similarities exist among the heads and faces; and also in the shape and modelling of the oxen.

A series of impressed lines visible in the surface of this drawing suggest that it has been used to take a tracing. In view of the similarities, it seems entirely likely that it was used for the production of the engraving.

Vienna, Albertina: Inv. no. 2584
'Trophies of Arms and Booty'

Size: H. 260 mm. W. 261 mm.
Brown ink and pen.

No. 53

There is a small margin along the bottom about 5 cms. broad, bearing an old inscription

[1] I am grateful to Professor John Shearman for bringing this drawing to my attention and to the present owner for

'Andrea Mantegna'. The bottom right-hand corner has been destroyed and somewhat indifferently repaired.

Wickhoff supposed this to be a copy after the Andreani woodcut. Waagen thought it to be after a Mantegna engraving. (See F. Wickhoff in *Jahrbuch der Kunsthistorischen Sammlungen des Allerhöchsten Kaiserhauses* XII (1891), p. ccv: 'Die italienischen Handzeichnungen der Albertina'. Cat. no. SL9. Wickhoff there quotes Waagen.) Neither suggestion is convincing. As already argued in the text (p. 78), it has rather the appearance of a copy of a preliminary study for the second canvas. It has certain obvious Mantegnesque characteristics. The central figure has the curving graceful elegance of Mars in the *Parnassus*. His rather fat, rounded face has a close parallel in the *Deceptione* figure of the British Museum drawing of the *Calumny of Apelles*. The trick of reinforcing the outlines of figures and objects with dark lines is also to be found in Mantegna's work—for instance, in the British Museum *Madonna and Child with an Angel*.
Nevertheless, this is a rather undistinguished drawing, lacking entirely Mantegna's deft and expressive handling. The cart wheel and the oval shield behind are peculiarly inept. Even more surprising is an apparently disembodied pair of legs to the right of the cart, drawn with great deliberation. The original of the drawing would probably have looked more like the Louvre drawing, see p. 163 (*no. 51*).

London, British Museum: Inv. no. 1895-9-15-773
'The Triumphal Chariot'

Size: H. 262 mm. W. 273 mm.
Pen and brown ink and some red chalk washed with brown, yellow and green and heightened with white.

No. 54

This is described by the authors of the British Museum catalogue as an 'old but feeble and unfinished variant'. (A. E. Popham and P. Pouncey, *Italian Drawings in the Department of Prints &*

generously collaborating by sending me details and photographs.

Drawings in the British Museum: The Fourteenth & Fifteenth Centuries [London, 1950]. It is catalogued as number 169.) It varies from the other drawings associated with the *Triumphs* in the extensive use of washes. This gives it the appearance of a water-colour rather than a line drawing. It is possible that the artist was, of his own accord, transforming the original. Equally, it is possible that the original had an appearance similar to the Uffizi *Judith*, which is dated 1491. The curving graceful figure of the *signifer*, like the foreground figure in the Albertina drawing, finds its nearest parallels in the smaller paintings of Mantegna such as the *Parnassus* (*no. 141*; see p. 80, above).

Chantilly, Musée Condé: Inv. École Italienne II, 33.
'The Captives'

Size: H. 270 mm. W. 270 mm.
Pen and brown ink. *No. 55*

This drawing may seem to be a rectangular with unequal sides but this is an optical illusion induced by the way in which it is mounted. The area of the design is almost exactly square.

The quality of this drawing is fine and very similar to the drawing of the 'Senators' now in Vienna. It is also very close to the engravings of the *Zuffa* and the Bacchanal. Many similarities are to be found in the facial types. The man dancing behind the prisoners is similar to Silenus. The bearded figure supporting Silenus and the bearded battling sea-god both have heads which are variants of the type used for the central (bearded) prisoner. Similar parallels can be found for the beardless prisoner who glances back and for the musicians on the right. There are close similarities in the manner of hatching on both drapery and limbs.
Parts of this drawing are very good—for instance, the eagle and swag. Others exhibit weakness. The lighting is slightly less effectively observed than in the Vienna 'Senators' and consequently the general effect is flatter and less interesting. The architectural setting displays strange inconsistencies. For instance, the portal is seen from the front but the window over it is seen slightly from

the right. The orthogonals of the building on the right do not converge towards the same point. Mantegna had a justifiable reputation as a perspectivist and these shortcomings would be unexpected in one of his works.

All in all, therefore, it seems likely that this is a copy of a Mantegna, but the artist has nevertheless given a very good account of the appearance of the original, if one may judge by the comparisons already made with Mantegna's engravings.

Vienna, Albertina: Inv. no. 2585
'The Senators'

Size: H. 250 mm. W. 268 mm.
Brown ink and pen. *No. 56*

It has in the past been suggested that this is a copy after the well-known engraving (*no. 60*). (See F. Wickhoff in *Jahrbuch der Kunsthistorischen Sammlungen des Allerhöchsten Kaiserhauses* XIII, 1891, p. ccv: 'Die italienischen Handzeichnungen der Albertina'. See p. cclii, Cat. no. SL10. Recently, Carandente, *op. cit.*, p. 135, note 195, said that the drawing was actually on the back of a 'Senators' engraving but this was a misunderstanding of a statement by Hind.) The fact that the procession proceeds from right to left— that is, the correct direction *vis-à-vis* the paintings —makes this unlikely. What is, however, decisive is that the drawing is in every respect better than the engraving. Throughout, the handling of light is more subtle, and detail more delicate.

The technique of this drawing is in some respects similar to the British Museum *Madonna and Child with an Angel*, particularly in the drapery. The drawing of the British Museum angel also has some similarity to the solitary child in the 'Senators'. Yet in spite of the superior quality of this drawing there are inconsistencies which make Mantegna's authorship unlikely. For instance, the faces are peculiarly lifeless. As in the Chantilly drawing, the architectural background has some peculiarities. In the main building, the first-floor window is viewed slightly from the right, but the loggia is seen from the left. The cornice of the palace façade to the right does not maintain a straight line. These are odd inconsistencies which one would not expect in Mantegna's work. They suggest that this is a copy by a sensitive artist who well understood Man-

tegna's figure style but was less well informed about perspective and was unable to see that the architecture looked unsatisfactory. It is of interest that, for all his comparative crudity, the artist of the engraving gave the first floor a frontal viewpoint and made the cornice run in a straight line.

Dublin, National Gallery of Ireland: Inv. no. 2187

'Trophy-Bearers'

Size: H. 260 mm. W. 260 mm.
Pen and brown ink. *No. 57*

There is an engraving (catalogued on p. 167) reproducing this composition but it is unfinished. The composition is discussed on p. 82 above. It is, in any case, unlikely that the Dublin drawing could be a copy of it, since the drawing is better in quality. For example, the draughtsman introduced lighting effects which were beyond the ability of the engraver (note especially the cuirasses and arms to the extreme right of the composition). These same details make a good comparison with the torsos in the *Zuffa* and Bacchanal engravings. They suggest, in fact, that the Dublin drawing brings one closer than the engraving to a Mantegna 'original'.

The technique has, nevertheless, a smudgy softness which one does not normally associate with Mantegna's work. The draughtsman has, on the whole, grasped the appearance of the most prominent objects and figures well, but figures set behind the front plane are little more than routine areas of drapery folds and limbs, of which it is sometimes difficult to make sense. What Mantegna's original drawing showed at these points is difficult to imagine. But it seems likely that the same areas were filled with exploratory flourishes, which the copyist then turned into hard certainties.

The Engravings

1 The Elephants

Size: H. 270 mm. W. 260 mm.
Bartsch, xiii.235.12
Hind, Mantegna 14 *No. 59*

Hind pointed out that this engraving is technic-
ally unremarkable. Fortunately there is a more
competent pen version (in Paris, see above,
p. 164) to give a better idea what the original
drawing was like. Hind noted thirty-eight sur-
viving pulls of this engraving.

There are a number of very indifferent drawings
which are probably derived from this engraving,
since they are virtually identical in detail to it.
They all show less competence in graphic tech-
nique:

(a) *Boston: Isabella Stewart Gardner Museum,*
 This is a fragment showing little more than
 the youth in the centre. It is on the same scale
 as the engraving.
(b) *Haarlem: Teyler Collection, Reference no.
 B12(8)*. 247 × 268 mm
 Slightly reduced in height with respect to the
 engraving. This drawing is similar in style to
 the Teyler version of the 'Senators' engrav-
 ing, which version is dated 1517 (see below,
 Cat. 3). They have the same provenance back
 to the collection of Queen Christina of Sweden
 and it seems possible that the two copies were
 originally made at the same time and have
 always been together.
(c) *Milan: Ambrosiana*
 It has not been possible to establish the details
 about this copy. It was seen by Kristeller
 ([G], p. 462) and there is a photograph of it
 in the Witt Library, Courtauld Institute, Lon-
 don. Although qualitatively weak, it has one
 small point of interest: the copyist tried to
 interpret the weakly drawn right hand of the
 youth in the centre. The result is that, in this
 drawing, the palm is facing downwards. The
 Paris drawing (*no. 52*) is difficult to interpret
 at this point, but seems to imply a right-hand
 palm facing upwards.

[1] I am grateful to Professor John Shearman for draw-
ing my attention to the existence of this drawing.

2 The Trophy-Bearers

Size: H. (to highest point of shaded area) 260
mm. W. 254 mm.
Bartsch, xiii.236.13
Hind, Mantegna 15 *No. 58*

For remarks on the style, see the Dublin drawing
of the same subject (above, p. 166). Of the three
engravings of this subject, this has the best
quality and, in those areas which are complete, is
closest to the Dublin drawing.

Hind noted thirty-seven surviving pulls of this
engraving. No other drawings are known of this
subject.

3 The Senators

Size: H. 270 mm. W. 262 mm.
Bartsch, xiii.234.11
Hind, Mantegna 16 *No. 60*

For remarks on the style, see the Vienna drawing
of the same subject (above, p. 165). As printed,
the procession is reversed, moving in a direction
opposite to that in the paintings. The engraving
includes along the top a section which has either
been lost or was omitted in the drawing (*no. 56*).

Hind noted forty-three surviving pulls of this en-
graving, which suggests a considerable circulation.
A poor drawn copy of this engraving dated 1517
exists at Haarlem in the Teyler collection.[1] Its
composition is considerably cut along the upper
margin.

4 The 'Trophy-Bearers' with an added pilaster

Size: H. 270 mm. W. 255 mm.
Bartsch, xiii.236.14
Hind, Mantegna 15b *No. 61*

The chief interest of this engraving lies in the

It has a reference number BII(5) and measures
188 × 251 mm.

added pilaster. Its relationship to the work of Mantegna has been discussed in the text on p. 35, note 4. The engraving bears a monogram of Mantegna similar to that which appears on the rump of the horse in the ninth canvas. But Hind pointed out that the pilaster was also very similar to two pilasters designed, engraved and signed by Zoan Andrea (*no. 62*) catalogued by Hind as Zoan Andrea 25, A1 & B. As already noted, its architectural detail has no parallel in Mantegna's work.

The engraver was presumably working from the same 'original' as the other copyists of this composition. The character of some of the decorative detail is slightly altered, especially on the elephant's trappings. The arabesques on these have been modified and follow the style of the pilaster.

5 (a) The Elephants

Size: H. 26.5 mm. W. 262 mm.
Bartsch, xiii.322.8
Hind, Mantegna 14a

(b) The Trophy-Bearers

Size: H. 280 mm. W. 254 mm.
Bartsch, xiii.322.9
Hind, Mantegna 15a

(c) The Senators

Size: H. 281 mm. W. 262 mm.
Bartsch, xiii.321.7
Hind, Mantegna 16a

Nos. 63–5

The interest of these deplorable engravings lies in the fact that they appear to be an early and deliberate attempt to 'republish' the existing engravings as a set. The procession is made to proceed uniformly in the same direction; each picture is branded with the same clumsy technique. Their author is unknown.

Hind noted the survival respectively of 16, 11 and 14 pulls of these engravings. Their circulation would therefore seem to have been on a smaller scale than that of the prints from which they derive. Indeed their value as collectors' pieces can never have been very great.

A monument exists (? existed) with these three triumphal scenes decorating its base, the procession proceeding uniformly from right to left. The scenes are painted. Unfortunately, I only know of this from detailed photographs seen in the Warburg Institute, London. The photographs (? pre-Second World War) are unlabelled and I have entirely failed to find out where or what this monument may be. Given the direction in which the 'Senators' are proceeding on the monument, it seems likely that the painter of the monument was working from a set of the engravings under discussion here.

APPENDICES
AND BIBLIOGRAPHY

Appendix I · The Triumphs, Hieroglyphs and Symbolism

In the early years of this century, Giehlow and Volkmann commented on the presence in Mantegna's *Triumphs* of hieroglyph-like emblems.[1] Both writers implied that this sign-language might have been extensively used in the paintings, but both added a suitable caveat on the difficulties inherent in trying to unravel private fifteenth-century intellectual conundrums.[2] Nothing has since been added to their comments, and something on the subject therefore seems necessary.[3] Perhaps one should begin by answering the question 'What are hieroglyphs?' The answer may be taken from Valturio (*op. cit.*, Book VII, Chapter XVIII), quoting Diodorus Siculus: *Est Aegyptorum quoque usus atque qui hunc sequuntur, varias animalium species pro litteras notant eorum more. Non enim syllabarum compositione aut literis verba eorum exprimuntur, sed imaginum huiusmodi forma, earum significatione usu memoriae tradita.*[4] Diodorus himself, in the same passage, added *Scribunt quidem accipitrem crocodillum serpētem hominis oculum manus faciem et caetera eiusmodi*, and then he gave a gloss on their several meanings. Thus the essential nature of the hieroglyph was twofold. The spectator was presented with a juxtaposition of seemingly unrelated objects forming an 'inscription', and these images had no syllabic significance but conveyed ideas.[5]

In fact, most of this is historically and epigraphically wrong. But hieroglyphs were already misinterpreted by the Roman antiquarians and their misconceptions have only comparatively recently been exposed.[6] Their views were known to, and accepted by, fifteenth-century antiquarians. However, the hieroglyph received a new and prolonged lease of life at the beginning of the century following the discovery of the writings of Horapollo.[7] Of course, the devising of *imprese* and *emblemata* was not new, but the *Hieroglyphica* of Horapollo appears to have provided a powerful stimulus to the fashion. It received, moreover, a particular twist which appears to be absent from previous iconographical history. The aim of most iconography is to reveal some sort of message, but the author of any hierographical scheme was landed uncomfortably between the desire to reveal and the desire to conceal. The reason for this lay in the supposed history of hieroglyphs, which were alleged to be in origin a sacred and secret code, the property of the Egyptian priesthood, and handed down from generation to generation of priests. Two illustrations show the way in which fifteenth-century scholars dealt with this aspect; the first is the well-known passage from Alberti's *De Re Aedificatoria* in which he stated that hieroglyphs were regarded as the common property of all educated men 'to whom alone the worthiest things should be communicated'.[8] The

[1] K. Giehlow, *Jahrbuch der Kunsthistorischen Sammlungen des Allerhöchsten Kaiserhauses*, XXXII, 2 (1915), 'Die Hieroglyphenkunde des Humanismus in der Allegorie der Renaissance besonders der Ehrenpforte Kaisers Maximilian I'. And L. Volkmann, *Bilderschriften der Renaissance* (Leipzig, 1923).

[2] See Volkmann, *op. cit.*, p. 27, on the motifs on the arch in the ninth canvas *Eine genaue Deutung lässt sich allerdings nicht mehr geben, wir können nur allgemein auf Siegesruhm, Friedenspreis und Lob der grossherzigen Gesinnung schliessen.*

[3] The problem was raised again briefly by Tietze-Conrat, *op. cit.*, p. 184, in agreement with Giehlow and Volkmann but without investigation in further detail. The significance of these ideas in the formation of the series is, for the most part, doubted by Italian writers—see, for instance, Bellonci and Garavaglia, *op. cit.*, pp. 110–11.

[4] The Βιβλιοθήκη Ἱστορική of Diodorus Siculus, newly translated into Latin by Poggio, had been printed in Bologna in 1472. The chapter division of Diodorus varies considerably according to the edition; in the 1472 edition the relevant passage appears in Chapter IV.

[5] There was probably always confusion on this last point. It is not difficult to find Renaissance examples of 'hieroglyph inscriptions which are more akin to the medieval

rebus (e.g. a human eye + a slip of foliage = Islip. [See, for example, E. Bentivoglio, *Mitteilungen des Kunsthistorischen Instituts in Florenz*, XVI (1972), p. 167, 'Bramante e il Geroglifico di Viterbo'.]

[6] The turning point was probably the discovery of the Rosetta stone in 1799. For an account of the history of hieroglyphs see E. Iversen, *The Myth of Egypt and its Hieroglyphs* (Copenhagen, 1961).

[7] For an account of this see the introduction by G. Boas to his translation of *The Hieroglyphics of Horapollo* (New York, 1950). The first printed edition (in Greek) is dated 1505. This was followed by a printed Latin translation from Bologna in 1517. Subsequent quotations are taken from this Latin edition. Indication of the manuscript distribution of Horapollo were given by F. Sbordone in his edition (Naples, 1940). It is not large, amounting to 12 complete copies and some scattered excerpts. The earliest dated manuscript is of 1419.

[8] L. B. Alberti, *De Re Aedificatoria*, printed at Florence in 1485, Book VIII, Chapter IV. (*autumāt*) *Suū aūt adnotādi genus quo istic aegyptii uterent' toto orbe terrarū a peritis viris quibus solis dignissime res cōmunicādae sint perfacile posse interpretari.* See edition of G. Orlandi and P. Portoghesi (Milan, 1966), p. 697.

implication is that important messages couched in hieroglyphs will be readable to scholars but unintelligible to lesser men. A similar application was envisaged by Valturio, although in rather different circumstances. He revealingly incorporated his available information on hieroglyphs into a chapter dealing mainly with military codes and the means of sending secret messages (Valturio, *op. cit.*, Book VII, Chapter XVIII).

Their past made hieroglyphs at once esoteric and academically respectable. At the same time, as a means of communication between scholars (let alone military commanders) they left much to be desired. The only extended fifteenth-century example of hieroglyphs 'in action' is the *Hypnerotomachia Poliphili* of Francesco Colonna (printed in Venice in 1499). In this, fortunately, various hieroglyphic inscriptions which Colonna had invented are not merely illustrated by woodcuts but described in the text and provided with translations into Latin. The author's intentions are thus made absolutely clear and the results are revealing. As a means of communicating anything, some sort of standardization of symbols was desirable. But as a means of concealing the meaning, symbols—like military codes—presumably have to be changed. Thus the significance of some symbols varies from inscription to inscription. This also corresponded to the belief that the scholarly imagination should be allowed room for manœuvre in the composition of hieroglyphs. The total result is something extremely imprecise. It is simple enough (indeed, almost puerile) if one possesses the key; otherwise it is very difficult—for scholars or anyone else.[1]

Mantegna's *Triumphs* fall well within this early period of the hieroglyphic revival. In the nine canvases there is one hieroglyph-like architectural

frieze and four clusters of objects carried on poles and possessing the appearance of hieroglyphic *imprese*. Two questions seem to be posed by what has so far been stated. First, how far can it be shown that Mantegna became involved in the composition of hieroglyphic messages? Second, supposing he did so, is it worth trying to unravel them, given the uncertainties already mentioned? Some of Mantegna's groups of objects certainly seem to contain a message. For instance, the Rudder, Orb and Cornucopia clustered near to Caesar's head in the ninth canvas appear on Republican coins issued under Caesar (*no. 251*). Among other things they are the attributes of *Fortuna* and presumably convey a general message about Good Fortune attending the *Triumphator*. Again, in the seventh canvas, an open right hand in a flaming bowl is set above an inscription SPQR LIBERATORI URBIS. Since, according to Diodorus Siculus, the open right hand signified *Libertas* (see p. 170, note 4, *Dextera manus digitas passis libertatem designat*), the conclusion is virtually inescapable here that the emblems and inscription go together. There is, however, no fifteenth-century key to the precise meaning of a flaming bowl.[2] A similar meaning (*Liberator urbis*) can perhaps be extended to the open right hand which, in the ninth canvas, is set over a castellated structure.[3] All these groups of symbols are concentrated in the last three canvases. This gives the impression that Mantegna, when he was planning them, wished to use symbols to heighten the effect created by Caesar. It is therefore tempting to explore other symbolic possibilities, of which several exist. There is one on Caesar's chariot itself, a cameo-like representation of *Roma* seated between Neptune and (probably) *Concordia*. The importance of such images on the chariot was

[1] Horapollo provided an extended precedent for the imaginative interpretation of images, many of his examples standing for the most diverse meanings. Thus the Egyptians were said to depict a crocodile to signify *raptorem vero vel multū generātem aut furentem* (Diodorus said merely that it indicated *Malum*). A dog signified *Sacrum vero Scribā rursus aut prophetā: Seu sepeliētē vel splenē, olfactū, risum, sternutamentū, Principatū et Iudicem* (for Colonna it denoted *Amicitia*). On some symbols there was a degree of agreement. An eye is given both by Alberti and Colonna as *deus* or *divus* (Diodorus gave *custos*). A vulture in Alberti, Colonna and Valturio signifies *natura*. But an ox, which to Alberti meant *pax*, was used by Colonna to denote *terra*. Moreover, Colonna himself varies his meanings. The dolphin appears both for *incolumis* and for *festinare*; serpents are used for *odium, pax et concordia* and *prudentia*. Although the lamp is used thrice to denote *vita*, the *bucranium* is used on the one hand for *labor* and on the other for *patientia*. As Volkmann observed (*op. cit.*, p. 21) *Klar ist aber gerade aus allen diesen Sinnbildern zu sehen, wie willkürlich gleiche*

Zeichen für verschiedene Bedeutungen, oder verschiedene Zeichen für gleiche Bedeutungen gesetzt werden, so dass von einer zweifelsfreien Auslegung oder 'Lesung' solcher 'Schriften' ernstlich keine Rede sein könnte.

[2] Fire has a general (especially Christian) association as a purifying agent. Giehlow, *op. cit.*, suggested that this whole group might be associated with the story of Mucius Scaevola, who 'liberated the city' by sacrificing his right hand on a brazier. So it might; but this merely illustrates how hard these pictorial puzzles are to solve conclusively, once the key has been lost.

[3] Giehlow, *op. cit.*, noted the open hands but stated that Diodorus' interpretation was *liberalitas*. This is not so. The eagle perched on a helmet in the seventh canvas could be interpreted in 'Hypnerotomachian' terms thus—*Protector* (helmet) *imperii* (eagle). (This is how the symbols were interpreted by Colonna.)

stressed by Flavio Biondo.[1] Indeed the relief showing the Triumph of Marcus Aurelius (*no. 194*) has three such figures—Roma between Neptune and Minerva. Mantegna's disruption of this 'Capitoline Trio' by the insertion of *Con-* *cordia* has not been explained but it is clearly done with some purpose. In addition, one can note the deliberate investment of Caesar with a palm branch, *Victoria* crowning him[2] and the putti playing in the foreground.[3] Finally, in the

[1] Flavio Biondo, *op. cit.*, Book X, towards the end *Sed ubi ī curru ullo circūcirca picti erant hinc iuppiter sceptrum; inde neptunus tridentem: iuno hastam quirini: manu gestantes: deīde mercurius caput pedesque alatus: in nostro curru: petrus claves: ensē paulusmanu gerens: Michael Georgiusque dracones perimant: Et bartholomaeus suā humero pellē portet.*

[2] Flavio Biondo, *op. cit.*, Book X, pointed out that it was the custom for a slave to ride behind the general, but he preferred to follow the representation of the Arch of Titus, where he interpreted the figure as *Fortuna quae . . . demissus caelo angelus esse videbitur.*

[3] These have always been a puzzle, and the suggestion that they have something to do with the general's family is unconvincing. It is more probable that they have a symbolic role; here a medal of Commodus may be mentioned which shows four standing *putti*, three of which are naked. Modern scholarship has identified them as the Four Seasons, but this is not obvious from the medal, which is simply inscribed *Temporum Felicitas*. Such a sentiment could be appropriate in this context. Even if this is not the correct reading, its decipherment is probably to be pursued along these lines.

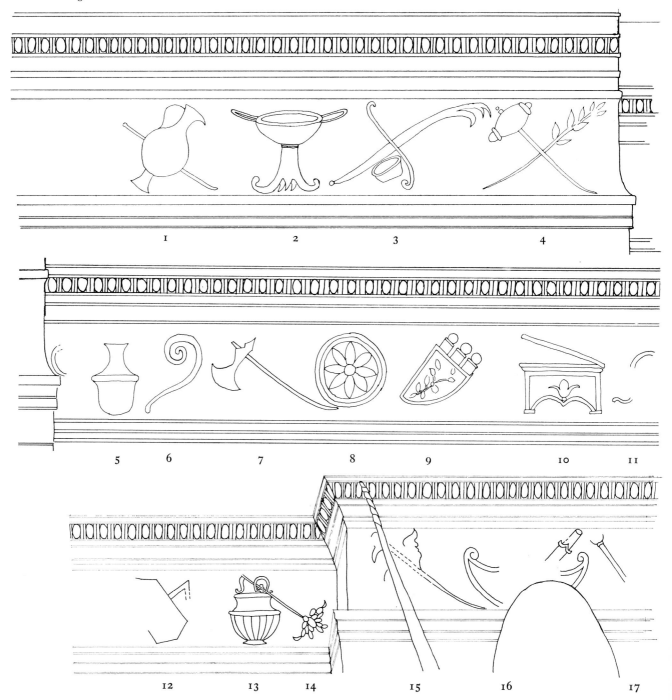

Carved emblems on frieze of triumphal arch in Canvas IX

eighth canvas, there is the strangely ambiguous figure of the Herculean *signifer*, examined further in the Catalogue, pp. 156–7.

It will be seen from this that there is much that is suggestive of symbolism in the later canvases. Equally, although the general sense of these symbols can usually be guessed at, often with some confidence, in no case is there any degree of precision or certainty. The situation deteriorates when one turns to the emblems 'carved' on the arch. However, before attempting an analysis, it is first necessary to state what is visible and a description is necessary because some writers have suggested the presence of objects not actually there. For example, Giehlow, *op. cit.*, noted an *aspergillum*. No *aspergillum* is shown of the sort identifiable in classical reliefs, but it is possible that no. 14 of the objects listed below might have suggested an ecclesiastical *aspergillum*. On small details of this sort, the copyists, who probably did not understand what they were copying are unreliable. Mantegna's painting is the only source of reliable information.

The table below produces twenty-three possible objects. Of these, thirteen can be named, three can probably be named, four are unidentifiable although mainly visible, and three are so obliterated as to be unreadable. The copies do not help in the process of decipherment. The Vienna version is the clearest, but the artist made one obvious error in reproducing no. 5 (a vase or jug) in a shape more like an incense-box. This naturally reduces the value of his testimony.

In the diagram above, the symbols have been numbered for ease of reference. They may be described as follows:

1 A sacrificial vase or jug, crossed with an unidentifiable object.

2 A shallow, two-handled drinking cup.

3 An unidentifiable pair of objects, crossed; and a small bowl beneath.

4 A sprig of foliage and a mallet-like object, crossed.

5 A sacrificial vase or jug, perhaps originally flanked by a *lituus* on the left (see the Vienna

copy). The fragmentary remains are inconclusive.

6 A *lituus*, the emblem of the augurs.

7 A *sacena*, or sacrificial axe.

8 A *patera*, or sacrificial dish.

9 Perhaps a *secespita*, or sacrificial knife.

This is quite similar to the *secespita* of the reliefs (see below) apart from the three knobs on the top which make it more like the representation of quivers on coins. There is, however, one representation of a three-knobbed *secespita* on the *Arco degli Argentarii* (*no. 172*), but one wonders what Mantegna thought it was.

10 An *acerra*, or incense box.

11 (obscured).

12 Partially obscured but probably a rudder.

13 & 14 A vase with an unidentifiable object leaning against it.

15 Obscured, but perhaps a *caduceus*.

This appears to be a short staff with a large wing attached to it. Assuming that there was originally a pair of wings this may have been a rather attenuated *caduceus*. Its form is really now a matter for conjecture. Giehlow identified a *caduceus* somewhere in the frieze.

16 A *Pelta*; behind it probably a sword.

17 Obscured.

It has been claimed that the inspiration for this strange assortment of objects was a series of Roman reliefs, now in the *Museo Capitolino*, but during the fifteenth century in S. Lorenzo fuori le Mura.[1] But there were other possible sources for ideas of this sort. Most notable of these are the friezes belonging to the Temple of Vespasian (*no. 174*; part of this frieze survives *in situ*, part is now in the *Tabularium*).[2] There is another such relief on the *Arco degli Argentarii* (*no. 172*). Then there are two further reliefs in the *Museo Capitolino*,

[1] These are catalogued as being in the *Stanza dei Filosofi*, nos. 99, 102 and 107. They were all drawn by the artist of the *Codex Escurialensis*. A further relief, no. 105, corresponds in reverse to no. 107 and probably comes from the same complex, but it cannot be traced at that date. See H. Stuart Jones, *The Sculptures of the Museo Capitolino*, Oxford, 1912. Giehlow, *op. cit.*, emphasized the importance of these particular carvings and they were again

stressed by Volkmann and Blum, *opera cit.*

[2] The carvings were mentioned by Paribeni (A. Luzio and R. Paribeni, *Il Trionfo di Cesare di Andrea Mantegna*, Rome, 1940), but their relevance was subsequently attacked by E. Tietze-Conrat, *op. cit.*, p. 184. The table there drawn up shows that there is much to recommend Paribeni's suggestion.

whose history, however, is unknown before 1572. They were engraved by Lafréry in *Speculum Romanae Magnificentiae*, 1572. (See H. Stuart Jones, *The Sculptures of the Palazzo dei Conservatori*, Oxford, 1926. They are catalogued as in the *Stanza dei Filosofi*, nos. 100, 104.)

These reliefs were not intended to be hieroglyphic in a fifteenth-century sense.[1] But it seems likely that many fifteenth-century antiquarians, including Colonna, read this into them. It can hardly be doubted that models of this sort underlie Mantegna's frieze although one may doubt, in parentheses, the relevance of the S. Lorenzo reliefs. Very few objects on those reliefs reappear in Mantegna's work. By contrast, the other possible sources 'score' comparatively highly. The Temple of Vespasian and the *Arco degli Argentarii* would in any case appear to be perhaps marginally more relevant since they were at least monuments which lay on Flavio Biondo's triumphal route. The following table illustrates the point.

However, to propose a source is not at all the same as explaining Mantegna's purpose. Eight objects on his frieze cannot be accounted for by referring to these reliefs. Of these, some, like the *pelta* or the *caduceus*, are imported from some other source. Others are simply unintelligible and these, in particular, form a stumbling block to any attempt at interpretation. For one thing, until they have been identified they pose the question whether this frieze is meant to be interpreted at all. It is possible that Mantegna was translating into his painting forms that had already been misunderstood by some other peripatetic antiquarian artist. Such misunderstandings indeed occurred;[2] and if Mantegna was inserting into his frieze shapes which he himself did not understand, then the whole case for its being 'hieroglyphic' must fall to the ground.

In spite of its apparent similarity to the inventions of Francesco Colonna, there is no compelling reason to assume that the frieze conveys a message. The devices may have been intended as

OBJECT	MUSEO CAPITOLINO						VESP.	TAB.	ARCUS ARG.
	99	100	102	104	105	107			
1 Vase	×			×			×	×	×
2 Cup									
3 ?									
4 ? & Foliage				×*					
5 Vase	×			×			×	×	×
6 Lituus	? ×			×	×	×			×
7 Sacena	×			×			×	×	
8 Patera	×			×			×	×	×
9 Secespita				×			×	×	×
10 Acera	×	×	×						
11 ?									
12 Rudder	×								
13 Bowl									
14 ?									
15 ? Caduceus									
16 Pelta									
17 ?									

* foliage only

no more than a species of architectural decoration or adornment added to the architectural structure, in the same way that the statues are added to the upper part or the spandrel figures added above the archway. The frieze would in this sense be classical in the same way that a Corinthian capital is classical—by virtue of its appearance and not by virtue of its contents. It is, of course, possible to pick up some of Mantegna's objects in other contexts, especially in the *Hypnerotomachia Polyphili*. Thus the ewer or vase (1) might stand for *paulatim*; the olive branch (4) for *clementia* or *misericordia*; the dish (8) for *liberaliter*; the *secespita* (9) for *dissolvere*; the incense box (10) for *servare*; and the rudder (12) for *gubernare*. The gaps, however, are still enormous. Volkmann, *op. cit.*, agreed that no exact reading was possible and suggested merely general themes (see p. 170, note 2). Again, this may well be so; it only illustrates the difficulties of the subject. Perhaps some day fresh information will emerge to illumine what is at the moment a highly speculative area of investigation.

[1] The bulk of the objects are sacrificial, occurring in some instances also on coins (*no. 231*). The S. Lorenzo reliefs have a strong nautical emphasis, which is absent in the others. Although the precise significance is lost, there is no reason to suppose that they were meant to be 'read' like the reliefs of Francesco Colonna.

[2] Francesco Colonna's hieroglyphs suggest two sorts of misunderstanding. The lamp which appears frequently (*vita*) looks very like a misinterpreted *simpulum*. This would be an example of the appearance of an object being transformed in the process of transmission. On another occasion (see fol. c. i.ʳ of the 1499 edition) the form of an object, an incense box, is transmitted correctly, but its significance is

misunderstood and it is called an altar in the text. (See M. T. Casella and G. Pozzi, *Francesco Colonna: Biografia e Opere*, Padua, 1959, II, p. 52 ff., where Pozzi argues strongly against Colonna having himself seen the objects which appear to underlie some of his monuments.) A more definite example of misinterpretation is to be found in the Wolfegg notebook of Aspertini [see P. P. Bober, *Drawings after the antique by Amico Aspertini*, London, 1957]. That artist, in copying relief no. 99 of the *Museo Capitolino*, made nonsense of an anchor (*ibid.*, fig. 66). It is possible in Mantegna's work that an anchor underlies items 14 and 15 (the 'caduceus'). It also seems likely that, within the third item of the above list, the long stem and the small bowl are derived from a misdrawn *simpulum*.

Appendix II · Mantegna's Inscriptions

In this section are collected all the Latin inscriptions relating to the *Triumphs of Caesar.* Some are still visible in the paintings; some are derived either wholly or partly from the copies; some are derived from the associated drawings. It is to be assumed that all Mantegna's inscriptions, at least where they are completely visible, were originally intelligible. The Latinity may perhaps have been questionable, but it seems highly unlikely that the various contractions could not have been expanded into something meaningful, informative and apposite. Unfortunately, this is now no longer the case, for the existing readings present many *lacunae.* This is especially unexpected since so many reasonably early copies of the *Triumphs* exist. It might be thought that these would be useful in the task of reconstruction where the original paintings are damaged and defective. It may be that the inscriptions had already become partially illegible by the late sixteenth century. It may be that copyists such as Dondo had a minimal grasp of the Latin they were meant to be copying. In any case, the Munich and Siena copies are virtually useless for the purpose of reconstruction, although Andreani's woodcuts are occasionally a little help. Only the Vienna copies are of any substantial value, and even these often leave much to be desired.

CANVAS I

(1) On *tabula ansata,*

SPQR

D

CPQM

In all the painted copies, the *tabula* is left blank; but Andreani repeats these letters, supplying D.I.C. as the centre line. In fact, D I C is still legible in old photographs of the original painting. The full inscription then reads S⟨ENATVS⟩ P⟨OPVLVS⟩Q⟨VE⟩ R⟨OMANUS⟩ DIC⟨TATORI⟩ C⟨ONSVLI⟩ P⟨ONTIFICI⟩ Q⟨VE⟩ M⟨AXIMO⟩. This would hardly now pass muster as a piece of imitation Roman epigraphy, but it recalls known stages in Caesar's career as recorded by Suetonius.

(2) On banners in Louvre drawing:

GALIA CAPTA

GALIA C.

(G)ALIA·C

This seems straightforward, although the misspelling of GALLIA is curious. The triple emphasis is reinforced by the banners which display three battles and three cities. It is conceivable that this is a somewhat oblique reference to the three parts of Transalpine Gaul described by Caesar at the opening of *De Bello Gallico.*

CANVAS II

(3) On *tabula ansata*:

IMP . IVLIO CAESARI

OB GALLIAM DEVICT

MILITARI POTENCIA

TRIVMPHVS

DECRETVS INVIDIA

SPRETA SVPERATA

This is the only inscription on which there is virtually complete agreement between the original and the various copies. The significance of the last three words is not clear. They could well refer to some aspect of Caesar's controversial career; they also have the sound of a fifteenth-century *impresa.*

CANVAS III

(4) In the Vienna Drawing (*no. 53*):

PONTIFEX . M . IMP

DANT

IIII·V·

TR·

NIVM

It is not worth speculating whether this inscription, surviving only in a copy, might ever have made complete sense. But PONTIFEX M⟨AXIMVS ET⟩ IMP⟨ERATOR⟩ agrees with information provided by Suetonius.

(5) On upper chest:

RVESTRI

See above; no attempt at interpretation seems worthwhile.

CANVAS IV

(6) On banner attached to trumpet:

S P Q R IVLIVS CAESAR P.M.

Presumably

S⟨ENATVS⟩ P⟨OPVLVS⟩Q⟨VE⟩ R⟨OMANVS⟩
IVLIVS CAESAR P⟨ONTIFEX⟩ M⟨AXIMVS⟩.

The last part ought to be in the dative case, since most of these inscriptions are invoking the senatorial decree of a Triumph *to* Caesar. However, all the copies agree on this reading.

(7) On banner attached to trumpet:

S P Q R DIVO IVLIO CAESARI D.P.P.P.

Following Suetonius, this must mean S⟨ENATVS⟩ P⟨OPVLVS⟩Q⟨VE⟩ R⟨OMANVS⟩ DIVO IVLIO CAESARI D⟨ICTATORI⟩ P⟨ERPETVO⟩ P⟨ATRI⟩ P⟨ATRIAE⟩. This is not the best epigraphical Latin, but it fits Suetonius' account of Caesar's aspirations at the height of his power.

(8) On a standard in the Vienna copy (*no. 81*):

DIVO

CESAR

PATER

PATRI

E

This area is now blank in the original, and the Vienna copyist alone suggests the presence of an inscription. His execrable Latin does not preclude the possibility of an original running DIVO CAESAR⟨I⟩ PATRI PATRIAE.

CANVAS VII

(9) On *tabula ansata*:

SPQR

LIBERATORI VRBIS

The precise application of this title in the context is not clear. It appears on the Arch of Constantine where it refers to that Emperor's defeat of Maxentius.

CANVAS IX

(10) On circular tablet behind Caesar:

GAL D

PRO DED

RIM

The Buccleuch tapestries supplement this reading as follows:

GALED

PRO DED

PRIMON

S A

D

Only the first two lines seem clear and may perhaps be rendered as GA⟨LLIA⟩ ED⟨OMITA⟩ PRO-⟨VINCIA⟩ DED⟨ICATA⟩. (This seems to be reflected in the first two lines of the Munich version GALIA DOM). The Vienna version offers slight variants, thus

GALL D

PRO DED

PRIM CN

S A

but the expansion of the last two lines in the spirit of the first remains a problem.

(11) On banner:

SPQR

DIC

For this see inscription (1).

(12) Over the arch:

CAIVS M C F

CO V PFTR

PIQ TRI

This area is now a blank in the original (neither X-ray nor infra-red photography reveals anything in this area), and the above inscription comes from one of the Bowhill tapestries belonging to the Duke of Buccleuch. It is in part confirmed by the Vienna copy which is inscribed:

CAIVS M C F

CCVII PRT

FRG

This inscription is important since it informs the reader of the significance of the triumphal arch, which commemorates Caius Marius, another great soldier and Caesar's formidable uncle by marriage. Expanded, it reads CAIVS M⟨ARIVS⟩ C⟨AII⟩ F⟨ILIVS⟩ CO⟨N⟩(S)⟨VL⟩ V(II) PR⟨AETOR⟩ (reading the Bowhill F as an R) TR⟨IBVNIS⟩ PL⟨EBIS⟩ (reading the Bowhill I as an L) Q⟨VE⟩ (AVGVR entirely missing) TRI⟨BVNIS⟩ (MILITARIS entirely missing). There is little doubt about this reading since the inscription is found in the fourteenth-century collection known as the *Sylloge Signoriliana* which was widely copied in the fifteenth century. Thus this Marian inscription appears in Marcanova's own *syllogai* at Modena (Bibl. Est. *α* L.5.15) and Berne (Stadtbibl. B. 42).

It was at that time thought to have come off an arch at Rimini.[1]

The triumphal arch itself is, in fact, even more explicit than this, since it has an arms trophy prominently displayed on its top. The most famous arms trophies in Rome were those formerly attached to the *Nymphaeum Aquae Juliae*; and these were supposed (erroneously) to have commemorated the victory of Marius over the Cimbri. (See Poggio, *De Varietate Fortunae*, Book I [*Opera Omnia* ed. R. Fulsini, Vol. II, Turin, 1966, p. 510]. The trophies are now on the Capitol, *no. 208*.) The complete version of the above inscription mentions his celebration of a Triumph for this achievement. The public monuments to Marius' victories, destroyed by Sulla, were, according to Suetonius (*De Vita Caesarum*, Loeb ed., *cit.* p. 14), restored by Caesar so that Mantegna's insertion of the arch at this point seems to be, in large part, an historical statement.

(13)

```
                    Q   R
                CLEMENTISSIMO
PRINCIPI    IN · B · G · P · ARM · V        Original
(PRINCIPI C · IN · B · G · P · ARM · V       Vienna)
(PRINCIPI C  IN  B  G  P  ARM  V             Bowhill)

CIV·          ·P AF · VICTOR DEDIC          Original
(CN       GR R AF   VICTOR DEDIC             Vienna)
(CIV      GR R AF  VICTOR DEDIC              Bowhill)

NUMINI           MAIESTATIQ·
```

This is the longest and most problematical inscription (*no. 47*). Fortunately, the Vienna copy and Bowhill tapestry can reasonably be used to supplement the original since, with the minor Vienna discrepancy of misreading N for IV (line 4), these versions in no way contradict what can now actually be seen. They have therefore been included above for the crucial two lines where *lacunae* occur in the original.

The Vienna and Bowhill copies are important. As it stands, it is possible with a small amount of editing to construe this inscription as celebrating far more than the Gallic War.

Thus:

> IN B⟨ELLO⟩ G⟨ALLICO⟩ P⟨ONTICO⟩
> ARM⟨ENIACO⟩ CIV⟨ILI⟩ (HIS)P⟨ANICO⟩
> AF⟨RICANO⟩ VICTOR⟨I⟩.[2]

This exercise, however, merely reveals the problems. Caesar's five Triumphs are named by Suetonius as Gallic, Alexandrian, Pontic, African and Spanish. The above solution omits Alexandria (or Egypt) completely; doubles up on Pontus by including Armenia; and introduces the entirely dubious concept of a Triumph for victory in a Civil War. This last is unacceptable. Fifteenth-century writers on Triumphs were aware of the rules governing them and to suggest that it was possible to have a Triumph for victory in a civil war would almost certainly have been seen as a political and archaeological blunder.[3] In any case, the impossibility of extracting from this inscription any reference to the Alexandrian campaign (presumably in the form AL, or ALEX, or AEG) forms a permanent stumbling block for those who would see this inscription as a record of Caesar's campaigns.

With the assistance of the Vienna and Bowhill copies, a solution must be sought along other lines. The following is a possibility:

> (S.P.) Q.R. (TRIVMPHVM) CLEMENTISSIMO
> PRINCIPI C⟨AESARI⟩ IN B⟨ELLO⟩ G⟨ALLICO⟩
> P⟨ER⟩ ARM⟨A⟩ V⟨ICTORI⟩ CIV⟨IVM⟩
> GR⟨ATIA⟩ R⟨OMANORVM⟩ AF⟨FERTORI⟩
> VICTOR⟨IAE⟩ DEDIC⟨ATVM⟩ NVMINI
> MAIESTATIQ⟨VE⟩

There is not much to recommend the Latinity of this reconstruction but, even in the legible parts, Mantegna has himself made technical errors. *Clemens* and *Princeps*, for instance, are both anachronistic in this context.[4]

[1] The recensions of the *sylloge signoriliana* were described in the *Corpus Inscriptionum Latinarum*, VI¹, p. xv, in the *Index Auctorum*. An account of the Rimini inscription is to be found in A. Degrassi, *Inscriptiones Italiae* (Rome, 1937), Vol. XIII, fasc. III, p. 64 (No. 83). It has subsequently been shown that the Rimini inscription was a provincial replica of one in the Forum of Augustus, Rome. (See D. R. Dudley, *Urbs Roma*, London, 1967, p. 128.)

[2] Mrs Jean Sampson and Mr A. R. Burn between them suggested this expansion of the central portion of the inscription. It will be noted that it ignores the presence of a

V at the end of line 3 of the inscription. It also ignores the letters GR in the 4th line (Bowhill and Vienna versions); and, in the same line, a stop before the P/R. It is fair to add that Mr Burn expressed some doubt about the inclusion of a civil war in such an inscription.

[3] See, on this, Flavio Biondo, *Roma Triumphans*, Book X, *Morisque item fuit non legis Imperatores belli civilis victoria quantumvis magna non triumphare: quia cives non hostes occiderint.*

[4] This was pointed out to me by Mrs Sampson and Mr Burn.

Appendix III · The Chief Textual Sources for the *Triumphs*

MANTEGNA	PLUTARCH Βίοι Παράλληλοι	APPIAN Ῥωμαικά BOOK VIII	SUETONIUS *DE VITA CAESARUM*
CANVAS I	Life of Aemilius Paulus; Latin translation of Bruni (Rome edition *c.* 1470)	Latin translation of Piero Candido Decembrio (Venice edition *c.* 1477)	Life of Caesar
Trumpeters		Sertis redimiti omnes, praecinentibus tubis	
Emblems & Banners	Prima enim dies vix signis tabulisque et colossis trans-mittendis suffecit quae vehiculis ducentis quin-quaginta portabantur		
CANVAS II Colossal figures on carts			
Model of a city		currus spoliis refertos deducebant. Ferebantur et ligneae turres captarum urbium simulacra prae-ferentes. Scripturae deinde et imagines earum quas gessissent	
Inscribed plaques Emblematic figures			
CANVAS III Trophies of captured arms	Secunda die pulcherrima et ornatissima Macedonum arma multis curribus delata fuerunt splendentia aere et ferro absterso atque ita disposita ut casu maxime cecidisse vide-rentur. Geleae, scuta, thoraces, ocreae et Crethenses Peltae; et Traicia Gerra Pharatrae, et equorum frena, ac enses nudi per haec iacentes et Sarissae infixae; ita ut nec victorum quidem absque metu aspectus.		
Carriers of booty & coin	Post hos armorum currus tria virorum milia sequebantur: qui numismata ferebant argentea vasis trecentis quin-quaginta. Vas erat quodlibet trium talentorum. Quattuor viri singula vasa portabant.	Aurum deinceps et argen-tum partim rudibus massis partim notis aut huiusmodi impressum figuris	
CANVAS IV	Alii crateras argenteas et Phialas calicesque ornatis-simos et ingentes certo ordine deferebant	Coronae praeterea quas virtutis gratia urbes aut socii aut exercitus urbi parentes militibus dedissent	
Carriers of booty including crowns			
White oxen		Candidi subinde boves	
CANVAS V Trumpeters	Tertia die prima luce tibicines [scil. tubicines] non mire nec suave sed bellicum sonantes primi ibant. Post eos centum et viginti boves auratis corni-bus ducebantur; victis ornati et sertis; ducebant eos adoles-centes succincti ad im-molandum; et pueri aureas et argenteas patinas sacrificii gratia deferebant		
White oxen			

MANTEGNA	PLUTARCH Βίοι Παράλληλοι	APPIAN Ῥωμαικά BOOK VIII	SUETONIUS *DE VITA CAESARUM*
Elephants with candelabra		et elephanti illos seque-bantur	Ascenditque Capitolium ad lumina quadraginta ele-phantis dextra sinistraque lychnuchos gestantibus
CANVAS VI Carriers of Booty & Coin	Post eos sequebantur qui aurea numismata gerebant in vasis trium talentorum: et supra de argenteis numismati-bus dictum est: numerus vasorum fuit tria et octoginta. His succedebant qui auream Phialam decem talentorum quem Emilius ex lapillis effecerat. Item qui Antigonea et Seleutia et Theridia et Persei vasa aurea portabant. Post haec Persei currus et arma et diadema super armis positum		
Special trophies of arms			
CANVAS VII Captives	Deinde, post modico inter-vallo, nati regii ducebantur: et cum ipsis alumnorum et magistrorum et pedagogorum lacrimans turba: qui et ipsi manus tendebant ad cives: et pueros eadem facere et prae-cari docebant: Erant masculi duo et una faemina non satis infortunium propter suam aetatem intelligentes . . . Ipse autem Perseus post filios et ministros ibat fusca veste amictus: et crepidas more patrio habens: propter magni-tudinem malorum ad omnia trepidus ac mente turbatus. Post eum ibat amicorum et familiarum mesta turba mise-rabiliter ipsum intuentes lacri-mantesque . . .	Post hos Carthaginensium ac Numidarum principes bello capti,	
Buffoons		Imperatorem lictores praei-bant purpureis amicti vesti-bus: tum citharedorum ac tibiarum turba ad Etruscae similitudinem pompae. Hi succincti coronisque aureis redimiti suo quique ordine canentes psallentesque prodibant. . . . Horum in medio quispiam talari veste fimbriis ac armillis auro splendentibus amictus gestus varios edebat: hosti-busque devictis insultans risus undique ciebat	
CANVAS VIII Musicians			
	Post eum deferebantur aureae coronae quibus Emilium virtutis gratia grecae donave-rant civitates. Erat numerus coronarum quater centum		
Signifer & Soldiers with Standards		Post thuris et odorum copia imperatorem circumsteterat:	

MANTEGNA	PLUTARCH Βίοι Παράλληλοι	APPIAN Ῥωμαϊκά BOOK VIII	SUETONIUS DE VITA CAESARUM
CANVAS IX Caesar in chariot	Deinde Emilius ipse seque-batur ornatissimo curru in-vectus. Vir et circa huiusmodi honorem spectaculo dignus purpuram auro contextam indutus; et lauri ramum dextera gerens	quem curru deaurato multi-fariamque notis refulgenti candidi vehebant equi auream capite gestantem coronam lapillis ornatam gemmisque. Hic vestem suc-cinctus purpuream patrio more aureis intextam syderi-bus altera manu eburneum sceptrum: altera laurum praeferebat: quem Romani victoriae insigne profitentur	
		Vehebantur et cum eo pueri virginesque: et ad habenas hinc inde cognati iuvenes: demum qui exercitum secuti fuerant scriptores: ministri: scutiferive:	Pontico triumpho inter pompae fercula trium ver-borum praetulit titulum VENI. VIDI. VICI.
ENGRAVING 'The Senators'	ferebat [scil. ferebant] et laurum milites currum Emilii secundum legiones cohortes et manipulos subsequentes partim carmina patria salibus permixta et risu; partim Emilii laudes cantantes	postremo exercitus in turmas aciesque divisus currum sequebatur. Milites quoque lauro redimiti laurum manu ferentes, quibus meritorum insignia adiuncta aderant. quae primores hos quidem laudibus ferrent: hos salibus insectarentur non nullos infamia notarent	

Appendix IV · Some Printed and Documentary Sources

In the succeeding register are included (a) all the documents or parts of documents I have been able to find that are relevant to painted *Triumphs* in Mantua, 1480–1520; and (b) the chief printed references to the *Triumphs of Caesar* during the time that these were still in the palace of S. Sebastiano (that is, down to 1607). I have omitted further references at this point for a number of reasons. First, the complete history of the *Triumphs* after 1520 has still to be written. The story, as told here (down to the present day), is little more than an outline. There are vast deposits of documents both in the *Archivio di Stato*, Mantua, and in the Public Record Office, London, which I have not been able to work through, and it will not escape notice that the later history of the *Triumphs* is here recounted almost entirely in terms of source material that, for whatever reason, already exists in print. In these circumstances, it would merely be misleading to present something that might appear to be masquerading as a complete body of source material; and it is for instance almost inconceivable that the body of archives in Mantua and London contains no further documentary references to the *Triumphs*, from the period after 1520. I have, however, allowed myself some inconsistency for the period 1520–1607. The available printed material contains much information relevant to the early history and condition of the *Triumphs*, and I have, for the convenience of the reader, reprinted it here *en bloc*. But, for the reasons given, it cannot be regarded as complete. By contrast, I feel reasonably confident that the documentation for the earlier period is as complete as it ever will be. In the interests of simplicity, every item has been termed a 'document'.

Document 1: 26 August 1486

MANTUA, ARCHIVIO GONZAGA. BUSTA 2434, f. 280r
Silvestro Calandra to the Marchese Francesco
From Mantua

. . . hozi lo Illmo. s. Duca ha voluto vedere la spalera, et doppo disnar' monto inbarcha per andar' un poco a' solazo per el laco. dove stette pero poco spatio perche laqua li facea male p no'

gli esser' consueto. et smonto al porto de corte per andare avedere li Triomphi de Cesar' che dipinge el mantegna: li quali molto li piaqueno. poi se ne venne per la via coperta in castello. . . .

Printed in P. Kristeller, *Andrea Mantegna* (Berlin and Leipzig, 1902)—German edition and hence called here Kristeller (G)—Dok. 96; and in P. Kristeller, *Andrea Mantegna* (London, 1901)—English edition and hence called here Kristeller (E)—Doc. 46.

Document 2: 31 January 1489

MANTUA, ARCHIVIO GONZAGA. SERIE AUTOGRAFI, CASETTA NO 7, f. 121r
Andrea Mantegna to the Marchese Francesco
From Rome

. . . Racomādo alla Exa. vostra litriōfi mej chelse faci fare qualche riparo ale finestre che nō siguastino p che īverita nōmene vergogno diaverli fati, et anco ho speranza difarne deglialtri, picendo adio et alla Sa. vostra alla quale me Racomādo infinitissime volte. . . .

The whole letter is printed in Kristeller (G) only Dok. 102.

Document 3: 23 February 1489

MANTUA, ARCHIVIO GONZAGA. BUSTA 2903, LIBRO 133, f. 11r
Marchese Francesco to Andrea Mantegna
From Mantua

Habiamo recevuto la v̄ra del ulto del passato: á la qual respondemo cħ nui siamo contenti faciati cosa grata á la. Ste. [sic] del n̄ro sigre. et cħ serviati á quella: nōdimeno haveressimo piacer', cħ quelle cose a vui imposte se expedessero presto, recondandovi [sic], cħ de qua ancħ haveti de lopere n̄re ad finire, et maxime li triumphi: quali come vui diceti e cosa digna, et nui voluntieri li vederessimo finiti: se posto bono ordine ad conservarli: cħ qatuncħ sia opera de le mane et inzegno v̄ro: nui nōdimeno ne gloriamo haverli in casa: il cħ ancħ sara memoria de la fede et virtu v̄ra. . . .

The whole letter is printed in Kristeller (G) only Dok. 103.

Document 4: 16 July 1491

MANTUA, ARCHIVIO GONZAGA. BUSTA 2440. CONTENTS UNNUMBERED

Bernardino Ghisulfo to the Marchese Francesco
From Mantua

. . . a Marmirolo se Comenciato afar quello solaro de la Logia Franc° e tondo In sieme anchora lor Comenzaran' a dipinger' quelli trionfi Iquali alor ge par' farli suso le tele secondo a facto M' Andrea Mantigna. et dicono cħ cosi facendo farana piu presto eseraño piu belle e piu durabile et anchora questo dice ognuno experto In tal exercicio. . . .

Printed in Kristeller (G) only Dok. 111.

Document 5: 4 February 1492

MANTUA, ARCHIVIO GONZAGA. LIBRO DEI DECRETI NO 24, f. 56ᵛ et seq.
Decree by the Marchese Francesco in favour of Andrea Mantegna
From Mantua

. . . et cū intueremur eius opa p̄clara et admiratione digna que in sacello et camera ñre arcis quōdā p̄ixerit: et que modo Iulii Cesaris triūp̄hū prope vivis et spirantibus adhuc imaginibus nobis pingit adeo ut nec rep̄sentari: sed fieri res videatur. . . .

The whole decree is printed in Kristeller (G) Dok. 115 and (E) Doc. 52.

Document 6: 10 December 1492

MANTUA, ARCHIVIO GONZAGA. SERIE AUTOGRAFI, CASETTA 10 f. 2ʳ
Antimacho to Isabella d'Este
From Mantua

. . . A q̄sto orator' [*scilicet* veneziano] se facta et farsi ogni honorevole dēmonstratiōe, et qui in la terra se li mōstra cioe cħ li e di bello: et gia ha veduto la spalera, la Camera depincta. la capelletta, et le cose de m' andrea mantegna vz li triumphi et altre sue gentileze. hozi el ñro illᵐᵒ si. li ha fact' monstrar' tuti li suoi belli e boni cavalli. . . .

*Document 7: 1492**

MANTUA, ARCHIVIO GONZAGA. BUSTA 2441, CONTENTS UNNUMBERED

Francesco di Bonsignori to the Marchese Francesco
From Mantua*

Avendo io intexo esser stado Dito avostᵃ eccelentia Io nō aver lavorado Da poi fu fato le targe: E q̄sto p esser sta hamalada mia muglier: Avixo v̄ra. s. Io haver sołcitado piu In q̄sto tenpo cħ ināci p cħ rare volte mi son partido di caxa. Le La verita. s. Io son stado solo A lavorar çoe senca conpagno: Oltra di q̄sto. s. mio Dovendo andar A retrar la ecelentia Del Signor zuan francesco. & etian li altri I quali voli La. s. v̄ra gli finza nel trionfo de la fama: Avegna cħ q̄la qualcħ volta mi manda In alcuno altº loco p li s'vitii Di q̄lla. . . .

* This letter has no date or place of origin. It is filed with letters written to the Marchese from Mantua in 1492.

Document 8: 18 November 1493

MANTUA, ARCHIVIO GONZAGA. BUSTA 2443. CONTENTS UNNUMBERED

Nicolo da Verona to the Marchese Francesco
From Mantua

Supplico cū q̄sta mia a v̄ra.s. narandogli come Io debbo ħre da v̄ra p̄fata f84. s. 16. p la camara di turchi depinta p me nel palazo del magᶜᵒ capitanio di q̄lla. E p cħ. Io. depingo al p̄nte lo trionfo a v̄ra. s. chie pur de bono pexo dovendo s'vir' bene como semp' e stato mio costume, pregolo se digni farmi p̄veder' de denari. . . .

Document 9: 2 March 1494

MANTUA, ARCHIVIO GONZAGA. BUSTA 2991, LIBRO 4, f. 33ᵛ
Isabella d'Este to the Marchese Francesco
From Mantua

. . . el Magᶜᵒ Iohanī di medici é venuto q̄sta mattina qua a disnar' lho facto allogiare in corte. & dattoli per compagnia m' Iohanpetro da gonzaga & m' lodovico di vberti. Doppo disnare e venuto a visitarme, io lho acarezato & factoli vedere la camera & triomphi. . . .

Printed in Kristeller (G) Dok. 123 and (E) Doc. 54·

Document 23: 3 November 1515

MANTUA, ARCHIVIO GONZAGA. BUSTA 2491. CONTENTS UNNUMBERED

Amycoma della Torre to Federico Gonzaga
From Mantua

. . . Udita la Messa li Ambasciatori [*scilicet* veneziani] andorno á visitare a s̄. sebastiano al sre. v̄ro p̄re: la extia dil quale haveva benissimo facto mettere ad ordine q̄llo pallazo: cussi sua extia gli expecto in camera sua disopra assetato . . . poi li pti Ambasciatori volsero veder' tutto il pallazo disopra sino la Camera de ms Ludovico che gli piacque assai et maxe li Triūphi de ms Andrea mantinea. . . .

Document 24*: 6 November 1515

MARINO SANUDO, *Diarii***
Piero Soranzo to Marco Contarini
From Chiari (Brescia)

Poi si andò a palazo dove era il Signor Marchese, e avanti si approximasemo al palazo, sentivamo profumi bonissimi, e intrati nel palazo, era adornato con bellissime depenture da la spaliera in su forte bellissime di man dil Mantegna. E fato riverentia al signor, ne fece benigna ciera. Era in una camera forte adornata, sentato al focho con tre ventagi che non li lassava andar uno pelo adosso, con tre terribelissimi levrieri intorno et infiniti falconi e zirifalchi in pugno li intorno, e su per le spaliere erano quadri che erano retrati li soi belli cavali e belli cani, e li era uno nanino vestito d'oro. Tolto licentia de soa signoria, andasemo a veder il palazo. In una camera era depinto le victorie e fati l'avea fato, e il baston auto quando fu fato Capitanio di la Signoria nostra. Poi intrati in certi camere, forsi diexe una dentro l'altra, tutte benissimo in hordine, e tutte si andava per scale in buovolo una in su l'altra in zoso, e su tutte le porte a modo uno armaro che se sera, erano retrati li soi favoriti naturali e belissimi. E andamo in una loza che havea una veduta di uno zardino forte grando quanto se potea vardar e forte belissimo: poi visto uno loco con uno altar dove el signor dice le sue devotione. E andati poi a disnar. . . .

* My attention was drawn to this by Professor Clifford M. Brown.
** Taken from Federico Stefani, Guglielmo Berchet, Nicolo Barozzi (ed.), *I Diarii di Marino Sanudo* (Venice, 1887), XXI, col. 279 ff.

Document 25*: c. 1515–19

MATTEO BANDELLO, *Le Novelle*
Novella Trentesima 'Diversi detti salsi de la viziosa e lorda vita d'un archidiacono mantovano'

(During the course of the visit by the archdeacon to the palace of S. Sebastiano) . . . Fu domandato dapoi fuor di camera [del Marchese] e andò in sala ove sono dipinti i divini trionfi di Giulio Cesare imperadore di mano d'Andrea Mantegna con tanti altri bellissimi quadri di pittura eccelentissima. . . .

* My attention was drawn to this by Professor Clifford M. Brown.

Document 26: 1521

M. EQUICOLA, *Commentarii Mantuani*, BOOK 4

Nel ultima parte de la cita, propinquo alla chiesa di san sebastiano palazo superbissimo, edificio e bello, per sicuramente collocare in una salla ad solo questo effecto fabricata, lo triumpho de C. Iulio Cesare fatiga de molti anni di misser Andrea Mantegna, parea dicto triumpho trunco e mutilato per non vi essere quella pompa che sequir solea il triumphante. Mancavanovi li spectatori al che provede Francesco prudentemente chiamando alla sua liberalita Lorenzo Costa, homo non solamente in pictura excellentissimo, ma amabile e honorato cortegiano. Questo, oltra le altre laudate opere, con ingegno, arte, e scientia, de dicta bellissima sala il capo e fine adorna.

Document 27: 1537

SEBASTIANO SERLIO
Libro Quarto di Architettura (Venice, 1537)
Chapter X

e in questo fu molto aveduto, e ricco di giudicio messer Andrea Mantegna ne i triomphi di Cesare, ch'ei fece in Mantoua al liberalissimo Marchese Francesco Gonzaga: ne la quale opera per esser i piedi de le figure superiori a la veduta nostra non si vede pianura alcuna, ma le figure (come ho detto) posano sopra una linea, ma tanto bene accomodate che fanno l'ufficio suo mirabilmente. e certo questa pittura di che io parlo è da esser celebrata, e tenuta in pregio grande: he la qual si vede profondità del disegno, la prospettiva artificiosa, la inventione mirabile, la innata discretione nel componimento de le figure, e la diligentia estrema nel finire

Document 28: 1550

G. VASARI, *Le Vite de' più eccellenti
architetti, pittori, et scultori italiani*
(Florence, 1550), Vol. I, p. 510

al detto Marchese [Lodovico] per memoria del-
l'uno e dell'altro nel palazzo di San Sebastiano in
Mantova dipinse il trionfi di Cesare, intorno a
una sala, cosa di suo la migliore ch'e facesse gia
mai. Quivi con ordine bellissimo situò nel trionfi
la bellezza e l'ornamento del carro: colui che
vitupera il trionfante, i parenti i profumi, gli
incensi, i sacrifizii e i sacerdoti i prigioni e le
prede fatte per gli soldati, e l'ordinanza delle
squadre, e tutte la spoglie e le vittorie: e le citta
e le rocche in vari carri contrafece con una
infinità di Trofei in su le aste, e varie armi per
intesta e per indosso, acconciature, ornamenti e
vasi infiniti; e tra le moltitudine de gli spettatori,
una donna che ha per la mano un' putto che
essendoseli fitto una spina in un piede, lo mostra
alla madre e piagne, cosa bellissima e naturale.
Et certo che in tutta questa opera pose il Man-
tegna gran diligenzia e fatica non punto piccola;
non guardando ne a tempo ne a industria nel
lavorare: et di continuo mostrò avere a quel
principe affezzion' grandissima; da che e' faceva
cortesie si rare alla sua virtu inamorato in tutto
di quella

Document 29: 1560

B. SCARDEONE, *De Antiquitate Urbis Patavii*
(Basle, 1560), p. 372

Pinxit autem ibi [Mantua] triumphos Caesaris
in septem tabulis arte stupenda, et admirabili
iudicio, et alias laudatissimas tabellas aereas,
incisas formis ad effingendos Romanos triumphos:
et festa Bacchi, et marinos Deos. Item deposi-
tionem Christi in cruce, et collocationem in
sepulchro, et alia permulta. Eae modo tabellae
sunt in maxima existimatione, et a paucis
habentur: novem tamen ex his apud nos sunt,
omnes diversae

Document 30: 1568

G. VASARI, *Le Vite de' più eccellenti pittori scultori
e architettori*
(Florence, 1568), Vol. I, p. 489

Al medesimo Marchese [Lodovico] dipinse nel
palazzo di S. Sebastiano in Mantoa in una sala

il Trionfo di Cesare, che è la miglior cosa che
lavorasse mai. In questa opera si vede con ordine
bellissimo situato nel trionfo la bellezza e l'orna-
mento del carro; colui, che vitupera il trionfante,
i parenti, i profumi, gl' incensi, i sacrifizii, i
sacerdoti, i tori pel sacrificio coronati, e prigioni,
le prede fatte da soldati, l'ordinanza delle squadre,
i Liofanti, le spoglie, le vittorie, e le città, e le
rocche, in varii carri, contrafatte con una in-
finità di trofei in sull'aste, e varie armi per testa, e
per in dosso, acconciature, ornamenti, e vasi in-
finiti: e tra la moltitudine degli spettatori una
donna, che ha per la mano un putto, alqual
essendosi fitto una spina, in un piè lo mostra egli
piangendo alla madre, con modo grazioso, e
molto naturale. Costui, come potrei haver ac-
cennato altrove, hebbe in questa historia una
bella, e buona avertenza, che havendo situato il
piano dove posavano le figure, più alto, che la
veduta, dell' occhio, fermò i piedi dinanzi in sul
primo profilo, e linea del piano, facendo sfuggire
gl' altri piu adentro di mano in mano, e perder
della veduta de piedi, e gambe, quanto richiedeva
la ragione della veduta, e così delle spoglie, vasi,
ed altri instrumenti, ed ornamenti: fece veder sola
la parte di sotto, e perder quella di sopra, come
di ragione di prospettiva si conveniva di fare,
e questo medesimo osservò con gran diligenza
ancora And. degli' impiccati, nel cenacolo, che
è nel refettorio di s. Maria Nuova. Onde si vede
che in quella età questi valenti huomini andarono
sottilmente investigando, e con grande studio
imitando la vera proprietà delle cose naturali. E
per dirlo in una parola, non pottrebbe tutta questa
opera esser ne piu bella ne lavorata meglio. Onde
se il Marchese amava prima Andrea l'amo poi
sempre, e honorò molto maggiormente

Document 31: 1568

G. VASARI, *Le Vite* etc. (Florence, 1568), p. 424

Dipinse [Lorenzo Costa] ancora nella sala grande
[del palazzo di S. Sebastiano], dove hoggi sono i
trionfi di mano del Mantegna, due quadri, cioè
in ciascuna testa uno. Nel primo, che è a guazzo
sono molti nudi, che fanno fuochi, e sacrifizii
a Hercole: e in questo è ritratto di naturale il
Marchese, con tre suoi figliuoli, Federigo, Her-
cole, e Ferrante, che poi sono stati grandissimi, e
illustrissimi signori. Vi sono similmente alcuni
ritratti di gran Donne. Nell'altra, che fu fatto a
olio molti anni dopo il primo, e che fu quasi del-
l'ultime cose che dipignesse Loren. è il Marchese

Federigo fatto huomo, con un bastone in mano, come generale di santa chiesa sotto Leone decimo: e intorno gli sono molti signori ritratti dal Costa di naturale

Document 32: 1587

RAFFAELLO TOSCANO
L'Edificatione di Mantova (Mantua 1587)

Di figure diverse adorne, e belle
 Quest' el palazzo [*scilicet* di S Sebastiano]
 in bellordin distinto
 Dove son sette Tavole, et in quelle
 Il trionfo di Cesare è dipinto
 Con magistero tal, chel grande Apelle
 Ne resta, e Zeusi superato, e vinto

Document 33: 1599

TITLE PAGE prepared for the woodcut reproductions of the 'Triumphs' by Andrea Andreani (*no. 88*).

Tabulae triunphi Caesaris. olim nutu Eccelsi Francisci Gonzagae, inclitae urbis Mantuae tunc Marchionis. IIII. prope D. Sebastiani aedes, in maiori eius aula, ab Andrea Mantinea Mantuano ea diligentia pictae, ut iam per annos supra centum, non solum incolarum, verumetiā ex variis orbis partibus, advenarum oculos tanquā mirabile quoddam ad sui inspectionem attrahant, quemadmodum non solum opus ipsū adhuc ostendit, verūetiam Georgii Vasarii historici in Vitis Pictorum testimonio comprobatur

Andreas Andrianus pariter Mantuanus, quo absentium voluntati, meliori qua posset ratione satisfaceret, et municipis tanti viri fama latius per ora virum et commodius volitaret. Idcirco his Typis Ligneis nova suar' formar' adūbratiōe incisit, tuaeq' Celsitudinis [*scilicet*, Vincentii Gonzagae Mantuae Ducis] invicto nomini omnium virtutis amatorum augusto Mecaenati, quod ipsum a Senarum etiam si cara sibi urbe, ad patriā benigne revocaveris, quod et ad opus perficiendum et ad victum necessaria, sponte, atq' abundantissime suppeditaveris maxima humilitate dicavit

Bibliography of the chief printed sources used in the preparation of this book

Alberti, L. B., *De Re Aedificatoria* (Florence, 1485). Edited by G. Orlandi and P. Portoghesi (Milan, 1966).

Amadei, F., *Cronaca Universale della Città di Mantova* (Mantua, 1954–7).

Anglo, S., *Spectacle, Pageantry & Early Tudor Policy* (Oxford, 1969).

Anon., *The Beauties of the Royal Palaces* (Windsor, 1796).

Anon., *The Hampton Court Guide* (Kingston, 1817).

Appian of Alexandria, Ῥωμαϊκά. Latin translation of Piero Candido Decembrio (Venice, 1477).

Ashmole, B., *Proceedings of the British Academy*, XLV (1957), p. 25, 'Cyriac of Ancona'.

Askew, P., *Burlington Magazine*, XCVIII (1956), p. 46 ff., 'Perino del Vaga's Decorations for the Palazzo Doria, Genoa'.

Baker, C. H. Collins, *Burlington Magazine*, LXIV (1934), 'Mantegna Cartoons at Hampton Court. II. The preservation of the Cartoons.'

Banchi, L. (ed.), *I Fatti di Cesare* (Bologna, 1863).

Bartsch, J. A. von, *Le Peintre-Graveur* (Vienna, 1803–21).

Battisti, E., *Arte, Pensiero e Cultura a Mantova nel Primo Rinascimento*, 'Il Mantegna e la letteratura classica' (Florence, 1965).

Bellonci, M., & Garavaglia, N., *L'Opera completa di Mantegna* (Milan, 1967).

Bentivoglio, E., *Mitteilungen des Kunsthistorischen Instituts in Florenz*, XVI (1972), p. 167, 'Bramante e il Geroglifico di Viterbo'.

Bickham, G., *Deliciae Britannicae or the Curiosities of Hampton Court & Windsor Castle Delineated* (London, 1742).

Biondo, Flavio, *Roma Instaurata* (Verona, 1482).

Biondo, Flavio, *Roma Triumphans* (Mantua, ?1472).

Blum, Ilse, 'Die Bedeutung der Antike für das Werk des Andrea Mantegna' (Strasbourg, 1936).

Boas, G., *The Hieroglyphics of Horapollo* (New York, 1950).

Bober, P. P., *Drawings after the Antique by Amico Aspertini* (London, 1957).

Bodnar, E. W., *Cyriacus of Ancona and Athens* (Brussels, 1960).

Bracciolini, Poggio, *Opera Omnia*, ed. R. Fubini (Turin, 1964).

Brilliant, R., *Memoirs of the American Academy at Rome*, XXIX (1967), 'The Arch of Septimius Severus'.

Brinton, S., *The Gonzaga Lords of Mantua* (London, 1927).

Brown, C. M., *Burlington Magazine*, CXIV (1972), p. 861, 'New documents for Andrea Mantegna's Camera degli Sposi'.

Brown, C. M., *Mitteilungen des Kunsthistorischen Instituts in Florenz*, XVII (1973), p. 153, 'Gleanings from the Gonzaga documents in Mantua—Gian Cristoforo Romano and Andrea Mantegna'.

Cannesio (Michele) of Viterbo, *Vita Pauli Secundi* in Muratori, L. A., *Rerum Italicarum Scriptores*, Vol. 3, Part II. (Milan, 1734).

Caprino, C., & others, *La Colonna di Marco Aurelio* (Rome, 1955).

Carandente, G., *I Trionfi nel Primo Rinascimento* (no place of publication, 1963).

Cartwright, J., *Isabella d'Este* (London, 1923).

Casella, M. T., & Pozzi, G., *Francesco Colonna: Biografia e Opere* (Padua, 1959).

Chartrou, J., *Les entrées solennelles et triomphales à la Renaissance 1484–1551* (Paris, 1928).

Cipriani, R., *Tutta la Pittura del Mantegna* (Milan, 1956).

Clark, K., *Journal of the Royal Society of Arts*, 106 (1957–8), p. 663, 'Andrea Mantegna'.

Colonna, F., *Hypnerotomachia Poliphili*. Edited by Giovanni Pozzi & Lucia A. Ciapponi (Padua, 1964).

Cosnac, G. J., Comte de, *Les Richesses du Palais Mazarin* (Paris, 1884).

Cottafavi, C., *Bollettino d'Arte*, Ser. III, Vol. XXV (1931–2), p. 377, 'Il Palazzo del Capitano'.

Cox, T., & Hall, A., *Magna Britannia & Hibernia* (London, 1720–31).

Croft-Murray, E., *Decorative Painting in England 1537–1837*, Vol. I (London, 1962) and II (Feltham, 1970).

Crous, J. W., *Mitteilungen des Deutschen Archäologischen Instituts, Römische Abteilung*, XLVIII (1933), p. 1, 'Florentiner Waffenpfeiler und Armilustrium'.

Coudenhove-Erthal, E., *Die Reliquienschreine des Grazer Doms* (Graz, 1931).

Curtius Rufus (Quintus), *La Historia d'Alexandro Magno*. Translated by Pietro Candido Decembrio (Florence, 1478).

D'Ancona, A., *Origini del Teatro Italiano* (Turin, 1877).

Davari, S., *Notizie storiche topographiche della Città di Mantova* (Mantua, 1903).

Degenhart, B., & Schmitt, A., *Münchner Jahrbuch der bildenden Kunst*, Dritte Folge, XI (1960), p. 59, 'Gentile da Fabriano in Rom und die Anfänge des Antikenstudiums'.

Deutsch, M. E., *The Philological Quarterly*, 1924, 'The Apparatus of Caesar's Triumphs'.

Diodorus Siculus, Βιβλιοθήκη Ἱστόρικη. Translated in Latin by Poggio Bracciolini (Bologna, 1472).

Dorez, L., in *Mélanges G. B. de Rossi* (Paris–Rome 1892), 'La Bibliothèque de Giovanni Marcanova'.

Egger, H., *Codex Escurialensis: ein Skizzenbuch aus der Werkstatt Domenico Ghirlandaios* (Vienna, 1906).

Eisler, R., *Monatsberichte über Kunst und Kunstwissenschaft*, III (1903), p. 159, 'Mantegnas frühe Werke und die römische Antike'.

Eisler, R., *Jahrbuch der KK Zentral-Kommission für Erforschung und Erhaltung der Kunst- und Historischen Denkmale*, NF Vol. III (1905), part II, p. 64, 'Die Hochzeitstruhen der letzten Gräfin von Görz'.

Engerth, E. R. von, *Kunsthistorische Sammlungen des Allerhöchsten Kaiserhauses. Gemälde. Beschreibendes Verzeichnis* (Vienna, 1884).

Equicola, M., *Commentarii Mantuani* (1521).

Ettlinger, L. D., *Mitteilungen des Kunsthistorischen Instituts in Florenz*, Vol. XVI (1972), p. 119, 'Hercules Florentinus'.

Fabriczy, C. von, *Jahrbuch der Königlich Preussischen Kunstsammlungen*, Vol. XIX (1898), pp. 1 and 125, 'Der Triumphbogen Alfonsos I am Castel Nuovo zu Neapel'.

Faccioli, E., *Mantova: Le Lettere* (Mantua, n.d.).

Fiennes, C., *The Journeys of Celia Fiennes*, ed. C. Morris (London, 1949).

Fiocco, G., *Mantegna* (Milan, 1937).

Fiocco, G., *L'Arte di Andrea Mantegna* (Venice, 1959).

Flutre, L.-F., *Les Manuscrits des Faits des Romains* (Paris, 1932).

Flutre, L.-F., *Li Fait des Romains dans les Littératures française et italienne du XIIIᵉ au XVIᵉ Siècle* (Paris, 1932).

Fossi, Todorow M., *I Disegni del Pisanello* (Florence, 1966).

Frutaz, A. P., *Le Piante di Roma* (Rome, 1962).

Furlan, C., *Arte Veneta* (1973), p. 81, 'I Trionfi della Collezione Kress: una proposta attributiva e divagazioni sul tema'.

Gauricus, Pomponius, *De Sculptura*, ed. A. Chastel and R. Klein (Geneva, 1969).

Gerola, G., *Atti del Reale Istituto Veneto di Scienze, Lettere ed Arti*, Vol. LXVIII (1908–9), pp. 905–15, 'Nuovi documenti mantovani sul Mantegna'.

Gerola, G., *Archivio Storico Lombardo*, XLV (1918), p. 97, 'Vecchie insegne di casa Gonzaga'.

Giehlow, K., *Jahrbuch der Kunsthistorischen Sammlungen des Allerhöchsten Kaiserhauses*, XXXII (2), (1915), p. 1, 'Die Hieroglyphenkunde des Humanismus in der Allegorie der Renaissance besonders der Ehrenpforte Kaisers Maximilian I'.

Gombrich, E. H., *Journal of the Warburg & Courtauld Institutes*, XVIII (1955), p. 16, 'Apollonio di Giovanni. A Florentine cassone workshop seen through the eyes of a humanist poet'.

Grundy, C. R., *Walpole Society*, 9 (1921), p. 77, 'Documents relating to an action brought against Joseph Goupy in 1738'.

Guasti, C., *Le Feste di San Giovanni Battista* (Florence, 1884).

Guasti, C., *Giornale Storico degli Archivi Toscani*, VI & VII (1862–3), 'Inventario della Libreria Urbinate compilato nel secolo XV'.

Guenée, B., *Comptes Rendus de l'Académie des Inscriptions et Belles-Lettres* (1967), p. 210, 'Les Entrées Royales Françaises à la Fin du Moyen Age'.

Gundersheimer, W. L., *Art and Life at the Court of Ercole I d'Este: the 'De Triumphis Religionis' of Giovanni Sabadino degli Arienti* (Geneva, 1972).

Gundolf, F., *Caesar, Geschichte seines Ruhms* (Berlin, 1924).

Haydon, B. R., *Diaries*, ed. W. B. Pope (Cambridge, Mass., 1960).

Hill, G. F., *A Corpus of Italian Medals* (London, 1930).

Hind, A. M., *Early Italian Engraving* (London, 1948).

Horapollo, *Hieroglyphica*. Translated into Latin by Filippo Fasianino of Bologna (Bologna, 1517)

Huelsen, C., *La Roma Antica di Ciriaco d'Ancona* (Rome (1061 '

Huelsen, C., *Il Libro di Giuliano da Sangallo* (Leipzig, 1910).

Huelsen, C., *Das Skizzenbuch des Giovannantonio Dosio* (Berlin, 1933).

Iversen, E., *The Myth of Egypt & its Hieroglyphs* (Copenhagen, 1961).

Jameson, A. B., *A Handbook to the Public Galleries of Art in and near London* (London, 1842).

Jones, H. Stuart, *The Sculptures of the Museo Capitolino* (Oxford, 1912).

Jones, H. Stuart, *The Sculptures of the Palazzo dei Conservatori* (Oxford, 1926).

Knabenshue, P. D., *Art Bulletin*, 41 (1959), p. 59, 'Ancient and medieval elements in Mantegna's Trial of St James'.

Knapp, F. (ed.), *Andrea Mantegna* (Klassiker der Kunst, Vol. XVI, Stuttgart & Leipzig, 1910).

Kristeller, P., *Andrea Mantegna* (London, 1901) (referred to as Kristeller, E.).

Kristeller, P., *Andrea Mantegna* (Berlin & Leipzig, 1902) (referred to as Kristeller, G.).

Kurz, O., *Studi in honori di Riccardo Filangieri* (Naples, 1959), Vol. II, p. 277 'Sannazaro and Mantegna'.

Law, E., *Historical Catalogue of the Pictures at Hampton Court Palace* (London, 1881).

Law, E., *The History of Hampton Court Palace* (London, 1885–91).

Law, E., *Mantegna's Triumph of Julius Caesar* (London, 1921).

Lawrence, E. B., *Memoirs of the American Academy in Rome*, 6 (1927), 'The Illustration of the Garret & Modena Manuscripts of Marcanova'.

Lehmann-Hartleben, K., *Die Trajanssäule* (Berlin & Leipzig, 1926).

Levi, A., *Sculture Greche e Romane del Palazzo Ducale di Mantova* (Rome, 1931).

Ludovici, S. Samek, *La Pittura Lombarda del Quattrocento* (Messina–Florence, 1952).

Luzio, A., *La Galleria dei Gonzaga venduta all'Inghilterra nel 1627–28* (Milan, 1913).

Luzio, A., & Paribeni, R., *Il Trionfo di Cesare di Andrea Mantegna* (Rome, 1940).

Luzio, A., & Renier, R., *Giornale storico della letteratura italiana*, XIII (1889), p. 430, 'Il Platina e i Gonzaga' and XVI (1890), p. 119, 'I Filelfo alla corte dei Gonzaga'.

Luzio, A., & Renier, R., *Mantova e Urbino* (Rome, 1893).

Mann, J. G., *Archaeologia*, 80 (1930), p. 117, 'The Sanctuary of the Madonna delle Grazie with notes on the evolution of Italian armour during the fifteenth century'.

Mann, J. G., *Archaeologia*, 87 (1937), p. 311, 'A further account of the Armour preserved in the Sanctuary of the Madonna delle Grazie near Mantua'.

Mansuelli, G. A., *La Galleria degli Uffizi. Le Sculture* (Rome, 1958).

Marani, E., & Perina, C., *Mantova: Le Arti. II Dall'inizio del Secolo XV alla metà del XVI* (Mantua, 1962): *III Dalla metà del Secolo XVI ai nostri giorni* (Mantua, 1962).

Mardersteig, G., *Felice Feliciano Veronese-Alphabetum Romanum* (Verona, 1960).

Meiss, M., *Andrea Mantegna as Illuminator* (New York, 1957).

Meroni, U., Exhibition Catalogue: *Mostra dei Codici Gonzagheschi* (Mantua, 1966).

Mezzetti, A., *Bollettino d'Arte*, Series IV, XLIII (1958), p. 232, 'Un Ercole e Anteo del Mantegna'.

Migne, J.-P., *Patrologia Latina*, Vol. 82, 'Sancti Isidori Libri XVIII Etymologiarum' (Paris, 1850).

Migne, J.-P., *Patrologia Latina*, Vol. 111, 'Rabani Mauri . . . De Universo'.

Milesi, R., *Festschrift für Rudolf Egger*, Vol. III, p. 382, 'Mantegna und die Reliefs der Brauttruhen Paola Gonzagas' (Klagenfurt, 1954).

Milesi, R., *Mantegna und die Reliefs der Brauttruhen Paola Gonzagas* (Klagenfurt, 1975).

Millar, O., *Walpole Society*, 37 (1958–60), 'Abraham van der Doort's catalogue of the collections of Charles I'.

Millar, O., *Walpole Society*, 43 (1970–2), 'The Inventories and Valuations of the King's Goods 1649–51'.

Mitchell, C., *Italian Renaissance Studies*, Editor E. F. Jacob (London, 1960), 'Archaeology and Romance in Renaissance Italy'.

Mitchell, C., *Proceedings of the British Academy*, XLVII (1961), p. 197, 'Felice Felicianus Antiquarius'.

Mommsen, T. E., *Art Bulletin*, 34 (1952), p. 95, 'Petrarch and the decoration of the *Sala Virorum Illustrium* in Padua'.

Moretti, G., *Ara Pacis Augustae* (Rome, 1948).

Moschetti, A., *Atti del Reale Istituto Veneto di Scienze, Lettere ed Arti*, LXXXIX (1929–30), p. 227, 'Le iscrizione lapidarie romani negli affreschi del Mantegna agli Eremitani'.

Muraro, M., *Arte, Pensiero e Cultura a Mantova nel Primo Rinascimento* (Florence, 1965), 'Mantegna e Alberti'.

Muraro, M., in *De Artibus Opuscula XL. Essays in Honor of Erwin Panofsky*, ed. M. Meiss (New York, 1961), 'La Scala senza Giganti'.

Nash, E., *Pictorial Dictionary of Ancient Rome* (London, 1961).

Newton, S., Renaissance Theatre Costume and the Sense of the Historic Past (London, 1975).

Nogara, B., *Scritti inediti e rari di Biondo Flavio* (Rome, 1927).

Paccagnini, G., *Mantova: Le Arti I* (Mantova, 1960).

Paccagnini, G., *Scritti di Storia dell'Arte in onore di Mario Salmi* (Rome, 1962), 'Appunti sulla technica della *Camera Picta* di Andrea Mantegna'.

Paccagnini, G., *Il Palazzo Ducale di Mantova* (Turin, 1969).

Paccagnini, G., *Pisanello* (London, 1973).

Paccagnini, G., & others, *Catalogo della Mostra: Andrea Mantegna* (Venice, 1961).

Paccagnini, G., & Figlioli, M., *Catalogo della Mostra: Pisanello alla corte dei Gonzaga* (Venice, 1972).

Paglia, E., *Archivio Storico Lombardo* (1884), p. 150, 'La Casa Giocosa di Vittorino da Feltre in Mantova'.

Parodi, E. G., *Studi di Filologia Romanza publicati da Ernesto Monaco*, IV (1889), p. 235, 'Le Storie di Cesare nella letteratura italiana dei primi secoli'.

Passavant, J. D., *Le Peintre-Graveur* (Leipzig, 1860–4).

Passavant, M., *Tour of a German Artist in England* (London, 1936).

Pauly-Wissowa, *Real-Enzyklopädie der Klassischen Altertumswissenschaft* (Stuttgart, 1893).

Payne, R., *The Roman Triumph* (London, 1962).

Petrarch, F., *Africa*, ed. Francisco Corradini (Padua, 1874).

Petrarch, F., *De Viris Illustribus*, ed. by L. Razzolini with the Italian Translation by Donato degli Albanzani (Bologna, 1874 & 1879).

Platner, S. B., & Ashby, T., *A topographical dictionary of Ancient Rome* (London, 1929).

Plutarch, Βίοι Παράλληλοι, Latin translation by various scholars (Rome, ?1470).

Popham, A. E., & Pouncey, P., *Italian Drawings in the Department of Prints & Drawings in the British Museum. The Fourteenth and Fifteenth Centuries* (London, 1950).

Portheim, F., *Repertorium für Kunstwissenschaft*, IX (1886), p. 266, 'Andrea Mantegnas Triumph Cäsars'.

Puppi, L., *Il trittico di Andrea Mantegna per la Basilica di San Zeno Maggiore in Verona* (Verona, 1972).

Quarrell, W. H., & Mare, M. (ed.), *London in 1710: from the Travels of Zacharias Conrad von Uffenbach* (London, 1934).

Rava, A., *Nuovo Archivio Veneto*, NS 39 (1920), p. 155, 'Il "Camerino delle Antigaglie" di Gabriele Vendramin'.

Redgrave, F. M., *Richard Redgrave. A Memoir compiled from his Diary* (London, 1891).

Redig de Campos, D., *I Palazzi Vaticani* (Bologna, 1967).

Reichel, A., *Die Clair-Obscur-Schnitte der XVI., XVII., und XVIII. Jahrhunderte* (Zürich–Leipzig–Vienna, 1926).

Restori, V. *Mantova e dintorni* (Mantua, 1937).

Ricci, C., *Iacopo Bellini e i suoi Libri di Disegni* (Florence, 1968).

Richardson, J. (Père et Fils), *Traité de la Peinture et de la Sculpture* (Amsterdam, 1728).

Robertson, G., *Giovanni Bellini* (Oxford, 1968).

Rossi, U., *Archivio Storico dell'Arte*, I (1888), p. 453, 'Il Pisanello e i Gonzaga'.

Rotondi, P., *The Ducal Palace of Urbino* (London, 1969).

Ryberg, I. S., *The Panel Reliefs of Marcus Aurelius* (New York, 1967).

Sainsbury, W. Noel, *Original Unpublished Papers Illustrative of the Life of Sir Peter Paul Rubens* (London, 1859).

Saintenoy, P., *Les Arts et les Artistes à la cour de Bruxelles* (Brussels, 1934).

Sannazaro, J., *Arcadia*, ed. by M. Scherillo (Turin, 1888).

Santi Bartoli, P., *La Colonna Traiana* (Rome, 1673).

Sanudo, M., *I Diarii*, ed. by Federico Stefani, Guglielmo Berchet and Nicolo Barozzi (Venice, 1887).

Saxl, F., *Journal of the Warburg & Courtauld Institutes*, IV (1941), p. 19, 'The Classical Inscription in Renaissance Art & Politics'.

Scaglia, G., *Journal of the Warburg & Courtauld Institutes*, XXVII (1964), p. 137, 'The Origin of an archaeological plan of Rome by Alessandro Strozzi'.

Scaglia, G., *Arte Lombarda* (1970), p. 9, 'Fantasy Architecture of Roma Antica'.

Scardeone, B., *De Antiquitate Urbis Patavii* (Basle, 1560).

Schmitt, A., *Münchner Jahrbuch der bildenden Kunst*, Dritte Folge, XXV (1974), p. 205, 'Francesco Squarcione als Zeichner und Stecher'.

Schubring, P., *Cassoni* (Leipzig, 1923).

Serlio, S., *Libro Quarto di Architettura* (Venice, 1537).

Shearer, C., *The Renaissance of Architecture in Southern Italy* (Cambridge, 1935).

Sighinolfi, L., *Collectanea variae doctrinae Leoni S. Olschi oblata* (Munich, 1921), 'La biblioteca di Giovanni Marcanova'.

Strong, S. A., *Papers of the British School at Rome*, Vol. VI (1913), p. 174, 'Six drawings from the column of Trajan with the date 1467'.

Suetonius Tranquillus (Caius), *De Vita Caesarum* (Rome, 1470).

Sutton, D. (ed.), *The Letters of Roger Fry* (London, 1972).

Tamaro, B. F., *Il Museo Archeologico del Palazzo Reale di Venezia* (Rome, 1969).

Tamassia, A. M., *Rendiconti della Pontificia Accademia Romana di Archeologia*, Ser. III, Vol. XXVIII (1955–6), p. 213, 'Visioni di Antichità nell'opera del Mantegna'.

Thode, H., *Andrea Mantegna* (Bielefeld & Leipzig, 1897).

Thomson, W. G., *A History of Tapestry*, 3rd ed. (Wakefield, 1973).

Thomson, W. G., *Tapestry Weaving in England* (London, 1914).

Tietze-Conrat, E., *Mantegna* (London, 1955).

Torelli, P., & Luzio, A., *Archivio Gonzaga di Mantova* (Ostiglia, 1920, & Verona, 1922).

Toscano, Raffaello, *L'Edificatione di Mantova* (Mantua, 1587).

Traversari, G., *Museo Archeologico di Venezia— I Ritratti* (Rome, 1968).

Uberti, Fazio degli, *Il Dittamondo*, ed. G. Corsi (Bari, 1952).

Valturio, R., *De Re Militari* (Verona, 1472).

Valturio, R., *De Re Militari*, translated into Italian, (Verona, 1483).

Varese, R., *Lorenzo Costa* (Milan, 1967).

Vasari, G., *Le Vite de' più eccellenti architetti, pittori, et scultori italiani* (Florence, 1550).

Vasari, G., *Le Vite de' più eccellenti pittori scultori e architettori* (Florence, 1568).
 See also G. Milanesi (ed.), *Le Opere di Giorgio Vasari* (Florence, 1878–85).

Vegetius Renatus (Flavius), *Epitoma Rei Militaris* (Rome, 1487).

Venturi, A., *Atti e Memorie della R. Deputazione di Storia patria per le Provincie di Romagna*, Ser. III, Vol. VI (1888), p. 91, 'L'Arte Ferrarese nel periodo d'Ercole I d'Este'.

Vermeule, C., *European Art & the Classical Past* (Cambridge, Mass., 1964).

Vermeule, C., *Berytus*, XIII (1959–60), p. 1, 'Hellenistic & Roman Cuirassed Statues'.

Vertue, G., 'The Notebooks', *Walpole Society*, Vols. 18, 20, 22, 24, 26, 29, 30 (Oxford, 1929–1950).

Vickers, M., *Burlington Magazine*, CXVIII (1976), p. 824, 'The "Palazzo Santacroce Sketchbook": a new source for Andrea Mantegna's "Triumph of Caesar", "Bacchanals" and "Battle of the Sea Gods"'.

Vickers, M., *Burlington Magazine*, CXX (1978), p. 365, 'The intended setting of Mantegna's "Triumph of Caesar", "Battle of the Sea Gods" and "Bacchanals"'. For comment on this article see also pp. 603 ff. and 675.

Volkmann, L., *Bilderschriften der Renaissance* (Leipzig, 1923).

Waagen, G. F., *Works of Art and Artists in England* (London, 1838).

Waterhouse, E. K., *Burlington Magazine*, LXIV (1934), p. 103, 'Mantegna's Cartoons at Hampton Court—Their Origin and History'.

Webster, G., *The Roman Imperial Army of the First and Second Centuries A.D.* (London, 1969).

Weisbach, W., *Trionfi* (Berlin, 1919).

Weiss, R., *The Renaissance Discovery of Classical Antiquity* (Oxford, 1969).

Weiss, R., *Journal of the Warburg & Courtauld Institutes*, XVI (1953), p. 1, 'The Castle of Gaillon in 1509–10'.

Wickhoff, F., *Jahrbuch der Kunsthistorischen Sammlungen des Allerhöchsten Kaiserhauses*, XII (1891), p. ccv, 'Die Italienischen Handzeichnungen der Albertina'.

Yriarte, C., *Cosmopolis*, V (1897), p. 738, 'La Maison de Mantegna à Mantoue et les Triomphes de César à Hampton Court'.

Yriarte, C., *Mantegna* (Paris, 1901).

ILLUSTRATIONS ⁓ PART ONE

MANTEGNA'S 'TRIUMPHS OF CAESAR'
RELATED DRAWINGS AND ENGRAVINGS
COPIES AND DERIVATIVES

*The Author and Publishers are grateful
to all institutions, museums, libraries and the many colleagues
who have helped with the illustrations for this publication*

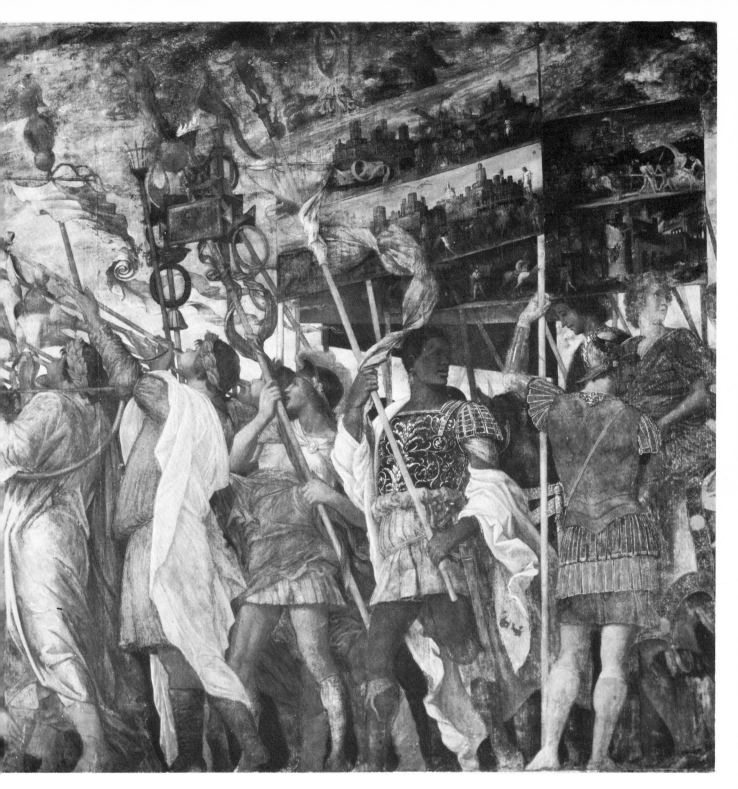

Canvas I: Trumpeters, Bearers of Standards and Banners

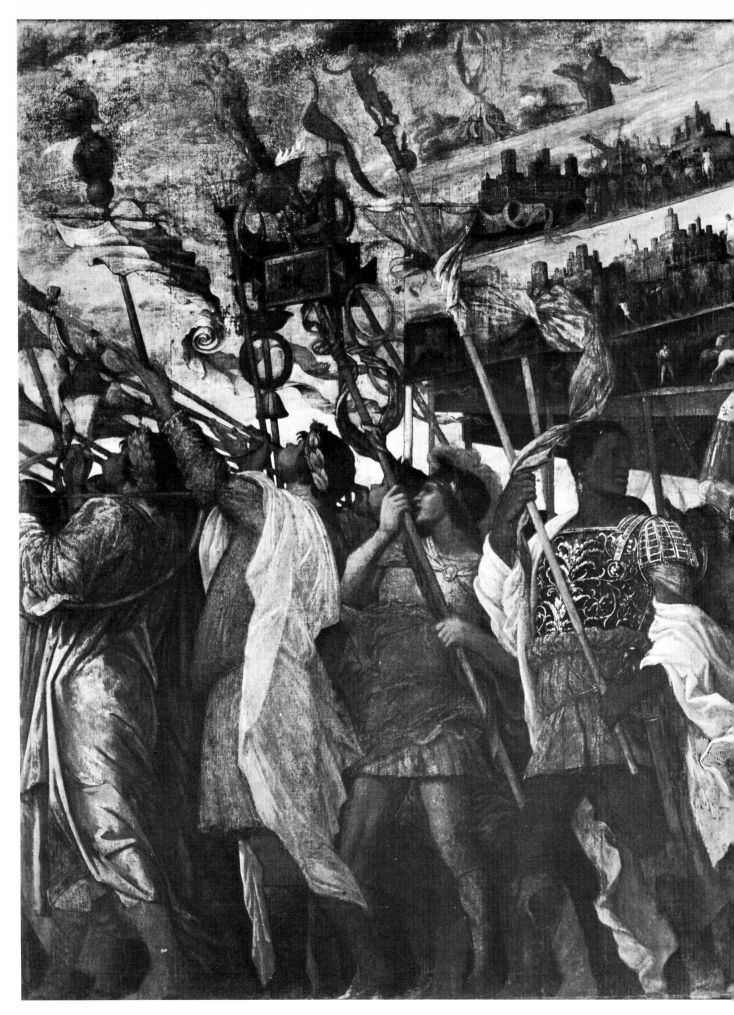

2. Detail of Canvas I

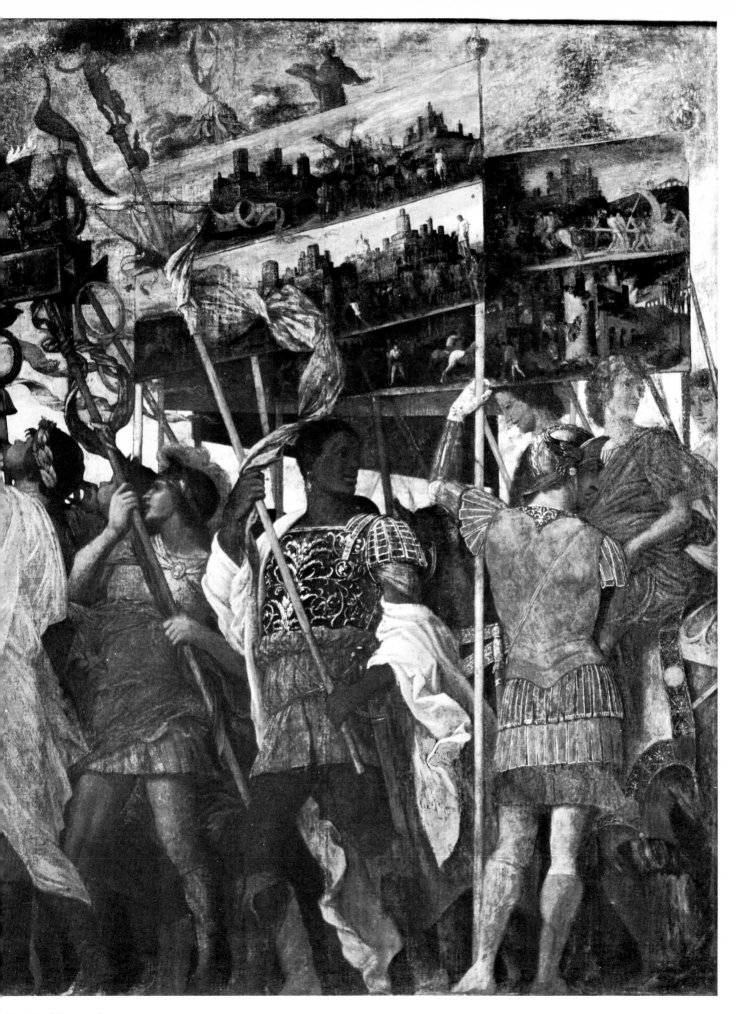

Detail of Canvas I

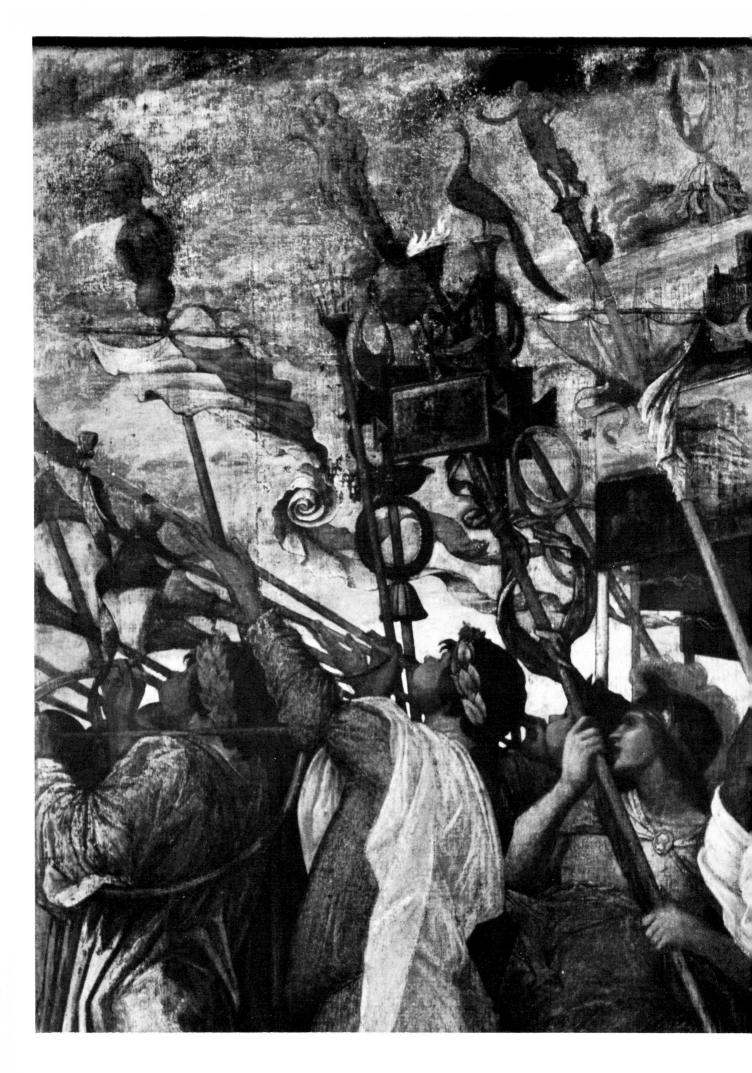

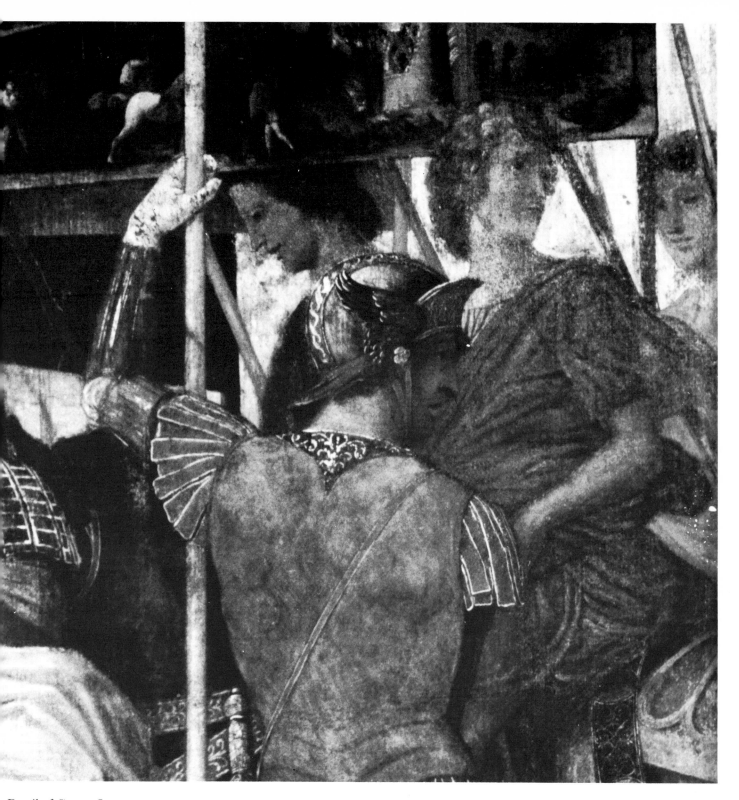

Detail of Canvas I

4. Detail of Canvas I

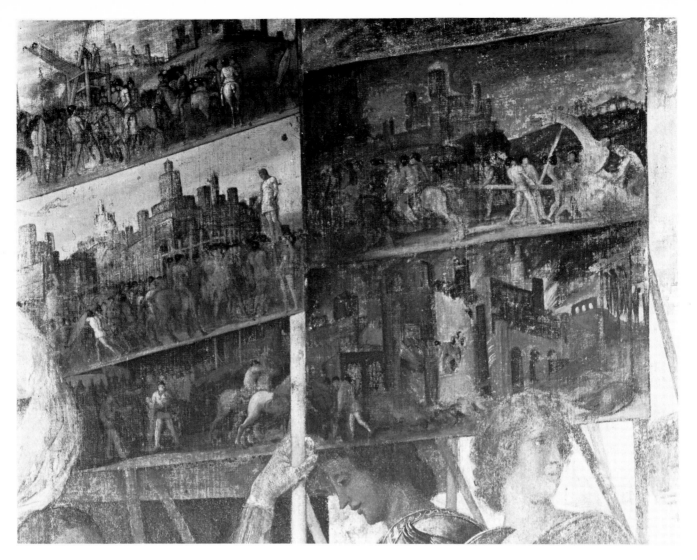

6. Detail of Canvas I

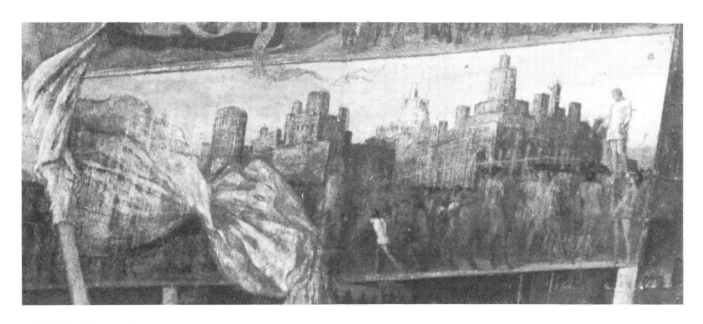

7. Detail of Canvas I

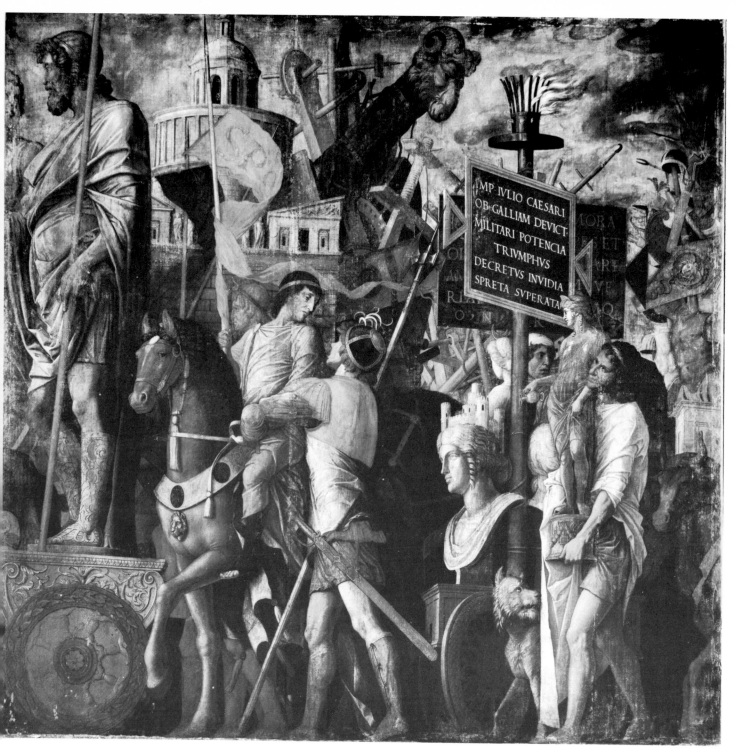

8. Canvas II: Colossal Statues on Carts; a Representation of a Captured City;
Siege Equipment; inscribed Plaques, Images

Within the painting, the inscribed plaque reads:

IMP· IVLIO CAESARI
OB· GALLIAM DEVICT
MILITARI POTENCIA
TRIVMPHVS
DECRETVS INVIDIA
SPRETA SVPERATA

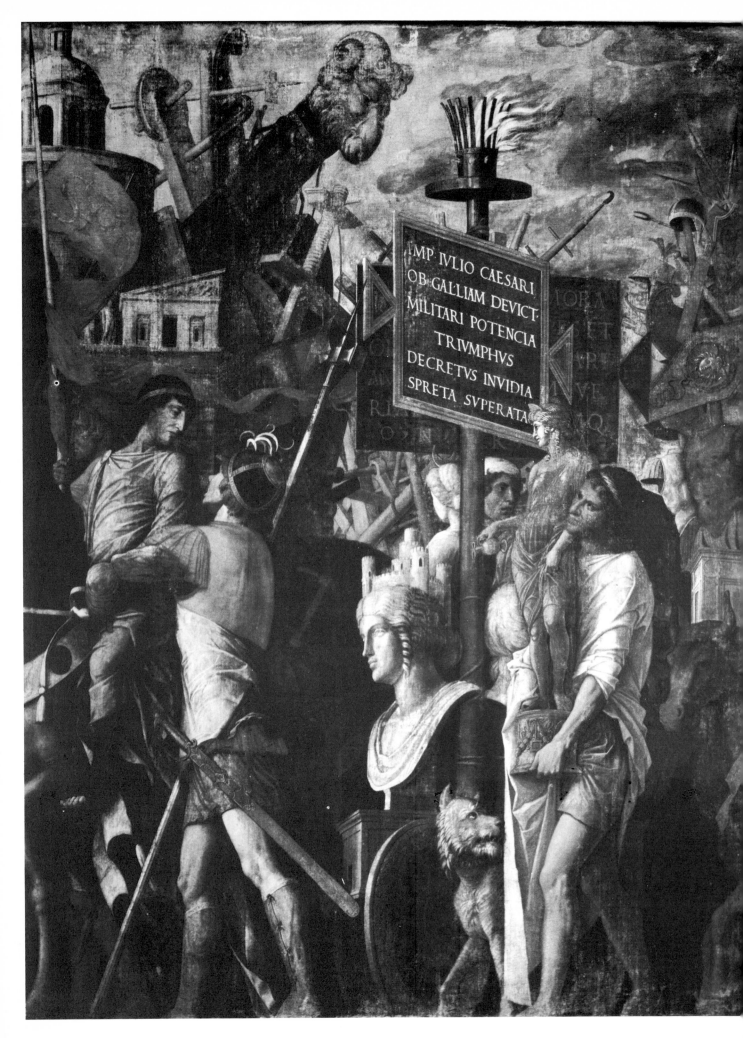

The inscription on the tablet reads:

IMP. IVLIO CAESARI
OB. GALLIAM DEVICT.
MILITARI POTENCIA
TRIVMPHVS
DECRETVS INVIDIA
SPRETA SVPERATA

9. Detail of Canvas II

10. Detail of Canvas II

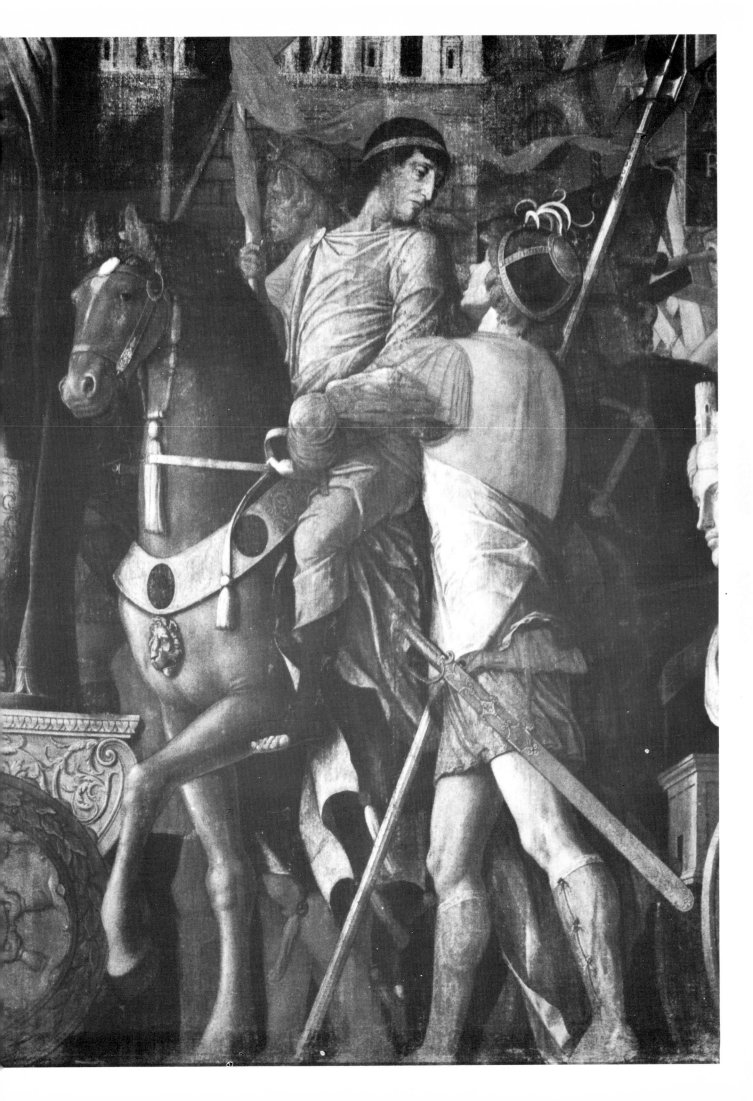

11. Detail of Canvas II

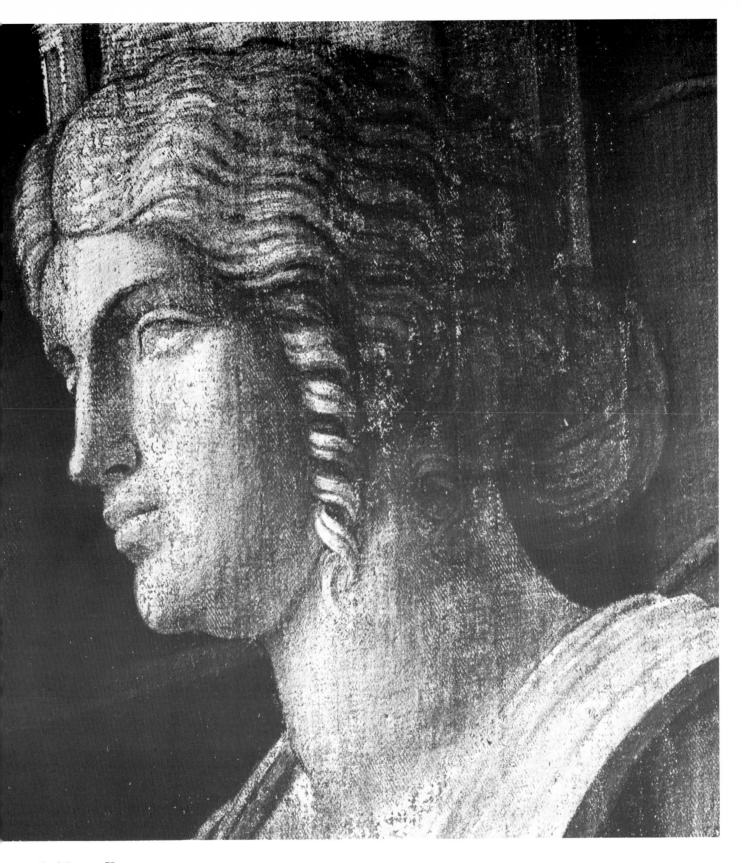

. Detail of Canvas II

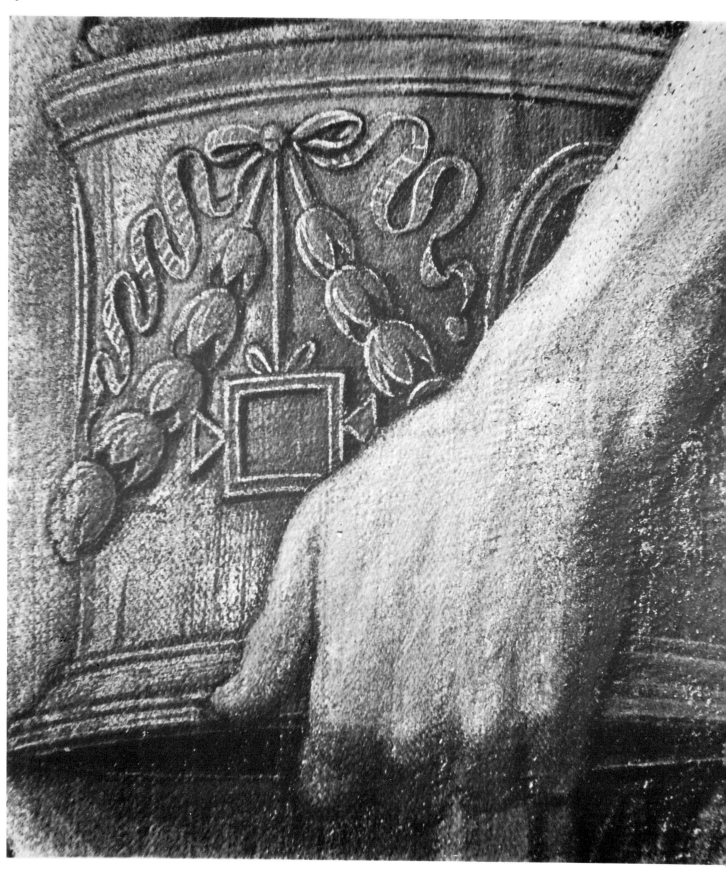

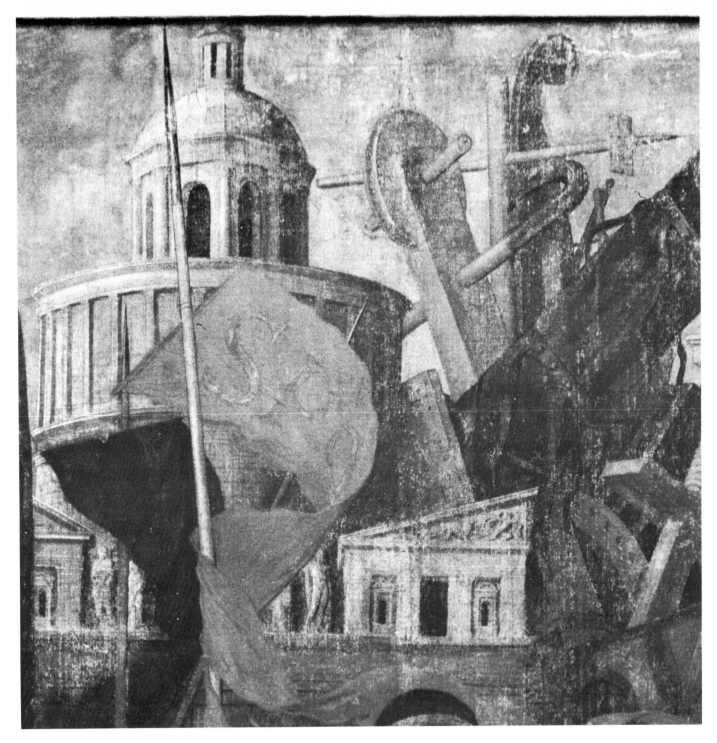

14. Detail of Canvas II

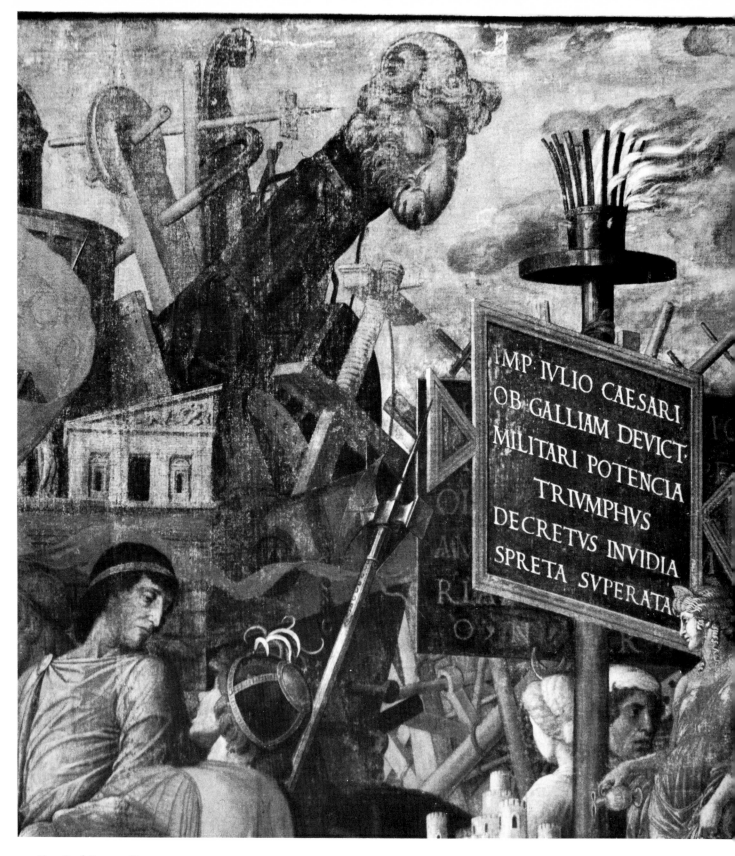

15. Detail of Canvas II

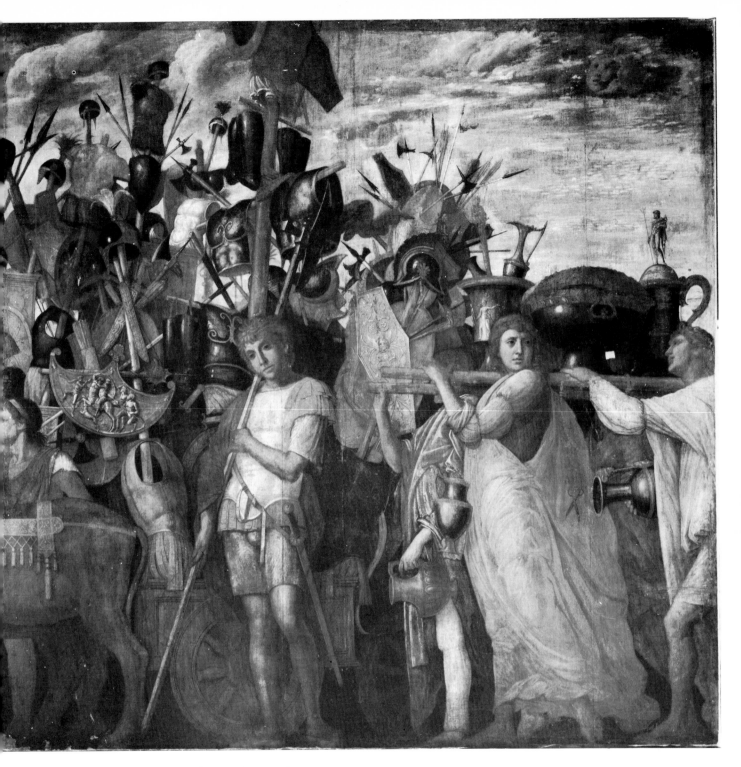

6. Canvas III: Bearers of Trophies of Arms, Coin and Plate

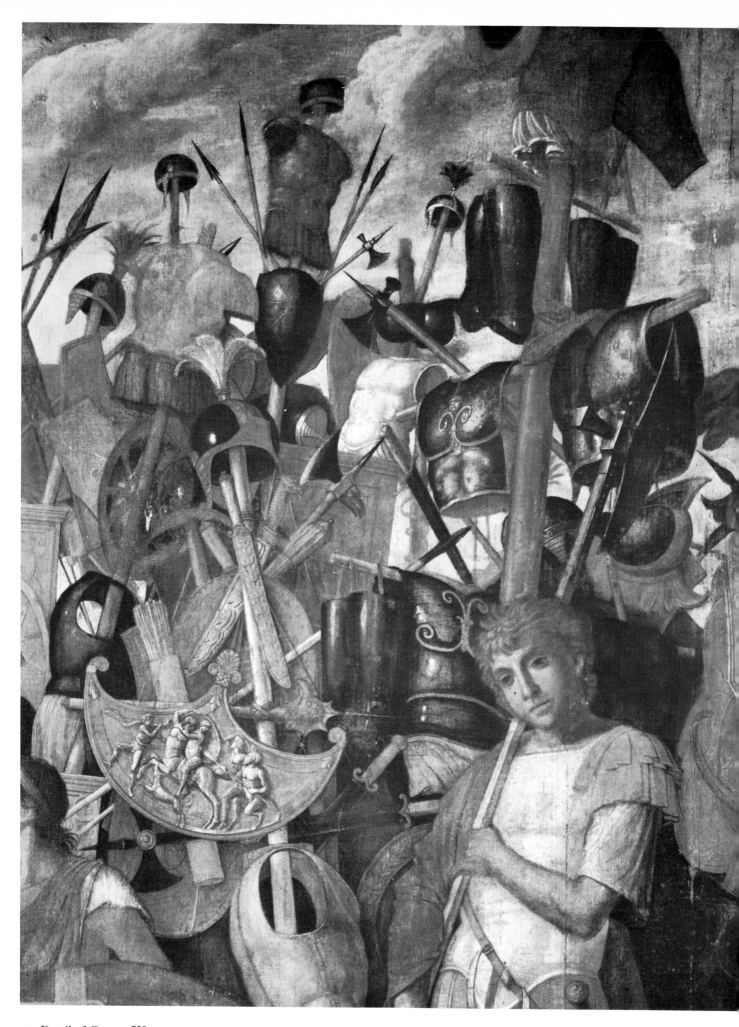

17. Detail of Canvas III

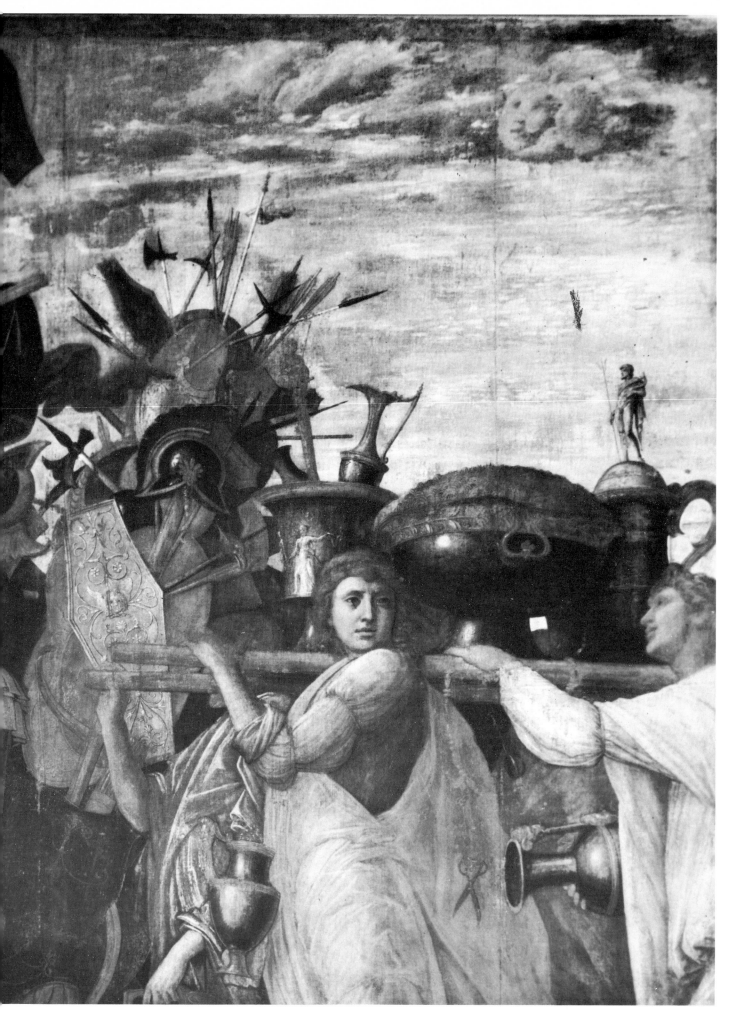

Detail of Canvas III

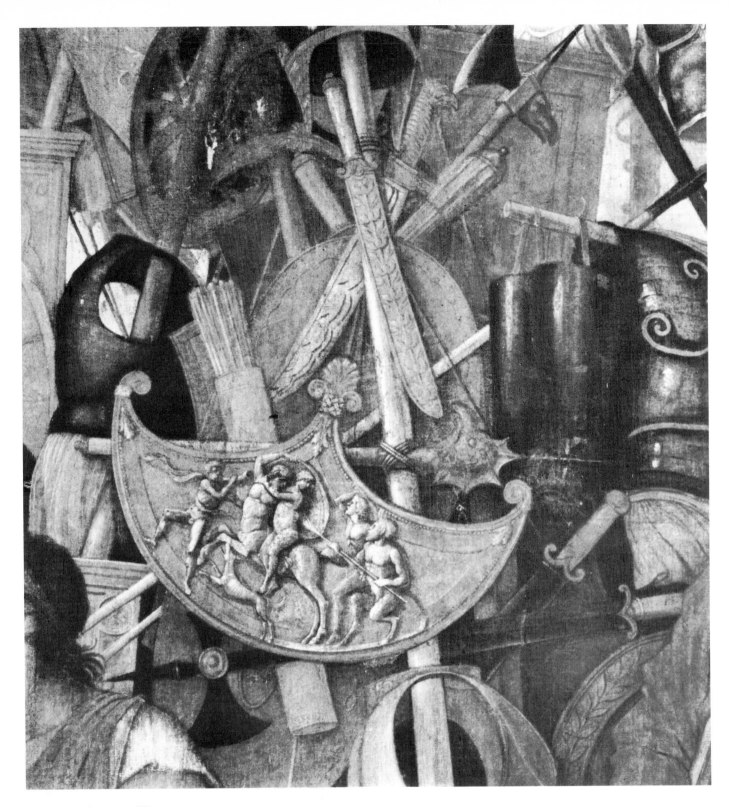

19. Detail of Canvas III

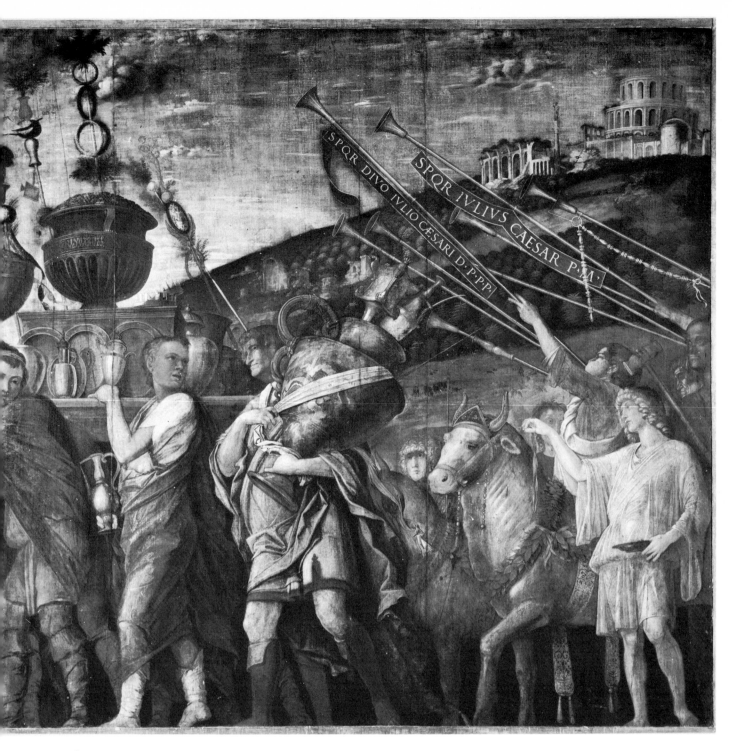

Canvas IV: Bearers of Coin and Plate; Man carrying a large Marble Vase
ntaining a Candelabrum; Oxen with attendant Youth; Trumpeters

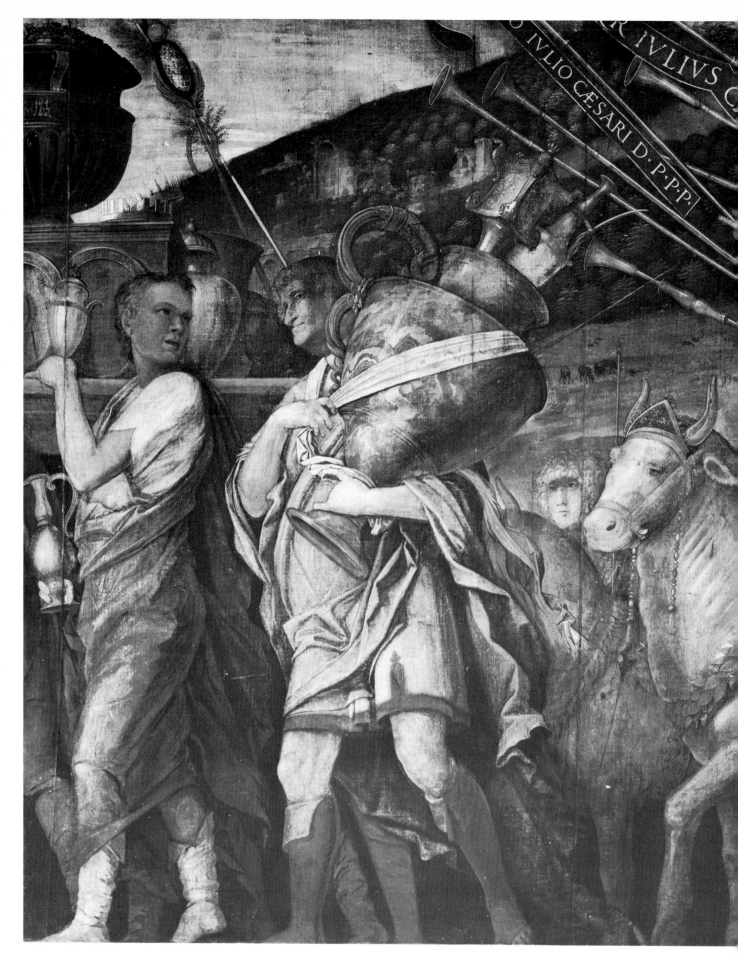

21. Detail of Canvas IV

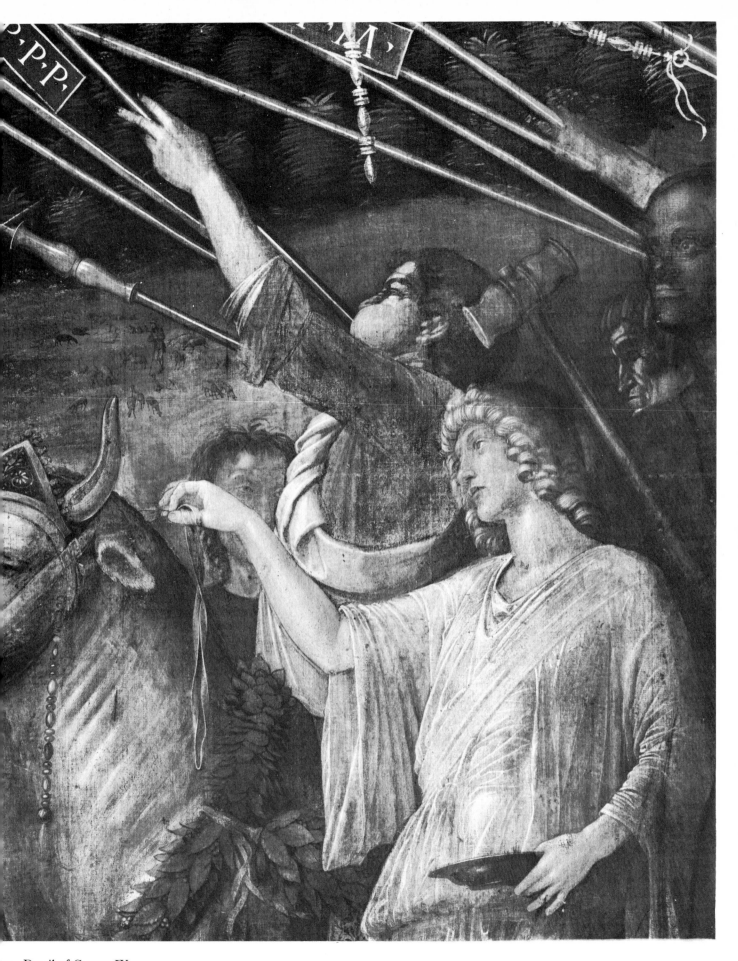

22. Detail of Canvas IV

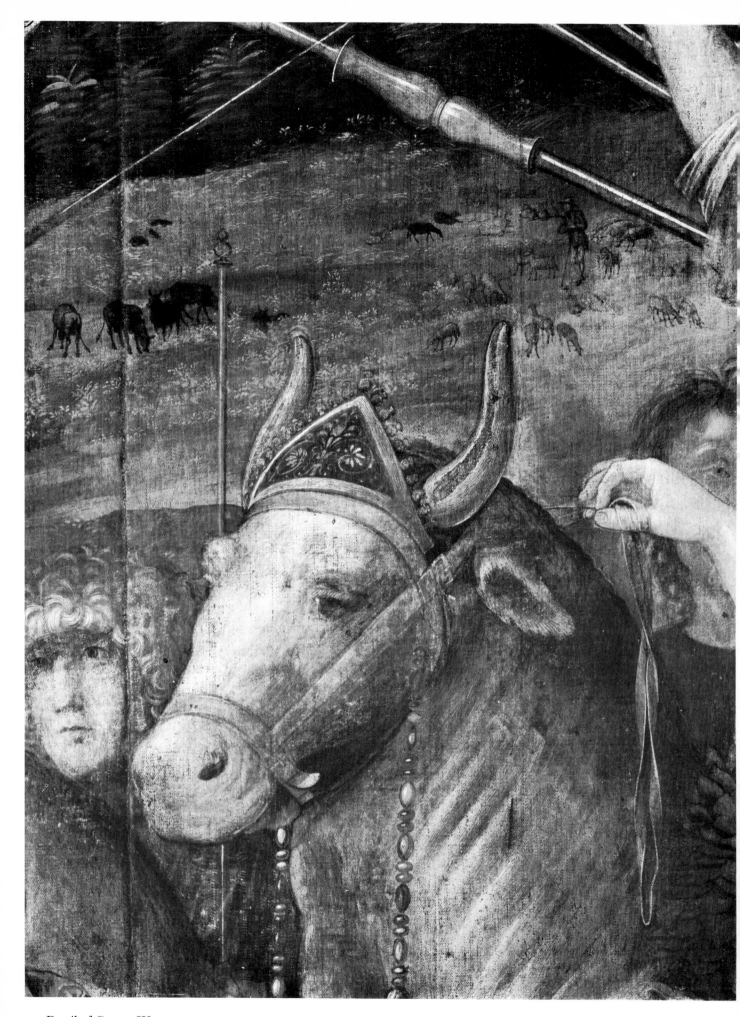

23. Detail of Canvas IV

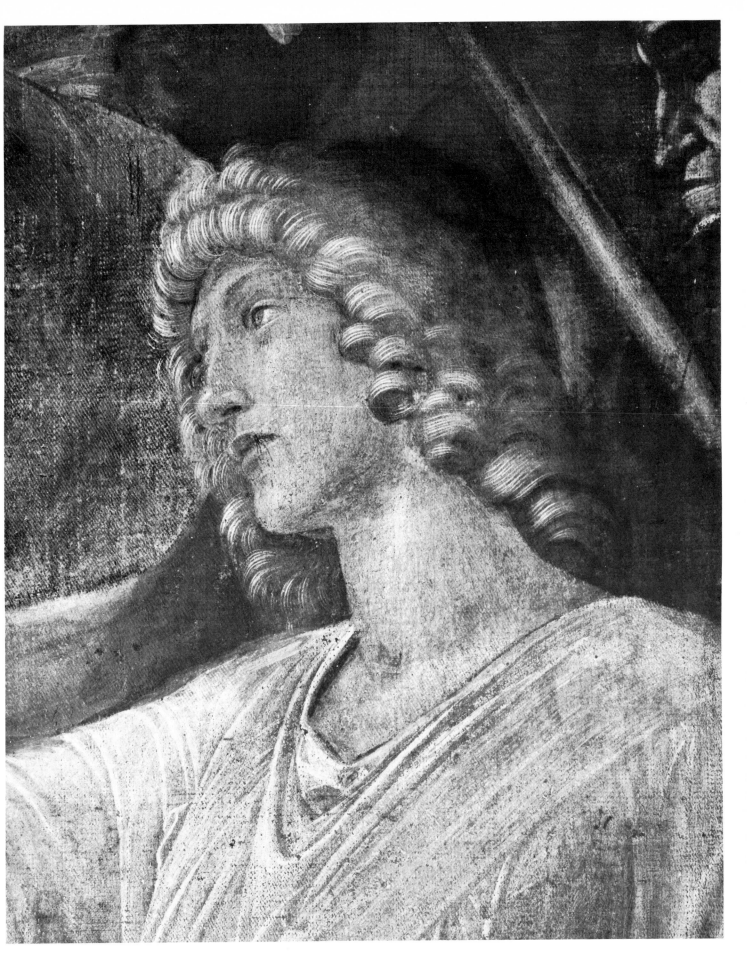

24. Detail of Canvas IV

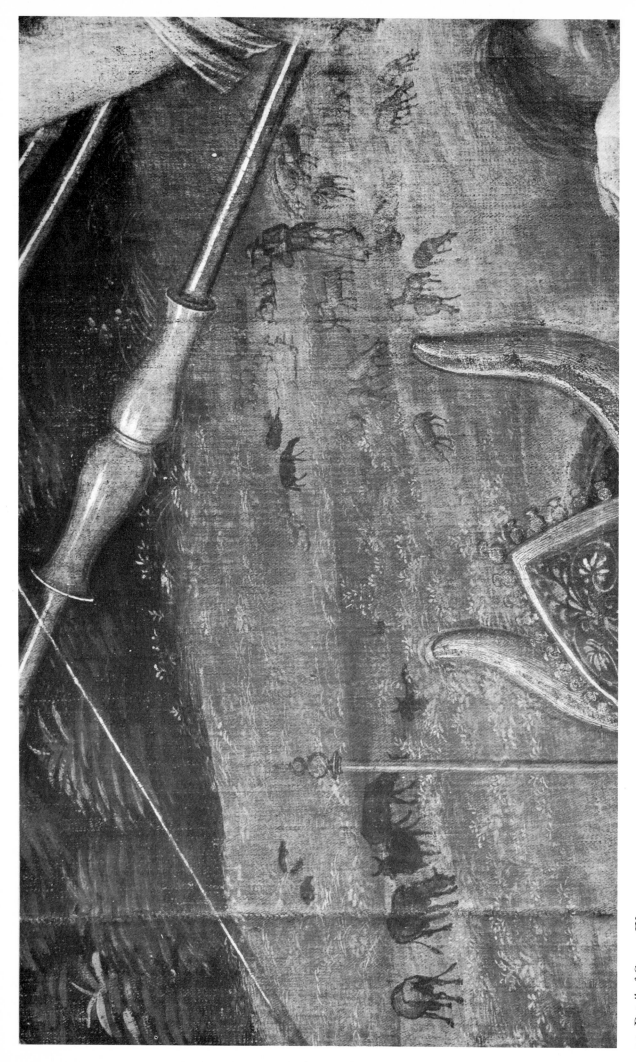

25. Detail of Canvas IV

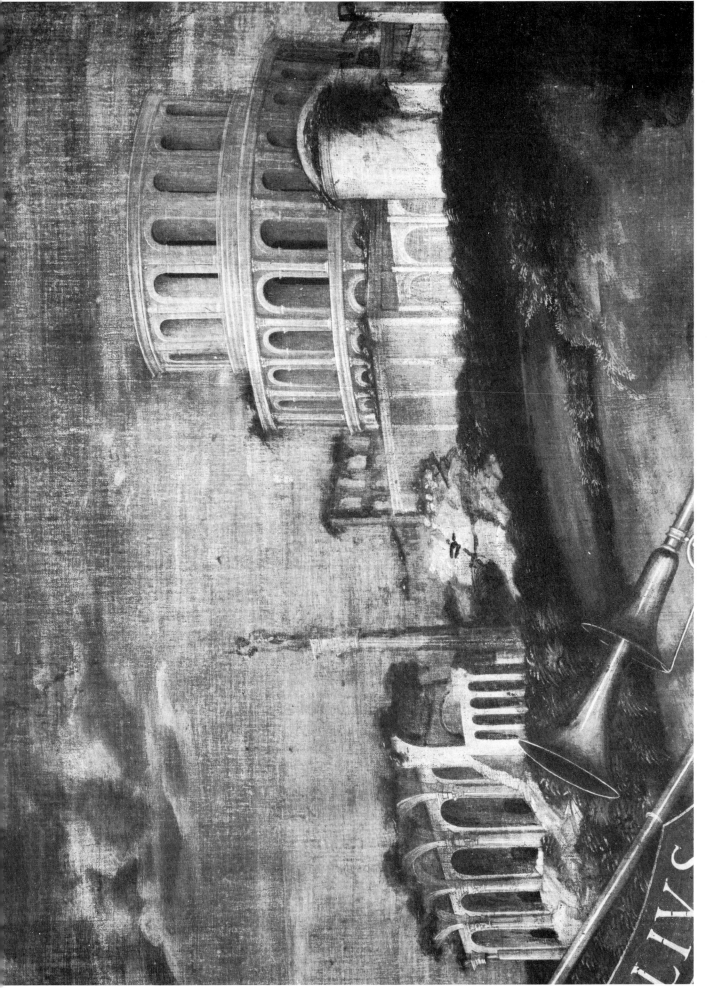

26. Detail of Canvas IV

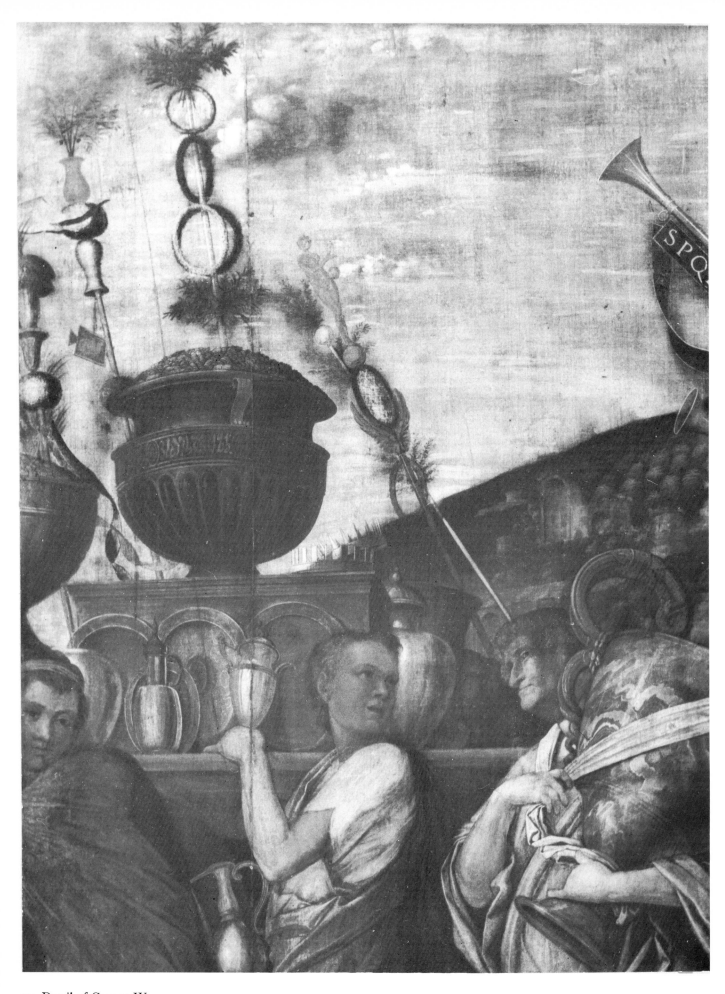

27. Detail of Canvas IV

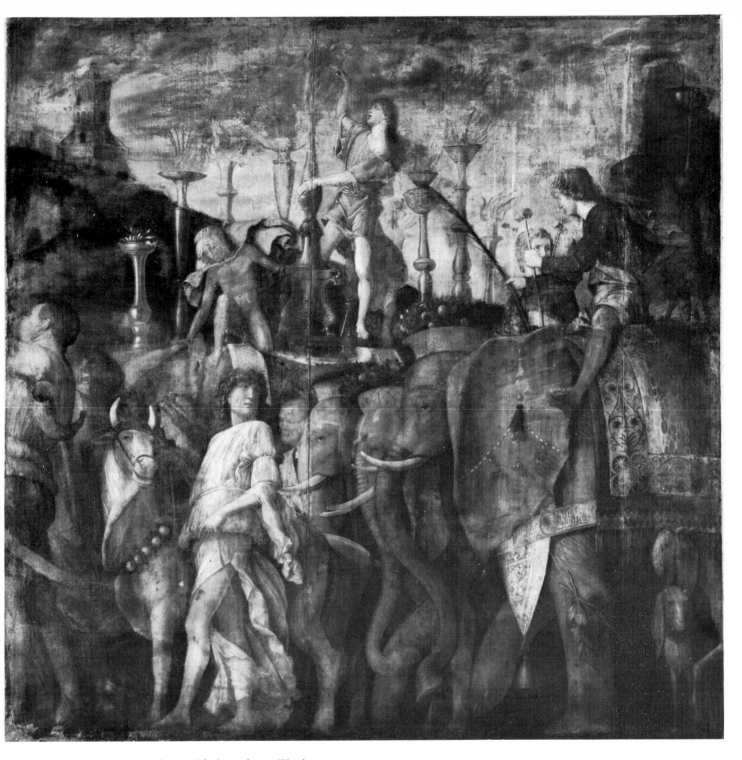

28. Canvas V: Trumpeters, Oxen with Attendants, Elephants

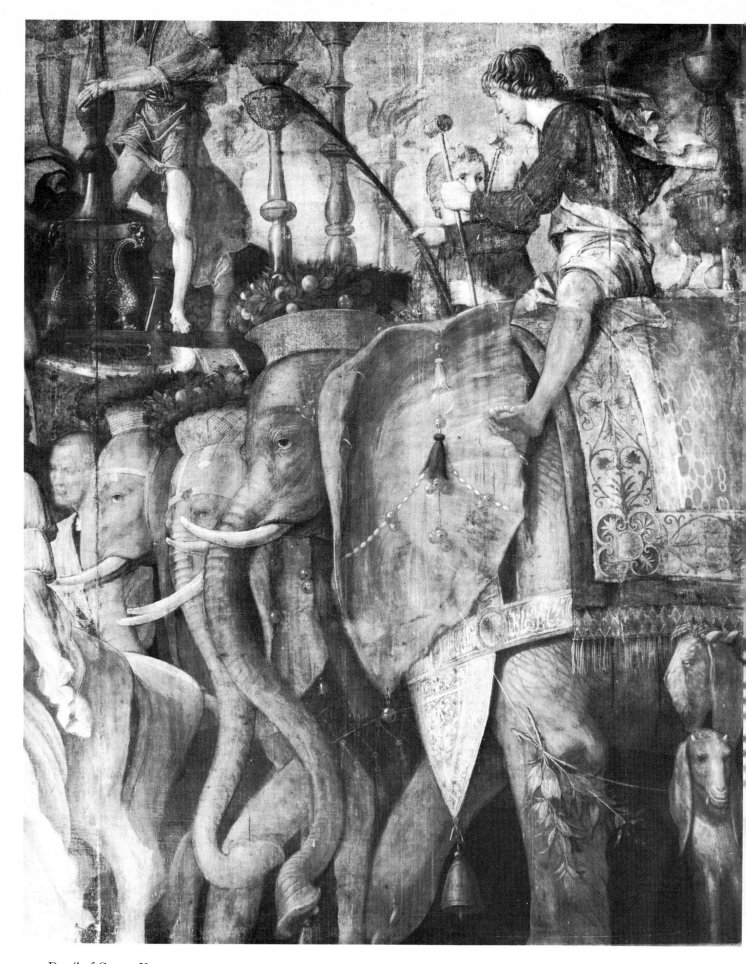

29. Detail of Canvas V

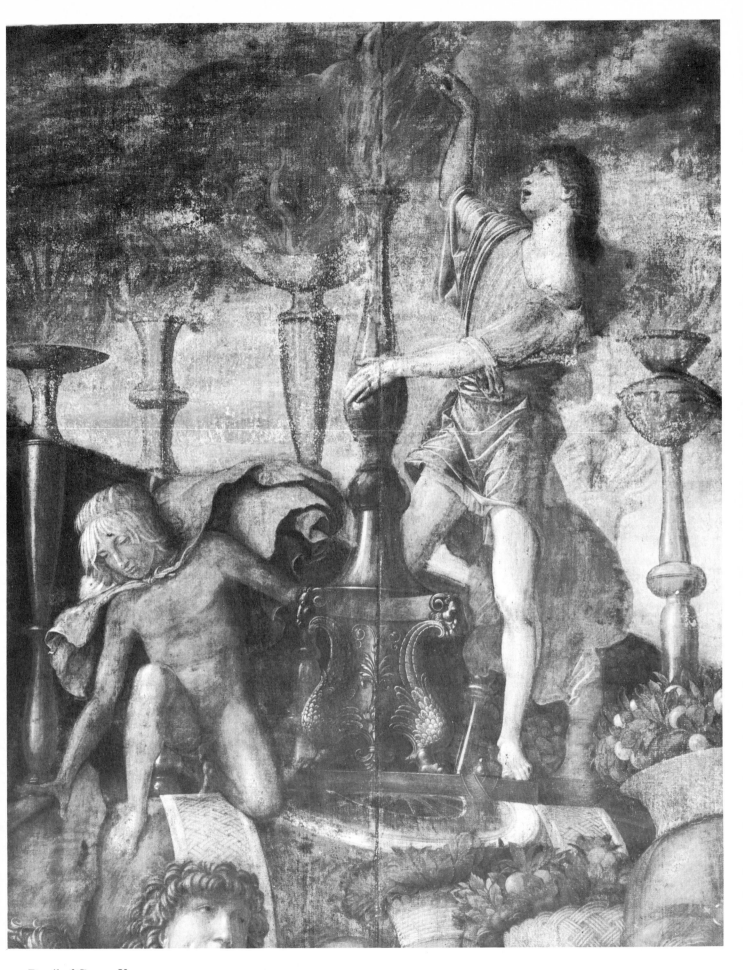

30. Detail of Canvas V

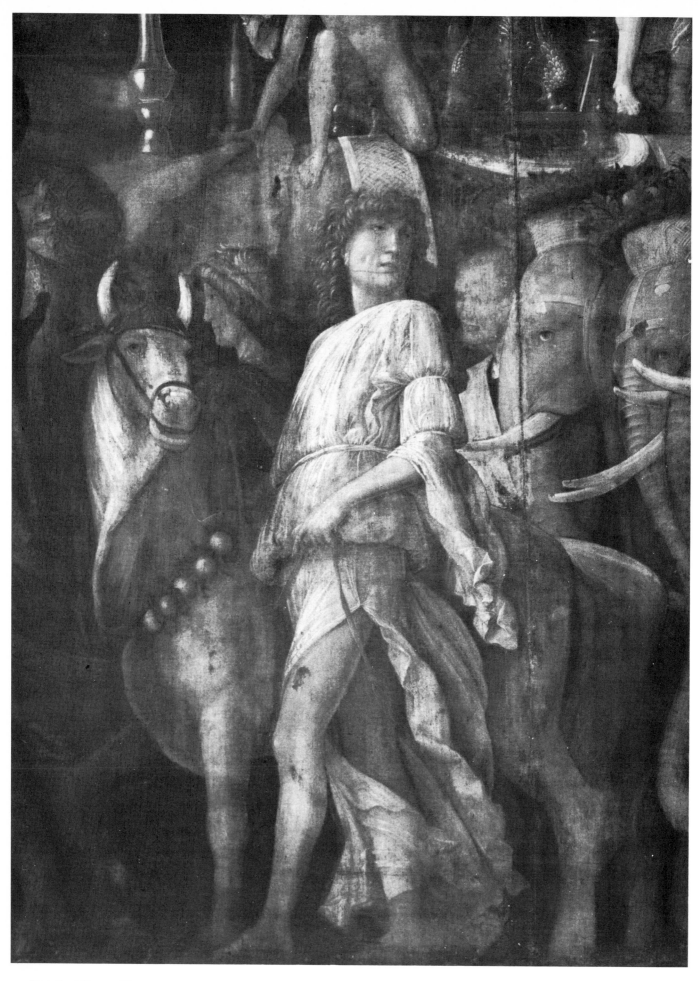

31. Detail of Canvas V

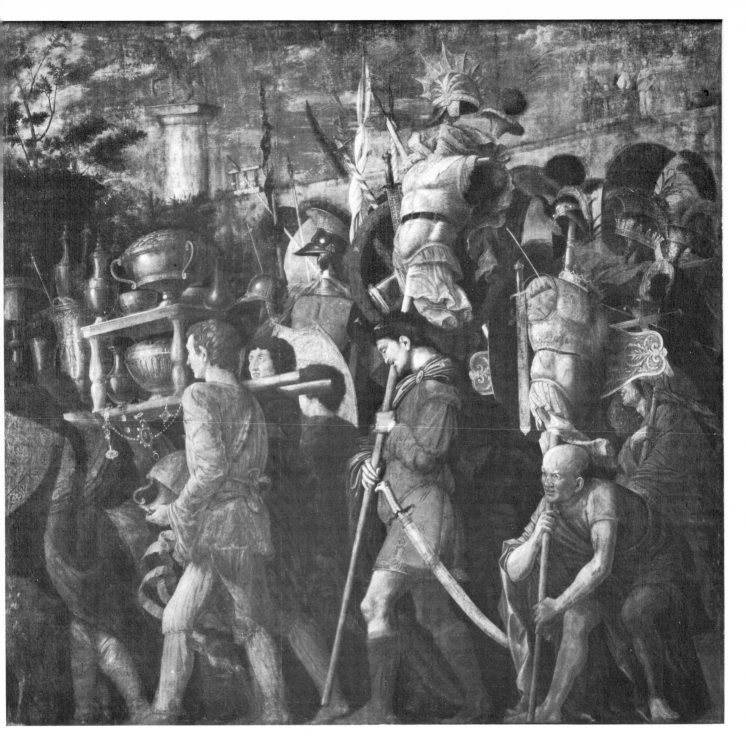

32. Canvas VI: Bearers of Coin and Plate; Bearers of Trophies of special armour

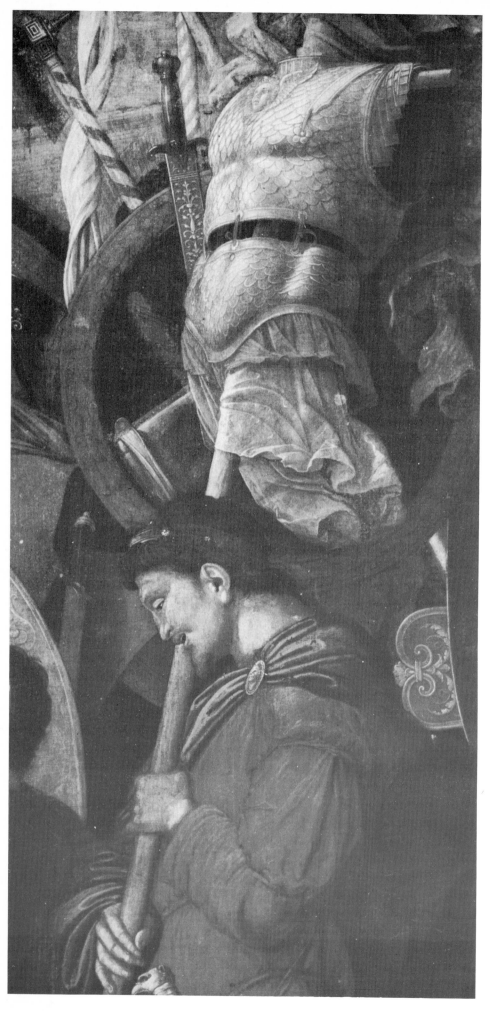

33. Detail of Canvas VI

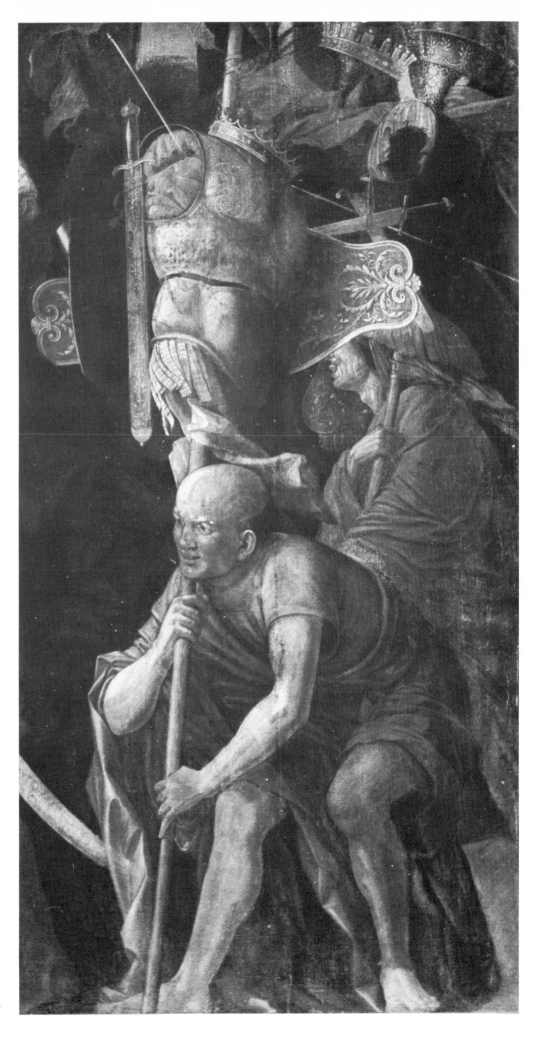

34. Detail of Canvas VI

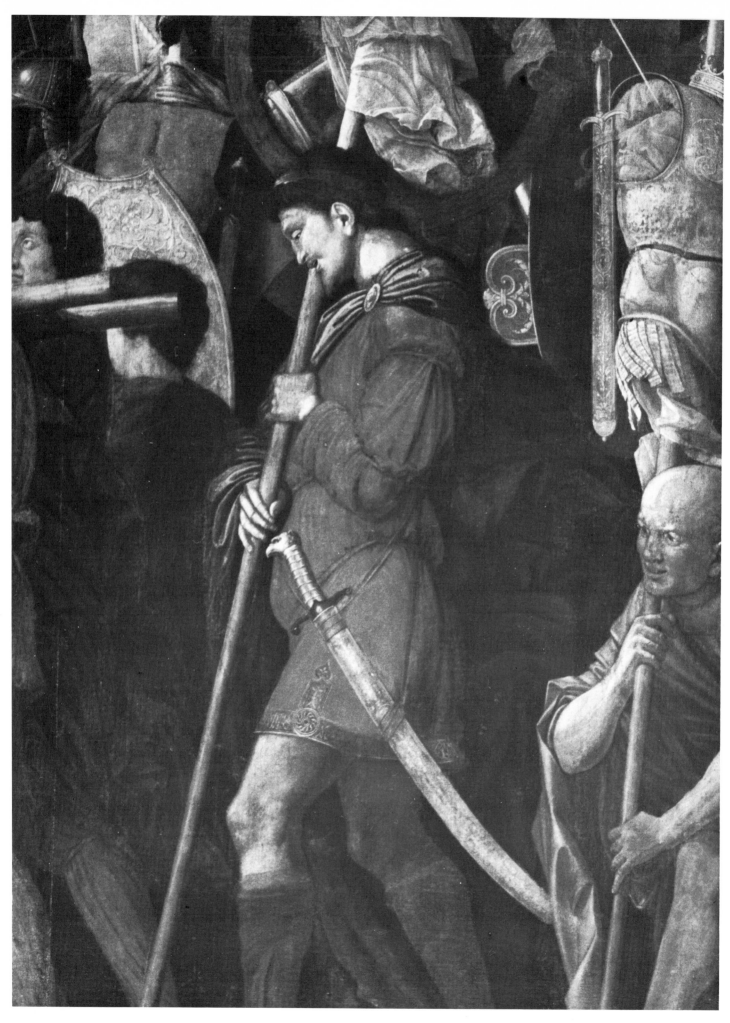

35. Detail of Canvas VI

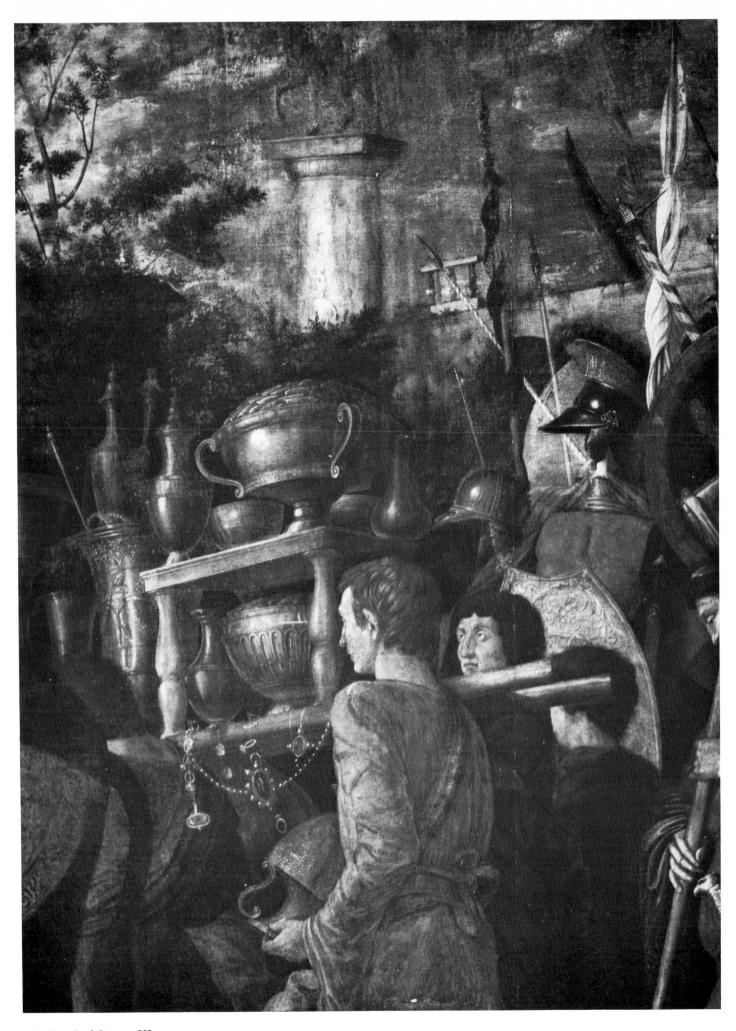

36. Detail of Canvas VI

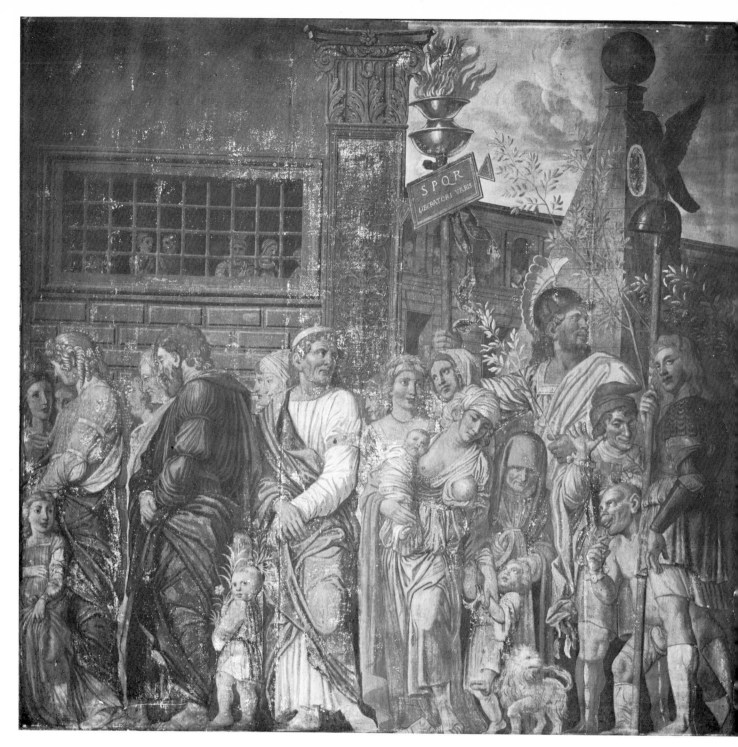

37. Canvas VII: Captives, Buffoons and Soldiers
(from an old photograph: see no. 273 for present condition)

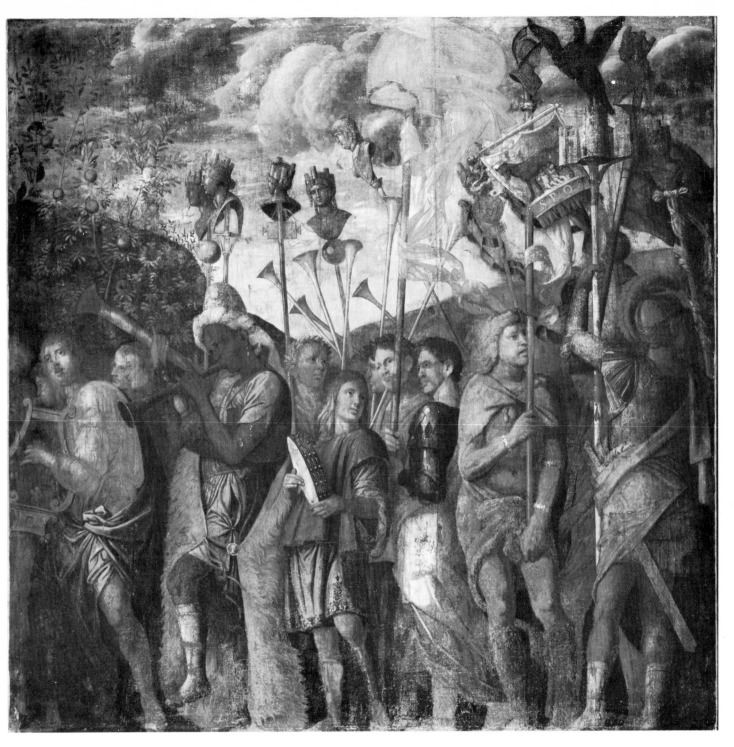

38. Canvas VIII: Musicians and Standard Bearers

39. Detail of Canvas VIII

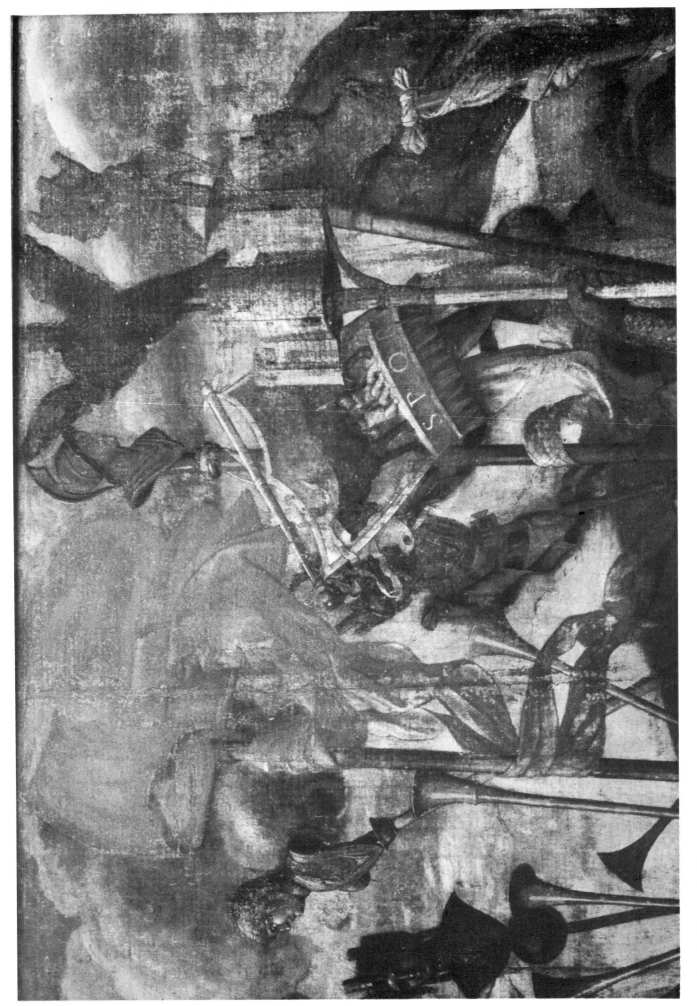

40. Detail of Canvas VIII

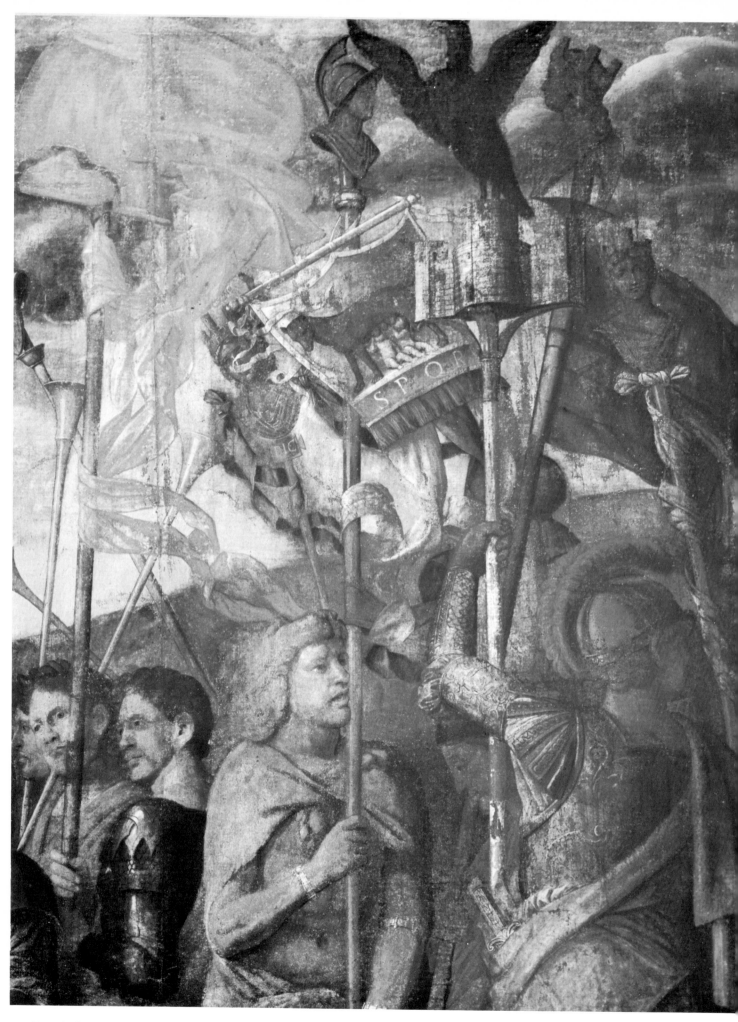

41. Detail of Canvas VIII

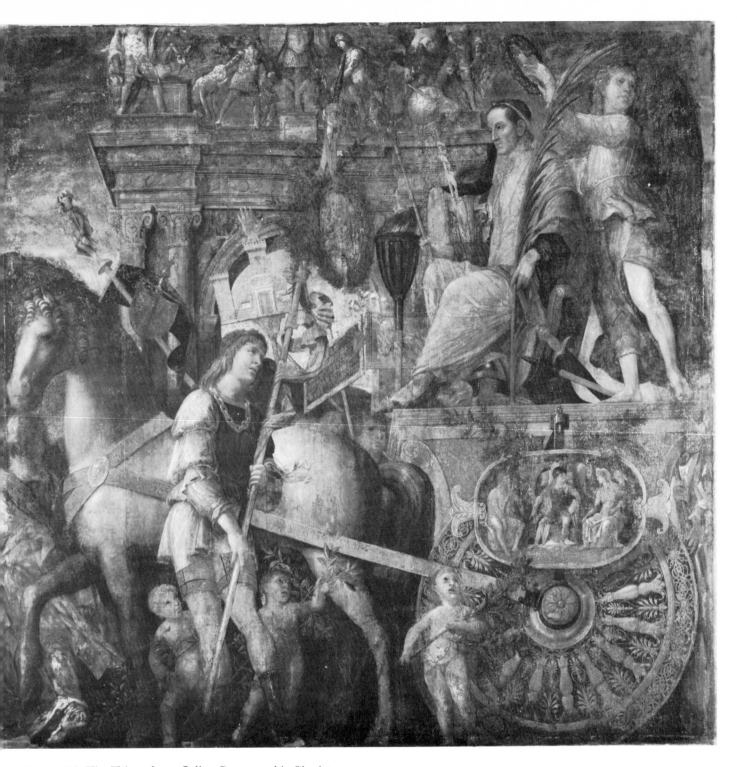

42. Canvas IX: The Triumphator Julius Caesar on his Chariot

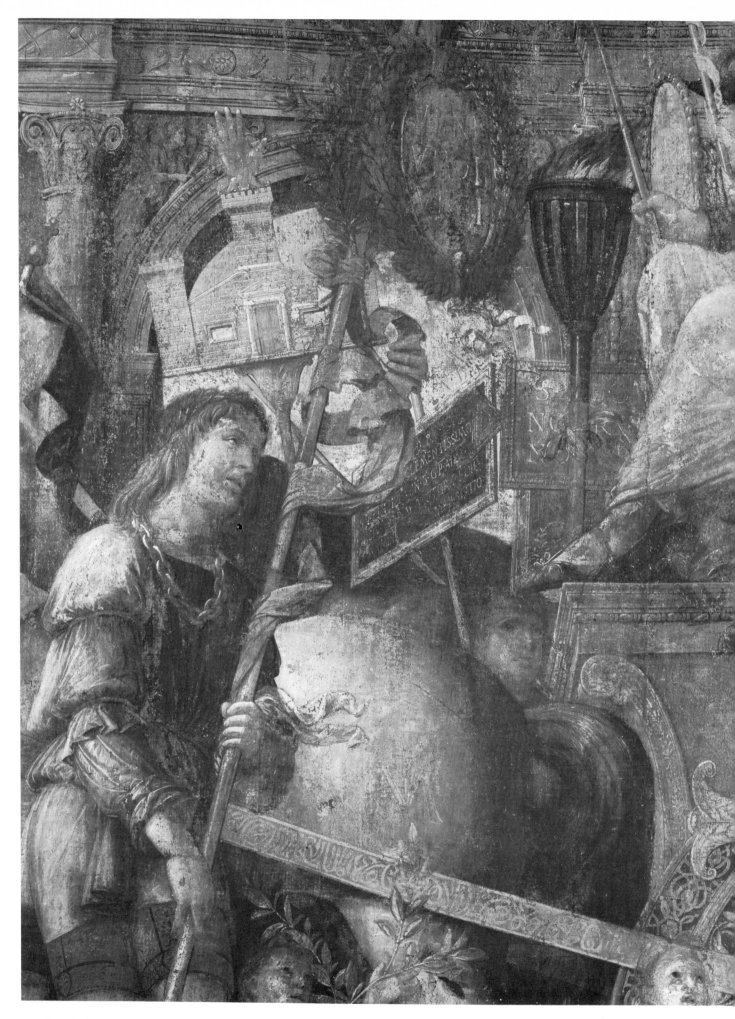

43. Detail of Canvas IX

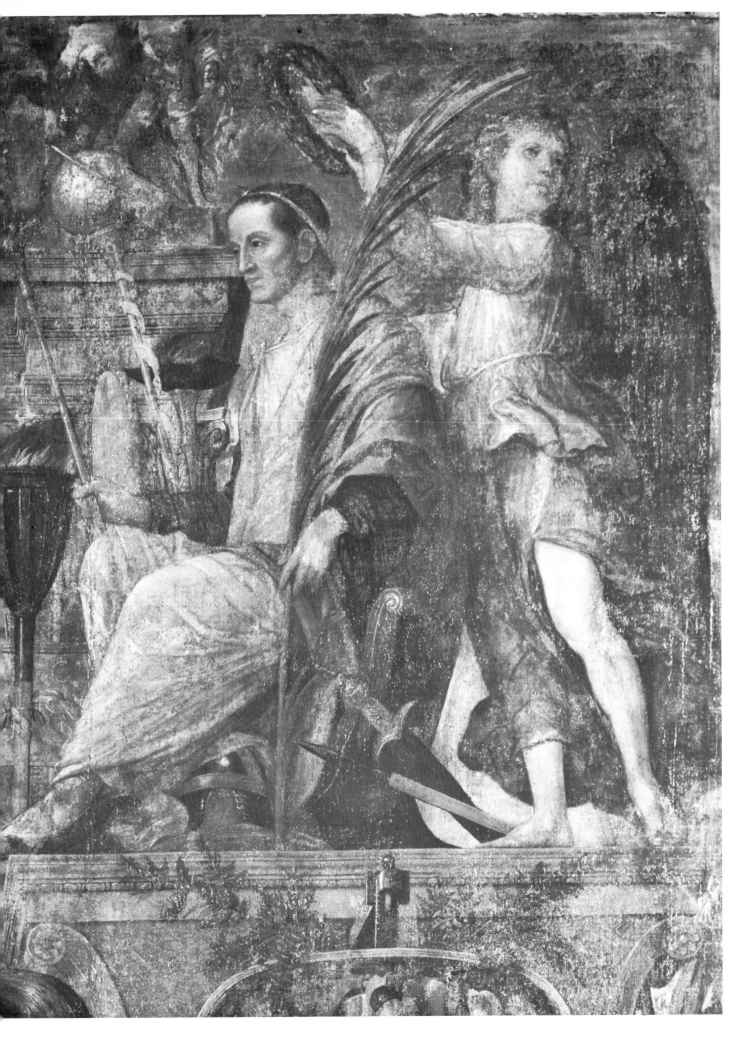

4. Detail of Canvas IX

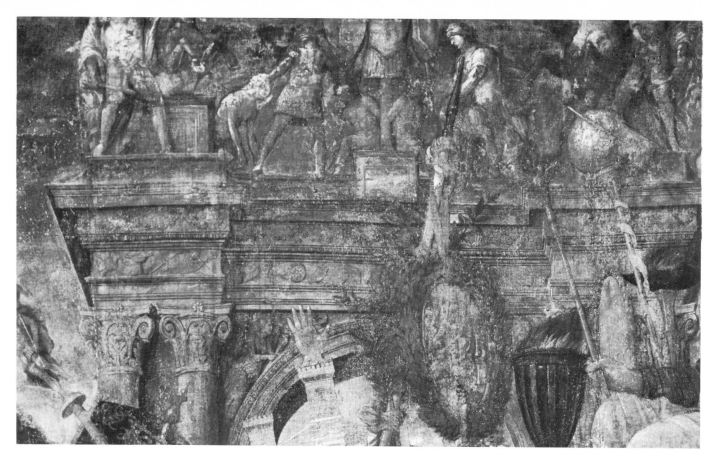

45. Detail of Canvas IX

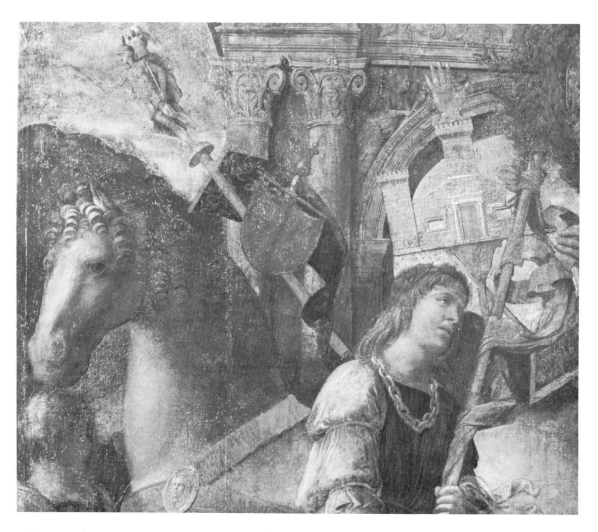

46. Detail of Canvas IX

7. Detail of Canvas IX

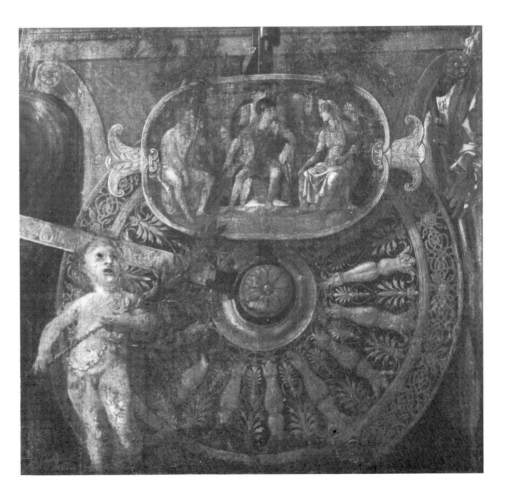

48. Detail of Canvas IX

49. Detail of Canvas IX

. Detail of Canvas IX

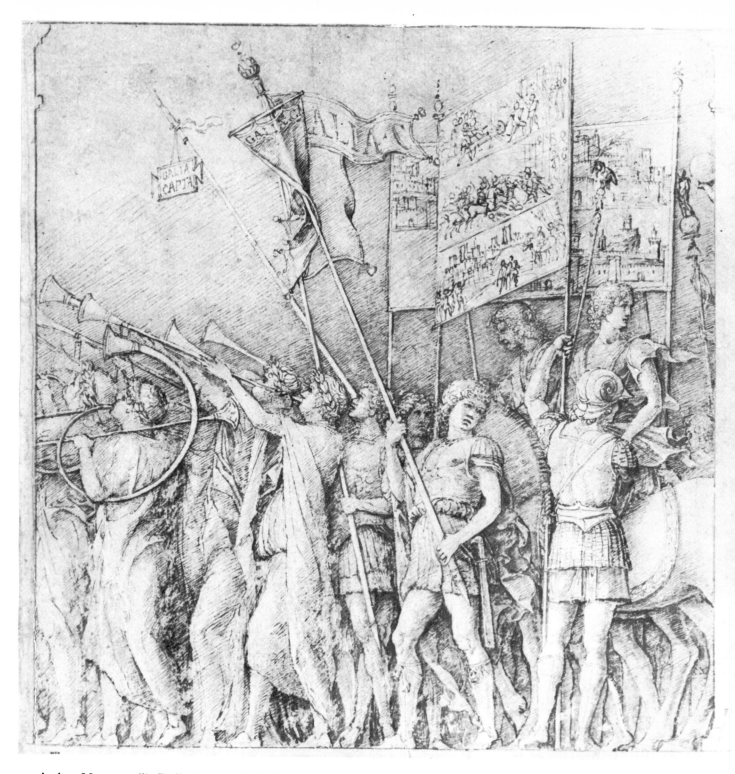

51. Andrea Mantegna (?): Preliminary study for Canvas I. Paris, Louvre

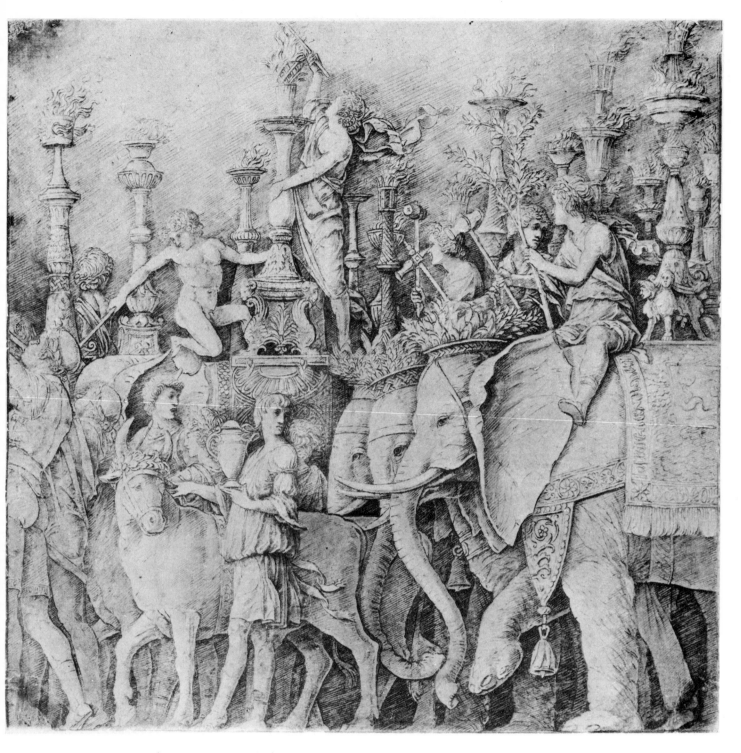

52. After Mantegna: Copy of a preliminary study for Canvas V. Paris, Private Collection

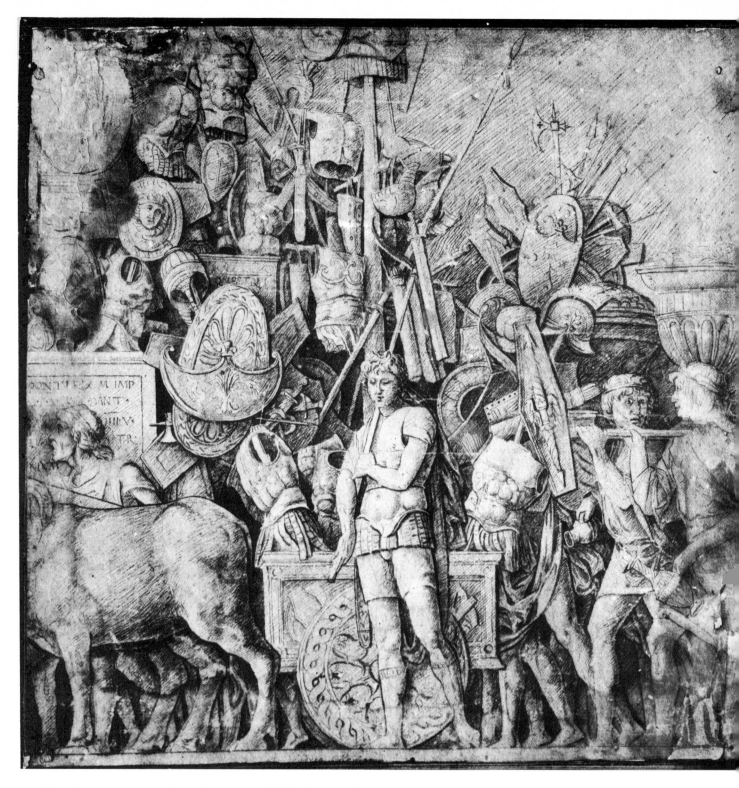

53. After Mantegna: Copy of a preliminary study for Canvas III. Vienna, Albertina

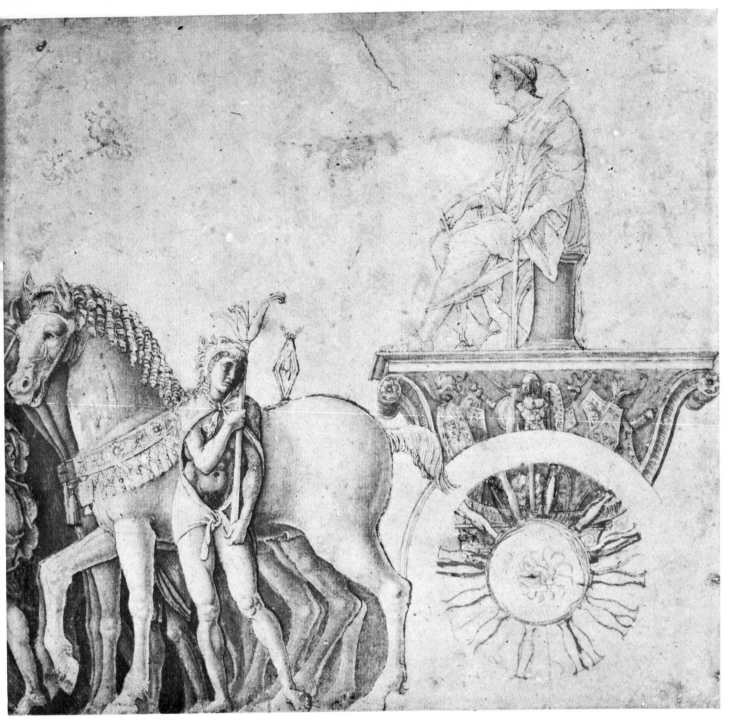

54. After Mantegna: Unfinished copy of a preliminary study for Canvas IX. London, British Museum

55. After Mantegna: Copy of a preliminary study for Canvas VII. Chantilly, Musée Condé

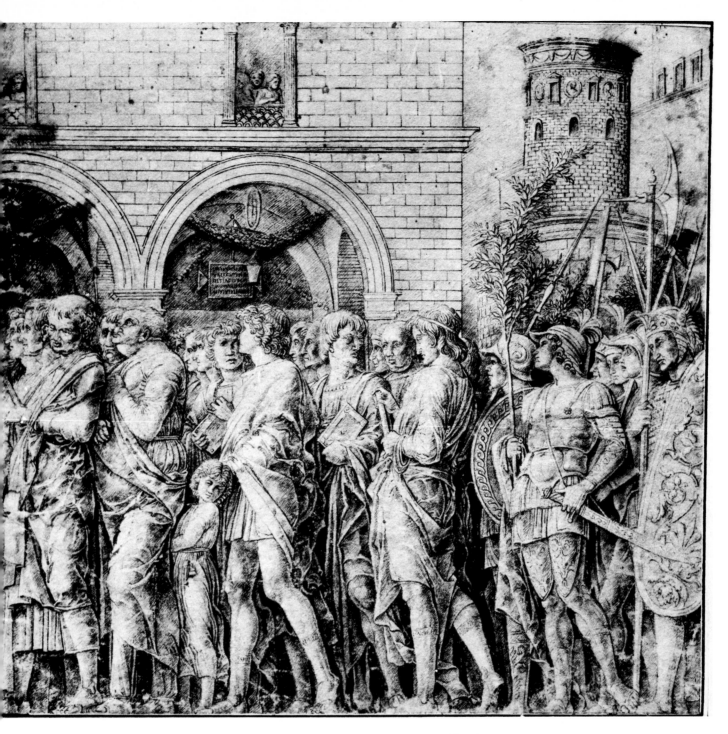

. After Mantegna: Copy of a study for a tenth composition, 'The Senators'. Vienna, Albertina

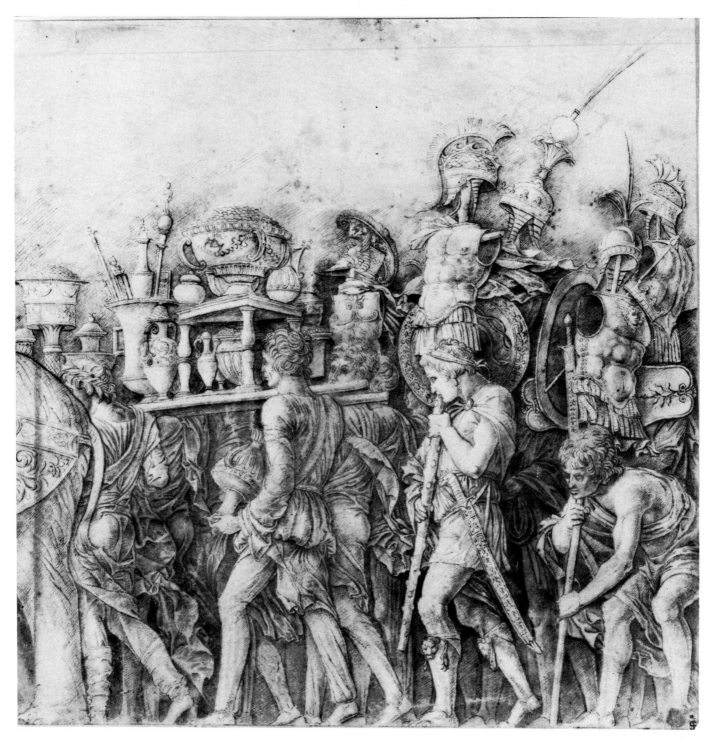

57. After Mantegna: Copy of a preliminary study for Canvas VI. Dublin, National Gallery of Ireland

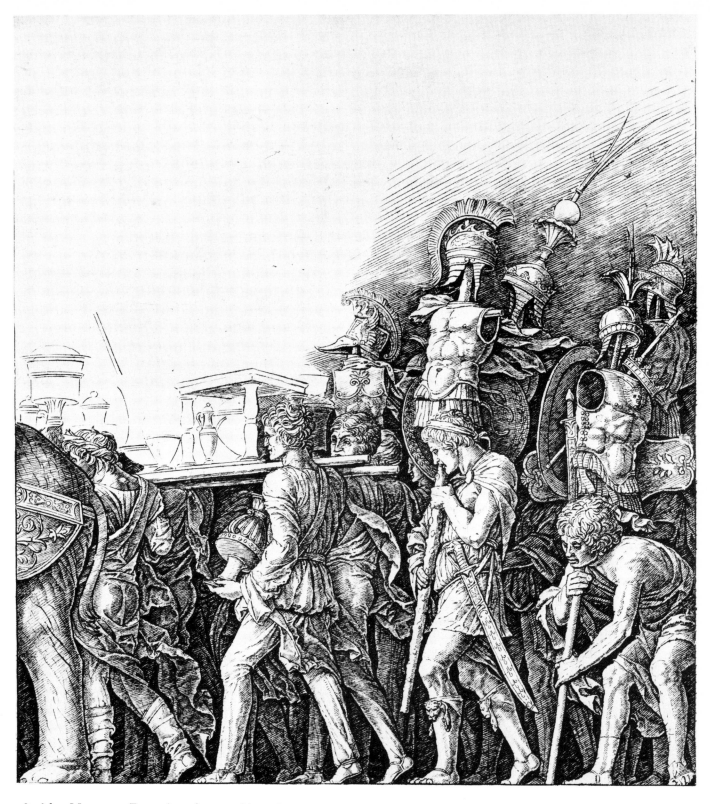

58. After Mantegna: Engraving of composition of no. 57

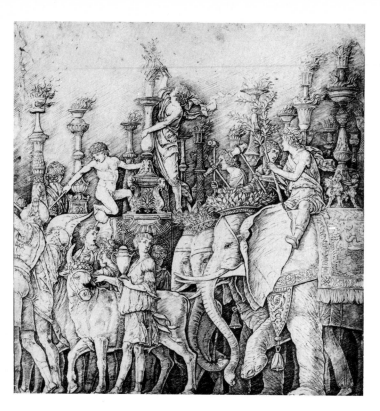

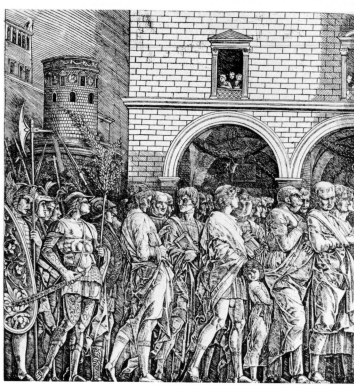

59. After Mantegna:
Engraving of composition of no. 52

60. After Mantegna:
Engraving of composition of no. 56, 'The Senators'

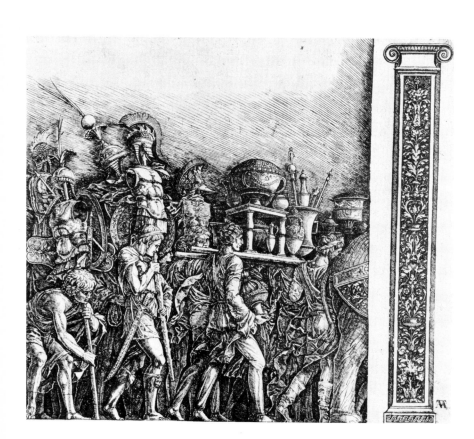

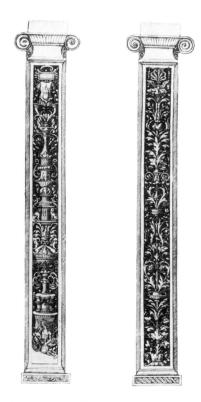

61. After Mantegna: Engraving of composition of no. 57 with an added pilaster

62. Zoan Andrea: Engraving of two pilasters

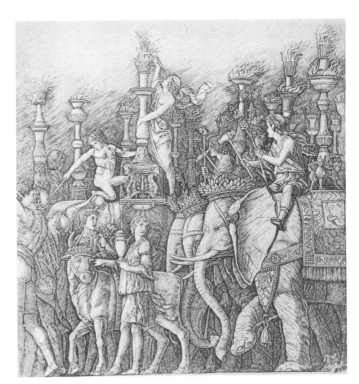

63. After Mantegna: Engraving of
composition of no. 52

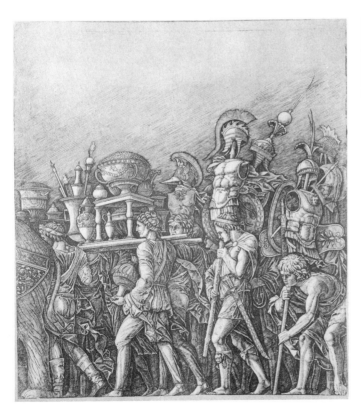

64. After Mantegna:
Engraving of composition of no. 57

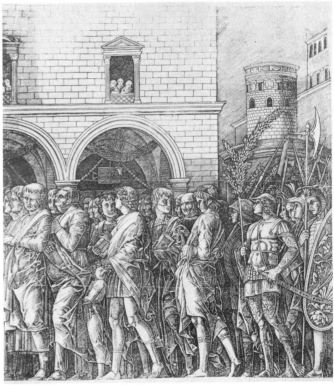

65. After Mantegna:
Engraving of composition of no. 56, 'The Senators'

66

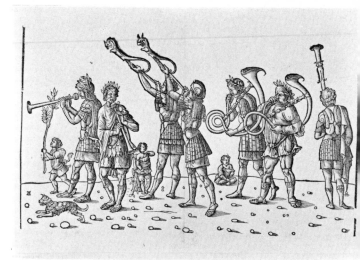

67

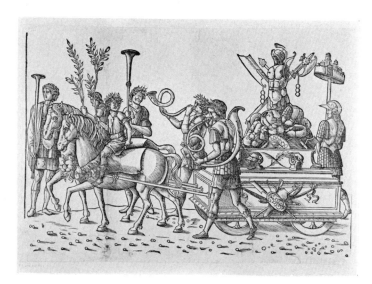

68

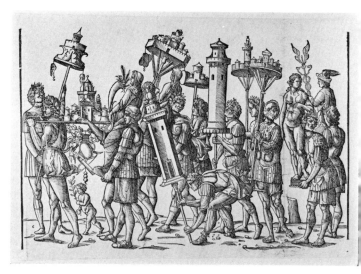

69

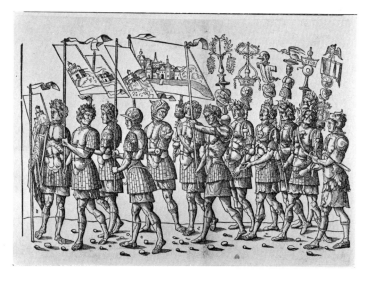

70

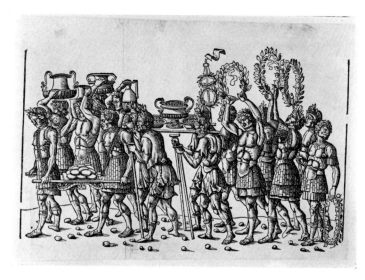

71

66–71. Jacopo da Strasbourg: The Triumph of Julius Caesar. Woodcuts, 1503

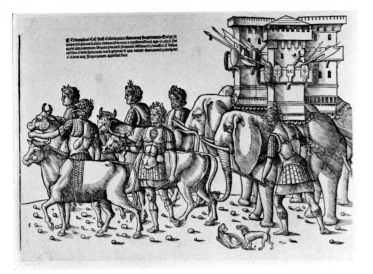

72

73

74

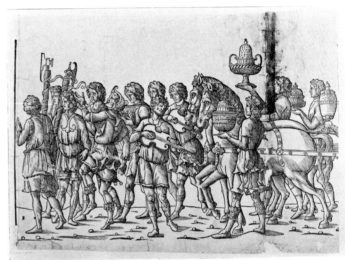

75

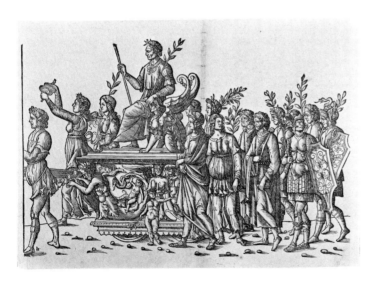

76

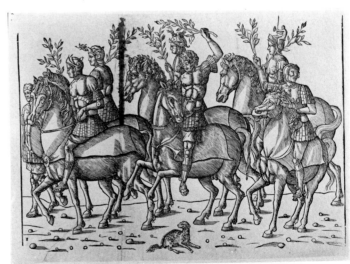

77

72–77. Jacopo da Strasbourg: The Triumph of Julius Caesar. Woodcuts, 1503

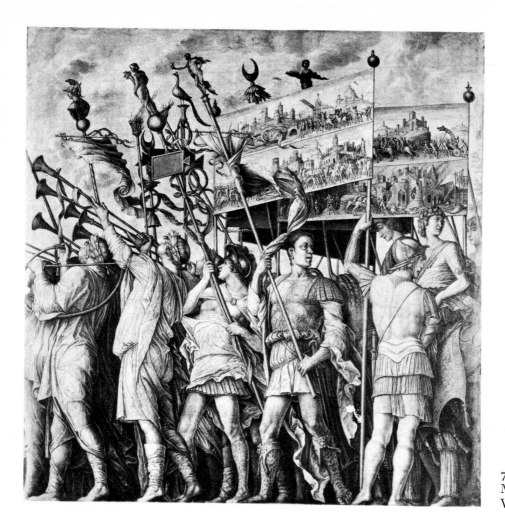

78. Anonymous sixteenth-century copy of
Mantegna's Triumphs of Caesar: Canvas I
Vienna, Kunsthistorisches Museum

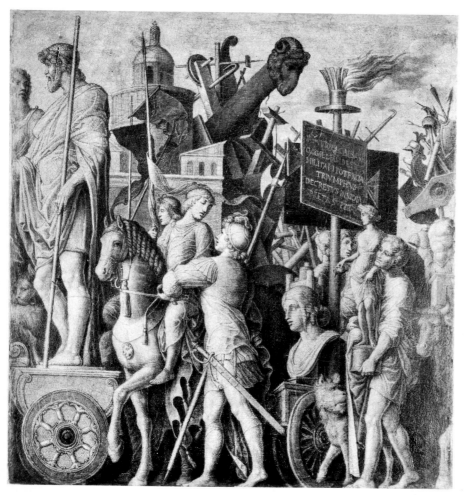

79. Anonymous sixteenth-century copy of
Mantegna's Triumphs of Caesar: Canvas II.
Vienna, Kunsthistorisches Museum

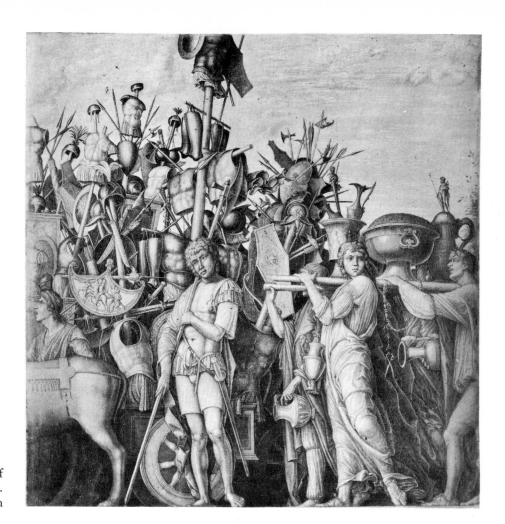

80. Anonymous sixteenth-century copy of
Mantegna's Triumphs of Caesar: Canvas III.
Vienna, Kunsthistorisches Museum

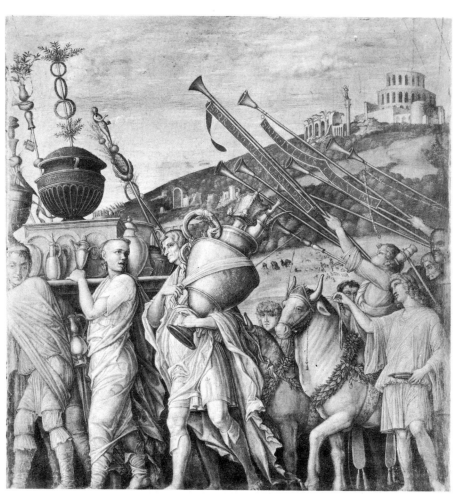

81. Anonymous sixteenth-century copy of
Mantegna's Triumphs of Caesar: Canvas IV.
Vienna, Kunsthistorisches Museum

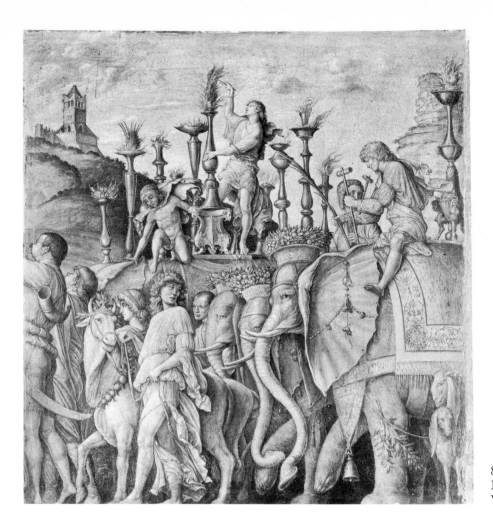

82. Anonymous sixteenth-century copy of
Mantegna's Triumphs of Caesar: Canvas V.
Vienna, Kunsthistorisches Museum

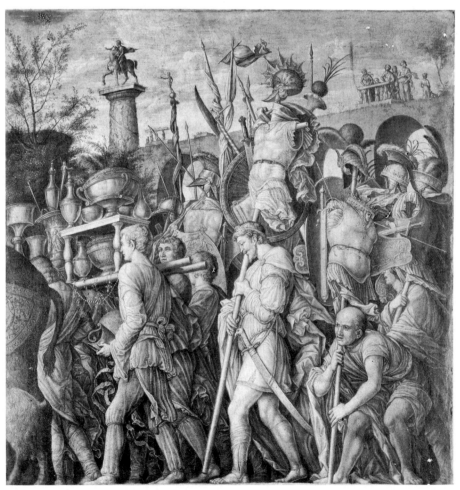

83. Anonymous sixteenth-century copy of
Mantegna's Triumphs of Caesar: Canvas VI.
Vienna, Kunsthistorisches Museum

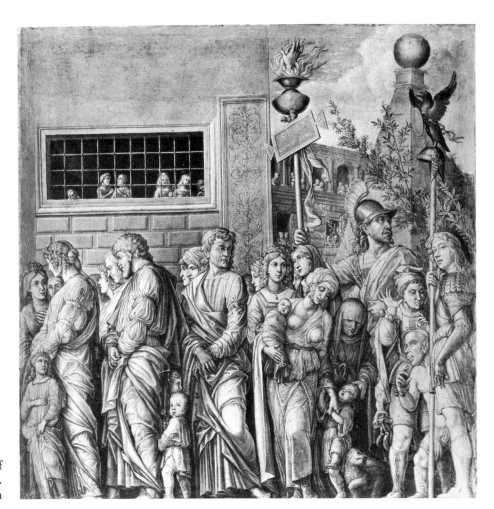

84. Anonymous sixteenth-century copy of
Mantegna's Triumphs of Caesar: Canvas VII.
Vienna, Kunsthistorisches Museum

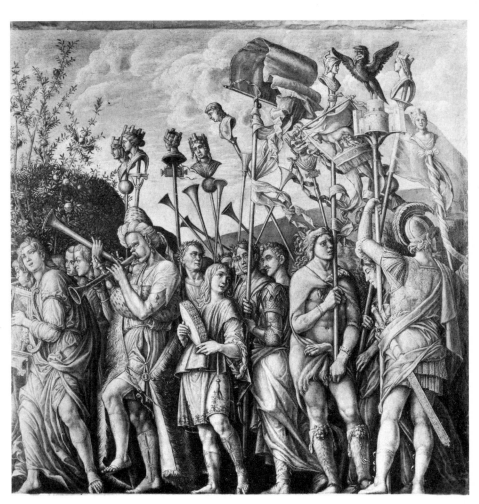

85. Anonymous sixteenth-century copy of
Mantegna's Triumphs of Caesar: Canvas VIII.
Vienna, Kunsthistorisches Museum

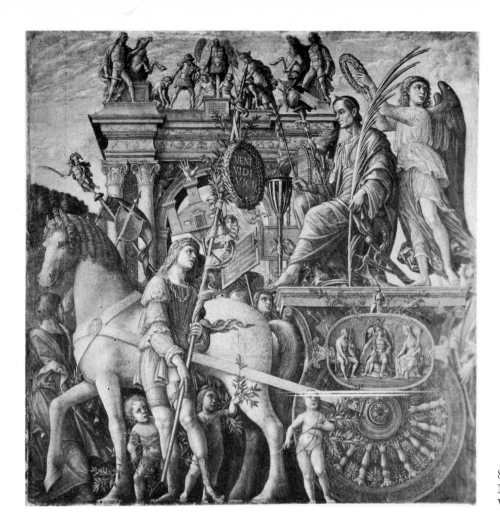

86. Anonymous sixteenth-century copy of
Mantegna's Triumphs of Caesar: Canvas IX.
Vienna, Kunsthistorisches Museum

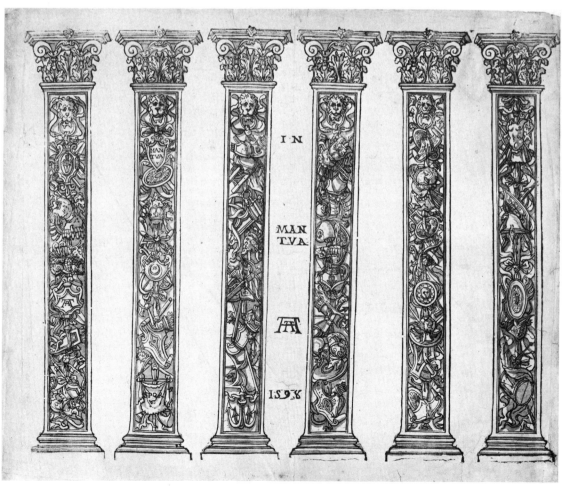

87. Andrea Andreani: Woodcut of Columns, 1598–9

88. Title-page

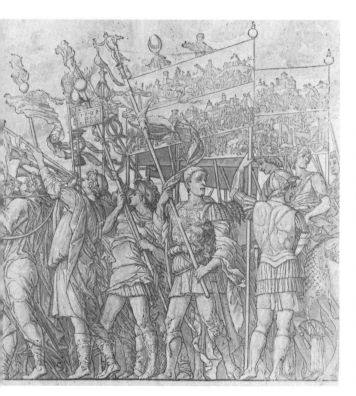

Canvas I

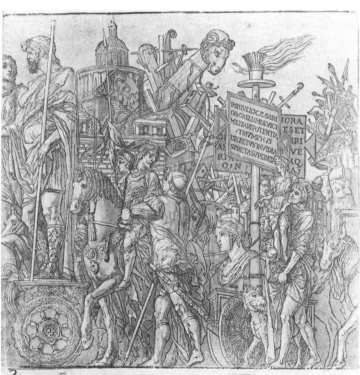

90. Canvas II

–90. Andrea Andreani: Woodcuts of Mantegna's Triumphs of Caesar, 1598–9

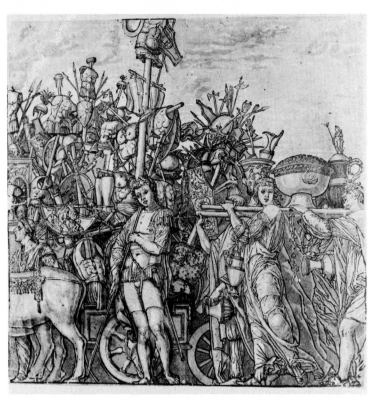

91. Canvas III

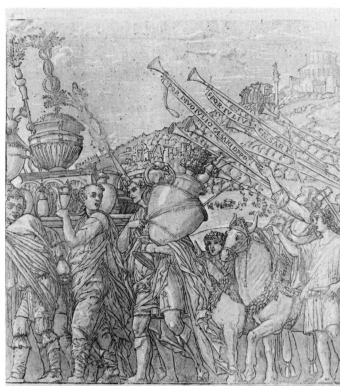

92. Canvas IV

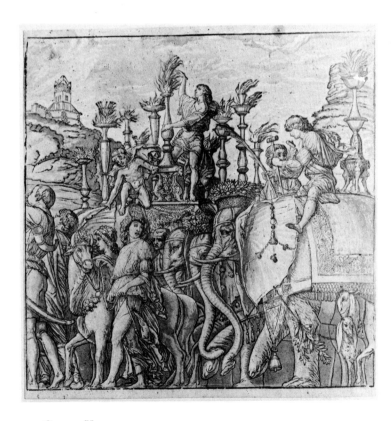

93. Canvas V

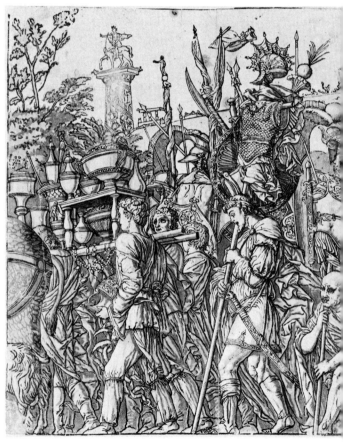

94. Canvas VI

91–94. Andrea Andreani: Woodcuts of Mantegna's Triumphs of Caesar, 1598–9

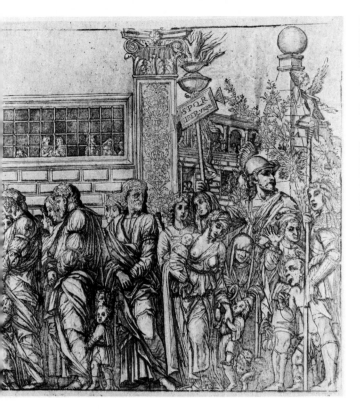

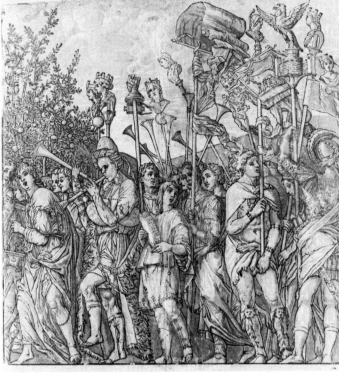

Canvas VII

96. Canvas VIII

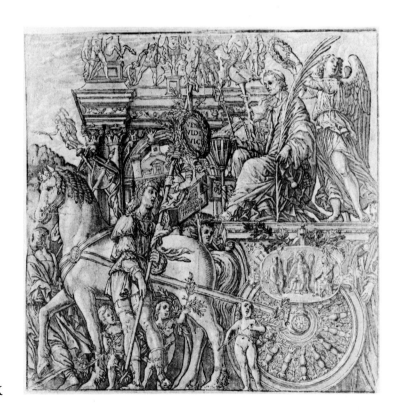

97. Canvas IX

–97. Andrea Andreani: Woodcuts of Mantegna's Triumphs of Caesar, 1598–9

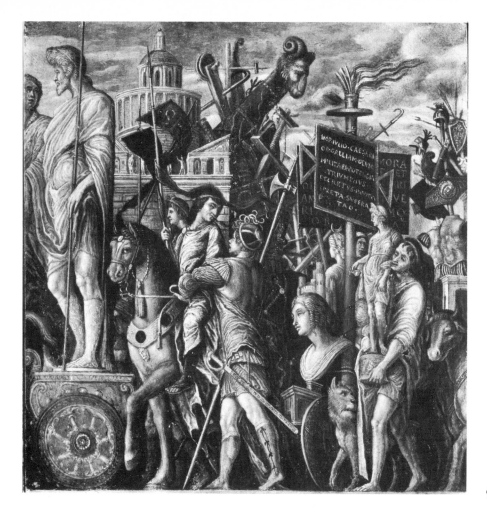

98. Canvas II

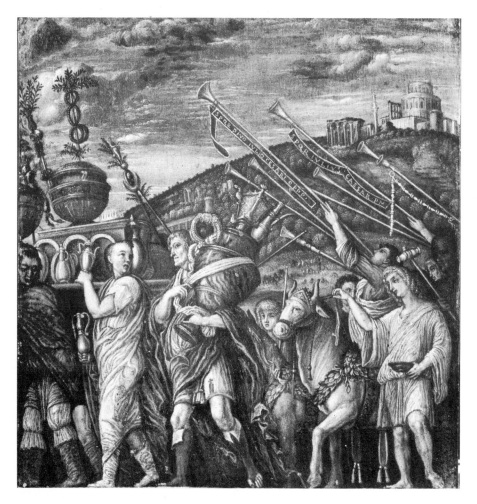

99. Canvas IV

98–102. Lodovico Dondo: Miniature copies of Mantegna's Triumphs of Caesar, 1602. Munich, Alte Pinakothek

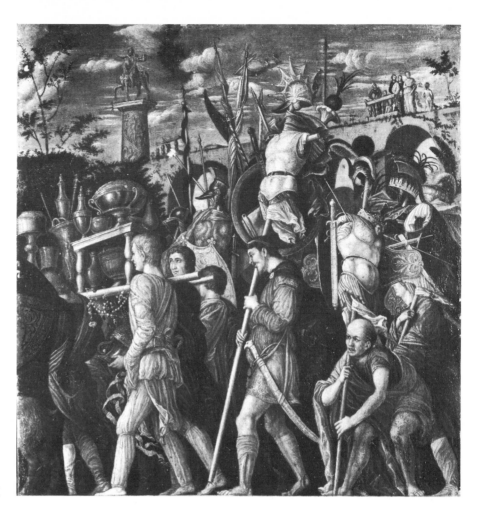

100. Canvas VI

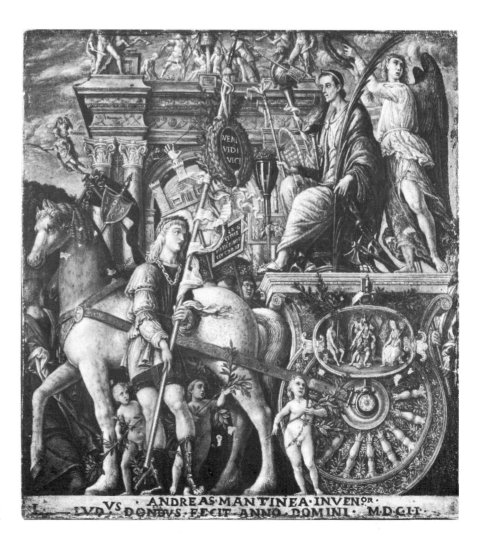

VS · ANDREAS·MANTINEA·INVEN^{OR}·
LVD^{VS}·DONBVS·FECIT·ANNO·DOMINI·M·D·CIT·

101. Canvas IX

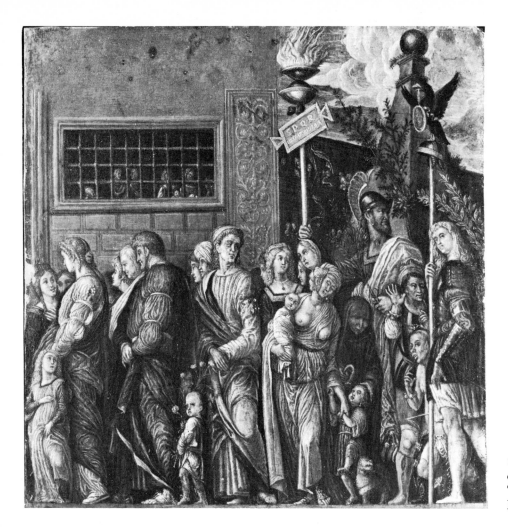

102. Lodovico Dondo: Miniature copy
of Canvas VII of Mantegna's
Triumphs of Caesar, 1602.
Munich, Alte Pinakothek

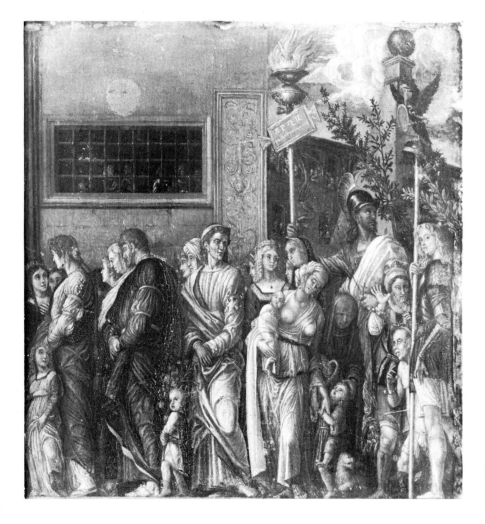

103. Lodovico Dondo: Miniature copy
of Canvas VII of Mantegna's
Triumphs of Caesar. Brescia,
Pinacoteca Tosio Martinengo

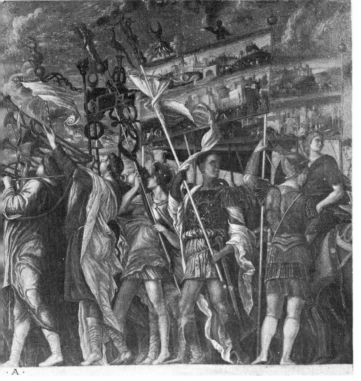

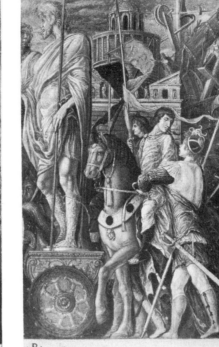

104. Canvas I

105. Canvas II

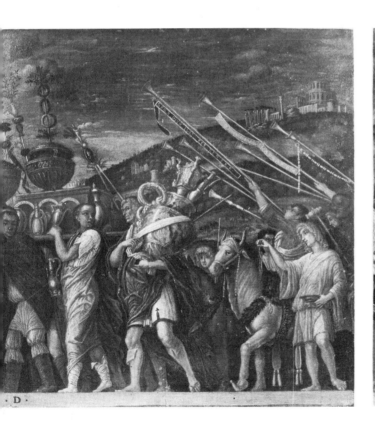

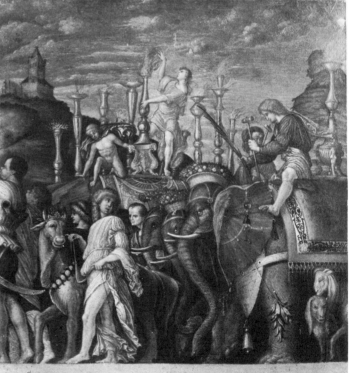

106. Canvas IV

107. Canvas V

104–107. Anonymous early seventeenth-century miniature copies of Mantegna's Triumphs of Caesar. Siena, Pinacoteca

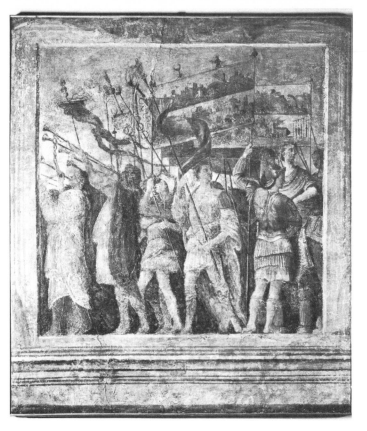

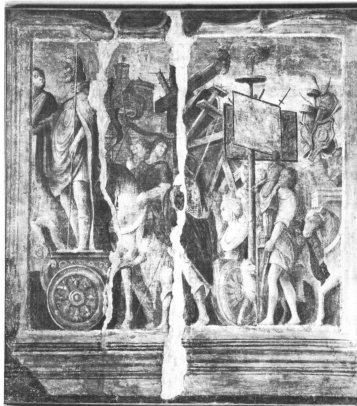

108. Canvas I

109. Canvas II

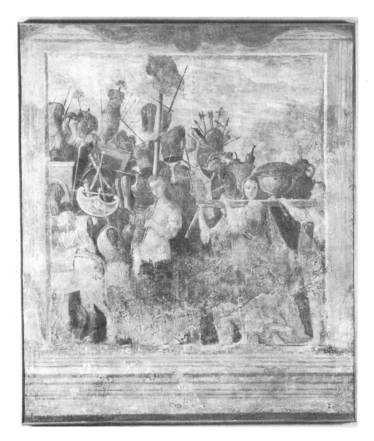

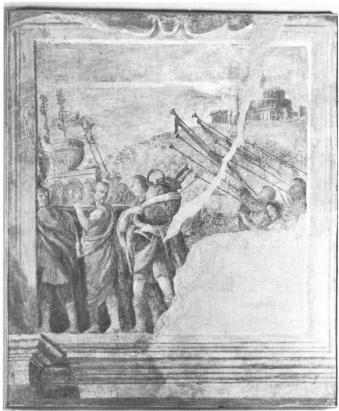

110. Canvas III

111. Canvas IV

108–111. Anonymous early seventeenth-century copies of Mantegna's Triumphs of Caesar.
Mantua, Castello di S. Giorgio

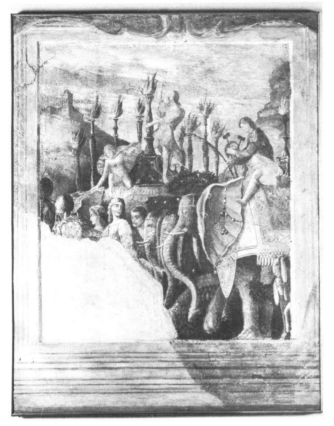

112. Canvas V

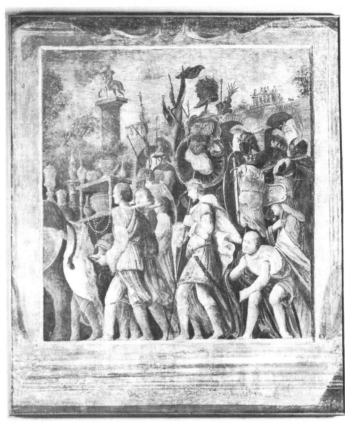

113. Canvas VI

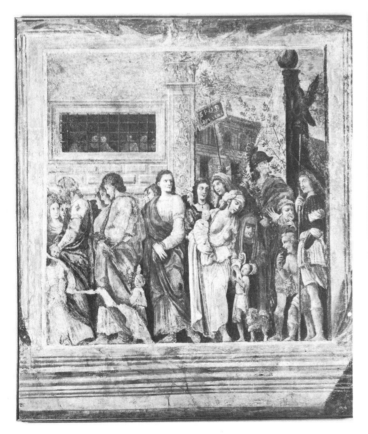

114. Canvas VII

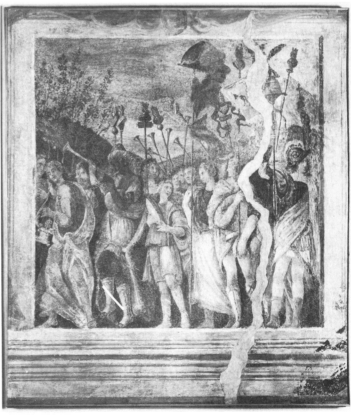

115. Canvas VIII

112–115. Anonymous early seventeenth-century copies of Mantegna's Triumphs of Caesar.
Mantua, Castello di S. Giorgio

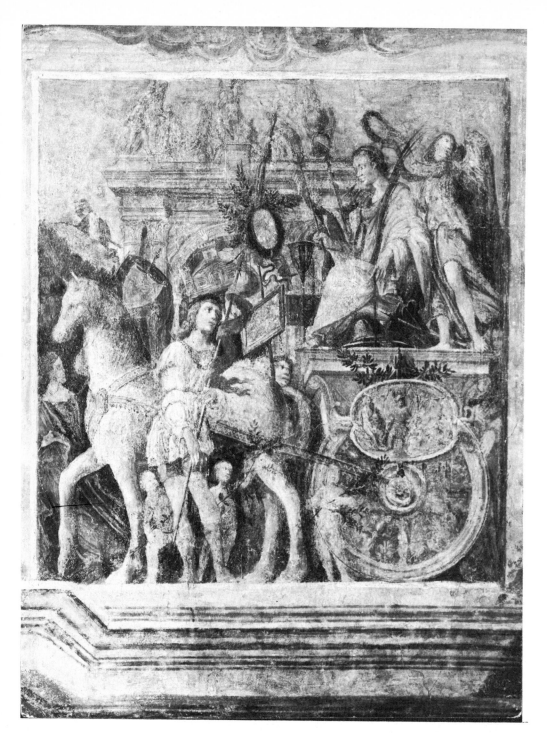

116. Anonymous early seventeenth-century copy of Mantegna's Triumphs of Caesar.
Canvas IX. Mantua, wall-painting now in Castello di S. Giorgio

119. Lorenzo Costa: *The Triumph of Federico Gonzaga.*
Prague, National Gallery

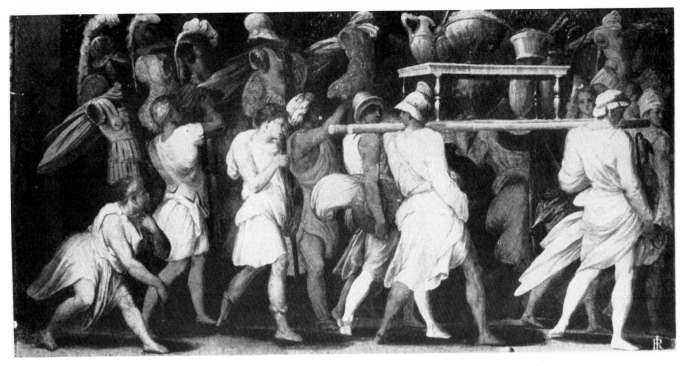

117. Perino del Vaga: *Triumphal Procession*. Detail of ceiling decoration, Sala dei Trionfi. Genoa, Palazzo Doria

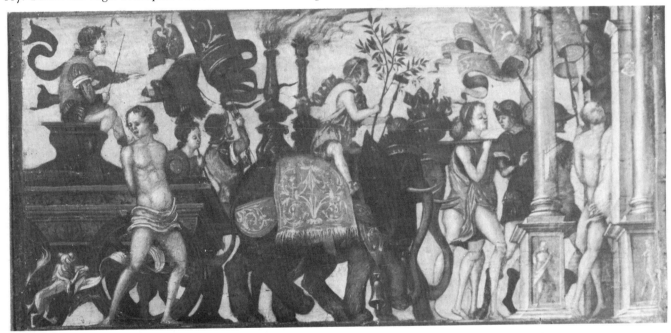

118. Giolfino (attributed): *Triumph of Pompey*. Verona, Museo Civico

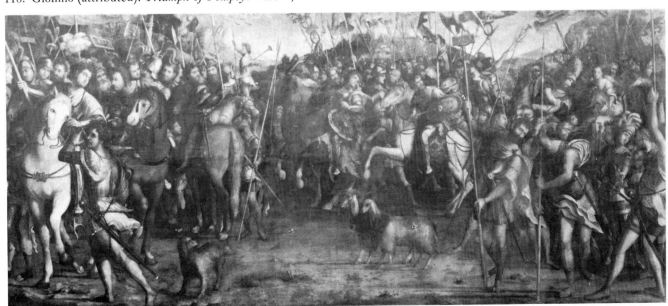

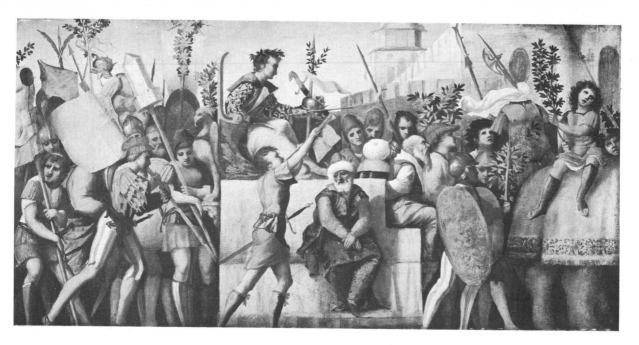

120. Palma Vecchio: *The Triumph of Caesar*. Coral Gables, Miami, Fla., Lowe Art Museum, Samuel H. Kress Collection

121. Jacopo Bellini:
Funeral of the Virgin.
Drawing from sketchbook,
p. 6. Paris, Louvre

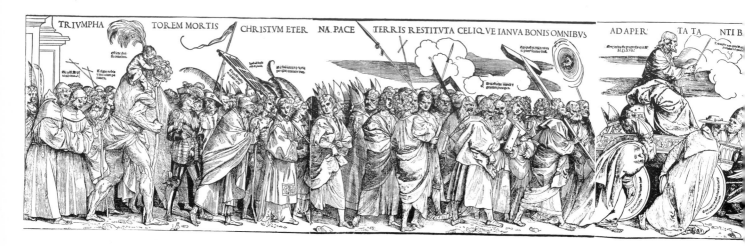

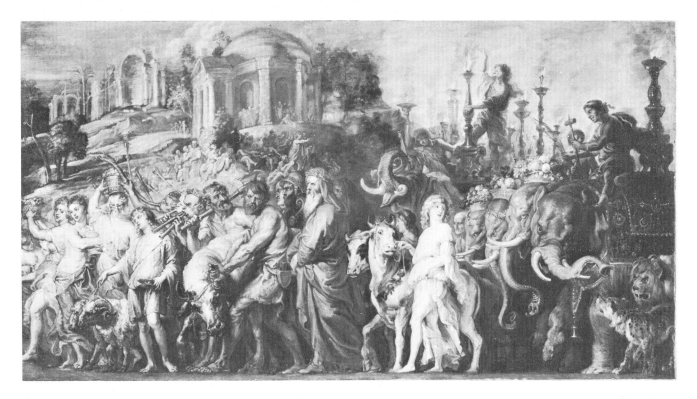

123. Rubens: *Scenes from a Roman Triumph* inspired by
Mantegna's Triumphs of Caesar. London, National Gallery

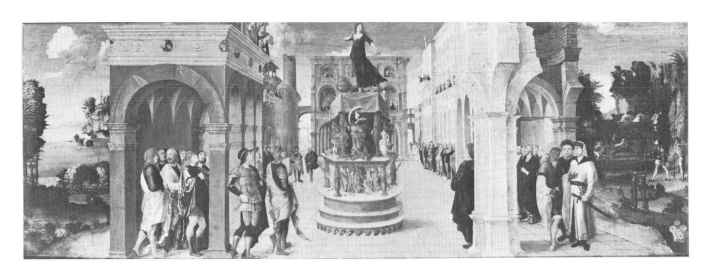

124. Liberale da Verona: *Dido's Suicide*. London, National Gallery

122. Titian: *Triumph of Faith*. Woodcut

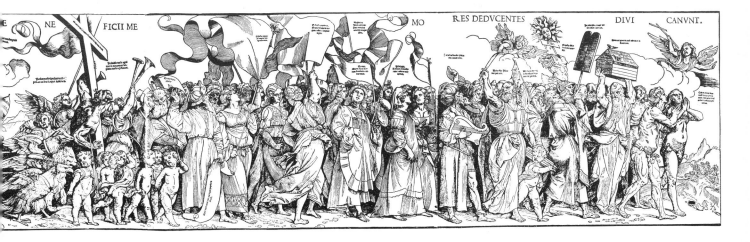

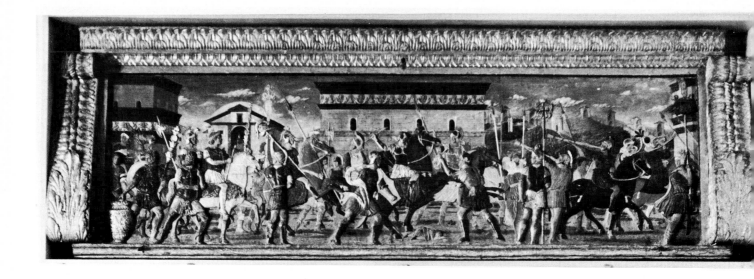

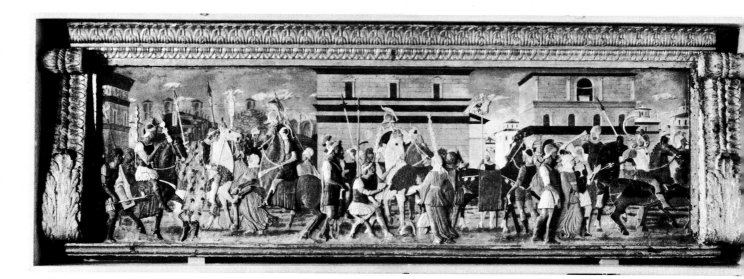

125–126. *The Justice of Trajan I and II*: Panels from two Cassoni. Klagenfurt, Landesmuseum

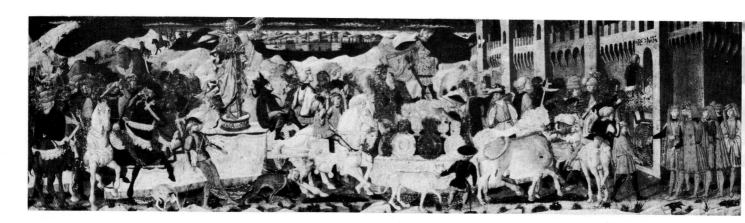

127. Anonymous mid fifteenth-century Florentine cassone panel:
The Triumph of Julius Caesar. New York, Historical Society

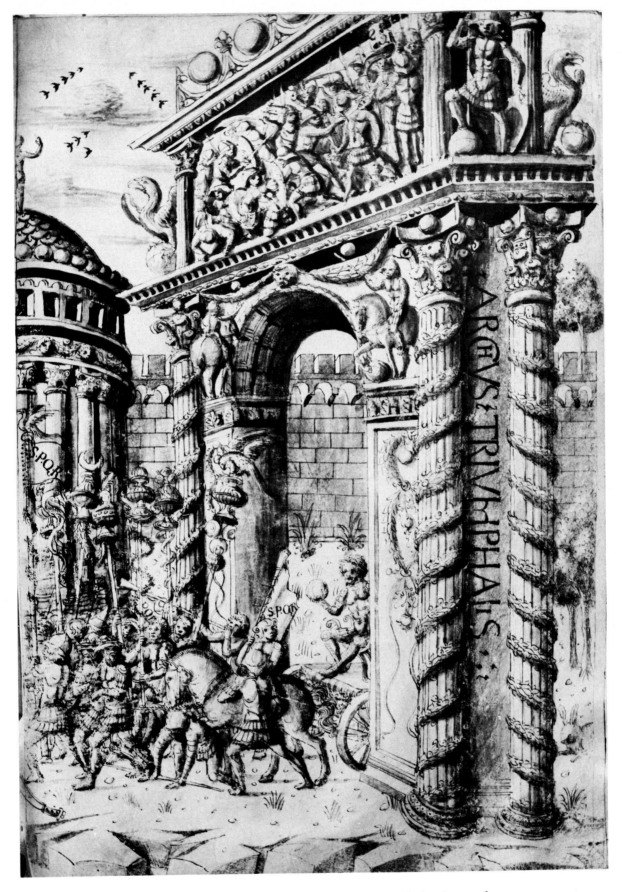

128. Felice Feliciano: *A Roman Triumph* (1465). Modena, Bibl. Estense. Cod. α L.5.15, f. 35

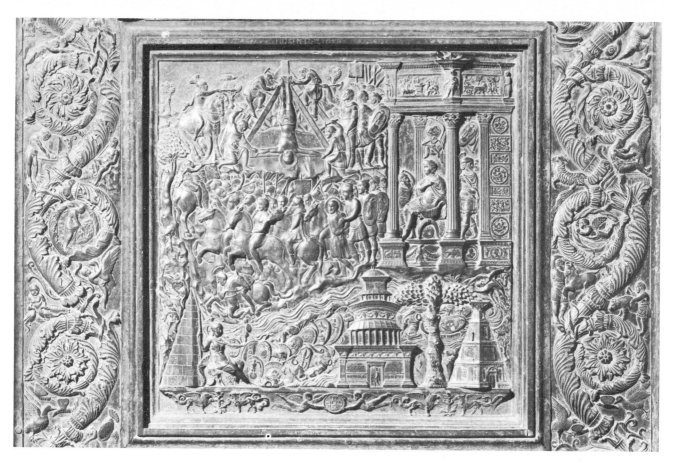

129. Filarete: *The Judgement and Martyrdom of St. Peter*. Bronze doors (1443). Rome, St. Peter's

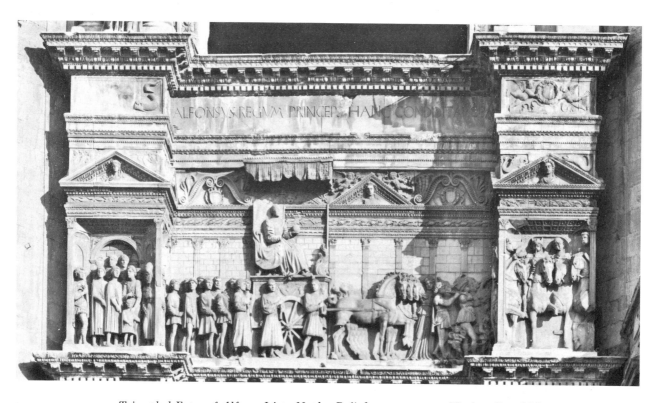

130. *Triumphal Entry of Alfonso I into Naples*. Relief over entrance. Naples, Castel Nuovo

ILLUSTRATIONS ∾ PART TWO

OTHER WORKS BY MANTEGNA
COMPARATIVE AND SOURCE MATERIAL
RELATING TO THE 'TRIUMPHS'

131. Anonymous Florentine, *c.* 1460:
Julius Caesar. Drawing from sketchbook, f. 55.
London, British Museum

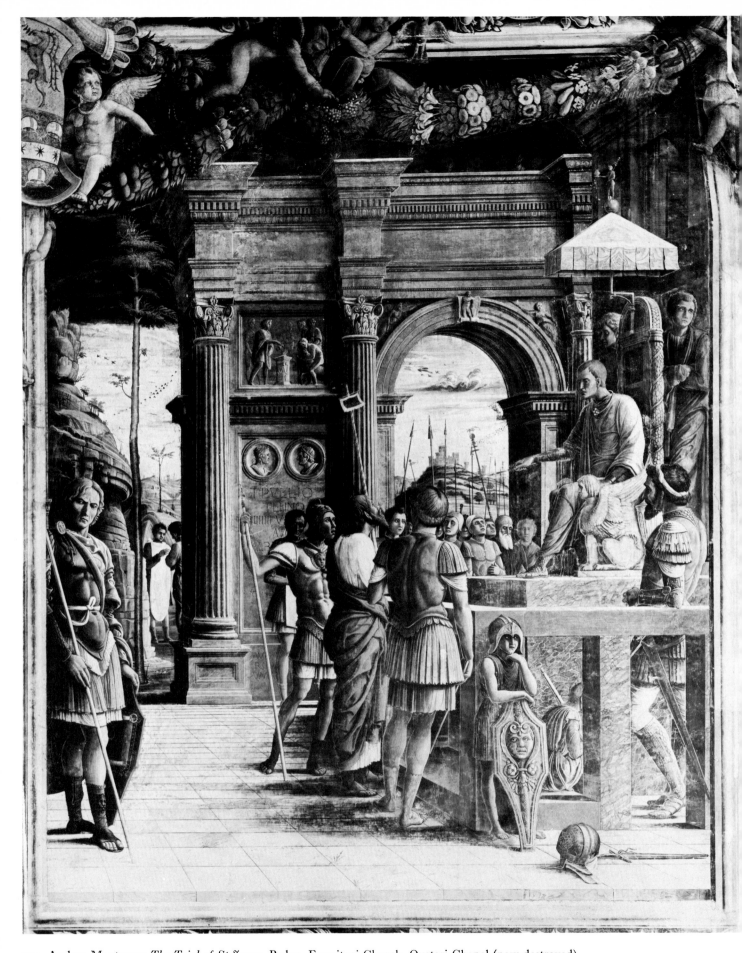

132. Andrea Mantegna: *The Trial of St James*. Padua, Eremitani Church, Ovetari Chapel (now destroyed)

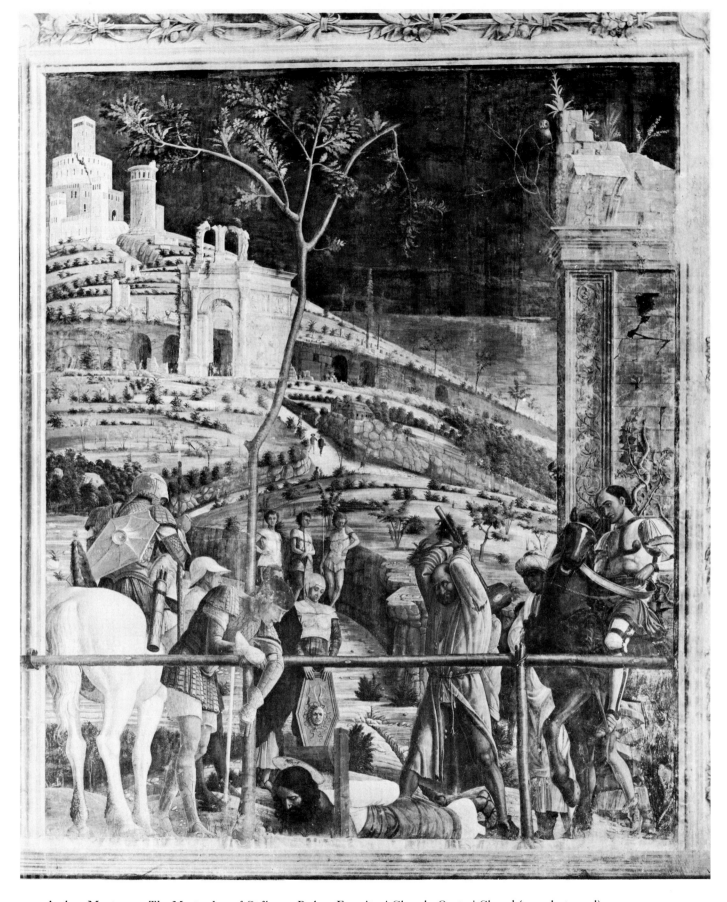

133. Andrea Mantegna: *The Martyrdom of St James*, Padua, Eremitani Church, Ovetari Chapel (now destroyed)

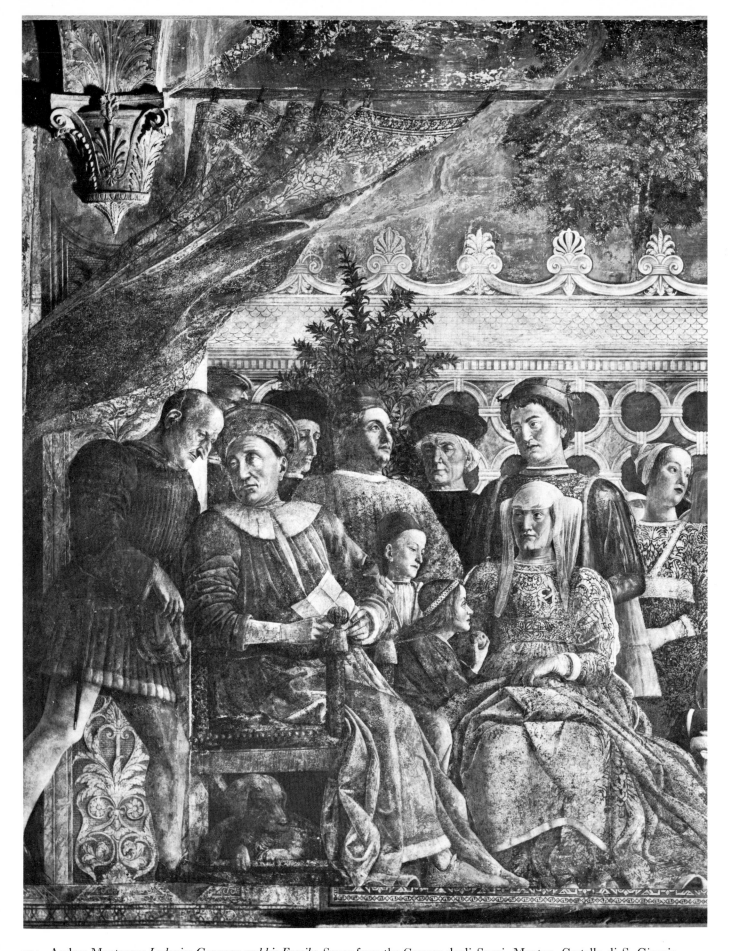

134. Andrea Mantegna: *Lodovico Gonzaga and his Family*. Scene from the Camera degli Sposi. Mantua, Castello di S. Giorgio

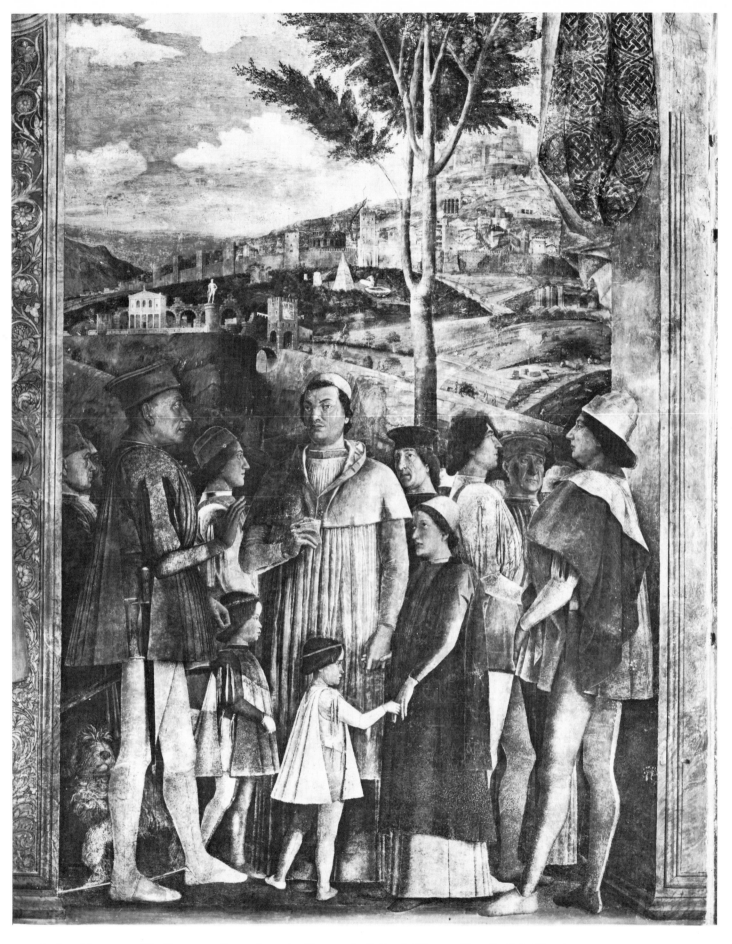

135. Andrea Mantegna: *The Encounter*. Scene from the Camera degli Sposi. Mantua, Castello di S. Giorgio

136. Andrea Mantegna: *Hercules with Bow and Arrow*.
From the ceiling of the Camera degli Sposi.
Mantua, Castello di S. Giorgio

137. Andrea Mantegna: *Hercules and Antaeus*.
From the ceiling of the Camera degli Sposi.
Mantua, Castello di S. Giorgio

138. Andrea Mantegna: *Deianira and Nessus*. From the ceiling of the Camera degli Sposi. Mantua, Castello di S. Giorgio

139. Andrea Mantegna (?): Drawing of part of the Great Trajanic Frieze (see no. 189). Vienna, Albertina

140. Andrea Mantegna (?): Drawing after the Antique. Verso of no. 139. Vienna, Albertina

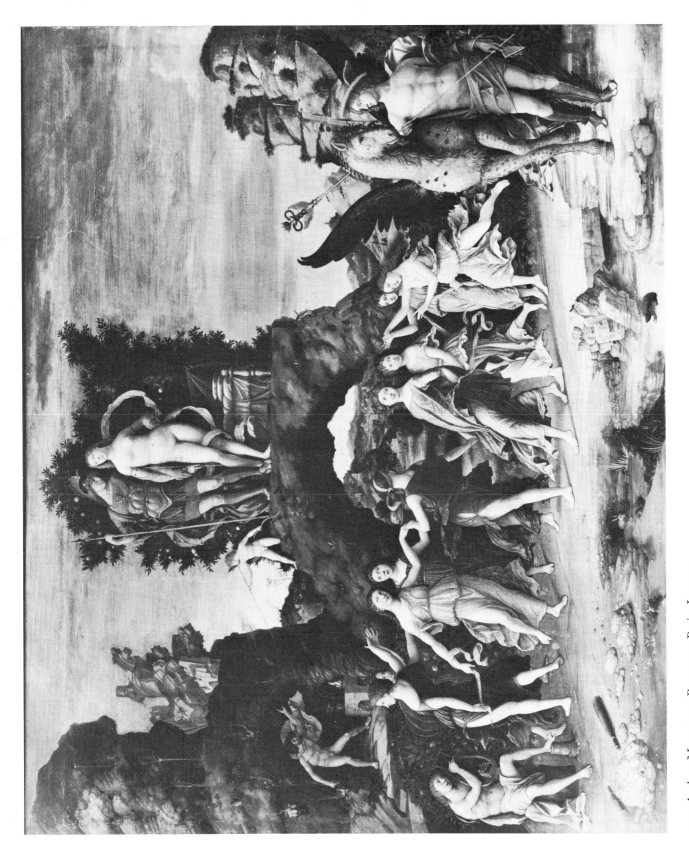

141. Andrea Mantegna: *Parnassus*. Paris, Louvre

142. Andrea Mantegna: *The Death of the Virgin*. Madrid, Prado

143. Andrea Mantegna: *The Agony in the Garden*. London, National Gallery

144. Andrea Mantegna: *The Crucifixion*. Predella panel from the S. Zeno Altar. Paris, Louvre

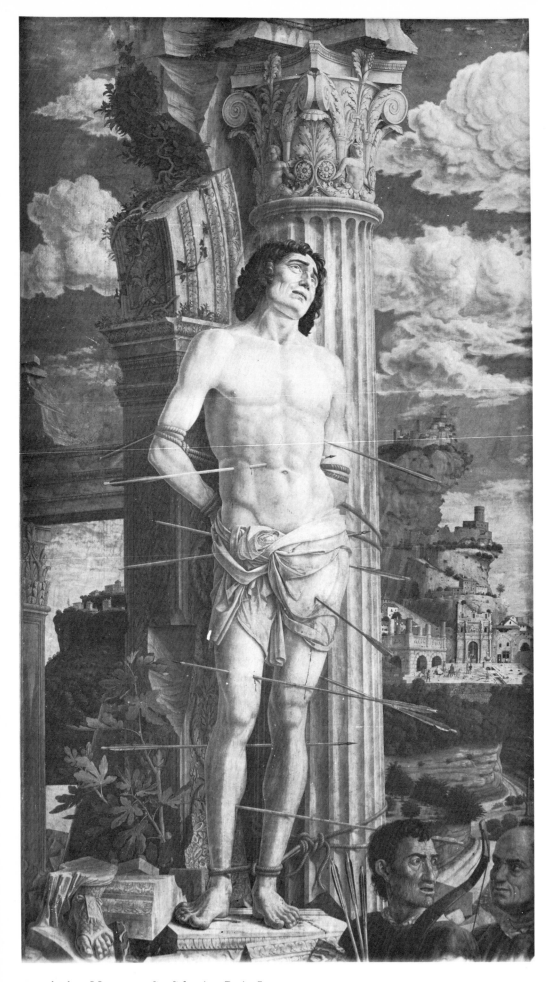

145. Andrea Mantegna: *St. Sebastian*. Paris, Louvre

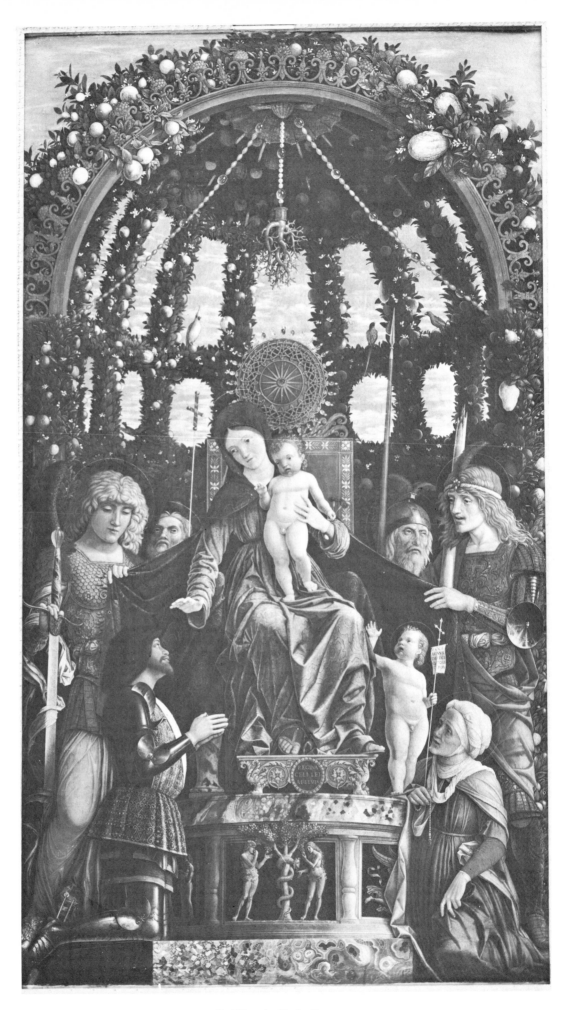

146. Andrea Mantegna: *Madonna della Vittoria*. Paris, Louvre

147–148. 'Mantegna Sketchbook'. Vases, ff. 35, 46. Berlin, Kunstbibliothek der Staatlichen Museen

149–150. 'Mantegna Sketchbook'. Candelabra, ff. 56, 71. Berlin, Kunstbibliothek der Staatlichen Museen

151-152. 'Mantegna Sketchbook'. S. Sabina Weapon Reliefs and Shields, f. 78; Capitoline Satyrs, f. 85. Berlin, Kunstbibliothek der Staatlichen Museen

153-154. Workshop of Ghirlandaio: S. Sabina Weapon Reliefs and Capitals, f. 12; Tomb of Caecilia Metella, f. 33. Madrid, Codex Escurialensis

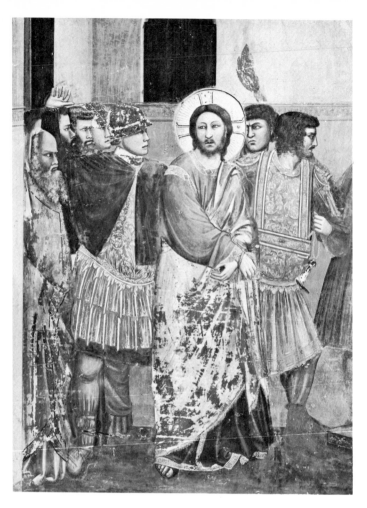

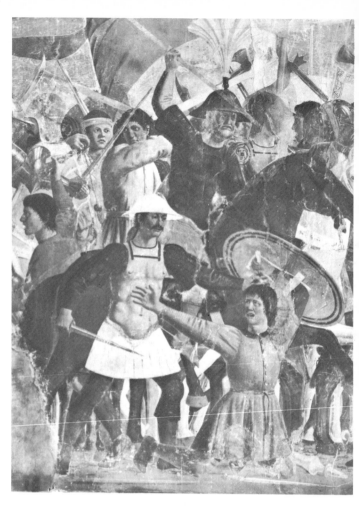

155. Giotto: Roman Soldiers (detail
from *Christ before Caiaphas*). Padua, Scrovegni Chapel

156. Piero della Francesca: Roman Soldiers (detail from
Victory of Heraclius over Chosroes). Arezzo, S. Francesco

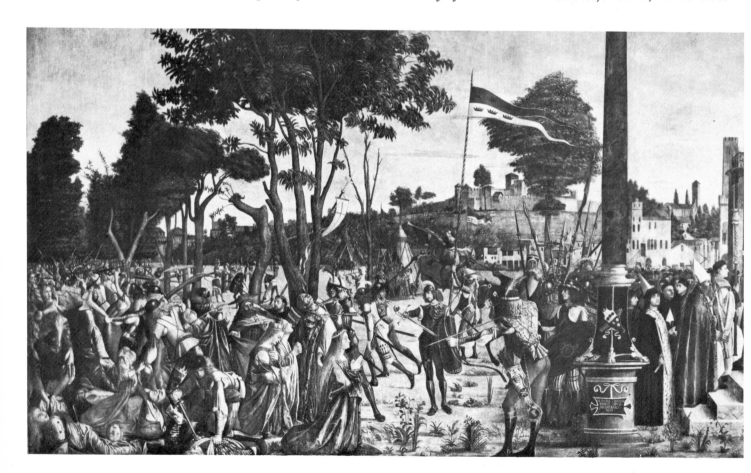

157. Carpaccio: *Martyrdom of St Ursula*. Venice, Accademia

158. Salade. Italo-French, c. 1470.
Vienna, Kunsthistorisches Museum

159. War Hammer. South German, late fifteenth-century. Vienna, Kunsthistorisches Museum

160. Andrea Verrocchio: Head of Bartolomeo Colleoni.
Venice, Colleoni Monument

161. Curved Sword. South German, late fifteenth-century. Vienna, Kunsthistorisches Museum

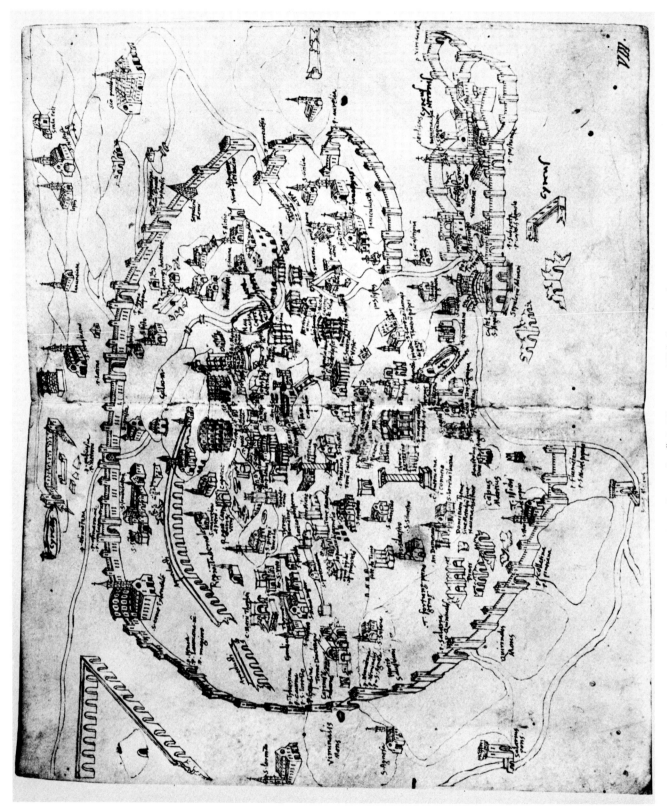

162. Alessandro Strozzi: Plan of Rome, 1474. Cod. Redi 77, ff. 7ᵛ–8. Florence, Bibl. Laurenziana

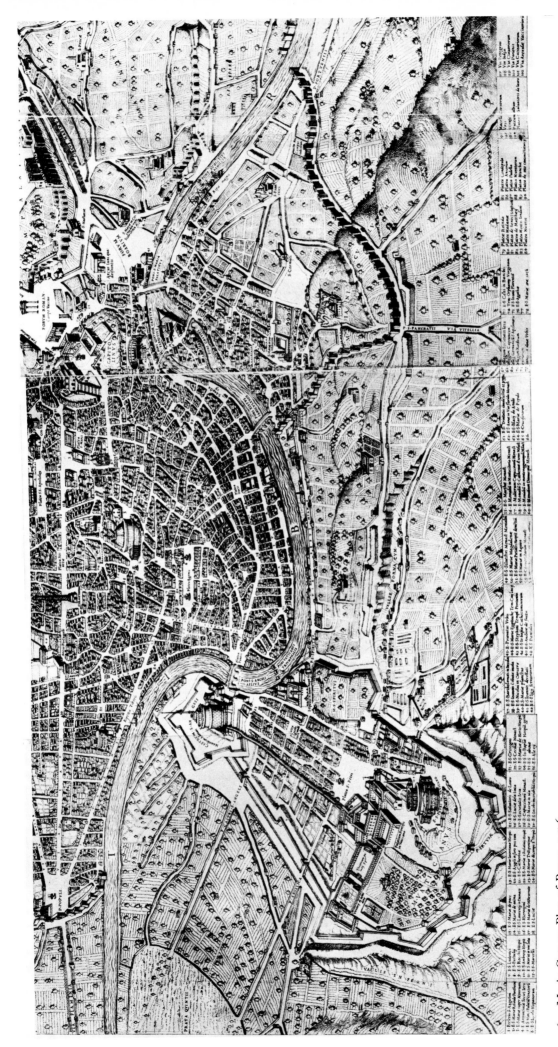

163. Mario Cataro: Plan of Rome, 1576

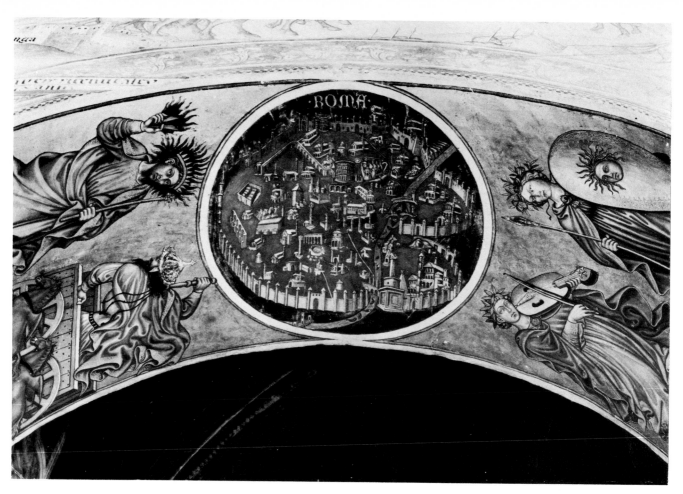

164. Taddeo di Bartolo: Plan of Rome. Siena, Palazzo Pubblico

165. Façade of Trajan's Market, Rome

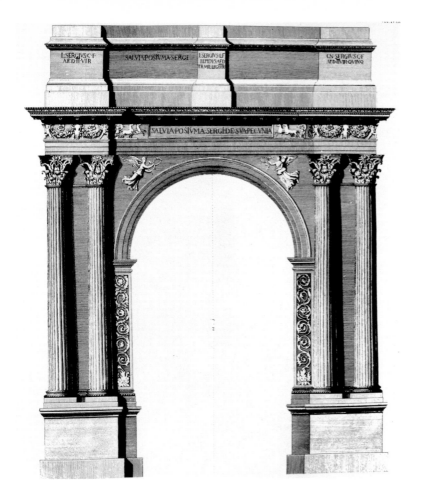

166. Arch of the Sergii, Pola (after Stuart and Revett)

167. Panel decorated with foliage and flowers.
Relief from the Ara Pacis Augustae, Rome

168. Capital.
Verona, Porta dei Leoni

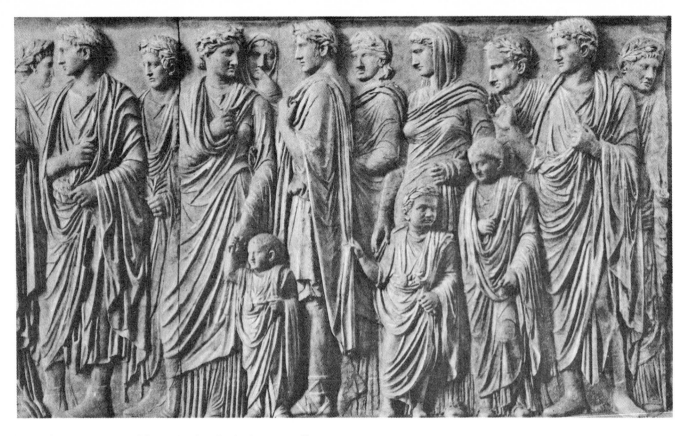

169. Processional relief from the Ara Pacis Augustae, Rome

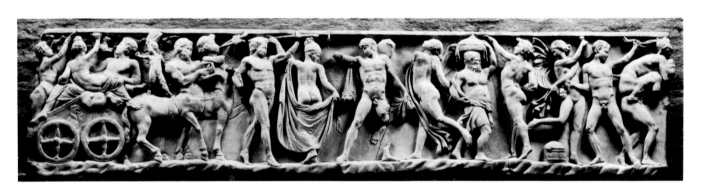

170. Dionysiac Scene. Sarcophagus relief. Munich, Glyptothek

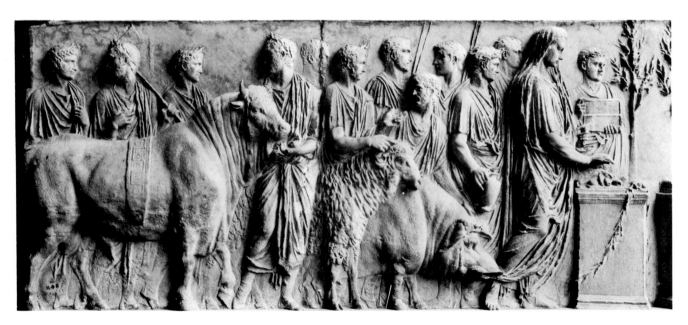

171. Sacrifice of the Suovetaurilia. Relief. Paris, Louvre

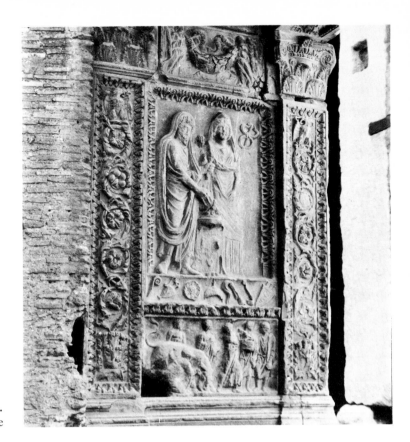

172. Scene of Sacrifice; Sacrificial Implements.
Relief from the Arco degli Argentarii, Rome

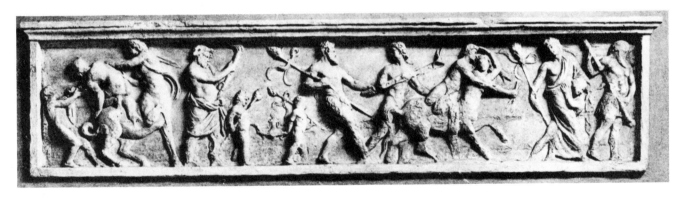

173. Dionysiac Procession. Hellenistic relief. Rome, Musei del Vaticano, Cortile del Belvedere

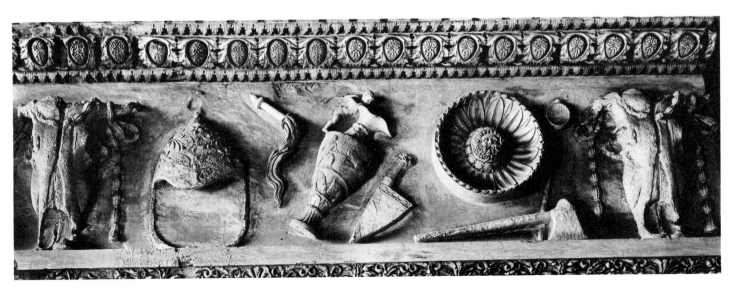

174. Bucrania and Sacrificial Instruments. Relief from the Temple of Vespasian. Rome, Tabularium

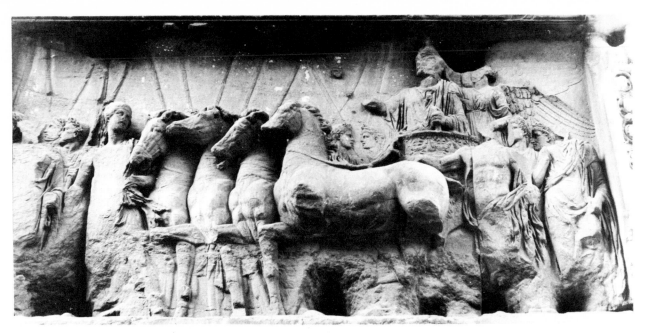

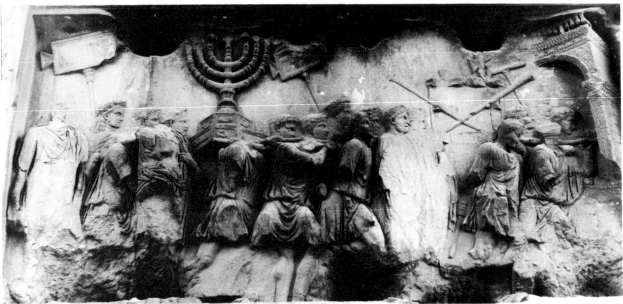

175–176. Reliefs from the Arch of Titus, Rome

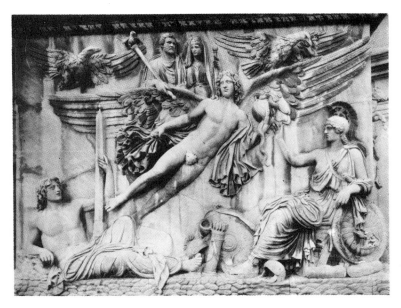

177. *Apotheosis of Antoninus Pius and Faustina*. Relief from the base of the Column of Antoninus. Rome, Vatican, Cortile della Pigna

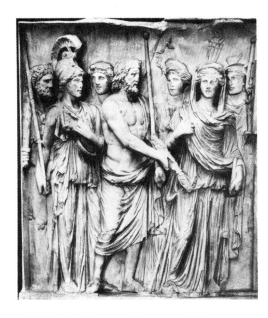

178. *Jupiter between Minerva and Juno*. Relief from the Arch of Trajan, Benevento

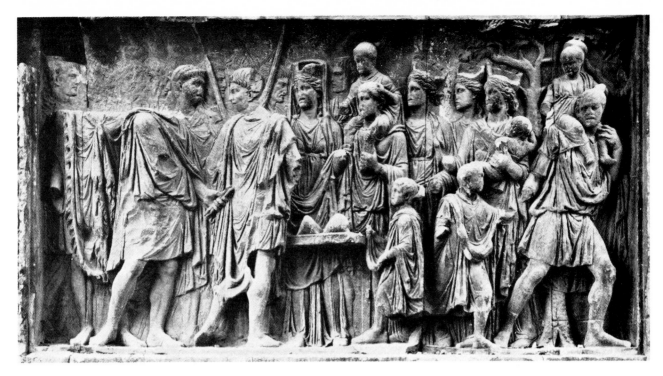

179. *Alimenta.* Relief from the Arch of Trajan, Benevento

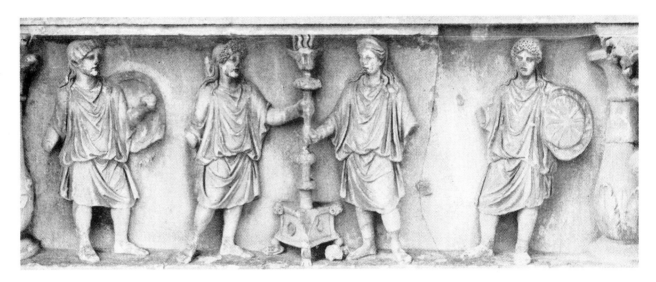

180. Figures with candelabra. Relief from the Arch of Trajan, Benevento

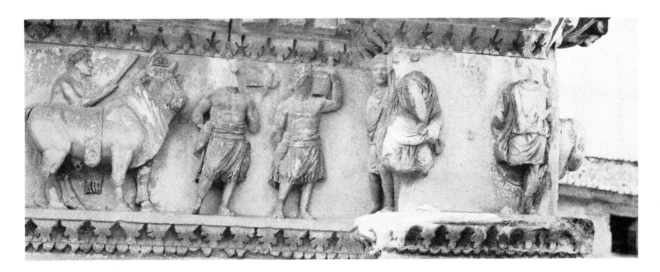

181. Triumphal Procession. Detail of the Arch of Trajan, Benevento

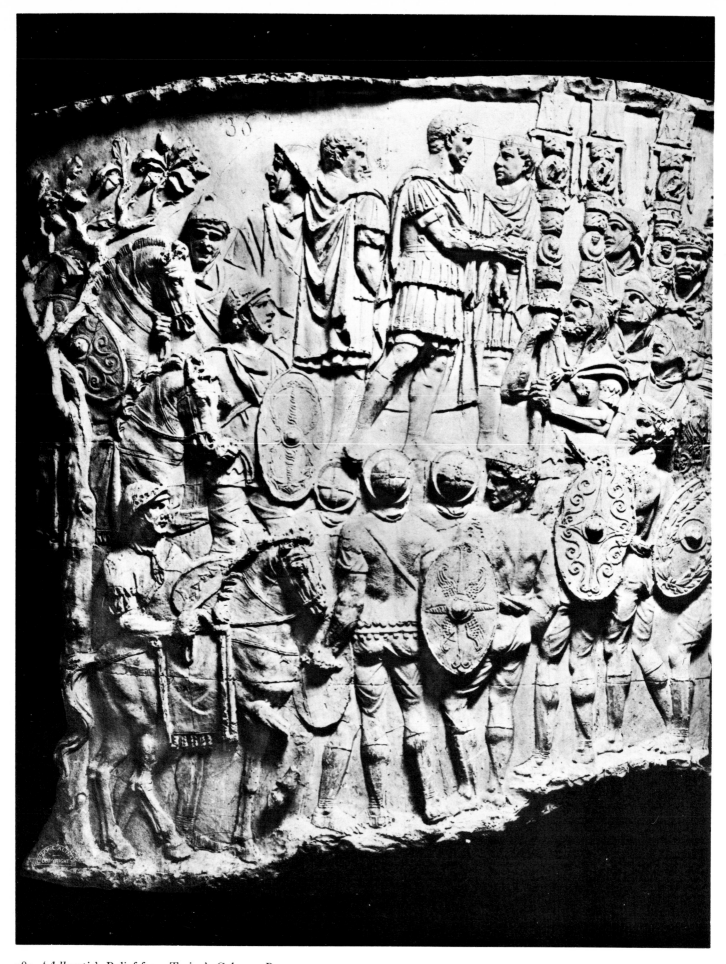

182. '*Adlocutio*'. Relief from Trajan's Column, Rome

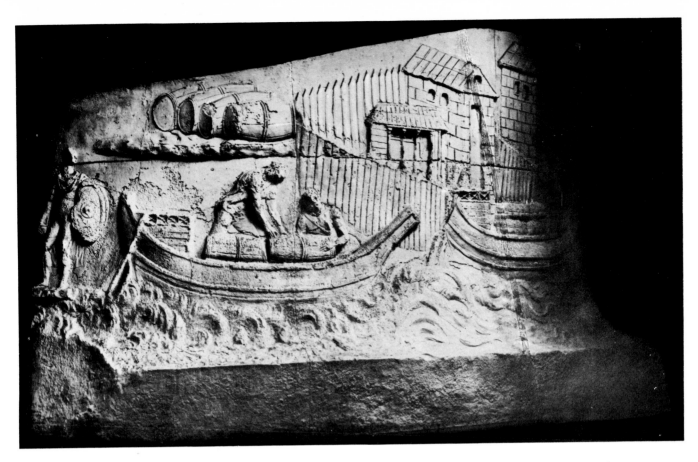

183. Opening scene from relief on Trajan's Column, Rome

184. Base of Trajan's Column, Rome (after Bartoli)

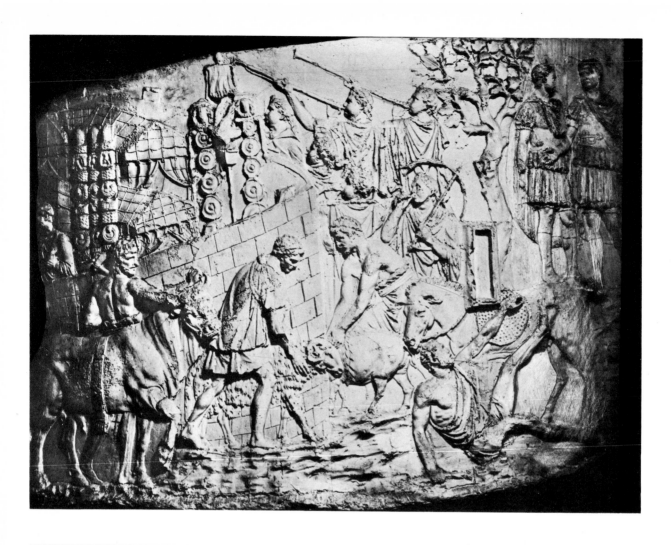

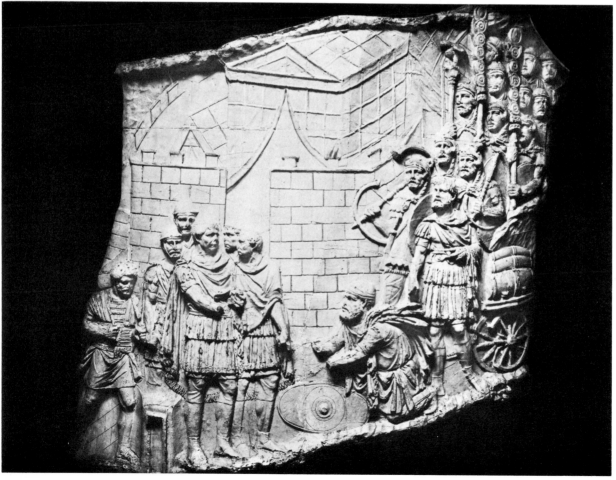

185–186. *Scene of Sacrifice; Trajan receiving a Dacian Emissary*. Reliefs from Trajan's Column, Rome

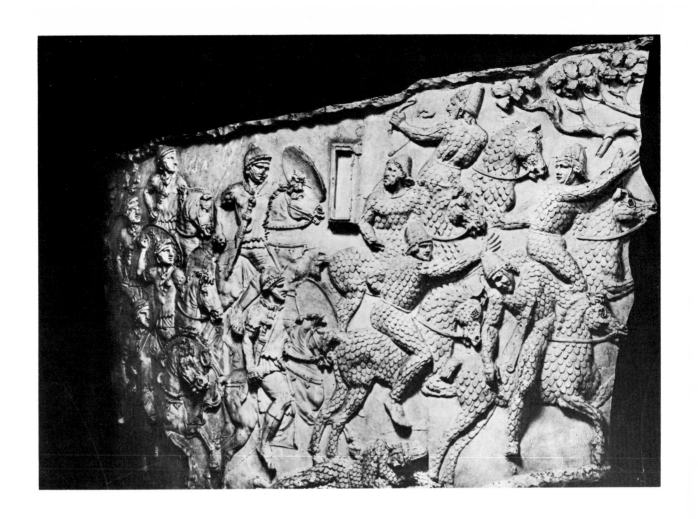

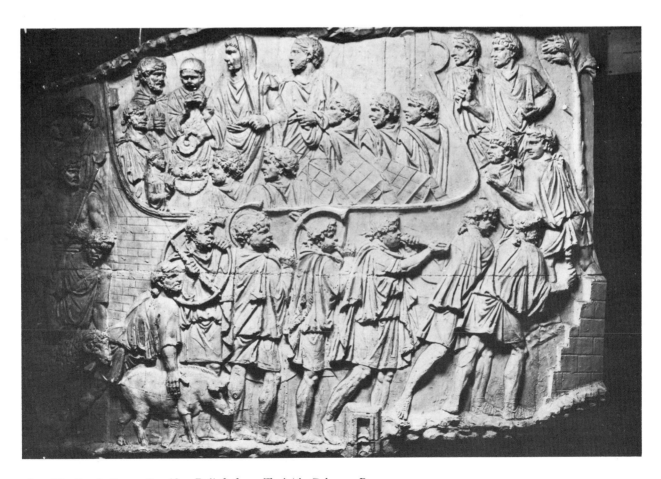

187–188. *Battle Scene; Sacrifice.* Reliefs from Trajan's Column, Rome

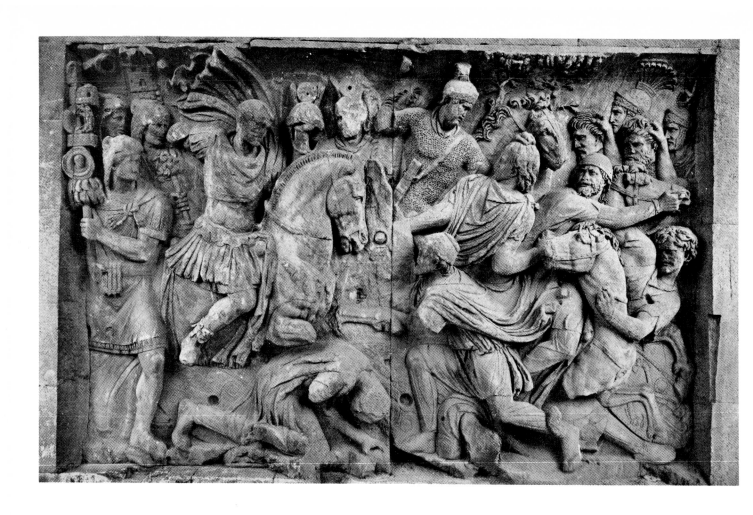

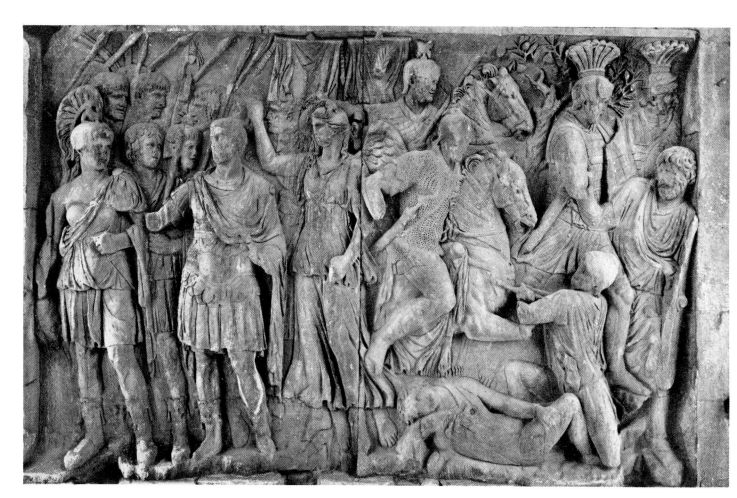

189–190. *Trajan's Battle with the Dacians; Entry of Trajan into Rome.* Part of the Great Trajanic Frieze, Arch of Constantine, Rome

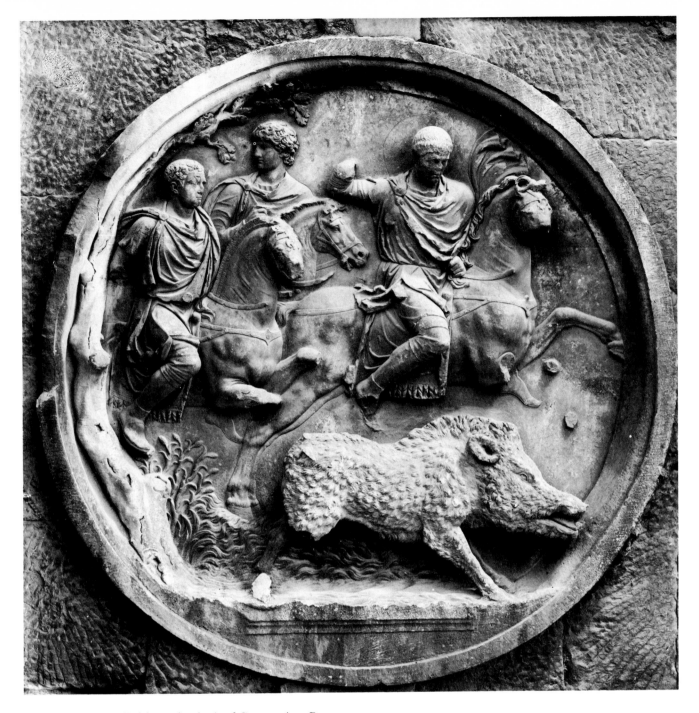

191. *Boar-hunt*. Relief from the Arch of Constantine, Rome

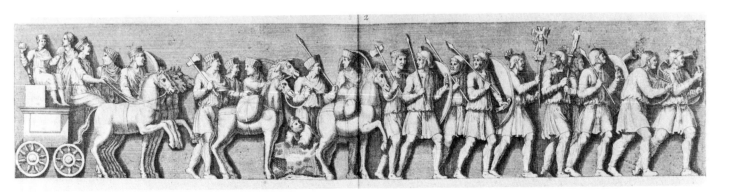

192. *The Army of Constantine setting out from Milan*. Relief from the Arch of Constantine, Rome (after Montfaucon)

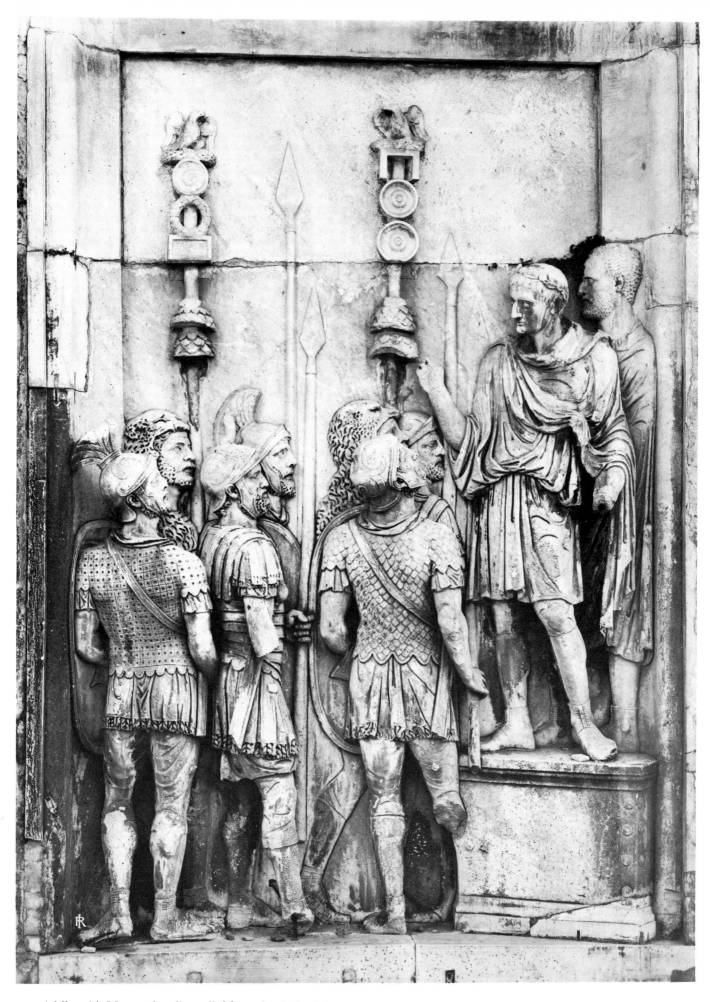

193. '*Adlocutio*'. Marcus Aurelius relief from the Arch of Constantine, Rome

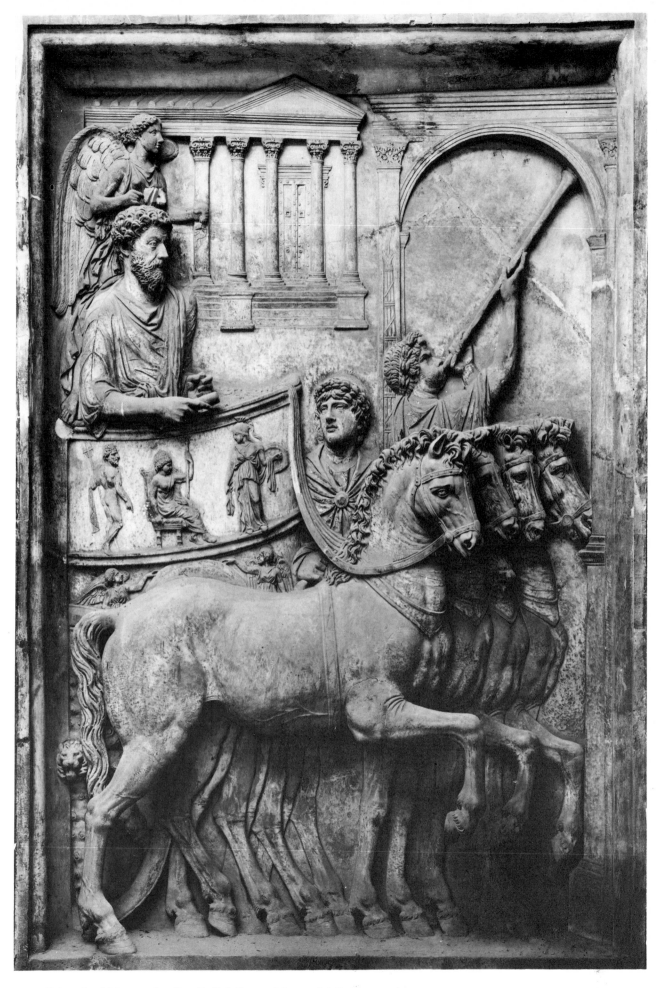

194. *Triumph of Marcus Aurelius*. Relief. Rome, Museo dei Conservatori

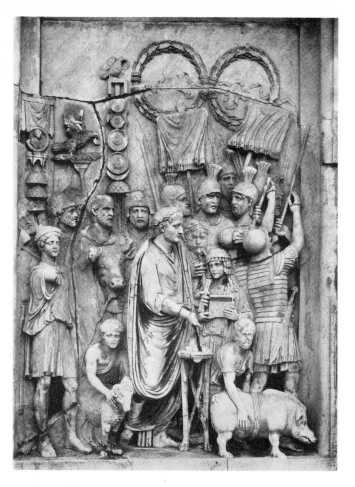

195. '*Lustratio*'. Marcus Aurelius relief
from the Arch of Constantine, Rome

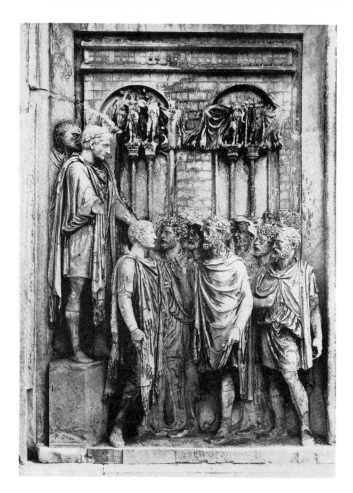

196. '*Rex Datus*'. Marcus Aurelius relief
from the Arch of Constantine, Rome

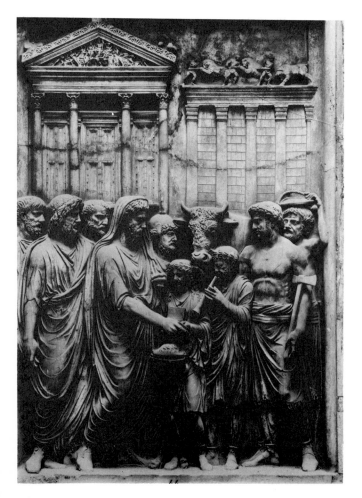

197. '*Sacrifice*'. Marcus Aurelius relief.
Rome, Museo dei Conservatori

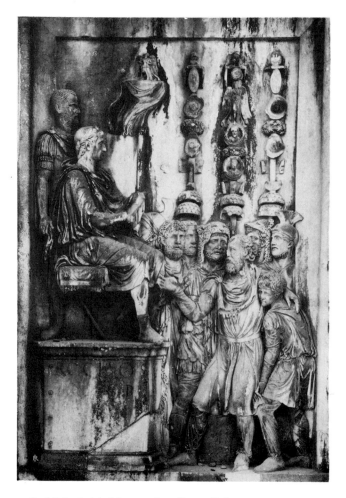

198. '*Submissio*'. Marcus Aurelius relief
from the Arch of Constantine, Rome

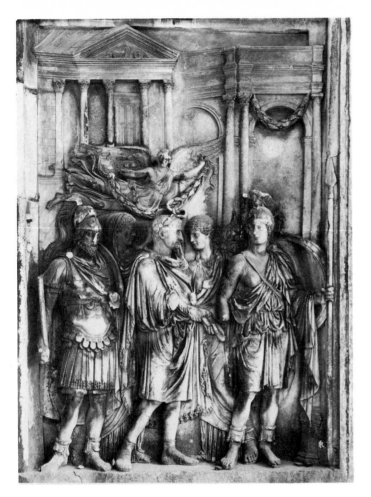

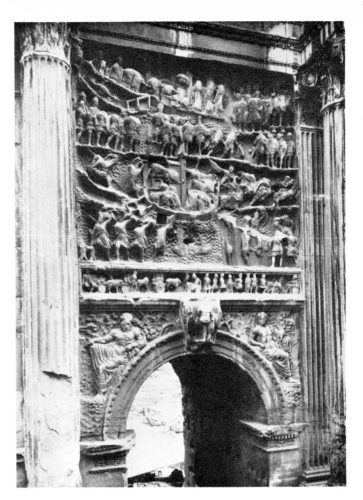

199. '*Adventus*'. Marcus Aurelius relief
from the Arch of Constantine, Rome

200. Scenes from the Parthïan Wars. Relief on
the Arch of Septimius Severus, Rome

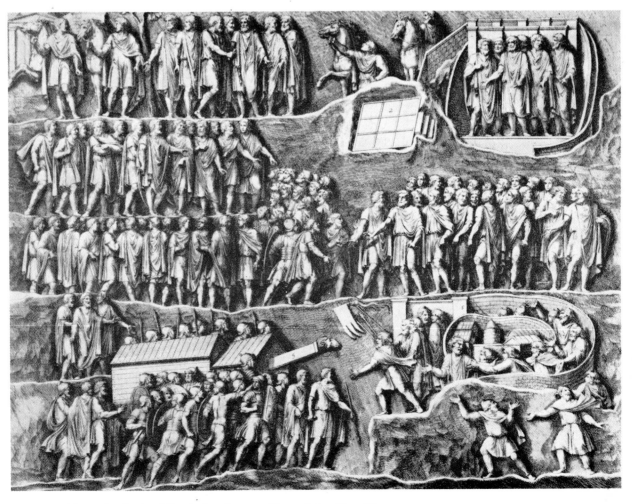

201. Relief from the Arch of Septimius Severus, Rome (after Bartoli)

202. Zeus. Marble bust. Florence, Uffizi

203. Bust of Lucilla (?). Mantua, Palazzo Ducale

204. 'Pomona'. Florence, Uffizi

205. Hercules. Rome, Musei Vaticani

206. *Eros*. Rome, Museo Capitolino

207. *Mars*. Rome, Museo Capitolino

TROFEI DI TRAIANO

208. Trophies of Arms. Rome, Capitol (after Bartoli)

209–210. Trophies of Arms. Rome, Palazzo dei Conservatori

211. Arms and Armour. Relief from the Arch of the Sergii, Pola (after Stuart and Revett)

212　　　　　　　213　　　　　　　214　　　　　　　215

216　　　　　　　217　　　　　　　218

212–218. Piers carved with Arms Trophies. Florence, Uffizi.

219. Legionary eagle between two standards. (SPQR OPTIMO PRINCIPI) Denarius, reign of Trajan (A.D. 98–117)

220. Crescent and Star. (COS III) Denarius, reign of Hadrian (A.D. 117–138)

221. Peacock. (CONCORDIA AVGVST) Aureus, reign of Domitian (A.D. 81–96)

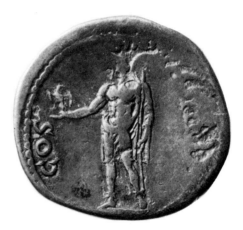

222. Oak Wreath. (SPQR ADSERTORI LIBERTATIS PVBLIC) Sestertius, reign of Vespasian (A.D. 69–79)

223. Jupiter, naked, except for cloak, holding eagle and sceptre. (COS III) Tetradrachm, reign of Hadrian (A.D. 117–38)

224. *Liberalitas*, holding account-board and Cornucopia. (LIBERALITAS AVG VII) Denarius, reign of Hadrian (A.D. 117–38)

225. *Pax*, holding branch and Cornucopia. (PAX AVGVSTI) Sestertius, reign of Vespasian (A.D. 69–79)

226. *Securitas* enthroned. (SECVRITAS AVG) Aureus, reign of Hadrian (A.D. 117–38)

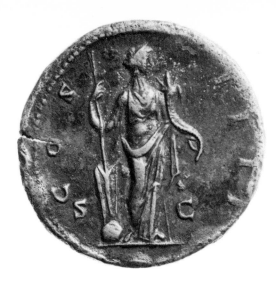

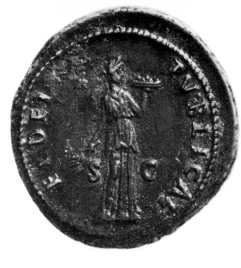

227. *Fortuna* beside Globe, holding Rudder and Cornucopia. (COS IIII SC) Sestertius, reign of Antoninus Pius (A.D. 138–61)

228. *Fides* holding raised dish of Fruits and Ears of Corn. (FIDES PVBLICAE SC) As, reign of Domitian (A.D. 81–96)

229. Head of *Roma* helmeted. Roman Republic

230. Cybele with turreted crown. (CESTIANVS) Roman Republic

231. Simpulum, sprinkler, jug and lituus. (AVGVR. TRI. POT) Denarius, reign of Vespasian (A.D. 69–79)

232. Triumphal Chariot drawn by four Horses; behind four Helmets on Poles. (SANCT DEO SOLI ELAGABAL) Aureus, reign of Elagabalus (A.D. 218–22)

233. Standing figure of Neptune. (PM TR P COS III) Aureus, reign of Hadrian (A.D. 117–38)

234. Winged Thunderbolt. (PROVIDENTIAE DEORVM SC) Sestertius, reign of Antoninus Pius (A.D. 138–61)

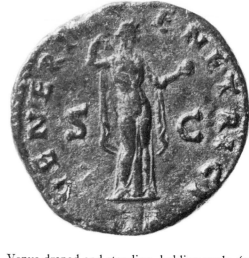

235. Venus draped and standing, holding apple. (VENERI GENETRICI SC) Sestertius, reign of Hadrian (A.D. 117–38)

236. Head of Domitian. (CAES DIVI AVG VESP F DOMITIANVS COS VII) Sestertius, reign of Titus (A.D. 79–81)

237. Augustus enthroned on Chariot, drawn by four Elephants. (DIVO AVGVSTO SPQR) Sestertius, reign of Titus (A.D. 79–81)

238. Bust of Faustina the Elder. (DIVA FAVSTINA) Sestertius, reign of Antoninus Pius (A.D. 138–61)

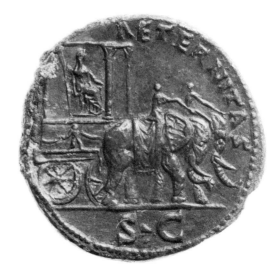

239. Faustina enthroned on car drawn by two Elephants. (AETERNITAS SC) Reverse of 238

240. Minerva, armed, dropping incense on candelabrum. (PM TR P COS III SC) Sestertius, reign of Hadrian (AD 117–138)

241. Antoninus on Horseback. (TR POT XIIII COS IIII SC) Dupondius, reign of Antoninus Pius (A.D. 138–161)

242. Legionary Eagle between two Standards, one surmounted by a Hand. (COS) Tetradrachm, reign of Nerva (A.D. 97)

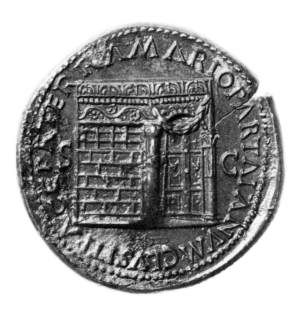

243. View of Temple of Janus. (PACE PR TERRA MARIQ PARTA IANVM CLVSIT SC) Sestertius, reign of Nero (A.D. 54–68)

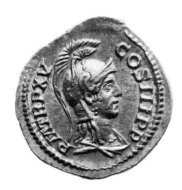

244. Bust of Minerva, helmeted. (PM TR P XV COX III PP) Aureus, reign of Septimius Severus (A.D. 193–211)

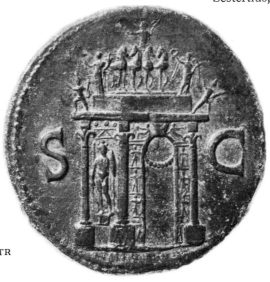

245. View of Triumphal Arch. (SC) Sestertius, reign of Nero (A.D. 54–68)

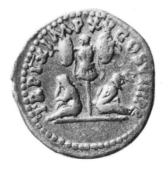

246. Two Captives seated on either side of a Trophy of Arms. (TR P IX IMP XV COS VIII PP) Aureus, reign of Titus (A.D. 79–81)

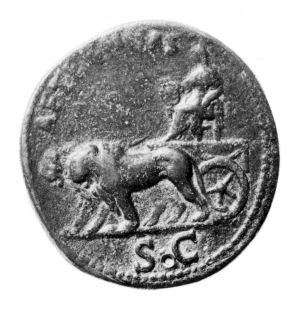

247. Faustina enthroned on car drawn
by two Lions. (AETERNITAS SC) Sestertius,
reign of Antoninus Pius (A.D. 138–61)

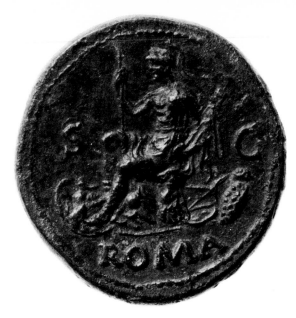

248. *Roma* seated, with Arms and
Armour. (SC ROMA) Sestertius, reign of Galba (A.D. 68–69)

249. Head of Caesar. (CAESAR IMP)
Roman Republic (B.C. 44)

250. Head of Caesar. Denarius,
Roman Republic (B.C. 42–39)

251. Rudder with Globe and
Cornucopia, winged Caduceus.
(L MVSSIDIVS LONGVS) Reverse of 250

252. *Victory* holding Palm and Wreath.
(SC) Sestertius, reign of Vespasian
(A.D. 69–79)

253. Ceres enthroned holding two Corn Ears and Poppy, and Cornucopia. (CONCORDIA AVG) Denarius, reign of Vespasian (A.D. 69–76)

254. Germanicus standing, armed, bearing eagle sceptre. (SIGNIS RECEP DEVICTIS GERM SC) Dupondius, reign of Caligula (A.D. 37–41)

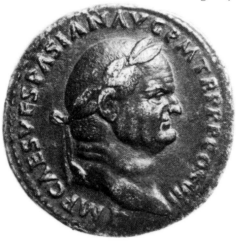

255. Head of Vespasian. (IMP CAES VESPASIAN AVG PM TRPPP COS VII) Sestertius, reign of Vespasian (A.D. 69–79)

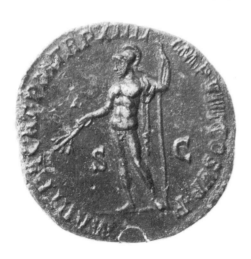

256. Mars, in Helmet and Cloak, holding Branch. (MART PACAT PM TR P XIIII IMP VIII COS V PP SC) Sestertius, reign of Commodus (A.D. 180–92)

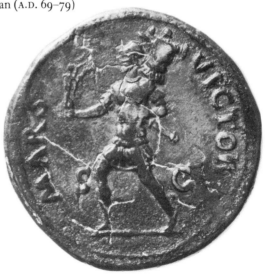

257. Mars holding Victory and military Trophy. (MARS VICTOR SC) Sestertius, reign of Vespasian (A.D. 69–79)

258. Neptune seated. Engraving of an Antique Gem
(after Jacobus de Wilde, Amsterdam 1703)

259. Roman Eagle. Rome, SS. Apostoli

260. Ponte delle Torre, Spoleto

261. Detail of Rustication. Venice, S. Michele in Isola

262. Balustrade of *pulpitum*. Venice, S. Maria dei Miracoli

263. Mantua, Palazzo Ducale. After Braun and Hohenberg, *Civitates Orbis Terrarum* (1574)

264. Mantua, Palazzo del Capitano and Domus Magna

265. Mantua, Palazzo Ducale (after Bertazzolo, 1628 edition)

266. Mantua, Palazzo del Capitano, Corridoio del Passerino

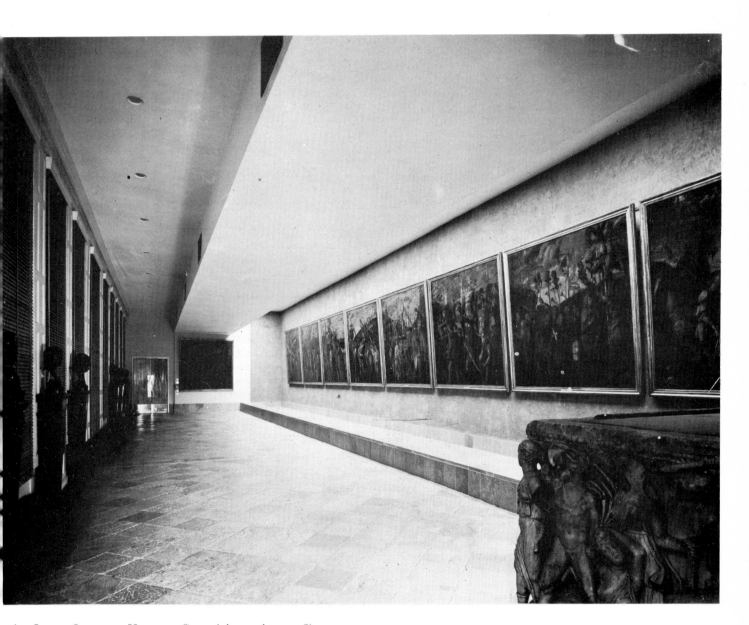

267. Lower Orangery, Hampton Court (photo taken 1978)

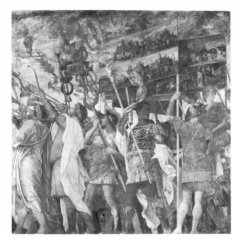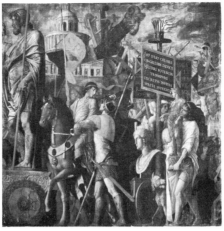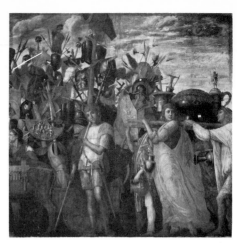

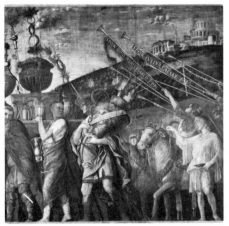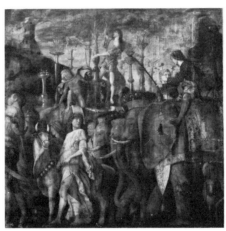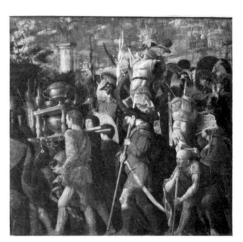

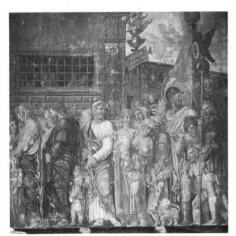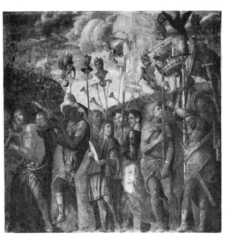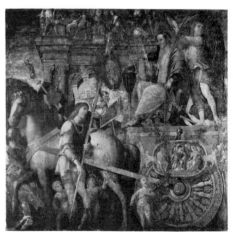

268. Mantegna's Triumphs of Caesar, at Hampton Court, reproduced in sequence

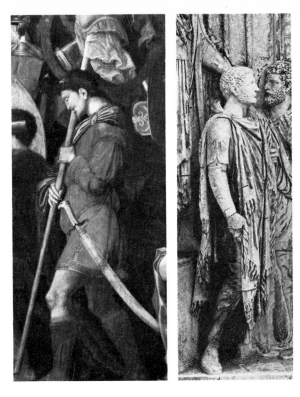
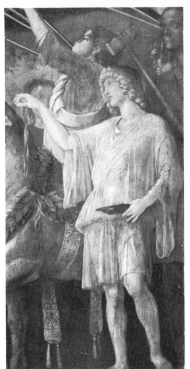
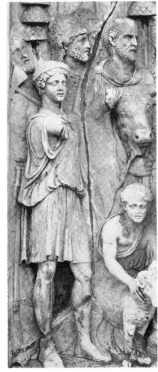

269. Short cloak fastened with clasp

270. Short tunic

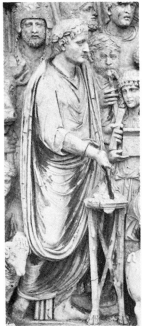

271. Toga

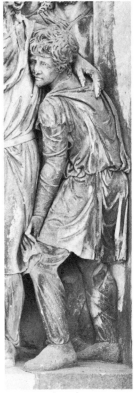

272. Barbarian trousers

273. Andrea Mantegna:
The Triumphs of Caesar, Canvas VII,
The Captives, present state, 1979

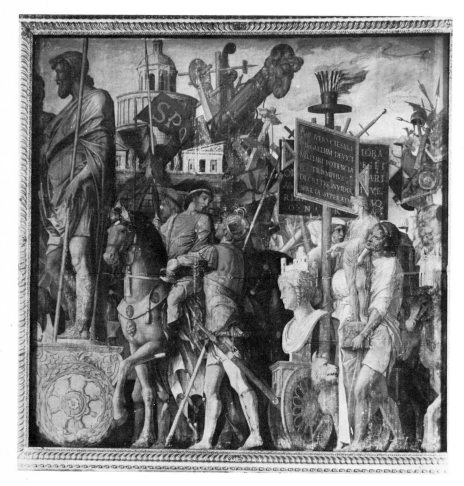

274. Andrea Mantegna:
The Triumphs of Caesar, Canvas II
shown in late seventeenth-century frame

275. Macro-photograph of part of Canvas of Mantegna's Triumphs of Caesar

276. Andrea Mantegna: The Triumphs of Caesar,
Lion's Head from Canvas II

INDEX

Index

INDEX

338